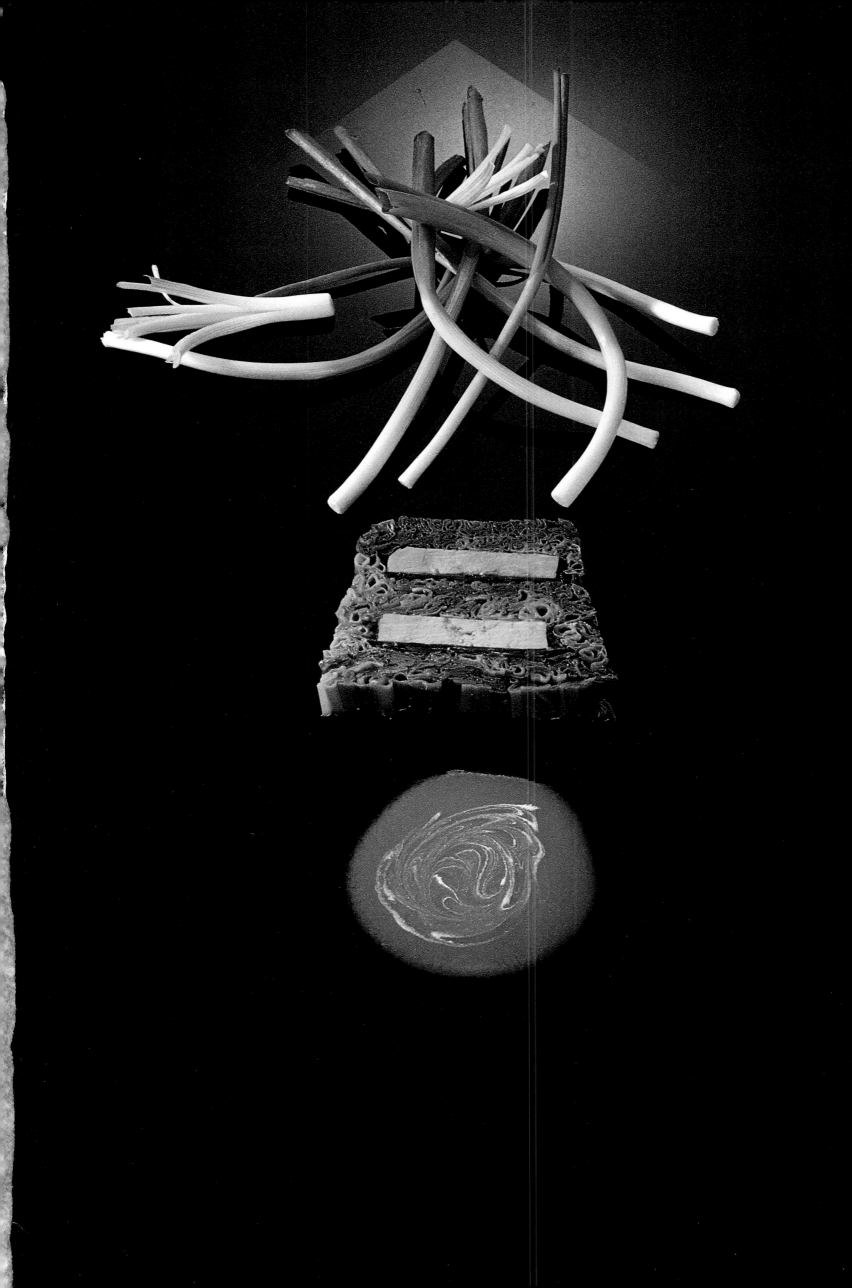

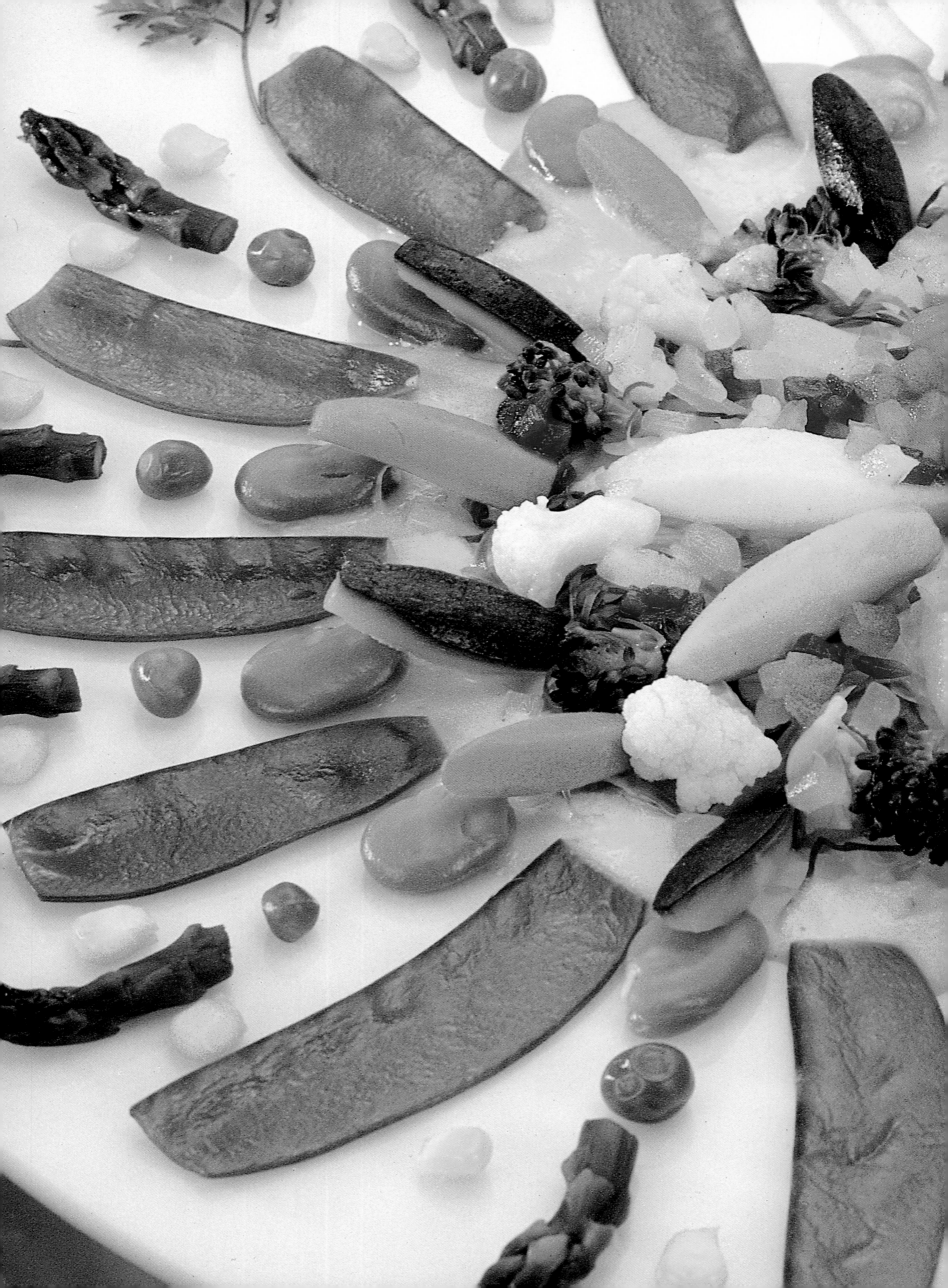

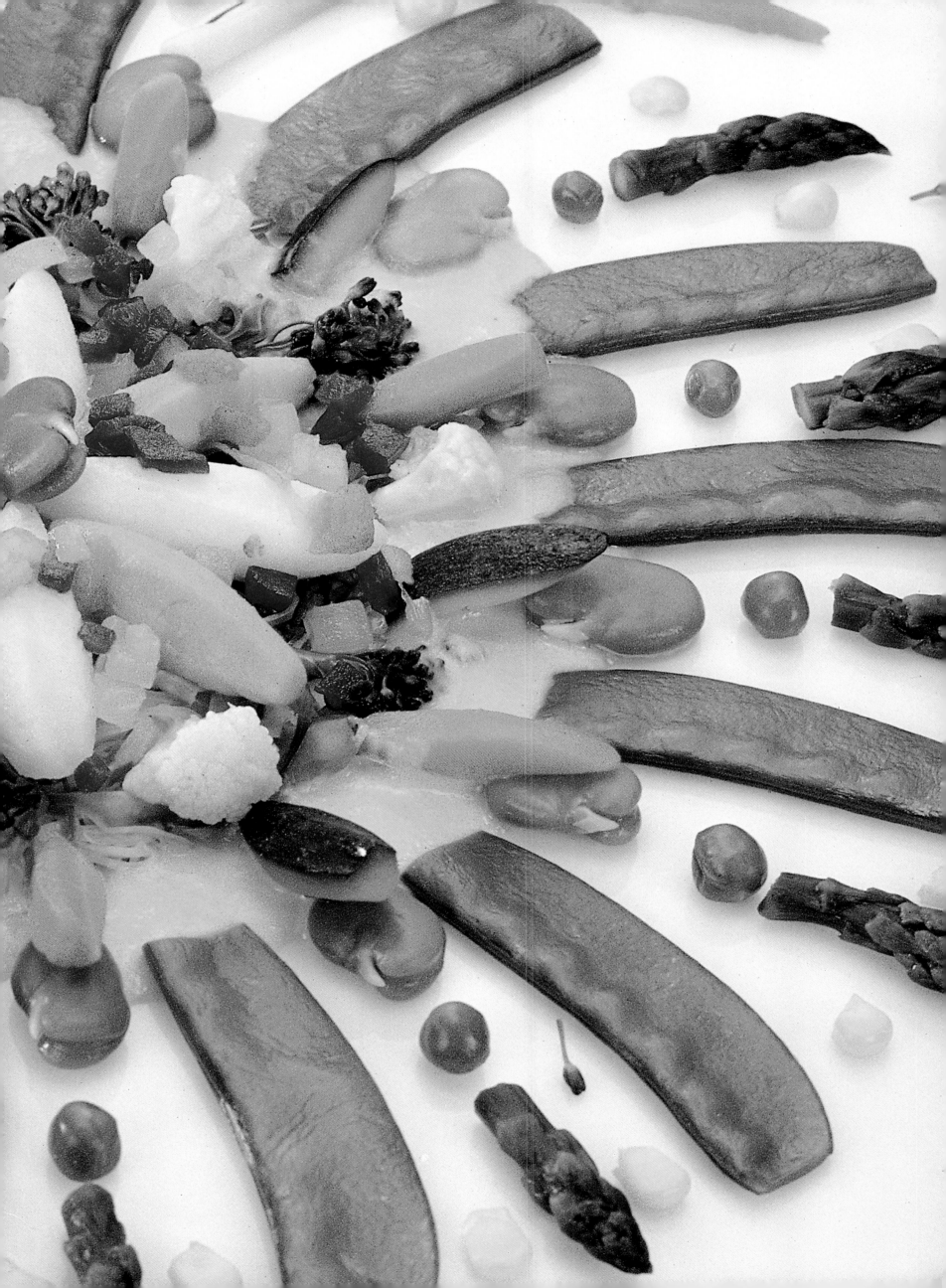

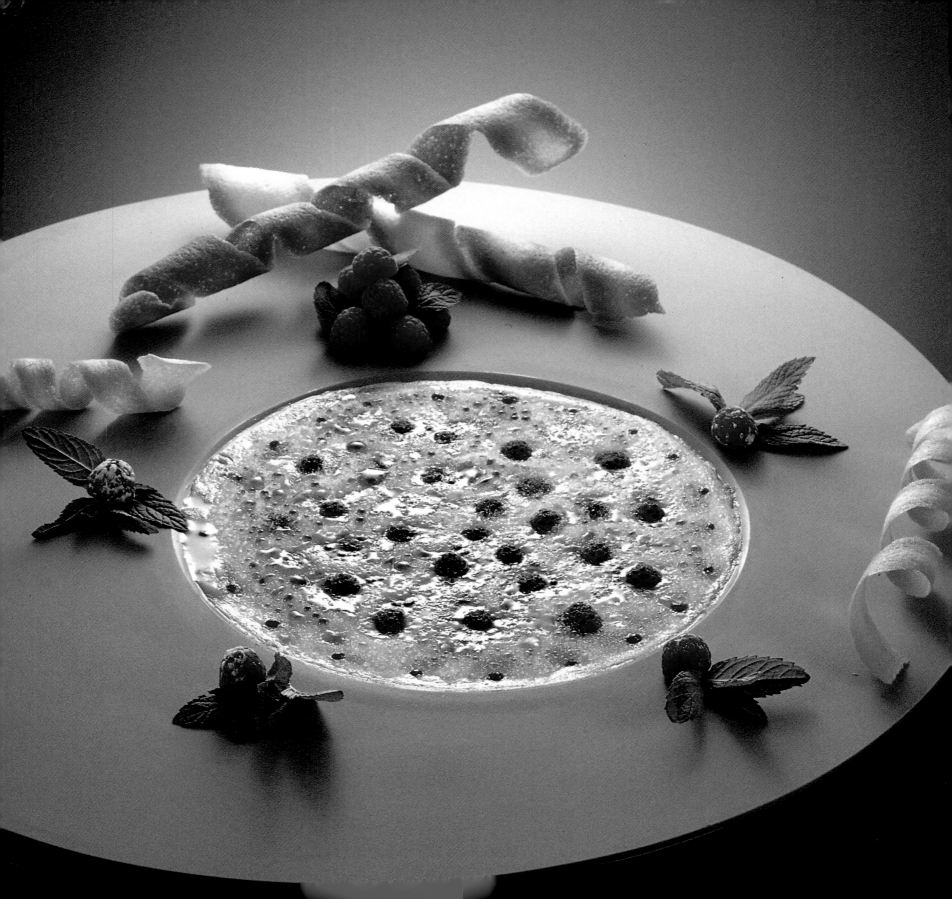

JEAN-LOUIS
COOKING WITH THE SEASONS

FRED J. MAROON

THOMASSON-GRANT

Published by Thomasson-Grant, Inc.: Frank L. Thomasson III and John F. Grant, Directors; C. Douglas Elliott, Vice President, Product Development; Carolyn M. Clark, Creative Director; Megan Rickards Youngquist, Mary Alice Parsons, Art Directors; Hoke Perkins, Senior Editor; Jim Gibson, Production Manager.

Designed by Megan Rickards Youngquist
Edited by Elizabeth L. T. Brown
and Rebecca Beall Barns
Concept and photography by Fred J. Maroon
Recipes by Jean-Louis Palladin
Acrylic sculptures by Jeffrey Bigelow
Interviews by Suzy Maroon
Recipes written and tested by Catherine Grove
and Paulette Rittenberg
Recipes edited by Paulette Rittenberg

Any inquiries should be directed to Thomasson-Grant, Inc., One Morton Drive, Suite 500, Charlottesville, Virginia 22901 (804) 977-1780

Library of Congress Cataloging-in-Publication Data

Maroon, Fred J.
 Jean-Louis, cooking with the seasons.

 Includes index.
 1. Cookery, French—Pictorial works. 2. Menus.
3. Palladin, Jean-Louis. I. Palladin, Jean-Louis.
II. Title.
TX652.M27 1989 641.5944 88-51106
ISBN 0-934738-49-1

(Page 1) TERRINE OF FOIE GRAS AND SPRING ONIONS with PROSCIUTTO AND FRESH HERB TOMATO SAUCE
(Pages 2-3) BLANQUETTE OF FRESH VEGETABLES with CARROT AND CHARDONNAY CREAM SAUCE
(Page 4) CREME BRULEE with RASPBERRIES

THOMASSON-GRANT
Charlottesville, Virginia

ACKNOWLEDGMENTS

Many talented and generous associates have been important in the making of this book. Photographic assistance was rendered by Richard Frasier, my children, Marc, Anne, Sophia, and Paul, and Jean-Louis himself, who pitched in good-naturedly when not occupied with his primary task. I am especially grateful to Ed Joseph, who made the still life platform that I used. Dick Slade and his assistants patiently filmed us on video through much of our studio production. Jack Beveridge and Ed Byrd participated during the early planning stages of the book. Louis Mercier, my long-time friend and agent, offered as always valuable critique and guidance. Chrome, Inc. in Washington gave me flawless film processing. Rod Mitchell provided hospitality and seafood while I was photographing in Camden, Maine. Thanks go also to all the people at Thomasson-Grant, masters of superb bookmaking, who never settle for anything less than the best. Finally, my wife, Suzy, kept things organized as usual and made an additional major contribution to this book by interviewing Jean-Louis and helping to edit the text. None of my books would be possible without her.

— Fred J. Maroon
Washington, D.C.

I would like to pay special tribute to the memory of René Sandrini, who introduced me to the world of cooking 30 years ago in Condom, France. I will be forever indebted to Ambassador Nicolas Salgo for bringing me to America. I am grateful to Fred Maroon for agreeing to do this book and to Jeffrey Bigelow for creating the exquisite acrylic sculptures. To Catherine Grove, I owe special thanks. She not only put a tremendous amount of work into recreating the dishes and testing the recipes, but she also put a lot of heart into helping me. Paulette Rittenberg edited the recipes with the painstaking patience of a Swiss watchmaker. With Michel Richard, I have enjoyed hours of conversation about our profession. Léon Pinto has been a source of good advice. Gérard Cabrol helped with the tasting of this book's wine, most of which was selected by my sommelier, Mark Slater. My friends Gaby Aubouin and Francis Layrle have always been there when I needed them. Jimmy Sneed gave me invaluable support during his five years with me. The Cunard Line's Albert Van Ness has allowed me the freedom I need to operate my business. Having Alain Matrat as my maitre d' has always given me complete confidence that the front of the house is running smoothly. Katherine Dinardo, who has worked with me for eight years, has shared with me the recipe for the world's best cheesecake. My restaurant's entire staff have earned my gratitude for their loyalty during some stormy moments. I have been fortunate to work with some remarkable pastry chefs, among them Ann Amernick and Richard Chirol. In particular, Cal Stamenov is responsible for a number of the desserts in this book. My thanks are due to my loyal purveyors and friends: David Yevzeroff, Richard Ober, Jean-François Calza and his family, Rod Mitchell and his divers, Ariane Daguin and her partner Georges, Bill and Carole Watman. Finally, my greatest thanks must go to my wife, Régine, my two children, Verveine and Olivier, and my sister, Monique, who for so many years have given me the strength and support I need to practice my beautiful métier, and who understand when I cannot spend as much time with them as I would like. It is to them that I dedicate this book.

— Jean-Louis Palladin
Jean-Louis at the Watergate Hotel
Washington, D.C.

Table of Contents

Introduction

I first met Jean-Louis Palladin in June 1984, when the French magazine *Elle* was gearing up to launch its new American edition. Jean-Louis, who at the age of 28 had become the youngest-ever Michelin two-star chef, was already highly regarded in France and was now quickly making a name for himself as one of the premier chefs in the United States. He was a natural subject for *Elle*, and it was my good fortune to be assigned to photograph Jean-Louis and his work. That two-day shoot introduced me to an exquisite, unique cuisine, and I was spoiled forever.

Several weeks after the article appeared in *Elle*, Jean-Louis called to sound me out on the idea of doing a book of photographs of his food. Until then, although I had photographed food many times, I had never really thought of it as something on which I might someday do a book, but neither had I encountered dishes as remarkable as those of Jean-Louis. Superb taste I expected; it was the sheer beauty of his presentations which captivated me. As a trained architect, student of painting, and professional photographer, I was convinced that his food could be photographed as art, and that this was a project I wanted to do. Soon Jean-Louis and I were off on a creative journey, mutually supportive and inspired.

Whenever I begin work on a new book, I try to approach the task with an open mind and let the structure evolve from the subject. However, I knew from the beginning that a book on the food of Jean-Louis Palladin would have to be as unconventional as his cuisine. Traditional table settings or flowers would only be distracting; his food needs no accessories.

When Jean-Louis and I were considering the best way to present his work, he suggested that we talk to his friend Jeffrey Bigelow, a nationally known sculptor who works in acrylic. We met in Bigelow's studio and asked him to design for us some vessels in a variety of geometric shapes that could serve as plates and bowls. He produced a series of fascinating pieces, some solid, some laminated, and all in neutral colors. Each was itself a work of art.

Back in my own studio, I found that I could play with the reflective qualities of the acrylic surfaces, creating patterns of light and shadow that directed the eye to the color and texture of Jean-Louis' food. With variations of lighting, lens, and perspective, different pieces took on different looks, thus providing an almost infinite choice of visual effects. The Bigelow sculptures gave both variety and continuity, resulting in a type of food photography unlike any I had ever done or seen.

We never planned a day's shoot ahead of time. At about ten in the morning, Jean-Louis would arrive at my studio with fresh produce. As always with master chefs, the quality of the produce available determined his menu. After he described what he planned to cook, we decided which sculpture to use. Occasionally he showed me a pencil sketch of the presentation he had in mind, but more often he worked intuitively on the acrylic, much as a painter does on canvas. Unlike canvas, however, the acrylic was unforgiving. The food placement had to be right the first time because grease showed glaringly in the camera if we moved an item. We also soon learned that no matter what we did to prevent static electricity, the acrylic quickly attracted dust.

Except for a few items that were cooked by necessity in his restaurant, Jean-Louis prepared everything right alongside the set in my studio's kitchen. As his work took shape, I organized my approach to the photograph and decided on the appropriate lighting, lens, and angle. Though many food specialists favor large-format cameras, I have always preferred shooting in 35mm. Combined with Professional Ektachrome 64 film, the sharpness of 35mm Leica optics, especially 60 Macro and 100 APO-Macro lenses on a Leica R5, give all the quality anyone could want. Furthermore, this equipment enables me to make rapid changes in angles, lenses, and camera bodies. Six Dynalite strobe heads, mounted in Photoflex softboxes or with snoots, or filtered through acrylic or Rolux, helped create the effects I desired.

Often it was early afternoon before a dish was ready for my camera. From that moment on, I battled time. Under the hot modeling lights, sauces would congeal, fish, meats, and vegetables would dry out and change color, and ice creams and sorbets would melt. Sometimes I had just a few minutes, rarely more than 10 or 15; an occasional salad could be shot over a leisurely 20-minute period. The challenges reminded me of fast-moving photojournalism.

What is more, each dish was one of a kind. We had no food stand-ins and used no photographic tricks. If anything went wrong, we had to start over from scratch. Everything we photographed was fresh, seasoned, and ready to eat. And eat it we did!

— Fred J. Maroon

Autumn

The rhythm of the seasons is wonderful. It has inspired painters and musicians for centuries, and it does the same for me. Autumn is the time when nature slows down a little, resting after the heat of summer. The trees quietly begin to lose their leaves, and the gorgeous colors make me want to walk in the forest to discover again the perfumes of autumn.

I have been cooking with the seasons all my life because people didn't have refrigerators in Condom when I was growing up. The cuisine in the Gascony area of southwest France developed from the fresh produce that was available locally at different times of the year. In the States, of course, there are many climates, and air freight is now so efficient that I can cook something at my restaurant in Washington that was picked in another part of the country that morning. Still, I prefer to focus on produce that is specific to the season because it's much more interesting, and I think that is the most important thing—to be happy with what you are doing. I use the same elements for three months, and then I like to forget them and move on to something else.

Autumn is the season of mushrooms, when the weather is humid and a little cold. If you live in a small French village, mushrooms are a big part of your life. When I was young, I used to wake up at five in the morning and go with friends into the forest where I knew mushrooms were growing. By eleven, I would have gathered four or five pounds of mushrooms, and I would be really happy because I knew I would have a good lunch that day. Ten years ago, if you were talking about mushrooms in America, you only meant button mushrooms; people didn't want to

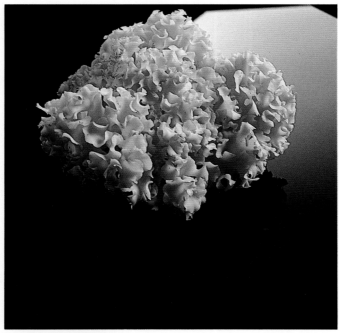

CAULIFLOWER MUSHROOM

taste any other type because they were afraid of getting sick. Now I have a supplier in Oregon who sends me morels, chanterelles, and other varieties—many more kinds than I ever saw in France. If someone brings me a mushroom I'm not familiar with, I make him eat one and tell him to call me in a few hours. Then I decide whether to put it on my menu.

Perhaps the best gift of the season is foie gras. Although we can have it year-round, I associate it with autumn because that is the time farmers began force-feeding the ducks and geese when I was a boy. You need about three weeks to fatten them, and before air-conditioning it was too hot in the summer for this. The birds would suffer and get short of breath, and the foie gras would not be as good.

Foie gras is an integral part of my cooking. Along with truffles and caviar, it is one of the three important ingredients which are difficult to find in this country. However, I'm sure the day will come when Americans raise geese for foie gras. We already have duck foie gras, but geese are more fragile and expensive to care for. Also, farmers have not been allowed to import the right kind of goose, the type we find around Toulouse.

Duck foie gras is very good, and I even prefer it to goose when it is served hot. But cold goose foie gras is a true delicacy. To make foie gras, the farmer fattens the geese with corn. Most foie gras you find comes from geese fed with white corn, but I really prefer the taste and color produced by feeding with yellow corn. It's a small difference, but when you are born in my area, you know ducks and geese like your own parents.

On each of my autumn and winter menus, you will find a hot soup or a consommé; in warm weather, I prepare cold soups. Even if people only want to eat three or four dishes, I always give them soup. I love soup because my mother taught me to love it. My father, an Italian, was a very hard worker, and if he didn't have a pot of soup every day, he was the most unhappy guy in the world. My mother made many different kinds, and for Christmas we often had pumpkin soup. I served soup a lot in my restaurant in France, but when I first came to America in 1979, there were very few interesting soups on the menus. The choice seemed limited to onion soup or vichyssoise. I think I helped introduce Washingtonians to a lot of new varieties because they're on my menu all the time. I have soup running through my veins!

CEPE MUSHROOM "PURSES" with SAUTEED CEPE CAPS and CEPE SAUCE
Bollinger Blanc de Noirs, "Vieilles Vignes," 1975

∽

CREAM OF PUMPKIN SOUP with SHALLOT FLAN, BREAST OF SQUAB
AND BLACK TRUFFLE QUENELLES, CONFIT OF MULARD DUCK GIZZARDS,
and MIREPOIX OF PUMPKIN, SQUAB, AND PROSCIUTTO
Mercurey, Lupé-Cholet, 1979

∽

SEA URCHIN "TONGUES" with SEA URCHIN FLAN and SEA URCHIN SAUCE
Château Haut-Brion Blanc, Graves Grand Cru, 1983

∽

FRICASSEE OF FRESH SNAILS, CRISPY SWEETBREAD MIREPOIX, PROSCIUTTO,
AND CHANTERELLE MUSHROOMS with SHALLOT SAUCE
Sanford Winery Pinot Noir, Central Coast, 1984

∽

SAUTEED SANTA BARBARA SHRIMP and CREAMED LEEKS
with FRESH AND SUN-DRIED TOMATO SAUCE
Chevalier-Montrachet, "Les Demoiselles," Domaine Louis Jadot, 1985

∽

CONFIT OF MULARD DUCK LEGS with POTATOES A LA SARLADAISE
and BLACK TRUFFLE SAUCE with MULARD DUCK "HAM"
Château Lynch-Bages, Pauillac, 1966

∽

PROFITEROLES with CHOCOLATE GINGER MOUSSE and CHOCOLATE SAUCE

APPLE AND PEAR TART with MINT ICE CREAM and GRAND MARNIER CREAM
WITH SAUTEED FRESH BERRIES IN PUFF PASTRY
Banyuls du Docteur Parcé

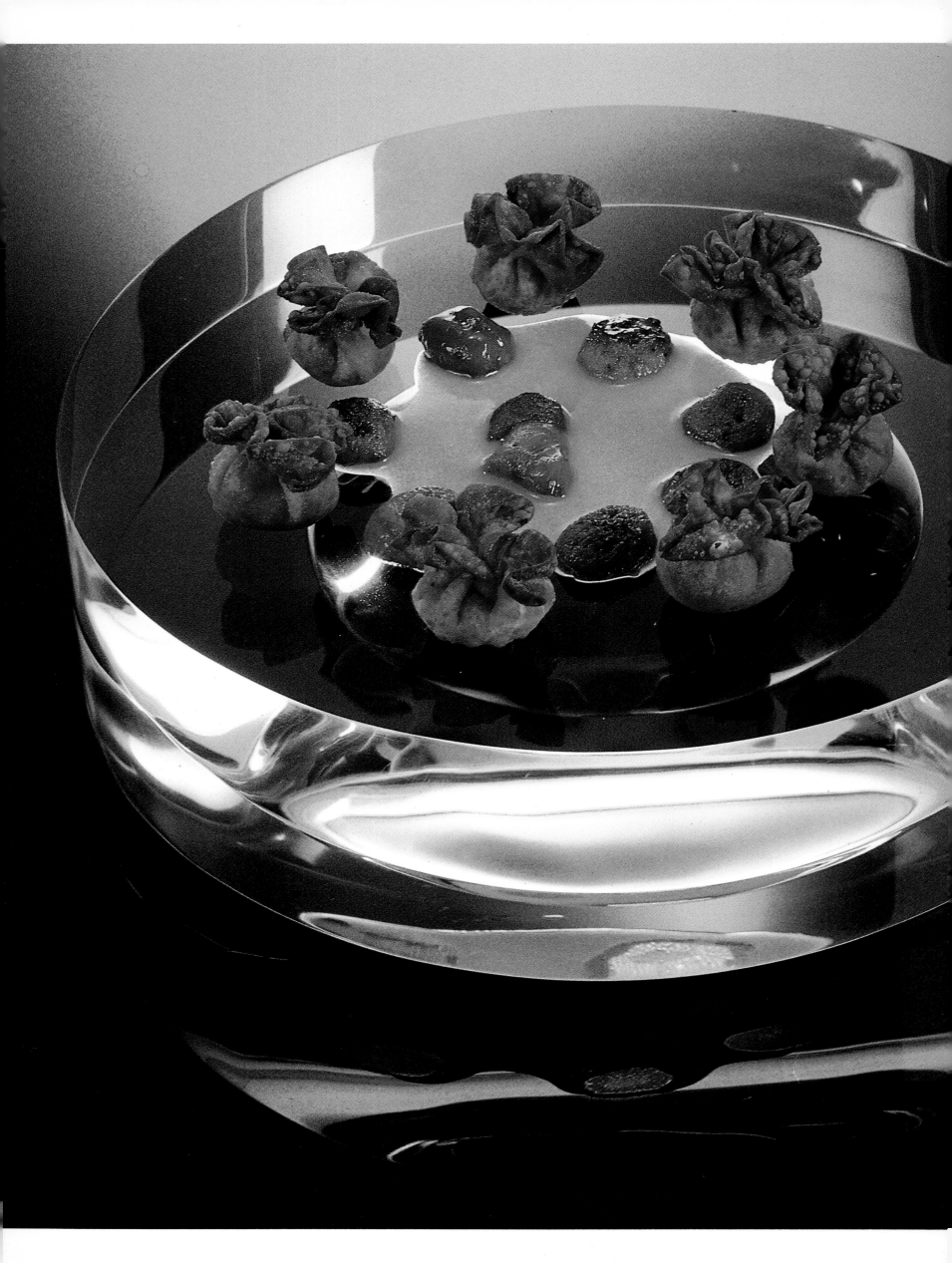

When I make up my restaurant menus each day, I follow a pattern. I usually begin with a "teaser," something small and amusing. Next comes a soup followed by a salad or a cold dish like a terrine. Then I might have a crustacean, and after that a fish and a hearty dish — meat or poultry. A sorbet cleanses the palate, and a beautiful and delicious dessert finishes the meal. They're big menus, but people can choose what they want, two courses or eight.

My wife got the idea for Cèpe "Purses" from Sylvie Foix, a friend in Mont-de-Marsan, in Landes, whom we visit once a year. Sylvie had made a nice dough filled with cèpes and frozen a large supply, and in the three days we were there, I ate them all. With her permission, I made something similar but different — I use won ton wrappers and put sautéed cèpes inside.

(Above) CEPE MUSHROOMS
(Left) CEPE MUSHROOM "PURSES"
with SAUTEED CEPE CAPS
and CEPE SAUCE

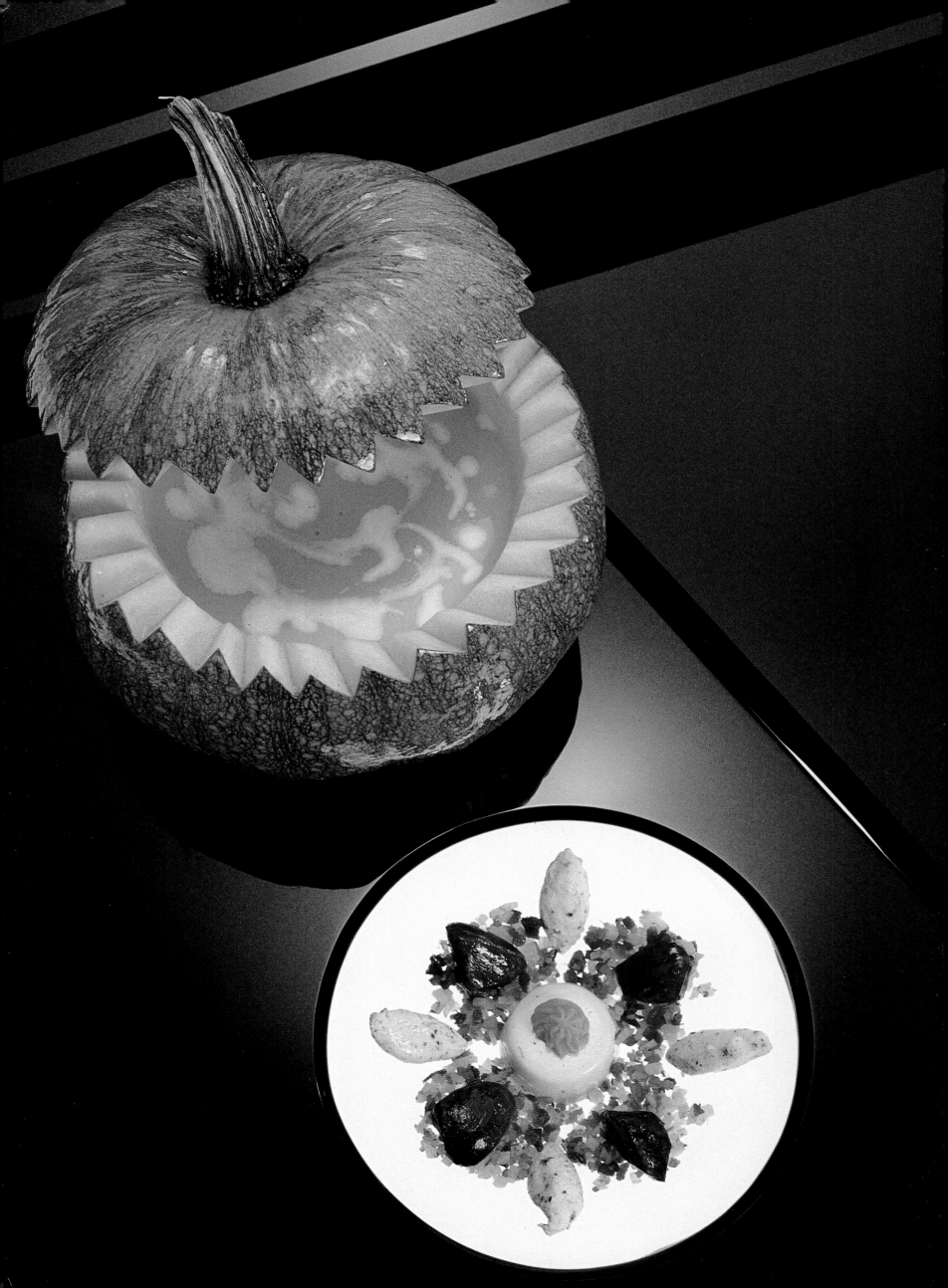

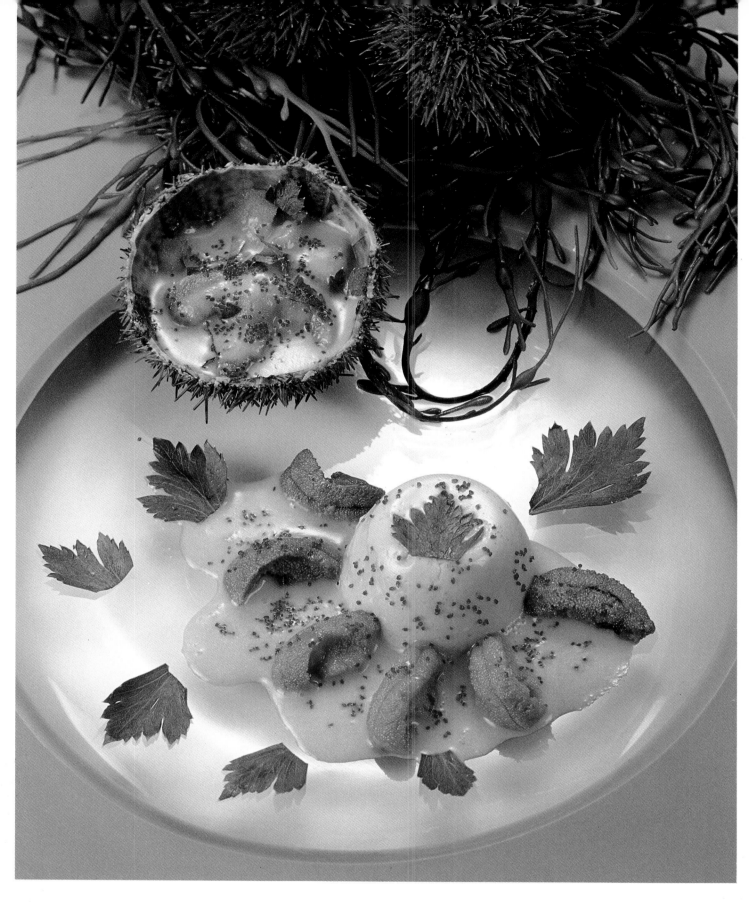

SEA URCHIN "TONGUES"
with SEA URCHIN FLAN
and SEA URCHIN SAUCE
(Left) CREAM OF PUMPKIN SOUP
with SHALLOT FLAN, BREAST OF SQUAB
AND BLACK TRUFFLE QUENELLES,
CONFIT OF MULARD DUCK GIZZARDS,
and MIREPOIX OF PUMPKIN,
SQUAB, AND PROSCIUTTO

In France, we eat sea urchins raw, but here I cook them to make them more acceptable to the American palate. They have a powerful taste of iodine which some people find hard to get accustomed to, and so I prepare a sea urchin flan, which cuts the taste considerably, and serve "tongues" of sea urchin on the side.

I grew up with hard workers who were big eaters, and the pumpkin soup the women made was simple but substantial. The first thing the men did was break up some bread in the soup to make it even more filling. Mine is a contemporary version of that, designed more to delight than to satiate. In place of bread, I arrange quenelles, confit of duck gizzards, and mirepoix of pumpkin, squab, and prosciutto in the bowls. Then the soup is ladled out at the table from a hollowed-out pumpkin shell tureen. The women never did it that way in Condom. There the soup went straight from pot to plate to mouth without ceremony.

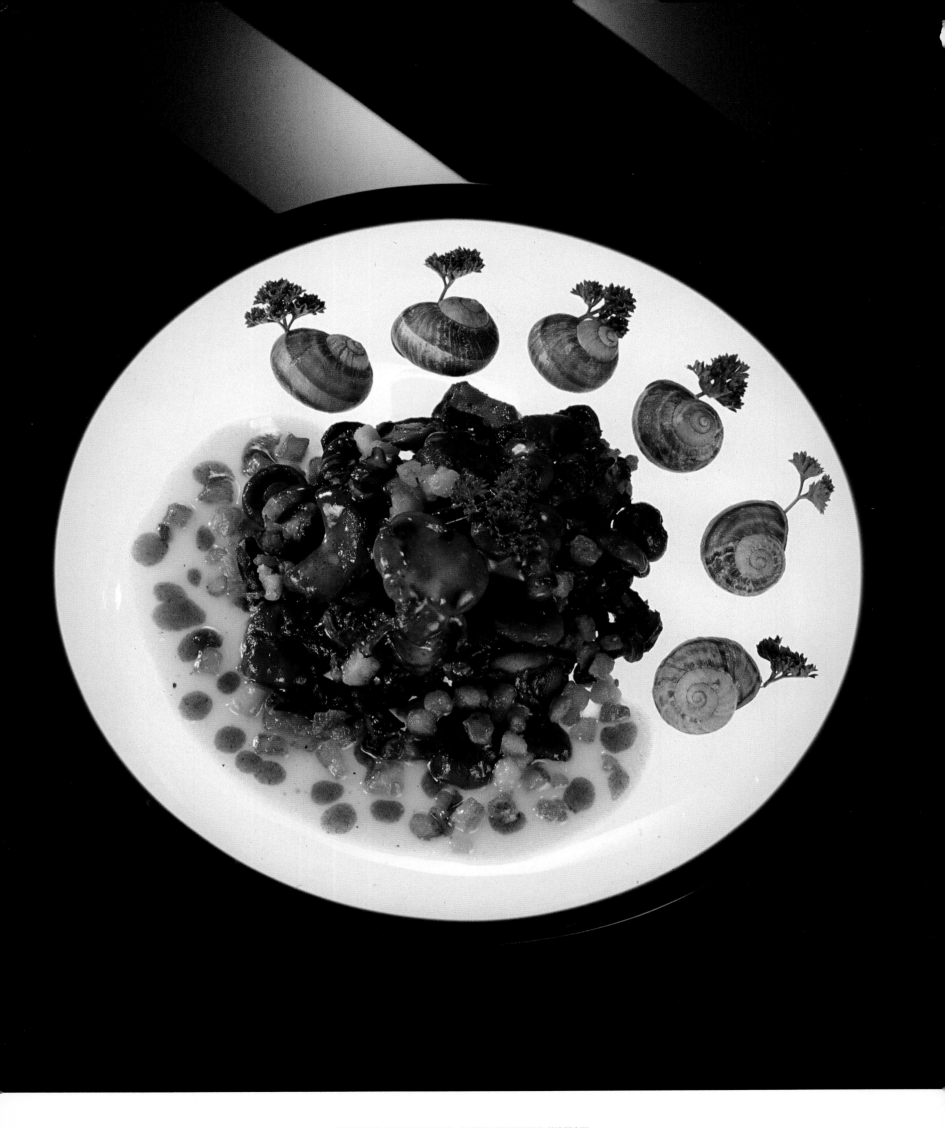

FRICASSEE OF FRESH SNAILS, CRISPY SWEETBREAD MIREPOIX,
PROSCIUTTO, AND CHANTERELLE MUSHROOMS with SHALLOT SAUCE

When I came to Washington in the late 1970s, I could not have served Fricassee of Fresh Snails on my menu because there were no fresh snails to be found. For years, Americans ate canned snails in garlic butter, and the only good thing about them was the garlic butter! Now I have a supplier in Washington, Charlie Novy, who sends me fresh snails in autumn and spring that are just as good as French ones. He feeds them a lot of vermicelli, cleans them, and ships them to me live. There's a big difference between the pieces of rubber we used to have here and the snails we have now.

I first encountered sun-dried tomatoes in Alba, Italy, and I fell in love with them because they have a powerful, earthy taste. I make a delicious tomato butter by combining them with equal amounts of fresh tomatoes to cut the acidity and balance the flavor a little.

**SAUTEED SANTA BARBARA SHRIMP
and CREAMED LEEKS
with FRESH AND SUN-DRIED
TOMATO SAUCE**

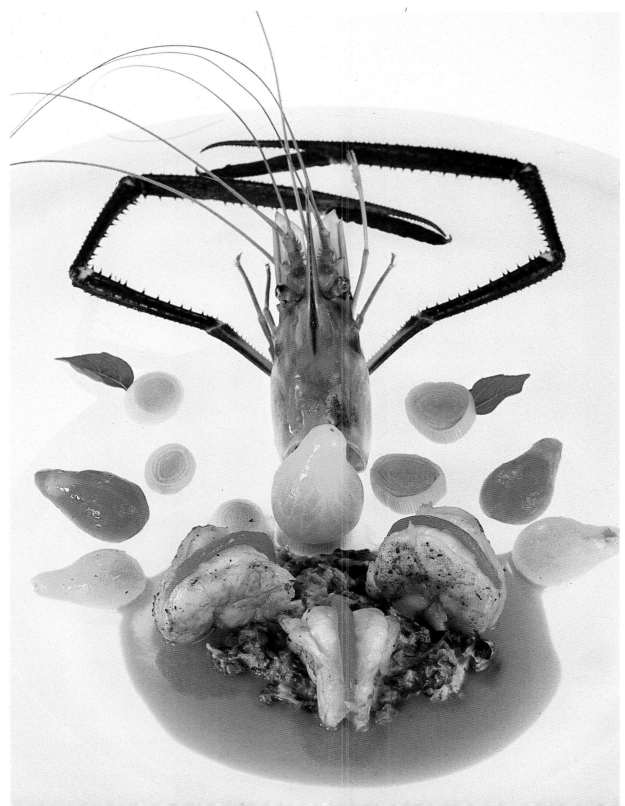

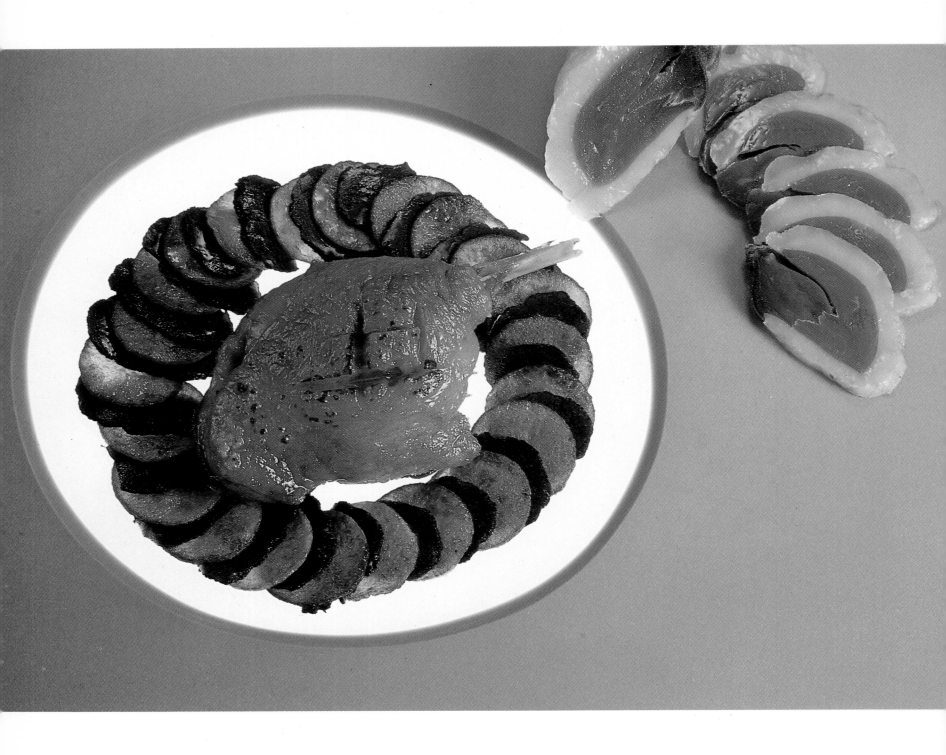

Confit of Duck Legs is a very regional dish. It's part of the repertoire I learned from my Spanish mother which has been such a major influence on my cooking. I think a chef must have a solid framework before he can begin to experiment and develop his own style. Perhaps he makes the food a little lighter than it was in earlier days, but it's still on the same track. Like a musician, he needs to have a strong background first, and then he can change his interpretation.

By a great stroke of luck, I inherited the notebook a very old woman kept of recipes from her mother and grandmother. This woman had known me since I was small, and she liked the fact that I was cooking old dishes from the southwest of France in a new, creative way. Her notebook contained some treasures, one of which was the recipe for duck "ham," which I serve with my Confit of Duck Legs. It must be at least 100 years old, but nobody prepared it anymore because it takes a lot of time — you need to cure the duck "ham" three or four weeks. When I saw the recipe, I said to myself, "Oh, God, that will be good!" I started to make it, and four or five years later everybody in France was making it, even commercially. If I received a royalty for reintroducing duck "ham," I would be rich today.

CONFIT OF MULARD DUCK LEGS
with **POTATOES A LA SARLADAISE**
and **BLACK TRUFFLE SAUCE**
with **MULARD DUCK "HAM"**

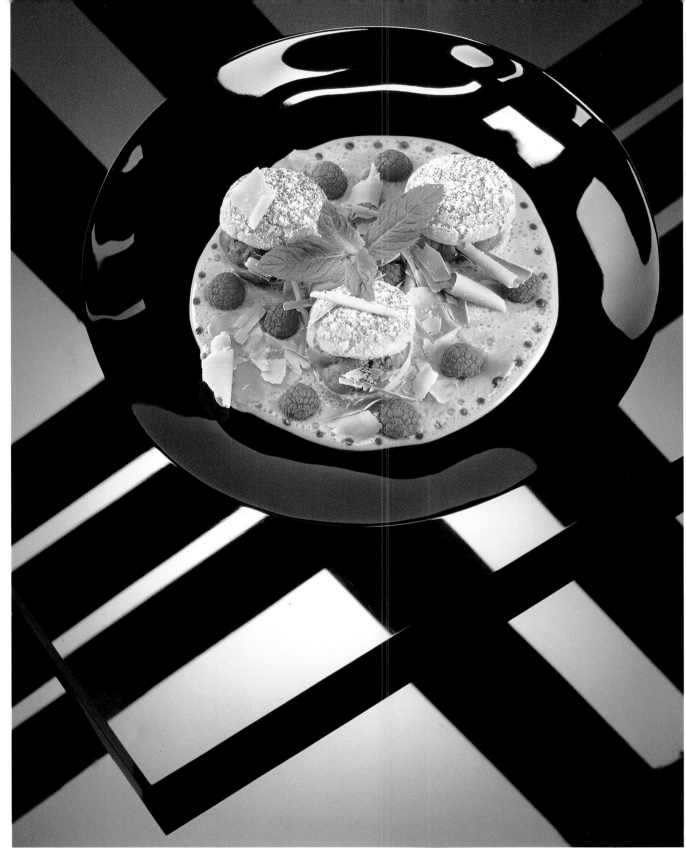

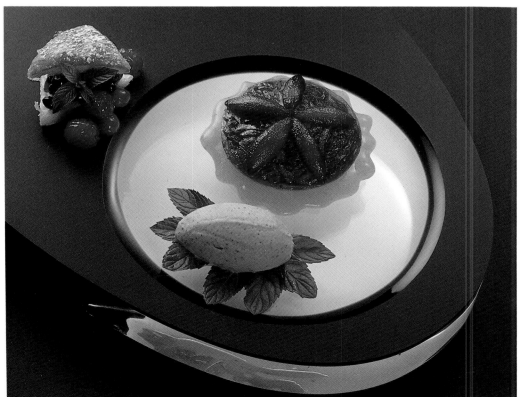

PROFITEROLES
with CHOCOLATE GINGER MOUSSE
and CHOCOLATE SAUCE
(Left) APPLE AND PEAR TART
with MINT ICE CREAM
shown with GRAND MARNIER CREAM
WITH SAUTEED FRESH BERRIES
IN PUFF PASTRY

OYSTER AND BELUGA CAVIAR DELIGHTS
Dom Ruinart Brut Blanc de Blancs, 1979

༄

CREAM OF CHESTNUT AND FOIE GRAS SOUP
with BREAST OF SQUAB AND CHESTNUT QUENELLES and MIREPOIX OF SQUAB
AND MULARD DUCK LEG CONFIT
Folie à Deux Dry Chenin Blanc, Napa Valley, 1985

༄

JUMBO LUMP CRAB CAKE with PIG'S EARS MUSHROOMS
and FRESH AND SUN-DRIED TOMATO SAUCE
Sancerre, "Clos de la Crêle," Lucien Thomas, 1986

༄

FOIE GRAS AND SWEETBREADS WRAPPED IN CABBAGE LEAVES
with SAUTEED CABBAGE and FOIE GRAS SAUCE
Ferrari Carano Sauvignon Blanc, Alexander Valley, 1985

༄

SAUTEED SALMON AND CILANTRO IN CAUL with CELERY ROOT AND LOBSTER CREAM SAUCE
Calera Winery Pinot Noir, Jensen Vineyard, Hollister, 1980

༄

NOISETTE OF ROASTED STUFFED VENISON LOIN WRAPPED IN VENISON MOUSSELINE
AND CEPE MUSHROOMS with JUNIPER SAUCE
Silver Oak Cellars Cabernet Sauvignon, Alexander Valley, 1982

༄

"PORCUPINE" PEAR and DATES STUFFED WITH VANILLA ICE CREAM

GRAND MARNIER CREAM IN PUFF PASTRY
with SAUTEED FRESH BERRIES IN RASPBERRY SAUCE and LEMON ICE CREAM
Cakebread Cellars Sauvignon Blanc, Late Harvest, "Rutherford Gold," Napa Valley, 1982

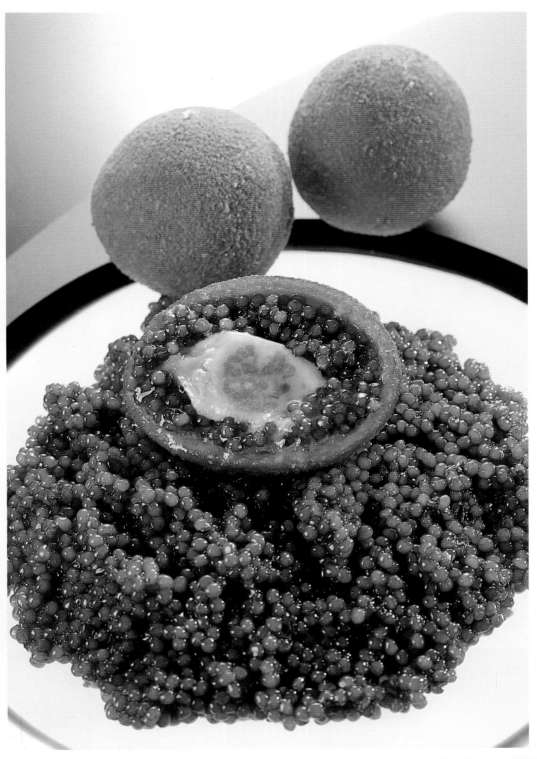

(Left) OYSTER AND BELUGA
CAVIAR DELIGHTS
(Right) CREAM OF CHESTNUT
AND FOIE GRAS SOUP
with BREAST OF SQUAB
AND CHESTNUT QUENELLES
and MIREPOIX OF SQUAB
AND MULARD DUCK LEG CONFIT

I didn't serve caviar much at my restaurant in France. There weren't many sturgeon in the Gironde River, and besides, people weren't coming to Condom to eat caviar. In the States, it's completely different. A lot of people here love caviar. There are three kinds: beluga is mild and not too fishy; ossetra (my favorite) is quite strong and fishy, and sevruga is somewhere between the two. Then there is pressed caviar. When the master chef sorts the eggs, he puts aside those that don't look perfectly round, and after he has enough of all three varieties, he presses them together into a paste. I like to use pressed caviar for caviar butter because it tastes more interesting than the kind made from just one type of egg.

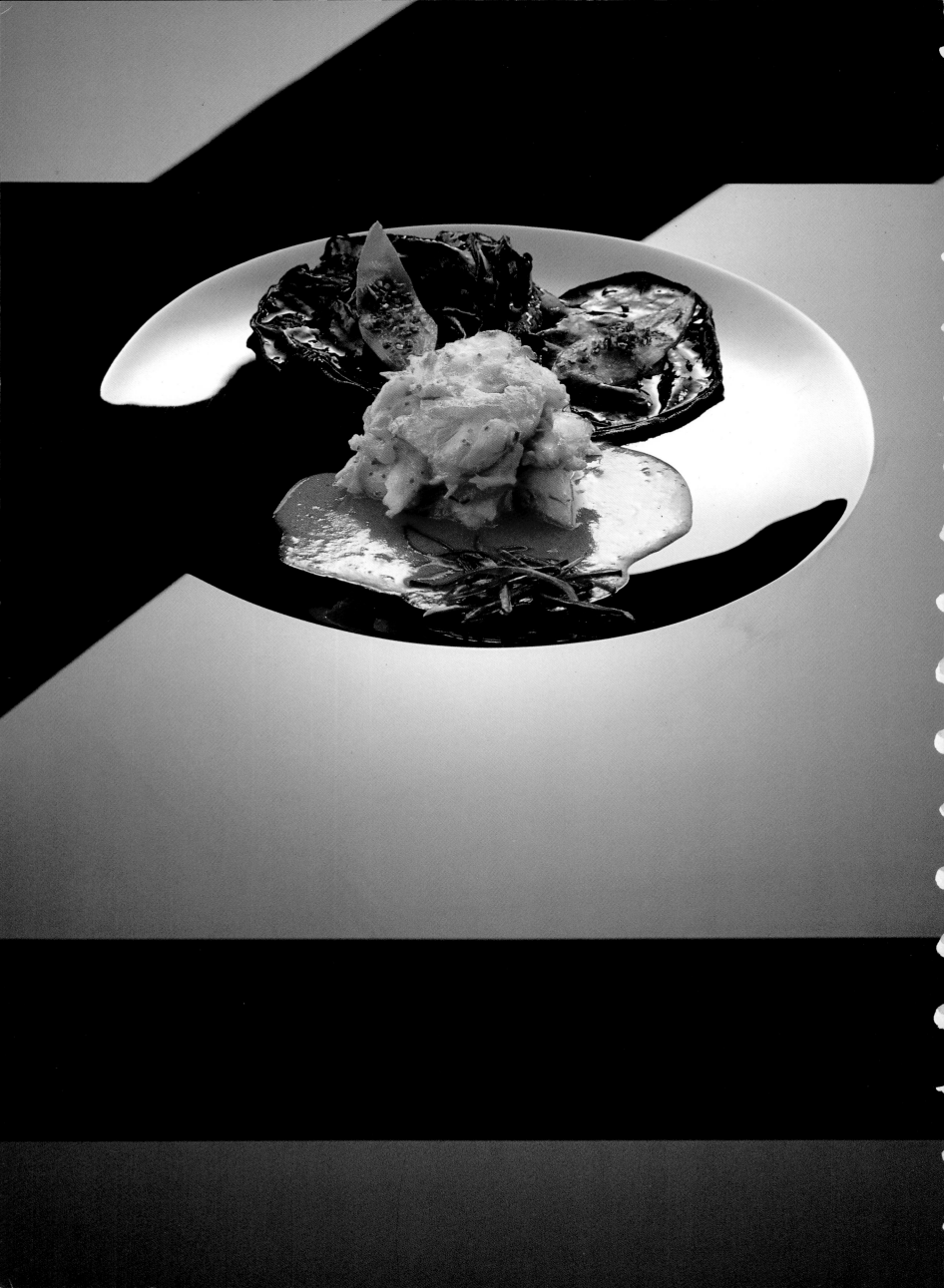

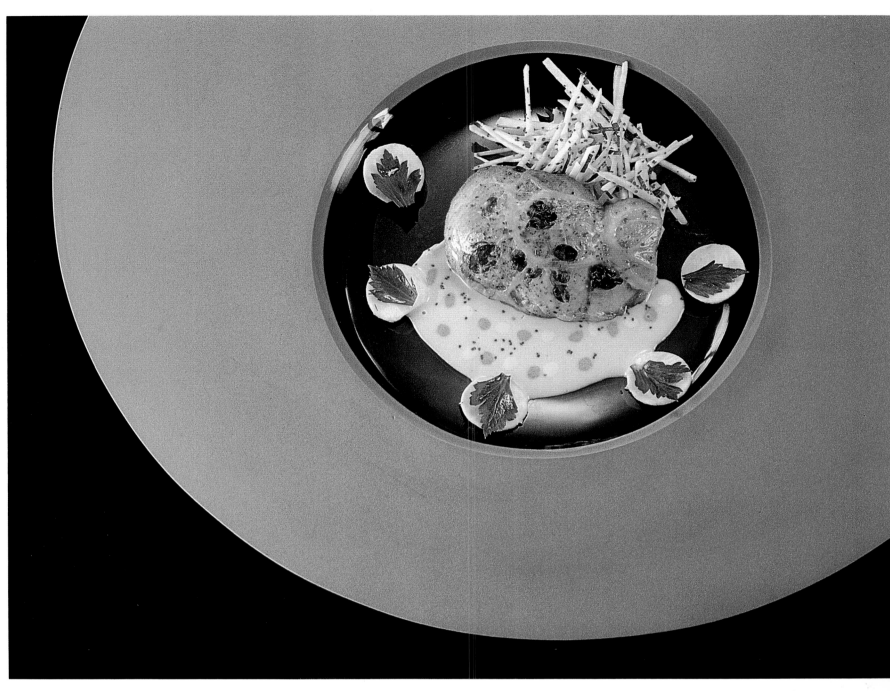

SAUTEED SALMON AND CILANTRO
IN CAUL with CELERY ROOT
AND LOBSTER CREAM SAUCE
(Left) JUMBO LUMP CRAB CAKE
with PIG'S EARS MUSHROOMS
and FRESH AND SUN-DRIED
TOMATO SAUCE
(Right) FOIE GRAS AND SWEETBREADS
WRAPPED IN CABBAGE LEAVES
with SAUTEED CABBAGE
and FOIE GRAS SAUCE

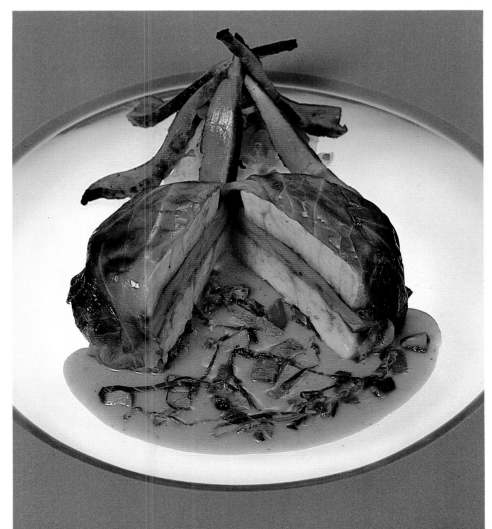

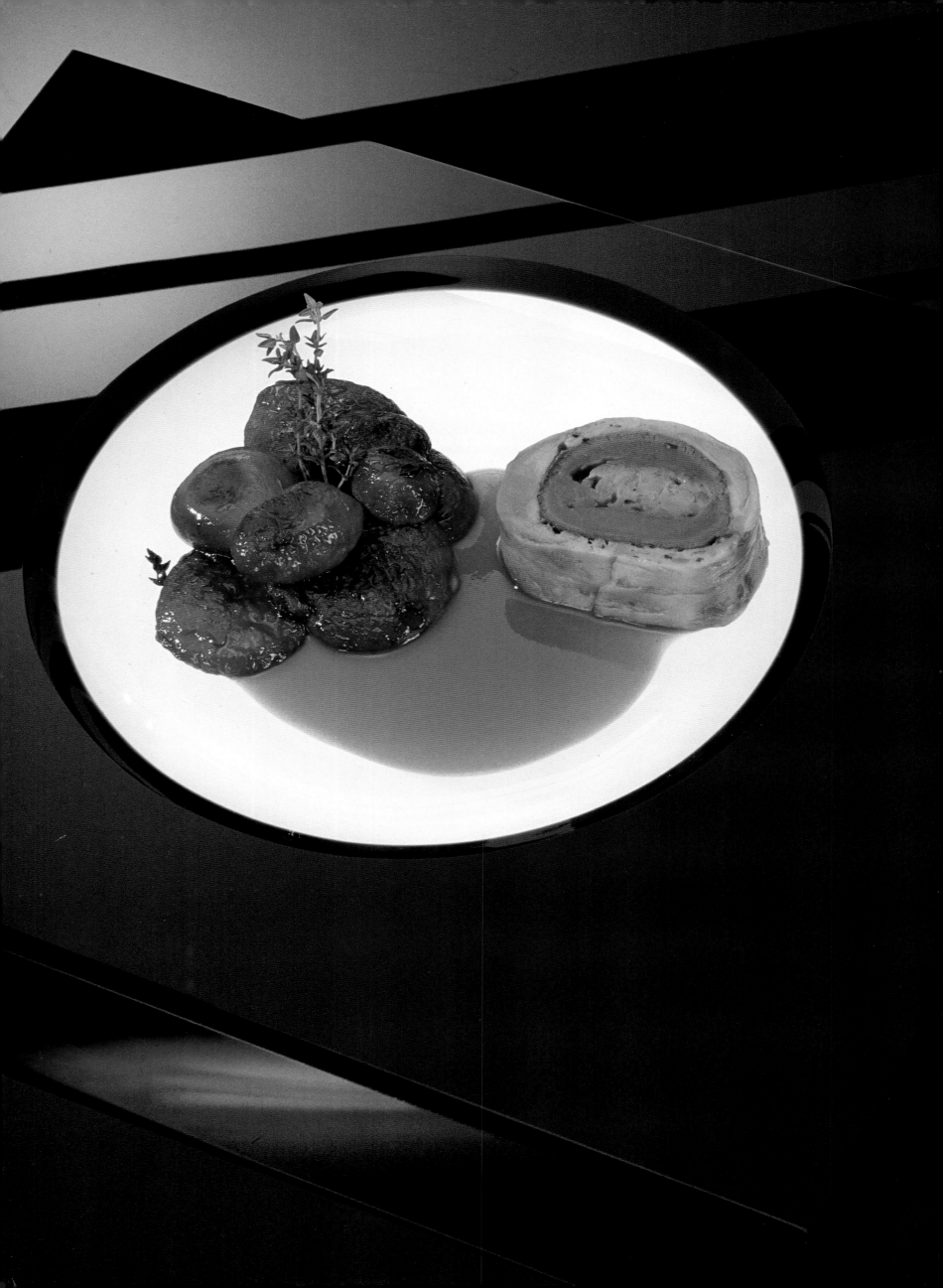

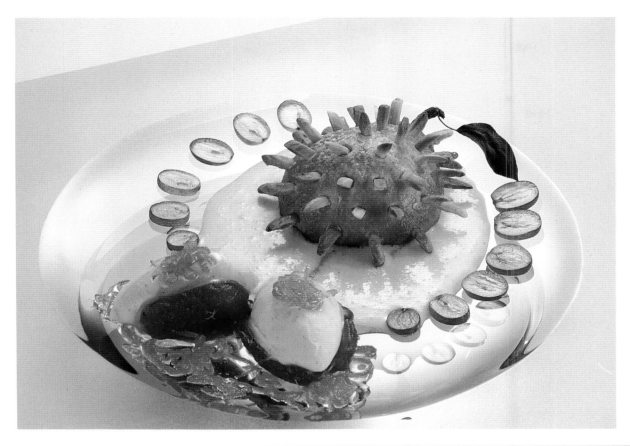

There are beautiful dates in the States, but dates are rich and sweet, and you need to balance them with something else. I think the combination of them with "Porcupine" Pears succeeds because pears are a bit acid and this particular vanilla ice cream is not too sweet.

(Above) "PORCUPINE" PEAR
and DATES STUFFED
WITH VANILLA ICE CREAM
(Left) NOISETTE OF ROASTED
STUFFED VENISON LOIN
WRAPPED IN VENISON MOUSSELINE
AND CEPE MUSHROOMS
with JUNIPER SAUCE
(Right) GRAND MARNIER CREAM
IN PUFF PASTRY
with SAUTEED FRESH BERRIES
IN RASPBERRY SAUCE
and LEMON ICE CREAM

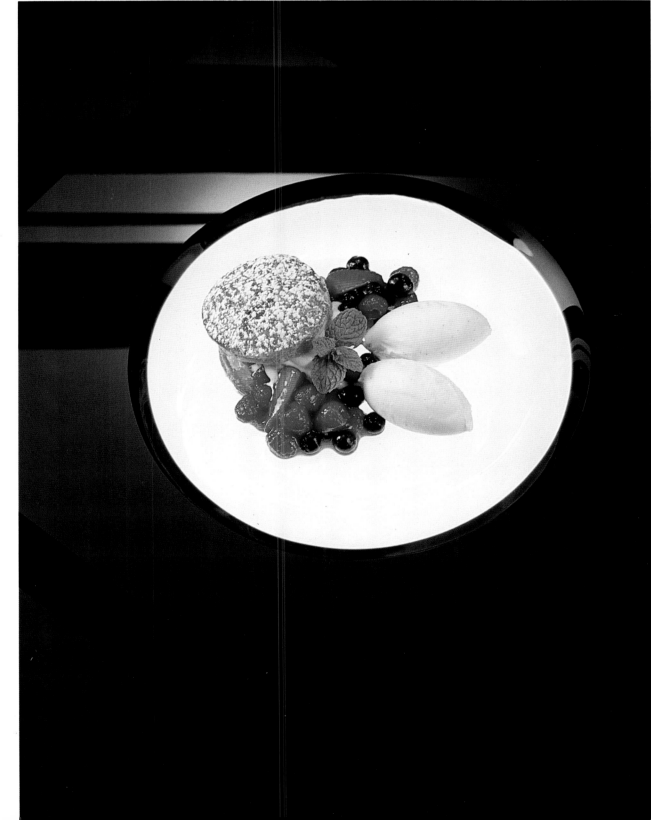

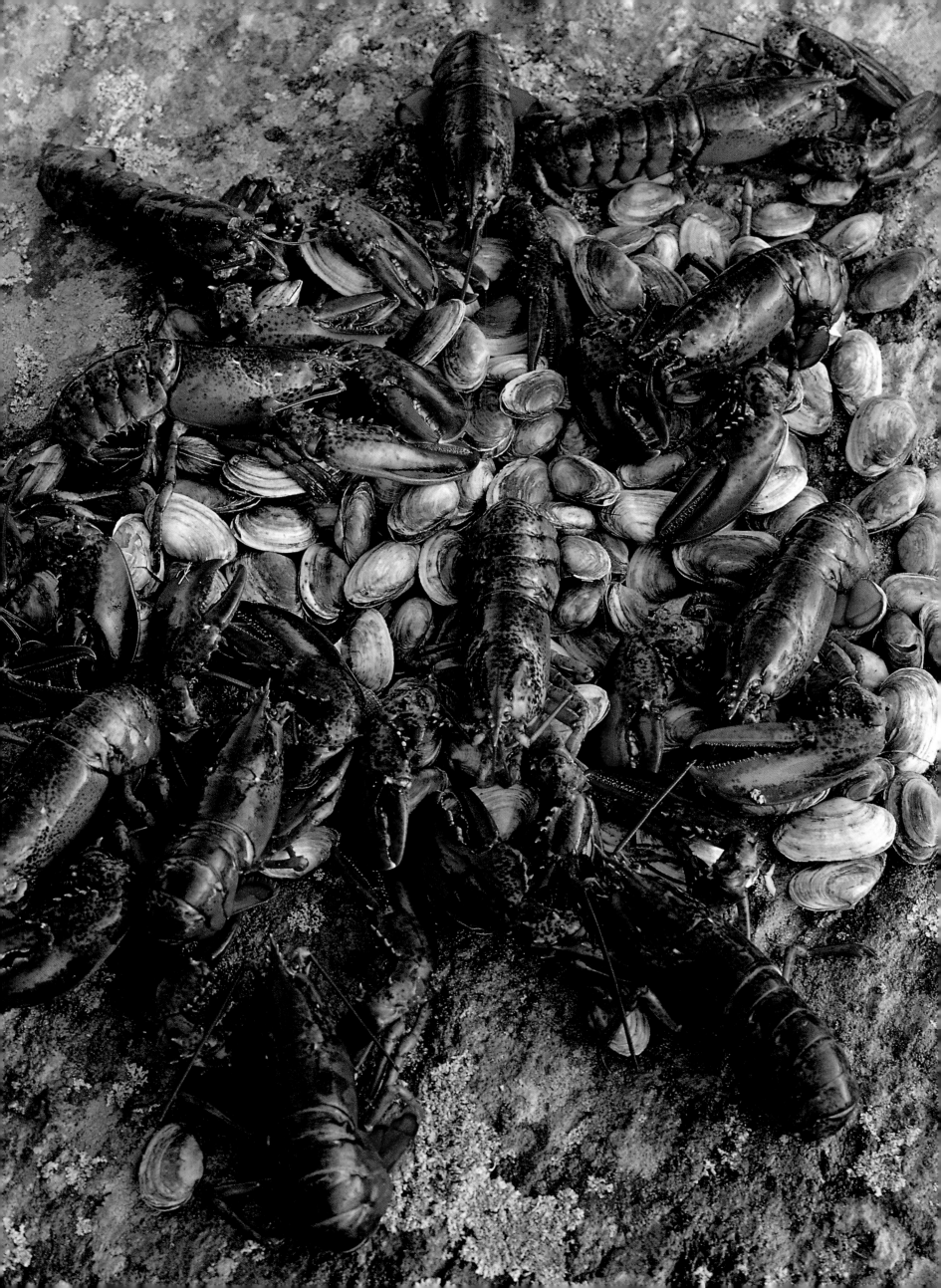

QUAIL EGGS IN BRIOCHE with BELUGA, OSSETRA, and AMERICAN GOLDEN CAVIAR and SMELT ROE
Bollinger Brut R.D., 1975

∽

CORN SOUP with LOBSTER QUENELLES and BELON OYSTERS
Riesling "Théo Faller," Domaine Weinbach

∽

SAUTEED LANGOUSTINES with BEETS and BEET AND LOBSTER CREAM SAUCE
Château Margaux, Pavillon Blanc, 1983

∽

BRAISED FOIE GRAS with HUCKLEBERRY SAUCE
Vouvray, Domaine Huet, Clos du Bourg, Moelleux, 1962

∽

**BROILED COD with SAFFRON POTATOES, SAFFRON GARLIC CREAM SAUCE,
and MIREPOIX OF RED AND YELLOW BELL PEPPERS**
Puligny-Montrachet, "Les Pucelles," Domaine Vincent Leflaive, 1983

∽

MAGRET OF DUCK with DAUBE OF CEPE MUSHROOMS
Richebourg, Domaine de la Romanée-Conti, 1980

∽

**BRIOCHE RAVIOLI FILLED WITH MANGO AND GINGER
and LIME ICE CREAM IN CARAMEL BASKET with MANGO SAUCE**

PEAR CROUSTADE with ARMAGNAC SAUCE
Muscat de Beaumes-de-Venise, Paul Jaboulet, 1984

One of my best friends, Michel Richard, was trained as a pastry chef and now owns a beautiful restaurant called Citrus in Los Angeles. He and I can talk for hours about food. I cook with salt, he cooks with sugar; we give ideas to each other. Quail Eggs in Brioche with Caviar is one of the recipes inspired by our relationship. As a pastry chef, Michel works precisely and uses molds. When he turns his training toward other kinds of cooking, he brings a cleanness and exactness that does not come quite so easily to me.

Corn soup is very American. If I have one bowl of it, I want two, and if I have two, I want three — I'm never going to stop!

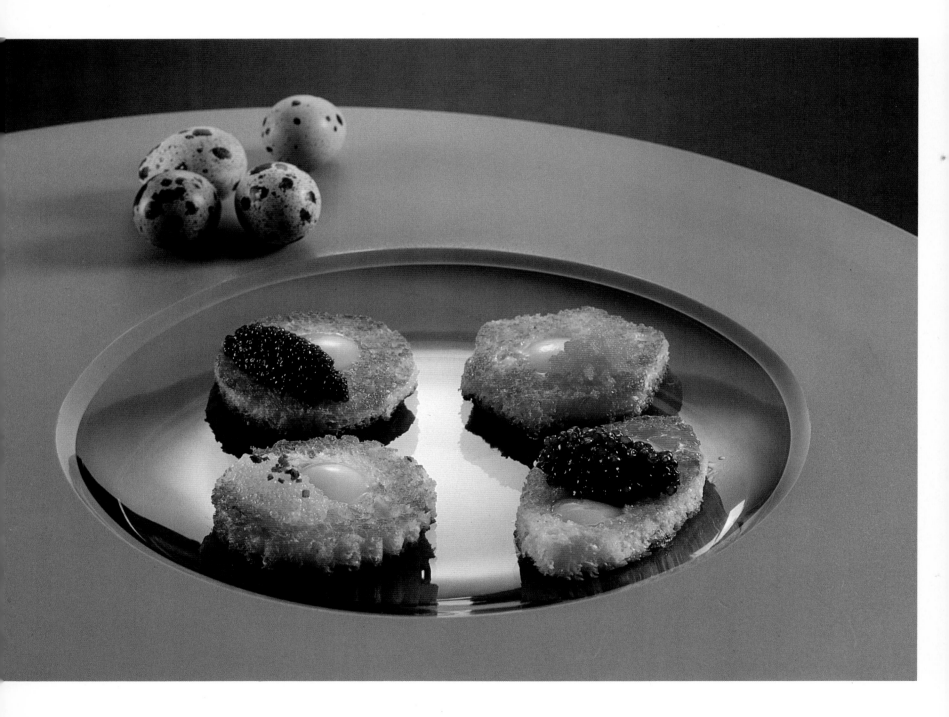

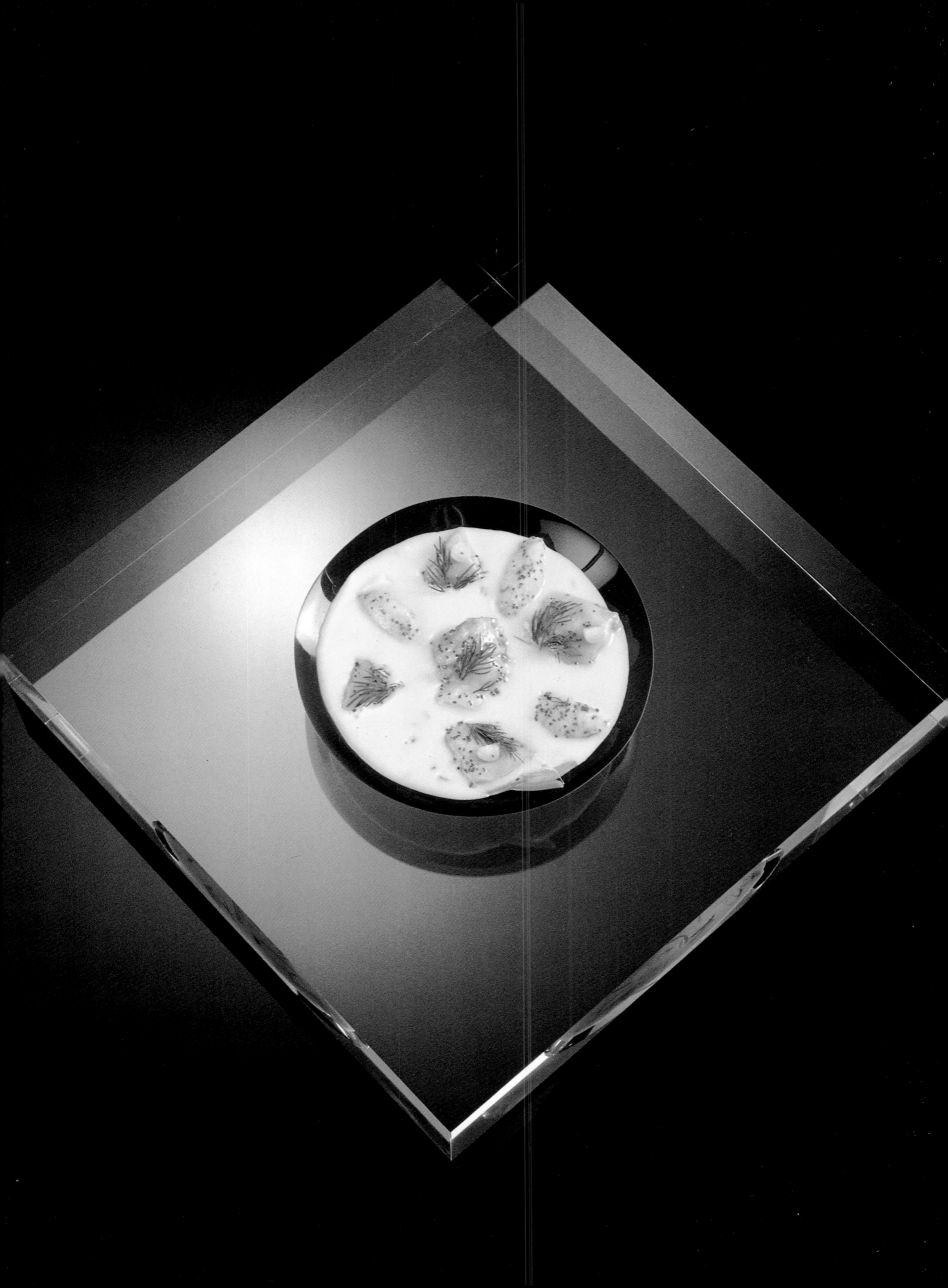

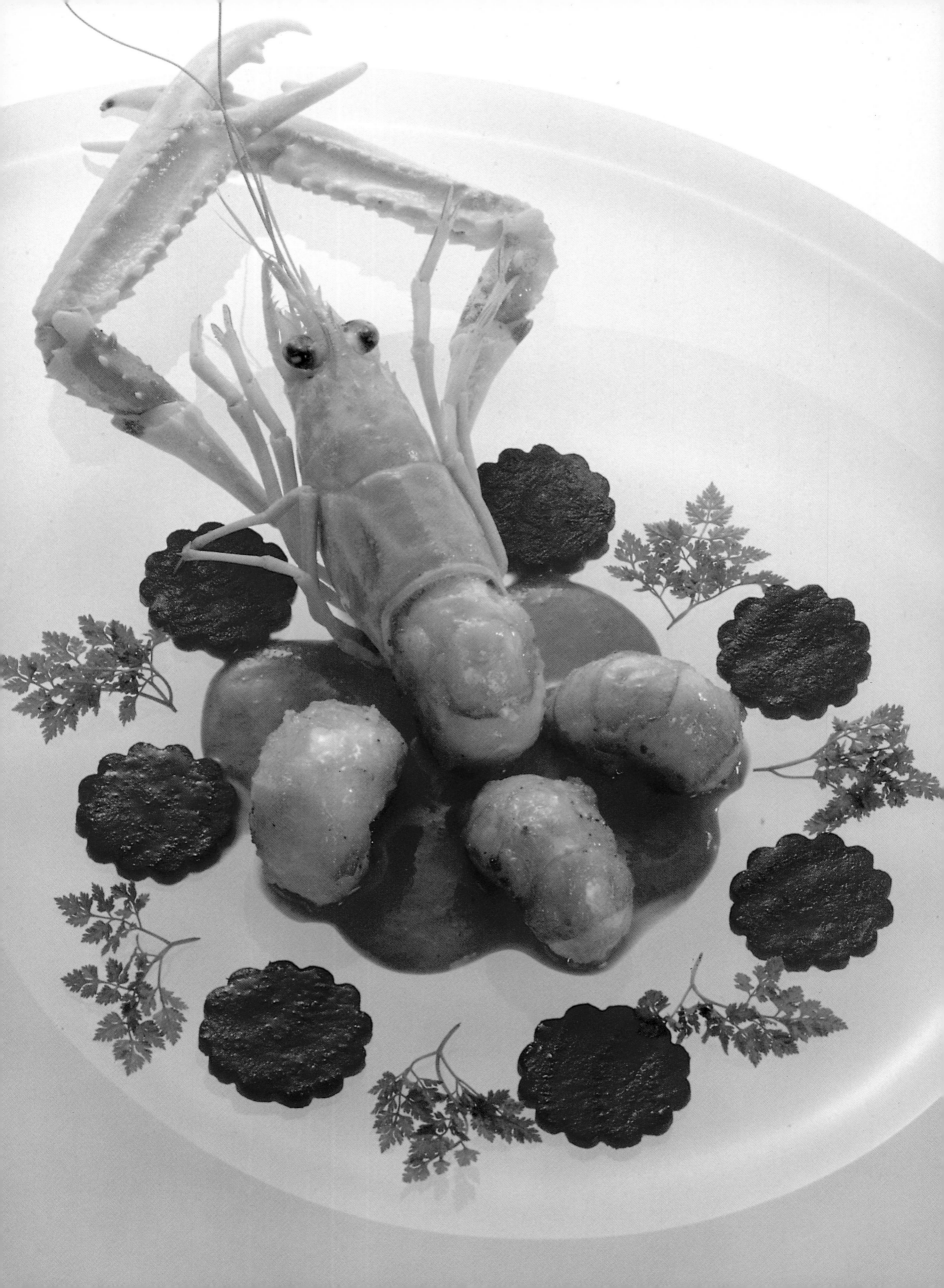

W hen I lived in France, I used to drive to the market in Bordeaux one night a week, get fresh langoustines, and arrive home just in time to start work again. Langoustines do not ship well, but two or three times a year my fish man here will call to tell me that he's getting in some live ones, and I always take them.

In the notebook of old recipes I inherited was one for foie gras braised with grapes. Before refrigeration, foie gras was eaten only in the autumn, at the time of the grape harvest, and the combination was a lucky and logical one. In my Braised Foie Gras, I have used huckleberries. They are a little more aggressive on the palate, but the principle is the same: the acidity and sugar of the fruit complement the foie gras very well.

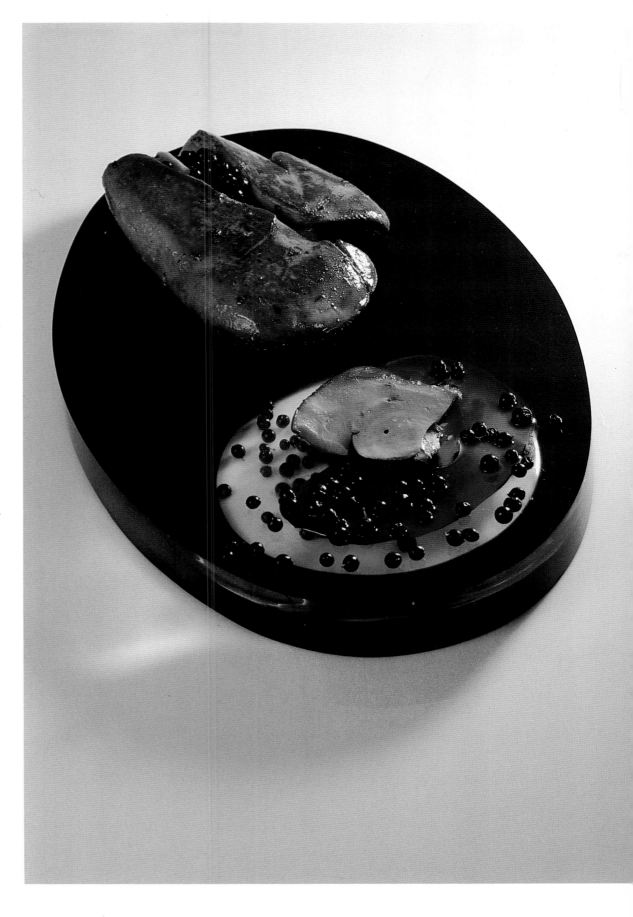

BRAISED FOIE GRAS
with **HUCKLEBERRY SAUCE**
(Left) **SAUTEED LANGOUSTINES**
with **BEETS**
and **BEET AND LOBSTER CREAM SAUCE**

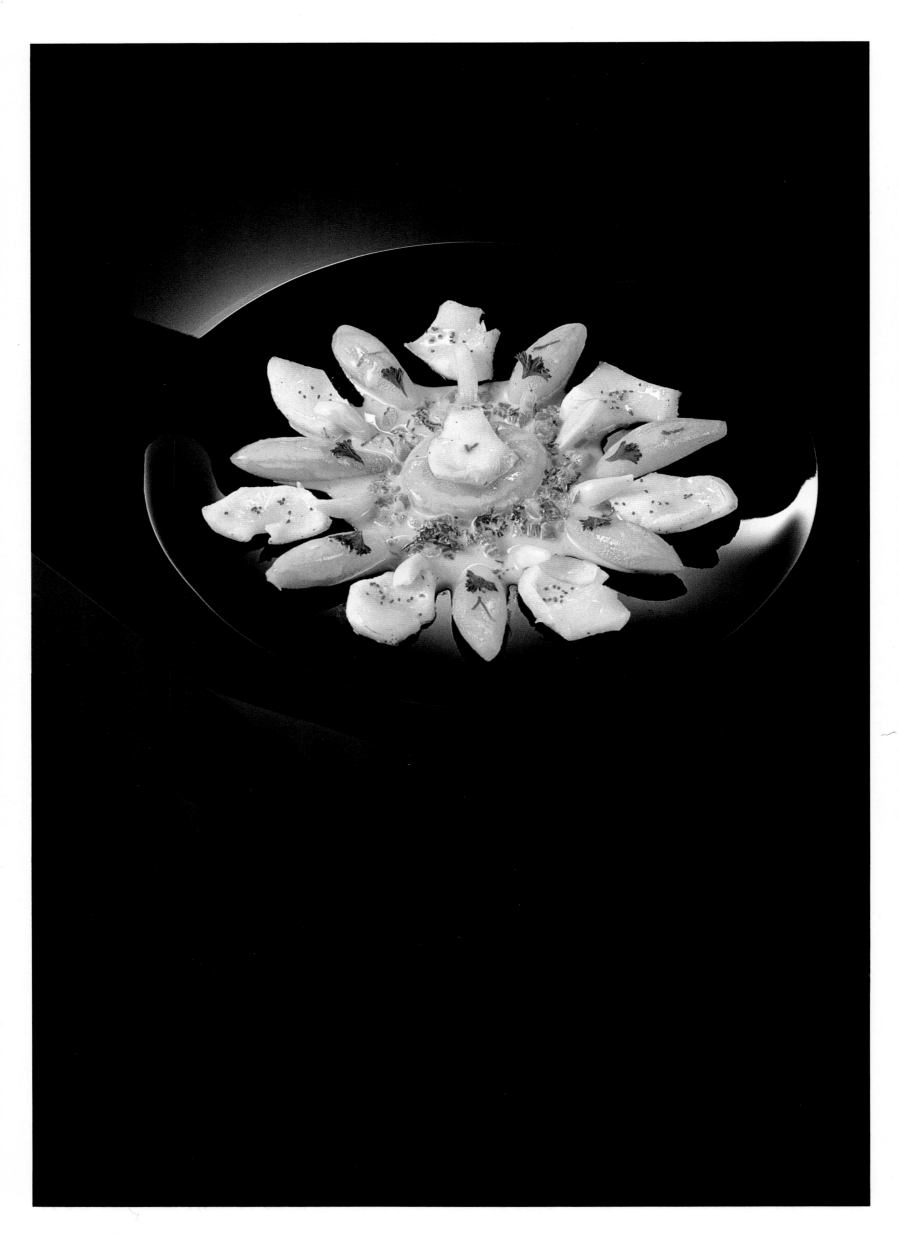

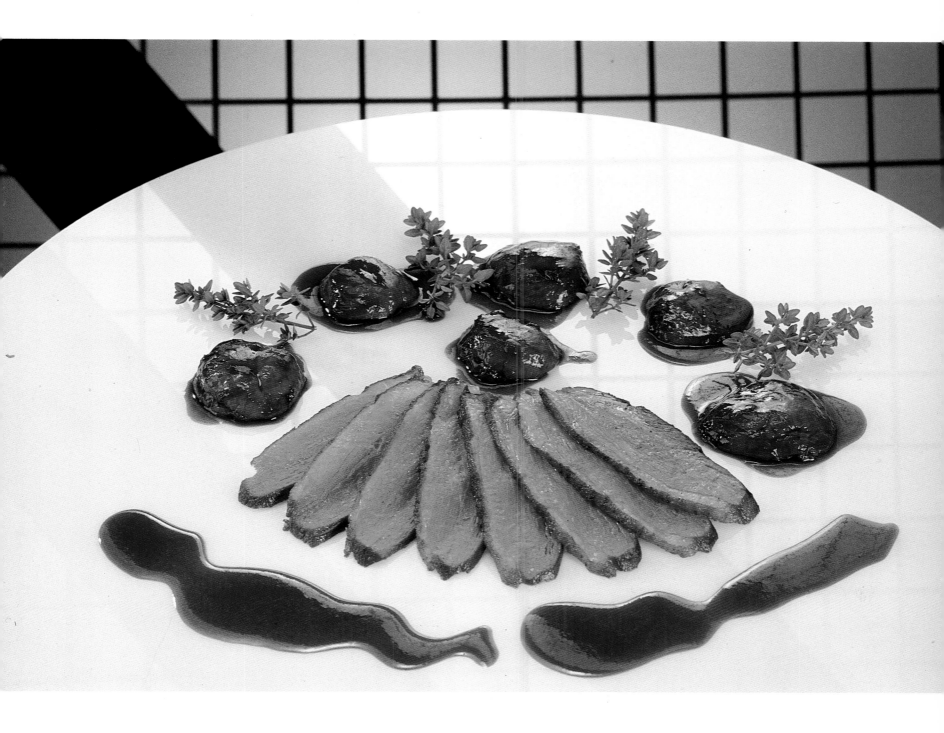

Magret de canard means breast of duck, specifically that of the mulard duck which is bred for foie gras. It has a completely different taste from regular duck, but I like them both. The magret is more expensive, of course, because the farmer needs to feed and care for the duck, while the other birds just run around having a good time. In my recipe, the magret is sautéed and served with a daube of cèpes. A daube is a traditional dish from the southwest of France, made here with very flavorful mushrooms cooked in red wine like a stew.

MAGRET OF DUCK
with DAUBE OF CEPE MUSHROOMS
(Left) BROILED COD
with SAFFRON POTATOES,
SAFFRON GARLIC CREAM SAUCE,
and MIREPOIX OF RED
AND YELLOW BELL PEPPERS
(Pages 36-37) BRIOCHE RAVIOLI
FILLED WITH MANGO AND GINGER
and LIME ICE CREAM IN CARAMEL BASKET
with MANGO SAUCE

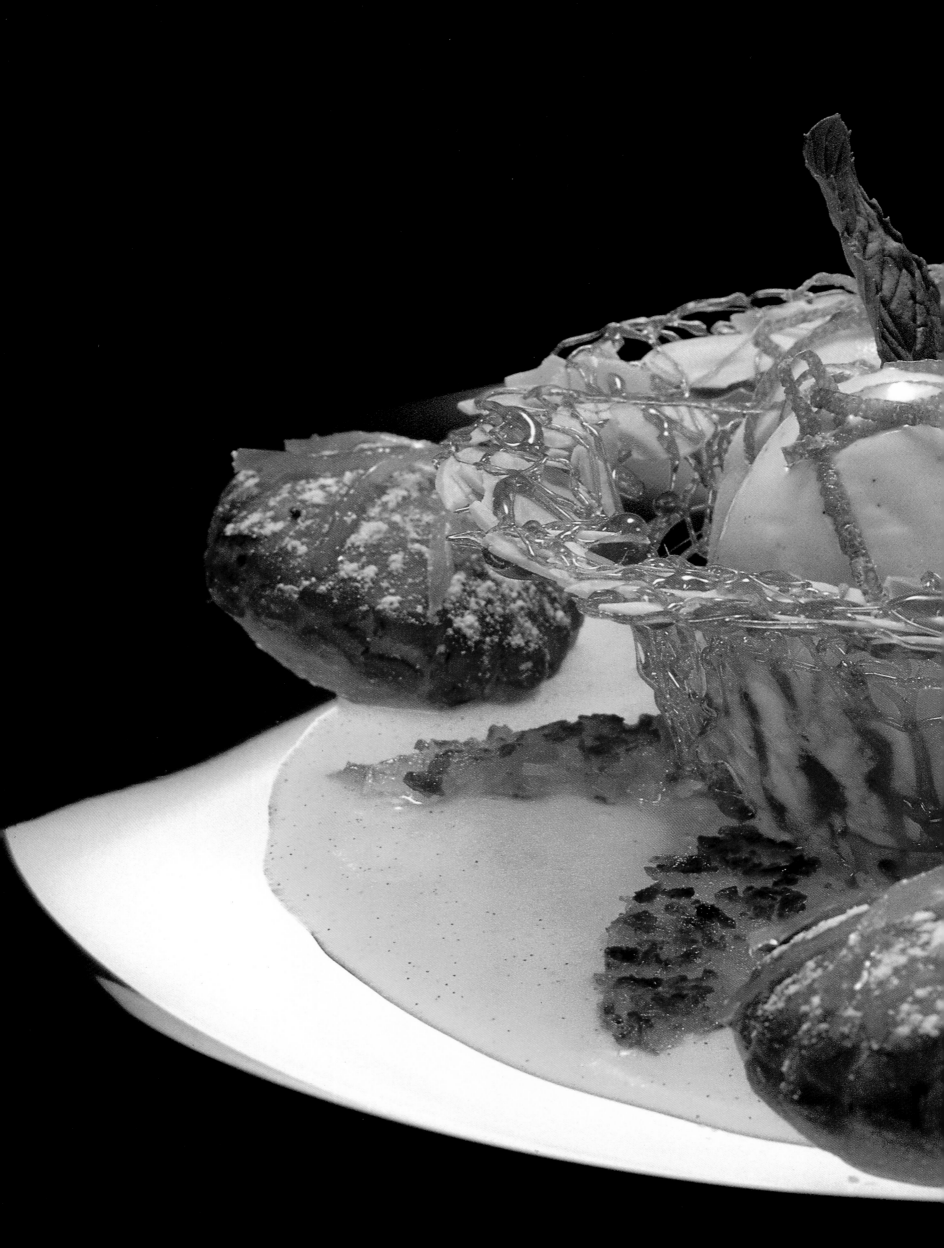

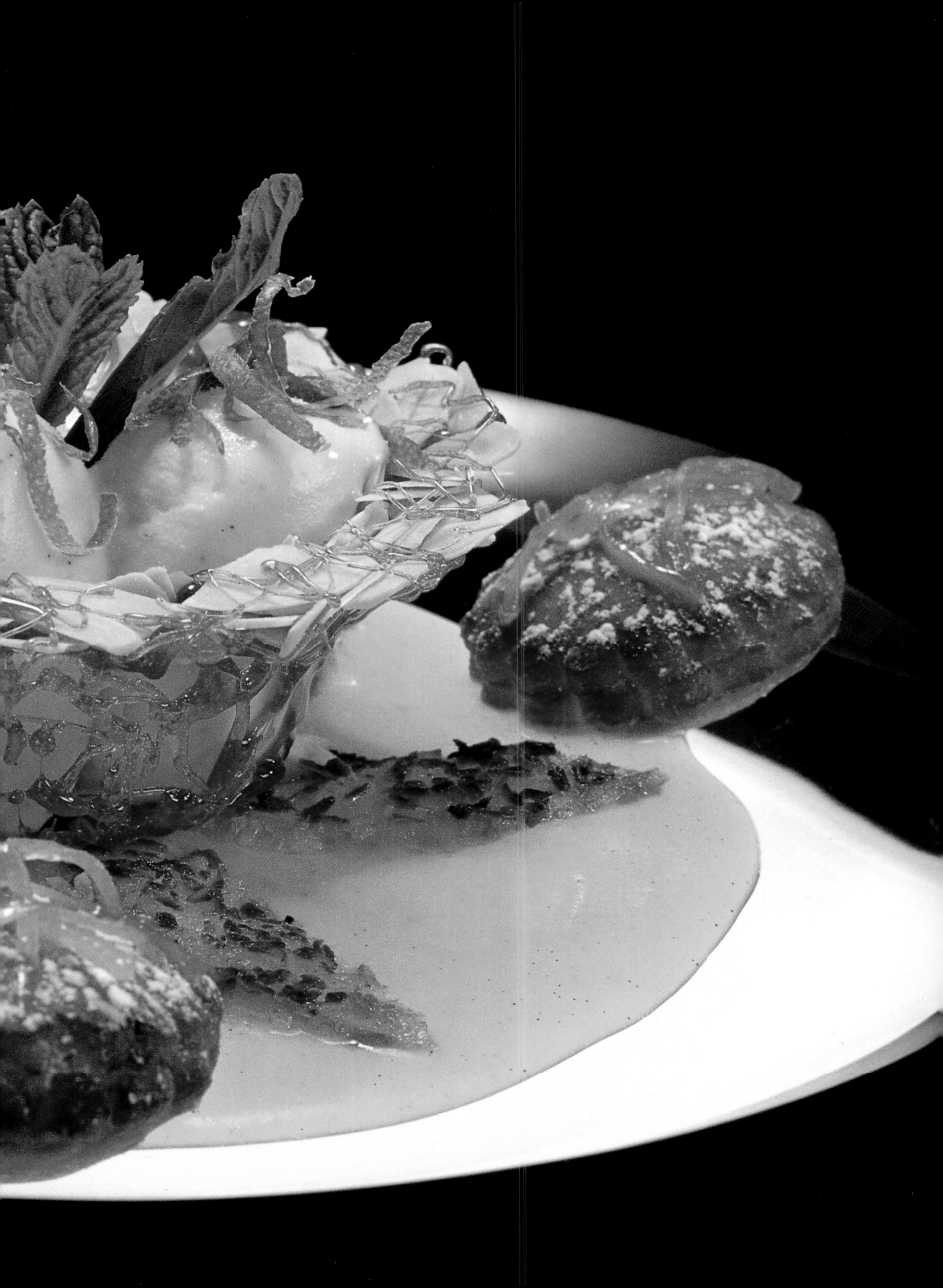

PEAR CROUSTADE WITH ARMAGNAC SAUCE

Winter

Some people might think that winter is not an interesting season for a chef. Nature seems to be asleep, waiting for spring. But people aren't asleep at all; in cold weather they want to eat heartily. When I was a child, the people in Gascony had to do a lot of hard physical work in winter, and they needed to have something substantial to eat. For most families, it was the time to eat the animals they had butchered and preserved in the fall, along with the pâtés, sausages, stews, and confits the women had made.

Since we had no refrigeration, all of our meat for the winter had to be preserved. After the harvest was finished and the ducks, geese, and pigs had been killed, we would put them in salt overnight with some seasoning — thyme, pepper, tarragon — depending on the taste we wanted. The next day we would cook the meat in duck or goose fat and then store it, covered with the same fat, in clay pots on shelves in the basement. We could keep meat for one or even two years like that because the fat hermetically sealed it.

One pig provided our family with enough meat for a year. From the head, we made headcheese and from the blood, blood sausage. The breast was salted to make *pancetta*; we preserved the loin and made ham from the thigh. We made sausage from the shoulder and cooked the feet for use in soups or salads. We made tripe stew, and the liver and heart went into pâtés. Even the ears went into a soup called *garbure*. Nothing was wasted.

Perhaps the most common classical winter dish in France is the pot-au-feu. It's a big, hearty dish, a kind of corned beef with vegetables and herbs cooked in a pot over a fire, which is what its name means. We could not afford tender cuts so my parents bought cheaper, tougher meat and boiled it until it was tender. The aroma was fantastic. Afterwards we had something we could eat for three or four days, served hot with vegetables and a little consommé, or cold with potato salad, Cornichons, and onions. It is a very economical and interesting way to feed a family; you can really play with what you have. A traditional pot-au-feu is made with beef, but in Condom I got the idea of doing one with veal, which I don't think had ever been done before.

On one of my winter menus, I have Cream of Eggplant Soup with "White Kidneys". They are not really kidneys, but we are in a country where I need to use a different name — some people aren't yet ready to know they are eating testicles. In Condom, nobody minded because it was natural; we ate every part of the animal. But we are not at that point yet in America. Sometimes customers will call me over and say, "Jean-Louis, they are delicious! What are they?" And if I don't know them, I will tell them they are quenelles. If I know them a little and they seem brave, I will say they are sweetbreads. And if I think they are strong enough to hear the truth, I will give it to them. This is one of the big differences between the French and Americans. Americans are not ready to try all the parts of the animal we eat in France.

People in this country have begun to eat sweetbreads, but it is still difficult to serve tripe or kidneys. When I started to serve calf's brain in my restaurant here, perhaps one person a night would take it, usually a European. But brain has a very good taste, so I tried to think how I could make it appealing to Americans. I prepared a crêpe and mixed the brain with egg and a lot of other good things, and the people ate that like crazy. It is really psychological. But a lot also depends on the chef and how the food is presented. Kidneys can have a strong taste, but if they are prepared well, they are very good. And tripe in red wine is a classic dish I learned from a friend of mine, Zizou Duffour, who owned a restaurant in Gascony. I hope one day we will be able to work with all the different parts of the animal in this country; I think people will enjoy them all.

PURPLE EGGPLANT

TOURTE OF FOIE GRAS, VENISON, AND BLACK TRUFFLES with MARCHAND DE VIN SAUCE
Krug Brut Rosé

∽

CONSOMME OF HONEY MUSHROOMS with ROASTED BREAST OF WOOD PIGEON,
POULTRY LIVER FLAN, BREAST OF WOOD PIGEON AND BLACK TRUFFLE QUENELLES,
and CABBAGE LEAVES STUFFED WITH WOOD PIGEON AND HONEY MUSHROOMS
Moulin-à-Vent, Domaine de Tajeau, 1985

∽

ROASTED PARTRIDGE with SAUTEED CABBAGE, CABBAGE SALAD DRESSED
WITH PARTRIDGE LIVER VINAIGRETTE, and BOILED RED POTATOES
Volnay, Premier Cru, "Les Chevrets," Henri Boillot, 1971

∽

SALMIS OF MULARD DUCK WITH HONEY MUSHROOMS and GLAZED PEARL ONIONS
Château du Montmirail Gigondas, "Cuvée de Beauchamps," 1979

∽

HARE A LA ROYALE with BEET PUREE and RED WINE SAUCE
Echezeaux, Domaine de la Romanée-Conti, 1952

∽

FRESH CHESTNUT SOUFFLE with POACHED PEARS, APPLES, AND PEACHES

MERVEILLES
Château Gilette Doux, 1955

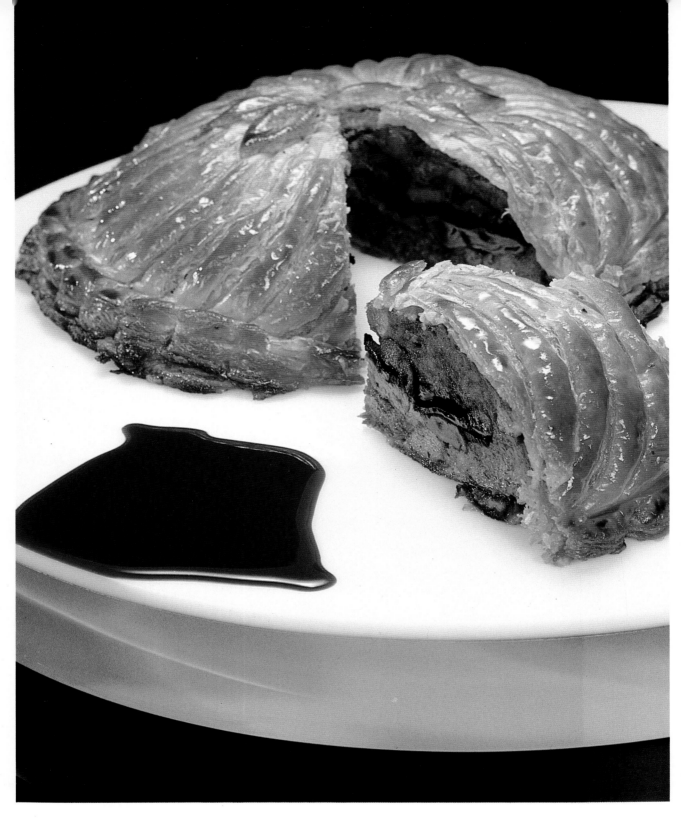

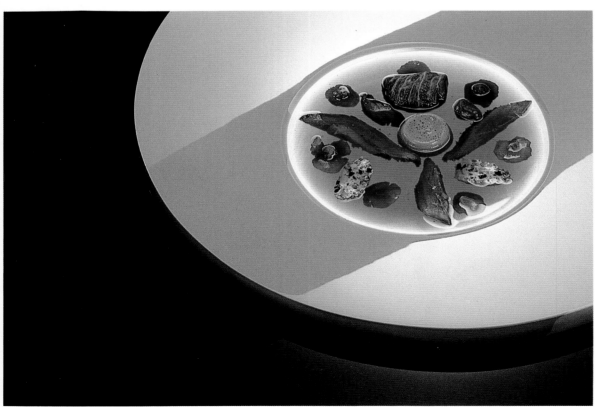

(Above) TOURTE OF FOIE GRAS,
VENISON, AND BLACK TRUFFLES
with MARCHAND DE VIN SAUCE
(Left) CONSOMME OF HONEY MUSHROOMS
with ROASTED BREAST OF WOOD PIGEON,
POULTRY LIVER FLAN,
BREAST OF WOOD PIGEON
AND BLACK TRUFFLE QUENELLES,
and CABBAGE LEAVES
STUFFED WITH WOOD PIGEON
AND HONEY MUSHROOMS

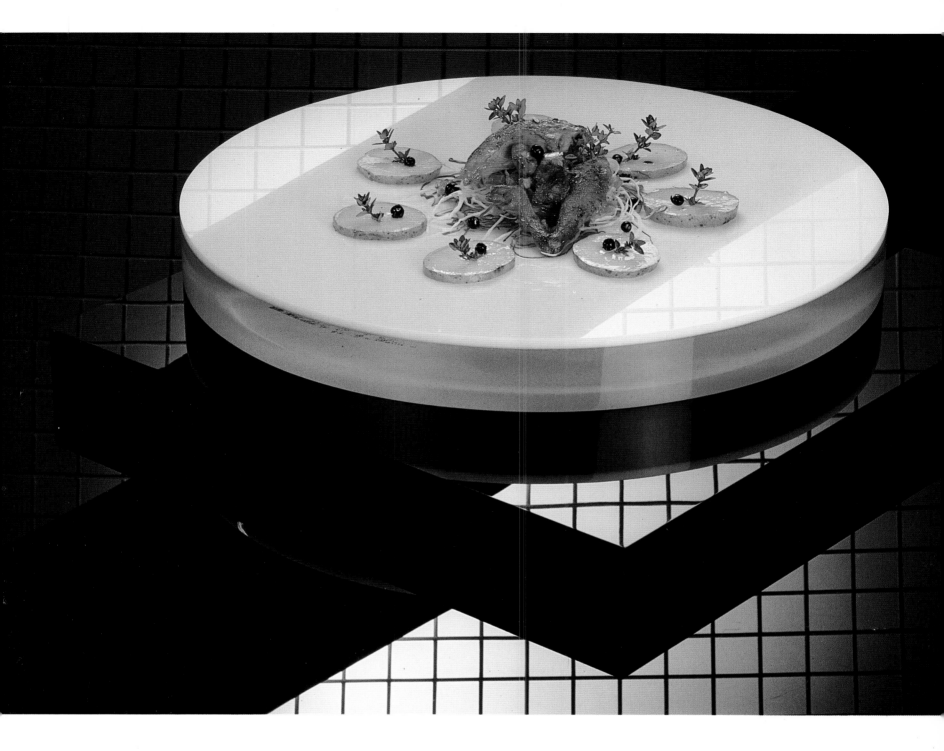

Hunting wood pigeons is a ritual in my area of France—some people spend their entire annual vacation that way. On the day the birds arrive, the hunters hide behind a blind. Live pigeons are attached to hinged platforms in the trees, and when parts of the platforms are dropped, the captive birds flap their wings, attracting the attention of the migrating flock. They in turn recognize some friends and decide to wait around in the trees to see what's happening.

Then the hunters play a tape of the wood pigeon's song. They also put other captive pigeons into the clearing with some food and water. The pigeons in the trees are hungry and thirsty because they have just flown 1,000 miles. When they hear the song and see the birds in the clearing, they say to themselves, "Look at that! They're singing! They're eating! It must be a party! Let's join in!" Down they fly, the master hunter gives a signal, the other hunters pull the nets from both sides, and 300 wood pigeons are in the bag. But there are always a few intelligent ones who stay in the trees. They are suspicious and somehow know better than to come down.

ROASTED PARTRIDGE
with **SAUTEED CABBAGE,**
CABBAGE SALAD DRESSED WITH
PARTRIDGE LIVER VINAIGRETTE,
and **BOILED RED POTATOES**

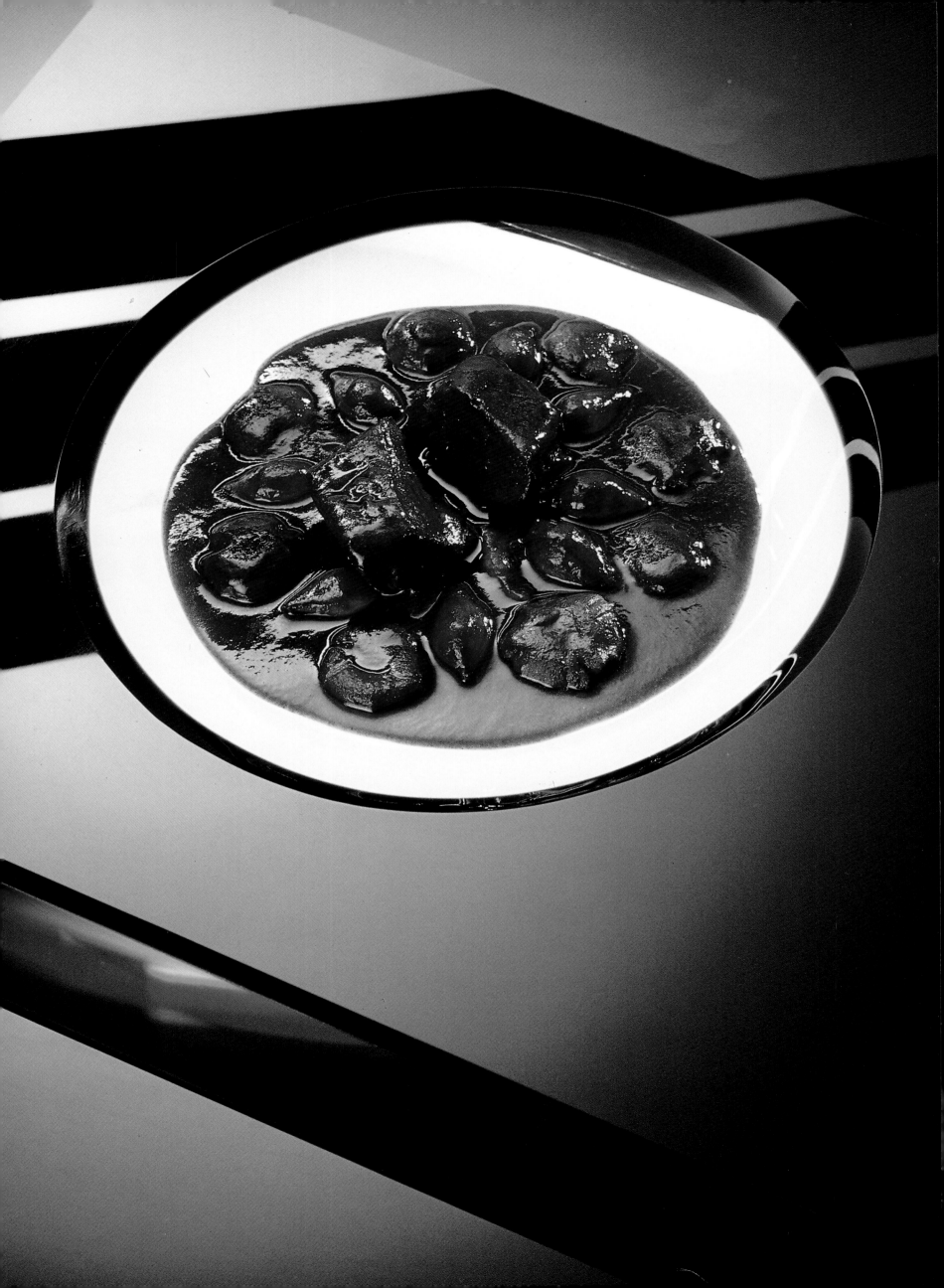

We make different kinds of stews with game. If the game has feathers, we call the stew a salmis; if it has fur, we call it a *civet*. The preparation is more or less the same, using red or white wine. After my Salmis of Mulard Duck cooks for two hours, the meat is very tender, and the sauce develops a rich flavor. The dish gets even better two to three days later.

This recipe for hare is very old, but it's so time-consuming that most chefs don't bother with it anymore. This particular version from Dordogne calls for boning the hare and making it into a stuffing with pork fat, fresh foie gras, truffles, truffle juice, and Armagnac. It is then wrapped in the skin, covered in caul fat, and cooked for three hours. The sauce is made using some of the hare's blood, which gives it a beautiful, black, shiny color. When the hare is sliced, it makes a wonderful presentation on the plate, but you have to really love working with game because the preparation is lengthy. For me, it's worth it.

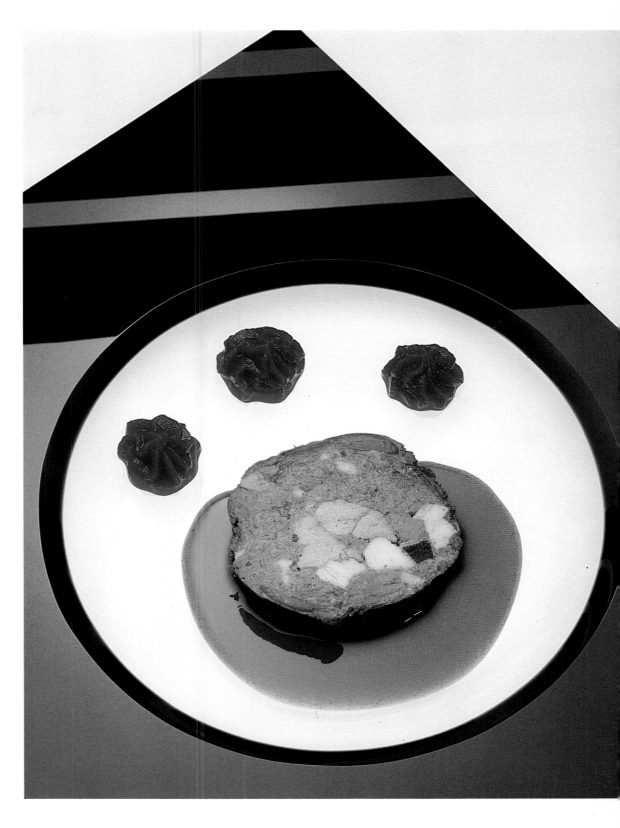

(Left) **SALMIS OF MULARD DUCK**
WITH HONEY MUSHROOMS
and **GLAZED PEARL ONIONS**
(Upper right) **HARE A LA ROYALE**
with **BEET PUREE**
and **RED WINE SAUCE**
(Lower right) **RED BEET**

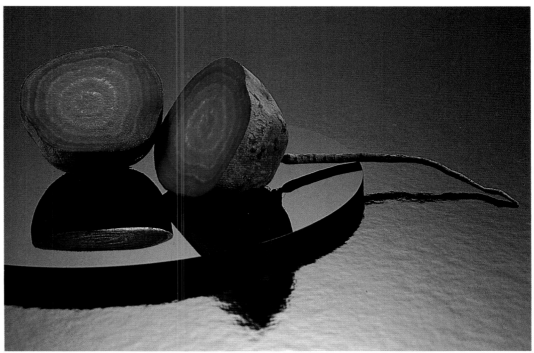

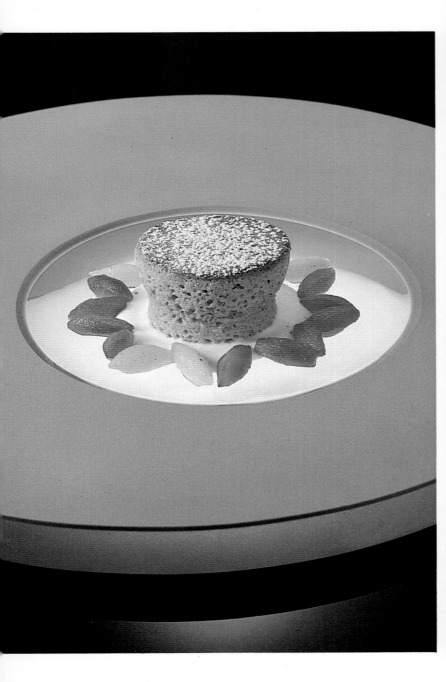

FRESH CHESTNUT SOUFFLE
with POACHED PEARS, APPLES,
AND PEACHES
(Right) MERVEILLES

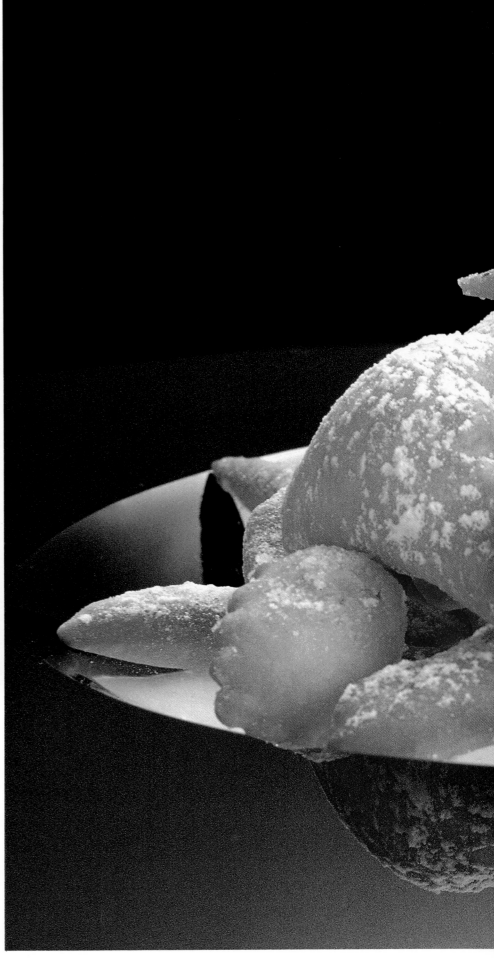

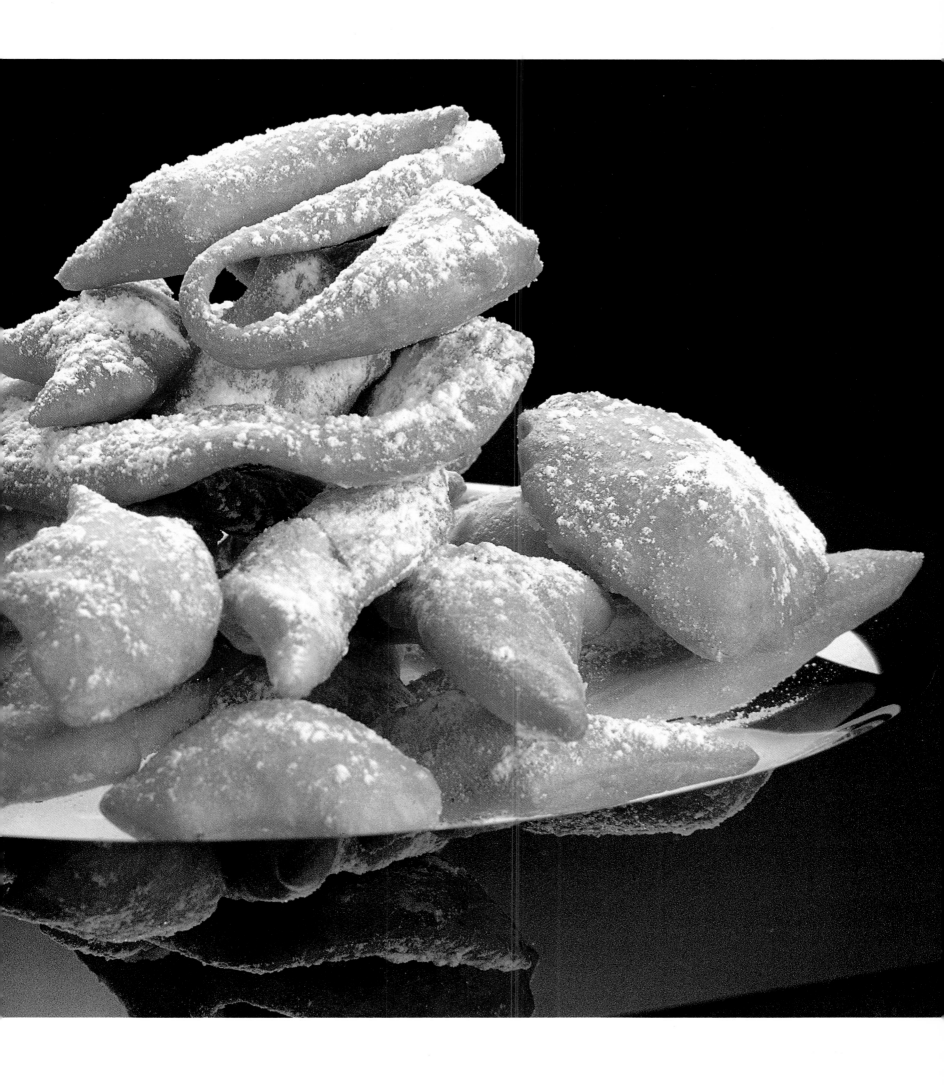

Winter

BELON OYSTERS AND LOBSTER MOUSSELINE WRAPPED IN POTATOES
De Venoge Brut, "Cordon Bleu," 1973

∽

**CREAM OF GREEN LENTIL SOUP with VEAL SHANK, "WHITE KIDNEYS,"
and FOIE GRAS, MAGRET OF DUCK, AND BLACK TRUFFLE SAUSAGE**
Cream Sherry, Antonio de la Riva

∽

**TERRINE OF FOIE GRAS, BLACK TRUFFLES, AND TRICOLORED PASTA
with PROSCIUTTO AND FRESH HERB TOMATO SAUCE**
Wehlener Sonnenuhr Kabinett, Reichsgraf von Kesselstatt, Mosel, 1985

∽

STEAMED MAINE LOBSTER with MANGO GINGER SAUCE, SEA BEANS, and MANGO PETALS
Château Montelena Chardonnay, Napa Valley, 1984

∽

BAKED SEA BASS with BASQUAISE VEGETABLES
Château Grillet, Domaine Neyrat-Gachet, 1984

∽

VEAL POT-AU-FEU with VEGETABLES and STUFFED CABBAGE LEAVES
Pommard, "Grands Epenots," Domaine Gaunoux, Grivelet, 1947

∽

APPLE TURNOVER with DATE SAUCE

FIG MOUSSE with FIG SAUCE and PEAR "ROSES"
Erbacher Marcobrunner Auslese, Langwerth von Simmern, 1971

Belon Oysters and Lobster Mousseline Wrapped in Potatoes is a study in contrasts. My idea was to have something hot and crunchy on the outside and cold and soft on the inside. When the raw oyster and mousseline are enveloped by the fried potatoes, it makes a very successful marriage.

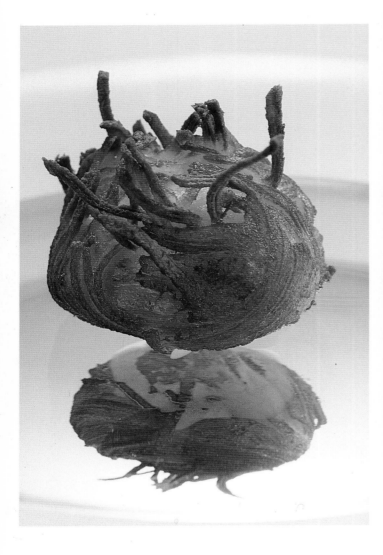

**BELON OYSTERS
AND LOBSTER MOUSSELINE
WRAPPED IN POTATOES
(Right) CREAM OF GREEN LENTIL SOUP
with VEAL SHANK, ''WHITE KIDNEYS,''
and FOIE GRAS, MAGRET OF DUCK,
AND BLACK TRUFFLE SAUSAGE**

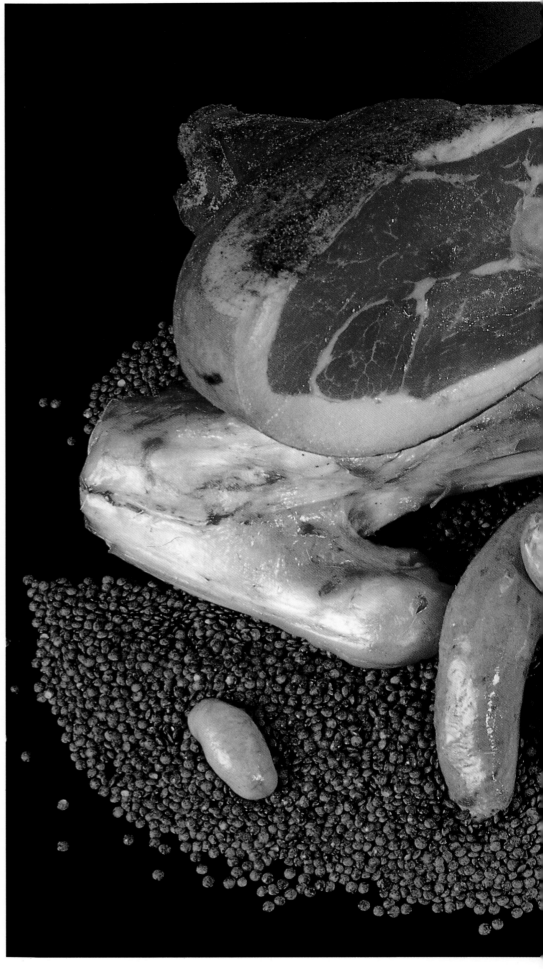

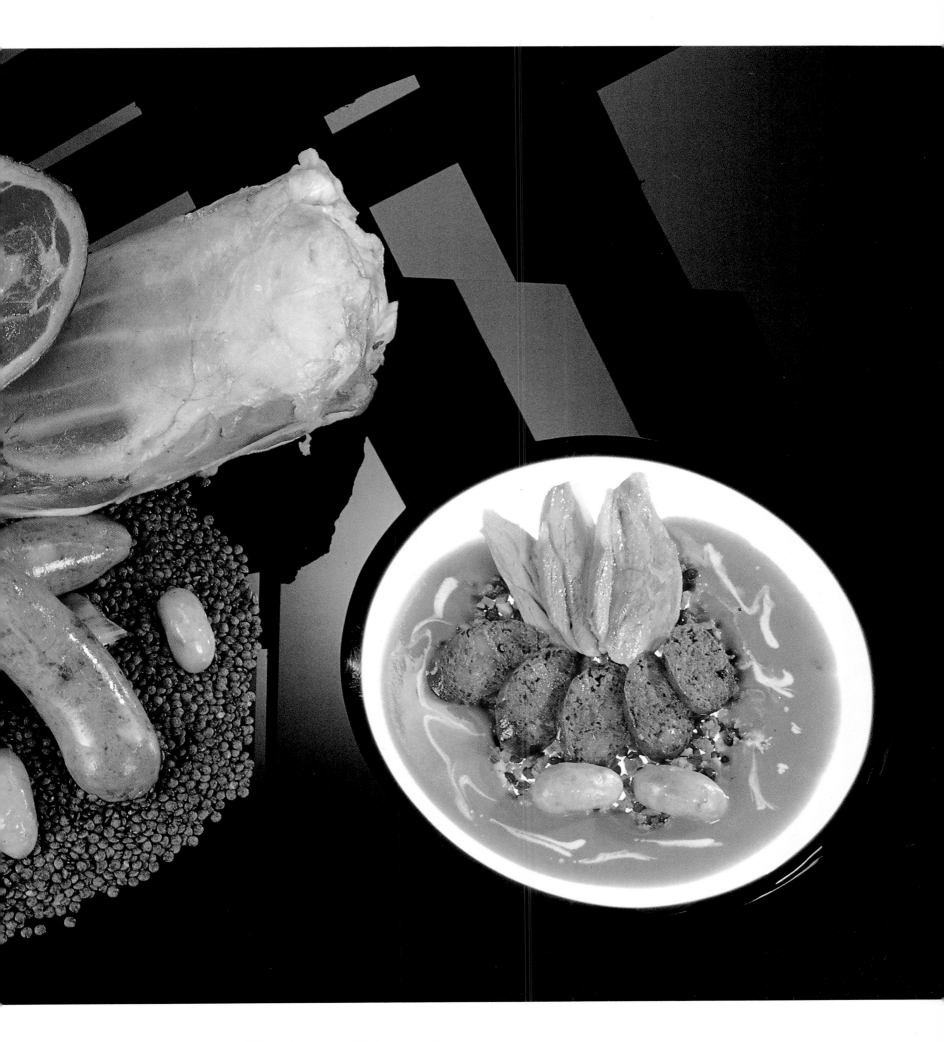

When I was a child, my mother fed me lentils every week in winter. I didn't like them too much then, but I do now; the more you eat lentils, the better they taste!

I like a sommelier who knows his job and doesn't wear blinders, who will look to the left and to the right and try to be imaginative. Taste is a very personal thing. That is why I always say there is no perfect wine for one dish. Great experts sit and say, "Oh, yes, the *only* wine you can drink with salmon is Mersault." I think that's ridiculous; I could never go that far.

The important thing about lobsters is not to overcook them and to let them rest—relax—after they have been cooked. In fact, it's important to do that with all meats. If you eat something that has just been cooked, it might be tough, but wait ten minutes, and you've got an entirely different piece of meat. I didn't use lobsters much in France; I probably didn't prepare them more than ten times during the 21 years I was cooking there. It was not that people didn't like them, but rather that Condom wasn't the area for that. But Americans are crazy about their lobsters, and I love to create different dishes with them.

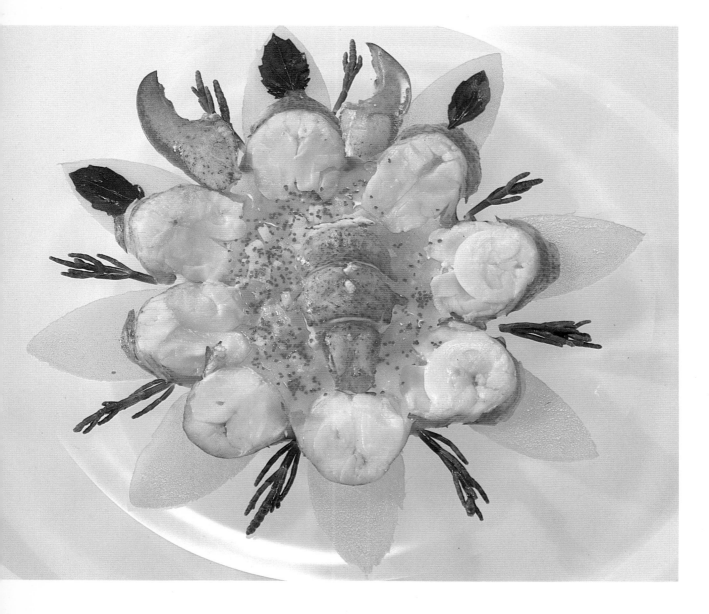

(Pages 52-53) TERRINE OF FOIE GRAS,
BLACK TRUFFLES,
AND TRICOLORED PASTA
with PROSCIUTTO
AND FRESH HERB TOMATO SAUCE
(Left) STEAMED MAINE LOBSTER
with MANGO GINGER SAUCE,
SEA BEANS, and MANGO PETALS
(Right) BAKED SEA BASS
with BASQUAISE VEGETABLES

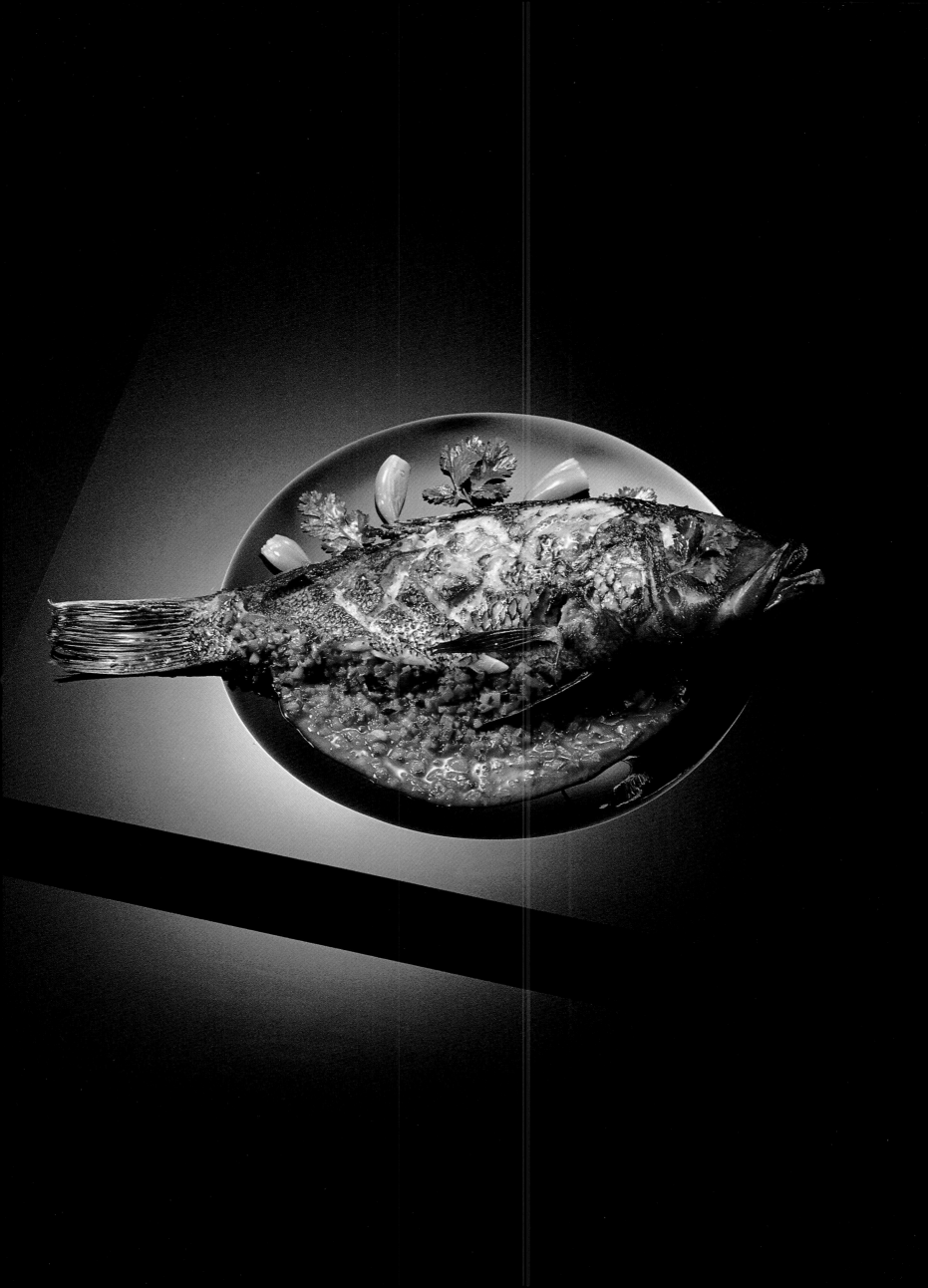

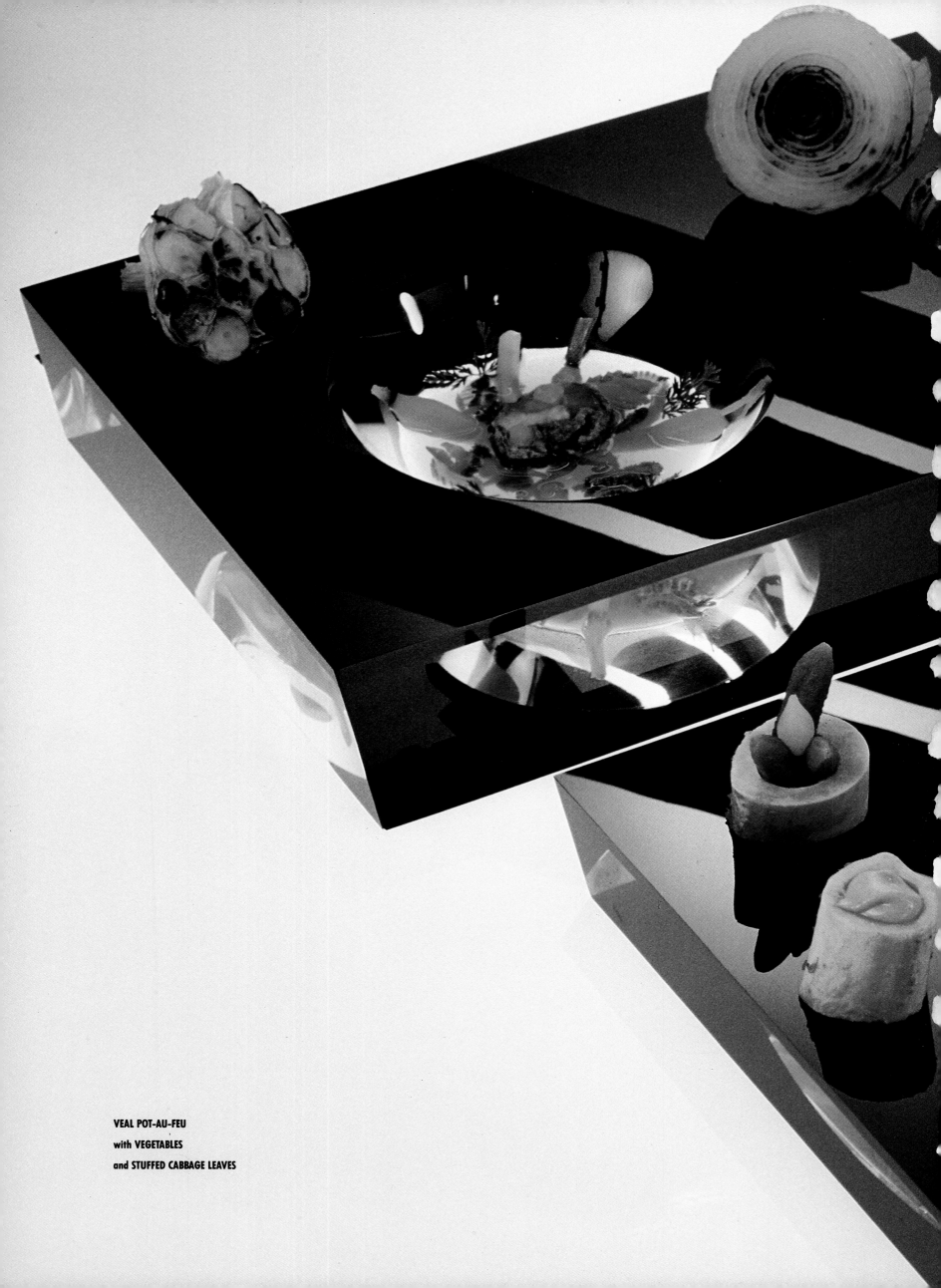

VEAL POT-AU-FEU
with VEGETABLES
and STUFFED CABBAGE LEAVES

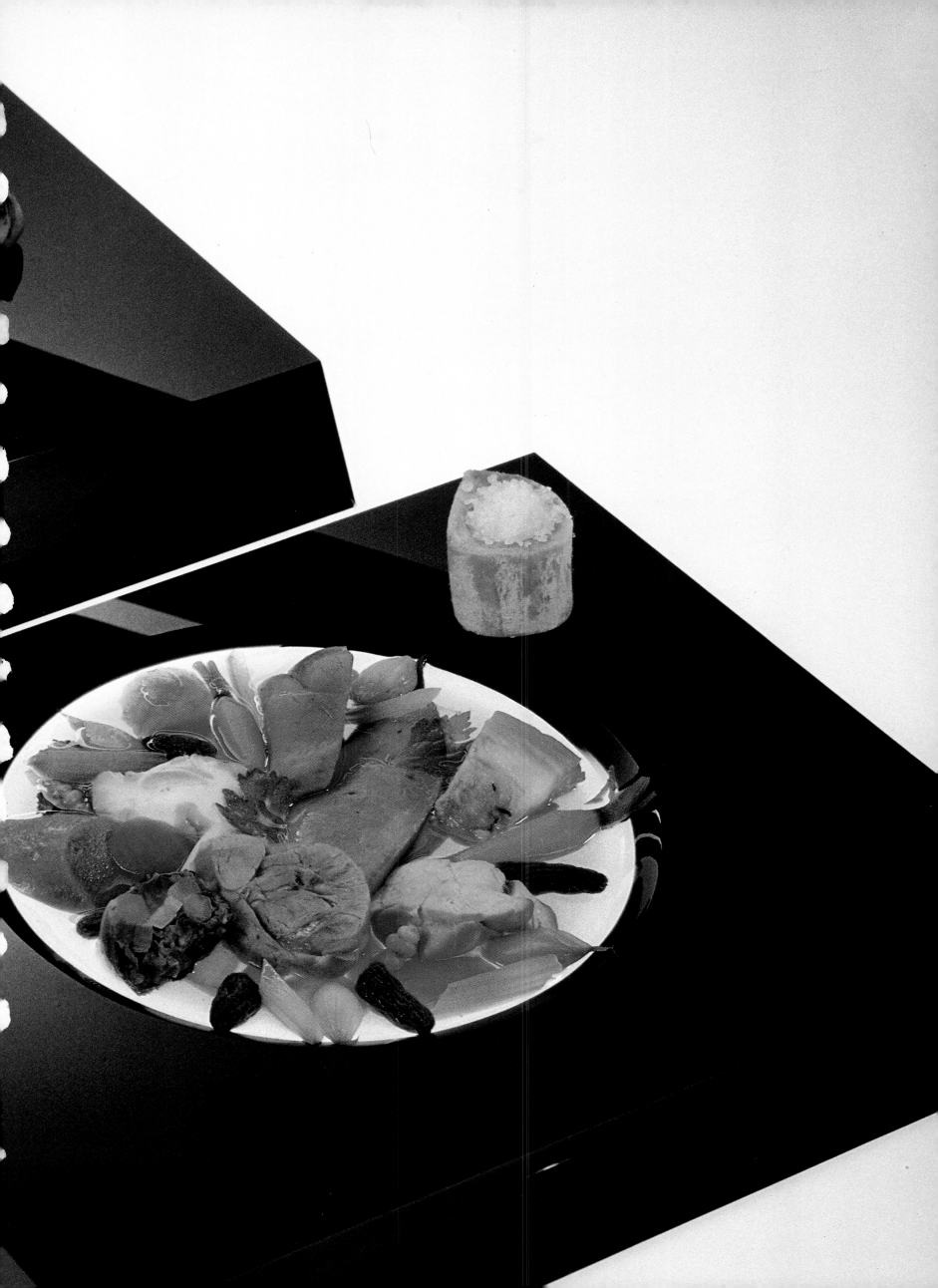

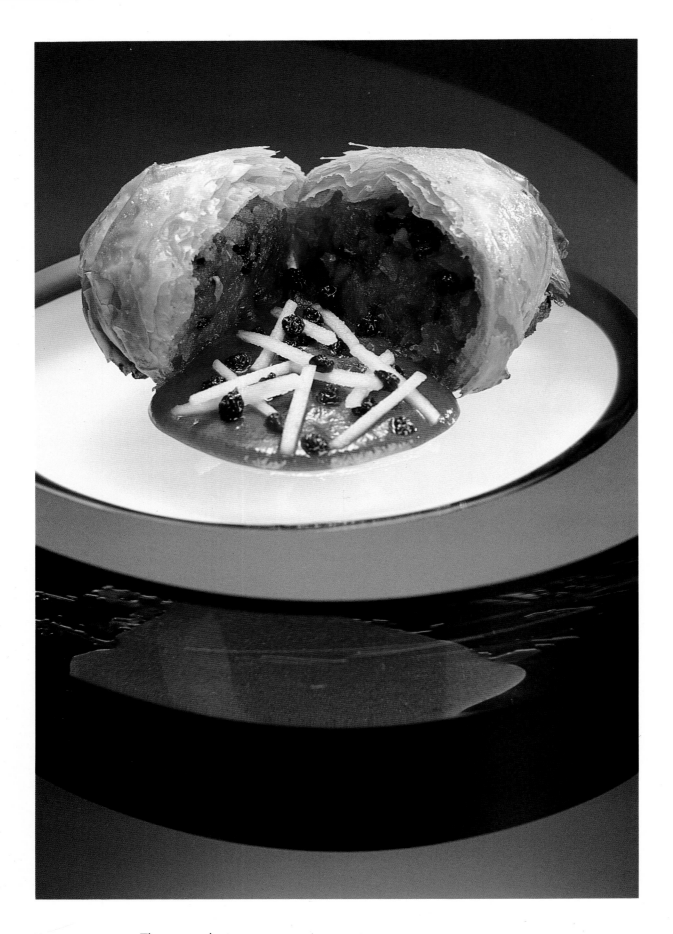

These apple turnovers are a creation of one of my former pastry chefs, Richard Chirol, who got the idea from watching me make crab cakes — the concept of apples held together with almond paste is comparable to my combination of crab meat and lobster mousseline. You can really play around with both dishes, adding spices and other ingredients as you like.

APPLE TURNOVER
with DATE SAUCE
(Right) FIG MOUSSE
with FIG SAUCE
and PEAR ''ROSES''

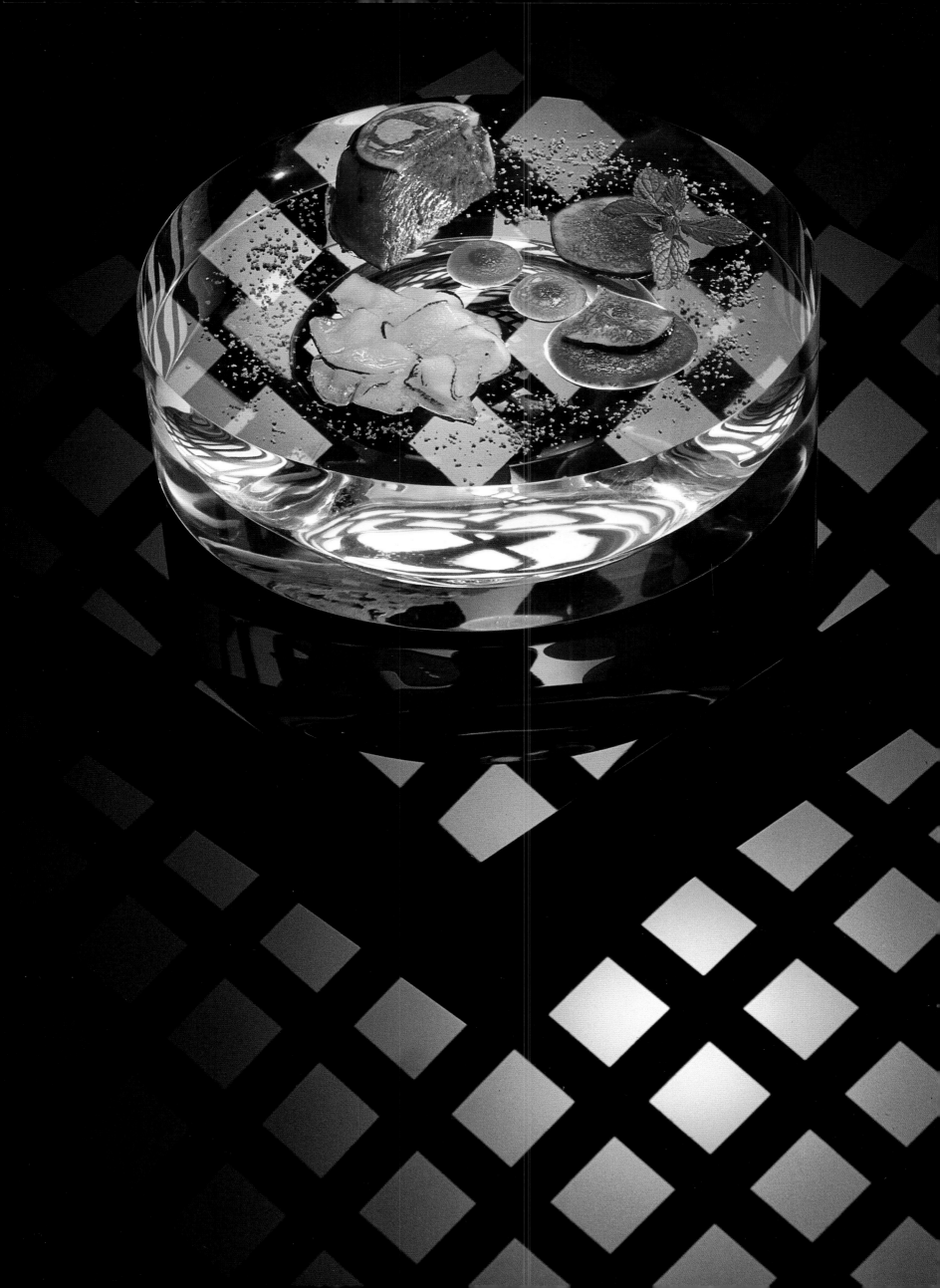

BELON OYSTERS ON THE HALF SHELL with OYSTER AND DILL SAUCE
Pol Roger Brut, "Cuvée Sir Winston Churchill," 1979

∾

**CREAM OF EGGPLANT SOUP with SHALLOT FLAN, RABBIT TENDERLOIN, "WHITE KIDNEYS,"
MIREPOIX OF CRISPY SWEETBREADS, PROSCIUTTO, AND EGGPLANT, and FRIED EGGPLANT**
Volnay, "Clos des Santenots," Jacques Prieur, 1980

∾

PAPILLOTE OF FOIE GRAS AND SEA SCALLOPS WITH JULIENNE VEGETABLES AND CHERVIL
Wehlener Sonnenuhr Auslese, Joh. Jos. Prüm, 1985

∾

**MINIATURE PUMPKIN STUFFED WITH STEAMED MAINE LOBSTER, LOBSTER MOUSSELINE,
AND SWEET POTATO-PUMPKIN PUREE with PUMPKIN AND LOBSTER CREAM SAUCE**
Mayacamas Vineyards Chardonnay, Napa Valley, 1984

∾

**SKATE STUFFED WITH LOBSTER MOUSSELINE
with FRIED JULIENNE VEGETABLES and SWEET MARJORAM CAPER SAUCE**
Hermitage Blanc, E. Guigal, 1982

∾

BEEF POT-AU-FEU with STUFFED CABBAGE LEAVES, VEGETABLES, and BONE MARROW FLAN
Château Haut-Brion, Graves Premier Grand Cru, 1966

∾

**ORANGE, LEMON, AND LIME SNOW EGGS with CUSTARD CREAM
and ORANGE, LEMON, AND LIME SAUCES**

**PERSIMMON CAKE, FROZEN HAZELNUT SOUFFLE with CHOCOLATE SAUCE,
and THREE CHOCOLATE MOUSSES with RASPBERRY SAUCE**
Taittinger Brut Rosé, Comtes de Champagne, 1979

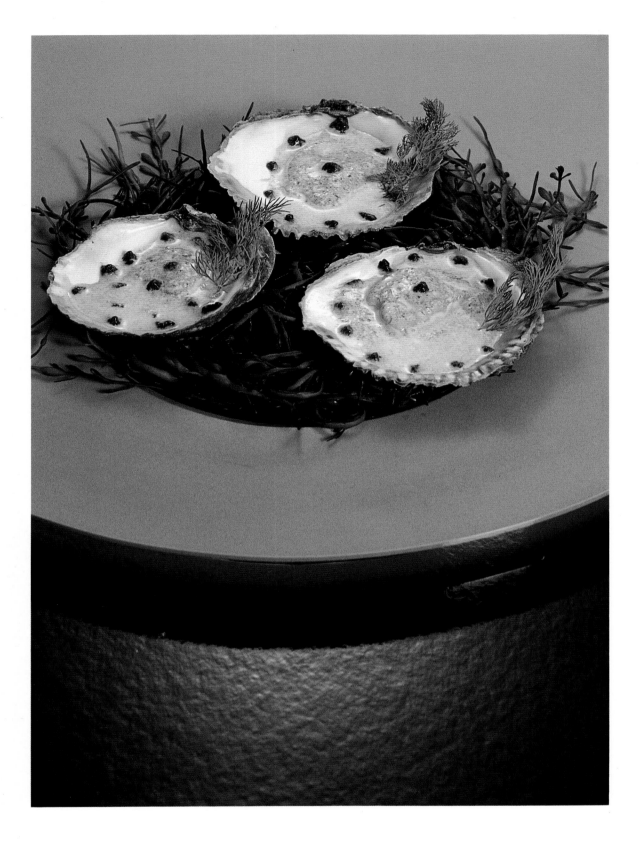

BELON OYSTERS ON THE HALF SHELL
with **OYSTER AND DILL SAUCE**
(Right) **CREAM OF EGGPLANT SOUP**
with **SHALLOT FLAN,**
RABBIT TENDERLOIN,
"WHITE KIDNEYS,"
MIREPOIX OF CRISPY SWEETBREADS,
PROSCIUTTO, AND EGGPLANT,
and **FRIED EGGPLANT**

I don't know if anyone ever made an eggplant soup before; you certainly don't see it every day. But eggplant is a very good vegetable, and since I love to create different kinds of soup, I just let my mind play with this dish. It's a combination of eggplant, prosciutto, and other vegetables stewed and then puréed in a food processor. The fried eggplant replaces the chunks of bread my mother and father used to drop in their soup, and the flan is there to balance the acidity of the eggplant seeds.

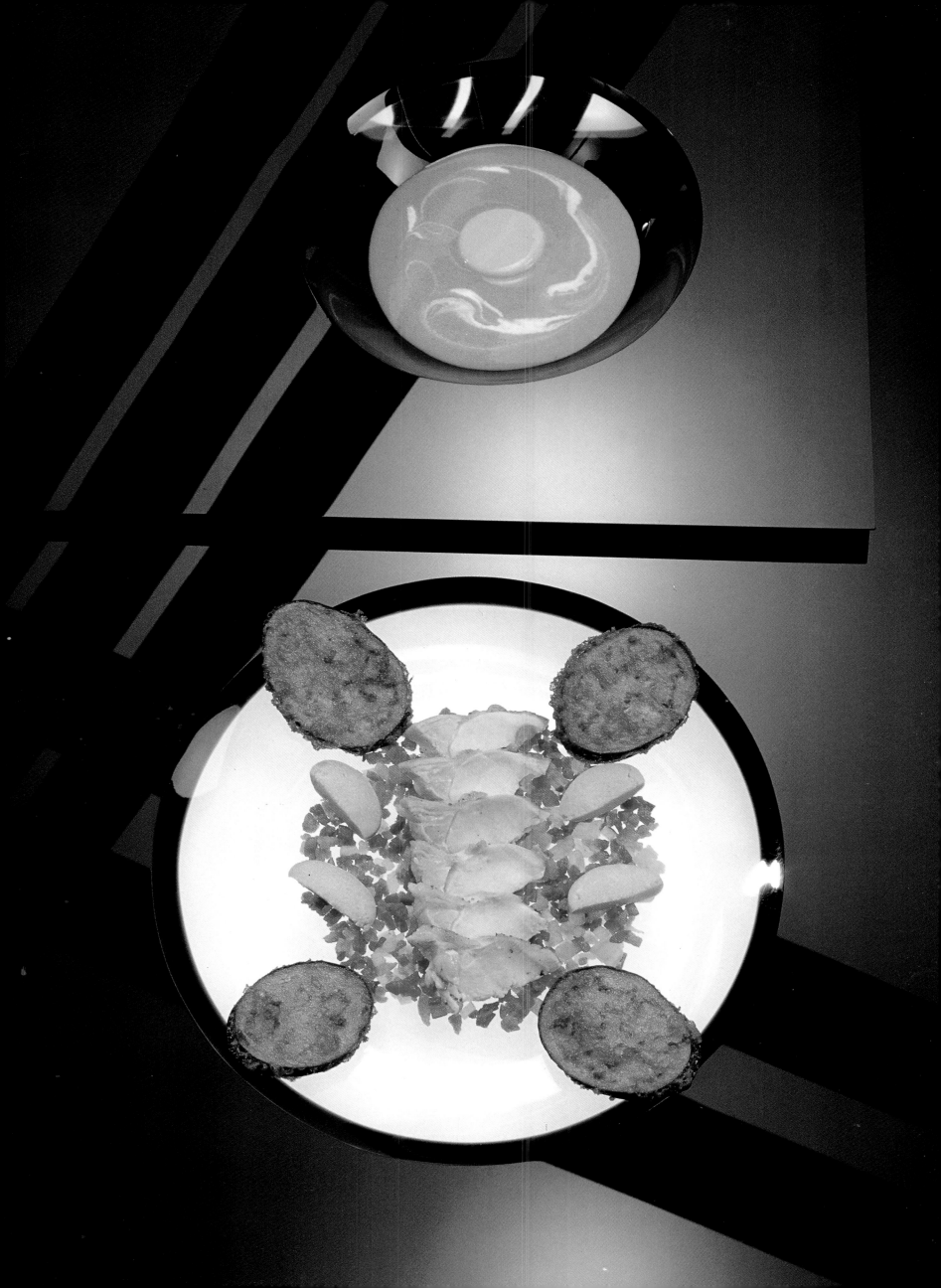

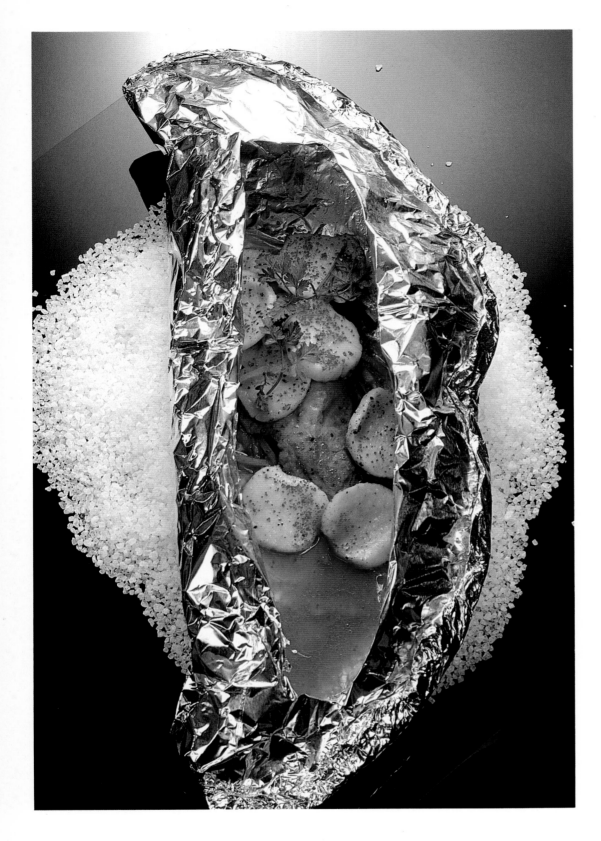

ften when we eat, not all of our senses are awakened, but *Papillotes* of Foie Gras and Sea Scallops is a creation that appeals to each one of them. Inside the *papillote*, a piece of foil or parchment, I put foie gras, herbs, vegetables, and scallops. This is baked in the oven or fireplace, and the foil puffs up as it cooks. First, when it is brought to the table, you have something that looks shiny and attractive. Second, you can hear what is inside still simmering. Third, when the waiter comes to open it with scissors, the aroma rushes out. And last, you taste it. All of your senses are satisfied.

I had the idea of marrying scallops with foie gras because scallops are very sweet and I didn't want to kill the foie gras by combining it with something too overpowering. It was the first time these two ingredients were put together, and the dish was a big hit in France. But you have to think carefully about which things can be successfully combined. To put unusual things together just for the sake of being different is dangerous.

PAPILLOTE OF FOIE GRAS
AND SEA SCALLOPS
WITH JULIENNE VEGETABLES
AND CHERVIL
(Right) MINIATURE PUMPKIN
STUFFED WITH STEAMED MAINE LOBSTER,
LOBSTER MOUSSELINE,
AND SWEET POTATO-PUMPKIN PUREE
with PUMPKIN AND LOBSTER
CREAM SAUCE

Some of the people who come to my restaurant don't want to try anything too unusual, but I also want to be ready for those who are willing to be adventurous. It's like putting a piece by an unknown composer on the program between the Bach and Beethoven. I'm very encouraged when people tell me that I have helped them learn about food. Most Americans have never eaten skate. It is an ugly-looking fish, but it has a beautiful fiber and texture all its own.

(Below) SKATE STUFFED WITH LOBSTER MOUSSELINE
with FRIED JULIENNE VEGETABLES
and SWEET MARJORAM CAPER SAUCE
(Right) BEEF POT-AU-FEU
with STUFFED CABBAGE LEAVES,
VEGETABLES, and BONE MARROW FLAN

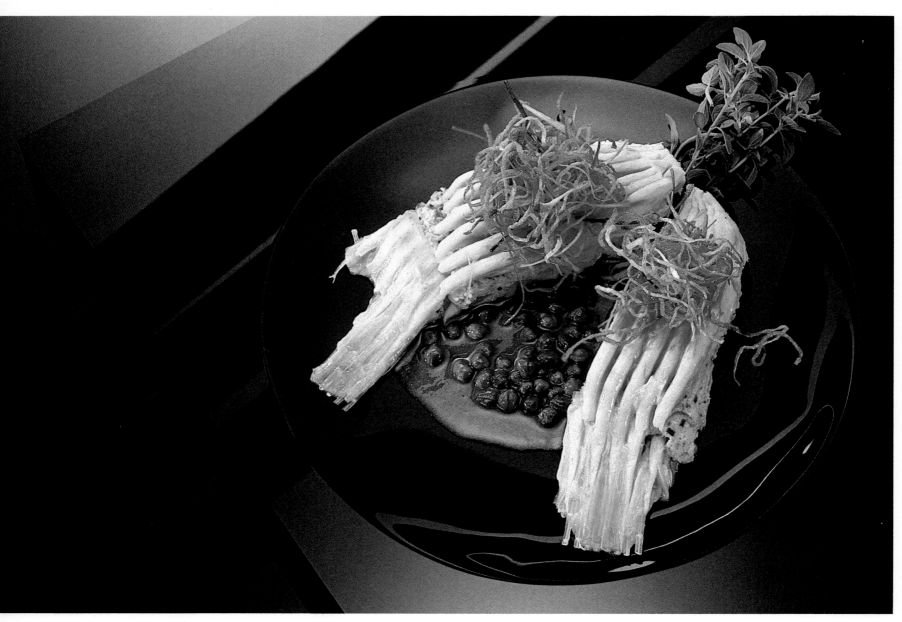

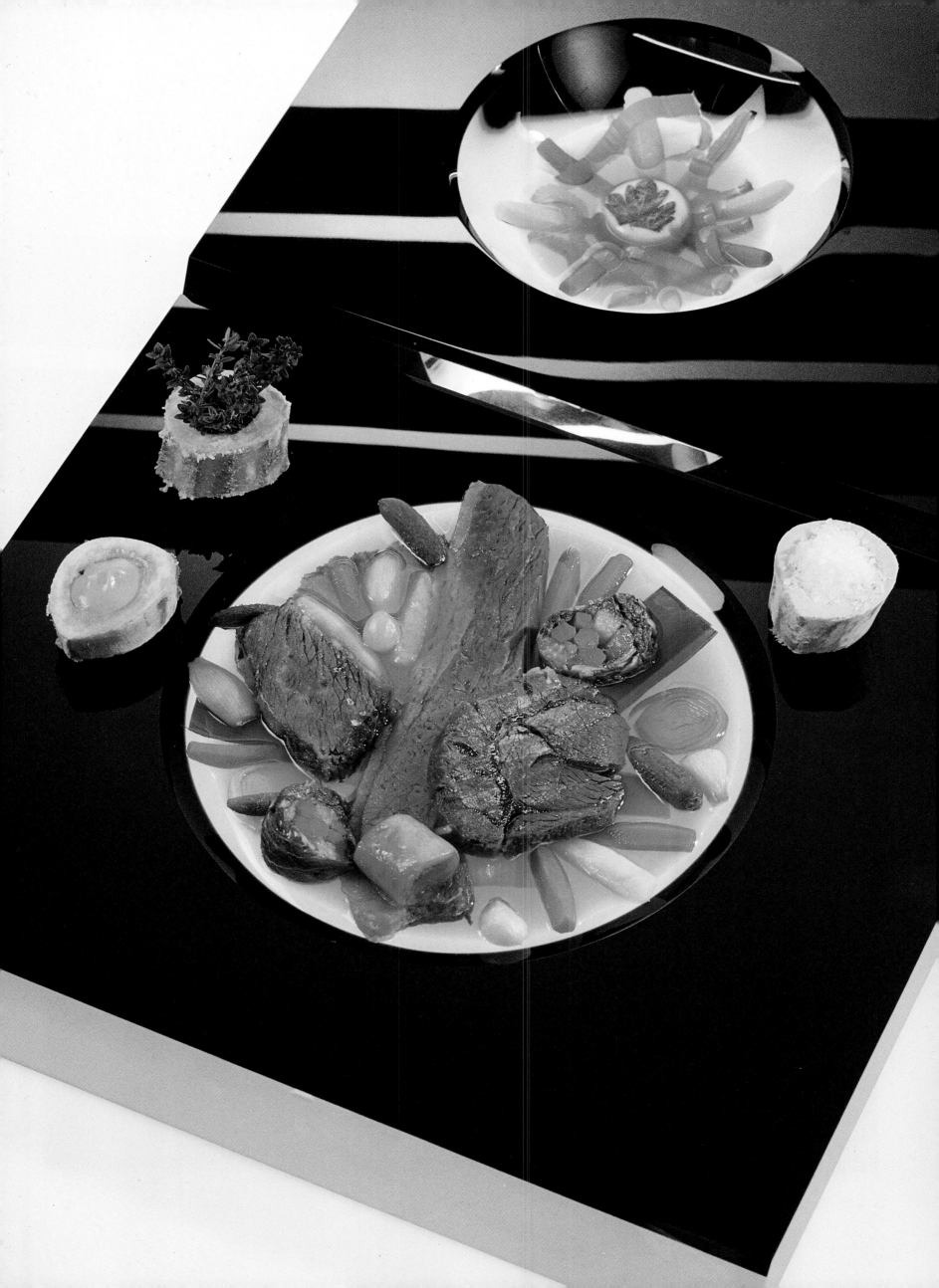

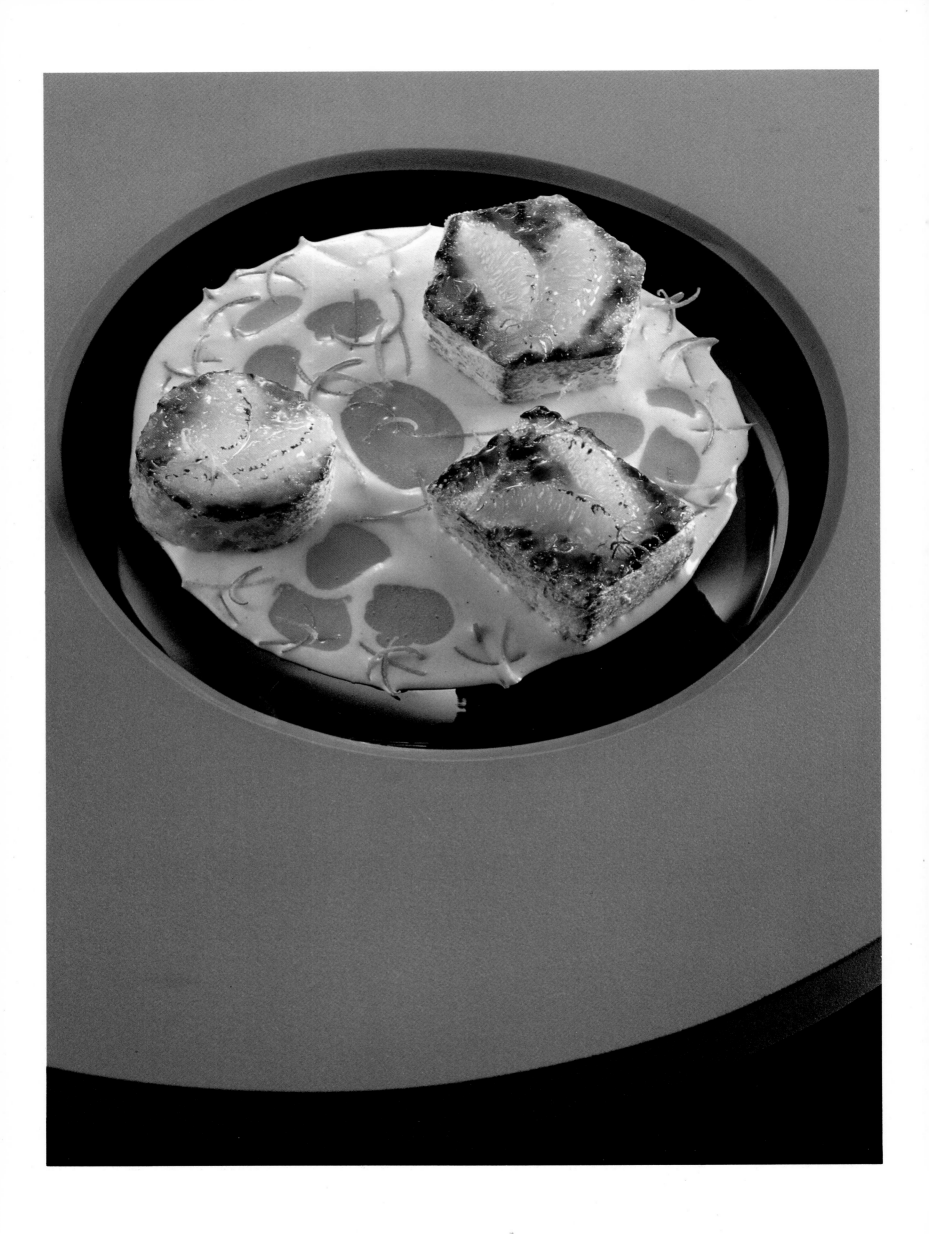

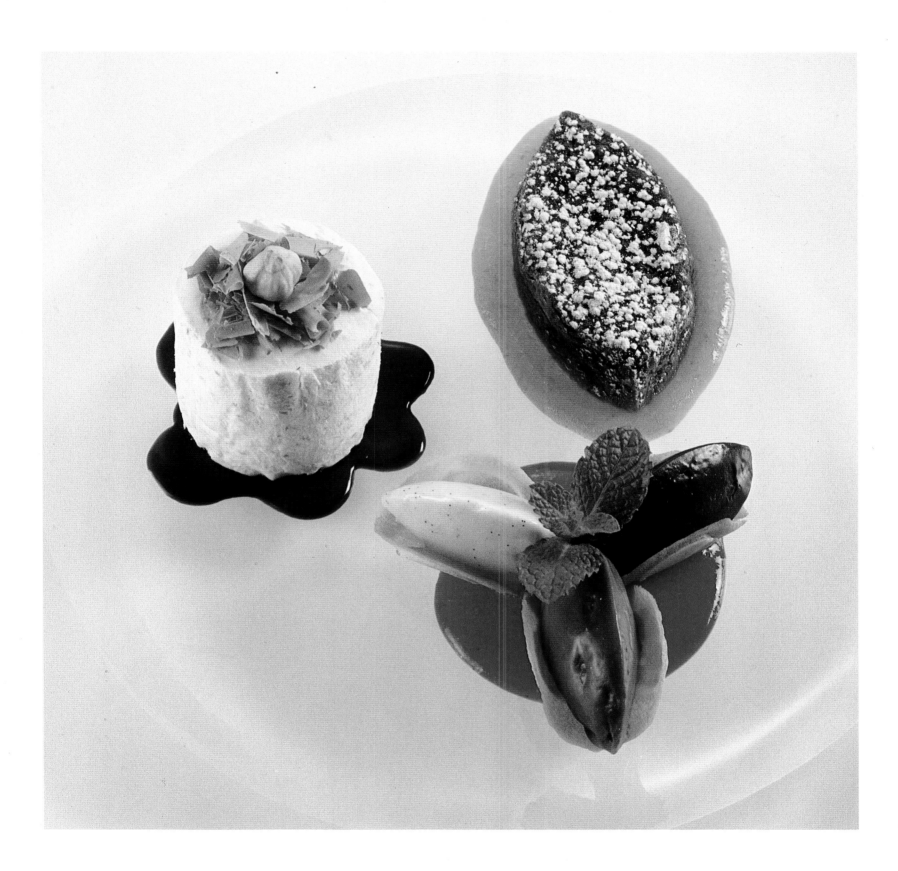

PERSIMMON CAKE,
FROZEN HAZELNUT SOUFFLE
with CHOCOLATE SAUCE,
and THREE CHOCOLATE MOUSSES
with RASPBERRY SAUCE
(Left) ORANGE, LEMON, AND LIME SNOW EGGS
with CUSTARD CREAM
and ORANGE, LEMON, AND LIME SAUCES

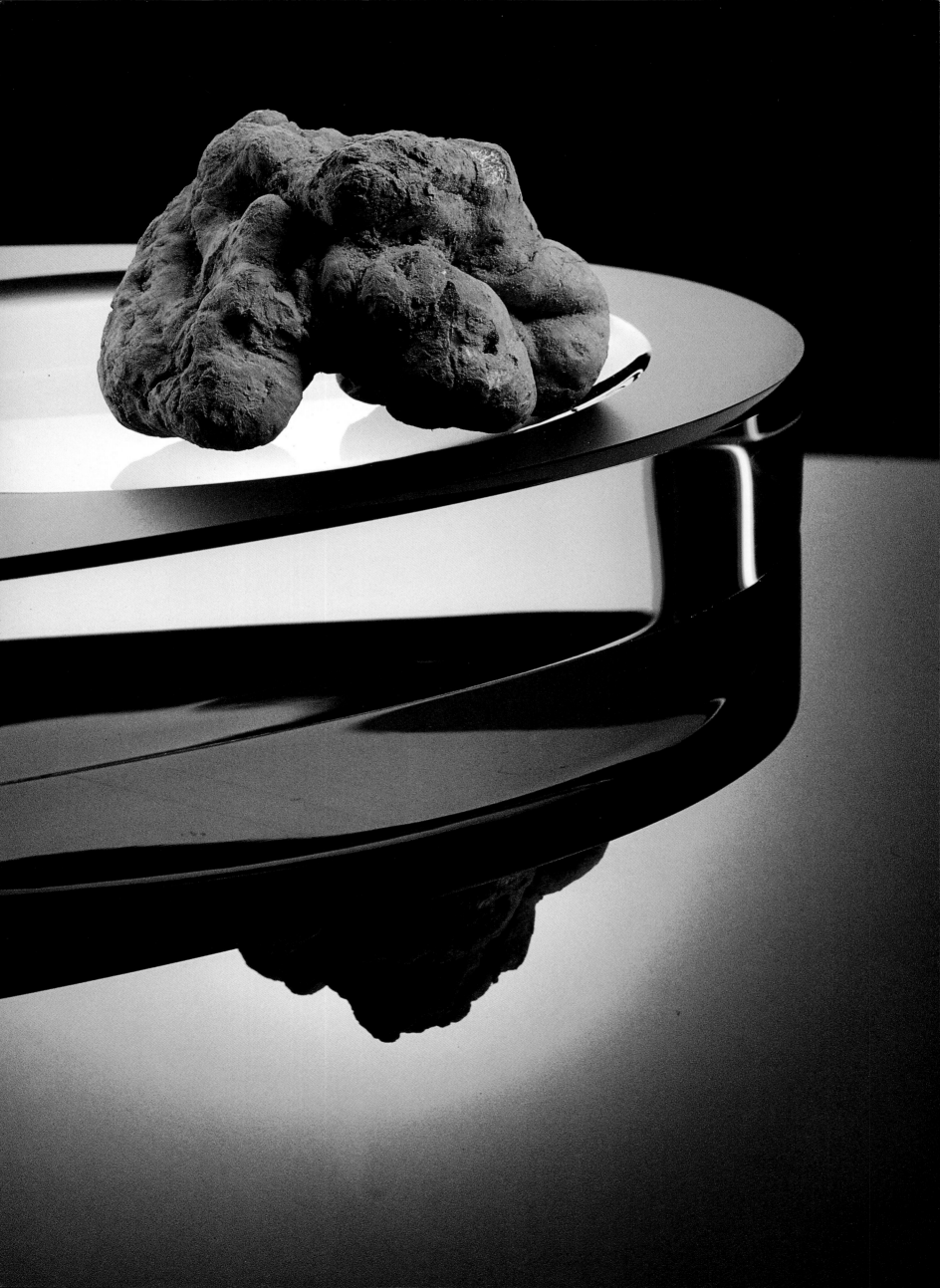

DUCK NECK STUFFED WITH FOIE GRAS, MAGRET OF DUCK, AND BLACK TRUFFLES
Piper Heidsieck, "Rare," 1976

∽

SALAD OF WARM SEA SCALLOPS, WHITE TRUFFLES, FRESH HEARTS OF PALM, AND MESCLUN with BALSAMIC VINAIGRETTE
Chassagne-Montrachet, "Morgeot," Bachelet-Ramonet, 1985

∽

ZUCCHINI FLOWERS STUFFED WITH BLACK TRUFFLE AND LOBSTER MOUSSELINE with BABY ZUCCHINI, BABY YELLOW SQUASH, and TRUFFLE SAUCE
Château Laville Haut-Brion, Graves Grand Cru, 1979

∽

POTATO AND BLACK TRUFFLE CAKE with BLACK TRUFFLE BALSAMIC VINAIGRETTE
Grgich Hills Cellars Sauvignon Blanc, Napa Valley, 1985

∽

BRAISED SWEETBREADS WRAPPED IN BLACK TRUFFLES with CELERY ROOT CREAM SAUCE
Chambertin-Clos de Bèze, Joseph Drouhin, 1979

∽

MONKFISH WRAPPED IN BLACK TRUFFLES AND PANCETTA with TRUFFLE SAUCE
Clos Blanc de Vougeot, L'Heritier Guyot, 1983

∽

ROASTED CAPON WITH BLACK TRUFFLES AND FRENCH BREAD STUFFING and BLACK TRUFFLE SAUCE
Château d'Yquem, 1961

∽

BLACK TRUFFLE ICE CREAM INSPIRED BY ANDRE DAGUIN

PETITS FOURS
Armagnac Blanc

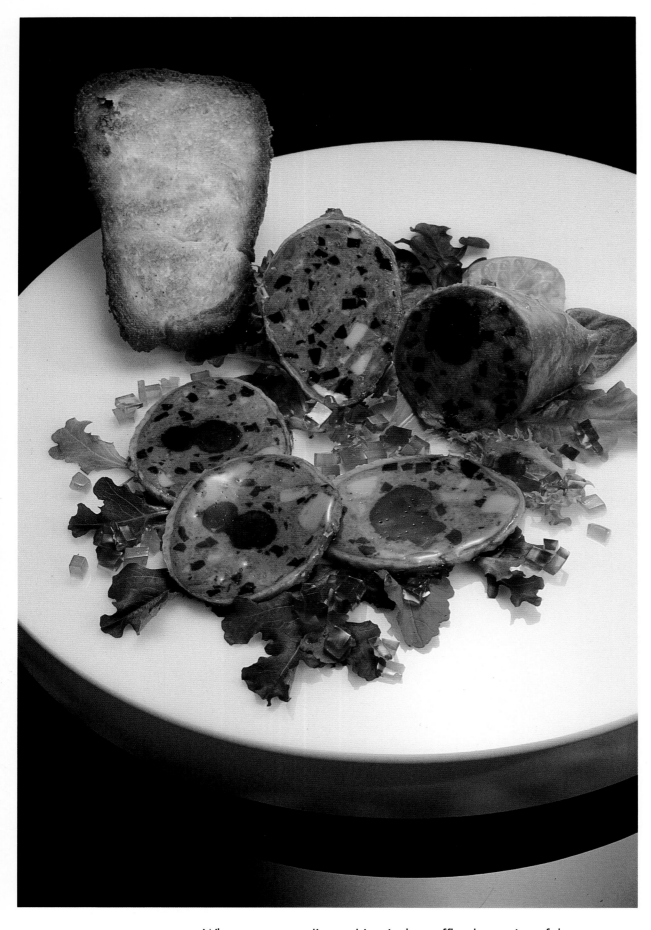

DUCK NECK STUFFED WITH FOIE GRAS,
MAGRET OF DUCK,
AND BLACK TRUFFLES
(Right) SALAD OF WARM SEA SCALLOPS,
WHITE TRUFFLES,
FRESH HEARTS OF PALM,
AND MESCLUN
with BALSAMIC VINAIGRETTE

What an extraordinary thing is the truffle, the caviar of the forest! I have been buying black truffles directly from Jacques Pebeyre in the Perigord for almost 30 years. He is responsible for having made the industry what it is today; he is the king of truffles.

Paolo Urbani in Alba ships me the best white truffles. They have a completely different taste from the black and are more scarce. After one and a half months, their growing season is over, and although they can be canned, the fresh ones are much better. White truffles have a strong taste of garlic, and Monsieur Pebeyre taught me a trick: if you rub a little garlic on the knife when you cut a black truffle, it will enhance the flavor and make it taste more like a white one.

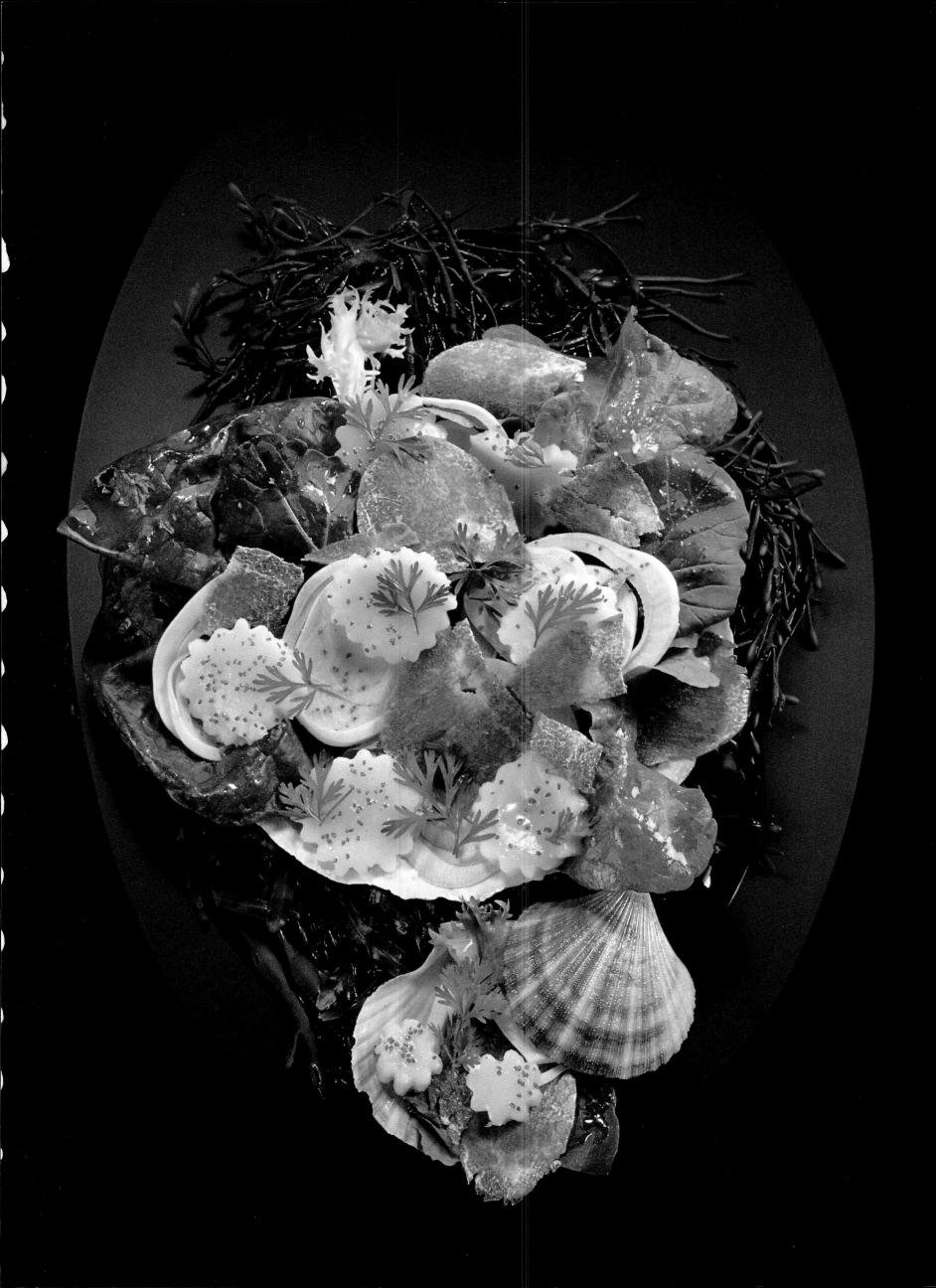

As a rule, I don't like to cook with flowers, but zucchini blossoms are an exception. I have also used rose petals in salads, which can be very interesting. But in general, I think eating flowers is the business of bees. Nor do I like to use flowers as decorations on the plate. To put something on the plate just to be beautiful is not my style. I don't like to think that my food needs that to make it look good. Flowers belong in the middle of the table or the corner of the room. When you grow up as I did, you want to be able to eat everything on your plate.

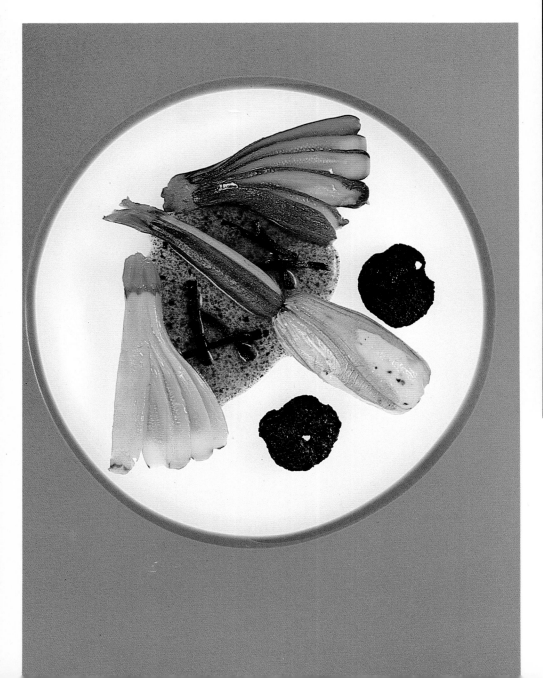

(Left) ZUCCHINI FLOWERS STUFFED WITH BLACK TRUFFLE AND LOBSTER MOUSSELINE with BABY ZUCCHINI, BABY YELLOW SQUASH, and TRUFFLE SAUCE

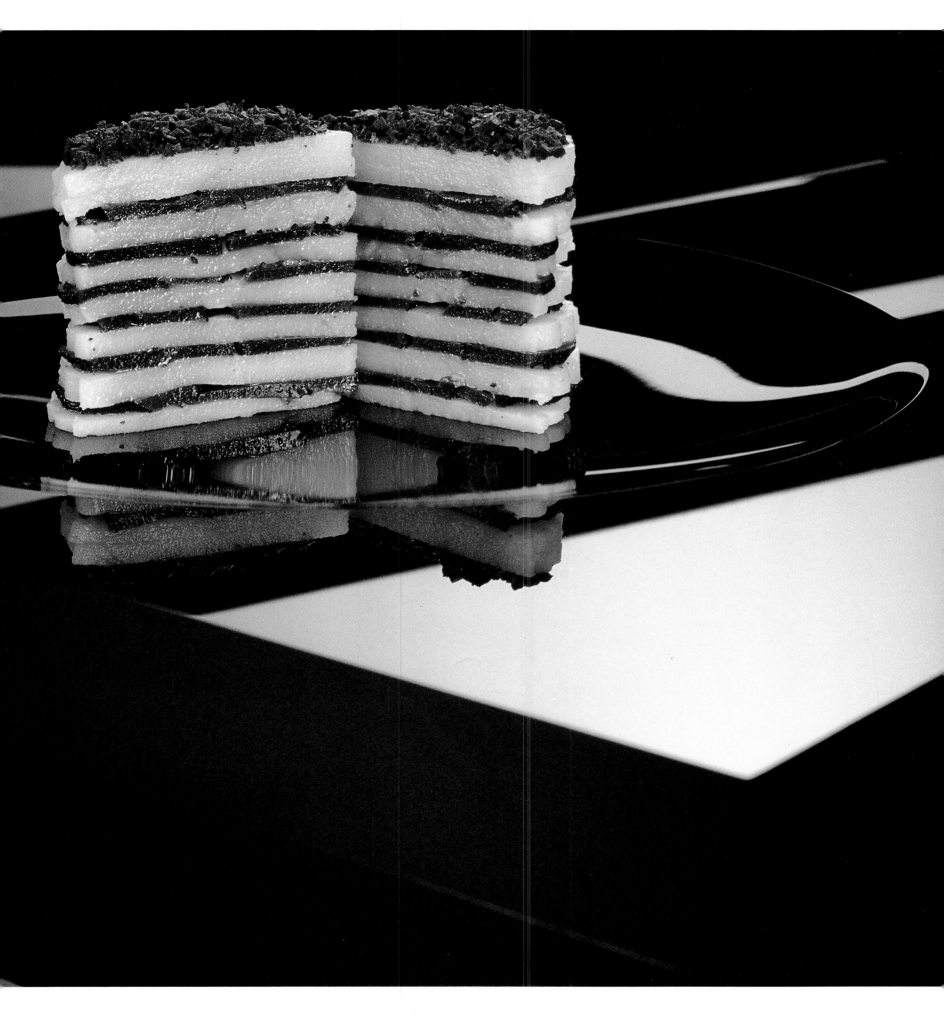

POTATO AND BLACK TRUFFLE CAKE

with BLACK TRUFFLE

BALSAMIC VINAIGRETTE

In Condom, we used to add some truffle, salt, vinegar, and oil to potatoes cooked in their skins, and eat them warm. I knew it was impossible to improve on that taste but thought I could do something with the presentation, so I built these Potato and Black Truffle Cakes. I like the contrast of black and white; it gives the dish an art deco effect.

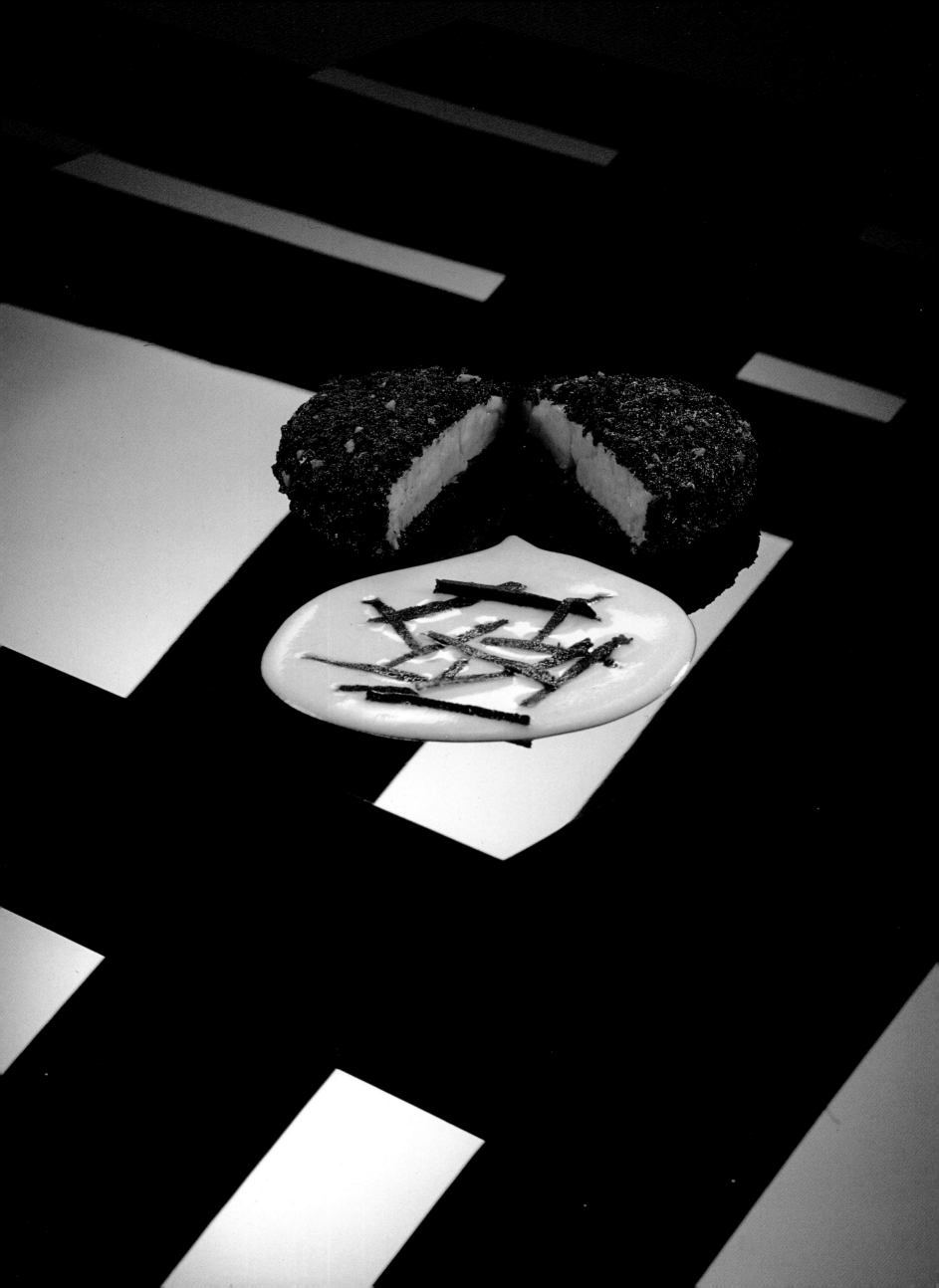

I've been preparing an entire menu of truffle dishes for years now, and, needless to say, it is expensive. However, when I write "truffle" on my menu, I do not mean a thin, one-gram slice that is more decoration than substance; I mean that truffles are a major element of the dish. I want those people who enjoy truffles to really taste them and to savor what they have eaten.

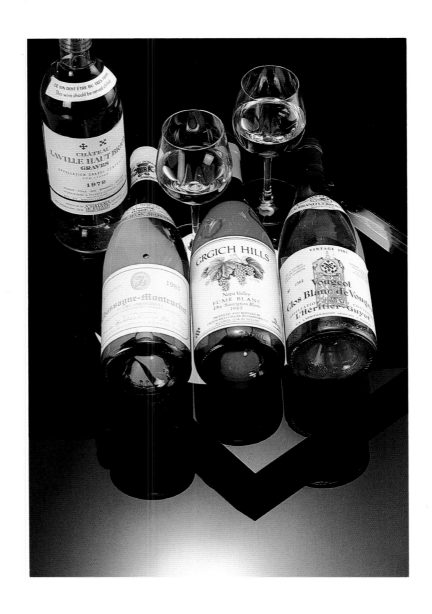

(Left) BRAISED SWEETBREADS
WRAPPED IN BLACK TRUFFLES
with CELERY ROOT CREAM SAUCE
(Below) MONKFISH WRAPPED
IN BLACK TRUFFLES
AND PANCETTA
with TRUFFLE SAUCE

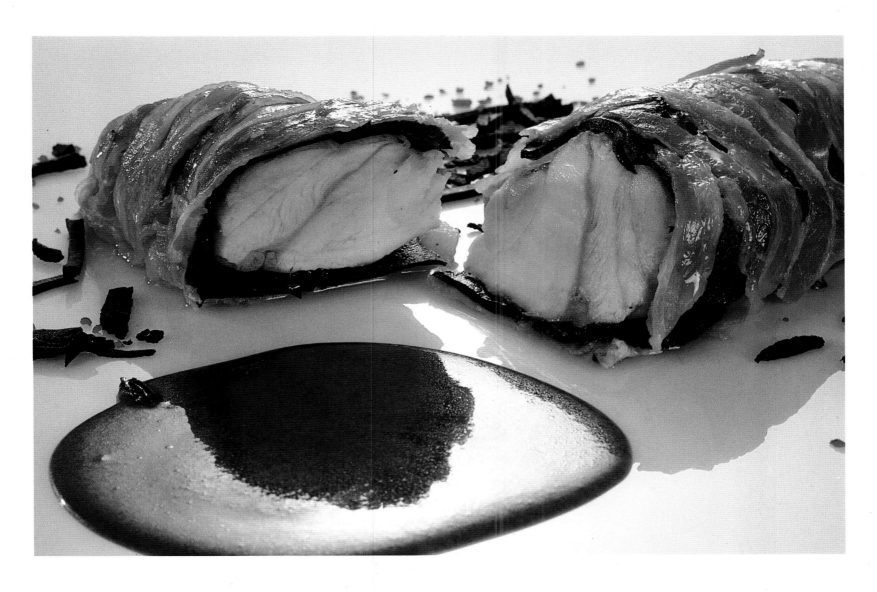

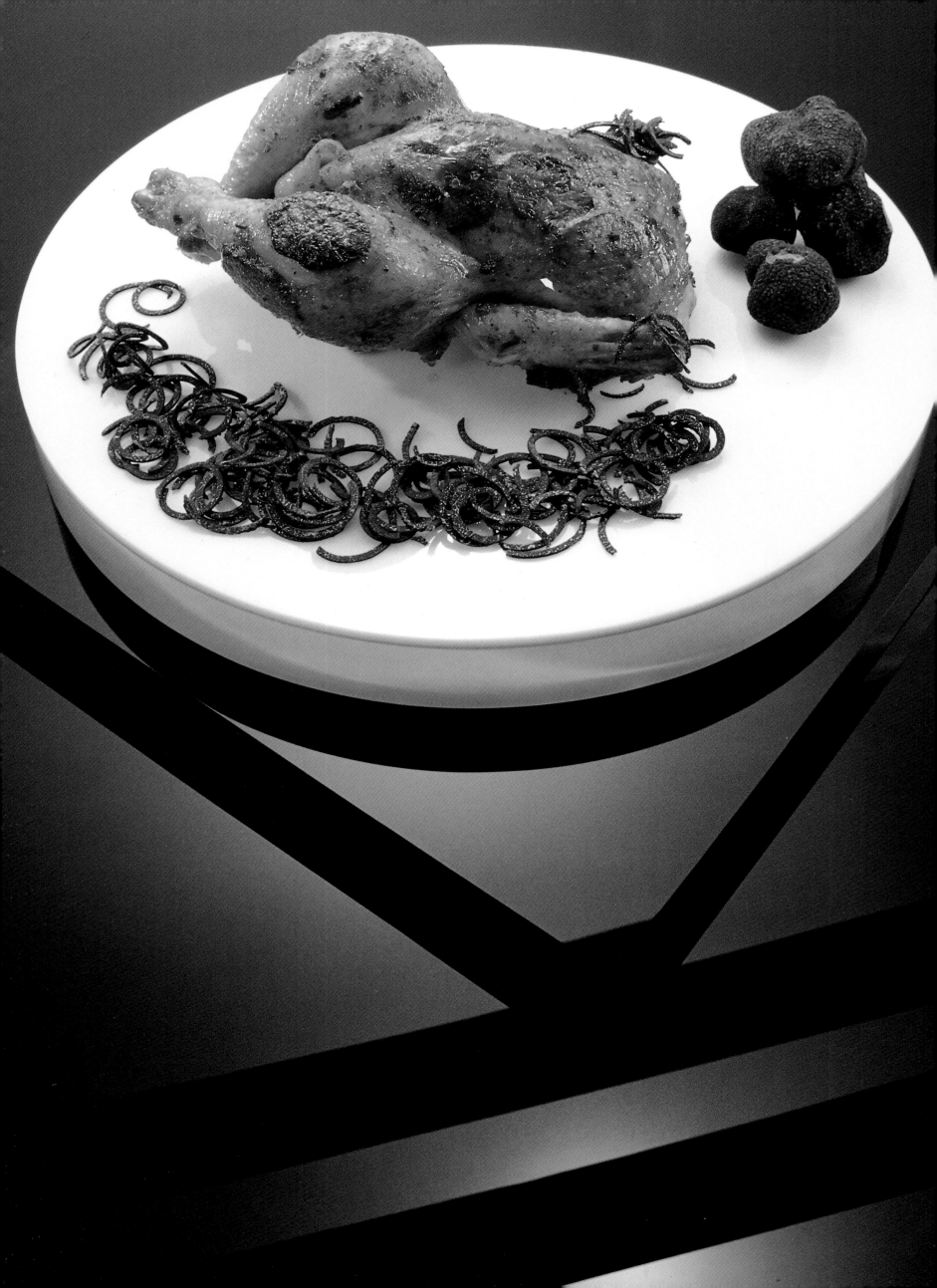

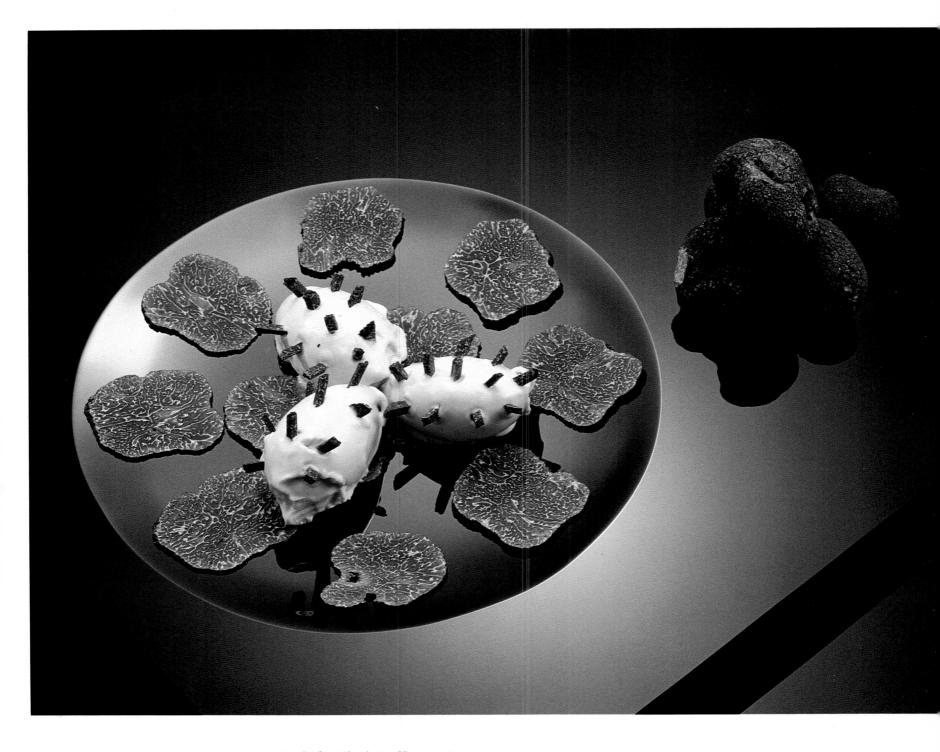

Credit for Black Truffle Ice Cream, which sounds a little crazy when you first hear of it, must go to my good friend André Daguin, a famous chef from Gascony. He and I have traveled a long road together. He found a recipe for truffle ice cream in a centuries-old cookbook and adapted it for contemporary cooking. It's the perfect ending to a meal built around truffles.

Stuffed Roasted Capon with Black Truffles is prepared on very special occasions in France. After truffles are placed beneath the skin of a capon or chicken, the bird is refrigerated overnight to allow the truffles' perfume to permeate the meat. Fantastic!

BLACK TRUFFLE ICE CREAM
INSPIRED BY ANDRE DAGUIN
(Left) ROASTED CAPON
WITH BLACK TRUFFLES
AND FRENCH BREAD STUFFING
and BLACK TRUFFLE SAUCE

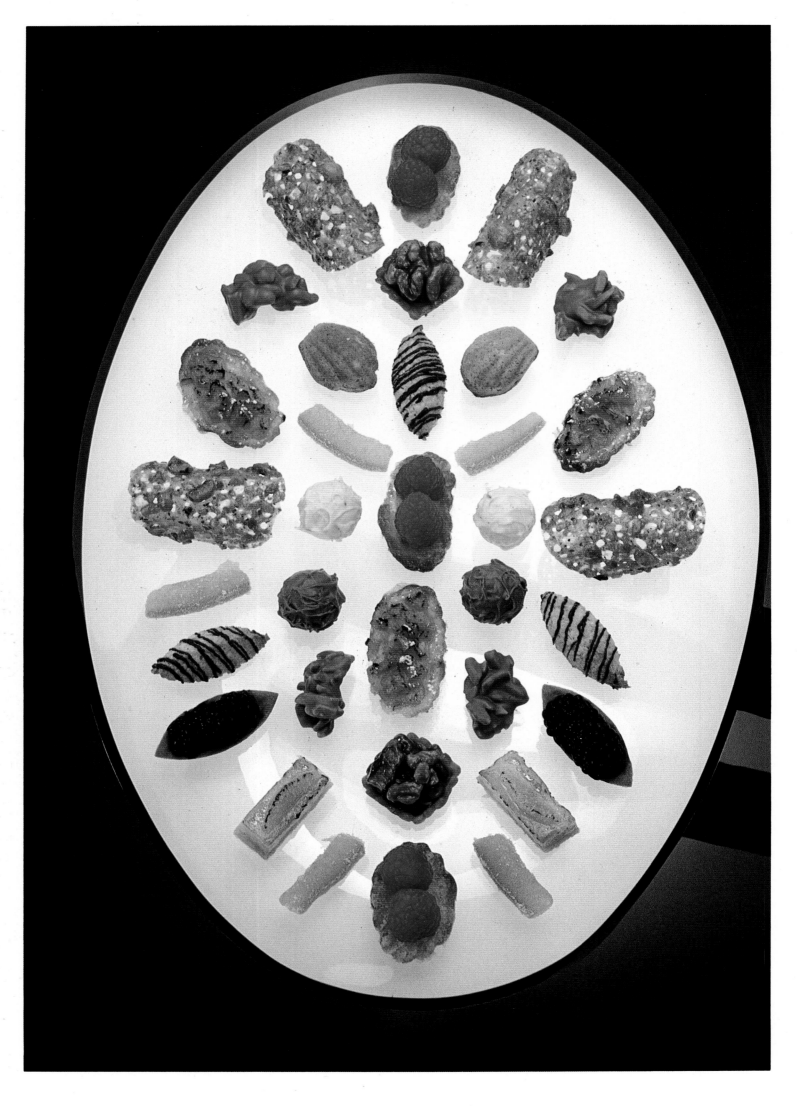

PETITS FOURS

Spring

Spring in Washington is the most glorious time of the year. When I think of winter's sad and dark weather, I see black-and-white pictures in my mind. But in spring, the pictures are full of color. What a joy for a chef! Here is a time to play with color again.

As a small boy, I spent many hours with a cabinetmaker, helping him work on his furniture and going with him to look at antiques. Since then, I have had a great appreciation for beauty. I used to think, "What beautiful work! If only I could make something like that, I would be a happy man." In my cooking, the taste, not the look, is the most important thing. But if you can combine the two, then you have something special, and the fresh appearance of spring produce always arouses in me the urge to see what I can create.

With spring comes a bounty of vegetables, fruits, and herbs once again. For a good chef, the produce is always the starting point; the market decides my menu. I often wake up in the morning with no idea of what I will do that day until I see what is available. Sometimes I surprise myself.

There is wonderful produce in America today. I have to say that the chefs and food writers in France are chauvinists. Until very recently, they always looked down on American produce. But ever since I came to the United States, I have been confident that we could have everything right here. I have been saying, "Watch out! In ten years, America will have the best produce in the world." And now it is being shown I was right.

I admire Americans; they lack Europeans' centuries of tradition and history, but they are willing to learn and to try new things. They want to be the best, and they succeed. When I first opened my restaurant, Jean-Louis at Watergate, a man named Richard Ober came in to see me with a bunch of mint and a bunch of thyme. He told me that he worked at the State Department but was bored with his job. He had made a bet with a friend that he could grow herbs and vegetables and sell them to the best restaurant in Washington.

I looked at him and said, "Did God send you to me? You are exactly what I've been looking for." He had a French seed catalogue with him, *Louise de Vilmorin*, and I read through it and listed everything I would like to be able to have by the next year. He grew it all, won his bet, and is still my supplier today.

He comes at the end of each season and asks me if I want anything new or different. We're always adding things, and that helps to keep me creative as a chef. The problem with the produce in supermarkets is that it is grown fast for volume and often with chemicals. The best fruits and vegetables are those grown naturally. My father owned an orchard he worked in every Sunday. He had cherry, apricot, apple, and peach trees, and the fruit he got from those trees was fantastic. Why? Because under his orchard was the old cemetery.

RED BELL PEPPERS

Spring

SEA SCALLOPS AND CORN PANCAKES with OSSETRA CAVIAR AND SOUR CREAM SAUCE
Louis Roederer Cristal Brut, 1982

**RED AND YELLOW BELL PEPPER SOUPS with BROILED COD
and MIREPOIX OF RED AND YELLOW BELL PEPPERS**
Robert Mondavi Winery Chenin Blanc, Napa Valley, 1985

**SALAD OF MACHE, CONFIT OF MULARD DUCK GIZZARDS, MULARD DUCK HEARTS
STUFFED WITH FOIE GRAS, JULIENNE FOIE GRAS, and QUAIL EGGS**
Cakebread Cellars Sauvignon Blanc, Napa Valley, 1985

SAUTEED SOFT-SHELL CRABS with PANCETTA SAUCE
Heitz Wine Cellars Chardonnay, Napa Valley, 1983

SAUTEED SWEETBREADS WRAPPED IN FAVA BEANS with FAVA BEAN CREAM SAUCE
Villa Mount Eden Pinot Noir, "Tres Niños Vineyard," Napa Valley, 1979

ROASTED BREAST OF SQUAB with DATE PUREE and DATE SAUCE
Grgich Hills Cellars Cabernet Sauvignon, Napa Valley, 1982

CREME BRULEE with RASPBERRIES

SORBETS OF MINT, RASPBERRY, HUCKLEBERRY, PERSIMMON, AND LIME
Château St. Jean Riesling, Late Harvest, "Robert Young Vineyard," Alexander Valley, 1982

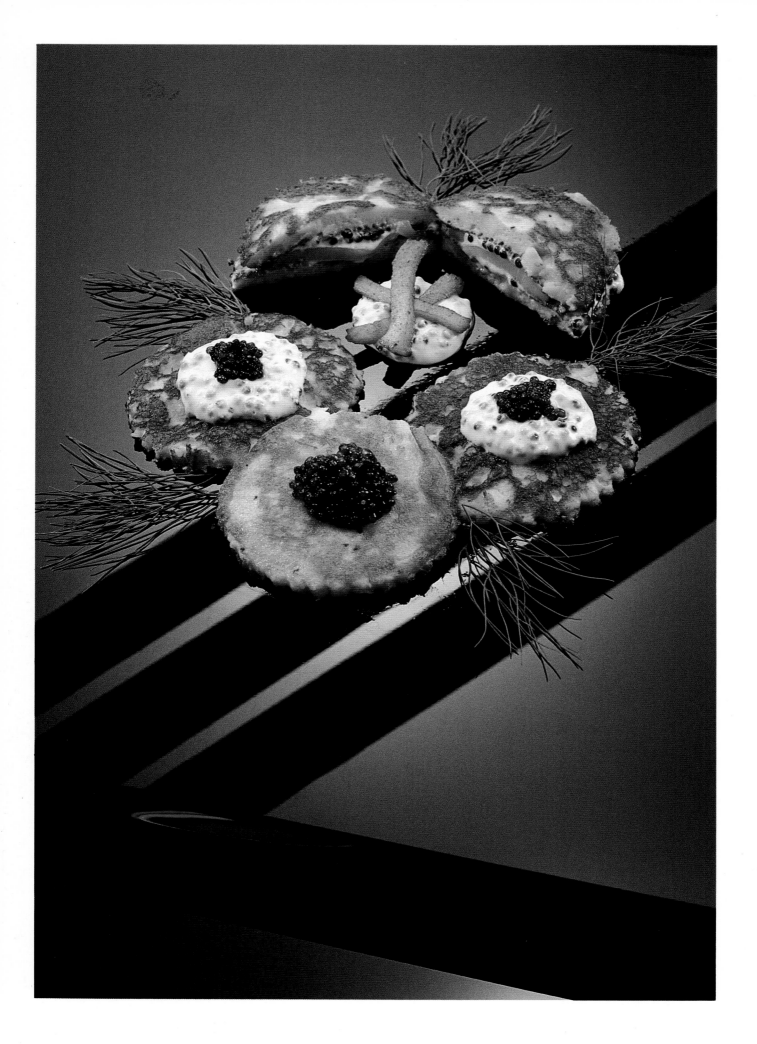

SEA SCALLOPS AND CORN PANCAKES
with OSSETRA CAVIAR
AND SOUR CREAM SAUCE
(Right) RED AND YELLOW
BELL PEPPER SOUPS
with BROILED COD
and MIREPOIX OF RED AND YELLOW
BELL PEPPERS

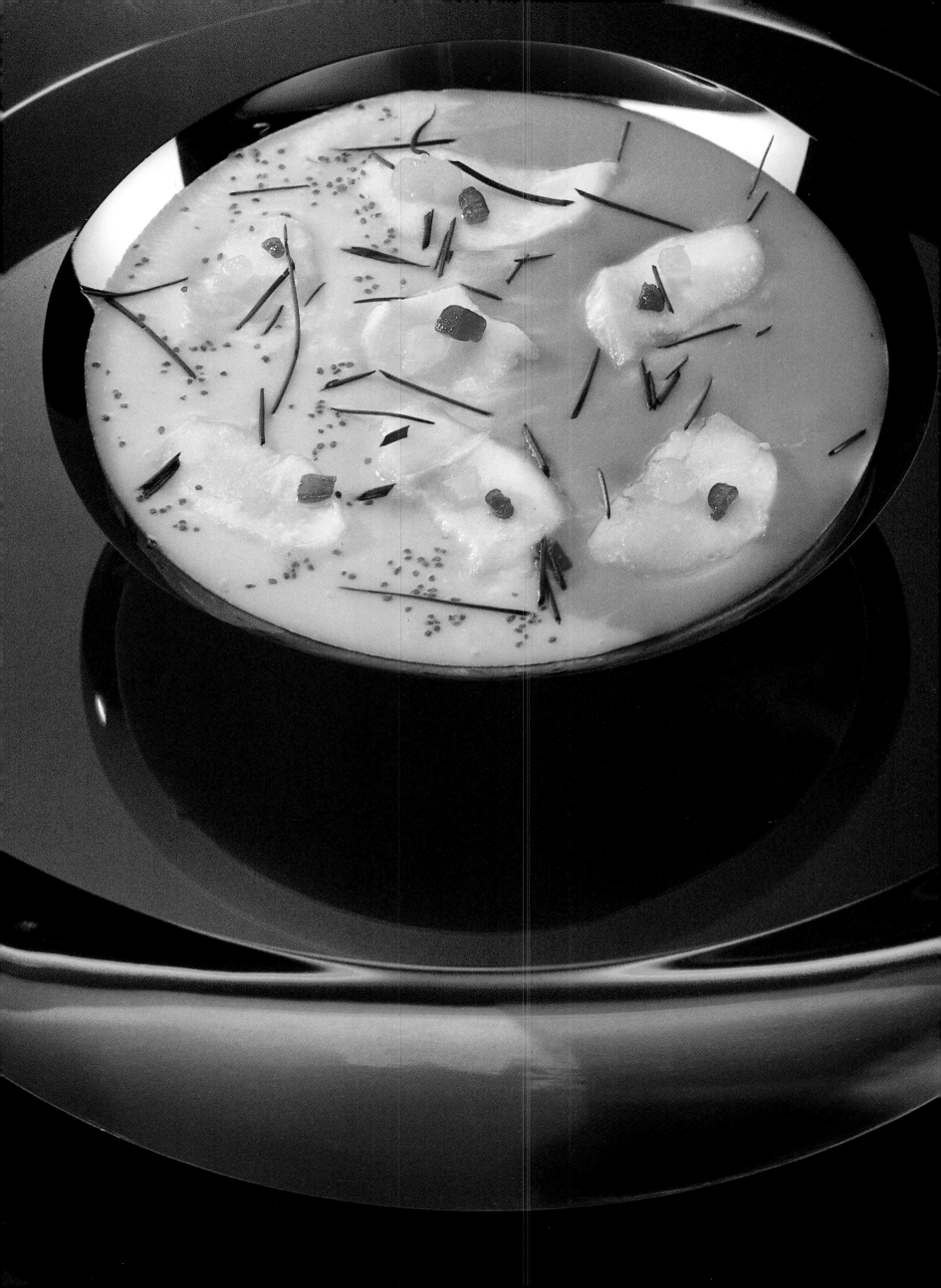

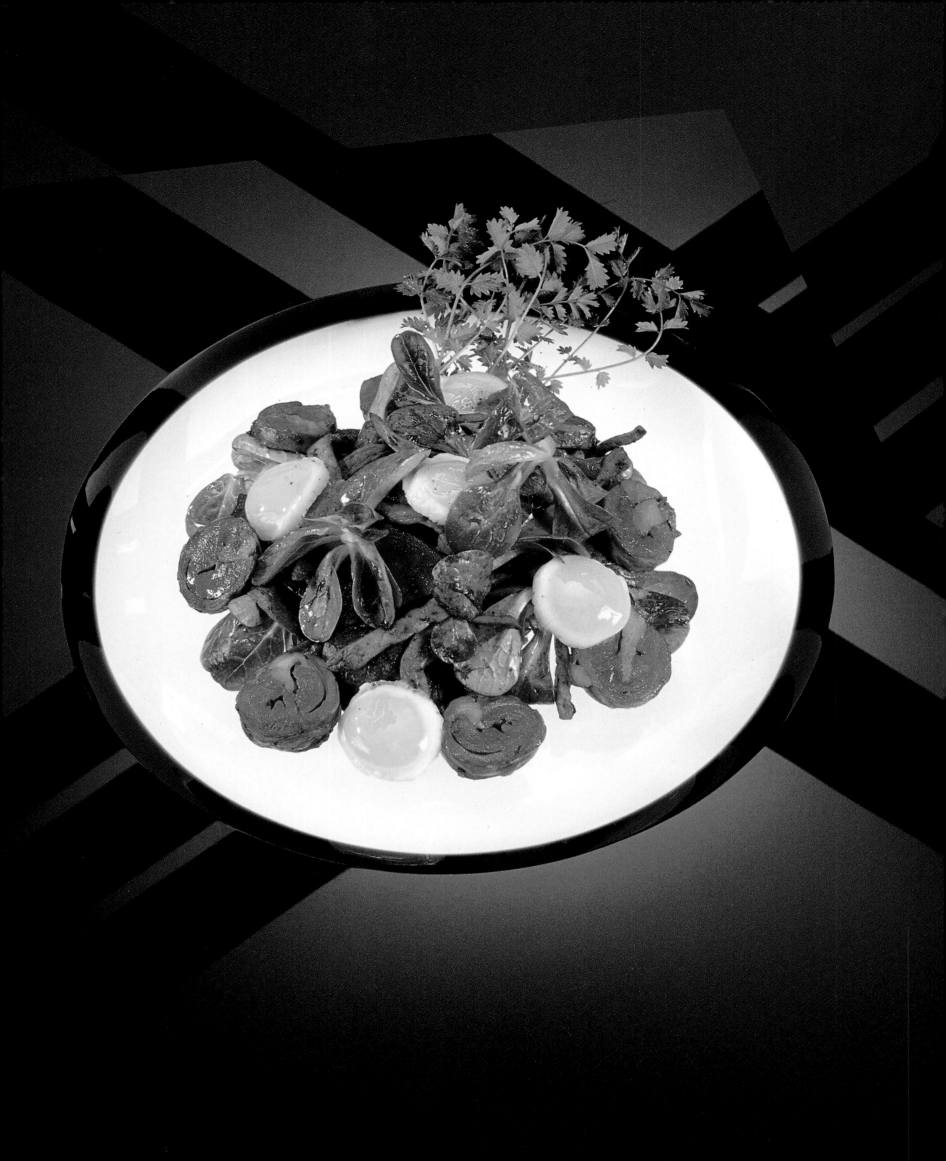

(Left) SALAD OF MACHE,
CONFIT OF MULARD DUCK GIZZARDS,
MULARD DUCK HEARTS
STUFFED WITH FOIE GRAS,
JULIENNE FOIE GRAS,
and QUAIL EGGS
(Below) SAUTEED SOFT-SHELL CRABS
with PANCETTA SAUCE

Soft-shell crabs are one of the bonuses of living near the Chesapeake Bay. It's teeming with crabs, and once a year, in the spring, they shed their shells. There's only a very short time before their new shells harden, but what a delicacy they are at that moment! *Pancetta* butter makes a nice sauce that's not too greasy; the marriage of sweet crab, salty bacon, and fresh dill is a good one.

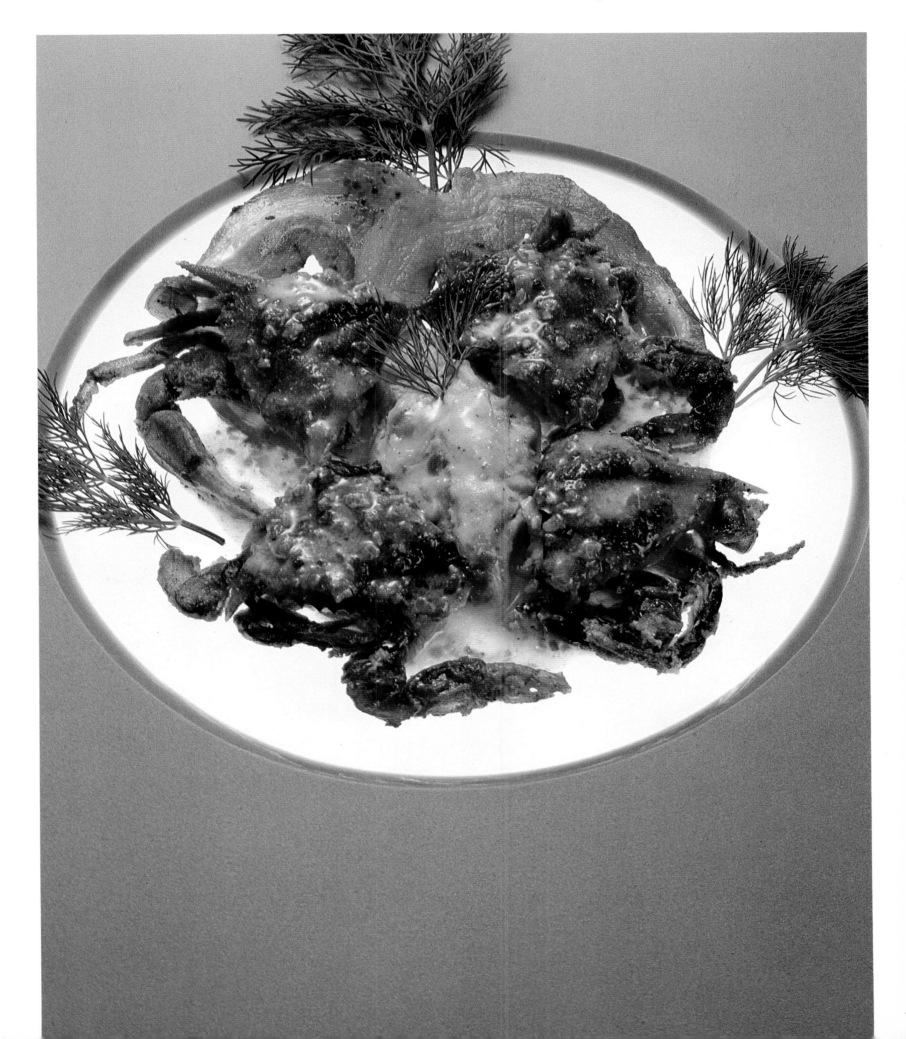

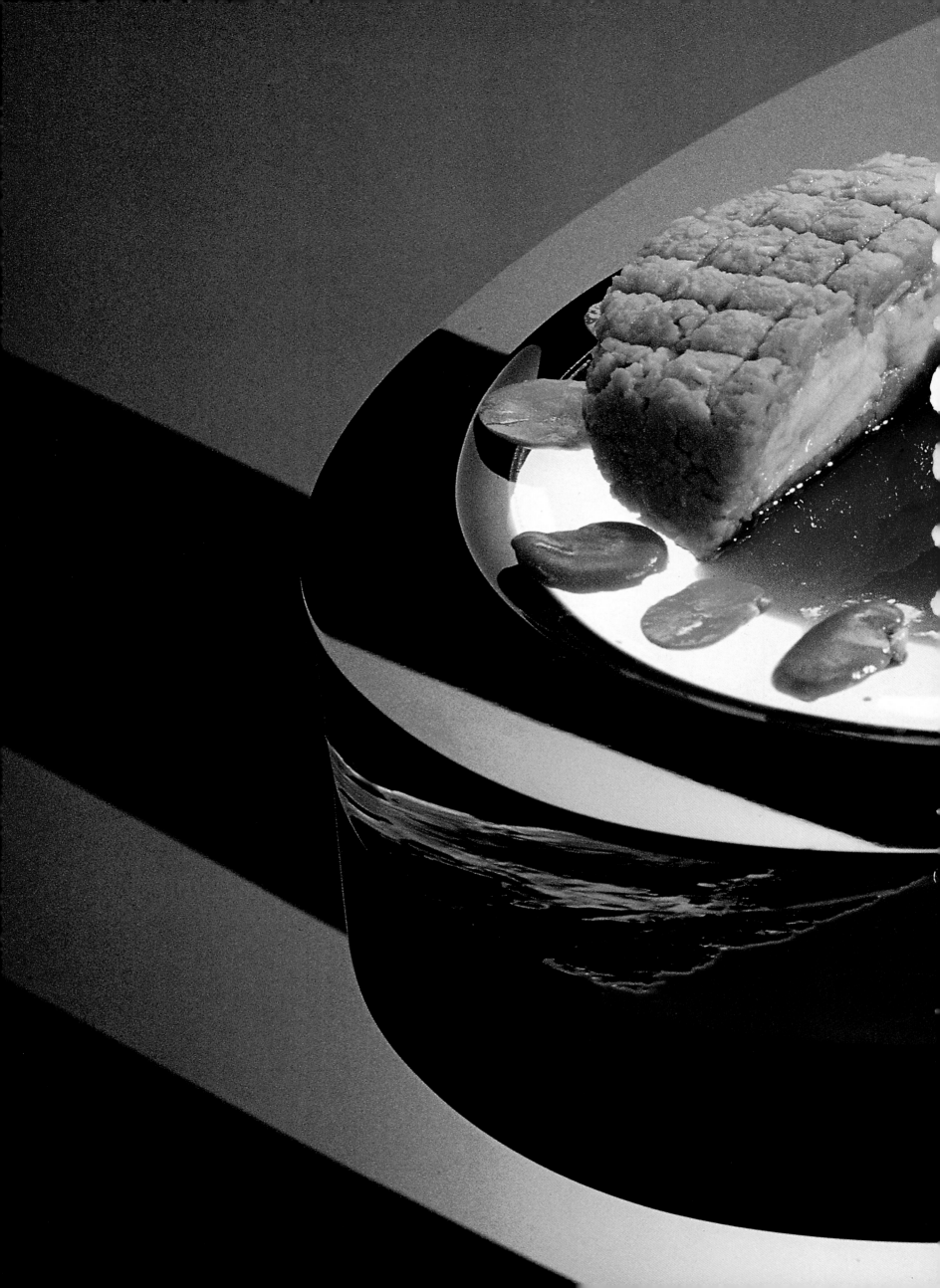

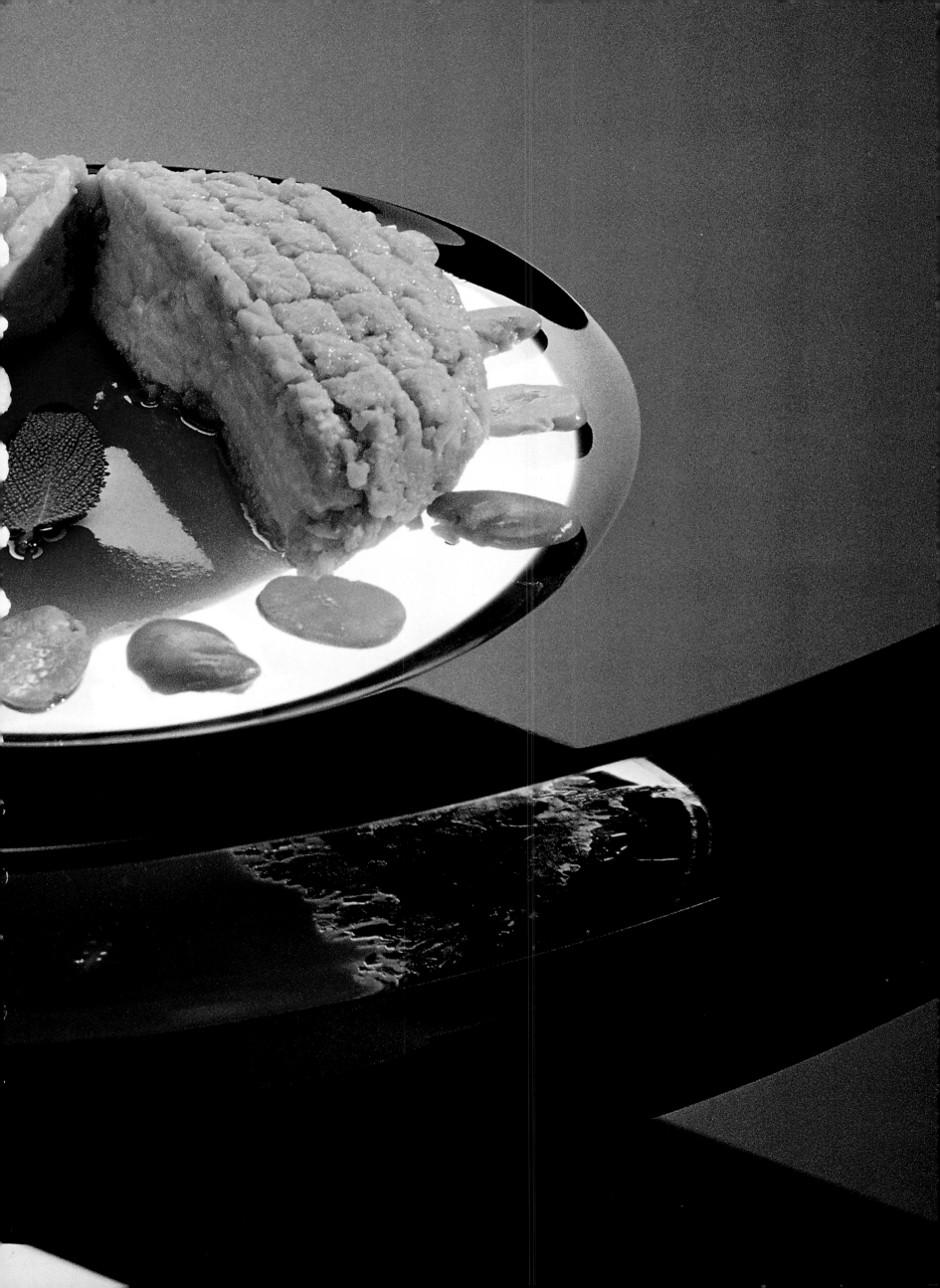

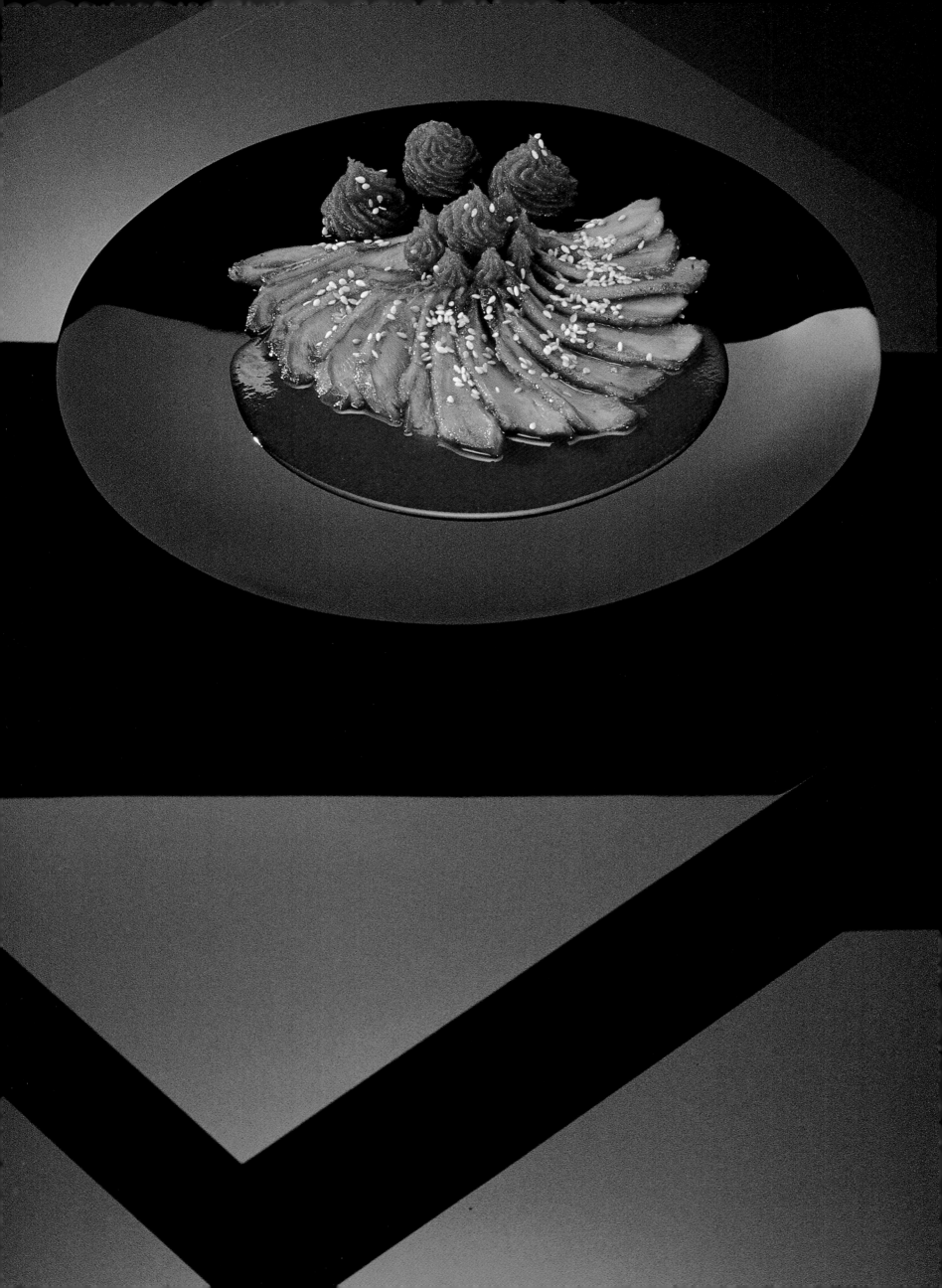

I hope I do not hurt any French feelings if I say that I have the world's best squabs in my kitchen, and they are American. When I first came to the States, I couldn't find squabs, but now I know a person who understands how to raise them, and by using the right species and taking great care with them, he has produced a very good-tasting and good-looking bird. His squabs are cultivated, but free ranging, fed on grain rather than flour. The inspiration for Roasted Breast of Squab comes from my former sous-chef, Larbi Dahrouch.

My Crème Brûlée with Raspberries is a variation of the classic dish. Whereas a traditional crème brûlée has a flat surface, I wanted to see the raspberries and make something that looked like an erupting volcano. What I like about this dessert is its three different consistencies: the raspberries, the really smooth cream, and the crunchy, caramelized top.

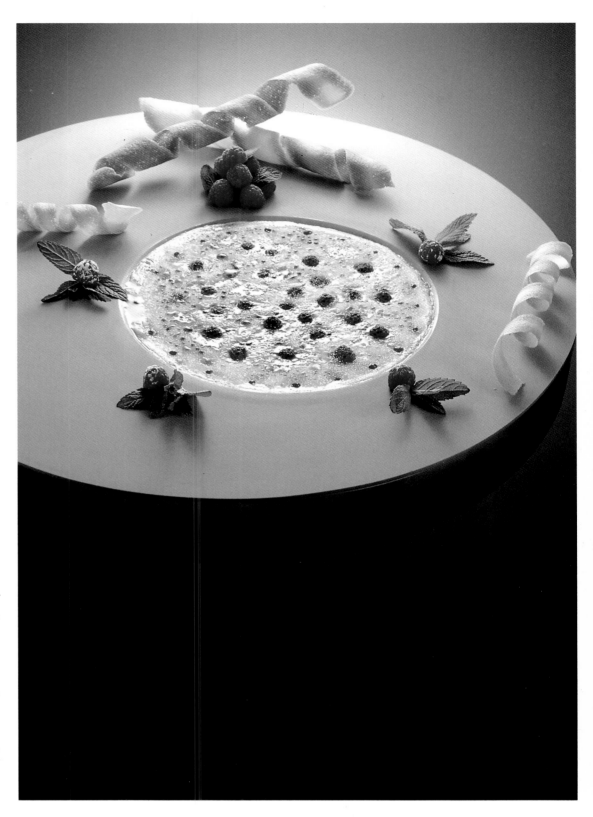

(Pages 88–89) SAUTEED SWEETBREADS
WRAPPED IN FAVA BEANS
with FAVA BEAN CREAM SAUCE
(Left) ROASTED BREAST OF SQUAB
with DATE PUREE
and DATE SAUCE
(Above) CREME BRULEE
with RASPBERRIES

RED RASPBERRIES
(Right) SORBETS OF MINT,
RASPBERRY, HUCKLEBERRY,
PERSIMMON, AND LIME

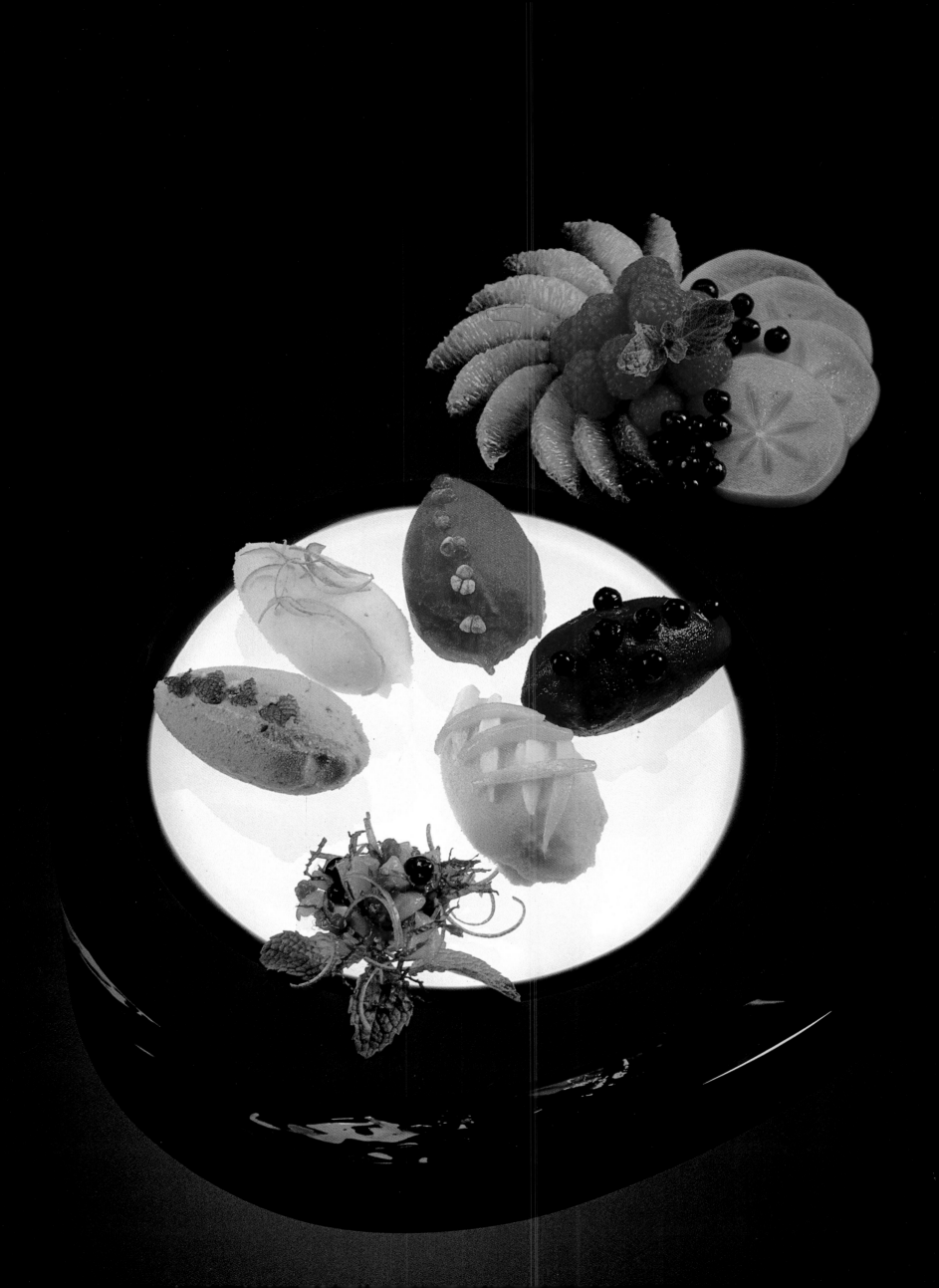

Spring
MENU TWO

**CAULIFLOWER STUFFED WITH SWEETBREADS AND MULARD DUCK
with BROCCOLI FLOWERETS and BROCCOLI CREAM SAUCE**
A. Salon Blanc de Blancs Brut, Le Mesnil, 1973

∽

SEA SCALLOPS AND CUCUMBERS ON THE HALF SHELL with CUCUMBER SAUCE
Château Smith Haut-Lafitte, Graves, 1985

∽

**BAKED POTATO STUFFED WITH LOUISIANA CRAWFISH, LOBSTER MOUSSELINE,
AND POTATO MOUSSELINE with LOBSTER CORAL SAUCE**
Condrieu, Georges Vernay, 1982

∽

**MULARD DUCK HEARTS STUFFED WITH FOIE GRAS
in NESTS OF TRICOLORED PASTA with SAGE SAUCE**
Beaune Grèves, "Vigne de L'Enfant Jésus," Bouchard, 1979

∽

LAMPREY A LA BORDELAISE
Château Cheval Blanc, 1967

∽

STUFFED HEN with VEGETABLES, STUFFED CABBAGE LEAVES, and GRATIN OF MACARONI
Corton-Charlemagne, Bonneau de Martray, 1981

∽

**BANANA AND CHOCOLATE MOUSSE CAKE, GRAND MARNIER ICE CREAM
IN A HAZELNUT CORNET, and FRESH FRUIT**

**CACTUS PEAR SORBET with CACTUS PEAR SAUCE, BLOOD ORANGE MOUSSE,
and PASSION FRUIT SOUFFLE with PASSION FRUIT SAUCE**
Coteaux du Layon, Chaume, Château de Plaisance, 1947

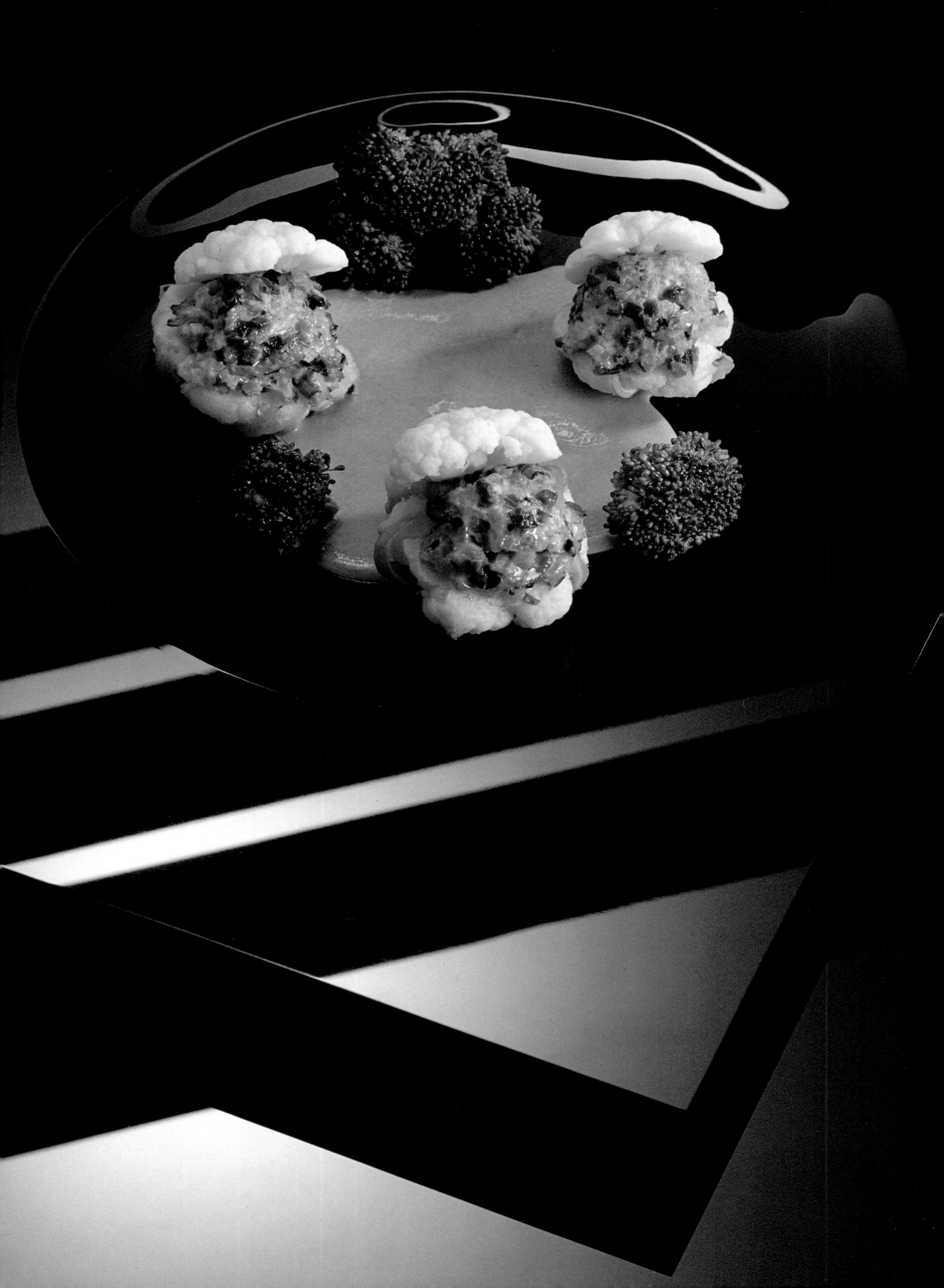

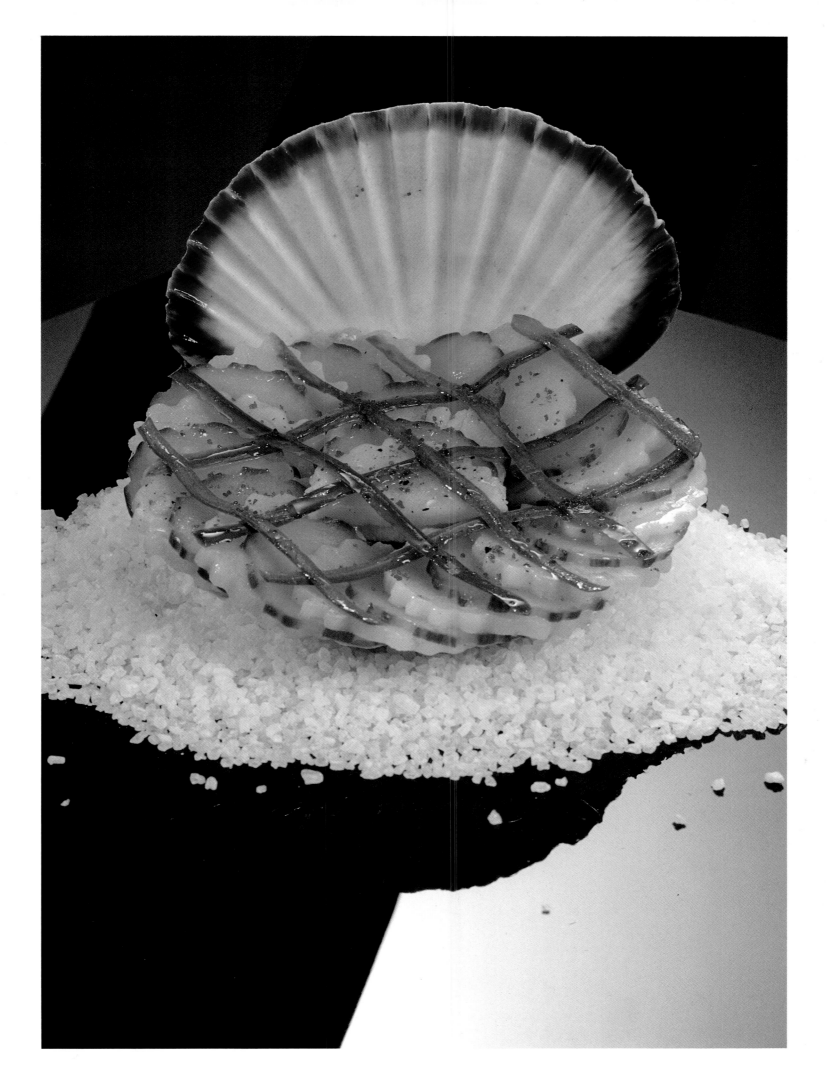

SEA SCALLOPS AND CUCUMBERS ON THE HALF SHELL
with CUCUMBER SAUCE
(Left) CAULIFLOWER STUFFED WITH SWEETBREADS
AND MULARD DUCK with BROCCOLI FLOWERETS
and BROCCOLI CREAM SAUCE

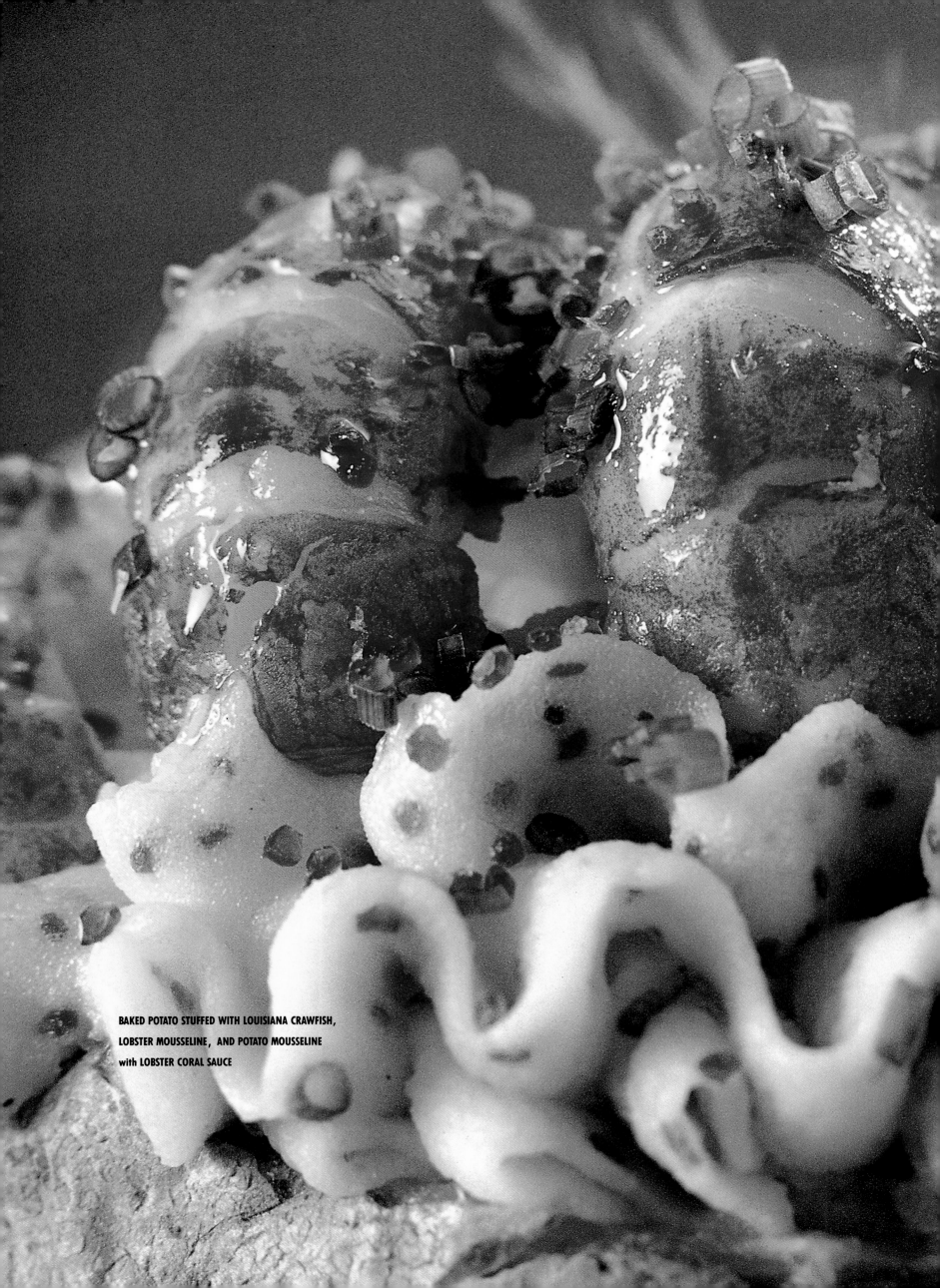

BAKED POTATO STUFFED WITH LOUISIANA CRAWFISH,
LOBSTER MOUSSELINE, AND POTATO MOUSSELINE
with LOBSTER CORAL SAUCE

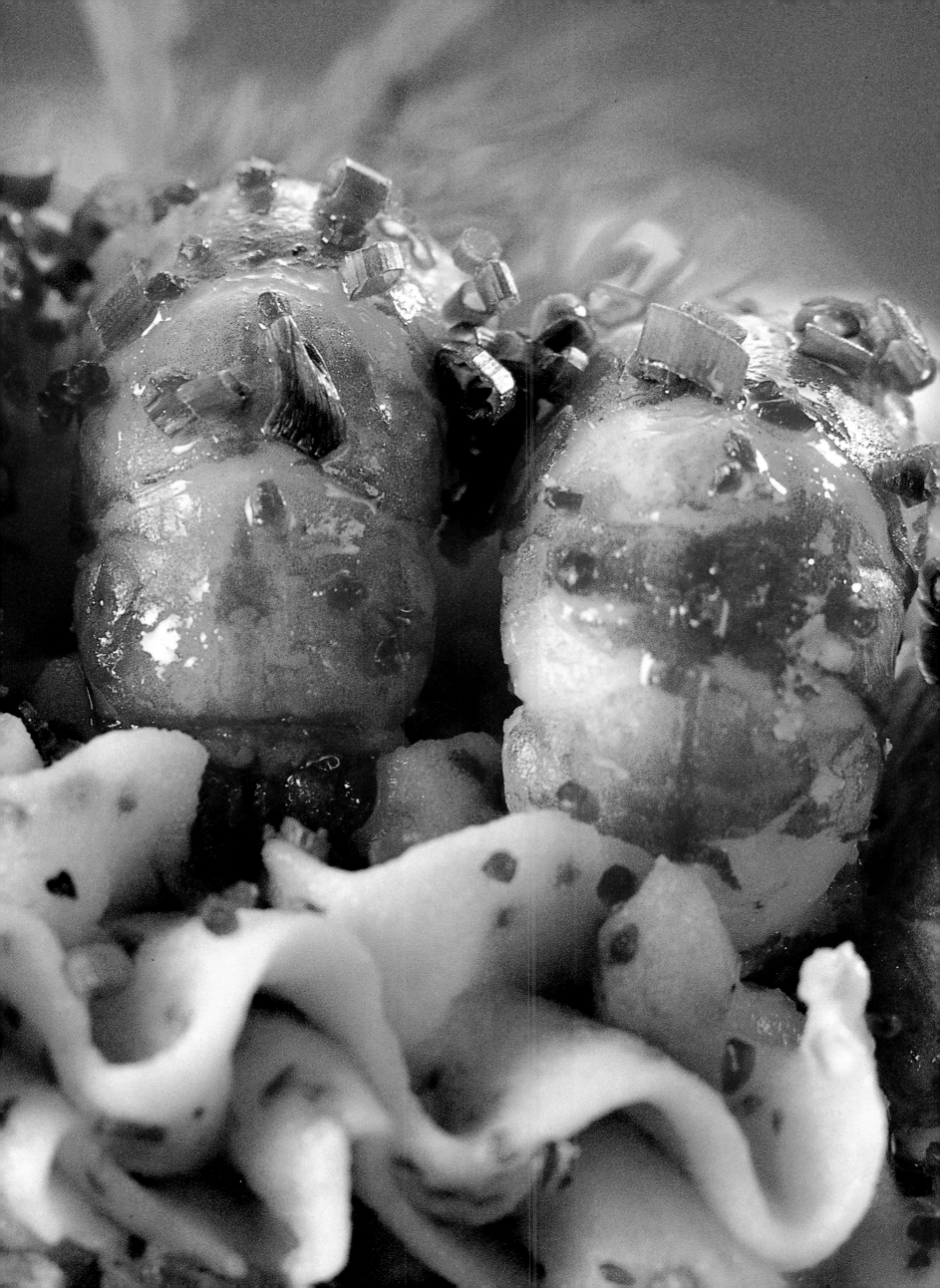

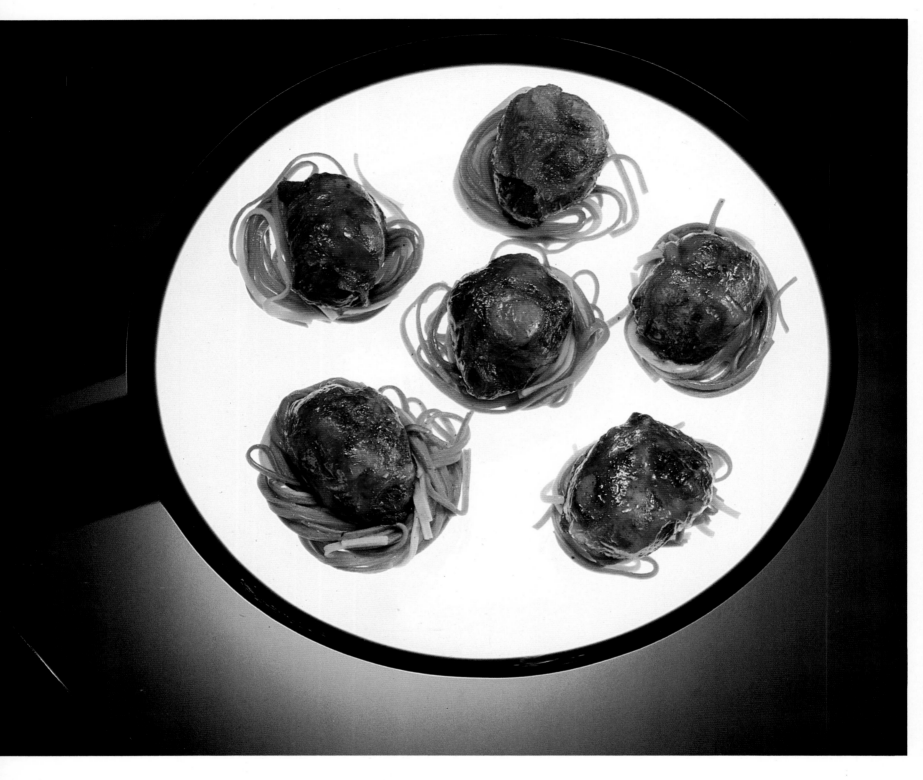

**MULARD DUCK HEARTS STUFFED WITH FOIE GRAS
in NESTS OF TRICOLORED PASTA with SAGE SAUCE
(Right) LAMPREY A LA BORDELAISE**

Pasta is a magic word. Ask one million people, and you will not find five who do not like pasta. When I tried to use it in an original recipe, I came up with Duck Hearts Stuffed with Foie Gras in Nests of Tricolored Pasta. Duck hearts are an unfamiliar meat to most Americans, but they are superb.

Lampreys are another one of those things that Americans have to learn to like. I really love them, but for years, I was afraid I would never find them here. Then one day I got desperate; I had to have them. I was sure that somewhere in this enormous country there had to be an estuary, and in that estuary there had to be eels. I told my supplier in Maine what I wanted, and three years later he called me with the good news—he had found lampreys. For me, eating eels is like going to the moon, but my customers are still not so sure.

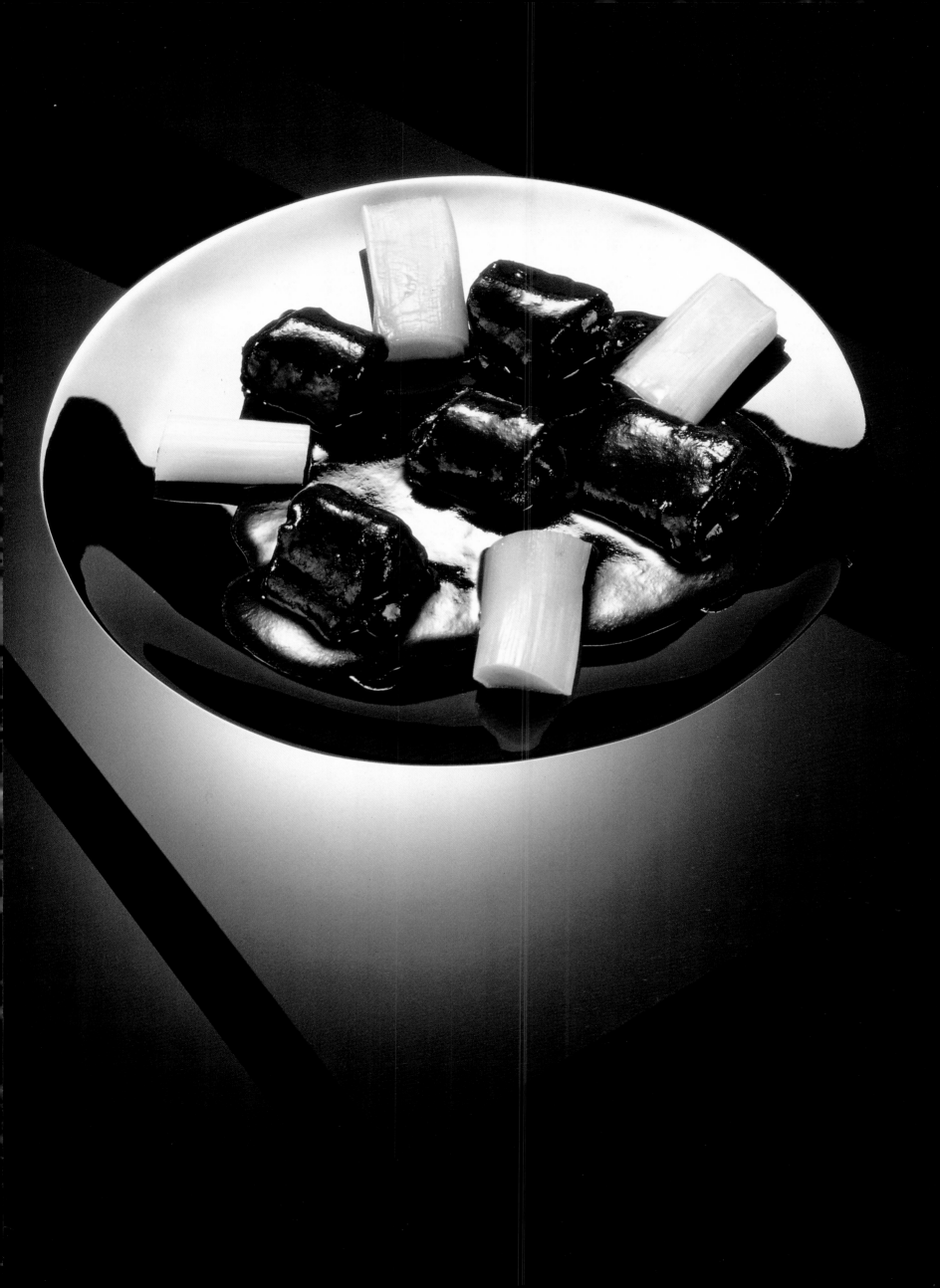

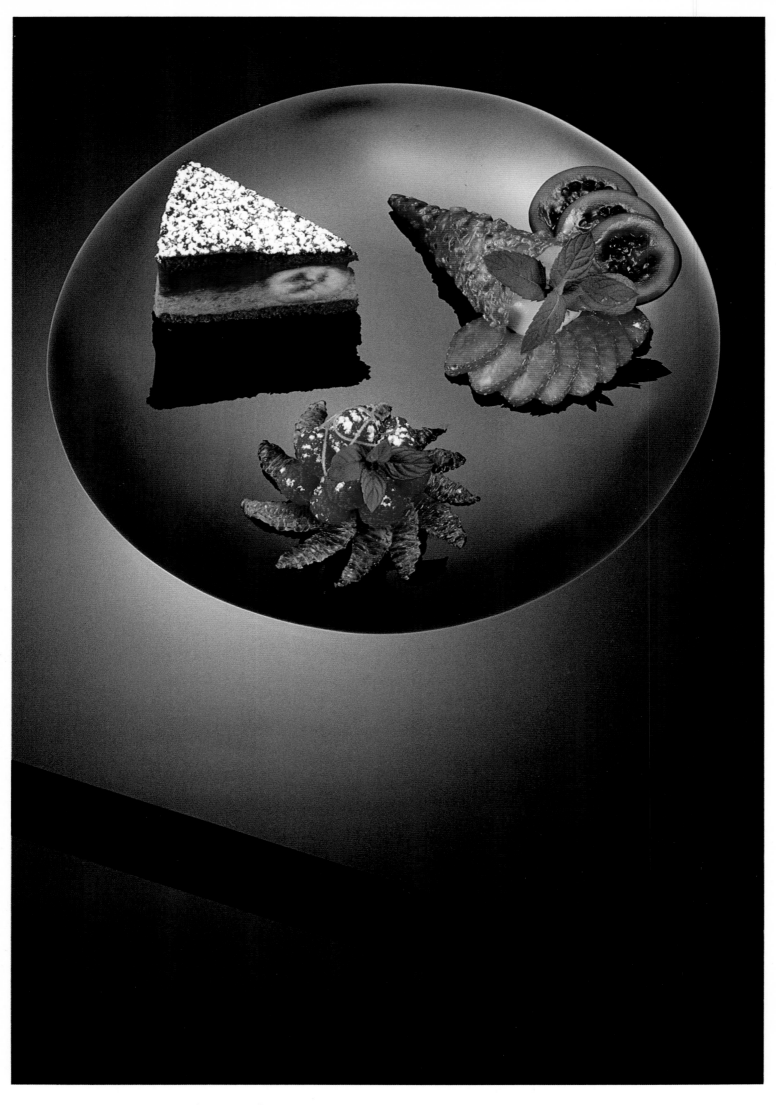

(Pages 102-103) STUFFED HEN with VEGETABLES, STUFFED CABBAGE LEAVES,
and GRATIN OF MACARONI
(Above) BANANA AND CHOCOLATE MOUSSE CAKE,
GRAND MARNIER ICE CREAM IN A HAZELNUT CORNET, and FRESH FRUIT
(Right) CACTUS PEAR SORBET with CACTUS PEAR SAUCE, BLOOD ORANGE MOUSSE,
and PASSION FRUIT SOUFFLE with PASSION FRUIT SAUCE

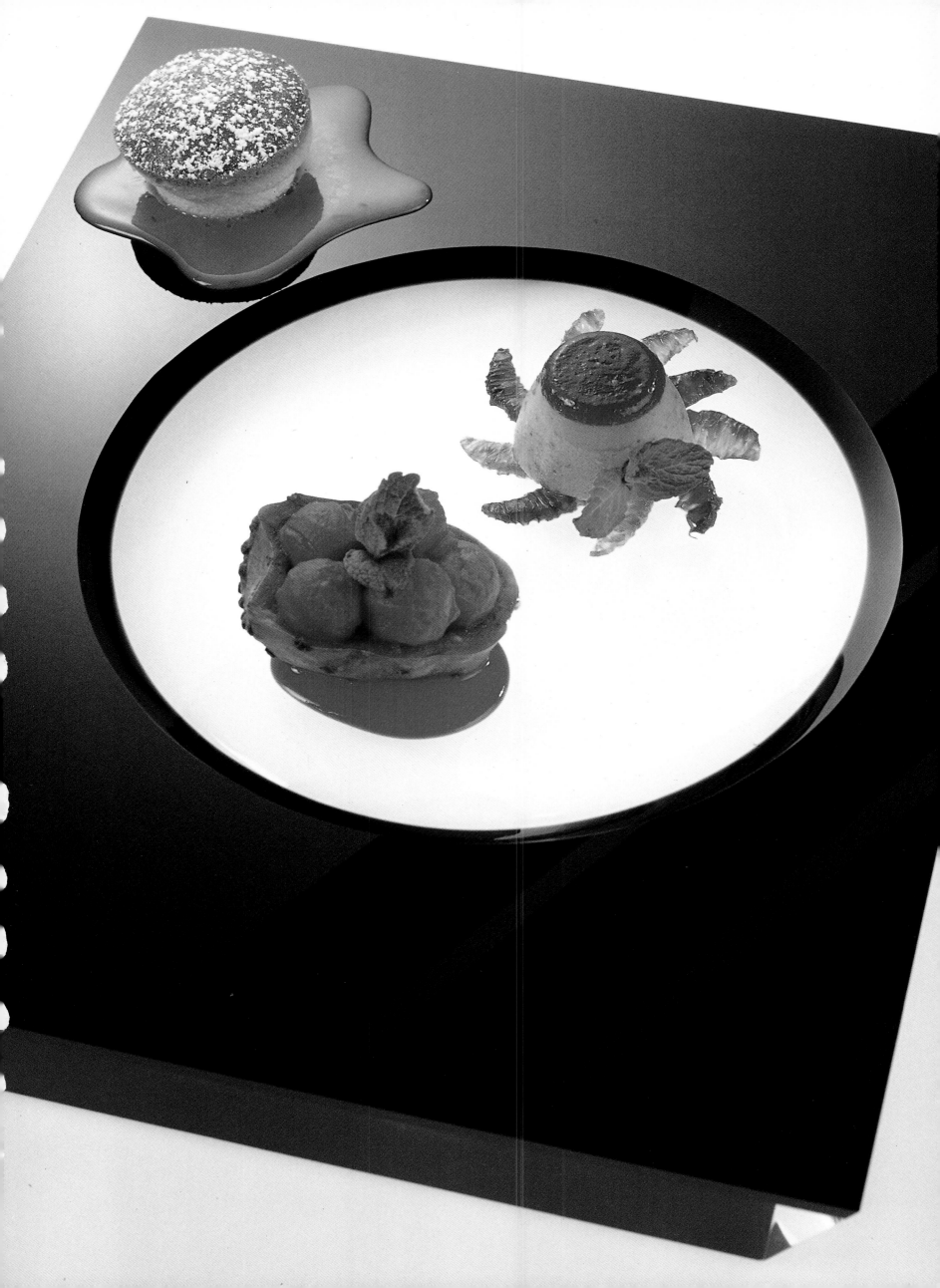

Spring

TERRINE OF SMOKED SALMON, SPINACH, AND ANCHOVY BUTTER
Taittinger Blanc de Blancs Brut, Comtes de Champagne, 1976

∽

**SALAD OF MOREL MUSHROOMS STUFFED WITH LOUISIANA CRAWFISH
ON FRESH HEARTS OF PALM, ENOKI MUSHROOMS, ASPARAGUS, AND BELL PEPPERS
with CRAWFISH VINAIGRETTE and HERB VINAIGRETTE**
Châteauneuf-du-Pape Blanc, Château de Beaucastel, 1985

∽

STEAMED MAINE LOBSTER AND ZUCCHINI with SMELT ROE SAUCE
Stag's Leap Cellars Sauvignon Blanc, Rancho Chimiles, Napa Valley, 1986

∽

SAUTEED FOIE GRAS with RHUBARB PUREE and RHUBARB SAUCE
Château Suduiraut, Sauternes Grand Cru, 1970

∽

**NAGE OF VENUS CLAMS with TOMATO ROUNDS,
JULIENNE VEGETABLES, and WARM BASIL VINAIGRETTE**
Folie à Deux Chardonnay, Napa Valley, 1984

∽

ROASTED RABBIT TENDERLOINS with SAUPIQUET, FAVA BEANS, and THYME SAUCE
Madiran, Domaine Pichard, 1983

∽

CHOCOLATE PASTA with MOCHA SAUCE and WHITE CHOCOLATE CURLS

FRESH RASPBERRIES AND ORANGE SECTIONS IN PUFF PASTRY with BASIL CUSTARD SAUCE
Quady Vineyard Orange Muscat, "Essensia," Madera, 1982

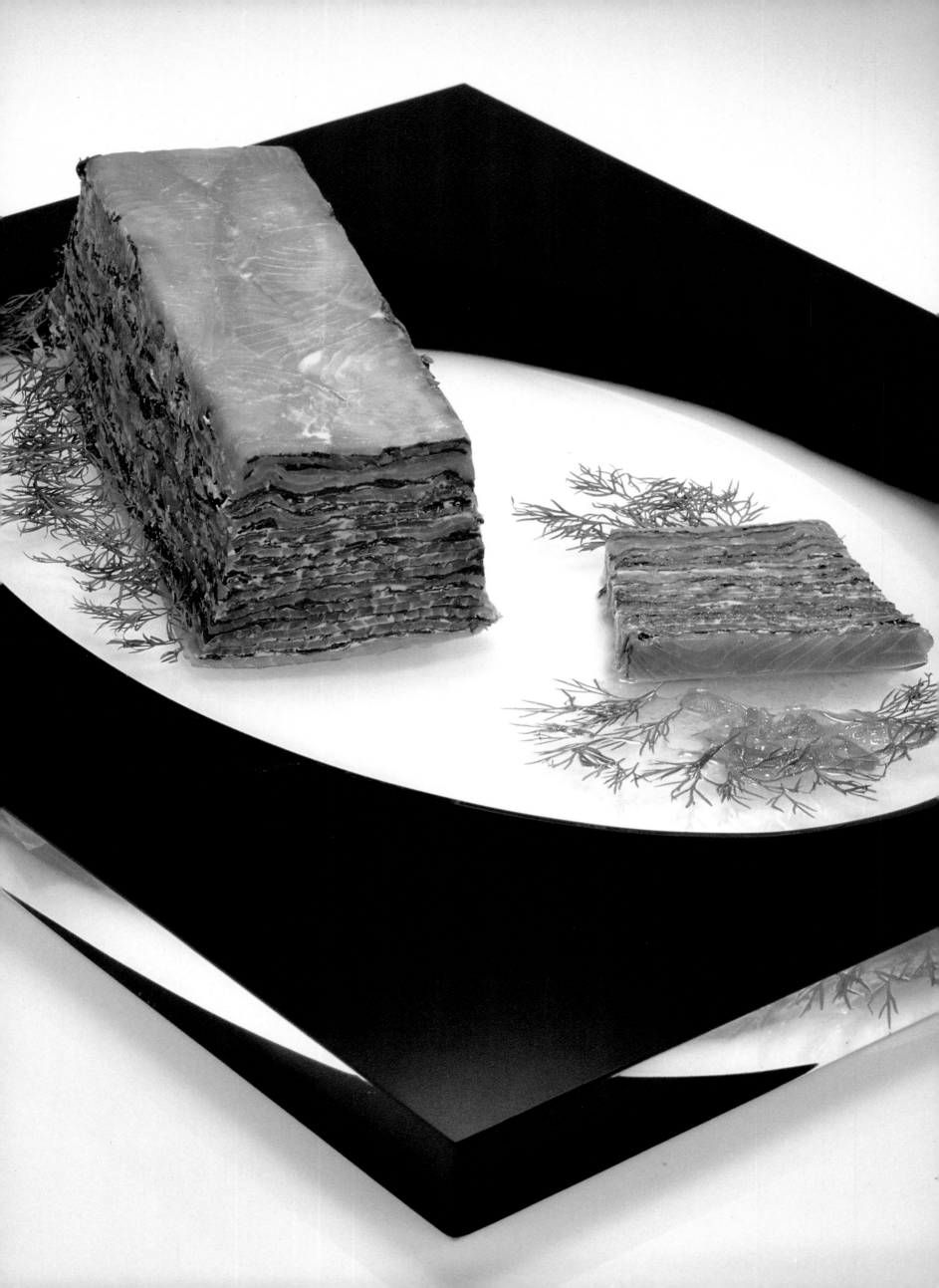

When you own a restaurant, you need to pay attention to the practical side of being a chef. If you don't have unlimited help, you must think about preparing dishes that do not require much last-minute supervision. A terrine is a wonderful course to follow a soup because at serving time you need only a minute or two to slice it and put the sauce on it. When I have a large banquet, I need to work fast, and both the soup and the terrine leave me free to concentrate on the fish and meat. A terrine also gives full rein to a chef's imagination, letting him or her play with taste, color, and texture.

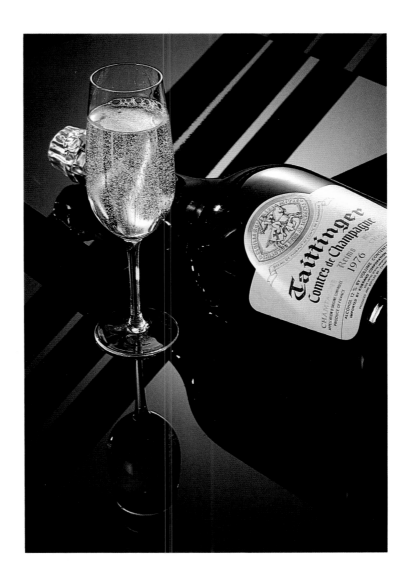

(Left) TERRINE OF SMOKED SALMON, SPINACH, AND ANCHOVY BUTTER

SPINACH

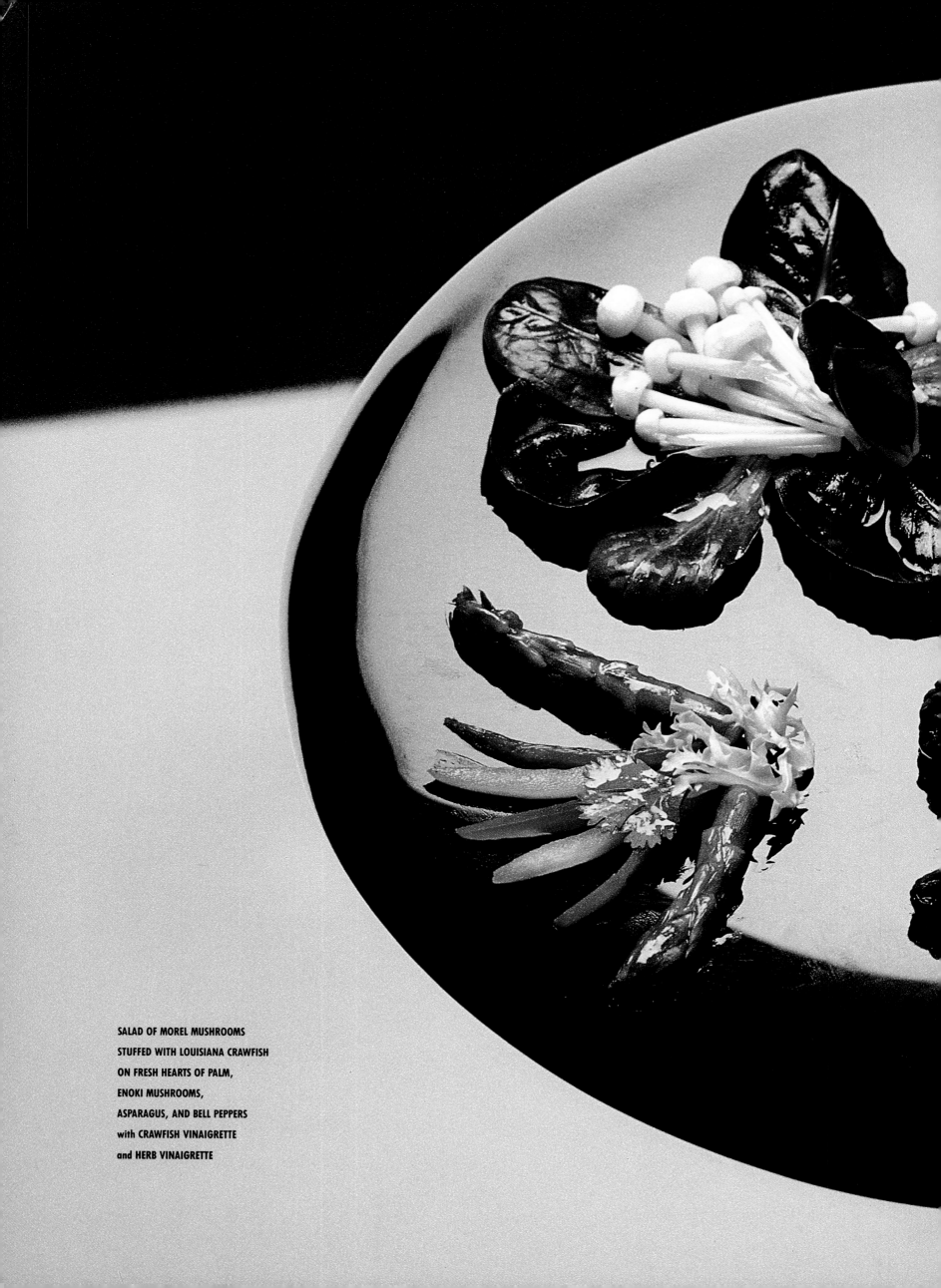

SALAD OF MOREL MUSHROOMS
STUFFED WITH LOUISIANA CRAWFISH
ON FRESH HEARTS OF PALM,
ENOKI MUSHROOMS,
ASPARAGUS, AND BELL PEPPERS
with CRAWFISH VINAIGRETTE
and HERB VINAIGRETTE

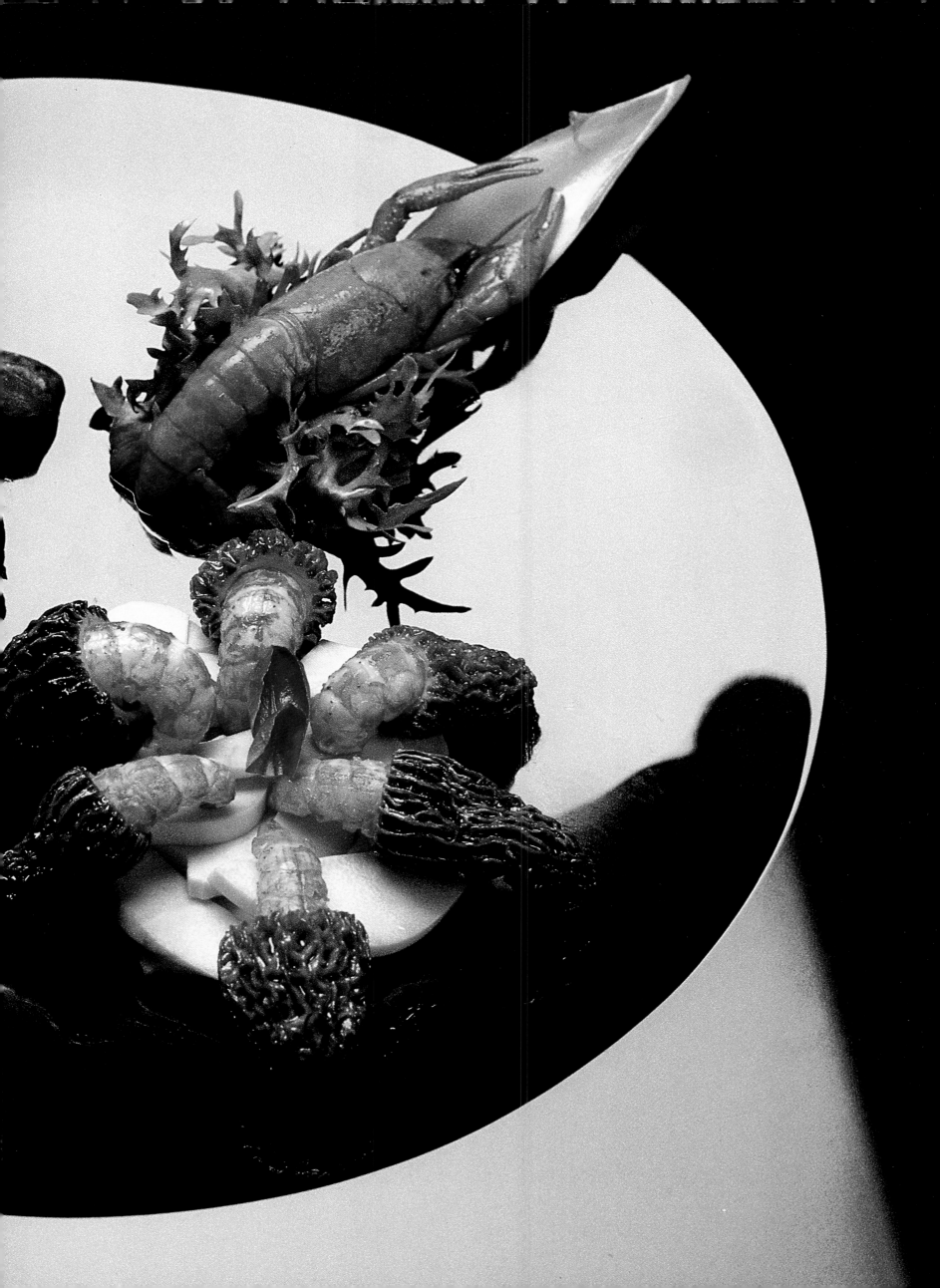

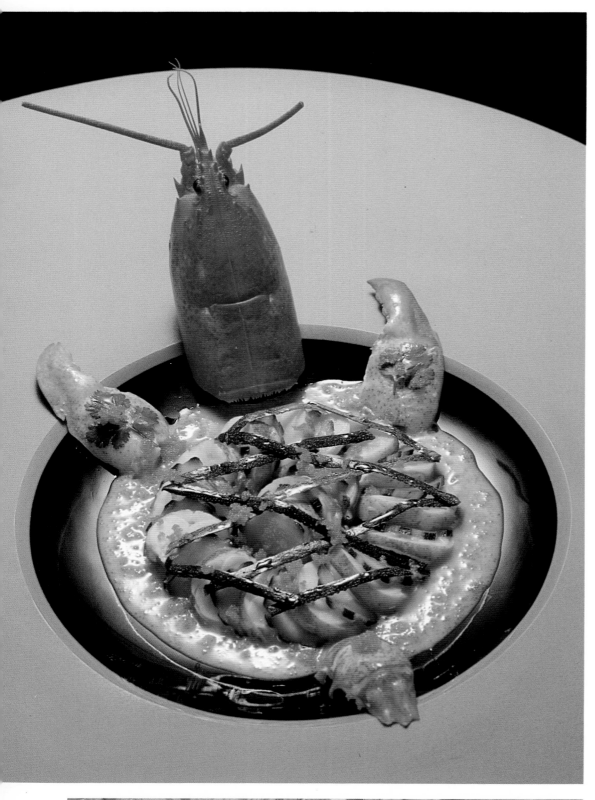

My idea for Steamed Maine Lobster and Zucchini with Smelt Roe Sauce was to use different colors together—red lobster, green zucchini, and yellow-orange smelt roe. With an essentially simple dish like this, even if I have never made it before, I can be ninety-nine percent sure that it will taste good because I know the quality of my ingredients.

(Upper left) STEAMED MAINE LOBSTER
AND ZUCCHINI
with SMELT ROE SAUCE
(Lower left) ZUCCHINI BLOSSOM
(Right) SAUTEED FOIE GRAS
with RHUBARB PUREE
and RHUBARB SAUCE

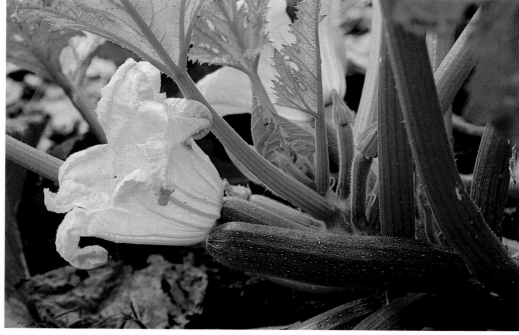

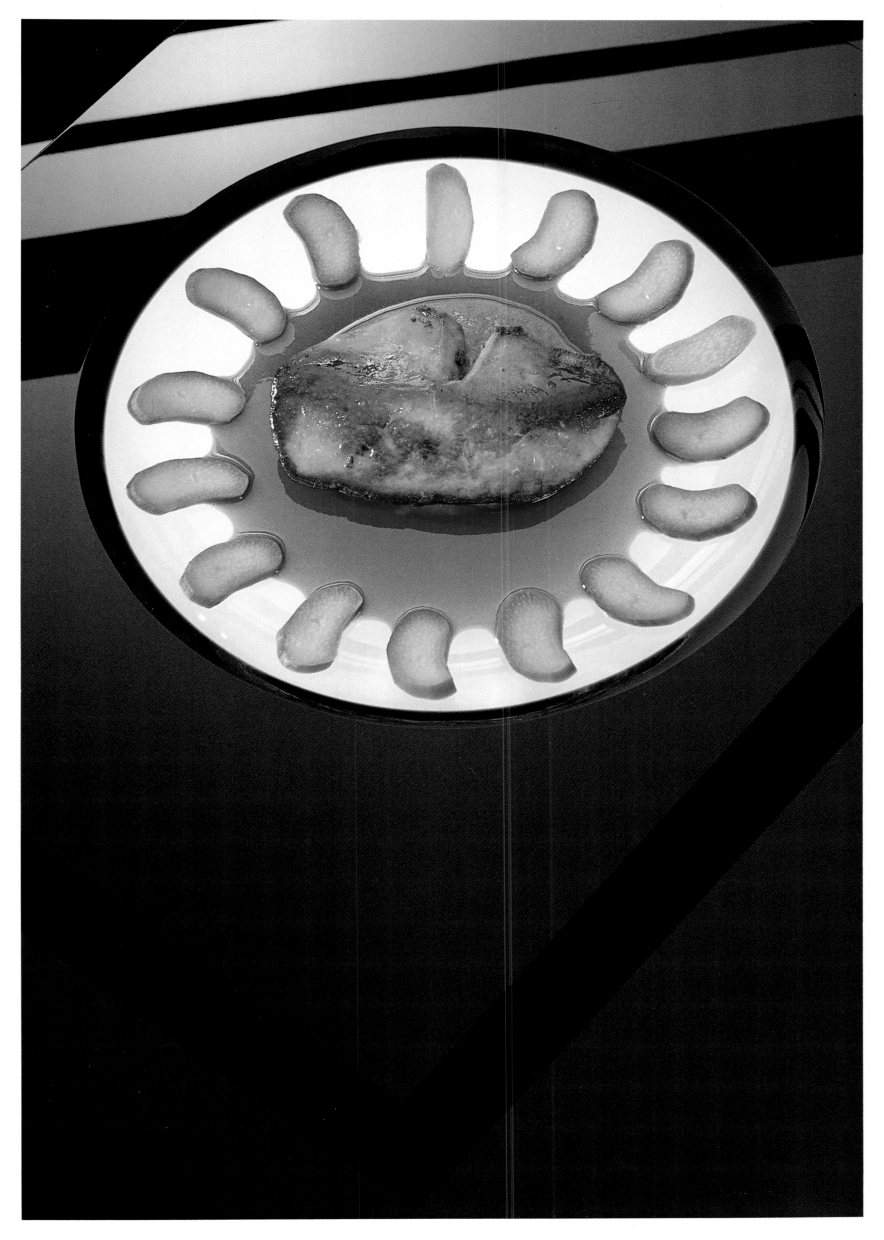

(Below) NAGE OF VENUS CLAMS with TOMATO ROUNDS,
JULIENNE VEGETABLES, and WARM BASIL VINAIGRETTE
(Right) ROASTED RABBIT TENDERLOINS
with SAUPIQUET, FAVA BEANS, and THYME SAUCE

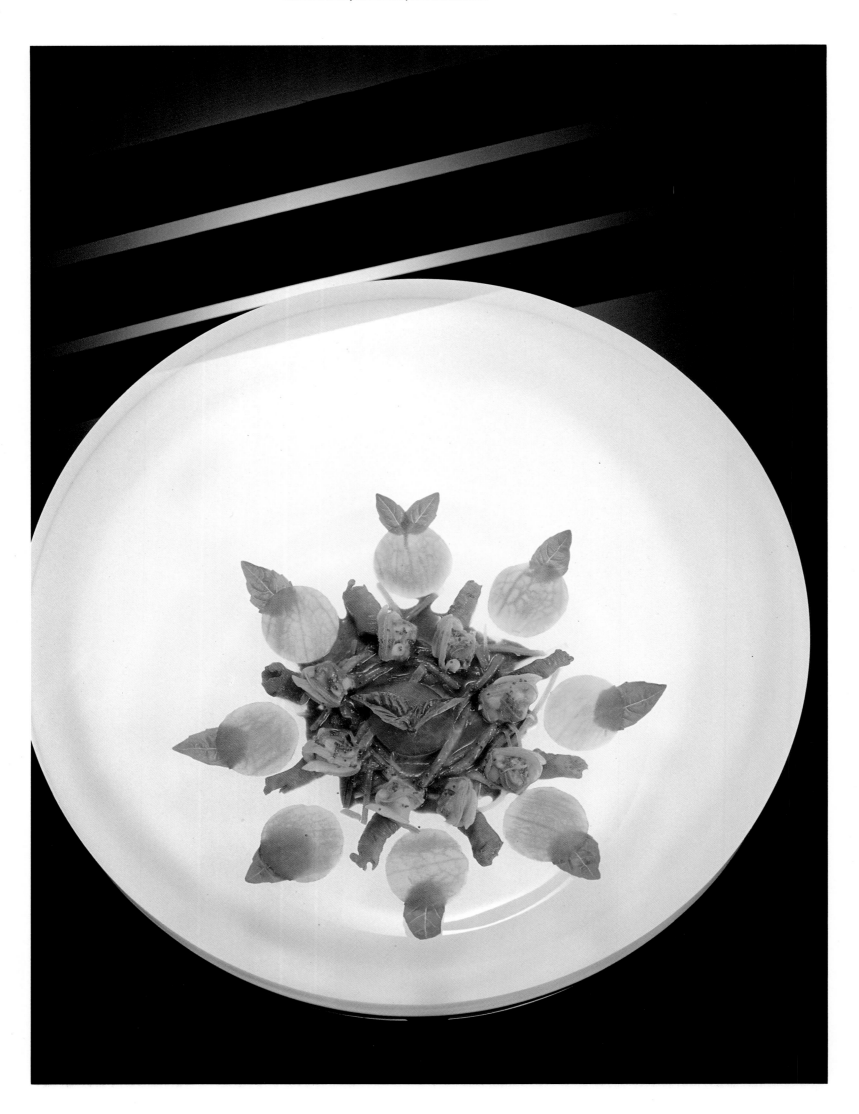

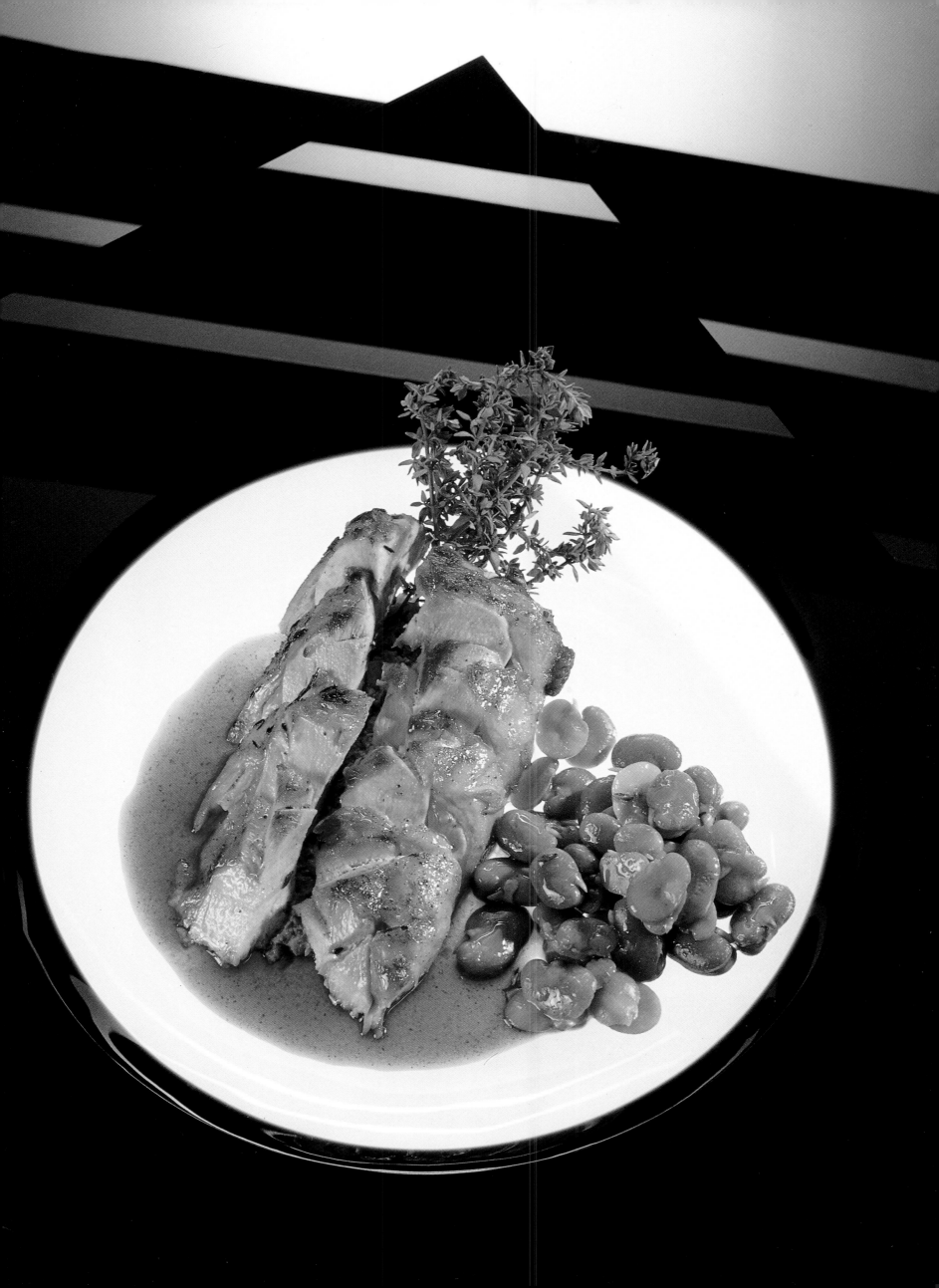

I believe that if you keep your mind alert, you can find inspiration all around you. But if you stay in the kitchen all the time, you get a little stale. When you travel and see different things and different ways of cooking, your mind is working all the time. That way you can continue to grow and diversify your repertoire. One year in Venice, I saw some pasta flavored with coffee. I was fascinated, but I thought, "Why do that if it has already been done? Why not try to make chocolate noodles?" It was a little difficult because, of course, chocolate melts when it gets warm. But I found a way. I think the presentation is a lot of fun, using white chocolate as cheese and mocha sauce as the spaghetti sauce.

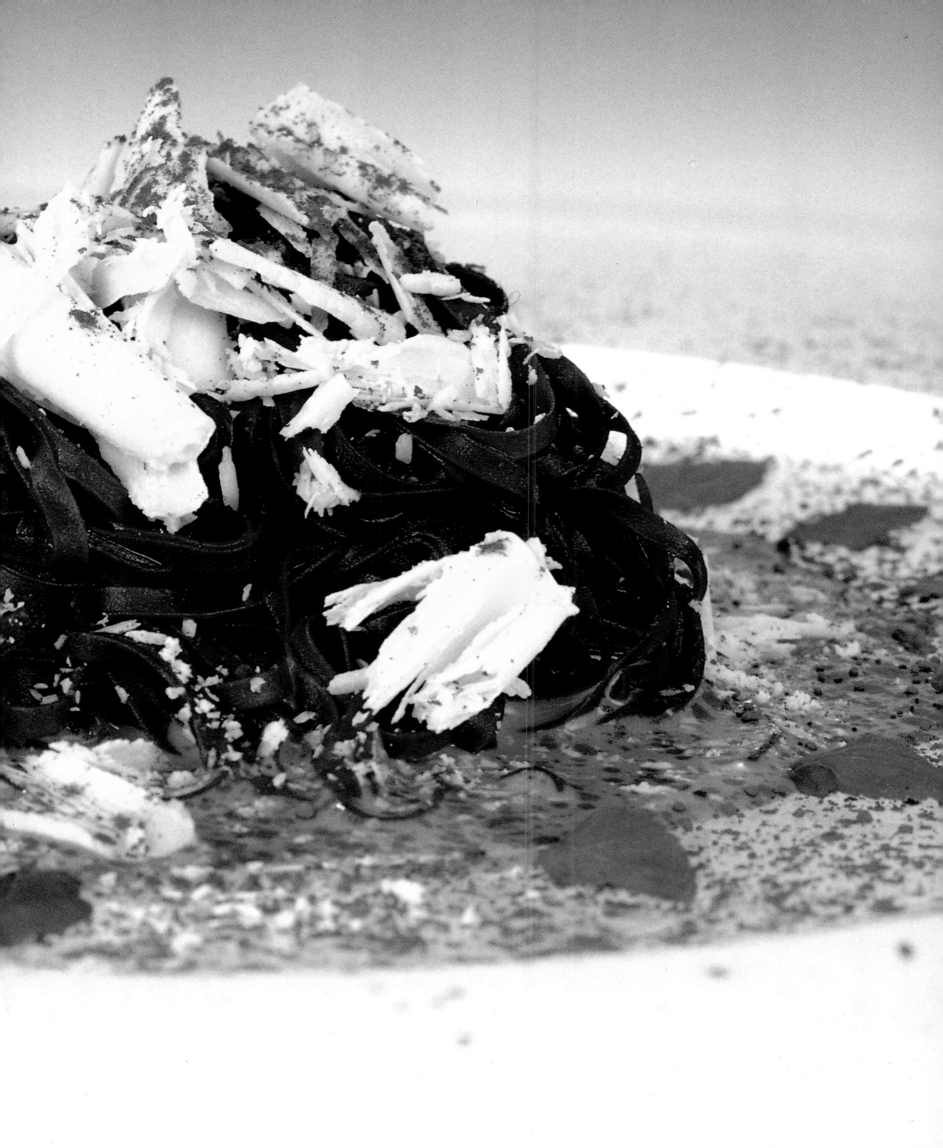

CHOCOLATE PASTA with MOCHA SAUCE
and WHITE CHOCOLATE CURLS

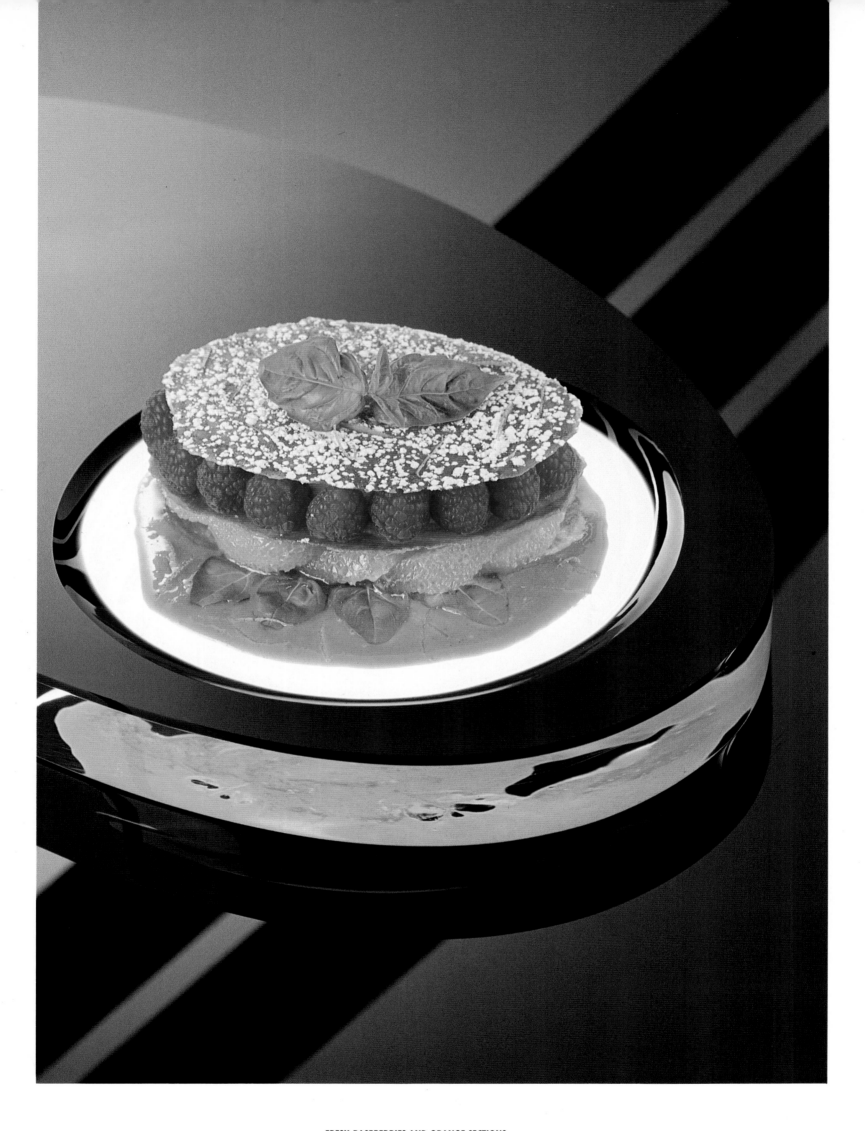

**FRESH RASPBERRIES AND ORANGE SECTIONS
IN PUFF PASTRY with BASIL CUSTARD SAUCE**

Summer

Most people relax in the summer. But for the chef, it is a season of challenge. He must come up with light and appealing dishes at a time when people don't feel like eating much. I find myself searching in the back of my head for ways to tempt summer appetites. Cold soups and salads are obvious offerings, and I love to experiment with all kinds of terrines.

Preparing meats in the summer here, I miss having an outdoor *cheminée*, or fireplace. In Condom, we grilled and barbecued everything outside in the summer. It's a much more interesting way to cook than in the oven. We used different kinds of wood — oak, apple, and cherry — and also vines. There was a boy whose sole job was to keep the fire burning and watch over the *cheminée*.

Like Paris, official Washington shuts down in August. Congress leaves town, and Washingtonians take their vacations. Some admirable tourists brave the heat, but even they don't feel like eating much or getting dressed up. In Condom, the summer was my busiest time, and for 21 years I never knew what it was to take a summer vacation. Now, when August arrives, I am happy to get out of my kitchen, look at wider horizons, and give myself a chance to grow in other directions. That way I know that when I return, I will be eager to rediscover the smells and tastes of autumn.

Washington summers can be terribly hot, but one thing more than compensates for the weather: fresh corn. When I was living in France, we didn't have sweet corn — we only grew feed corn for the animals. I fell in love with corn when I first came to America, and the affair is still going on. I like the sharpness of yellow corn; the white I find a little more subtle. I will always have corn on my menus in summer because it is one of the glories of American produce, and there are so many ways of using it. Of all the wonderful fruits and vegetables we have in summer, the best, for me, is corn.

WHITE ASPARAGUS

Summer

LACE-BATTERED FRIED CALAMARI with FRIED PARSLEY
Moët et Chandon, "Cuvée Dom Pérignon," 1980

⁓

CHILLED MAINE LOBSTER and LOBSTER CORN CAKE
with SALAD OF MACHE, RADICCHIO, AND FRISEE
Riesling, "Clos Hauserer," Zind Humbrecht, 1983

⁓

GREEN AND WHITE ASPARAGUS IN PUFF PASTRY with ASPARAGUS CREAM SAUCE
Château Olivier, Graves Grand Cru, 1983

⁓

SAUTEED BABY EELS AND MIREPOIX OF RED
AND YELLOW BELL PEPPERS with GARLIC AND CHIVE SAUCE
Pacherenc de Vic Bilh, Vignoble Laplace Aydie, 1986

⁓

SAUTEED RED SNAPPER and NIÇOISE OLIVES
with BLACK OLIVE AND ANCHOVY QUENELLES, BASIL SAUCE, and TOMATO AND OLIVE FLOWERS
Chassagne-Montrachet, Marquis de LaGuiche, 1985

⁓

PRIME RIB with BONE MARROW FLAN, CONFIT OF ONIONS IN RED WINE,
SAGE POTATO CHIPS, and MARCHAND DE VIN SAUCE
Château Mouton-Rothschild, Pauillac Premier Grand Cru, 1970

⁓

COCONUT ICE CREAM with FRIED COCONUT, FRIED PEACHES,
POACHED PEACHES, and CARAMEL SAUCE

CHERRY CLAFOUTIS
Château d'Yquem, 1947

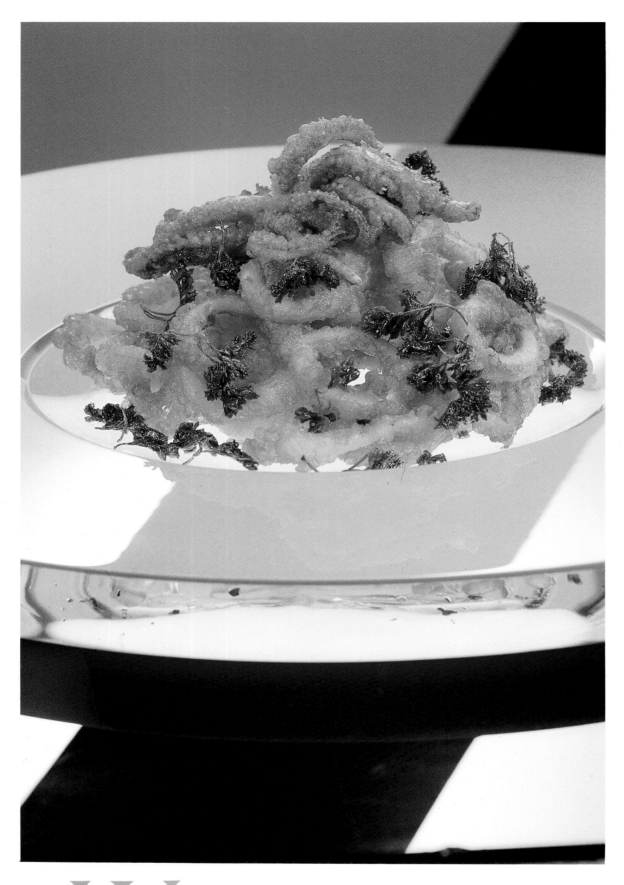

We have beautiful cala-mari here in the States. With a good, crunchy, light batter, they make a perfect "teaser" to serve with an apéritif at the beginning of a summer meal. Calamari ink has a taste of iodine; I sometimes use it for coloring sauces and pasta.

LACE-BATTERED FRIED CALAMARI
with FRIED PARSLEY
(Right) CHILLED MAINE LOBSTER
and LOBSTER CORN CAKE
with SALAD OF MACHE,
RADICCHIO, AND FRISEE

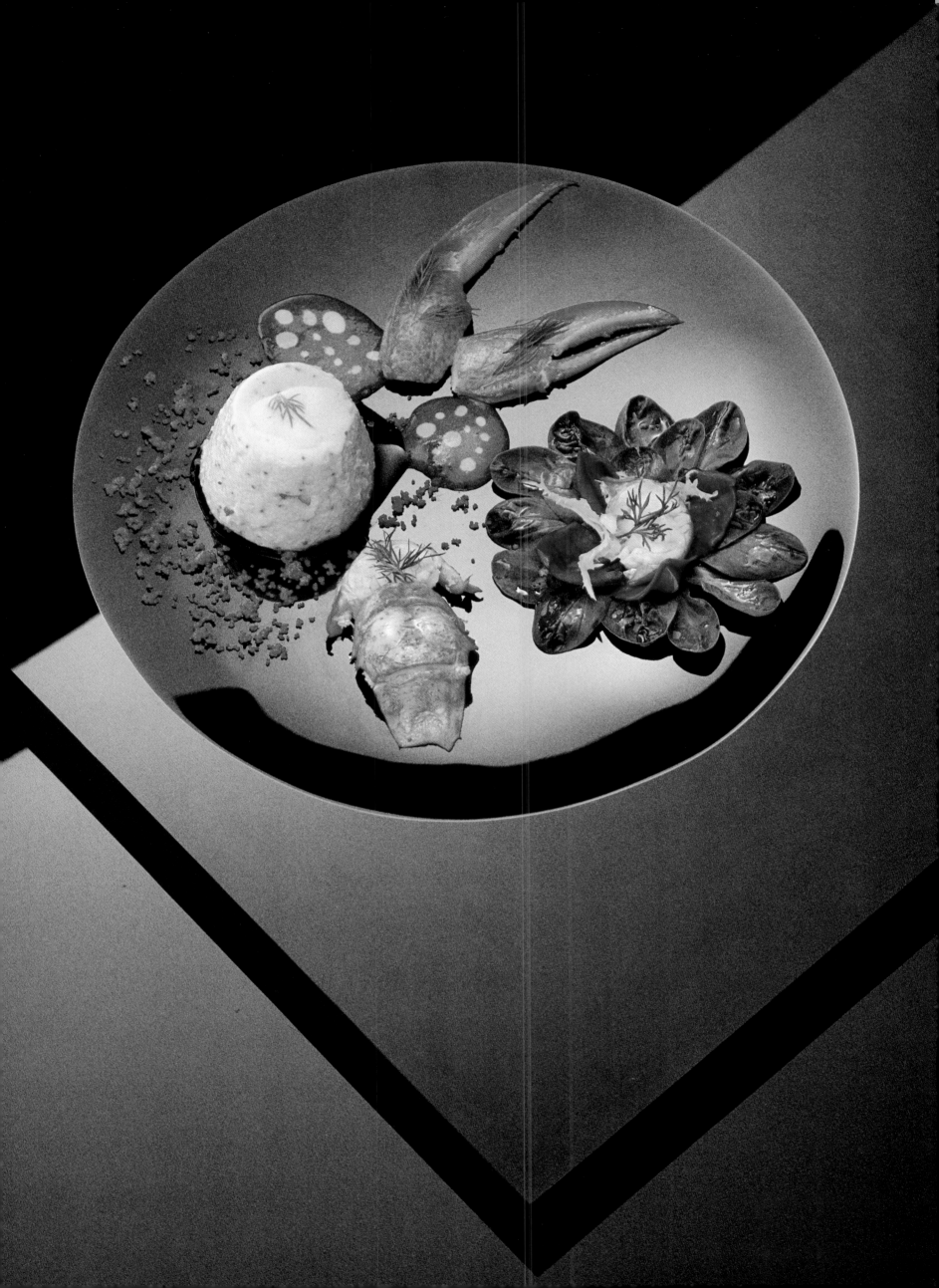

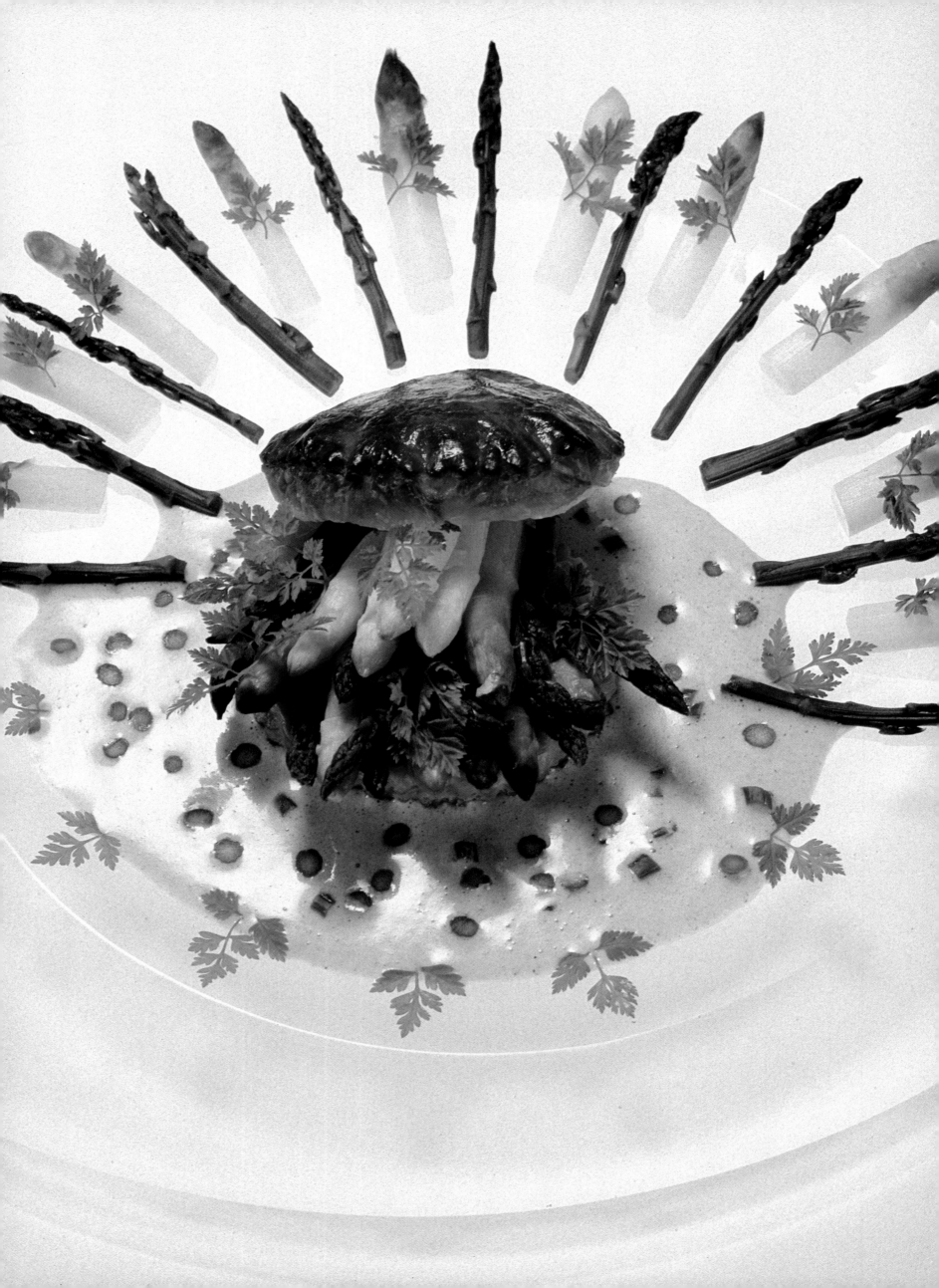

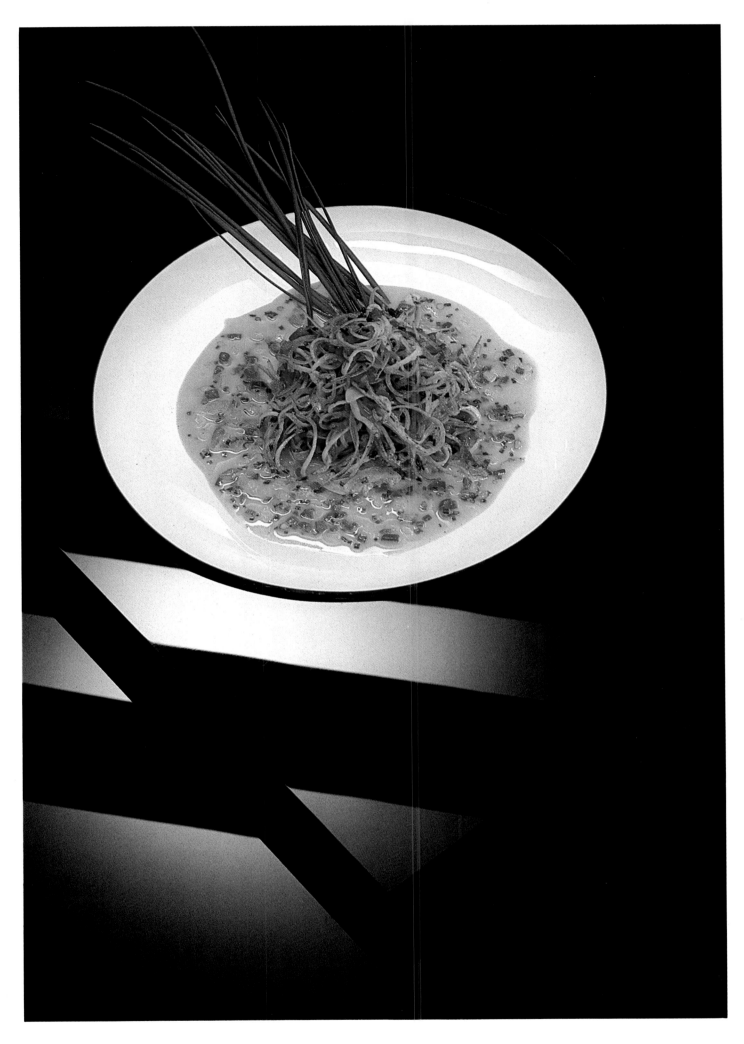

Piballes, or baby eels, do not have a strong taste, but, as always, it's a little difficult to interest people in eating things they are not used to. Still, I continue to serve *piballes*. Even if only a handful of people order them, I want those people to remember that they have eaten something very good, something they could not find anywhere else.

SAUTEED BABY EELS
AND MIREPOIX OF RED AND YELLOW BELL PEPPERS
with GARLIC AND CHIVE SAUCE
(Left) GREEN AND WHITE ASPARAGUS
IN PUFF PASTRY
with ASPARAGUS CREAM SAUCE

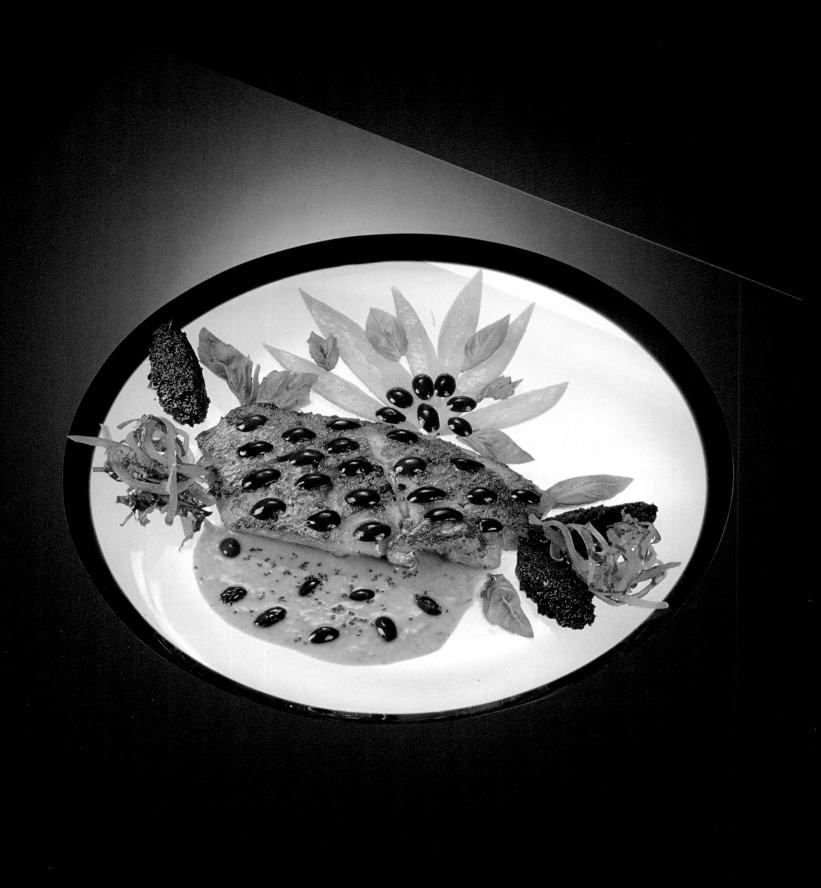

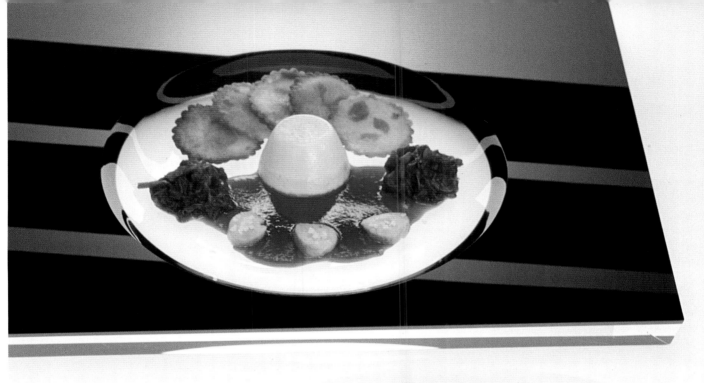

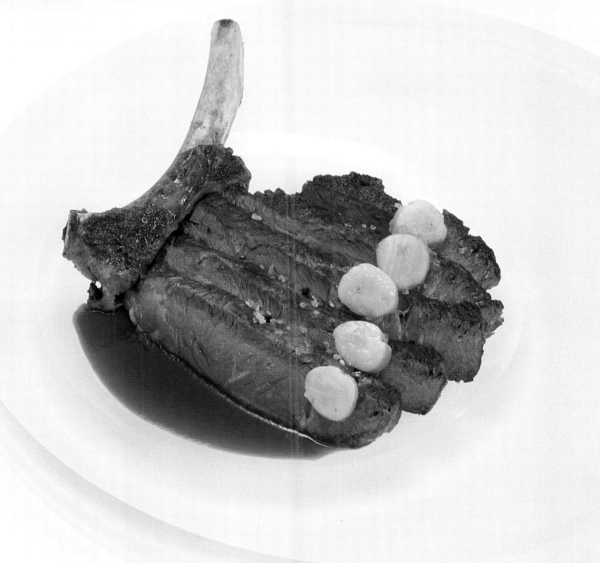

Americans love their beef, but they are not so eager to try bone marrow. We eat it a lot in France, and when I order pot-au-feu in a bistro, I always ask for three bones with marrow inside, some rock salt, and pickles — fantastic! Americans tend to find bone marrow's flavor too strong, so I tried to discover a way to cut the taste and make it acceptable, and came up with a type of flan. This way you can have the character of bone marrow without the shock of its taste.

PRIME RIB
with **BONE MARROW FLAN,**
CONFIT OF ONIONS IN RED WINE,
SAGE POTATO CHIPS,
and **MARCHAND DE VIN SAUCE**
(Left) **SAUTEED RED SNAPPER**
and **NICOISE OLIVES**
with **BLACK OLIVE AND ANCHOVY QUENELLES,**
BASIL SAUCE,
and **TOMATO AND OLIVE FLOWERS**

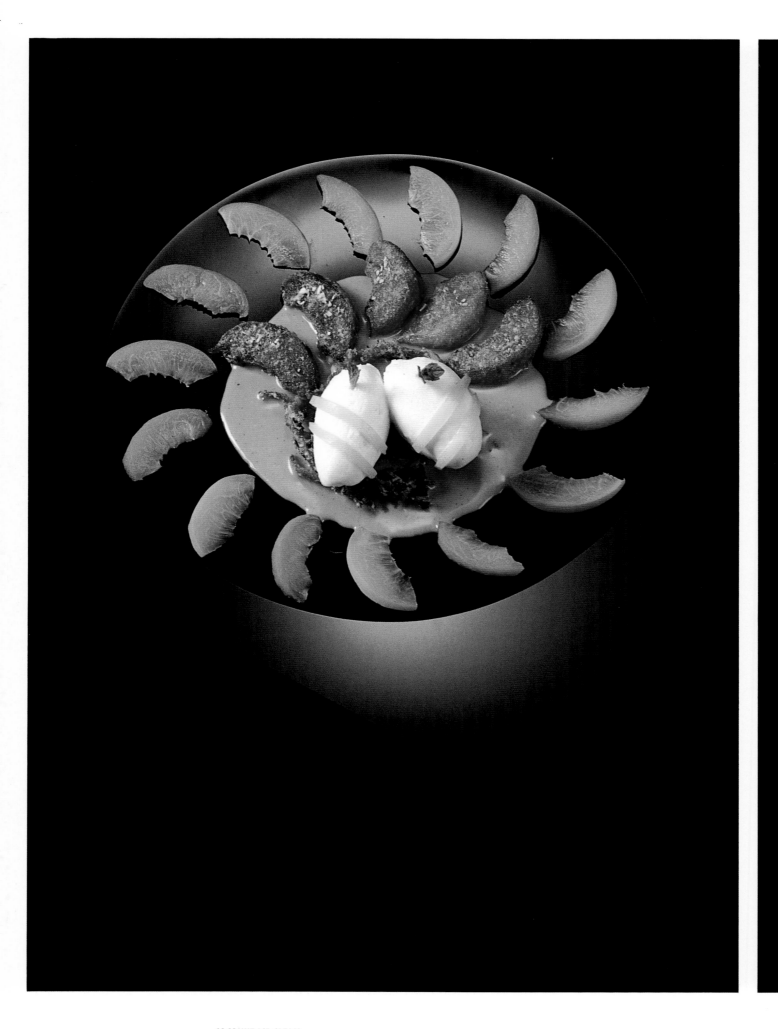

COCONUT ICE CREAM
with **FRIED COCONUT,**
FRIED PEACHES, POACHED PEACHES,
and **CARAMEL SAUCE**

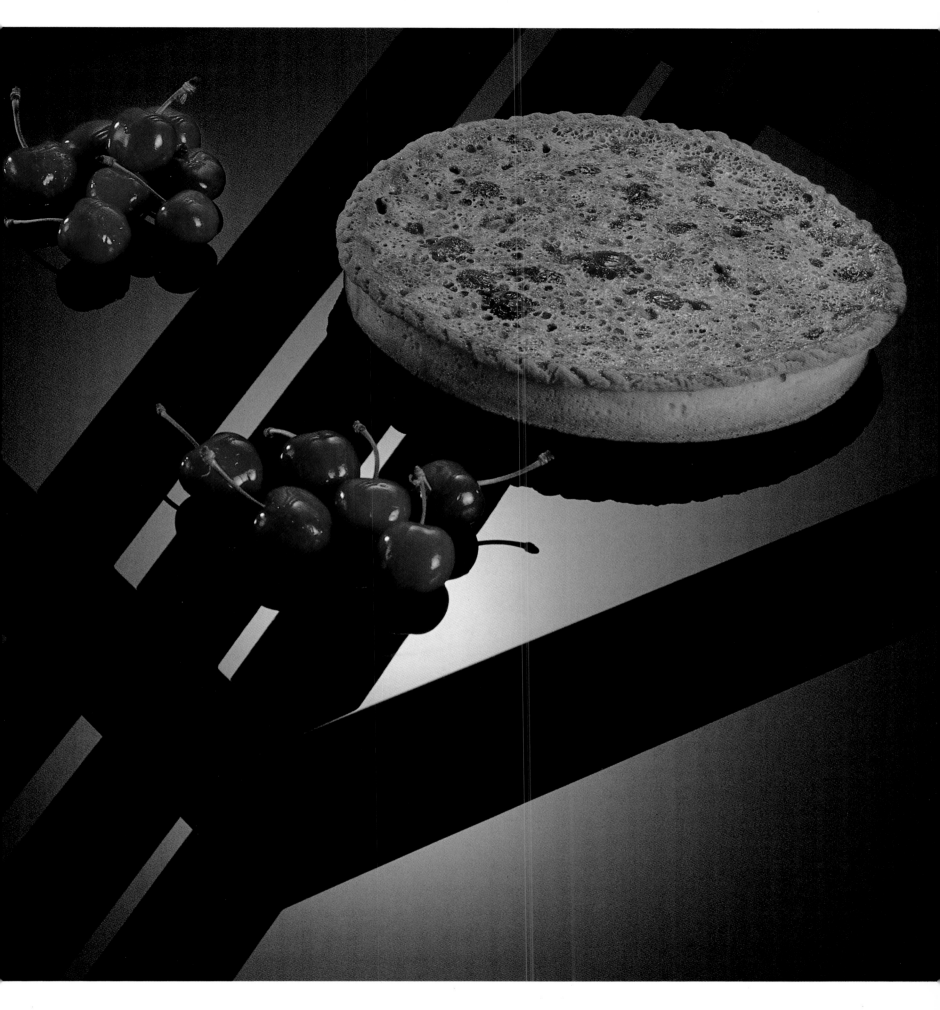

CHERRY CLAFOUTIS

Every family from my area has a clafoutis recipe. It is a very old dessert, a tart traditionally made with cherries. In my opinion, it's the best way to prepare cherries when they are in season.

POTATO RAVIOLI WITH SEA SCALLOP FILLING
Louis Roederer Cristal Rosé, 1981

∽

CHILLED CONSOMME OF THREE MELONS AND SAUTERNES
with JULIENNE VEGETABLES AND MINT
Antonio de la Riva Palo Cortado, Jerez

∽

TERRINE OF FOIE GRAS AND SPRING ONIONS
with PROSCIUTTO AND FRESH HERB TOMATO SAUCE
Navarro Vineyards Gewürztraminer, Late Harvest, 1982

∽

SAUTEED SWORDFISH AND OSSETRA CAVIAR CAKE with CAVIAR SAUCE
William Wheeler Sauvignon Blanc, Napa Valley, 1983

∽

SAUTEED PUERTO RICAN SHRIMP with SHRIMP QUENELLES,
CHANTERELLE MUSHROOMS, and CHANTERELLE MUSHROOM SAUCE
Acacia Winery Chardonnay, Carneros, Napa Valley, 1985

∽

RACK OF VEAL STUFFED WITH HONEY MUSHROOMS
with PAILLASSON POTATOES and THYME SAUCE
Château Bouchaine Pinot Noir, Winery Lake, Napa Valley, 1981

∽

PEACH CHARLOTTE with PEACH SAUCE

CHOCOLATE "HAT" with THREE CHOCOLATE SAUCES
Freemark Abbey Winery Johannesberg Riesling, Late Harvest, "Edelwein Gold," 1982

CHILLED CONSOMME
OF THREE MELONS AND SAUTERNES
with JULIENNE VEGETABLES
and MINT
(Left) POTATO RAVIOLI
WITH SEA SCALLOP FILLING

132

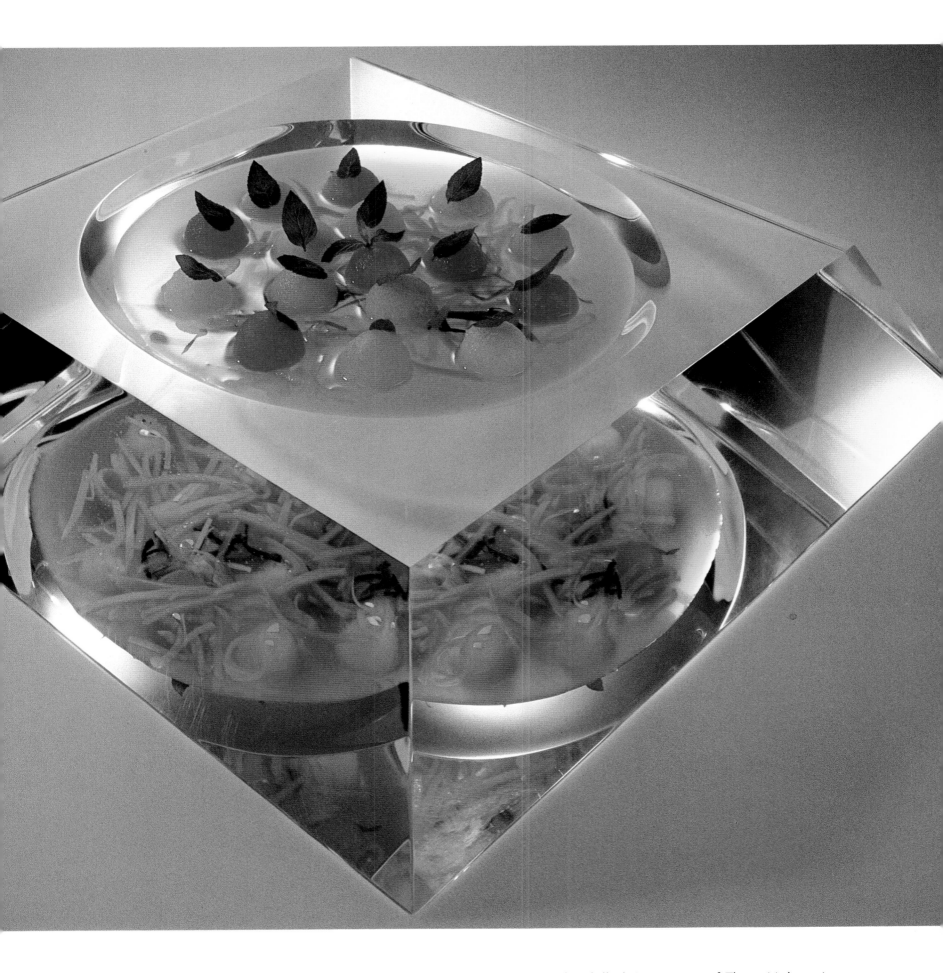

When I first made Chilled Consommé of Three Melons, it was a big hit in France. It is a refreshing way to start a summer meal, and the three kinds of melon balls — cantaloupe, honeydew, and watermelon — make it very colorful. Use a really good consommé as a base, combine it with a fine Sauternes, and you will have a fantastic result.

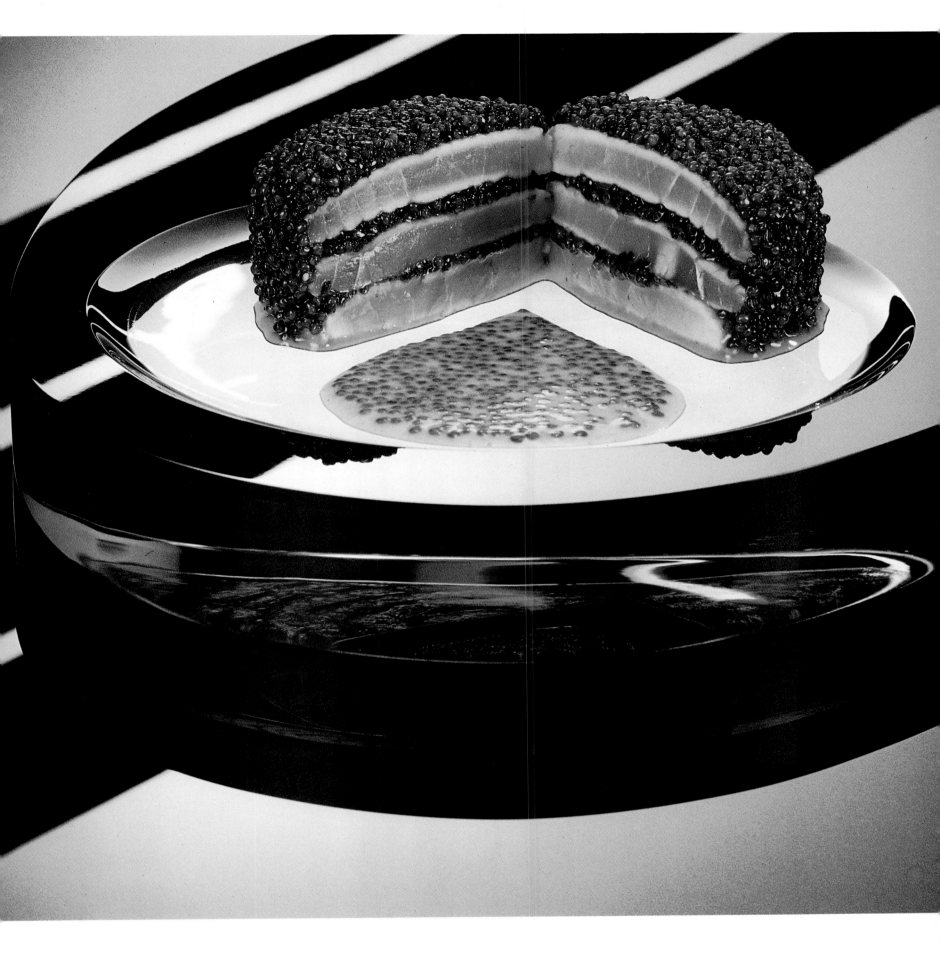

SAUTEED SWORDFISH

AND OSSETRA CAVIAR CAKE

with **CAVIAR SAUCE**

(Left) **TERRINE OF FOIE GRAS**

AND SPRING ONIONS

with **PROSCIUTTO**

AND FRESH HERB TOMATO SAUCE

Swordfish is very tricky to cook — a few seconds too long, and it's ruined. The taste is beautiful, but a little plain; combining it with caviar gives it just the twist it needs because caviar is salty and has a lot of iodine.

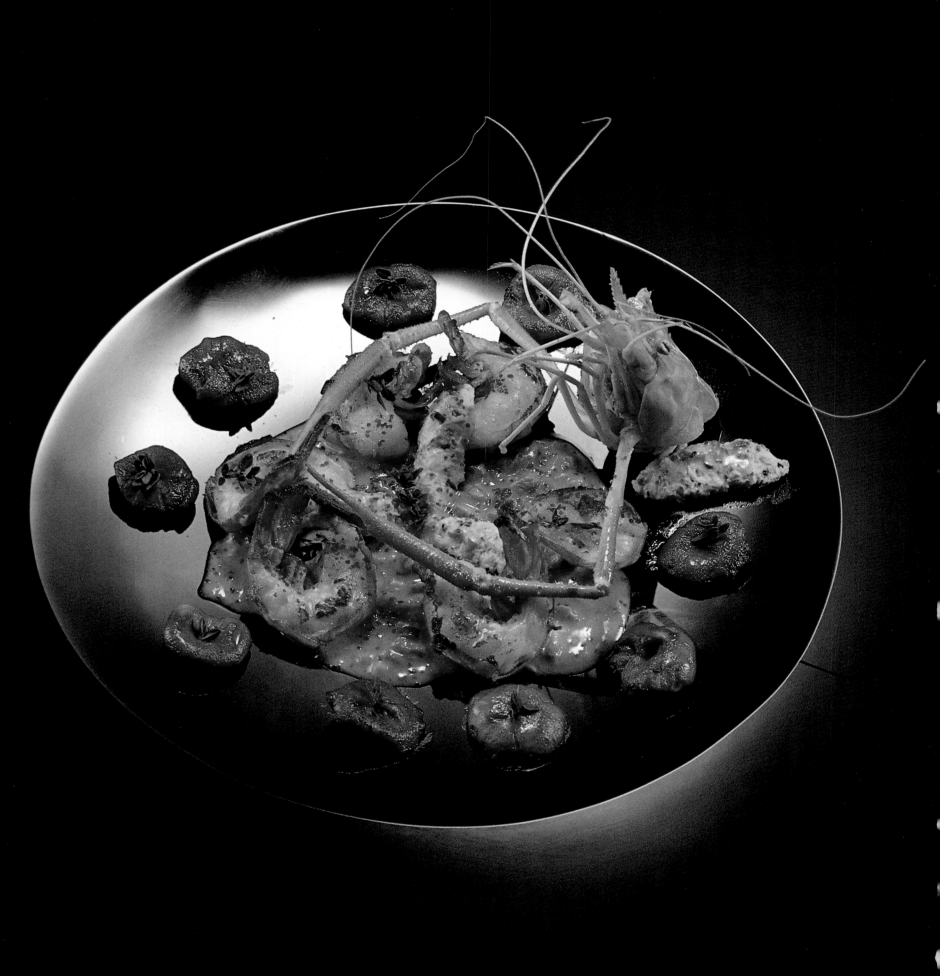

(Left) SAUTEED PUERTO RICAN SHRIMP
with SHRIMP QUENELLES,
CHANTERELLE MUSHROOMS,
and CHANTERELLE SAUCE
(Below) RACK OF VEAL STUFFED
WITH HONEY MUSHROOMS
with PAILLASSON POTATOES
and THYME SAUCE

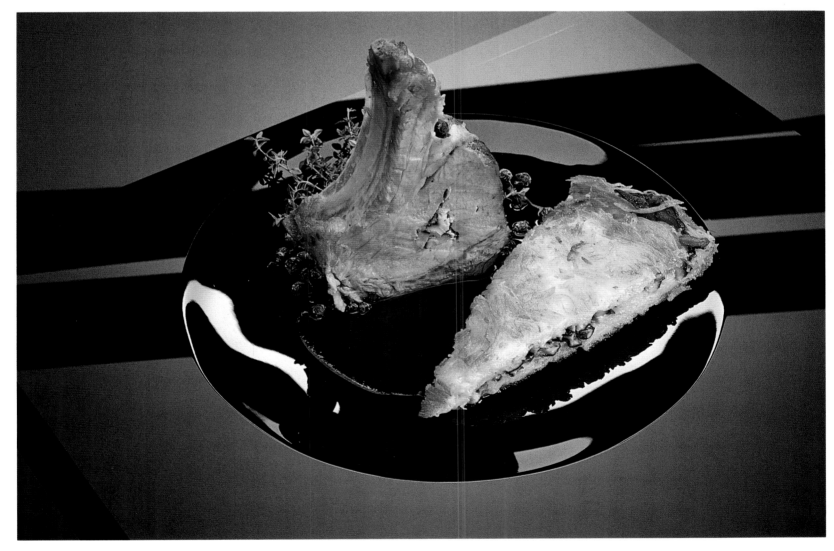

When you put shrimp on an American menu, you will certainly sell them. The best in this country are a bit like langoustines. They come from Santa Barbara, but are difficult to get. The blue prawns from Puerto Rico and the pink ones from Louisiana are both good. For large shrimp, France cannot compete with America, but the little ones we have there, *crevettes grises* and *crevettes roses*, are wonderful.

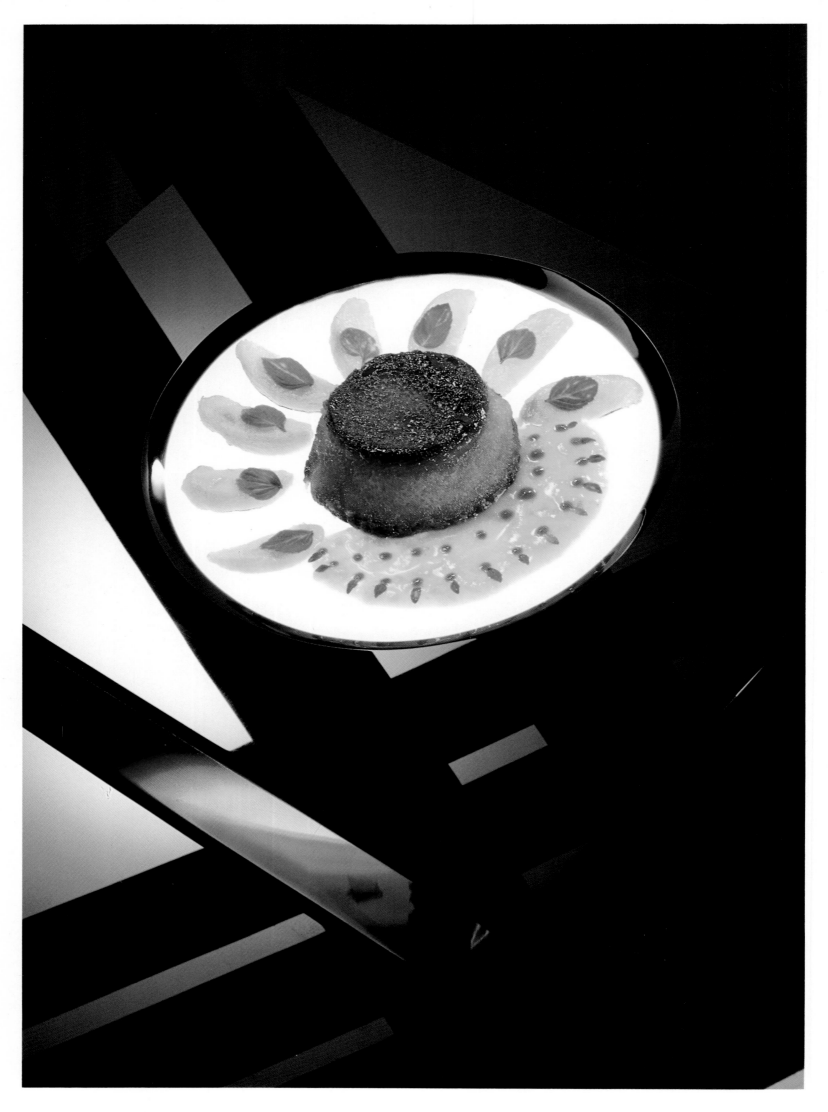

Peach Charlottes are for the person who doesn't have much time to shop or cook but wants to make a really good, inexpensive dessert. Everything you need for them can be found in the supermarket, and they're easy to make.

PEACH CHARLOTTE with PEACH SAUCE
(Right) CHOCOLATE ''HAT''
with THREE CHOCOLATE SAUCES

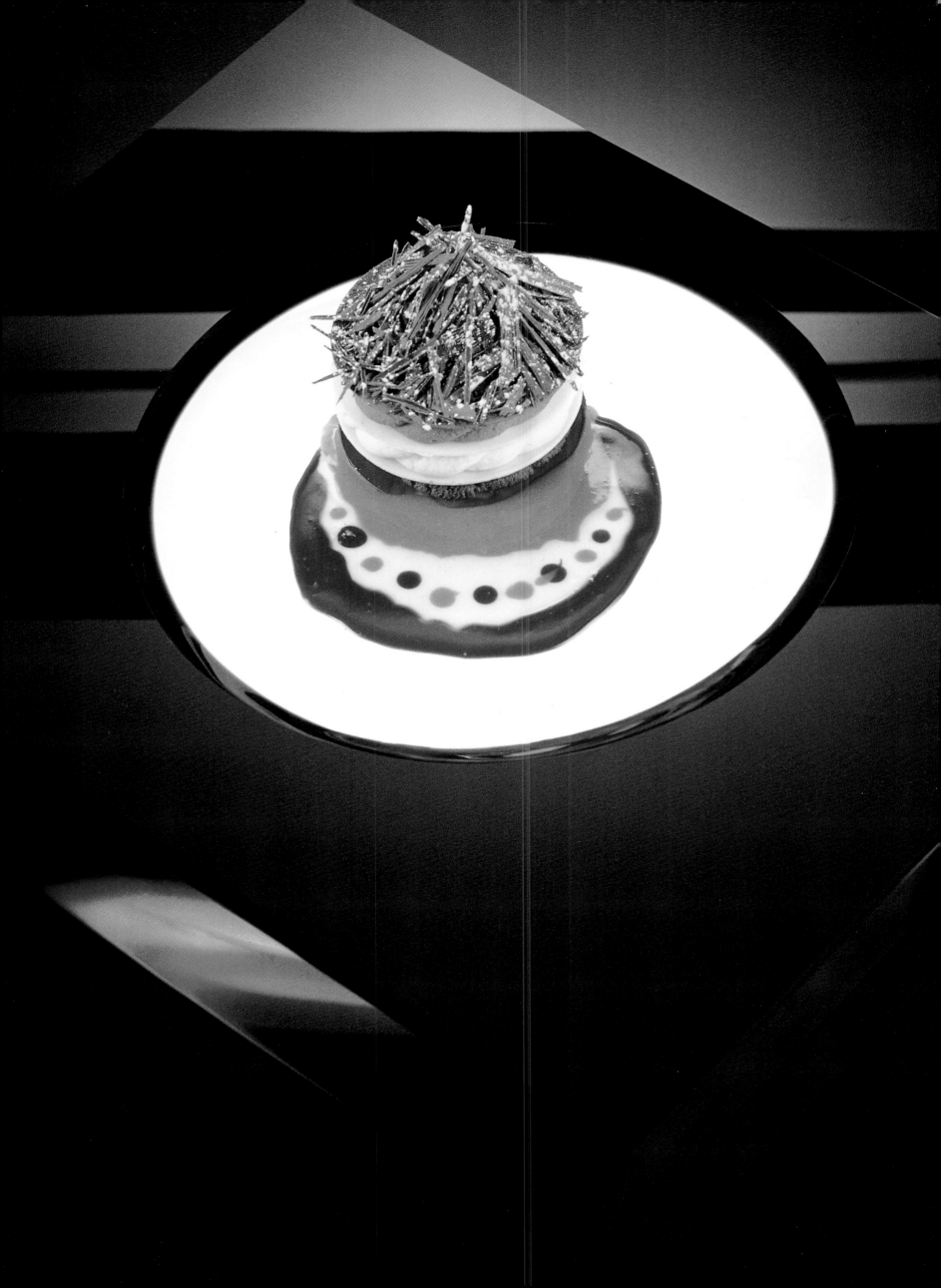

SMOKED SALMON, SMOKED ROCKFISH, AND SMOKED TUNA
with OSSETRA CAVIAR AND SOUR CREAM SAUCE
Gosset Grand Millésime Brut, 1973

∽

FOIE GRAS in BRIOCHE
Jurançon Moelleux, "Cru Lamairoux," 1984

∽

HERB RAVIOLI AND SMOKED TUNA with JULIENNE VEGETABLES and HERB VINAIGRETTE
Sancerre, Clos de la Crêle, Lucien Thomas, 1986

∽

LOUISIANA CRAWFISH, LOBSTER FLAN,
and ASPARAGUS with GINGER SAUCE and ASPARAGUS CREAM SAUCE
Vichon Winery Chevrignon Blanc, Napa Valley, 1984

∽

SAUTEED ABALONES with ENOKI MUSHROOMS and ENOKI SAUCE
Corton-Charlemagne, Domaine Louis Latour, 1983

∽

SALAD OF ROASTED MILK-FED LAMB, LAMB LIVER QUENELLES, BLACK OLIVE QUENELLES, ARTICHOKES, and
CAULIFLOWER with VOSNE-ROMANEE 1972 VINAIGRETTE
Volnay, "Les Angles," Henri Boillot, 1961

∽

APRICOT TARTE TATIN with APRICOT CUSTARD SAUCE

PEPPERMINT MOUSSE on CHOCOLATE LEAF with MINT CUSTARD SAUCE
Hattenheimer Wisselbrunner Trockenbeerenauslese, Schloss Reinhartshause, Rheingau, 1971

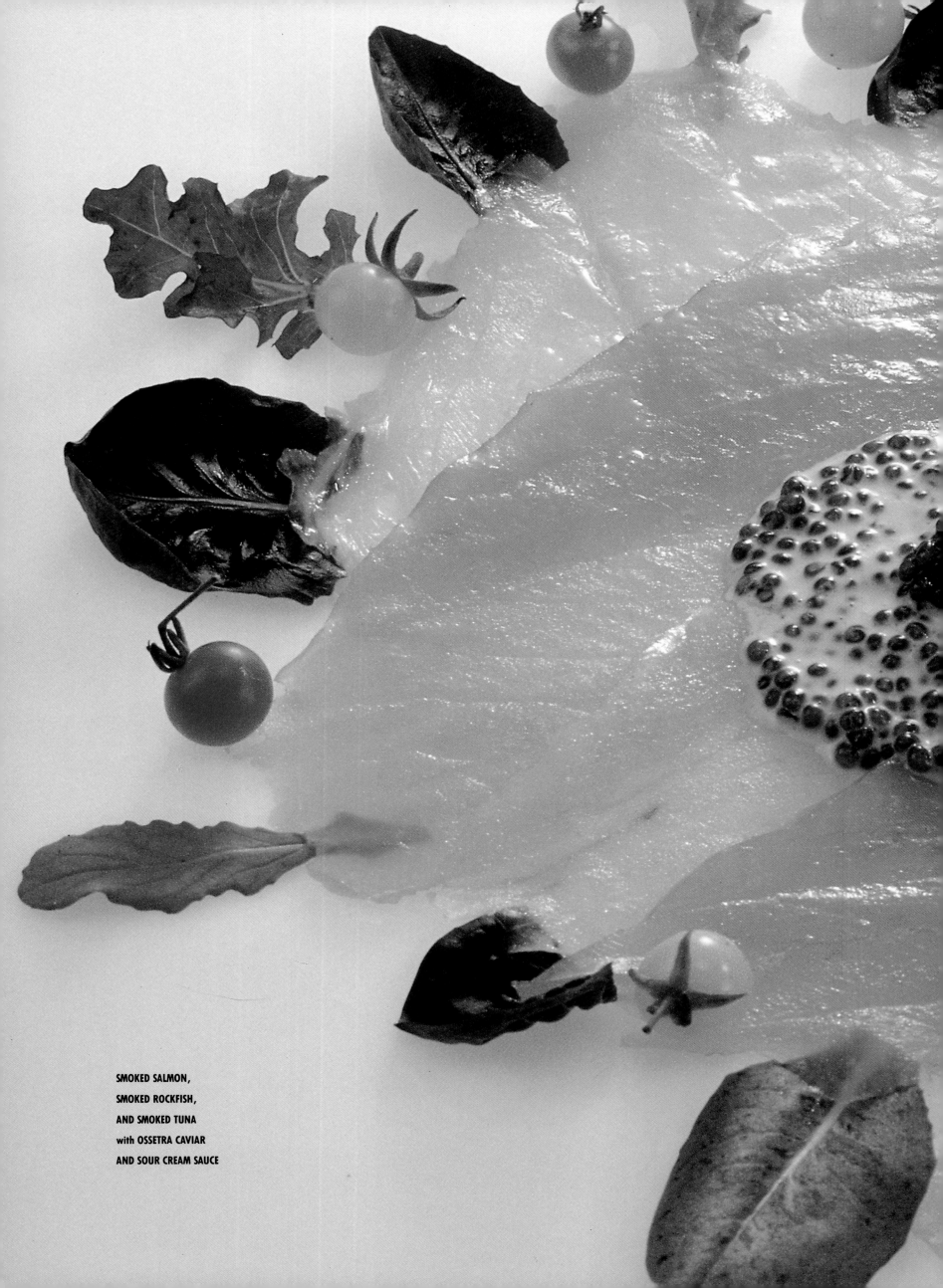

SMOKED SALMON,
SMOKED ROCKFISH,
AND SMOKED TUNA
with OSSETRA CAVIAR
AND SOUR CREAM SAUCE

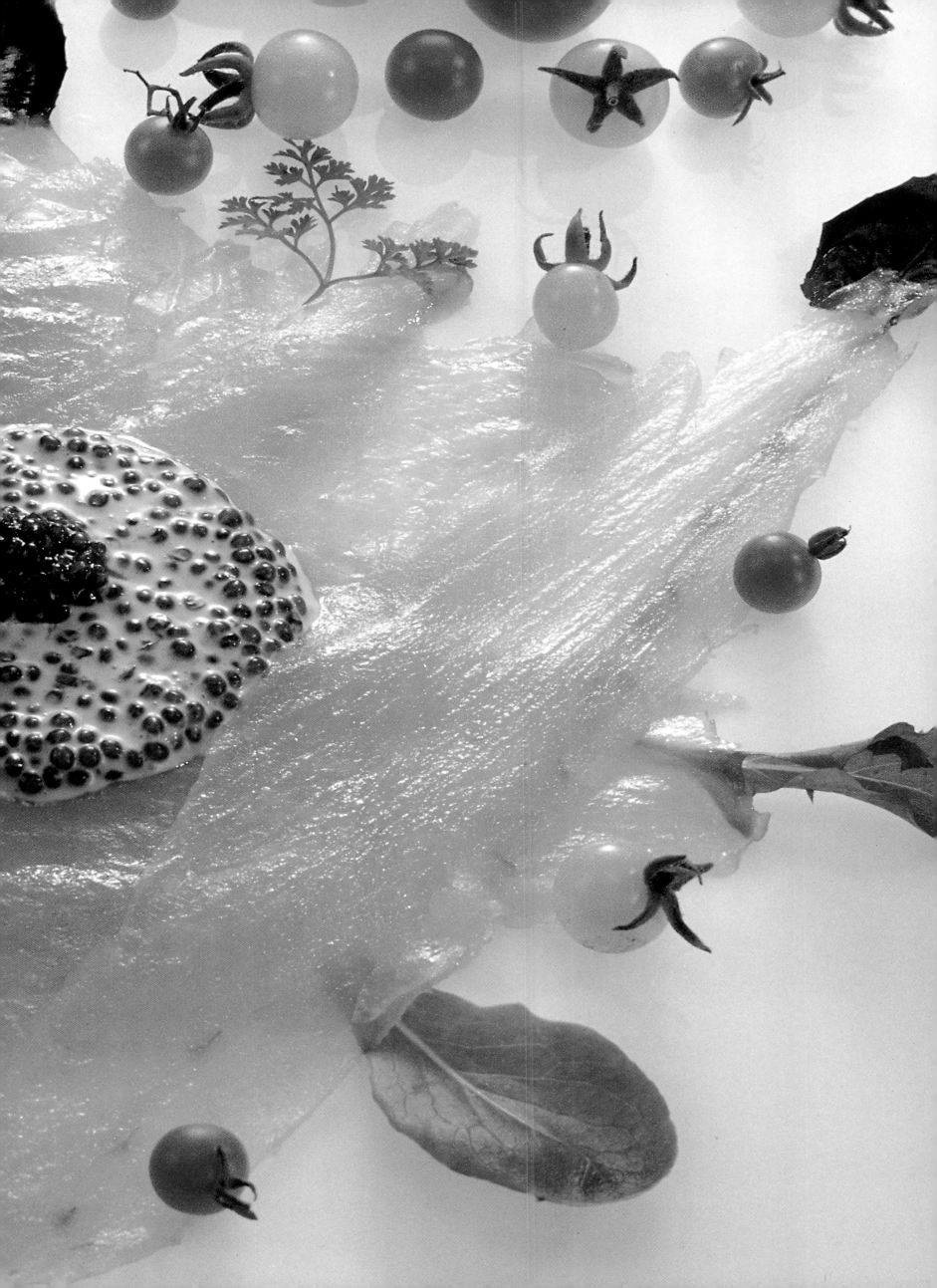

(Left) FOIE GRAS in BRIOCHE
(Below) HERB RAVIOLI AND SMOKED TUNA
with JULIENNE VEGETABLES
and HERB VINAIGRETTE
(Right) LOUISIANA CRAWFISH,
LOBSTER FLAN,
and ASPARAGUS with GINGER SAUCE
and ASPARAGUS CREAM SAUCE

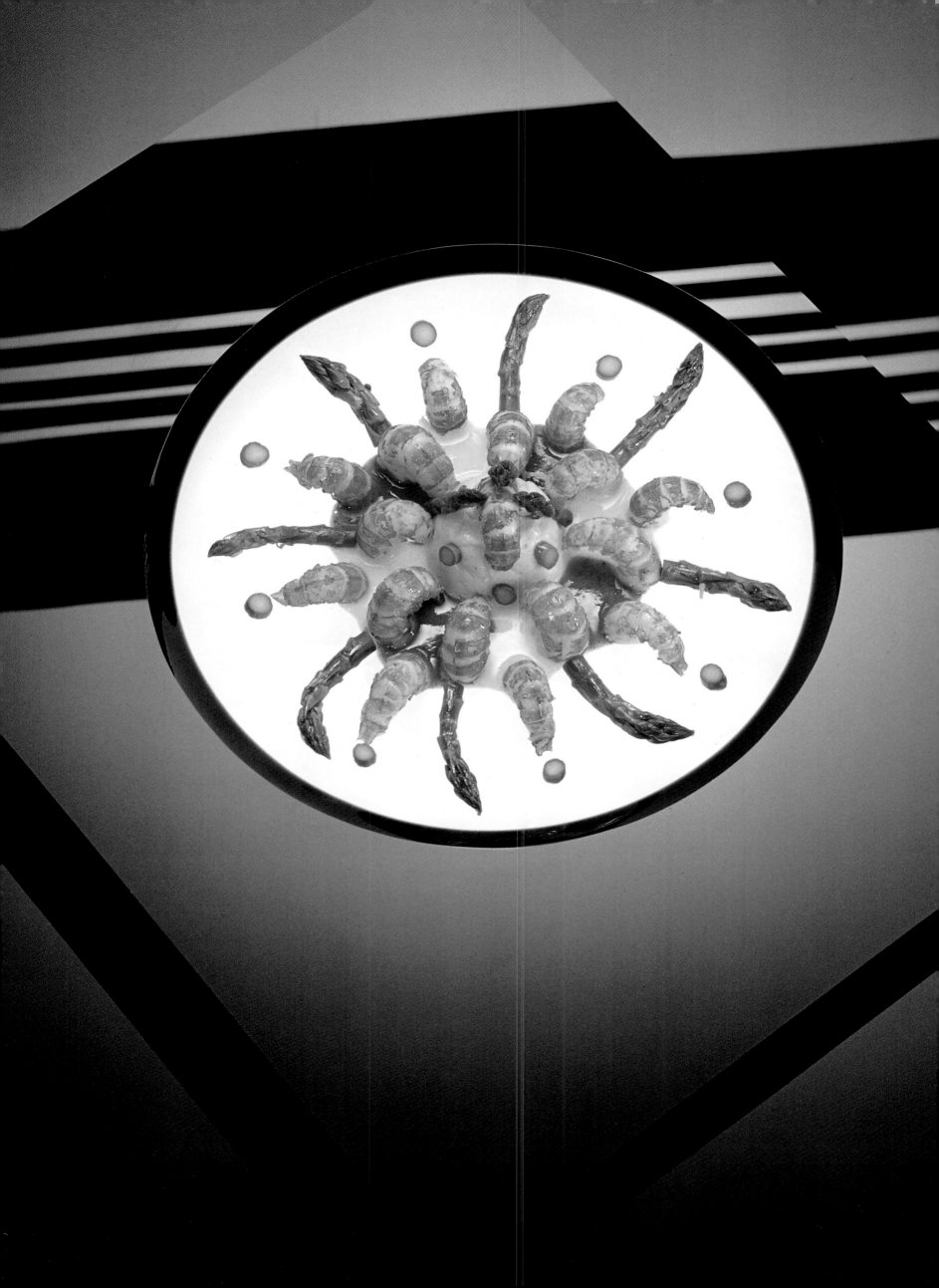

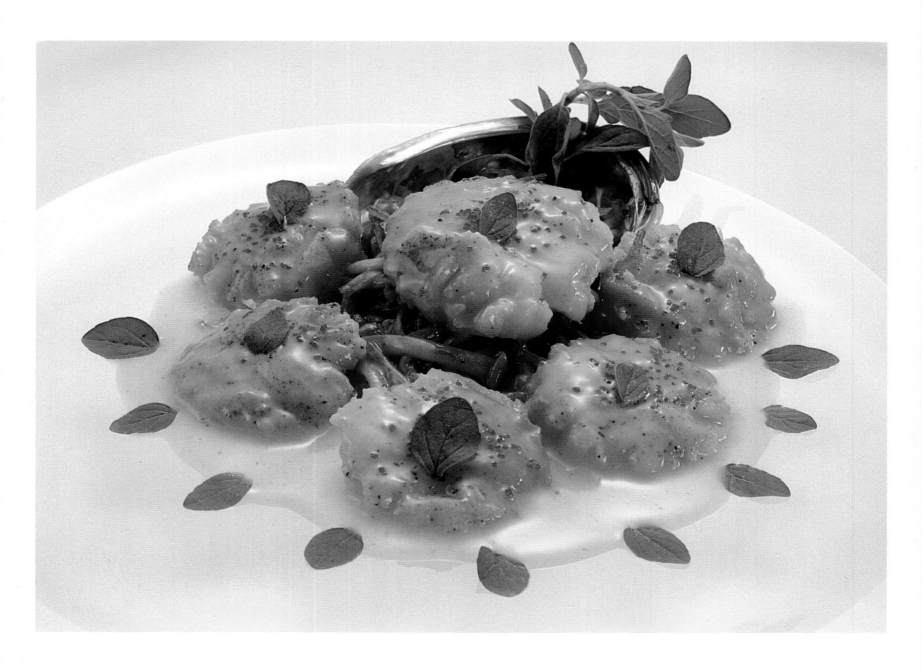

Once I discussed abalones with a Breton fisherman who said they are no longer as popular in France as they used to be. I told him that if the French tried the ones we get from Santa Barbara, that would change, but he would not believe me. Abalones are expensive because they are time-consuming to prepare; you have to pound them to make them tender. The Japanese use abalones a lot; in this dish I combine them with enokis, very good Japanese mushrooms.

The unique thing about my Salad of Roasted Milk-fed Lamb is the vinaigrette of Vosne-Romanée. I have a customer, Henry Greenwald, who is crazy about wine. He receives a lot of it through an organization to which he belongs, and whatever is left in the bottles, he separates and puts in oak barrels to make into vinegar. He doesn't do it commercially, just for his own pleasure. I am very fortunate to know him; you certainly won't find vinegar made from Vosne-Romanée 1972 anywhere else.

SAUTEED ABALONES
with **ENOKI MUSHROOMS**
and **ENOKI SAUCE**
(Right) **SALAD OF ROASTED MILK-FED LAMB,**
LAMB LIVER QUENELLES,
BLACK OLIVE QUENELLES,
ARTICHOKES, and CAULIFLOWER
with **VOSNE-ROMANEE 1972 VINAIGRETTE**

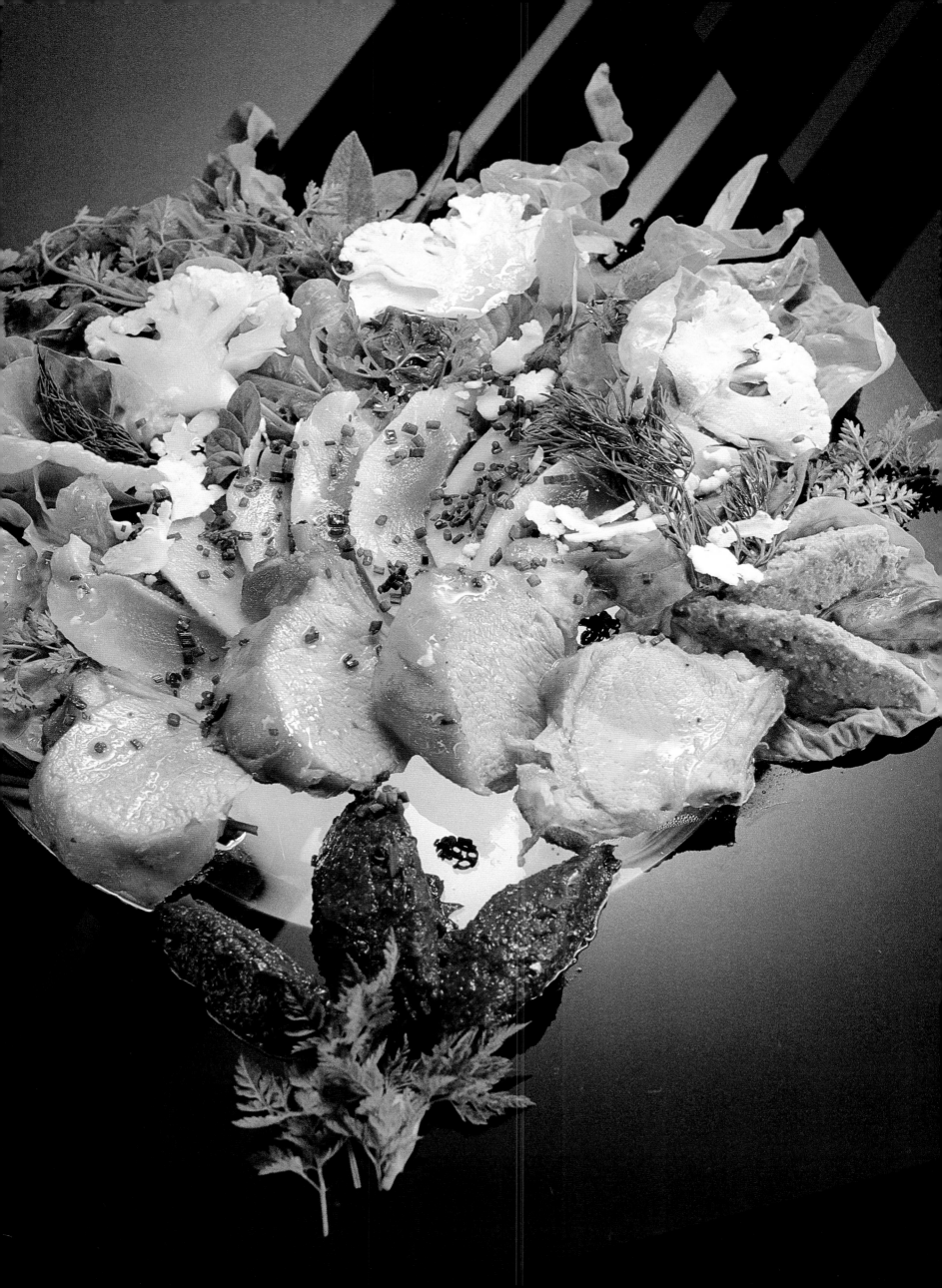

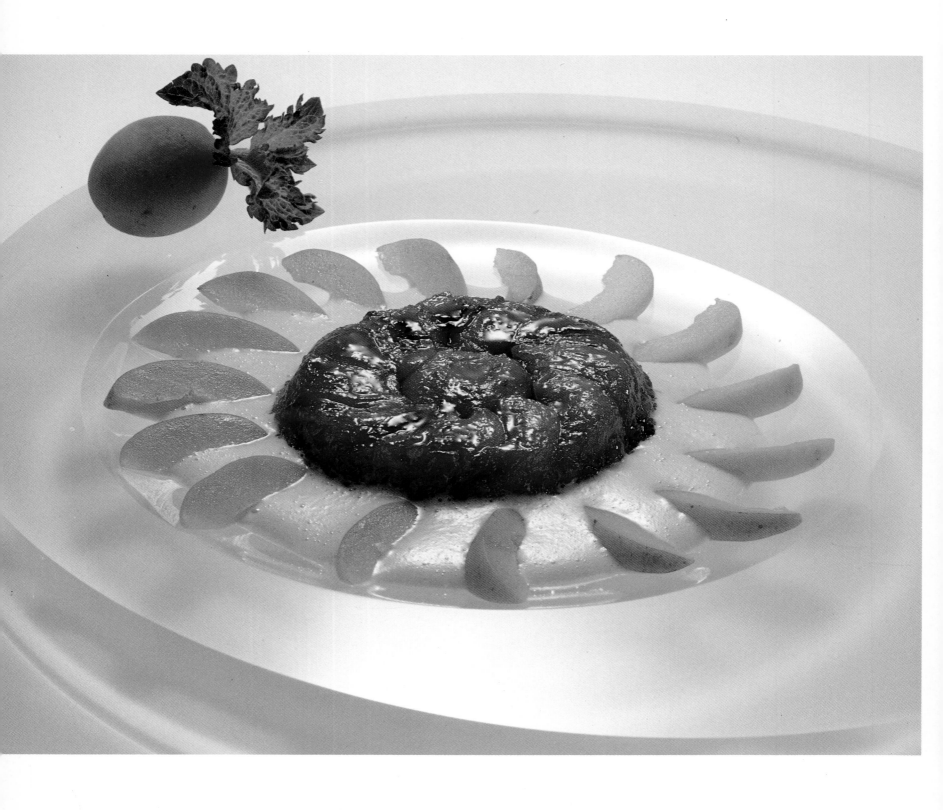

Tarte Tatin originated with two sisters, *les dames Tatin*, who lived in Sologne in the Loire Valley. The classical *tarte* is made with apples, but I love the taste of apricots and have simply given a contemporary twist to an old recipe.

APRICOT TARTE TATIN
with APRICOT CUSTARD SAUCE
(Right) PEPPERMINT MOUSSE
on CHOCOLATE LEAF
with MINT CUSTARD SAUCE

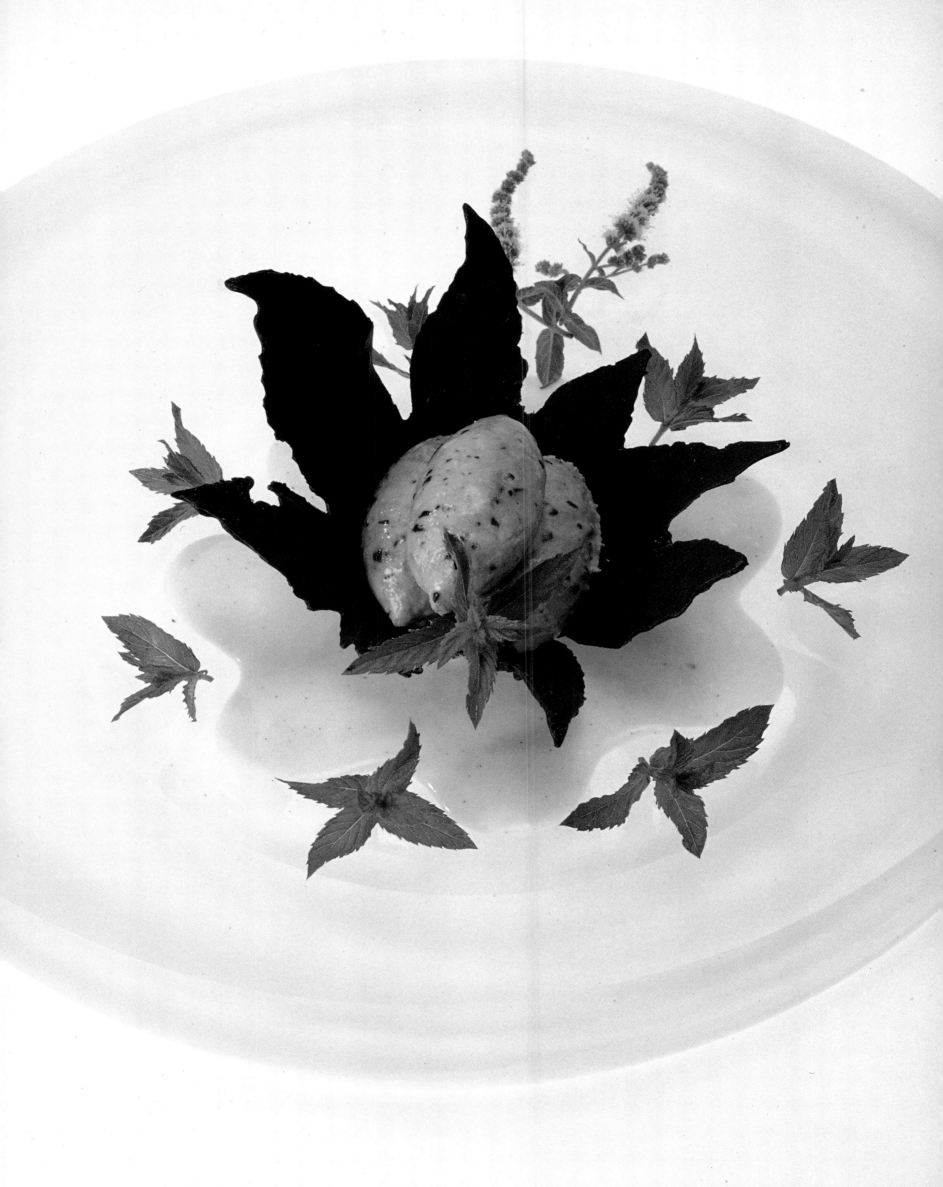

CAULIFLOWER, TOMATO, CARROT, BROCCOLI, AND BEET GRANITES
Paul Bara Brut, "Comtesse Marie de France," 1976

∽

CHILLED CREAM OF AVOCADO AND CHEVRE SOUP with CHEVRE QUENELLES and DILL
Hermitage Blanc, E. Guigal, 1982

∽

VEGETABLE TERRINE PROVENÇALE with RED AND YELLOW BELL PEPPER SAUCES
Caillou Blanc du Château Talbot, 1985

∽

BLANQUETTE OF FRESH VEGETABLES with CARROT AND CHARDONNAY CREAM SAUCE
Chablis, "Les Blanchots," Lupé-Cholet, 1985

∽

LACE-BATTERED FRIED VEGETABLES with LIME MOUSSELINE
Meursault-Blagny, Château de Blagny, Louis Latour, 1984

∽

BRAISED BELGIAN ENDIVE and SAUTEED FENNEL with FENNEL SAUCE
Corton, "Cuvée Charlotte Dumay," Hospices de Beaune, 1983

∽

**CHARTREUSE OF ASPARAGUS TIPS, ASPARAGUS FLAN,
AND FRIED JULIENNE VEGETABLES with ASPARAGUS CREAM SAUCE**
Cornas, Auguste Clape, 1981

∽

ANN AMERNICK'S TUILES

KATHY DINARDO'S CHEESECAKE with CONFIT OF PARIS MUSHROOMS
Château Nairac, Barsac, 1975

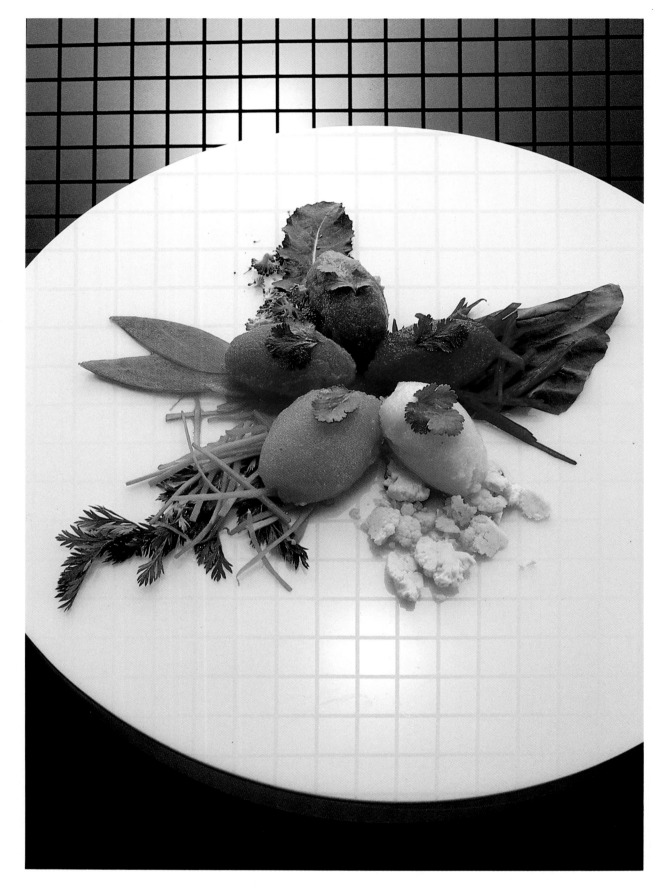

The idea of being a vegetarian seems, on the face of it, very alien to a chef. What a shame not to be able to eat all the beautiful meats, foie gras, and confits! However, for some, it is a spiritual choice, for others, a question of health or taste. Whatever the reason, we have to respect the decision. My sister has been a vegetarian for many years, and at least once a week I receive a call warning me that a vegetarian is coming to eat in my restaurant, so I have given a lot of thought to vegetarian menus and can state absolutely that they need never be boring.

CAULIFLOWER, TOMATO, CARROT, BROCCOLI, AND BEET GRANITES
(Right) CHILLED CREAM OF AVOCADO AND CHEVRE SOUP
with CHEVRE QUENELLES and DILL

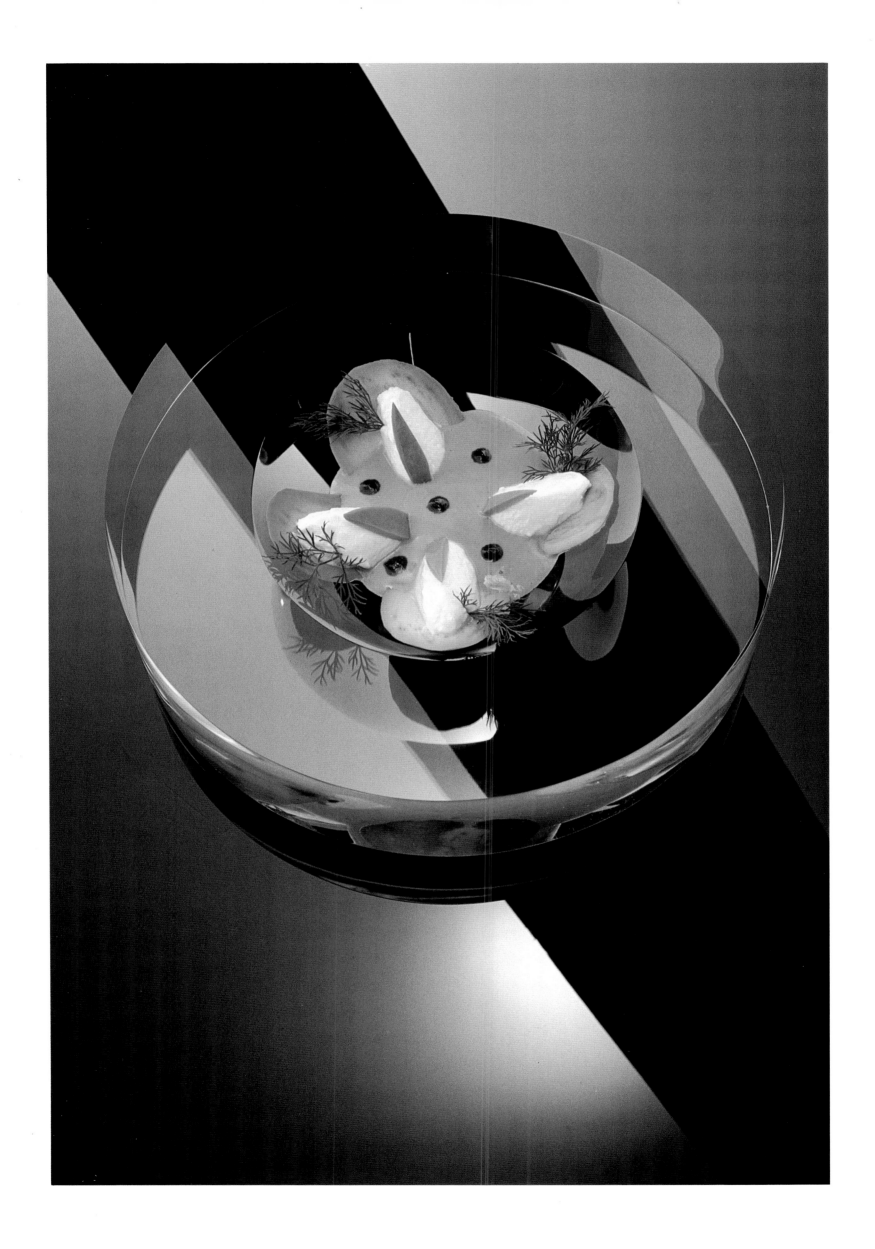

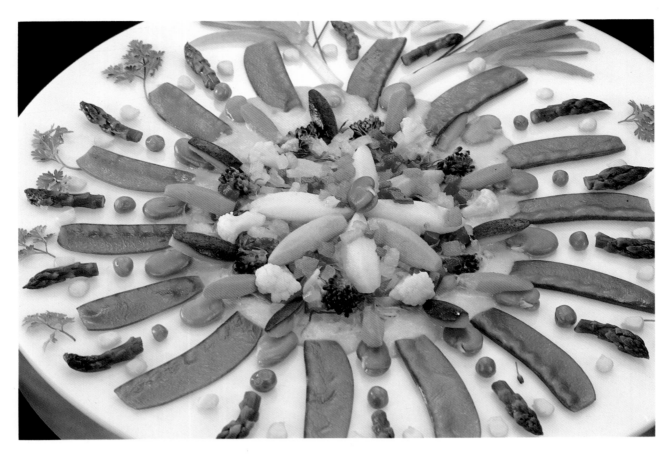

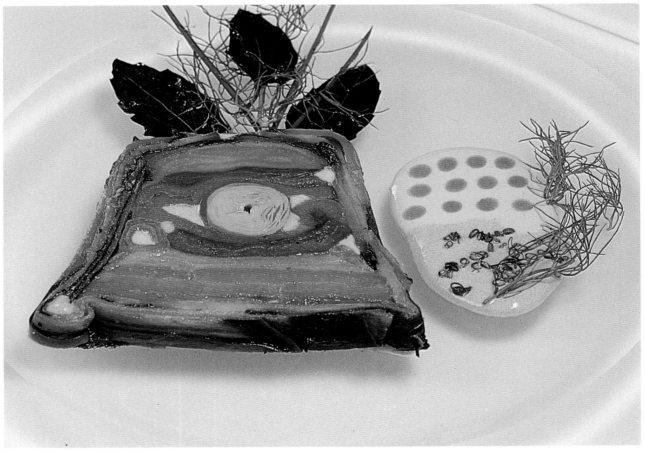

(Upper) BLANQUETTE OF FRESH VEGETABLES
with CARROT AND CHARDONNAY CREAM SAUCE
(Lower) VEGETABLE TERRINE PROVENÇALE
with RED AND YELLOW BELL PEPPER SAUCES
(Right) LACE-BATTERED FRIED VEGETABLES
with LIME MOUSSELINE

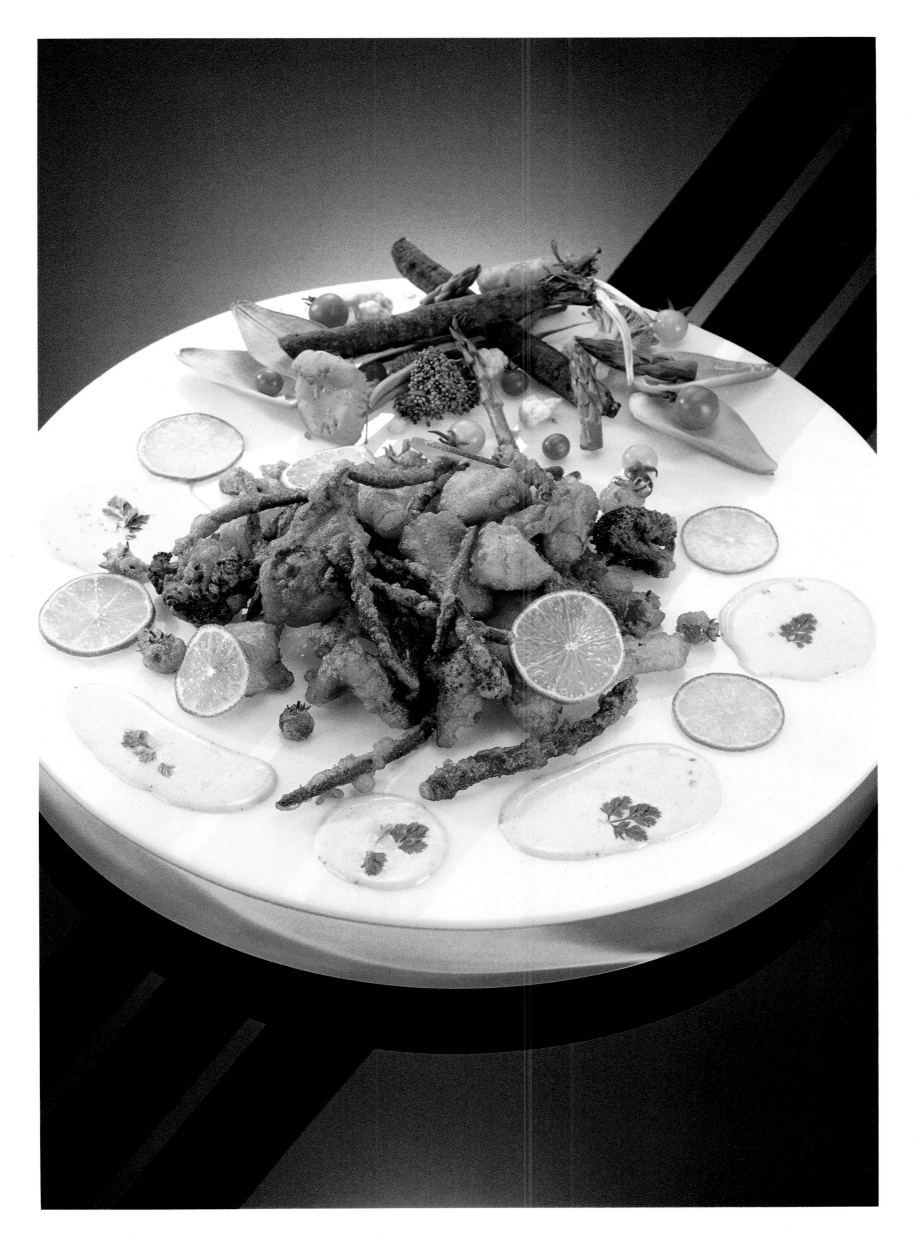

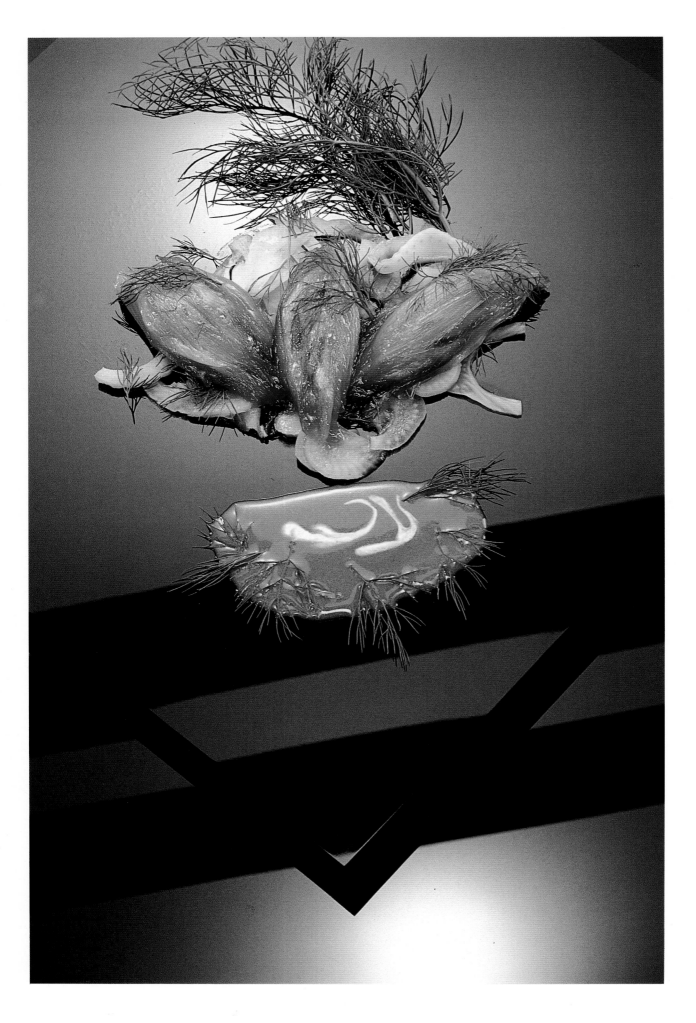

BRAISED BELGIAN ENDIVE
and SAUTEED FENNEL
with FENNEL SAUCE
(Right) CHARTREUSE OF ASPARAGUS TIPS,
ASPARAGUS FLAN,
AND FRIED JULIENNE VEGETABLES
with ASPARAGUS CREAM SAUCE

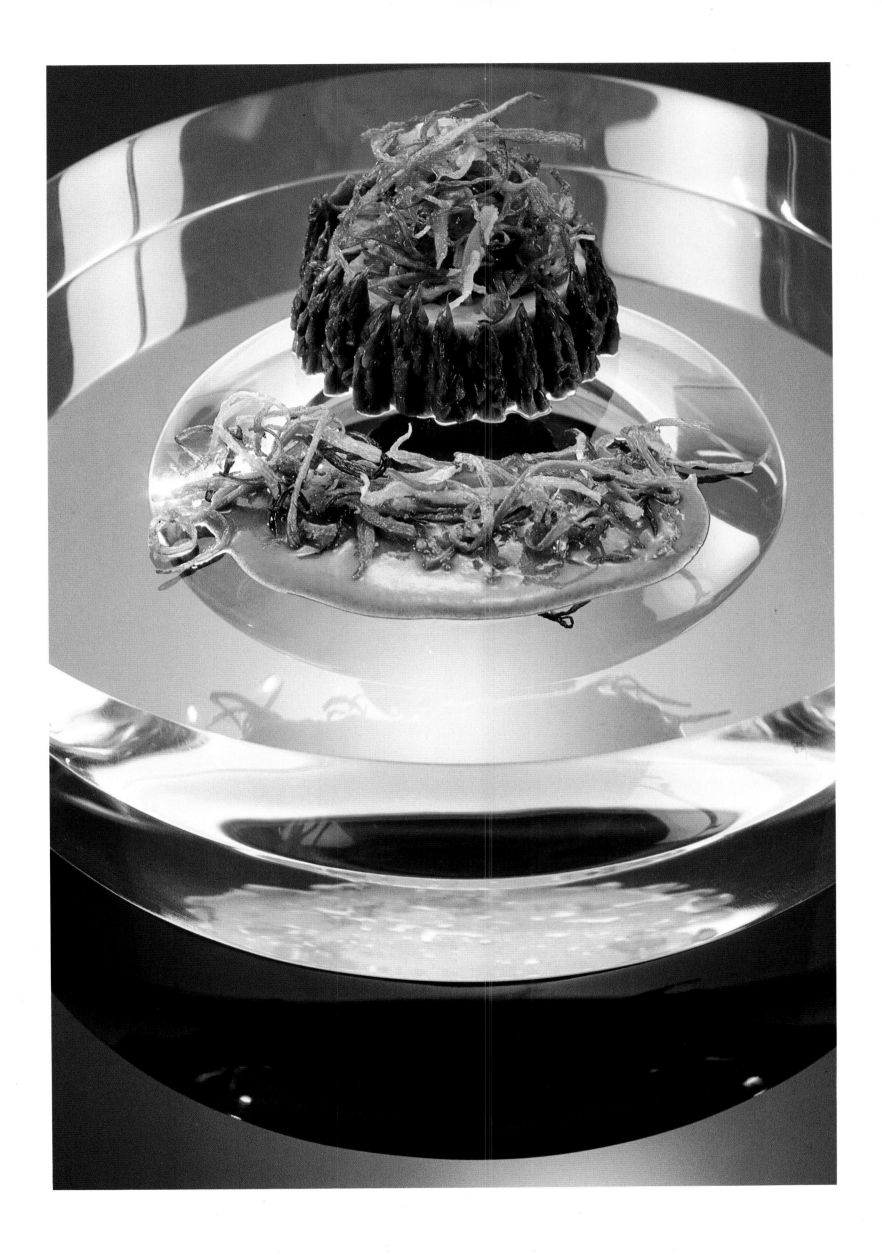

ANN AMERNICK'S TUILES

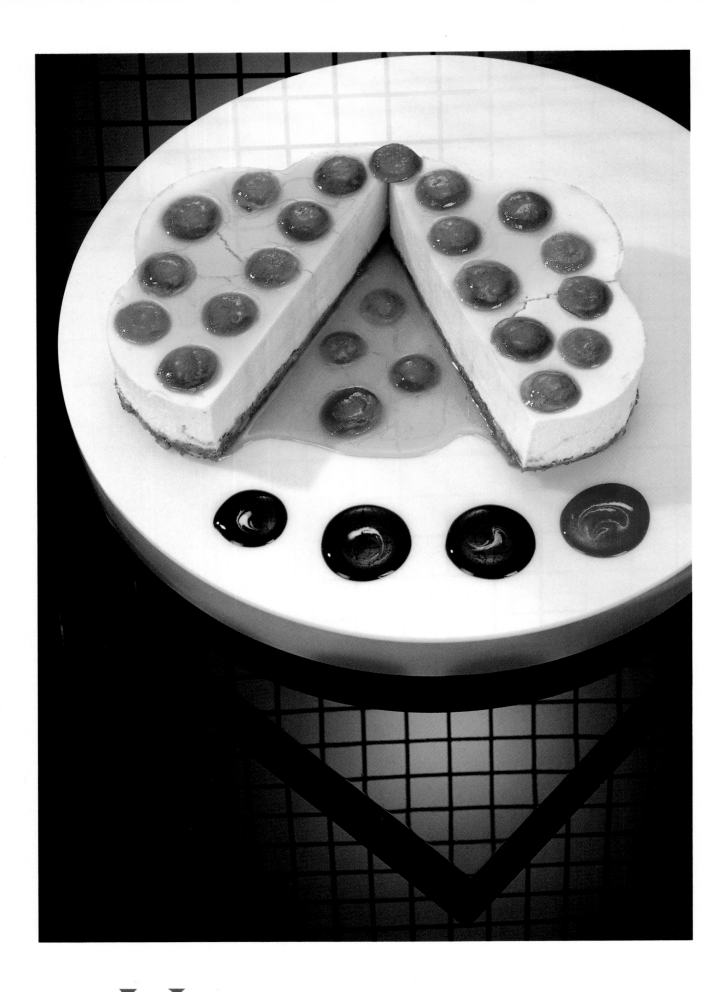

U sing mushrooms in a dessert is perhaps a bit too *nouvelle*, but in my opinion, it works. The cheesecake is not too sweet, and the confit of mushrooms has just what it needs to make the whole dish come together.

KATHY DINARDO'S CHEESECAKE
with CONFIT OF PARIS MUSHROOMS

Recipes

Cooking is a celebration of life. Being creative, trying out new combinations of food, and always striving for something better are part of the festivities. I hope using these recipes will enhance *your* celebration.

I'd like to offer some advice that will help you use my recipes. I'm very particular about produce, and I want you to be, too. Always use the freshest and best ingredients you can find. If you do this, you will be well on the way to becoming an excellent cook.

Then, at least the first time, follow each recipe exactly. They have been painstakingly written and tested so that you will be satisfied with your results. Carefully following instructions can also prevent expensive mistakes.

Some of my recipes seem complicated, but they are really just simple recipes put together. So, for example, if you don't have time to prepare the wood pigeon, flans, quenelles, and stuffed cabbage leaves that go into my Consommé of Honey Mushrooms recipe on page 173, it's okay! You can pick and choose which components to serve with it or serve the consommé as is. And don't forget that you can use components within recipes as side dishes or garnishes for recipes already in your repertoire.

If an ingredient is not available in your area, you can probably get it through the mail, often with next-day delivery. One mail-order source in particular, D'Artagnan, 1-800-DARTAGN, sells many of the products called for in my recipes—foie gras, mulard duck, hare, venison, wood pigeon, and more.

Once you have followed a recipe precisely, I hope you will be inspired to experiment with it. What I want most is for my recipes to give you new ideas and inspire you to create something of your own; ultimately I want *you* to be the boss, to make my recipes *your* recipes by using them as a guide to uncharted territory. That would make me very happy.

—Jean-Louis Palladin

CEPE MUSHROOM "PURSES" with SAUTEED CEPE CAPS and CEPE SAUCE

Makes 4 first-course servings or 18 to 20 purses

1¼ pounds flash-frozen cèpe mushrooms, thawed and well drained (juices reserved)
¼ cup extra-virgin olive oil
Fine sea salt and freshly ground black pepper
¼ pound (1 stick) unsalted butter, softened
¼ cup minced shallots
18 to 20 (3¼-inch) squares won ton dough
2 egg yolks (from large eggs), lightly beaten
Vegetable oil for deep frying

SPECIAL UTENSILS:
Chinois
Deep fryer with a basket

START THE SAUCE AND PREPARE THE PURSES:

Separate 8 small cèpe caps (2½ to 3 ounces) from their stems; cover well and reserve, refrigerated, for sautéing just before serving. Chop the remaining caps and stems and drain on paper towels, then measure out ⅓ cup for the sauce; set aside the remaining chopped cèpes (about 1½ cups) for the purse filling. (Refrigerate if prepared ahead.)

To start the sauce, place 1 tablespoon of the olive oil in a small skillet (preferably nonstick). Heat over high heat, 2 to 3 minutes. Add the ⅓ cup chopped cèpes and season with salt and pepper; sauté about 5 minutes, stirring frequently. Drain on paper towels. Let cool to room temperature, then purée with the butter in a food processor or blender until smooth. Cover cèpe butter and refrigerate until firm, at least 1 hour or overnight.

For the purse filling, place 2 tablespoons more olive oil in a large skillet (preferably nonstick); heat over high heat, 2 to 3 minutes. Add the remaining chopped cèpes and 3 tablespoons of the shallots and season with salt and pepper. Sauté until liquid has evaporated and cèpes are well browned, 5 to 6 minutes, stirring occasionally. Cool to room temperature, then taste for seasoning; set aside.

Line a cookie sheet with parchment or waxed paper. Place 4 or 5 of the won ton squares in a single layer on a work surface and use a pastry brush to brush tops evenly with some of the egg yolk; then mound about 1½ teaspoons of the cooled filling in the center of each; next, working with 1 square at a time, lift the 4 corners of the square and pinch the top folds of the dough together to seal the filling inside, forming a pouchlike purse with the pouch about 1¾ inches wide and ¾ inch tall, and the purse top about ½ inch tall. Brush some of the egg yolk around the neck of each finished purse so it stays sealed and place on the prepared cookie sheet. Repeat to form remaining purses. Refrigerate purses if frying the same day as made, or freeze if made a day ahead. (To freeze, cover cookie sheet with aluminum foil and freeze until purses are frozen hard, then transfer purses to zip-lock bags and return to freezer; do not thaw before frying.)

TO FINISH THE DISH AND SERVE:

(See photograph pages 12-13.) Heat oven to 300 degrees. To finish the sauce, combine the reserved chilled cèpe butter and 2 tablespoons of the reserved cèpe juices in a small heavy saucepan. Cook over high heat just until butter melts, whisking constantly. Strain sauce through the chinois into another saucepan, using the bottom of a sturdy ladle to force as much through as possible; it should yield about ½ cup. Set aside.

For the sautéed cèpe caps, drain the reserved 8 cèpe caps on paper towels and blot dry with more towels. Place the remaining 1 tablespoon olive oil in a small skillet (preferably nonstick); heat over high heat, 2 to 3 minutes. Add the caps and the remaining 1 tablespoon shallots and season with salt and pepper. Sauté until all liquid has evaporated and caps are well browned, about 5 minutes, stirring occasionally. Set aside.

Now fry the purses in batches as follows: Heat the vegetable oil in the deep fryer to 375 degrees if purses are frozen, or to 400 degrees if purses are not frozen. Place purses upright in the fry basket and fry until dark golden brown and hot in the centers, about 2 minutes if frozen, or 1 minute if not frozen; lift the basket part way out of the oil to keep tops from overbrowning, if needed. Maintain oil temperature at about 375 or 400 degrees. Drain on paper towels and keep warm, uncovered, in the preheated oven while frying remaining batches; heat the serving plates in the oven about 2 to 3 minutes before using. Once all purses have been fried, serve promptly.

To serve: Reheat the sautéed cèpe caps over low heat a few seconds and reheat sauce. Arrange 4 or 5 purses in a circle on each heated serving plate; spoon about 2 tablespoons sauce in the center and garnish sauce with 2 of the sautéed cèpe caps.

CREAM OF PUMPKIN SOUP with SHALLOT FLAN, BREAST OF SQUAB AND BLACK TRUFFLE QUENELLES, CONFIT OF MULARD DUCK GIZZARDS, and MIREPOIX OF PUMPKIN, SQUAB, AND PROSCIUTTO

Makes 4 servings

Confit of Mulard Duck Gizzards (recipe follows)
PUMPKIN SOUP AND PUMPKIN MIREPOIX:
 1 (about 3¾-pound) pumpkin (or enough to yield 4 cups coarsely chopped pumpkin flesh for soup and ⅓ cup cubed pumpkin flesh cut into ⅛-inch cubes for mirepoix)
 1 cup water for cooking pumpkin mirepoix
 1 tablespoon vegetable oil
 4 ounces very lean prosciutto, cut into ¼-inch cubes
 ½ cup chopped onions
 2 tablespoons very finely chopped shallots
 Freshly ground black pepper
 2½ cups Poultry Consommé (page 214) (preferred) or other Meat or Vegetable Consommé (page 214)
 1 cup peeled and coarsely chopped russet potatoes
 1½ cups heavy cream
QUENELLE MIXTURE AND SQUAB MIREPOIX:
 1 squab pigeon, dressed (about ¾ pound dressed)
 Fine sea salt and freshly ground black pepper
 ¼ cup plus 1 teaspoon heavy cream
 ⅓ ounce flash-frozen black truffles, thawed and minced (about 2 teaspoons minced)
 1 teaspoon vegetable oil
 1 (5- to 6-pound) attractive pumpkin with a stem for soup tureen
 1 recipe Shallot Flans (see recipe for Cream of Eggplant Soup, pages 180-181)
Vegetable oil for oiling outside of soup tureen
2 cups Meat or Vegetable Consommé (page 214) (preferred) or Meat or Vegetable Stock (page 214) for poaching quenelles
1½ ounces very lean prosciutto, cut into ⅛-inch cubes

SPECIAL UTENSIL:
Very fine mesh strainer

Make the Confit of Mulard Duck Gizzards at least 1 day ahead; refrigerate. Prepare the soup and remaining components of the dish on the same day as served.

MAKE THE SOUP AND PUMPKIN MIREPOIX:

Coarsely chop just enough of the 3¾-pound pumpkin to yield 4 cups chopped flesh; set aside. Cut just enough of the remaining flesh into ⅛-inch cubes to yield ⅓ cup. For the mirepoix, boil the pumpkin cubes in the 1 cup water until tender, about 6 minutes. Drain through the strainer; cover and refrigerate.

For the soup, heat the oil in a heavy 4-quart saucepan over high heat for about 1 minute. Add the prosciutto, onions, and shallots, and season with pepper; sauté 1 to 2 minutes, stirring occasionally. Add the consommé, potatoes, and the reserved 4 cups coarsely chopped pumpkin. Bring to a boil, then reduce heat and strongly simmer for 35 minutes, stirring occasionally. Purée mixture in a food processor, then add the cream and continue processing just a few seconds more until well blended; do *not* overmix, or the soup will curdle. Strain soup through the strainer, using the bottom of a sturdy ladle to force as much through as possible. Refrigerate. (The pumpkin mirepoix and soup may be prepared several hours ahead.)

PREPARE THE QUENELLE MIXTURE AND SQUAB MIREPOIX:

Carve the breast meat from the squab. (Save the carcass, if desired, for making stock.) Trim skin and fat from the breast meat and chop exactly 2 ounces of the meat; set aside. Cut remaining breast meat into ⅛-inch cubes; set aside.

To prepare the quenelle mixture, place the 2 ounces chopped squab in a food processor, season generously with salt and pepper, and process to a paste, then add the cream and continue processing just until well blended; do *not* overmix. Strain through the strainer, using the bottom of a sturdy ladle to force as much through as possible; the strained mixture should yield ⅓ cup. Stir in truffles and refrigerate.

For the squab mirepoix, season the reserved squab cubes with salt and pepper. Heat the oil in a small nonstick skillet over high heat until very hot, 4 to 5 minutes. Add the squab cubes and sauté about 45 seconds, just until very lightly browned, stirring constantly. Drain on paper towels; refrigerate. (The quenelle mixture and squab mirepoix may be prepared several hours ahead.)

MAKE THE SOUP TUREEN:

Carve the top off the 5- to 6-pound pumpkin in a neat zigzag pattern similar to the one shown on page 14, and scoop out seeds to form a soup tureen with a lid. Set aside. (This may be done several hours ahead.)

TO FINISH THE DISH AND SERVE:

(See photograph page 14.) About 1½ hours before serving time, make the Shallot Flans. Once flans are out of the oven, leave oven set at 300 degrees to heat the soup bowls. Lightly oil the outside of the pumpkin soup tureen and lid; set aside.

About 15 minutes before serving, form and cook the quenelles as follows: Bring the consommé to a simmer in a small skillet. Remove from heat. With 2 teaspoons, mold the quenelle mixture into quenelles (oval shapes), allowing a scant 1 teaspoon for each quenelle; you should have enough of the mixture for 12 to 16 quenelles. As each quenelle is formed, ease it into the hot consommé. Once all quenelles are formed,

return skillet to low heat (*do not* let consommé reach a simmer) just until cooked through, about 5 minutes; set aside in the hot consommé.

Remove the duck gizzards from the cooking fat and heat them in an empty skillet just until heated through; drain on paper towels. Unmold the flans into the center of 4 wide ovenproof soup bowls. Spread a portion of each mirepoix (pumpkin, squab, and prosciutto) in the bottom of each bowl, then arrange 3 or 4 drained quenelles (use a slotted spoon) and 6 gizzard halves around the edges. Heat the uncovered bowls in the preheated oven for about 3 minutes. Meanwhile, reheat soup and place it in the pumpkin tureen. Serve immediately, ladling the soup into the bowls at the table.

CONFIT OF MULARD DUCK GIZZARDS

⅓ cup rock salt
1 dozen mulard duck gizzards (about ¾ pound), cut in half with membranes trimmed away
¼ teaspoon whole black peppercorns
6 thyme sprigs (very leafy single stems, each 4 to 5 inches long)
1½ cups rendered duck fat or pork lard (preferred) or vegetable oil

Place the rock salt in a large bowl. Working with 1 gizzard half at a time, rub each in the salt, pressing it in to coat evenly; place in a single layer on a small cookie sheet lined with parchment or waxed paper. Once all gizzards are prepared, there should be no more than 1 to 2 tablespoons of salt left over. Sprinkle any leftover salt over the gizzards, then sprinkle ½ of the peppercorns and thyme sprigs on top and distribute remaining peppercorns and thyme sprigs underneath. Cover and refrigerate for about 3 hours.

Once gizzards have chilled 3 hours, brush away most of the salt and all peppercorns and thyme sprigs. Dry gizzards thoroughly with paper towels. In a small heavy saucepan, heat the fat to between 220 and 230 degrees over medium heat. Add the gizzards and cook until tender (when done, they will still be very firm but should not be tough), about 1½ to 2 hours, adjusting heat to keep fat just hot enough to slowly bubble (about 200 degrees). Remove from heat and let gizzards cool in the cooking fat for about 1 hour; then transfer gizzards and fat to a deep glass bowl, making sure all gizzards are completely submerged. Cover and keep refrigerated until used. Use within 2 weeks.

To serve, reheat as directed in the recipe in which they are a component. If not using all the gizzards at the same time, make sure the ones left behind in the bowl are still completely submerged in fat. *Makes 24 confit of gizzard pieces.*

SEA URCHIN "TONGUES" with SEA URCHIN FLANS and SEA URCHIN SAUCE

Makes 4 servings

Enough live sea urchins to yield ½ pound (1 cup) "tongues" (roe sacs) or ½ pound fresh or thawed sea urchin roe sacs (see Note)
¼ pound (1 stick) unsalted butter, softened
Unsalted butter for greasing flan molds
¾ cup heavy cream
¾ cup milk
2 large eggs
Fine sea salt and freshly ground black pepper
About ¾ cup cool Lobster Consommé (page

214) (preferred), Lobster Stock (page 214) or other Consommé or Stock (page 214)

About 32 small fresh cilantro leaves or other green herb leaves for garnish

Lobster Coral Garnish (page 215) (optional)

SPECIAL UTENSILS:

10 (¼-cup-capacity) Pyrex flan molds, 2¼-inch diameter at inside top, 1⅝-inch diameter at outside base, 1⅞ inches tall

Chinois

NOTE:

Live sea urchins or their roe sacs are available in some Japanese food markets from late fall through early spring.

START THE SAUCE:

If using live sea urchins, remove the roe sacs from each as follows:

Hold each urchin with a thick cloth to protect your skin, and with sharp scissors cut through the top of the shell to make a 1- to 2-inch hole; then use a spoon or your fingers to scoop out the yellowish-orange roe sacs inside each shell, being careful to keep them intact.

Reserve 3½ ounces (about 2 dozen) of the most attractive roe sacs, covered and refrigerated, for poaching. Reserve separately 2 ounces (¼ cup) more roe sacs for the flans; cover and refrigerate. To start the sauce, process the remaining 2½ ounces (a generous ¼ cup) roe sacs with the butter in a food processor until smooth; cover roe butter and refrigerate until firm, at least 1 hour. (This may be done several hours ahead.)

MAKE THE FLANS AND FINISH THE DISH:

Heat oven to 300 degrees. Generously butter the 10 flan molds. (You will need 8 flans for serving, and at least 1 more for testing doneness.) Combine the cream and milk in a small pot and bring to a boil. Remove from heat and let cool about 10 minutes.

In a blender, process the scalded cream-milk mixture with the eggs, the reserved 2 ounces (¼ cup) roe sacs, and a generous amount of salt and pepper until smooth. Strain through the chinois, using the bottom of a sturdy ladle to force as much through as possible. Pour into the prepared molds and place molds in a baking pan; add enough boiling water to the pan to come up the sides of molds 1¼ inches. Bake uncovered until done, about 1 hour 35 minutes. To check doneness, after 1 hour 25 minutes of cooking, remove a mold from the oven, loosen sides of flan with a thin flexible-bladed knife in 1 clean movement, and invert onto a plate; if done, the flan will hold its shape and when cut in half, the center will be solid, not runny. Remove cooked flans from oven and let them sit in the hot water for at least 10 minutes or up to 30 minutes; then unmold and serve promptly. Once flans are out of the oven, reduce temperature to 250 degrees and heat serving plates in it until ready to use.

Meanwhile, poach the reserved 3½ ounces roe sacs and finish the sauce.

To poach the roe sacs, combine the 3½ ounces roe sacs with 6 tablespoons of the cool consommé in a small pot; if needed, add more consommé to cover. Heat over very low heat just until roe sacs are heated through, about 8 minutes; do *not* overcook or let the consommé reach a simmer, or the roe sacs will fall apart. Set aside in the consommé to keep warm.

To finish the sauce, place the reserved chilled roe butter in a small heavy saucepan. Add 6 tablespoons of the consommé and season with salt and pepper. Cook over high heat, whisking constantly and vigorously, until butter melts and sauce is hot, about 3 minutes. Immediately remove from heat and strain through the chinois, using the bottom of a sturdy ladle to force

as much through as possible; the strained sauce should yield about 1 cup. Return to saucepan and set aside.

TO SERVE:

(See photograph page 15.) Unmold 2 of the flans onto each heated serving plate. Drain the poached roe sacs and arrange a portion on each plate; garnish each roe sac and flan with a small cilantro (or other herb) leaf. Reheat sauce over high heat a few seconds, whisking constantly, then spoon about 2 tablespoons on each plate. Sprinkle dish lightly with Lobster Coral Garnish, if using. Serve immediately.

FRICASSEE OF FRESH SNAILS, CRISPY SWEETBREAD MIREPOIX, PROSCIUTTO, AND CHANTERELLE MUSHROOMS with SHALLOT SAUCE

Makes 4 servings

2 pounds live snails
2 cups vinegar (any kind will do)
2 cups rock salt
6 cups Meat or Vegetable Consommé (page 214) (preferred), Meat or Vegetable Stock (page 214), or water
3 dozen thyme sprigs (very leafy single stems, each 4 to 5 inches long)
1 teaspoon whole black peppercorns
3 large bay leaves
SAUCE:
 2 cups water for cooking shallots
 3½ ounces shallots (3 very large shallots), peeled and quartered
 ¼ pound (1 stick) unsalted butter, softened
 2 tablespoons Meat or Vegetable Consommé (page 214) (preferred) or Meat or Vegetable Stock (page 214)
 Fine sea salt and freshly ground black pepper
8 ounces fresh chanterelle mushrooms, brushed clean and stems trimmed
¼ cup extra-virgin olive oil
Fine sea salt and freshly ground black pepper
2 recipes Crispy Sweetbread Mirepoix (recipe follows)
1 tablespoon very finely chopped shallots
1 teaspoon very finely chopped garlic
1½ ounces lean prosciutto, cut into ⅛-inch cubes (about ¼ cup)
1 tablespoon very finely sliced chives
24 parsley sprigs, snipped into small pieces for garnish
4 parsley sprigs for garnish
About 1 teaspoon Parsley Purée (page 215) for garnish (optional)

SPECIAL UTENSILS:

Very large deep bowl
Rack large enough to fit over bowl to keep snails in
Chinois

PREPARE THE SNAILS:

Place snails in the very large deep bowl; add 1 cup of the vinegar and 1 cup of the rock salt, stirring about 2 minutes until mixture is very foamy. Place the rack over the bowl and rinse snails under cool running water for 10 minutes. Let snails soak in the bowl of water for 30 minutes, keeping bowl covered with the rack. Drain and repeat entire procedure, using the remaining 1 cup each vinegar and rock salt. Once snails have soaked the final 30 minutes, drain; keep bowl covered with rack.

In a heavy 4-quart saucepan, combine the consommé, thyme sprigs, peppercorns, and bay leaves and bring to a boil. With a slotted spoon, transfer snails to the pan and return to a boil. Reduce heat and simmer until snails are tender,

about 2 hours. Let snails cool in the cooking liquid, then drain.

Remove snails from their shells with a long needle or toothpick; reserve shells. Pull off and discard any white matter from the snails and pinch off the swirly tip ends of tails. Cover snails and refrigerate. Set aside 24 of the most attractive shells, rinsed and well drained, for garnishing the plates. (This may be done up to 2 days ahead.)

START THE SAUCE:

Bring the 2 cups water to a boil in a small pot. Add the quartered shallots and boil until tender, about 15 minutes. Drain and let cool to room temperature, then process with the butter in a food processor until creamy and fairly smooth. Cover shallot butter and refrigerate until firm, at least 1 hour or overnight.

PREPARE THE CHANTERELLES:

Cut large chanterelle caps in half or into quarters. Heat 2 tablespoons of the oil in a small skillet (preferably nonstick) over high heat, 2 to 3 minutes. Add the chanterelles, season with salt and pepper, and sauté about 1 minute, stirring almost constantly. Reduce heat to medium and cook about 5 minutes more, stirring occasionally. Drain on paper towels. Set aside or refrigerate if made ahead. (This may be done a day ahead.)

FINISH THE SAUCE:

In a small heavy saucepan, combine the reserved chilled shallot butter with the consommé. Cook over high heat just until butter melts, whisking almost constantly. Remove from heat and strain through the chinois into another small heavy saucepan. Season to taste with salt and pepper; set aside. (This may be done up to 1 hour ahead.)

TO FINISH THE DISH AND SERVE:

(See photograph page 16.) Heat oven to 250 degrees. Arrange 6 snail shells in a semicircle around the edge of each ovenproof serving plate and heat uncovered in the preheated oven until ready to use. Next, cook the Crispy Sweetbread Mirepoix if not already done; set aside. Reheat sauce over low heat while finishing the fricassee.

To finish the fricassee, heat the remaining 2 tablespoons oil in a large nonstick skillet over high heat, 2 to 3 minutes. Add the reserved chanterelles and the snails, chopped shallots, and garlic. Sauté about 4 minutes, stirring occasionally. Add the Crispy Sweetbread Mirepoix, prosciutto, and chives and continue cooking about 1 minute. Serve immediately.

To serve: Remove plates from the oven and tuck a snippet of parsley under each snail shell. Into the center of each plate, spoon ¼ of the fricassee and garnish with a parsley sprig, then spoon about 2 tablespoons sauce around the edges. If desired, garnish sauce with droplets of Parsley Purée.

CRISPY SWEETBREAD MIREPOIX

2½ ounces very fresh veal sweetbreads
Cool water for soaking sweetbreads
1¼ cups Meat or Vegetable Consommé (page 214) (preferred), Meat or Vegetable Stock (page 214), or water
2 large leafy thyme sprigs
1 small bay leaf
5 whole black peppercorns
¼ cup all-purpose flour
2 tablespoons vegetable oil for sautéing

SPECIAL UTENSIL:
Fine mesh strainer

Trim any large chunks of fat from the sweetbreads. Cover sweetbreads with cool water and

soak for 10 minutes; drain. Cover with fresh water and let soak 10 minutes more; drain again. Cover a third time with fresh water and refrigerate overnight.

Drain the sweetbreads. Pull off and discard most of the membrane surrounding them, leaving just enough attached to hold sweetbreads together. Combine them in a small pot with the consommé, thyme sprigs, bay leaf, and peppercorns. Bring to a boil. Reduce heat and simmer for 4 minutes. Drain sweetbreads and let cool slightly, then cut into ⅛-inch cubes.

Place cubes in the strainer. Working over a bowl, sprinkle the flour on the cubes and toss to coat them thoroughly, shaking excess flour through the strainer; discard excess flour.

Heat the oil in a small skillet over high heat, about 2 minutes. Add the cubes and sauté until golden brown and crisp, about 3 minutes, stirring frequently and separating any cubes that are stuck together. Drain on paper towels. Use immediately or within 2 hours. (If made ahead, let cool, then cover loosely and set aside at room temperature.) *Makes ¼ cup.*

SAUTEED SANTA BARBARA SHRIMP and CREAMED LEEKS with FRESH AND SUN-DRIED TOMATO SAUCE

Makes 4 servings

1 medium vine-ripened fresh tomato (about 7 ounces), peeled and quartered
¼ pound (1 stick) unsalted butter, softened
2 ounces well-drained sun-dried tomatoes (about ½ cup)
2 large leeks (about 6 ounces each), trimmed
Salt water (2 tablespoons coarse salt mixed with 6 cups water) for cooking leeks
Ice water for cooling cooked leeks
¼ cup plus 2 tablespoons Lobster Consommé (page 214) (preferred), Lobster Stock (page 214), or other Consommé or Stock (page 214)
Fine sea salt and freshly ground black pepper
½ cup heavy cream
1 tablespoon unsalted butter
12 large unpeeled shrimp tails (Santa Barbara shrimp preferred; about 10 ounces), peeled and deveined (see Note)
2 tablespoons extra-virgin olive oil for sautéing shrimp
1 tablespoon extra-virgin olive oil for tomato garnish (optional)
8 tiny red and yellow pear-shaped tomatoes (preferred) or 8 cherry tomatoes, peeled for garnish (optional)
Fine sea salt and freshly ground black pepper for tomato garnish (optional)
4 shrimp heads, rinsed and well drained for garnish (see Note) (optional)

SPECIAL UTENSIL:
Chinois

NOTE:

If unpeeled shrimp tails are not available, use 12 large peeled and deveined shrimp (about 8 ounces). If using shrimp heads for garnish, get them from your fish market when you buy the shrimp.

START THE SAUCE AND PREPARE TOMATO JULIENNE FOR THE SHRIMP:

Place the fresh tomato quarters skinned side down; cut away the top soft portion of each, leaving about a ¼-inch-thick slice of firm tomato pulp. Julienne just enough of the tomato to yield twelve 1 x ⅛ x ⅛-inch strips; cover and reserve, refrigerated, for garnishing shrimp. Process the remaining slices in a food processor with 1 stick butter and sun-dried tomatoes until creamy and

all tomatoes are minced. Cover tomato butter and refrigerate until firm, at least 1 hour or overnight.

PREPARE THE LEEKS:

Cut a 6-inch piece from the white end of 1 of the leeks and set aside; cut the remainder of that leek and the other whole leek into ¼-inch slices.

Bring the salt water to a rolling boil in a medium-size pot over high heat. Add the reserved 6-inch piece of leek and cook for 2 minutes, then add the sliced leeks to the pot and continue cooking until slices are very tender, about 10 minutes more. Immediately drain and cool in the ice water. Drain on paper towels.

Cut just enough of the 6-inch piece of leek into ⅛-inch slices to yield 16 attractive slices; very finely chop the rest of the piece. Cover ⅛-inch slices and reserve, refrigerated, for garnishing plates. Next, squeeze dry the ¼-inch leek slices and very finely chop them; add to the other very finely chopped leeks and reserve, covered and refrigerated, for the creamed leeks. (This may be done several hours ahead.)

FINISH THE SAUCE:

In a small heavy nonreactive saucepan, combine the reserved chilled tomato butter with the consommé. Heat over high heat just until butter melts, whisking constantly. Remove from heat and strain through the chinois, using the bottom of a sturdy ladle to force as much through as possible; the strained sauce should yield about 1 cup. Return to the saucepan and season to taste with salt and pepper; set aside. (This may be done up to 1 hour ahead.)

TO FINISH THE DISH AND SERVE:

(See photograph page 17.) Heat oven to 350 degrees. For the creamed leeks, in a small skillet combine the reserved very finely chopped leeks with the cream and the 1 tablespoon butter. Cook over medium heat until most of the liquid has evaporated, about 3 minutes, stirring occasionally. Season to taste with salt and pepper; set aside.

If using, sauté the pear-shaped (or cherry) tomatoes as follows: Heat the 1 tablespoon oil in a large skillet (preferably nonstick) over high heat, 2 to 3 minutes. Add the tomatoes and cook for 1 minute, turning frequently; season with salt and pepper and drain on paper towels, then cut in half.

Now arrange a portion of the tomato quarters and 4 of the reserved ⅛-inch leek slices around the edges of each of 4 ovenproof serving plates; set aside.

Season the shrimp on both sides with salt and pepper. In a very large skillet (preferably nonstick), heat the 2 tablespoons oil over high heat, 2 to 3 minutes. Add the shrimp and sauté just until cooked through, about 2 minutes on the first side and 1½ minutes on the second side; do *not* overcook. Drain on paper towels and cover with more towels to keep warm.

Meanwhile, heat serving plates, uncovered, in the preheated oven for 2 minutes. Reheat sauce and creamed leeks over low heat, stirring occasionally.

When serving plates are heated, mound a portion of the creamed leeks in the center of each and arrange 3 shrimp on top; garnish each shrimp with a strip of the reserved julienne tomatoes. As each plate is assembled, return it uncovered to the hot oven to keep warm. Once all plates are assembled, spoon about 2 tablespoons sauce on each and, if desired, garnish with a shrimp head. Serve immediately.

CONFIT OF MULARD DUCK LEGS with POTATOES A LA SARLADAISE and BLACK TRUFFLE SAUCE with MULARD DUCK "HAM"

Makes 4 servings

Mulard Duck "Ham" (recipe follows)
CONFIT OF DUCK LEGS:
 4 leg/thigh pieces of mulard duck; each piece about ¾ pound (if cutting leg/thigh pieces from whole ducks, each duck should weigh 8½ to 9 pounds dressed)
 ½ cup rock salt
 ½ teaspoon whole black peppercorns
 12 thyme sprigs (very leafy single stems, each 4 to 5 inches long)
 5 cups rendered duck fat or pork lard (preferred) or vegetable oil
 1 pound unpeeled russet potatoes, scrubbed
 3 ounces flash-frozen black truffles, thawed
 ½ cup Meat or Vegetable Consommé (page 214) (preferred) or Meat or Vegetable Stock (page 214)
 1 cup *Fond de Veau* (page 214)
 2 tablespoons canned truffle juice
 ⅓ cup rendered duck fat or pork lard (preferred) or vegetable oil (use duck fat from the confit of duck legs, if desired)
Fine sea salt and freshly ground black pepper

SPECIAL UTENSILS:
Meat slicer or mandoline
1½-inch cookie cutter
Meat slicer or truffle slicer

Prepare the Mulard Duck "Ham" and age at least two weeks as directed; serve very thinly sliced.

COOK THE CONFIT OF DUCK LEGS:

Don't trim fat or skin from the duck leg/thigh pieces. Place the salt in a large bowl and rub each duck piece in it, pressing it in with your hands to coat all surfaces evenly; place in a single layer on a cookie sheet lined with parchment or waxed paper. Once all 4 pieces are prepared, there should be no more than 1 tablespoon of salt left over. Sprinkle any leftover salt over the duck, then sprinkle half of the peppercorns and thyme sprigs on top and distribute the remaining peppercorns and thyme sprigs underneath. Cover and refrigerate overnight.

The next day, brush away a little of the salt and all peppercorns and thyme from the duck pieces and blot thoroughly dry with paper towels. In a heavy 4-quart saucepan, heat the duck fat to between 220 and 230 degrees over medium heat. Add the duck pieces and cook until meat is very tender and draws away from the bone, about 1 hour 45 minutes; make sure the meatiest parts stay submerged throughout cooking and adjust heat to keep fat just hot enough to slowly bubble (about 220 degrees). Remove from heat and let duck cool in the cooking fat for about 1 hour. (The confit may be cooked up to 2 weeks in advance; if made ahead, once the duck pieces have cooled 1 hour, transfer duck and fat to a deep glass bowl, making sure all pieces are completely submerged; cover and keep refrigerated.)

TO FINISH THE DISH AND SERVE:

(See photograph page 18.) Heat oven to 400 degrees. Also preheat broiler if it's a separate unit from oven. Cut the unpeeled potatoes into ¹⁄₁₆-inch slices with the meat slicer or mandoline; place slices in a bowl of cool water as cut so they don't discolor. Next, cut the slices into rounds with the cookie cutter, returning them to the

water as formed. You will need about 60 potato rounds, but it's a good idea to cut several extras. Set aside, soaking in the water.

Use the meat (or truffle) slicer to cut the truffles into paper-thin slices. Count out 17 slices for the sauce; cover and set aside the remaining slices for the potato dish.

To make the sauce, combine the 17 truffle slices with the consommé in a heavy 3-quart saucepan. Bring to a simmer, then continue simmering until liquid reduces by half, about 8 minutes. Stir in the *Fond de Veau* and return to a simmer; continue simmering 10 minutes more, stirring occasionally. Purée sauce in a blender until very smooth, then transfer to a small heavy saucepan and add the truffle juice. Set aside.

Now drain or scrape off most of the fat from the duck pieces and place pieces in an ungreased 13 x 9-inch baking pan. Bake uncovered in the preheated oven just until heated through, 15 to 20 minutes. Once heated, remove from oven and set aside, loosely covered; leave oven set at 400 degrees.

Meanwhile, finish the potato dish as follows: Drain the potato rounds and dry thoroughly. Heat the ⅓ cup duck fat in a large nonstick skillet, 2 to 3 minutes, then fry the potato rounds in batches until golden brown, about 2 minutes, turning at least once. Drain on paper towels and blot tops with more towels; season with salt and pepper. Reheat oil a few seconds before cooking each remaining batch.

To serve: On each of 4 ovenproof serving plates, arrange ¼ of the potato rounds and the reserved truffle slices alternately in a large circle. Heat the plates uncovered in the 400 degree oven, with the door ajar 4 to 5 inches, just until potatoes are hot, about 3 minutes.

Meanwhile, if you have a separate broiler, broil the heated duck pieces about 4 inches from the heat source just until skin on top is crisp, 1 to 2 minutes, watching carefully; drain on paper towels. (If you don't have a separate broiler, omit this broiling procedure.)

Once potatoes are heated, arrange a duck leg/thigh piece in the center of each serving plate and spoon about 2 tablespoons sauce over it. Serve immediately.

MULARD DUCK "HAM"

2 (10- to 12-ounce) boneless *magrets de canard* (breasts of mulard duck), skin and fat layer still attached
½ cup rock salt
½ teaspoon whole black peppercorns
14 thyme sprigs (very leafy single stems, each 4 to 5 inches long)
Freshly ground black pepper

SPECIAL UTENSILS:
2 rectangles of cheesecloth, each about 1 x 2 feet and 4 layers thick
Kitchen twine

Trim away the skin but not the fat from the *magrets*. Place the salt in a large bowl and rub each *magret* in it, pressing it in with your hands to coat all surfaces evenly; place in a single layer on a cookie sheet lined with parchment or waxed paper. Once both *magrets* are prepared, there should be no more than 2 tablespoons of salt left over. Sprinkle any leftover salt over the *magrets*, then sprinkle ½ of the peppercorns and 6 thyme sprigs on top and distribute remaining peppercorns and 6 more thyme sprigs underneath. Cover and refrigerate overnight.

Wipe the *magrets* free of seasonings, then very generously season both sides with pepper; end with *magrets* fat side down. Remove the leaves from the remaining 2 thyme sprigs and sprinkle leaves over the duck.

Place 1 *magret* fat side down across the end of 1 of the cheesecloth rectangles (the length of the meat should run along 1 of the shorter sides of the rectangle); fold the *magret* in half lengthwise, making sure the fat is on the outside, then wrap in the cheesecloth as tightly as possible to form a log with a 1½- to 2-inch diameter; tie one end of the cheesecloth closed with kitchen twine, then tightly wrap the twine around the log from 1 end to the other and tie the second end closed. Repeat with the second *magret*. Hang the duck from more twine in a cool, dark, and dry place that is draft-free. Let age 2 to 3 weeks, then use immediately or refrigerate and use within a few days.

To serve, unwrap and cut into very thin slices. Wrap leftovers well and keep refrigerated. *Makes 2 duck "hams."*

PROFITEROLES with CHOCOLATE GINGER MOUSSE and CHOCOLATE SAUCE

Makes 4 servings

MOUSSE:
 1½ ounces ginger root
 Sugar water (½ cup sugar mixed with ½ cup water)
 1 cup heavy cream
 6 ounces semisweet chocolate, cut into small pieces
 2 tablespoons chocolate liqueur
 2 egg whites from large eggs, at room temperature
 ⅛ teaspoon lemon juice
 2 tablespoons sugar
SAUCE:
 1 cup heavy cream
 1½ ounces semisweet chocolate, cut into small pieces
 1 tablespoon unsalted butter, softened
 1 tablespoon chocolate liqueur
PROFITEROLE DOUGH:
 ¾ cup water
 4 tablespoons unsalted butter, cut into pieces
 ½ teaspoon sugar
 Pinch of salt
 ¾ cup all-purpose flour, sifted
 3 large eggs
 About ½ egg yolk
Sifted powdered sugar for garnish
½ cup fresh raspberries for garnish (optional)
3 ounces milk chocolate, cut into curls or shavings for garnish (optional)
Mint sprigs for garnish (optional)

SPECIAL UTENSILS:
Very fine mesh strainer
Pastry bag fitted with a ½-inch plain nozzle

START THE MOUSSE:

Peel the ginger and very finely grate just enough of it to yield 1 teaspoon; cover and refrigerate. Cut the remaining ginger into ¹⁄₁₆-inch slices, then cut these slices into ¹⁄₁₆-inch cubes. Bring the sugar water to a boil in a small heavy pot. Add the ginger cubes and simmer until tender and liquid becomes a syrup, 30 to 35 minutes, stirring occasionally. Remove from heat and drain through the strainer for at least 5 minutes; discard strained syrup. Cover and refrigerate until ready to use. (This may be done several hours ahead.)

MAKE THE SAUCE:

Bring ½ cup of the cream to a boil in a small pot; remove from heat and set aside. Whip the remaining ½ cup cream just until very soft peaks form; refrigerate.

Melt the chocolate and butter in the top of a double boiler over slowly simmering water, stirring occasionally. Add the scalded cream and

the liqueur, mixing well. Remove from heat and let cool to room temperature, then fold in the reserved whipped cream. Set aside at room temperature.

MAKE THE PROFITEROLES AND FINISH THE MOUSSE:

Heat oven to 400 degrees. To prepare the profiterole dough, combine the water, butter, sugar, and salt in a small heavy saucepan; bring to a boil over high heat. Remove from heat momentarily and add the flour, then cook over medium heat for 1 minute, stirring constantly. Immediately transfer mixture to the large bowl of an electric mixer fitted with a paddle. Beat in 1 egg at a time at low speed until all 3 eggs are mixed in; continue beating until dough is smooth and falls from a spoon in a wide ribbon, about 1 minute more.

Spoon the dough into the pastry bag and pipe onto a cookie sheet lined with parchment paper to form smooth rounds that are about 1½ inches wide and 1¼ inches tall; leave about 2 inches between rounds. Use a pastry brush to lightly brush rounds with some of the egg yolk, being careful not to "glue" them to the paper with the yolk or they won't rise properly; wipe away any yolk from the parchment paper and rinse out pastry bag for piping the mousse. Transfer cookie sheet to the preheated oven and bake until profiteroles are lightly browned and puffed, about 15 minutes; then prop open the oven door about ½ inch and continue baking until cooked through, golden brown, and hollow, 18 to 20 minutes more. Remove from oven and let cool on a wire rack for at least 10 minutes before using; use within 1 hour. (Once cooled, store in an airtight container.)

Meanwhile, finish the mousse as follows: Whip the cream until soft peaks form; refrigerate.

Melt the chocolate pieces in the top of a double boiler over slowly simmering water, stirring occasionally. Remove from heat and add the liqueur, stirring until smooth (the mixture will be quite thick at this point). Stir in the reserved grated ginger and set aside.

In the medium-size bowl of an electric mixer (make sure bowl is very clean), combine the egg whites and lemon juice; beat at low speed for about 30 seconds. Increase speed to medium and beat about 30 seconds until frothy bubbles begin to form, then add 1 tablespoon of the sugar and beat at medium for 30 seconds more. Increase speed to high, add the remaining 1 tablespoon sugar, and continue beating just until stiff peaks form, about 1 minute more.

With a rubber spatula, lightly fold ¼ of the egg white mixture into the reserved chocolate-ginger mixture just until barely blended, then gently fold in the remaining egg whites and the reserved whipped cream, then the reserved ginger cubes; do *not* overmix. Serve immediately.

TO SERVE:

(See photograph page 19.) Place the cooled profiteroles on a work surface and cut each in half horizontally; set top halves aside. Spoon the mousse into the pastry bag and pipe about 1½ tablespoons into the bottom halves; cover with the tops and dust with powdered sugar.

Spoon about ¼ cup sauce in the center of each serving plate, then arrange 3 or 4 profiteroles on top of the sauce. If desired, garnish with raspberries, chocolate curls or shavings, and mint sprigs.

APPLE AND PEAR TARTS with MINT ICE CREAM

Makes 4 servings

1 recipe Tart Dough (see page 203)
Flour for rolling out dough

Mint Ice Cream (recipe follows)
4 tablespoons unsalted butter, softened
1 cup plus 3 tablespoons sugar
2 large eggs
⅔ cup whole or sliced almonds, ground to a fine powder
2 tablespoons all-purpose flour
3 medium-size firm ripe D'Anjou or Bartlett pears, peeled
2 medium-size Granny Smith apples, peeled
Lemon water (3 tablespoons lemon juice mixed with 1½ cups water)
¼ cup Armagnac brandy
Fresh mint leaves for garnish

SPECIAL UTENSILS:
4 individual tart molds (preferably nonstick); 3½-inch diameter at top, 3-inch diameter at bottom, ¾ inch deep
4-inch cookie cutter

Prepare the Tart Dough; refrigerate or freeze until ready to roll out; if freezing the dough, thaw before rolling out.

ROLL OUT THE DOUGH:

Generously butter the tart molds if not the nonstick type; set aside. Lay out a piece of parchment or waxed paper on a work surface and lightly sprinkle with flour. Place dough in the center and flatten it slightly; lightly flour top, cover with another piece of parchment or waxed paper, and roll out to a ⅛-inch thickness; if dough sticks excessively to paper while rolling, lightly flour dough again. Peel off top piece of paper and use the cookie cutter to cut out 4 rounds of dough; discard scraps. Line the tart molds evenly with the dough rounds, pressing them gently into place. Trim the edges and prick the dough lining the mold bottoms several times with a fork. Refrigerate for at least 30 minutes or overnight. (If short on time, freeze for 15 minutes.)

On the day of serving, make the Mint Ice Cream; if needed, transfer from ice cream machine to freezer to store until ready to serve.

MAKE THE FILLING AND FINISH THE TARTS:

Heat oven to 375 degrees. For the almond paste, combine the butter with ¼ cup of the sugar and the eggs in a medium-size bowl, whisking until light and creamy, about 1 minute. Add the ground almonds and flour, mixing well. Refrigerate.

Cut 1 of the pears and 1 of the apples into 8 oval shapes each; the ovals should be 1½ to 2 inches long and about ½ inch wide at the widest part. As prepared, combine the ovals in the lemon water; reserve all scraps. Set ovals aside.

Cut the remaining pears and apple and the fruit scraps into ½-inch cubes; the combined cubes should yield about 3 cups. Place the cubes in a bowl and pour the brandy over the top; let sit for 10 minutes.

Meanwhile, heat a large skillet (preferably nonstick) over high heat for about 3 minutes. Add ¾ cup sugar and cook until a light caramel color, about 5 minutes, stirring almost constantly with a wooden spoon. Remove from heat.

Once the fruit-Armagnac mixture has sat for 10 minutes, add it to the skillet of syrup. Cook over medium heat until most of the liquid has evaporated, about 15 minutes, stirring constantly. Set aside.

Assemble the tarts and bake as follows: Place 2 tablespoons of the reserved almond paste in the bottom of each chilled tart mold, spreading it out evenly with the back of a spoon. Spoon ¼ of the filling into each mold. Place molds on a baking sheet and bake until crust is golden brown and almond paste underneath filling is cooked through, 25 to 30 minutes. Once the

tarts have finished cooking, let cool for 10 minutes.

Meanwhile, drain the pear and apple ovals and blot dry with paper towels; set aside. Heat a small skillet (preferably nonstick) over high heat for about 2 minutes. Add the remaining 3 tablespoons sugar and cook until a light caramel color, about 2 minutes, stirring constantly with a wooden spoon. Remove from heat and add the fruit ovals to the skillet, then place over medium heat and cook until fruit is tender and caramelized, about 5 minutes, stirring almost constantly; set aside.

TO SERVE:

(See photograph page 19.) Unmold the tarts and place to one side of each of 4 dessert plates; garnish top of each tart with 4 of the caramelized fruit ovals. Next, arrange a small bed of mint leaves on each plate; use 2 tablespoons to form 4 quenelles (oval shapes) of ice cream and place on top of the leaves. Serve immediately.

MINT ICE CREAM

1½ cups heavy cream
1½ cups milk
3 ounces mint sprigs (about 30 single stems, each about 6 inches long)
7 egg yolks (from large eggs)
¾ cup sugar
3 tablespoons crème de menthe liqueur

SPECIAL UTENSILS:
Chinois placed over a heatproof bowl
Ice cream machine

In a heavy nonreactive 3-quart saucepan, combine the cream, milk, and mint sprigs. Bring to a boil, then remove from heat and let sit for at least 15 minutes or up to 1 hour.

Combine the egg yolks and sugar in a large bowl, whisking vigorously until thick and pale yellow, about 2 minutes.

Return the cream mixture to a boil; remove from heat, discard mint sprigs, and gradually add to the egg yolk mixture, whisking constantly. Return mixture to the saucepan and cook over medium heat, stirring constantly and scraping pan bottom evenly with a wooden spoon, just until it thickens and leaves a distinct trail on the back of the spoon when you draw a finger through it, about 2 to 3 minutes; do *not* let mixture boil. Immediately strain through the chinois into the bowl. Stir in the liqueur, cover, and refrigerate until well chilled, at least 3 hours or overnight.

Freeze in the ice cream machine according to manufacturer's instructions until firm, about 20 to 45 minutes, depending on the type of machine used. *Makes about 1 quart.*

OYSTER AND BELUGA CAVIAR DELIGHTS

Makes 4 delights

¼ pound (1 stick) unsalted butter, softened
3 tablespoons plus ½ teaspoon pressed caviar (2 ounces)
2 tablespoons plus 2 teaspoons Beluga or other top-quality caviar (about 2 ounces)
4 shucked medium to large oysters (about 3 ounces; preferably Belon); trimmed of dark edges and drained in a colander
¾ cup all-purpose flour
2 large eggs, lightly beaten
¾ cup very fine dry breadcrumbs (preferably Brioche, pages 214-215)
Vegetable oil for deep frying

Cut out four 10-inch squares of plastic wrap; set aside. For the caviar butter, process the butter with the pressed caviar in a food processor until creamy (it should be a soft spreading consistency). For each delight, mound 2 teaspoons of the caviar butter in the center of 1 of the plastic squares, spreading it into a 2½-inch circle; cover circle with 1 teaspoon Beluga caviar, then add 1 well-drained oyster, then 1 teaspoon more Beluga caviar, then 2 teaspoons more caviar butter; spread the last addition of caviar butter with your fingertips to cover the Beluga caviar and oyster as completely as possible; next, draw up sides and corners of the plastic wrap and wrap up ingredients snugly to form a 1¾- to 2-inch ball, twisting edges of plastic so they coil very tightly, securely sealing the delight inside. Freeze overnight. (The caviar butter left over is wonderful eaten on toast.)

The next day bread the frozen delights. First cut out 4 more 10-inch squares of plastic wrap; set aside. Place the flour, eggs, and breadcrumbs in 3 separate medium-size bowls. Working with 1 frozen delight at a time (leaving the others in freezer), carefully unwrap it, then dredge in the flour, shaking off excess; coat well with egg, then roll in the breadcrumbs, gently pressing them in; now repeat the process of dredging the delight in flour, coating with egg, and then rolling in breadcrumbs, again pressing crumbs in; wrap in a square of plastic wrap and seal as directed before; return to freezer. Repeat with remaining 3 delights. Freeze overnight or up to 2 weeks; keep frozen until just before frying.

TO FRY AND SERVE:

(See photograph page 22.) Heat oven to 400 degrees. Heat the oil in a deep fryer or deep pan to 400 degrees. Fry 1 or 2 delights at a time. Just before frying each, unwrap it and carefully ease into the hot oil with a slotted spoon; fry without turning until golden brown, about 1 minute, maintaining oil at about 400 degrees. Transfer with the slotted spoon to drain on paper towels. When all delights are fried, promptly place on an ungreased cookie sheet and bake uncovered until done, about 7 minutes. (Heat serving plates in the oven for the last 2 to 3 minutes.) To test doneness, remove a delight from the oven and gently shake it; if done, you will feel the oyster inside bump against the crust's inner wall as you shake. Remove from oven, drain a second on paper towels, then serve immediately on the heated serving plates.

CREAM OF CHESTNUT AND FOIE GRAS SOUP with BREAST OF SQUAB AND CHESTNUT QUENELLES and MIREPOIX OF SQUAB AND MULARD DUCK LEG CONFIT

Makes 4 servings

CREAM OF CHESTNUT AND FOIE GRAS SOUP:
2 quarts water for blanching chestnuts
1¼ pounds unpeeled chestnuts (scant 4 cups)
Ice water for cooling blanched chestnuts
5 ounces fresh uncooked duck or goose foie gras (Grade C)
3 ounces lean prosciutto, chopped
¼ cup thinly sliced shallots
Freshly ground black pepper
3 cups Poultry Consommé (page 214) (preferred) or other Meat or Vegetable Consommé (page 214)
1½ cups heavy cream
Fine sea salt, if needed
QUENELLE MIXTURE AND SQUAB MIREPOIX:
1 squab pigeon, dressed (about ¾ pound dressed)
Fine sea salt and freshly ground black pepper
¼ cup plus 1 teaspoon heavy cream
3 peeled chestnuts (reserved from preparing chestnuts for soup)
1 teaspoon vegetable oil
2 cups Meat or Vegetable Consommé (page 214) (preferred) or Meat or Vegetable Stock (page 214)
1 ounce skinless and boneless Confit of Mulard Duck Legs (page 164) (preferred) or other cooked duck meat, cut into ⅛-inch cubes (¼ cup)

SPECIAL UTENSILS:
Fine mesh strainer
Very fine mesh strainer
1-quart capacity soup tureen

MAKE THE SOUP:

Bring the water to a rolling boil in a large pot. Add the chestnuts and blanch for 5 minutes. Immediately drain and cool in the ice water; drain again. Slice off the bottom of each shell with a sharp knife, then peel off remaining shell. Very finely chop 3 of these chestnuts for the quenelles; set aside. Set aside 10 more chestnuts for the roasted chestnut garnish. Reserve remaining chestnuts for the soup.

With a sharp thin-bladed knife, trim away any green spots on the foie gras caused by contact with the gall bladder, then coarsely chop the foie gras; set aside. Heat a heavy 3-quart saucepan over high heat for about 2 minutes. Add the foie gras and cook about 1 minute, stirring occasionally. Add the chestnuts reserved for the soup and the prosciutto and shallots; season generously with pepper and cook and stir for 1 minute. Add the consommé and bring to a boil. Reduce heat and simmer for 30 minutes, stirring and skimming occasionally. Purée mixture in a food processor, then strain through the fine mesh strainer, using the bottom of a sturdy ladle to force as much through as possible; it should yield a generous 2 cups.

Return strained purée to a heavy 2-quart saucepan. Stir in the cream and taste for seasoning. Bring to a boil, stirring occasionally. Remove soup from heat, cool slightly, and refrigerate. (This may be prepared several hours ahead.)

PREPARE THE QUENELLE MIXTURE AND SQUAB MIREPOIX:

Carve the breast meat from the squab. (Save the carcass, if desired, for making stock.) Trim away skin and any fat from breast meat and chop exactly 2 ounces of the meat; set aside. Cut the remaining breast meat into ⅛-inch cubes; set aside.

To prepare the quenelle mixture, place the 2 ounces chopped squab in a food processor, season generously with salt and pepper, and process to a paste, then add the cream and continue processing just until well blended; do *not* overmix. Strain through the very fine mesh strainer, using the bottom of a sturdy ladle to force as much through as possible; the strained mixture should yield ⅓ cup. Stir in the reserved very finely chopped chestnuts and refrigerate.

For the squab mirepoix, season the reserved squab cubes with salt and pepper. Heat the oil in a small nonstick skillet over high heat, 4 to 5 minutes. Add the squab cubes and sauté about 45 seconds, just until very lightly browned, stirring constantly. Drain on paper towels; refrigerate. (The quenelle mixture and squab mirepoix may be prepared several hours ahead.)

TO FINISH THE DISH AND SERVE:

(See photograph page 23.) Heat the soup tureen and 4 wide soup bowls in a 250 degree oven. About 15 minutes before serving, roast the 10 chestnuts reserved for garnish as follows: Cut chestnuts in half and place in a small nonstick skillet; cook over high heat until well browned, 6 to 8 minutes, turning occasionally. Transfer to a heatproof dish; set aside.

Meanwhile, form and cook the quenelles. To do this, bring the consommé to a simmer in a small skillet. Remove from heat. With 2 teaspoons, mold the quenelle mixture into quenelles (oval shapes), allowing a scant 1 teaspoon of the mixture for each; you should have enough of the mixture for 12 to 14 quenelles. As formed, ease the quenelle into the hot consommé. Once all quenelles are formed, return skillet to low heat and heat (do not let consommé reach a simmer) just until cooked through, about 5 minutes; set aside in the hot consommé.

Reheat soup; if needed, thin with cream or some of the consommé used for poaching the quenelles. Serve immediately.

To serve: Spread a portion of the mirepoix of squab and the duck meat cubes (mirepoix) in the bottom of each heated soup bowl, then arrange 3 or 4 drained quenelles (use a slotted spoon) and ¼ of the roasted chestnuts around the edges. Place the soup in the heated soup tureen for ladling into the bowls at the table.

JUMBO LUMP CRAB CAKES with FRESH PIG'S EARS MUSHROOMS and FRESH AND SUN-DRIED TOMATO SAUCE

Makes 4 servings

2 medium-size vine-ripened tomatoes (about 14 ounces), peeled and quartered
¼ pound (1 stick) unsalted butter, softened
2 ounces well-drained sun-dried tomatoes (about ½ cup)
CRAB CAKES:
½ cup Lobster Mousseline (page 215)
½ pound jumbo lump crabmeat (preferred) or lump crabmeat, picked over (about 1¾ cups)
About ⅓ heaping cup tomato cubes (reserved from preparing fresh tomatoes for this recipe)
1 tablespoon very finely sliced chives
½ teaspoon Lobster Coral Garnish (page 215) (optional)
Fine sea salt and freshly ground black pepper
1 tablespoon extra-virgin olive oil for greasing baking pan
¼ cup plus 2 tablespoons Lobster Consommé (page 214) (preferred), Lobster Stock (page 214), or other Consommé or Stock (page 214)
Fine sea salt and freshly ground black pepper
3 tablespoons extra-virgin olive oil for sautéing mushrooms
8 ounces fresh pig's ears mushrooms (or small fresh shiitake mushrooms), washed quickly, drained, and thinly sliced
2 tablespoons very finely sliced chives for garnish

SPECIAL UTENSIL:
Chinois

Place the fresh tomato quarters skinned side down on a work surface; cut away the top soft portion of each, leaving about a ¼-inch-thick slice of firm tomato pulp. Cut 3 of the slices into ¼-inch cubes and reserve for the crab cakes.

For the tomato petal garnish, cut 2 more of the tomato slices in half horizontally with a sharp thin-bladed knife; then cut each of these 4 slices into 2 petal shapes to yield 8 petals; cut the trimmings from the petals into ¼-inch cubes and add to the reserved tomato cubes for the crab cakes. Cover petals and cubes separately; refrigerate.

To start the sauce, place the remaining 3 tomato slices in a food processor; add the butter and the sun-dried tomatoes and process until creamy and all tomatoes are minced. Cover this tomato butter and refrigerate until firm, at least 1 hour or overnight.

On the same day the crab cakes are to be served, make the Lobster Mousseline; refrigerate at least 1 hour before using.

FINISH THE DISH:

Heat oven to 400 degrees. For the crab cakes, place the Lobster Mousseline in a medium-size bowl; add the crabmeat, reserved tomato cubes, chives, and, if using, the Lobster Coral Garnish, mixing gently to keep lumps of crabmeat intact. Season to taste with salt and pepper.

Grease a large baking pan (about 11½ x 9-inch) with the 1 tablespoon oil. Divide the crab cake mixture into 4 equal portions and form each portion into a loosely packed ball. Place in the baking pan and bake uncovered just until heated through, 15 to 20 minutes. Heat the serving plates in the oven for the last 2 to 3 minutes.

Meanwhile, finish the sauce and sauté the mushrooms. Once the crab cakes are out of the oven, serve immediately.

To finish the sauce: In a small heavy non-reactive saucepan, combine the reserved chilled tomato butter with the consommé. Heat over high heat just until butter melts, whisking constantly. Remove from heat and strain through the chinois, using the bottom of a sturdy ladle to force as much through as possible; the strained sauce should yield about 1 cup. Return to the saucepan and season to taste with salt and pepper; set aside.

To sauté the mushrooms: In a very large skillet (preferably nonstick), heat the 3 tablespoons oil over high heat, about 3 minutes. Add the mushrooms, season with salt and pepper, and sauté about 1 minute, stirring almost constantly. Reduce heat to medium and continue cooking until tender, about 5 minutes more, stirring frequently; set aside.

TO SERVE:

(See photograph page 24.) Place a heated crab cake on each heated serving plate and arrange 2 tomato petals around the edges; garnish the petals with chives. Reheat sauce if needed and spoon about 2 tablespoons around the edges of each crab cake; garnish sauce with a portion of the mushrooms.

FOIE GRAS AND SWEETBREADS WRAPPED IN CABBAGE LEAVES with SAUTEED CABBAGE and FOIE GRAS SAUCE

Makes 4 servings

1½ to 1¾ pounds very fresh veal sweetbreads; each piece should be at least 2¾-inches wide and long so it can be cut into 1 or more rounds with a 2¾-inch cookie cutter
Cool water for soaking sweetbreads
1 recipe Mirepoix of Prosciutto and Onions (recipe follows)
FOR POACHING SWEETBREADS:
8 cups Meat or Vegetable Consommé (pages 214) (preferred) or Meat or Vegetable Stock (page 214)
10 very full and leafy thyme sprigs
3 medium-size bay leaves
1 teaspoon whole black peppercorns
½ teaspoon fine sea salt
1 medium-size head Savoy cabbage (about 2½ pounds)
Salt water (¼ cup coarse salt mixed with 3 quarts water) for blanching cabbage
Ice water for cooling blanched cabbage
1 whole fresh uncooked duck or goose foie gras (Grade A, about 18 ounces)
Fine sea salt and freshly ground black pepper
½ cup thinly sliced shallots
Foie Gras Sauce (recipe follows)

SPECIAL UTENSILS:
Fine mesh strainer
2¾-inch cookie cutter
Steamer

PREPARE THE SWEETBREADS FOR COOKING:

Trim any large chunks of fat from the sweetbreads. Cover sweetbreads with cool water and soak for 10 minutes; drain. Cover with fresh water and let soak 10 minutes more; drain again. Cover a third time with fresh water and refrigerate overnight.

Make the Mirepoix of Prosciutto and Onions; refrigerate. (This may be done a day ahead.)

POACH THE SWEETBREADS AND FORM SWEETBREAD ROUNDS:

Early on the day of serving, poach the sweetbreads and form them into rounds precisely as directed in the Sautéed Sweetbreads Wrapped in Fava Beans recipe on page 190, except form the poached sweetbreads into eight 2¾-inch rounds that are between ¼ and ⅓ inch thick; if needed, cut thick rounds in half horizontally to make 8 rounds. Cover and refrigerate until ready to use. Reserve the strained poaching liquid, refrigerated, for the sauce.

BLANCH THE CABBAGE:

Remove from the cabbage head 12 of the largest, darkest green, and most perfect cabbage leaves; set aside. Very finely shred enough of the remaining cabbage to yield 6 cups, making strips no wider than ⅛-inch (a meat slicer works well for this). Set aside.

Bring the salt water to a rolling boil in a large pot. Add the cabbage leaves and blanch until tender enough to fold, about 2 minutes. Immediately transfer with a slotted spoon to the ice water, being careful not to rip them; reserve salt water. Drain leaves (reserve ice water) and blot dry with paper towels. Shave or trim the thick stem end of each leaf so it will fold easily; set aside.

Return salt water to a boil. Add the shredded cabbage and blanch until tender but still crisp,

about 2 minutes. Drain and cool in the ice water, then drain on paper towels. Measure out 1⅓ cups of the shredded cabbage for the sauce, and reserve the remainder (about 2½ cups) for the sautéed cabbage dish; refrigerate separately. (This may be done several hours ahead.)

BRAISE THE FOIE GRAS AND ASSEMBLE THE CABBAGE LEAVES STUFFED WITH FOIE GRAS AND SWEETBREADS:

Heat oven to 400 degrees. With a sharp thin-bladed knife, carefully trim away any green spots on the foie gras caused by contact with the gall bladder. Cutting crosswise, neatly remove just enough meat from the tip end of the foie gras's smaller lobe to yield ½ cup coarsely chopped meat; set aside this chopped foie gras, covered and refrigerated, for the sauce.

Generously salt and pepper all surfaces of the remaining foie gras. Heat a heavy ovenproof 2-quart sauté pan or small heavy roasting pan over high heat until very hot, 4 to 5 minutes. Brown the foie gras well on all sides in the hot pan, 1 to 2 minutes. Add the shallots around the edges of the foie gras and transfer pan, uncovered, to the preheated oven. Bake for 5 minutes, then turn foie gras over with 2 sturdy spatulas, being very careful to keep it intact. Continue baking until done, about 8 minutes more; do *not* overcook, or the foie gras will dry out and loose its unique buttery texture. (To test doneness, pierce foie gras with a thin wood or metal skewer to the center of the thickest part and withdraw skewer; then press very gently around skewer hole, and, if after a few seconds the juices from the hole run slightly pink, not clear and not bloody, it's done.) Remove foie gras from oven and drain on paper towels; blot well with more towels. Set aside foie gras fat from the pan for the sautéed cabbage dish (refrigerate if foie gras was cooked well ahead).

Cut the foie gras crosswise into ¼-inch-thick slices; set aside, covered with a dishtowel to keep from drying out. Generously season each reserved sweetbread round on both sides with salt and pepper. To assemble each cabbage leaf stuffed with foie gras and sweetbreads, spread 1 of the reserved cabbage leaves smoother side down on a work surface and arrange a sweetbread round in the center, then completely cover the round with a single layer of foie gras slices (trim slices to be about the same size as the sweetbread round, reserving all trimmings; be sure to keep remaining foie gras covered); next, season top of foie gras with salt and pepper and cover with another sweetbread round, then wrap the sweetbreads and foie gras completely with the cabbage leaf, forming a cabbage roll; if the leaf is ripped or isn't large enough, wrap with a second leaf (and a third, if necessary). Repeat with the remaining sweetbread rounds and as many foie gras slices and cabbage leaves as needed to form 3 more stuffed cabbage leaves.

Place 1 stuffed cabbage leaf seam side up in the center of a large (about 14-inch) square of plastic wrap, bring all edges of the wrap up together, and twist wrap tightly to snugly bundle the stuffed cabbage leaf inside, forcing out as much air as possible as you wrap. Continue twisting edges of plastic until tightly coiled so it won't unwrap when the stuffed cabbage leaf is steamed. Next, prick 4 or 5 tiny holes through the plastic surrounding the stuffed cabbage leaf with a pin; if the holes enlarge, wrap with more plastic without removing the first piece and prick new holes. Repeat with the remaining 3 stuffed cabbage leaves. Set aside or refrigerate if prepared ahead.

Cut the leftover foie gras slices and trimmings into ¼-inch cubes. Measure out ½ cup of the cubes for adding to the sauce just before serving, and reserve the remaining cubes for the sautéed cabbage dish; cover and set aside (refrigerate if prepared ahead). If any cabbage leaves were left over, finely julienne enough of them to yield ¼ cup for garnishing the serving plates; refrigerate if prepared ahead. (This may be done several hours in advance.)

TO FINISH THE DISH AND SERVE:

(See photograph page 25.) Heat oven to 400 degrees. First, make the Foie Gras Sauce; set aside (reserve some of the leftover poaching liquid for thinning sauce just before serving). Next, steam the plastic-wrapped cabbage leaves stuffed with foie gras and sweetbreads in the covered steamer over boiling water just until heated through, about 7 minutes. Once heated, remove from steamer and set aside, still wrapped in plastic.

Meanwhile, prepare the sautéed cabbage dish as follows: Place 2 tablespoons of the reserved foie gras fat into a large nonstick skillet (set aside remaining fat at room temperature). Heat over high heat for 1 minute. Add the reserved 2½ cups shredded cabbage and the Mirepoix of Prosciutto and Onions and sauté for 1 minute, stirring occasionally. Season to taste with pepper and gently stir in the reserved foie gras cubes; remove from heat.

Unwrap each stuffed cabbage leaf and cut it in half vertically; arrange 2 halves on each of 4 ovenproof serving plates. Place ¼ of the sautéed cabbage to one side of each plate, then transfer plates, uncovered, to the preheated oven and heat just until all food is heated through, about 2 minutes. Once finished heating, remove plates from oven and promptly brush stuffed cabbage leaves lightly with some of the reserved foie gras fat.

Meanwhile, reheat sauce over high heat, whisking constantly; do *not* let sauce boil, or it will curdle. (If needed, thin with some of the reserved sweetbreads poaching liquid.) Remove from heat and stir in the reserved ½ cup foie gras cubes. Spoon about 3 tablespoons sauce on each heated serving plate and, if using, garnish sauce with a portion of the reserved ¼ cup julienne cabbage. Serve immediately.

MIREPOIX OF PROSCIUTTO AND ONIONS

1 tablespoon unsalted butter
3 ounces very lean prosciutto, cut into ⅛-inch cubes
¼ cup cubed onions (⅛-inch cubes)
Freshly ground black pepper
½ cup Meat or Vegetable Consommé (page 214) (preferred) or Meat or Vegetable Stock (page 214)

Melt the butter in a small nonstick skillet over medium heat. Add the prosciutto and onions and season generously with pepper. Sauté for 1 minute, stirring frequently. Add the consommé, reduce heat, and slowly simmer until most of the liquid evaporates, about 20 minutes. Use immediately or cover and refrigerate until ready to use. This may be made a day ahead. *Makes a scant ½ cup.*

FOIE GRAS SAUCE

2 tablespoons Parsley Purée (page 215)
1⅓ cups shredded and blanched cabbage
½ cup reserved sweetbreads poaching liquid
½ cup coarsely chopped foie gras
2 tablespoons unsalted butter, softened
Fine sea salt and freshly ground black pepper

SPECIAL UTENSIL:
Fine mesh strainer

Make the Parsley Purée; refrigerate if made ahead. In a blender, purée together the shredded cabbage and sweetbreads poaching liquid; add the foie gras, butter, the 2 tablespoons Parsley Purée, and a small amount of salt and pepper and continue processing until smooth. Transfer to a small heavy saucepan and cook over high heat 1 to 2 minutes, whisking constantly. Remove from heat and taste for seasoning.

Strain sauce through the strainer, using the bottom of a sturdy ladle to force as much through as possible. Return sauce to the saucepan and set aside (do not refrigerate). *Makes 1 to 1¼ cups.*

SAUTEED SALMON AND CILANTRO IN CAUL with CELERY ROOT AND LOBSTER CREAM SAUCE

Makes 4 servings

SAUCE:
½ cup Lobster Cream Base Sauce (page 215) (preferred) or heavy cream
Salt water (1 tablespoon coarse salt mixed with 3 cups water)
2 tablespoons lemon juice
1 cup peeled and coarsely chopped celery root (celeriac) (from about one 9-ounce bulb; see Note)
Fine sea salt and freshly ground black pepper
About ½ cup Lobster Consommé (page 214) (preferred), Lobster Stock (page 214), or other Consommé or Stock (page 214)
SAUTEED SALMON:
4 (1-foot) squares pork caul fat (about 1½ pounds; see Note)
4 (6-ounce) fillets of salmon, cut about 1 inch thick
Fine sea salt and freshly ground black pepper
About 80 small fresh cilantro leaves
2 tablespoons extra-virgin olive oil
CELERY ROOT AND CILANTRO GARNISH:
1 small bulb celery root (celeriac; about 9 ounces)
Lemon water (2 tablespoons lemon juice mixed with 2 cups water)
40 fresh cilantro leaves
1 tablespoon plus 2 teaspoons extra-virgin olive oil
Fine sea salt and freshly ground black pepper
A few drops of Red Bell Pepper Sauce and Yellow Bell Pepper Sauce (see recipe for Vegetable Terrine *Provençale*, pages 210-211) for garnish (optional)
Lobster Coral Garnish (page 215) (optional)

SPECIAL UTENSILS:
Chinois
1¼-inch cookie cutter

NOTE:
Caul fat is available from butcher shops. Ask for pieces with few if any holes and ones without extra large veins of fat running through them; refrigerate, soaking in water, until used. Store chopped celery root in acidulated water if prepared ahead.

Make the Lobster Cream Base Sauce; refrigerate.

PREPARE THE SALMON:

Rinse the caul fat well and squeeze dry; trim any very large veins of fat from the edges of the squares. Generously season both sides of the salmon with salt and pepper. Arrange about 10 small cilantro leaves on top of each fillet and invert onto a square of caul so leaves are now underneath fillet. Arrange 10 more cilantro leaves on top of each fillet and wrap securely in the caul, trimming or stretching caul if needed to cover salmon without much overlap. Refrigerate. (The salmon may be prepared to this point several hours ahead.)

MAKE THE SAUCE:

Bring the Lobster Cream Base Sauce (or heavy cream) to a boil in a small pot; remove from heat and set aside. Combine the salt water and lemon juice in a medium-size nonreactive pot and bring to a boil. Add the chopped celery root and simmer until tender, about 30 minutes. Drain and purée in a blender or food processor, adding salt and pepper to taste; add the scalded Lobster Cream Base Sauce and ¼ cup plus 3 tablespoons of the consommé and continue processing until well blended. If needed, thin with more consommé to achieve a sauce consistency. Strain through the chinois, using the bottom of a sturdy ladle to force as much through as possible; the strained sauce should yield a generous ¾ cup. Taste for seasoning. If using almost immediately, transfer to a small heavy nonreactive saucepan and set aside. If made ahead, cover and refrigerate. (The sauce may be made several hours ahead.)

PREPARE THE CELERY ROOT AND CILANTRO GARNISH:

Trim away any stalk from the celery root bulb. Cut bulb into ⅛-inch slices. Cut out 12 of the slices with the cookie cutter to form 12 rounds; place rounds in the lemon water. Julienne the remaining slices into ⅛-inch or thinner strips and add to the lemon water. Set aside 12 of the most attractive cilantro leaves for garnishing the 12 celery root rounds. Very finely julienne the remaining 28 cilantro leaves; cover to prevent browning (you will sauté these momentarily, but they brown very quickly once cut). Now drain the julienne celery root and celery root rounds separately on paper towels.

Heat 1 tablespoon of the oil in a large nonstick skillet over high heat, 2 to 3 minutes. Add the julienne celery root and sauté for 1 minute, stirring constantly. Reduce heat to medium, season to taste with salt and pepper, and cook until tender but still slightly crunchy, 2 to 3 minutes, stirring frequently. Add the julienne cilantro leaves and continue cooking and stirring just a few seconds more. Remove from heat and drain on paper towels.

In the same skillet, heat the remaining 2 teaspoons oil over high heat, 2 to 3 minutes. Add the celery root rounds, reduce heat to medium, and sauté until tender but still quite firm, 2 to 3 minutes, turning occasionally. Season lightly with salt and pepper, then remove from heat. Drain on paper towels. Set aside.

SAUTE THE SALMON:

Heat the serving plates in a 250 degree oven. Before proceeding, keep in mind that the salmon should be served rare and that it will cook a bit further through residual heat even after removed from the pan. Therefore, if your fillets are not about 1 inch thick, use your best judgment to adjust the cooking time up or down.

Heat a very large nonstick skillet over high heat, about 1 minute. Add the 2 tablespoons oil and heat until oil is hot, about 1 minute more. Add the caul-wrapped fillets, seam side down, and cook for 3 minutes, then turn and cook just until heated through but still rare, 2 to 3 minutes more; do *not* overcook. Remove from heat and drain on paper towels. Serve immediately, still wrapped in caul.

TO SERVE:

(See photograph page 25.) Reheat sauce over medium heat, whisking occasionally. Meanwhile, mound ¼ of the julienne celery root mixture to one side of each heated serving plate

and arrange 3 celery root rounds along the opposite side; garnish each round with 1 of the reserved cilantro leaves; then place a salmon fillet, most attractive side up, in the center and spoon about 2 tablespoons sauce around the edges. If desired, garnish sauce with droplets of Red Bell Pepper Sauce and Yellow Bell Pepper Sauce and sprinkle dish lightly with Lobster Coral Garnish.

NOISETTE OF ROASTED STUFFED VENISON LOIN WRAPPED IN VENISON MOUSSELINE AND CEPE MUSHROOMS with JUNIPER SAUCE

Makes 4 to 6 servings

1½ pounds flash-frozen cèpe mushrooms, thawed (juices reserved for juniper sauce, if desired)
1 cup mixture thawed cèpe juices and Meat or Vegetable Consommé (page 214) (preferred), or 1 cup Meat or Vegetable Consommé or Meat or Vegetable Stock (page 214)
¼ cup unpeeled chopped carrots
2 tablespoons chopped celery
2 tablespoons chopped leeks (mostly white part)
2 tablespoons chopped onions
2 tablespoons unpeeled chopped turnips
2 tablespoons fresh or dried juniper berries
1 tablespoon chopped shallots
1 cup *Fond de Veau* (page 214)
1 (18-ounce) trimmed loin of sika or axis venison
Fine sea salt and freshly ground black pepper
1 cup heavy cream
1 tablespoon very finely sliced chives
6 tablespoons vegetable oil
2 (14-inch) squares pork caul fat (about ¾ pound; see Note)
Thyme sprigs for garnish (optional)

SPECIAL UTENSILS:
Chinois
Very fine mesh strainer
Pastry bag without a nozzle
Steamer

NOTE:
Caul fat is available from butcher shops. Ask for pieces with few if any holes and ones without extra large veins of fat running through them; refrigerate, soaking in water, until used.

MAKE THE SAUCE:
If using the thawed cèpe juices in the sauce, drain cèpes well and add enough consommé to the juices to yield 1 cup; set aside. Refrigerate cèpes. In a small bowl, combine the carrots, celery, leeks, onions, turnips, juniper berries, and shallots. Heat a heavy 3-quart saucepan over high heat for about 1 minute, then add the vegetable mixture. Reduce heat to medium and cook for 3 minutes, stirring occasionally. Add the 1 cup mixture of thawed cèpe juices and consommé and cook until liquid reduces to ½ cup, 15 to 20 minutes. Add the *Fond de Veau* and continue cooking until liquid is a thin sauce consistency, 10 to 15 minutes more, stirring occasionally. Strain sauce through the chinois, using the bottom of a sturdy ladle to force as much through as possible; it should yield ⅔ to 1 cup. Refrigerate. (This may be done a day ahead.)

PREPARE THE MOUSSELINE:
Cutting the venison crosswise, remove an 11-ounce portion (about a 9½-inch-long slice) from the thicker end of the loin; this 11-ounce portion is the roast to be stuffed, and the remaining venison is for the mousseline. Cover the 11-

ounce roast and refrigerate. Purée the remaining venison in a food processor with a generous amount of salt and pepper until smooth, then add the cream and continue processing just until well blended; do *not* overbeat, or mousseline will curdle.

Form and cook a test quenelle (oval shape) to taste the mousseline for seasoning. To do this, mold a scant 1 teaspoon of the mousseline into a quenelle; poach uncovered in a small pan of hot (not simmering) water for about 2 minutes. Remove from heat and transfer quenelle with a slotted spoon to a dish. Let cool briefly, then taste for seasoning, and if needed, adjust seasoning of remaining mousseline. Strain mousseline through the strainer, using the bottom of a sturdy ladle to force as much through as possible; it should yield about 1¼ cups. Stir in the chives; cover and refrigerate. (This may be done 1 day ahead.)

TO FINISH THE DISH AND SERVE:
(See photograph page 26.) Heat oven to 450 degrees. With a long thin-bladed knife, make a 1-inch-wide lengthwise slit through the center of the roast to form a pocket. Season roast generously with salt and pepper; set aside.

Separate the cèpe caps and stems. Measure out 2 cups of the caps for wrapping the venison; if needed, use some of the stems (cut into ¼-inch slices) to make 2 cups. Chop any remaining caps and the stems for stuffing the roast; drain the 2 cups cèpe caps and the remaining chopped cèpes separately on paper towels; pat thoroughly dry with more towels.

Heat 1 tablespoon of the oil in a small nonstick skillet over high heat for about 1 minute. Add the 2 cups cèpe caps and season with salt and pepper; sauté until well browned, 4 to 5 minutes, stirring occasionally. Transfer to a bowl and set aside. Add 1 tablespoon more oil to the hot skillet and heat a few seconds over high heat. Add the chopped cèpes and season with salt and pepper; sauté until well browned, 4 to 5 minutes, stirring occasionally. Transfer to a separate bowl from the cèpe caps; set aside.

In a large nonstick skillet, heat 2 tablespoons of the oil over high heat, 2 to 3 minutes. Add the roast and brown the underside about 45 seconds, then turn and brown the other side for 45 seconds more. Remove from heat and drain on paper towels. Place the reserved chopped cèpes in the pastry bag and pipe into the pocket of the roast, using them all (you may need to stuff the last few in by hand); set aside.

Rinse the caul fat well and squeeze dry; trim any large veins of fat from the edges of the squares and set 1 square aside. Lay out the other square and place the venison mousseline in the center, spreading it to form an 8-inch square, then arrange the 2 cups cèpe caps evenly over the mousseline and place the roast in the center. Next, lift the edges of the caul over the roast to wrap the roast completely; as you do so, smooth the mousseline with your fingertips so it's uniformly thick over all surfaces of the roast and tuck in the ends of the caul. Once done, wrap the roast securely in the second square of caul and salt and pepper all surfaces.

Snugly roll the roast in a large piece of plastic wrap. Force out as much air as possible as you wrap and twist excess plastic at each end of the roast until tightly coiled so roast is sealed inside. When finished, the roast should be a solidly packed log-shaped bundle about 8 inches long and 3 inches in diameter. Prick 10 to 15 tiny holes through the plastic covering the roast with a pin; if the holes enlarge, wrap with more plastic without removing the first piece and prick new holes.

Heat a large ungreased roasting pan in the preheated oven until hot. Meanwhile, steam the

plastic-wrapped roast in the covered steamer over boiling water for 4 minutes; turn roast, cover steamer, and continue cooking until the mousseline turns light brown, about 2 minutes more. Remove roast from steamer with tongs and unwrap the plastic wrap but not the caul. Place the remaining 2 tablespoons oil in the heated roasting pan, then add the roast and bake uncovered in the preheated oven for 5 minutes. Turn roast over with tongs, being very careful not to pierce or rip the caul, and continue baking until meat is rare, about 8 minutes more (for rare, a meat thermometer inserted into the thickest part of the meat, not the cèpe stuffing, will register about 120 degrees); do *not* overcook, or the roast will be dry. Transfer roast to a cutting board and let rest about 10 minutes; discard pan juices.

Meanwhile, heat the serving plates in a 250 degree oven and reheat sauce. When the roast has rested 10 minutes, cut it crosswise into 1-inch slices. Serve immediately (still wrapped in caul) on the heated serving plates, allowing 1 slice of roast and about 2 tablespoons sauce for each serving; garnish plates with thyme sprigs, if desired.

"PORCUPINE" PEARS and DATES STUFFED WITH VANILLA ICE CREAM

Makes 4 servings

Vanilla Ice Cream (recipe follows)
1 recipe Pastry Cream (page 215)
1 tablespoon plus 2 teaspoons *Poire* William liqueur
About 5 cups water for poaching pears
⅓ cup sugar plus about 2 tablespoons sugar
¼ cup lemon juice
A 4-inch piece of vanilla bean
4 small, firm, ripe, well-formed D'Anjou or Max Red Bartlett pears (5 to 6 ounces each)
Enough top-quality frozen puff pastry dough to cut out 4 (3-inch) squares (if dough sheets are folded, thaw just enough to unfold; if not folded, do not thaw)
1 egg yolk (from large egg)
8 large pitted dates, sliced open lengthwise
3 tablespoons unsalted butter, softened
2 tablespoons heavy cream
¼ cup slivered almonds, dry roasted
1 recipe Confit of Orange Rind (recipe follows) for garnish (optional)
Seedless red grapes, cut into ¼-inch slices for garnish (optional)

SPECIAL UTENSILS:
Fruit corer
Pastry bag fitted with a ¼-inch plain nozzle
Heavy baking sheet

Make the Vanilla Ice Cream; transfer from ice cream machine to freezer for storing until ready to form into quenelles (oval shapes) and place inside dates shortly before serving.

Make the Pastry Cream; while it's still hot, stir in 2 teaspoons of the liqueur. Cover with plastic wrap directly on the surface of the cream; chill for at least 30 minutes before using.

For poaching the pears, combine 5 cups of water with ⅓ cup of the sugar and the lemon juice in a nonreactive 3-quart saucepan; cut the vanilla bean in half lengthwise, scrape, and add scrapings and bean halves to the pan. Peel the pears and core with the fruit corer to form a neat lengthwise hole through each; add each pear to the saucepan as prepared. Once all pears are in the pan, add more water if needed to completely cover them. Bring to a boil over high heat, then reduce heat and very slowly simmer until pears are tender but still firm, about 20 minutes.

Transfer with a slotted spoon to drain on paper towels; cover with a damp dishtowel and let cool to room temperature. Meanwhile, reduce the pear cooking liquid over high heat to ½ cup, about 45 minutes; then remove vanilla beans (if desired, rinse beans and save for future use). Set reduced liquid aside for the sauce. (This may be done several hours ahead; refrigerate pears and reduced cooking liquid if prepared in advance.)

TO FINISH THE DISH AND SERVE:
(See photograph page 27.) Heat oven to 425 degrees. Spoon the chilled Pastry Cream into the pastry bag and pipe it into the hole cored in each cooled pear. Set aside.

Line the baking sheet with parchment paper; set aside. Cut out four 3-inch squares of frozen puff pastry dough; refrigerate 3 of the squares. Sprinkle 1 teaspoon of the sugar on a cool work surface suitable for rolling out dough, then place the dough square on top of it and sprinkle evenly with ½ teaspoon more sugar. Roll dough out to a 1/16-inch-thick square, turning it over once or twice as you roll it; if needed, add a little more sugar to keep dough from sticking but don't add more than necessary since any excess sugar will caramelize when the dough is baked.

Place 1 of the filled pears on its side in the center of the dough and wrap dough around it, trimming edges so they overlap ½ to 1 inch. Reopen edges slightly, using a pastry brush to brush them with a little of the egg yolk, then gently press edges together to completely seal pear inside. Place the finished pear on its side, seam side down, on the prepared baking sheet; refrigerate. Repeat with the remaining 3 pears and 3 dough squares, using about 1½ teaspoons more sugar to roll out each square; refrigerate each dough-wrapped pear as completed. (The dough-wrapped pears may be kept up to 1 hour in the refrigerator before baking.) Transfer baking sheet, uncovered, to the preheated oven and bake until pastry is well browned, about 25 minutes.

Meanwhile, form 8 quenelles of Vanilla Ice Cream and place 1 inside each date; freeze until ready to serve.

Also now finish the sauce as follows: Bring the reserved ½ cup reduced pear cooking liquid to a boil. Remove from heat and process in a blender with the butter until smooth; then, with the machine running, add the cream and the remaining 1 tablespoon liqueur and continue processing about 30 seconds more. Set aside at room temperature until ready to serve.

When the pears have finished baking, remove from oven and, while still on their sides, stud the exposed surfaces with the slivered almonds so each pear resembles a porcupine. Serve immediately.

To serve: Place a porcupine pear on each large dessert plate and spoon about 2 tablespoons sauce around the edges. Arrange 2 ice-cream-stuffed dates on each plate and, if desired, garnish ice cream with a little (undrained) Confit of Orange Rind and garnish sauce with grape slices.

VANILLA ICE CREAM

1 cup heavy cream
1 cup milk
An 8-inch piece of vanilla bean
6 egg yolks (from large eggs)
⅓ cup sugar

SPECIAL UTENSILS:
Chinois placed over a heatproof bowl
Ice cream machine

In a heavy 3-quart nonreactive saucepan, combine the cream and milk; cut the vanilla

bean in half lengthwise, scrape thoroughly, and add scrapings and bean halves to the pan. Bring to a boil, then remove from heat, and let sit 15 minutes.

Combine the egg yolks and sugar in a medium-size bowl, whisking vigorously until thick and pale yellow, about 2 minutes. Return the cream mixture to a boil, then remove from heat and gradually add to the egg yolk mixture, whisking constantly. Return mixture to the saucepan and cook over medium heat, stirring constantly and scraping pan bottom evenly with a wooden spoon, just until it thickens and leaves a distinct trail on the back of the spoon when you draw a finger through it, about 2 to 3 minutes; do *not* let mixture boil. Immediately strain through the chinois into the bowl. Promptly cover and refrigerate until well chilled, at least 3 hours or overnight.

Freeze in the ice cream machine according to manufacturer's instructions until firm, about 20 to 40 minutes, depending on the type of machine used. *Makes 3 to 4 cups.*

CONFIT OF ORANGE RIND

10 ounces oranges with perfect skins (about 2 medium to large oranges), rinsed and dried
½ cup sugar
¼ cup water

Use a vegetable peeler to peel the rind from the oranges in fairly long pieces, being careful not to include any white pith; cut these pieces into ⅛-inch or thinner julienne strips. Squeeze ¼ cup of juice from the orange pulp and combine it with the sugar and water in a small heavy nonreactive saucepan. Bring to a boil, then add the julienne strips and simmer until tender and liquid becomes a syrup, about 30 minutes, stirring occasionally. Use immediately or store up to 2 hours at room temperature, then cover and refrigerate until ready to use. The confit will keep about 1 week refrigerated. *Makes about ¼ cup.*

GRAND MARNIER CREAM IN PUFF PASTRY with SAUTEED FRESH BERRIES IN RASPBERRY SAUCE and LEMON ICE CREAM

Makes 4 servings

Lemon Ice Cream (recipe follows)
Enough top-quality frozen puff pastry dough to cut 4 (3½-inch) rounds (if dough sheets are folded, thaw just enough to unfold; if not folded, do not thaw)
1 cup heavy cream
2 tablespoons Grand Marnier
About 3 teaspoons sifted powdered sugar
Generous 1 cup fresh raspberries for Raspberry Sauce
3 tablespoons granulated sugar
2 tablespoons water
4 cups fresh berries (such as raspberries, strawberries, huckleberries, blueberries, or blackberries, or a mixture; large berries cut in half or in quarters)
4 mint sprigs for garnish

SPECIAL UTENSILS:
3½-inch round cookie cutter
Chinois placed over a heatproof bowl
Pastry bag fitted with a Number 4 star tip

First make the Lemon Ice Cream; transfer from ice cream machine to freezer to store until ready to serve.

Heat oven to 450 degrees. Chill an electric mixer bowl and beaters in the freezer for the Grand Marnier Cream. Meanwhile, cut out 4 rounds of frozen puff pastry dough with the cookie cutter. Place rounds on a cookie sheet lined with parchment paper and bake in the preheated oven until tops are golden brown, about 12 minutes. Reduce oven setting to 375 degrees and continue baking until well browned, puffed, and cooked through, about 8 minutes more. (Make sure insides of these fragile pastries are done by carefully slicing 1 of them in half horizontally with a bread knife.) Set aside.

For the Grand Marnier Cream, combine cream, 1 tablespoon of the Grand Marnier, and 2 teaspoons powdered sugar in the chilled mixing bowl; beat until soft peaks form. Refrigerate until ready to serve.

TO FINISH THE DISH AND SERVE:
(See photograph page 27.) Start the Raspberry Sauce by puréeing the generous 1 cup raspberries with 1 tablespoon of the granulated sugar and the water in a blender. Strain purée through the chinois, using the bottom of a sturdy ladle to force as much through as possible; it should yield about ⅔ cup. Set aside.

Slice the puff pastries in half horizontally; scoop out flaky insides of bottom portions to form bowls for the Grand Marnier Cream and place 1 bowl on each large serving plate. Spoon the Grand Marnier Cream into the pastry bag and pipe an equal portion into the pastry bowls, using most if not all of the cream; then dust top portions of pastry with powdered sugar and place over the Grand Marnier Cream. Set aside.

Heat a large empty skillet (preferably nonstick) over high heat for about 1 minute. Add the reserved raspberry purée and the remaining 2 tablespoons granulated sugar; cook about 2 minutes, stirring frequently. Add the 4 cups berries and cook until they give off some of their juices but are still firm, about 2 minutes, shaking the pan occasionally in a gentle back and forth motion instead of stirring. Add the remaining 1 tablespoon Grand Marnier and continue cooking about 30 seconds more. Remove from heat and spoon ¼ of the mixture on each serving plate; then add the Lemon Ice Cream to the plates, formed into quenelles (oval shapes) if desired. Garnish with mint sprigs and serve immediately.

LEMON ICE CREAM

1 cup heavy cream
1 cup milk
A 4-inch piece of vanilla bean
9 egg yolks (from large eggs)
½ cup plus 1 tablespoon sugar
1 tablespoon very finely grated lemon zest
¾ cup lemon juice
1 tablespoon plus 1½ teaspoons vodka

SPECIAL UTENSILS:
Chinois placed over a heatproof bowl
Ice cream machine

Make the custard cream as follows: In a heavy 3-quart nonreactive saucepan, combine the cream and milk; cut the vanilla bean in half lengthwise, scrape, and add scrapings and bean halves to the pan. Bring to a boil, then remove from heat, and let sit 15 minutes.

Combine 7 of the egg yolks with ½ cup of the sugar in a large bowl, whisking vigorously until thick and pale yellow, about 2 minutes. Return the cream mixture to a boil, then remove from heat and gradually add to the egg yolk mixture, whisking constantly. Return mixture to the saucepan and cook over medium heat, stirring constantly and scraping pan bottom evenly with a wooden spoon, just until it thickens and leaves a distinct trail on the back of the spoon when you draw a finger through it, about 2 to 3 minutes; do *not* let mixture boil. Immediately strain through the chinois into the bowl. Promptly cover this custard cream and refrigerate until well chilled, at least 3 hours or overnight.

When ready to finish the ice cream, combine the lemon zest with the remaining 1 tablespoon sugar on a cutting board or plate, kneading mixture with the back of a spoon until it becomes a paste. Bring 2 inches of water to a simmer in a 2-quart pot. Meanwhile, in a large wide heatproof bowl combine the zest-sugar paste with the lemon juice and the remaining 2 egg yolks, whisking until frothy; set bowl over the simmering water and immediately start whisking constantly and very vigorously until mixture becomes a thick cream soup consistency, about 10 minutes. Remove from heat and whisk in the vodka. Fold vodka mixture into the custard cream.

Freeze in the ice cream machine according to manufacturer's instructions until firm, about 20 to 45 minutes, depending on the type of machine used. *Makes about 1 quart.*

QUAIL EGGS IN BRIOCHE with BELUGA, OSSETRA, and AMERICAN GOLDEN CAVIAR and SMELT ROE

Makes 4 first-course servings

8 to 10 quail eggs (see Note)
About 8 (¼-inch-thick) slices Brioche (pages 214-215)
Vegetable oil for greasing cookie sheet or baking pan
Freshly ground black pepper
2 ounces (about 2 teaspoons each type) beluga, ossetra, and American golden caviar and smelt roe *or* 1¼ ounces (about 8 teaspoons) smelt roe
½ teaspoon minced chives (optional)

SPECIAL UTENSILS:
Two or more cookie cutters of assorted geometric shapes, each about equal in area to a 3-inch round cookie cutter, for cutting brioche into a variety of shapes
One 1-inch round cookie cutter for cutting a center hole in each larger brioche shape
Cookie sheet or baking pan large enough to hold 8 brioche shapes and also fit under broiler

NOTE:
You will need 8 eggs, but it's a good idea to have 1 or 2 extra in case any break.

Heat oven to 400 degrees and preheat broiler if it's a separate unit from your oven.

If you are inexperienced at opening quail eggs, first remove the top of the shells so the contents can be quickly added to the brioche shapes when called for. To do this, with the flatter end of egg upright, carefully peel away the top quarter of each shell with your fingertips (start the first crack by gently slicing through the shell or lightly tapping it crosswise ¼ of the way down from the top with a sharp paring knife); place opened eggs upright in an "egg carton" fashioned from crumpled aluminum foil. Set aside.

Use the larger cookie cutters to cut out 8 geometric shapes of brioche, then use the smaller round cutter to cut out a hole in the center of each.

Grease the cookie sheet and heat it in the preheated oven, about 1 minute. Remove pan from oven (leave oven set at 400 degrees) and arrange the brioche shapes on it in a single layer. Promptly open quail egg shells, if not already done, and add the contents of 1 to the center hole in each brioche shape. Return pan, uncovered, to the 400 degree oven and bake for 2 minutes, then immediately broil just a few seconds, about 4 inches from the heat source, until brioche is lightly toasted and egg whites are opaque (the yolks should still be very runny). Remove from broiler, season tops with pepper, and serve immediately.

TO SERVE:
(See photograph page 30.) Transfer 2 brioche shapes to each of 4 heated serving plates. With 2 teaspoons, mold the caviar or smelt roe into 8 quenelles (oval shapes), allowing about 1 level teaspoon of caviar and/or smelt roe for each. As each is formed, place on top of 1 of the brioche shapes next to the egg. Sprinkle with chives, if desired.

CORN SOUP with LOBSTER QUENELLES and BELON OYSTERS

Makes 4 servings

1 recipe Lobster Cream Base Sauce (page 215)

169

1 recipe Lobster Mousseline (page 215)
1 small zucchini (about 6 ounces)
Salt water (¼ cup coarse salt mixed with 3 quarts water) for cooking cubed vegetables and zucchini peelings
⅓ cup peeled and cubed carrots (⅛-inch cubes)
⅓ cup peeled and cubed turnips (⅛-inch cubes)
⅓ cup scraped and cubed celery (⅛-inch cubes)
Ice water for cooling cooked vegetables and zucchini peelings
Salt water (2 tablespoons coarse salt mixed with 3 quarts water) for cooking corn
5 (7-inch) ears of yellow corn, shucked (preferred) or 3 cups frozen yellow corn kernels, cooked according to package directions and drained
Ice water for cooling cooked corn
Fine sea salt and freshly ground black pepper
2 cups Lobster Consommé (page 214) (preferred), Lobster Stock (page 214), or other Consommé or Stock (page 214) for poaching quenelles
12 medium to large shucked oysters (preferably Belon), undrained (about 9 ounces)
½ cup water for heating oysters
Dill sprigs, snipped for garnish
Lobster Coral Garnish (page 215) (optional)

SPECIAL UTENSILS:
Fine mesh strainer
1-quart-capacity covered soup tureen

Make the Lobster Cream Base Sauce and the Lobster Mousseline; refrigerate.

PREPARE THE VEGETABLES:
Peel the skin from the zucchini in ⅛-inch-thick sheets, then cut peelings into ⅛-inch cubes; set aside.
Bring the salt water for cooking the cubed vegetables and zucchini peelings to a rolling boil in a large pot. Add the carrots, turnips, and celery and cook for 5 minutes, then add the zucchini peeling and continue cooking 1 minute more. Immediately transfer vegetable mixture with a strainer or skimmer to the ice water to cool; drain again. Cover and refrigerate. (This may be done several hours ahead.)

MAKE THE SOUP:
Bring the salt water for cooking the corn on the cob to a rolling boil in a large pot. Add the ears of corn and cook just until tender, about 3 minutes. Drain and cool in the ice water; drain again. Cut kernels from cobs. Set aside 2 tablespoons of the kernels, covered, for soup bowls; purée remaining kernels in a food processor. Place purée in a 4-quart saucepan with 2½ cups of the Lobster Cream Base Sauce, stirring well; reserve remaining base sauce, refrigerated. Bring to a boil over high heat, stirring occasionally. Remove from heat and strain through the strainer, using the bottom of a sturdy ladle to force as much through as possible. Return soup to saucepan and season to taste with salt and pepper. Set aside.

FORM AND COOK THE QUENELLES:
Bring the consommé to a simmer in a small skillet. Remove from heat. With 2 teaspoons, mold the Lobster Mousseline into quenelles (oval shapes), allowing a rounded teaspoon for each; as formed, ease the quenelle into the hot consommé and simultaneously heat both teaspoons in the consommé to facilitate forming the next quenelle. Once all quenelles are formed, return skillet to low heat and heat (do not let consommé reach a simmer) just until cooked through, about 5 minutes; set aside in the hot consommé. (Note: If not serving the quenelles

fairly promptly, cook for only 3 minutes, then remove from heat, and set aside in the hot consommé; serve within 1 hour.)

TO FINISH THE DISH AND SERVE:
(See photograph page 31.) Heat oven to 350 degrees and heat the soup tureen in it. Place the undrained oysters in a small saucepan with the ½ cup water and warm over low heat 4 to 5 minutes (do not allow liquid to reach a boil); set aside.
Meanwhile, thin soup if needed with more Lobster Cream Base Sauce and reheat over high heat; taste for seasoning and skim, if necessary. Transfer soup to the heated soup tureen and cover; set aside. Leave oven setting at 350 degrees.
Spread a portion of the reserved vegetable mixture and reserved corn kernels in the bottom of each of 4 wide ovenproof soup bowls; then arrange ¼ of the drained oysters (use a slotted spoon) and 3 to 4 drained quenelles on top. Cover bowls with aluminum foil and heat in the 350 degree oven just until bowls are hot, about 2 minutes. Remove bowls from oven, uncover, and garnish each with dill and, if desired, a light sprinkle of Lobster Coral Garnish. Serve promptly, ladling about ¾ cup soup into each bowl once at the table.

SAUTEED LANGOUSTINES with BEETS and BEET AND LOBSTER CREAM SAUCE

Makes 4 servings

1 cup Lobster Cream Base Sauce (page 215) (preferred) or heavy cream
Salt water (2 tablespoons coarse salt mixed with 2 quarts water) for cooking beets
22 ounces fresh unpeeled beets without stalks (about 4 medium-size beets), trimmed and rinsed well
¼ cup plus about ½ teaspoon extra-virgin olive oil
¼ cup Lobster Consommé (page 214) (preferred), Lobster Stock (page 214), or other Consommé or Stock (page 214)
Fine sea salt and freshly ground black pepper
2 dozen langoustines with heads and shells (about 6½ pounds) (preferred) or 2 dozen peeled langoustine tails (about 1½ pounds)
Chervil or dill sprigs, snipped for garnish

SPECIAL UTENSILS:
1-inch round scallop-edged cookie cutter
Chinois

Make the Lobster Cream Base Sauce; refrigerate.

PREPARE THE BEETS AND MAKE THE SAUCE:
Bring the salt water to a rolling boil in a large pot. Add the beets and cook over high heat just until tender, about 45 minutes. Let cool, then peel and cut into ⅛-inch slices. Cut out just enough slices with the cookie cutter to form 7 or 8 rounds for each of 4 ovenproof serving plates (the number of rounds needed depends on the size of the plates); set aside scraps. Arrange rounds in a large circle on the plates, brush tops lightly with about ½ teaspoon of the oil, and cover with plastic wrap. Set aside. (Refrigerate plates if prepared more than 2 hours ahead; they may be assembled to this point several hours in advance. Return to room temperature before heating in the oven.)
For the sauce, chop enough of the reserved beet scraps to yield 1⅔ cups; set aside. Bring the Lobster Cream Base Sauce (or heavy cream) to a boil in a small pot. Remove from heat and purée in a blender with the reserved chopped

beets, the consommé, and a little salt and pepper. Strain through the chinois, using the bottom of a sturdy ladle to force as much through as possible; the strained purée should yield about 1½ cups. If serving almost immediately, place sauce in a small heavy saucepan and set aside. If made ahead, cover and refrigerate. (The sauce may be made several hours ahead.)

PREPARE THE LANGOUSTINES:
Separate the langoustine heads from the tails. If desired, reserve 4 heads for garnishing plates; rinse thoroughly, drain well, and set aside. Remove tail meat from the shells, keeping meat intact. Season on both sides with salt and pepper; set aside. (Cover and refrigerate if prepared ahead.)

TO FINISH THE DISH AND SERVE:
(See photograph page 32.) Heat oven to 350 degrees. Heat the remaining ¼ cup oil in a very large skillet (preferably nonstick) over high heat, about 3 minutes. Add ½ of the langoustines to the skillet and sauté 1½ minutes, turning occasionally. Reduce heat to low and continue cooking and turning just until cooked through, about 2½ minutes more; do *not* overcook. Drain on paper towels and cover with more towels to keep warm. Repeat with remaining langoustines.
Meanwhile, reheat sauce (do *not* let it boil) and taste for seasoning. Heat serving plates, uncovered, in the preheated oven for about 2 minutes.
Once langoustines are sautéed and plates are hot, position a langoustine head on each plate (as shown on page 32), if using. Spoon about 3 tablespoons sauce in the center of each plate and arrange a portion of the langoustines on top of the sauce. Garnish plates with chervil or dill and serve immediately.

BRAISED FOIE GRAS with HUCKLEBERRY SAUCE

Makes 4 servings

SAUCE:
⅓ cup sugar
1½ cups fresh huckleberries (or small blueberries; about 8 ounces), stems removed
1 cup Meat or Vegetable Consommé (page 214) (preferred) or Meat or Vegetable Stock (page 214)
¼ cup unpeeled chopped carrots
2 tablespoons chopped celery
2 tablespoons chopped leeks (mostly white part)
2 tablespoons chopped onions
2 tablespoons unpeeled chopped turnips
1 tablespoon chopped shallots
1 cup *Fond de Veau* (page 214)
About 4 to 6 tablespoons braising liquid (reserved from braising foie gras)
Fine sea salt and freshly ground black pepper
1 whole fresh uncooked duck or goose foie gras (Grade A; about 1 pound)
Fine sea salt and freshly ground black pepper
BRAISING BED:
1 cup unpeeled chopped carrots
½ cup chopped celery
½ cup chopped leeks (mostly white part)
½ cup chopped onions
½ cup unpeeled chopped turnips
¼ cup chopped shallots
10 very leafy thyme sprigs
3 medium-size bay leaves
1 teaspoon fine sea salt
1 teaspoon whole black peppercorns
2 tablespoons vegetable oil
½ cup Meat or Vegetable Consommé (page

214) (preferred) or Meat or Vegetable Stock (page 214)
1 cup port wine

SPECIAL UTENSIL:
Chinois

START THE SAUCE:
Place the sugar in a heavy 4-quart saucepan and cook over high heat until a rich caramel color, 3 to 4 minutes, stirring almost constantly with a wooden spoon; be careful not to let it burn. Add 1 cup of the huckleberries, stirring until berries are well coated, then promptly add the consommé, carrots, celery, leeks, onions, turnips, and shallots; cook until mixture reduces to about 1 cup, about 20 minutes, stirring occasionally. Add the *Fond de Veau* and bring to a boil. Reduce heat and simmer about 7 minutes, stirring occasionally. Remove from heat and strain through the chinois, using the bottom of a sturdy ladle to force as much through as possible; the strained sauce should yield about 1¼ cups. Add the remaining ½ cup huckleberries. Return to saucepan and set aside. (This may be done up to 2 days ahead; keep refrigerated.)

TO FINISH THE DISH AND SERVE:
(See photograph page 33.) Heat oven to 350 degrees. With a sharp thin-bladed knife, carefully trim away any green spots on the foie gras caused by contact with the gall bladder. Season both sides of the foie gras very generously with salt and pepper; set aside.
In a medium-size bowl, combine all the ingredients for the braising bed. Place the oil in a heavy 13 x 9-inch roasting pan and heat over high heat on top of the stove about 1 minute. Add the braising-bed mixture and sauté until it starts to brown, about 10 minutes, stirring frequently. Add the consommé and continue cooking and stirring about 3 minutes more, then mound the vegetables in the center of the pan and place the foie gras on top. Remove from heat and seal pan with aluminum foil; pierce foil 2 or 3 times with the tip of a pointed knife so steam can escape during cooking. Bake in the preheated oven for 8 minutes; then momentarily remove pan from oven, uncover, and turn foie gras over with two sturdy rubber spatulas to prevent marring the foie gras's smooth surface, being very careful to keep it intact. Cover pan and continue baking until done, about 10 minutes more; do *not* overcook, or the foie gras will loose its unique buttery texture. (To test doneness, pierce foie gras with a thin wood or metal skewer to the center of the thickest part and withdraw skewer; then press very gently around skewer hole and, if after a few seconds the juices from the hole run slightly pink, not clear and not bloody, it's done.) Transfer foie gras to a plate and cover loosely with foil to keep warm while finishing the sauce.
To finish sauce, place the roasting pan with the braising liquid and vegetables in it over high heat on top of the stove and bring to a boil. Add the port and return to a boil; then continue boiling until liquid reduces to about ⅔ cup, about 8 minutes more, stirring occasionally. Strain braising liquid through the chinois into a bowl, using the bottom of a sturdy ladle to force as much through as possible. Skim all fat from surface and add remaining liquid to the reserved huckleberry sauce. Reheat sauce and, if needed, let it reduce to a thin sauce consistency. Season to taste with salt and pepper and serve immediately.
To serve: Cut the foie gras crosswise into 1-inch-thick slices on the diagonal. Spoon 2 to 3 tablespoons sauce on each heated serving plate and arrange a slice of foie gras on top of sauce.

BROILED COD with SAFFRON POTATOES, SAFFRON GARLIC CREAM SAUCE, and MIREPOIX OF RED AND YELLOW BELL PEPPERS

Makes 4 servings

MIREPOIX OF RED AND YELLOW BELL PEPPERS:
½ well-formed medium-size red bell pepper, cored (about 3 ounces)
½ well-formed medium-size yellow bell pepper, cored (about 3 ounces)
1 quart water for cooking bell peppers
1 pound Finnish or russet potatoes (about 2 medium-size potatoes)
3 cups water for poaching garlic cloves
4 large garlic cloves, peeled
SAFFRON GARLIC CREAM SAUCE:
½ cup Chardonnay wine
1 tablespoon very finely chopped shallots
1 teaspoon minced garlic
Scant ½ teaspoon saffron threads
2 cups heavy cream
Fine sea salt and freshly ground black pepper
Olive oil for greasing broiling pan
Fine sea salt and freshly ground black pepper
1½ pounds cod fillets, about 1 inch thick at the thickest part
Parsley sprigs, snipped for garnish (optional)
Saffron threads, crumbled into tiny bits for garnish (optional)
Lobster Coral Garnish (page 215) (optional)

SPECIAL UTENSIL:
Heatproof fine mesh strainer

PREPARE THE MIREPOIX OF PEPPERS:

Working with 1 piece of bell pepper at a time, place the piece skin down on a cutting board and very carefully trim away the skin with a sharp thin-bladed knife, slicing horizontally as close to the skin as possible. If needed, cut pieces smaller, then skin them. Next, cut the pulp into ⅛-inch squares and combine the red and yellow squares; the combined yield should be about ⅔ cup.

Bring the 1 quart water to a rolling boil in a small pot. Place the bell peppers in the heatproof strainer and dip strainer bowl into the boiling water for 30 seconds to blanch peppers. Drain on paper towels. Cover and refrigerate. (This may be done several hours ahead.)

PREPARE THE POTATOES:

Carve the potatoes into 36 oval shapes, each about 1 inch long and ½ inch wide at the widest part; once each oval is carved, there should be no skin remaining on it. Place in a bowl of cool water as each is shaped. Refrigerate. (These may be prepared several hours ahead.)

POACH THE GARLIC:

Bring 1½ cups of the water to a rolling boil in a small pot. Add the garlic cloves and cook over high heat for 5 minutes; drain. In the same pot, combine the garlic cloves with the remaining 1½ cups water. Bring to a boil, then continue boiling until tender, about 7 minutes more. Drain and cut in quarters lengthwise. Cover and set aside.

MAKE THE SAUCE:

In a small heavy saucepan, combine the wine, shallots, minced garlic, and saffron threads. Cook over medium-low heat until wine reduces by half, about 10 minutes. Add the cream and the reserved drained potato ovals and season with salt and pepper. Bring to a strong simmer over medium heat and continue simmering until potatoes are tender, 20 to 25 minutes, stirring occasionally.

Meanwhile, broil the cod, then serve immediately.

TO BROIL THE COD AND SERVE:

(See photograph page 34.) Preheat broiler and, if broiler is separate from your oven, preheat oven to 400 degrees. Generously grease a heavy broiling pan with olive oil. Salt and pepper the cod on both sides and add to the pan, turning to coat both sides well with some of the oil; end with skin down. Broil about 4 inches from the heat source, without turning, just until cooked through, 3 to 4 minutes; watch carefully and do *not* overcook. (The cooking time will depend on thickness of fillets.) Remove cod from broiler; if your broiler is part of your oven, now reduce oven setting to 400 degrees. Flake the cod.

To serve, arrange an equal portion of the bell pepper mirepoix in a small circle in the center of each ovenproof serving plate. Set aside 4 attractive cod flakes for garnishing center of plates, then arrange 9 of the remaining most attractive cod flakes around the edges of each plate; arrange any remaining flakes on top of the mirepoix.

Next, strain the sauce through a fine mesh strainer into a bowl. Around the edges of each plate, arrange 1 of the drained potato ovals from the sauce between each of the 9 cod flakes; then heat plates, uncovered, in the preheated oven for 2 minutes. Meanwhile, reheat sauce.

Once plates are out of the oven, spoon 2 to 3 tablespoons sauce in the center of each, arrange ¼ of the reserved garlic clove quarters on top of the sauce, and garnish center with 1 of the remaining cod flakes. If desired, garnish potato ovals with parsley sprigs and crumbled saffron and sprinkle dish lightly with Lobster Coral Garnish.

MAGRET OF DUCK with DAUBE OF CEPE MUSHROOMS

Makes 4 servings

DAUBE:
1 pound flash-frozen cèpe mushrooms, thawed and undrained
¼ cup vegetable oil
Freshly ground black pepper
5½ ounces finely chopped prosciutto (about 1 cup)
¾ cup finely chopped onions
3 tablespoons very finely chopped shallots
1 teaspoon very finely chopped garlic
15 thyme sprigs (very leafy single stems, each 4 to 5 inches long)
3 large bay leaves
¾ cup Cabernet Sauvignon wine
2 cups *Fond de Veau* (page 214)
1 cup Meat or Vegetable Consommé (page 214) (preferred) or Meat or Vegetable Stock (page 214)
3 (7- to 8-ounce) boneless *magrets de canard* (breasts of mulard duck), with skin and fat layer still attached
Fine sea salt and freshly ground black pepper
Thyme sprigs for garnish (optional)

SPECIAL UTENSIL:
Very fine mesh strainer

MAKE THE DAUBE:

Drain the cèpes well, reserving juices. Separate caps and stems; cut stems into ¼-inch slices. Heat 2 tablespoons of the oil in a very large nonstick skillet over high heat, 2 to 3 minutes. Add the caps and stems and sauté about 30 seconds. Reduce heat to medium, season with pepper, and continue cooking until browned, about 5 minutes more, stirring occasionally. Drain on paper towels and set aside.

In a bowl, combine the prosciutto, onions, shallots, garlic, thyme sprigs, and bay leaves. Heat the remaining 2 tablespoons oil in a heavy 4-quart saucepan over high heat, 2 to 3 min-

utes. Add the prosciutto mixture, mixing well with a wooden spoon. Reduce heat to medium and cook for 5 minutes, stirring occasionally. Stir in the wine and return to a boil. Add the *Fond de Veau*, consommé, and the reserved cèpe juices. Bring to a simmer, then gently simmer for 1 hour 15 minutes, stirring and skimming occasionally. Remove from heat and strain through the strainer, using the bottom of a sturdy ladle to force as much through as possible; the strained sauce should yield about 2 cups. Return to a small heavy saucepan and add the cèpes. Slowly simmer for 30 minutes, stirring and skimming occasionally. Set aside. (The daube may be made 1 day ahead; if made ahead, refrigerate.)

TO COOK THE *MAGRETS* AND SERVE:

(See photograph page 35.) Trim the skin from the *magrets*, leaving as much fat as possible attached to the meat; remove any gristle and large clumps of fat from the side opposite the skinned side. Trim edges to neatly shape each *magret*. Score the fat layer (but not meat) in a crisscross pattern, making cuts about 1 inch apart. Season both sides with salt and pepper.

Heat a large nonstick skillet over high heat for about 1 minute. Add the *magrets* to the hot skillet, fat side down, and cook until well browned on the underside, about 5 minutes. Turn *magrets* and continue cooking about 1 minute more for a very rare center, 2 to 3 minutes more for rare, or 4 to 5 minutes more for medium rare; do *not* overcook, or the *magrets* will be tough. (The cooking time will depend on thickness of the meat.) Remove from heat and transfer *magrets* to a cutting board; cover and let sit about 10 minutes. Meanwhile, heat the serving plates in a 250 degree oven and reheat daube.

When the *magrets* have rested 10 minutes, cut them crosswise into ⅛-inch slices. Serve immediately.

To serve, arrange a portion of the drained cèpes (use a slotted spoon) in a semicircle around the edge of each heated serving plate. Fan ¼ of the *magret* slices in the center of each plate and spoon about 2 tablespoons sauce around the edge of plate opposite cèpes. Garnish with thyme sprigs, if desired.

BRIOCHE RAVIOLI FILLED WITH MANGO AND GINGER and LIME ICE CREAM IN CARAMEL BASKETS with MANGO SAUCE

Makes 4 servings

BRIOCHE RAVIOLI AND MANGO SAUCE:
1 recipe brioche dough (see recipe for Brioche, pages 214-215)
1½ ounces ginger root, peeled
¾ cup plus 1 tablespoon sugar
1 cup water
2¼ pounds ripe firm mangoes
1 tablespoon lime juice
Flour for rolling out dough
2 egg yolks (from large eggs), lightly beaten
Vegetable oil for deep frying
Sifted powdered sugar
Lime Ice Cream (recipe follows)
Caramel Baskets (recipe follows)
1 teaspoon paper-thin julienne lime zest for garnish (optional)
Mint sprigs for garnish (optional)

SPECIAL UTENSILS:
Very fine mesh strainer
Chinois
2-inch round scallop-edged cookie cutter

Prepare the brioche dough up through the point of refrigerating overnight; keep refrigerated until ready to use.

Prepare the Lime Ice Cream up to the point of freezing it in the ice cream machine (this may be done a day ahead); refrigerate.

On the day of serving, prepare the Caramel Baskets; store in an airtight container until ready to use. Prepare the ginger for the ravioli filling. To do this, peel the ginger and cut into 1/16-inch slices, then cut these slices into 1/16-inch cubes. Combine ½ cup of the sugar and ½ cup of the water in a small heavy pot; bring to a boil. Add the ginger cubes and simmer until tender and liquid becomes a syrup, 30 to 35 minutes, stirring occasionally. Remove from heat and drain through the strainer. Cover and refrigerate.

Meanwhile, use a sharp, thin-bladed knife to peel the mangoes and cut each lengthwise into as many solid ⅛-inch-thick slices as possible; be sure to make slices of uniform thickness. Cut just enough of these slices into ⅛-inch cubes to yield 1½ cups; set aside for the filling. Coarsely chop enough leftover mango slices to yield 1 cup for the sauce; if needed, trim pulp still attached to the pits to make 1 cup. Set aside.

To finish the filling, place the reserved mango cubes and ginger cubes in a small saucepan. Add ¼ cup of the sugar and the lime juice; gently simmer 10 to 12 minutes, stirring occasionally. Drain filling through the strainer, reserving strained liquid for the sauce. Refrigerate filling at least 15 minutes or until ready to assemble ravioli.

Meanwhile, prepare the sauce by placing the strained liquid from the filling in a blender; add the 1 cup reserved mango pulp and the remaining ½ cup water and 1 tablespoon sugar and purée until smooth. Strain sauce through the chinois, using the bottom of a sturdy ladle to force as much through as possible; it should yield about 1¼ cups. Cover and refrigerate until ready to serve.

At least 1½ hours before serving time, but no more than 3 hours ahead, assemble the ravioli as follows: Line a cookie sheet with parchment or waxed paper and generously flour the paper; set aside. Remove the brioche dough from the refrigerator and pinch off about ¼ of it; refrigerate remaining dough. Roll out the dough on a floured surface into a ⅛-inch-thick rectangle; make sure it's of even thickness. Cut rolled out dough into 2½-inch squares. Brush ½ of the squares with some of the egg yolk and mound about 1 teaspoon ravioli filling in the center of each yolk-coated square; cover with the remaining squares and lightly press edges together with your fingertips to seal. Next, cut the ravioli out with the cookie cutter, making sure filling is centered; place on the prepared cookie sheet. Repeat with the remaining dough until all filling is used. (You should have enough filling for about 25 ravioli. Any leftover dough may be baked into brioche as directed on pages 214-215. It's also excellent rolled out, deep fried, sprinkled with powdered sugar, and served as a snack or dessert; see *Merveilles*, page 176, for how to do this.) Refrigerate ravioli for at least 1 hour; keep refrigerated until ready to fry.

Meanwhile, freeze the ice cream as directed on page 172; transfer from the ice cream machine to your freezer, if needed, to store until ready to serve.

TO FINISH THE DISH AND SERVE:

(See photograph pages 36-37.) Spoon about 3 tablespoons sauce in the center of each serving plate and arrange a caramel basket on top; set aside.

Make sure the edges of the chilled ravioli are still completely sealed; if not, coat edges with a little egg yolk and reseal. Deep fry ravioli in small batches in 350 degree oil until golden brown and cooked through, about 3 minutes, turning frequently; maintain oil temperature at

about 350 degrees. Drain on paper towels. Sprinkle generously with powdered sugar and arrange an equal portion around the edges of each serving plate. Now form the ice cream into quenelles (oval shapes) with 2 tablespoons and place 2 quenelles in each caramel basket. If desired, garnish ice cream with julienne lime zest and mint sprigs. Serve immediately.

LIME ICE CREAM

1 cup heavy cream
1 cup milk
A 4-inch piece of vanilla bean
5 egg yolks (from large eggs)
½ cup plus 1 tablespoon sugar
1 tablespoon very finely grated lime zest
½ cup lime juice
3 tablespoons light rum

SPECIAL UTENSILS:
Chinois placed over a heatproof bowl
Ice cream machine

In a heavy 3-quart nonreactive saucepan, combine the cream and milk; cut the vanilla bean in half lengthwise, scrape, and add scrapings and bean halves to the pan. Bring to a boil, then remove from heat and let sit 15 minutes.

Combine the egg yolks with ½ cup of the sugar in a medium-size bowl, whisking vigorously until thick and pale yellow, about 2 minutes. Return the cream mixture to a boil, then remove from heat and gradually add to the egg yolk mixture, whisking constantly. Return mixture to the saucepan and cook over medium heat, stirring constantly and scraping pan bottom evenly with a wooden spoon, just until it thickens and leaves a distinct trail on the back of the spoon when you draw a finger through it, about 2 to 3 minutes; do *not* let mixture boil. Immediately strain through the chinois into the bowl. Promptly refrigerate.

Next, combine the lime zest with the remaining 1 tablespoon sugar on a cutting board or plate, kneading mixture with the back of a spoon until it becomes a paste. Add this paste to the cooling cream mixture, then stir in the lime juice and rum. Cover and refrigerate until well chilled, at least 3 hours or overnight.

Freeze in the ice cream machine according to manufacturer's instructions until firm, about 20 to 40 minutes, depending on the type of machine used. *Makes about 1 quart.*

CARAMEL BASKETS

Vegetable oil for greasing aluminum-foil-wrapped soufflé dishes
About ½ cup sliced almonds
1¼ cups sugar
¼ cup plus 1 tablespoon water
¼ cup plus 1 tablespoon light corn syrup

SPECIAL UTENSILS:
4 (½-cup-capacity) individual straight-sided soufflé dishes, inside diameter 2⅝ inches, 1½ inches tall
Candy thermometer

Cover the outer surfaces of each soufflé dish completely with an 8-inch square of aluminum foil, folding edges inside the dish and pressing all folds very flat. Line a cutting board or other heatproof work surface with parchment or waxed paper; place dishes upside down on the paper at least 5 inches apart. Use vegetable oil to generously oil the foil on the outside of the dishes and a 2- to 3-inch border of the paper immediately surrounding each dish. Spread about 1½ teaspoons of the almond slices evenly over the top of each dish and sprinkle another 1 tablespoon almond slices evenly around the edges to form

a 1-inch border, making sure several slices touch the dish itself.

Make the caramel syrup as follows: Have ready a large bowl of ice water for quickly cooling the pan of caramel syrup once cooked. In a small heavy saucepan, combine the sugar, water, and corn syrup, stirring until well blended. Dip a pastry brush in cold water (use the ice water for this) and wash down sugar crystals on sides of pan. Cook mixture over high heat just until it's a golden honey-colored syrup and reaches about 300 degrees on the candy thermometer, about 6 minutes; as the syrup cooks, gently move the pan in a back and forth motion occasionally (do not stir) and continue brushing down sugar crystals as needed. Immediately remove from heat and set pan in the ice water. Let cool, stirring constantly, just until threads dropped from a table fork are fairly thick and amber-colored and temperature of syrup has reduced to about 275 degrees.

Next, working quickly and carefully (so you don't burn yourself), use the fork to drizzle the syrup over the prepared dishes, back and forth and crisscross, to form 4 webbed baskets. Use all but about 1 to 2 tablespoons of the syrup (this will be needed for finishing the baskets). As you work, hold the saucepan at an angle to make a deep pool of syrup for dipping the fork into. Make sure to fill in any large gaps and circle the almond border with additional syrup to glue all almond slices together and securely attach the rims to the baskets. If the syrup thickens too much to drizzle, return pan to high heat and cook until sugar liquifies again, stirring constantly, then remove from heat and continue using.

Let baskets cool thoroughly, about 10 minutes. Next, very carefully (they are fragile) peel each basket, including the dish inside it, away from the parchment paper. With scissors trim off any very long threads from around the rims. Now very carefully unmold baskets, 1 at a time. To do this, first completely unfold the foil tucked inside the dish. While holding the basket in one hand, use the other hand to very gently work the basket free from the dish; do not apply any direct pressure to the basket itself, or it will crack apart. Next, carefully peel the foil away from the basket. If any small parts of the basket break off as it's unmolded, "glue" them back on with a little more syrup; make sure syrup is fairly cool so it won't melt the basket. Repeat with remaining 3 baskets.

Now turn baskets right side up and drizzle just a little of the remaining syrup (it should be fairly cool) on the top surface of the rims so they won't be completely flat. Store baskets in an airtight container until ready to use. These may be made several hours ahead. *Makes 4 baskets.*

PEAR CROUSTADE with ARMAGNAC SAUCE

Makes one 15 x 10½-inch croustade or 12 to 16 servings

3½ to 3¾ pounds ripe pears (about 8 medium-size pears; preferably Bartlett), peeled, halved lengthwise, and cored
2 cups Armagnac brandy
About 3 cups plus 2 tablespoons sugar
About ¾ pound (3 sticks) plus 5 tablespoons unsalted butter, melted
1 (16-ounce) package top-quality frozen phyllo dough sheets, thawed according to package instructions
Sifted powdered sugar

SPECIAL UTENSILS:
Heavy 15 x 10½ x ¾-inch baking sheet, plus another slightly larger baking sheet
6 glasses or bowls with about 3-inch bases

Cut the pears into paper-thin slices with a mandoline or sharp thin-bladed knife and place in a large glass or ceramic bowl. Stir in the brandy and 1½ cups of the sugar. Cover and refrigerate overnight.

The next day, heat oven to 400 degrees. Prepare the croustade's bottom crust as follows: Use a pastry brush to brush the bottom and sides of the 15 x 10½ x ¾-inch baking sheet with 1 tablespoon of the butter. Line the pan bottom and a little up the sides with a single layer of phyllo dough sheets (keep remaining dough well covered with a slightly damp dishtowel so it doesn't dry out). Lightly brush top of dough with about 2 tablespoons of the butter and fold down any dough extending up sides of pan, then sprinkle top of dough evenly with about 2 tablespoons of the sugar. Add another single layer of dough sheets and lightly brush with about 2 tablespoons more butter, then sprinkle with about 2 tablespoons more sugar. Continue layering until there are 7 layers of buttered and sugared dough sheets in the pan; set aside remaining dough, butter, and sugar.

Bake bottom crust, uncovered, on the middle rack of the preheated oven until lightly browned and almost cooked through, 12 to 15 minutes; keep the larger baking sheet on the next lower oven rack throughout the baking procedure to catch any overflow.

Meanwhile, invert the 6 glasses or bowls and drape ½ of a sheet (about a 12 x 7½-inch rectangle) of the reserved dough or the equivalent in dough scraps over the base of each. Let dough sit uncovered until dried out and stiff, at least 20 minutes or until ready to use; cover remaining dough and set aside. Drain the marinated pears in a strainer placed over a bowl to catch the marinade.

Once the bottom crust has finished baking, remove from oven and reduce oven setting to 350 degrees. Arrange the drained pears evenly over the bottom crust, spreading them to the very edge of the pan; cover marinade and set aside for the sauce. Next, assemble the top crust by layering enough of the remaining dough sheets on top of the pears to have 6 single layers of dough sheets; butter and sugar the top of each layer precisely as you did the bottom crust. Return pan, uncovered, to the 350 degree oven and bake until top crust is cooked through and lightly browned, 25 to 30 minutes.

Meanwhile, make the sauce. To do this, place the reserved marinade in a medium-size saucepan. Bring to a boil, then strongly simmer until syrupy and reduced to about ⅔ cup, about 45 minutes. Remove sauce from heat and set aside.

Once finished baking, remove croustade from the oven and increase oven setting to 400 degrees. Carefully lift the dried dough off the glasses or bowls and heap it evenly over the top of the croustade. Drizzle about 2 tablespoons more butter over the dried dough and sprinkle generously with powdered sugar. Bake uncovered in the 400 degree oven until dried dough is well browned, about 5 minutes. Remove croustade from oven and let cool about 20 minutes before serving. If made ahead, let cool, then cover loosely, and set aside at room temperature; when ready to serve, rewarm uncovered in a 350 degree oven for about 10 minutes.

TO SERVE:

If desired, transfer the croustade to a serving platter and present it to your guests before cutting. Cut into portions with a sharp knife; as you do so, the top crust will crumble. Serve on dessert plates with a little of the sauce spooned over the top (see photograph page 38).

TOURTE OF FOIE GRAS, VENISON, AND BLACK TRUFFLES with MARCHAND DE VIN SAUCE

Makes 6 main-dish or 10 first-course servings

1 recipe *Marchand de Vin* Sauce (see recipe for Prime Rib, page 202)
12 ounces fresh uncooked duck or goose foie gras (Grade B)
12 ounces trimmed loin of sika or axis venison
6 ounces rindless pork fatback
4 ounces boneless pork neck meat or pork shoulder, coarsely chopped
¼ cup chopped onions
1 tablespoon chopped shallots
5 very leafy thyme sprigs
1 garlic clove, peeled and crushed
2 large eggs, lightly beaten
1 tablespoon fine sea salt
2 teaspoons freshly ground black pepper
1 tablespoon Armagnac brandy
1 tablespoon canned truffle juice
2 tablespoons vegetable oil for greasing baking sheet
2 (12-inch or larger) sheets of top-quality frozen puff pastry dough (if sheets are folded, thaw just enough to unfold; if not folded, do not thaw)
Flour for rolling out dough
Pinch of salt
6 (¼-inch-thick) slices fresh black truffles (preferred) or flash-frozen black truffles, thawed

SPECIAL UTENSILS:
Meat grinder fitted with a fine grinding disc
Heavy baking sheet wide enough to hold a 9½-inch *tourte* and still fit inside your refrigerator
Plain metal ½-inch pastry bag tip

Make the *Marchand de Vin* Sauce, then refrigerate.

PREPARE THE FILLING:

With a sharp thin-bladed knife, carefully trim away any green spots on the foie gras caused by contact with the gall bladder. Cutting crosswise, remove 2 ounces of meat from one end of the foie gras and 2 ounces from one end of the venison loin; cut the 2 ounces of each meat into ½-inch cubes and combine in a bowl. Cut 2 ounces of the fatback into ½-inch cubes and add to the bowl with the foie gras and venison cubes; set aside.

Again cutting crosswise, remove 4 ounces of meat from one end of the foie gras and 4 ounces from one end of the venison; coarsely chop the 4 ounces of each meat and place in a large bowl. Coarsely chop the remaining 4 ounces fatback and add it and the pork neck meat to the bowl; set aside.

Cut the remaining 6 ounces foie gras lengthwise into ½-inch-thick slices; cover and refrigerate. Cut the remaining 6 ounces venison into 4 strips, each about 4 inches long and 2 inches wide and thick; cover and refrigerate.

Now add the onions, shallots, thyme sprigs, and garlic to the coarsely chopped meat-fatback mixture and grind mixture in the meat grinder; place in a large bowl. Add 1 of the eggs, the 1 tablespoon salt, and the pepper, Armagnac, and truffle juice, mixing by hand until thoroughly blended; then add the cubed meat-fatback mixture and continue gently mixing until well blended. Set aside. (This may be done several hours ahead; keep refrigerated.)

ASSEMBLE THE *TOURTE*:

(Do this between 1½ and 4 hours before baking.) Grease the heavy baking sheet with the oil; set aside. Roll out 1 of the pastry dough

sheets on a lightly floured surface to a ⅛-inch thickness and cut from it a 9½-inch round; place round on the prepared baking sheet and refrigerate. Roll out the second sheet of dough to a ⅛-inch thickness and cut from it a 12-inch round; place this round and all dough scraps on a cookie sheet lined with parchment or waxed paper and refrigerate.

In a small bowl, lightly beat the remaining egg with the pinch of salt. Remove the 9½-inch dough round from the refrigerator and use a pastry brush to brush the top with a small amount of the egg; set aside leftover egg. Spoon ½ of the reserved filling in the center of the round and spread it to within 1 inch of the edge. Arrange the venison strips over the filling, then cover venison strips with the foie gras slices, and on top of the foie gras arrange the truffle slices. Mound the remaining filling in the center and spread it into a dome shape extending to within 1 inch of the dough's edge.

Next, brush a little more egg around the 1-inch border of dough, then remove the 12-inch dough round from the refrigerator and cover the filling with it (the top round should slightly overlap the bottom round) and gently press edges of dough together to seal; trim edges. Use the dull side of a knife blade to make a decorative border around the *tourte*'s edges with shallow ¼-inch-long indentations at ½-inch intervals. Cut out a ½-inch hole in the very center of the top with a paring knife and insert the narrower end of the pastry bag tip in the hole (this allows steam to escape during baking). Now brush top of dough lightly with more egg (avoid getting it on the decorative border or the dough won't rise properly).

To decorate the top of the *tourte*, draw a pattern of curved lines from the center vent hole to the outer edges with the tip of a paring knife (see photograph page 42), being careful not to cut completely through dough. Next, cut out a few small leaf shapes from some of the reserved dough scraps and arrange them around (but not over) the vent hole; lightly brush tops of leaf shapes with more egg. Refrigerate *tourte* on the baking sheet at least 1 hour or up to 4 hours before baking.

TO BAKE THE *TOURTE* AND SERVE:

Heat oven to 450 degrees. Transfer the baking sheet holding the *tourte* to the preheated oven and bake uncovered until crust is golden brown and slightly puffed, about 20 minutes; then reduce oven setting to 350 degrees and continue baking until done, 45 to 50 minutes more. To check doneness, after 45 minutes of cooking, cut a small slit through the top crust with the tip of a pointed knife; if done, the juices running from the slit will be clear and the crust will be cooked through and crisp. Remove from oven and let cool about 10 minutes.

Meanwhile, heat the serving plates in a 250 degree oven. Also now reheat sauce and place in a sauceboat for serving at the table. Once *tourte* has cooled 10 minutes, cut into wedges and serve immediately on the heated serving plates.

CONSOMME OF HONEY MUSHROOMS with ROASTED BREAST OF WOOD PIGEON, POULTRY LIVER FLANS, BREAST OF WOOD PIGEON AND BLACK TRUFFLE QUENELLES, and CABBAGE LEAVES STUFFED WITH WOOD PIGEON AND HONEY MUSHROOMS

Makes 4 servings

CONSOMME OF HONEY MUSHROOMS:
 5 cups Poultry Consommé (page 214)

(preferred) or other Meat or Vegetable Consommé (page 214)
2 quarts water for blanching mushrooms
4 ounces (2 cups) small fresh honey mushrooms (or mousseron mushrooms), stems discarded (do *not* eat honey mushrooms raw)
QUENELLE MIXTURE:
 1 wood pigeon (or squab), dressed (about ¾ pound dressed; 2 leg/thigh pieces carved off and reserved for stuffed cabbage leaves; liver reserved, if received, for flans)
 Fine sea salt and freshly ground black pepper
 ½ cup plus 2 teaspoons heavy cream
 ½ ounce flash-frozen black truffles, thawed and minced (about 4 teaspoons minced)
Stuffed Cabbage Leaves (recipe follows)
Poultry Liver Flans (recipe follows)
ROASTED BREAST OF WOOD PIGEON:
 1 wood pigeon (or squab), dressed (about ¾ pound dressed; 2 leg/thigh pieces carved off and reserved for stuffed cabbage leaves; liver reserved, if included, for flans)
 Fine sea salt and freshly ground black pepper
 1 tablespoon vegetable oil
2 cups Meat or Vegetable Consommé (page 214) (preferred) or Meat or Vegetable Stock (page 214) for poaching quenelles

SPECIAL UTENSILS:
Chinois
Cheesecloth
Very fine mesh strainer
1-quart-capacity soup tureen

MAKE THE MUSHROOM CONSOMME

Place the poultry consommé in a medium-size pot and bring to a simmer. Meanwhile, bring the 2 quarts water to a boil in a separate pot and blanch the mushrooms in it for 15 seconds to clean them, stirring constantly. Immediately transfer mushrooms with a slotted spoon to the simmering consommé (discard blanching water) and very slowly simmer for 30 minutes. Line the chinois with a double thickness of damp cheesecloth and strain the mushroom consommé through it into a bowl; reserve drained mushrooms for garnishing the soup bowls. Refrigerate consommé and mushrooms separately. (This may be done several hours ahead.)

MAKE THE QUENELLE MIXTURE:

Carve the breast meat from the pigeon. (Save the carcass, if desired, for making stock.) Trim away skin and any fat from breast meat and chop the meat. Place in a food processor, season generously with salt and pepper, and process to a paste. Add the cream and continue processing just until well blended; do *not* overmix. Strain through the strainer, using the bottom of a sturdy ladle to force as much through as possible; the strained mixture should yield ⅔ to ¾ cup. Stir in the truffles. Set aside ½ cup of the mixture for the stuffed cabbage leaves. Cover remaining mixture and refrigerate until ready to form the quenelles. (This may be done several hours ahead.)

Now prepare the Stuffed Cabbage Leaves up to the point of steaming; refrigerate.

TO FINISH THE DISH AND SERVE:

(See photograph page 42.) About 1½ hours before serving, make the Poultry Liver Flans.

Once the flans are out of the oven, immediately increase oven setting to 400 degrees for roasting the pigeon, then roast it as follows: Season the pigeon generously with salt and pepper. Heat the oil in a small ovenproof skillet (preferably nonstick) over high heat, 2 to 3

minutes. Place pigeon in the hot skillet, resting on 1 breast, and cook until breast is browned, about 1 minute. Repeat to brown the other breast, then brown the breasts at the midline for about 30 seconds. Turn pigeon breast up and immediately transfer skillet, uncovered, to the preheated oven. Roast until breast meat is medium rare, about 15 minutes. Do *not* overcook, or the meat will be dry; keep in mind that it will cook a bit more when reheated just before serving. (To test doneness, pierce breast meat with a skewer; if done, the juices will run pink, not bloody and not clear.) Remove from oven, leaving oven set at 400 degrees for briefly heating the soup bowls just before serving. Drain pigeon on paper towels. Cover loosely and let rest about 10 minutes.

While the pigeon is resting, form and cook the quenelles as follows: Bring the consommé for poaching the quenelles to a simmer in a small skillet. Remove from heat. Divide the reserved quenelle mixture into 12 equal portions and mold each into a quenelle (oval shape) with 2 teaspoons; as formed, ease the quenelle into the hot consommé. When all quenelles are formed, return skillet to low heat (do not let consommé reach a simmer) just until cooked through, 5 to 7 minutes; set aside in the hot consommé.

Next, steam the stuffed cabbage leaves as directed in the Stuffed Cabbage Leaves recipe; remove from steamer and set aside, still wrapped in plastic.

Meanwhile, carve the breast meat from the pigeon and cut lengthwise into ⅛-inch slices with a sharp knife.

To serve: Unmold a flan into the center of each of 4 wide ovenproof soup bowls; arrange a portion of the reserved mushrooms from infusing the consommé around each flan. Unwrap the stuffed cabbage leaves, cut each in half, and add 2 halves to each bowl. Add ¼ of the drained quenelles (use a slotted spoon) and sliced pigeon to each bowl, then heat uncovered bowls in the 400 degree oven with door ajar just until all food is heated through, about 2 minutes. Also now heat the soup tureen in the oven for about 2 minutes.

Meanwhile, reheat the mushroom consommé. Once the food in the soup bowls is heated, place the mushroom consommé in the heated tureen for ladling into the bowls at the table.

CABBAGE LEAVES STUFFED WITH WOOD PIGEON AND HONEY MUSHROOMS

3 tablespoons vegetable oil
2 ounces (1 cup) small fresh honey mushrooms (or mousseron mushrooms), stems discarded and caps brushed clean (do *not* eat honey mushrooms raw)
Fine sea salt and freshly ground black pepper
4 reserved leg/thigh pieces of wood pigeon (or squab)
1½ ounces lean prosciutto, cut into ⅛-inch cubes (about ¼ cup)
½ cup reserved quenelle mixture
Salt water (2 tablespoons coarse salt mixed with 6 cups water) for blanching cabbage leaves
4 perfect medium-size Savoy cabbage leaves
Ice water for cooling blanched cabbage leaves

SPECIAL UTENSIL:
Steamer

For the filling, heat a large nonstick skillet about 1 minute over high heat. Add 2 tablespoons of the oil and heat, 1 to 2 minutes. Add the mushrooms, season with salt and pepper, and sauté for 1 minute, stirring frequently.

Reduce heat to medium and cook until well browned, about 6 minutes, stirring occasionally. Remove from heat. Drain mushrooms on paper towels and very finely chop; set aside.

Season the pieces of pigeon with salt and pepper. In a small nonstick skillet, heat the remaining 1 tablespoon oil over high heat, 4 to 5 minutes. Add the pigeon pieces and sauté about 1½ minutes on the first side; turn and continue cooking until meat is cooked through, about 2 minutes more. Drain on paper towels. Carve the meat from the bones and very finely chop it (it should yield about 3 tablespoons); combine in a bowl with the prosciutto, quenelle mixture, and the reserved chopped mushrooms. Season this filling with a generous amount of pepper but no salt; set aside.

For the cabbage leaves, bring the salt water to a rolling boil in a medium-size pot. Add the leaves and blanch until tender enough to fold, about 2 minutes, gently stirring occasionally (be careful not to rip leaves). Immediately cool in the ice water; drain and blot dry with paper towels. Shave or trim the thick stem end of each leaf so it will fold easily and spread leaves smoother side down on a work surface.

Place ¼ of the filling in the center of each leaf and fold them as you would an envelope to form rolls. Place 1 stuffed cabbage leaf seam side up in the center of a large (about 1 foot) square of plastic wrap; bring all edges of the wrap together and twist wrap tightly to snugly bundle the stuffed cabbage leaf inside, forcing out as much air as possible as you wrap. Continue twisting edges of plastic until tightly coiled so it won't unwrap when stuffed cabbage leaf is steamed; once done, the packaged leaf should be a 2-inch ball. Next, prick 4 or 5 tiny holes through the plastic with a pin; if the holes enlarge, wrap with more plastic without removing the first piece and prick new holes. Repeat with the remaining 3 stuffed cabbage leaves. Refrigerate until ready to steam.

When ready to serve, steam the plastic-wrapped stuffed cabbage leaves in the covered steamer over boiling water just until heated through, about 7 minutes. *Makes 4 stuffed cabbage leaves.*

POULTRY LIVER FLANS

1 tablespoon unsalted butter, plus butter for greasing flan molds
¼ cup heavy cream
¼ cup milk
¼ cup (about 2 ounces) wood pigeon livers or other poultry livers
Fine sea salt and freshly ground black pepper
1 large egg

SPECIAL UTENSILS:
5 (¼-cup-capacity) Pyrex flan molds, 2¼-inch diameter at inside top, 1⅝-inch diameter at outside base, 1⅞ inches tall
Chinois

Heat oven to 300 degrees. Generously butter flan molds; set aside. Combine the cream and milk in a small pot and bring to a boil. Remove from heat and set aside.

Melt the butter in a small nonstick skillet over medium heat. Add the livers, season with salt and pepper, and sauté for 2 minutes, stirring occasionally. Transfer livers to a blender; add the scalded cream-milk mixture, the egg, and a generous amount of salt and pepper, and process until smooth. Strain through the chinois, using the bottom of a sturdy ladle to force as much through as possible.

Pour the strained mixture into the prepared molds and place molds in a small baking pan; add enough boiling water to the pan to come up

the sides of molds 1½ inches. Bake uncovered in the preheated oven until done, about 50 minutes. (To test doneness, after about 45 minutes of cooking, remove a mold from the oven, loosen sides of flan with a thin flexible-bladed knife in 1 clean movement, and invert onto a plate; if done, the flan will hold its shape and when cut in half, the center will be solid, not runny.) Remove cooked flans from oven and let them sit in the hot water for at least 10 minutes or up to about 30 minutes; then unmold and serve promptly. *Makes 4 flans, plus 1 for testing doneness.*

ROASTED PARTRIDGE with SAUTEED CABBAGE, CABBAGE SALAD DRESSED WITH PARTRIDGE LIVER VINAIGRETTE, and BOILED RED POTATOES

Makes 4 servings

1 recipe Mirepoix of Prosciutto and Onions (page 167)
Salt water (2 tablespoons coarse salt mixed with 6 cups water) for boiling potatoes
5 medium-size well-formed red potatoes (about 1¾ pounds), scrubbed well
Ice water for cooling boiled potatoes
3½ cups very finely shredded Savoy cabbage (see Note)
3½ cups very finely shredded red cabbage (see Note)
Salt water (¼ cup coarse salt mixed with 3 quarts water) for blanching cabbage
Ice water for cooling blanched cabbage
2 tablespoons unsalted butter
34 fresh or dried juniper berries
Fine sea salt and freshly ground black pepper
Extra-virgin olive oil for oiling potato slices
4 young partridges, dressed (each about 14 ounces dressed)
¼ cup vegetable oil
VINAIGRETTE:
　¼ cup (about 2 ounces) partridge or other poultry livers
　Fine sea salt and freshly ground black pepper
　¼ cup plus 2 tablespoons vegetable oil
　1 tablespoon minced shallots
　1 tablespoon minced spring (green) onions
　3 tablespoons sherry wine vinegar
　1 tablespoon extra-virgin olive oil
24 thyme sprigs, snipped into small pieces for garnish

NOTE:
A vegetable shredder works well for this; cut each slice less than ⅛ inch thick.

Make the Mirepoix of Prosciutto and Onions; refrigerate.

Bring the salt water for boiling the potatoes to a boil in a large pot. Add the potatoes and very slowly simmer just until tender, about 40 minutes. Check doneness with a thin metal skewer (if done, it will insert and withdraw easily), but do this sparingly since the potatoes, once sliced, tend to crack apart where pierced. Immediately drain and cool thoroughly in the ice water; drain again and set aside.

Meanwhile, prepare the sautéed cabbage as follows: Measure out 2 cups of *each* color of cabbage (keep colors separated); combine the remaining cabbage in a medium-size bowl and set aside, covered, for the cabbage salad. Bring the salt water for the cabbage to a rolling boil in a large nonreactive pot. Add the 2 cups *green* cabbage and blanch just until tender, about 2 minutes. Immediately transfer with a slotted spoon to the ice water, then add the 2 cups *red*

cabbage to the boiling water and blanch until tender, about 2 minutes. Promptly drain red cabbage and cool in the ice water with the green cabbage; drain on paper towels.

Melt the butter in a large nonstick skillet over medium heat. Add the blanched cabbage, the Mirepoix of Prosciutto and Onions, and 10 of the juniper berries; sauté about 3 minutes, stirring occasionally, then season with salt and pepper and remove from heat. Set sautéed cabbage aside.

Now cut the unpeeled potatoes into ¼-inch slices. Lightly brush tops of the 24 prettiest slices with olive oil and arrange 6 slices around the edges of each serving plate; discard leftover slices. Cover plates with plastic wrap and set aside.

Heat oven to 400 degrees for roasting the partridges. Season partridges generously with salt and pepper; tuck legs into skin folds under the tails or tie close to bodies with kitchen twine. Cut off and discard the first two joints of the wings. Heat the vegetable oil in a very large ovenproof skillet (preferably nonstick) over high heat, 2 to 3 minutes. Add each partridge, resting on 1 breast, and cook until breast is browned, about 1 minute. Repeat to brown the other breast, then brown the breasts at the midline for about 30 seconds more. Turn partridges breast up and transfer skillet, uncovered, to the preheated oven. Roast until breast meat is medium rare, 12 to 15 minutes; do *not* overcook, or the meat will be dry. (To test doneness, pierce breast meat with a skewer; if done, the juices will run pink, not bloody and not clear.) Remove partridges from oven and drain on paper towels; cover loosely and let sit about 10 minutes.

Meanwhile, make the vinaigrette and finish the cabbage salad. For the vinaigrette, season the livers with salt and pepper. Heat 1 tablespoon of the vegetable oil in a small nonstick skillet over high heat for 1 minute. Add the livers, shallots, and spring onions and sauté about 1½ minutes. Turn livers over and cook another 1½ minutes, then add 1 tablespoon of the vinegar and continue cooking just 30 seconds more, stirring constantly. Process mixture in a blender with the remaining 5 tablespoons vegetable oil, remaining 2 tablespoons vinegar, and the olive oil until thoroughly blended.

Add 2 tablespoons of the vinaigrette to the raw cabbage reserved for the cabbage salad, tossing well (reserve leftover vinaigrette). Season to taste with salt and pepper; set aside.

To serve: (See photograph page 43.) Once the partridges have cooled for 10 minutes, carve the breast meat and leg/thigh pieces from each (save carcasses, if desired, for making stock). Reheat sautéed cabbage, then unwrap serving plates, and mound ¼ of it in the center of each plate; cover sautéed cabbage with a portion of the cabbage salad, then arrange the partridge breasts and leg/thigh pieces on top. Brush the partridge and potato slices with the remaining vinaigrette and garnish potatoes with the remaining 24 juniper berries and the snipped thyme. Serve immediately.

SALMIS OF MULARD DUCK WITH HONEY MUSHROOMS and GLAZED PEARL ONIONS

Makes 4 servings

1 mulard duck, dressed (8½ to 9 pounds dressed)
½ cup chopped lean prosciutto (about 2½ ounces)
½ cup unpeeled chopped carrots
½ cup chopped onions
½ cup chopped leeks (white and green parts)
½ cup chopped celery

2 tablespoons finely chopped shallots
10 large parsley sprigs
10 thyme sprigs (very leafy single stems, each 4 to 5 inches long)
2¼ cups Cabernet Sauvignon wine
3 large bay leaves
6 cups Meat or Vegetable Consommé (page 214) (preferred) or Meat or Vegetable Stock (page 214)
2 cups *Fond de Veau* (page 214)
GLAZED PEARL ONIONS:
　¾ pound pearl onions, peeled (about 1¾ cups)
　2 cups water
　¼ pound (1 stick) unsalted butter
　¼ cup sugar
　½ teaspoon fine sea salt
6 ounces (3 cups) small fresh honey mushrooms (or mousseron mushrooms), stems discarded (do *not* eat honey mushrooms raw)
1 quart boiling water for blanching mushrooms
1 tablespoon cornstarch

SPECIAL UTENSIL:
Fine mesh strainer

START THE SALMIS:
Heat oven to 500 degrees. Carve the breast meat from the duck to form 2 half-breast portions with fat and skin still attached, then cut off each leg/thigh piece. Refrigerate breast and leg/thigh pieces.

Cut the wings from the carcass and chop carcass into 3 pieces with a cleaver. Place carcass, wings, neck, and any giblets in a roasting pan and brown in the preheated oven for about 45 minutes. Remove pan from oven and transfer bones to a bowl; set aside.

Strain the fat from the roasting pan and place 3 tablespoons of it in a large nonstick skillet; set aside remaining fat. Heat over high heat, 4 to 5 minutes. Add the duck leg/thigh pieces, skin side down, and brown about 3 minutes on each side; transfer to a plate. Next, brown the breasts, skin side down first, about 3 minutes per side. Remove from heat and transfer breasts to plate with the leg/thigh pieces; set aside.

Place 2 tablespoons more strained fat in a heavy 8-quart pot and heat about 2 minutes until hot. Add the prosciutto, carrots, onions, leeks, celery, shallots, and parsley and thyme sprigs and sauté about 4 minutes, stirring frequently. Add the reserved browned bones, 2 cups of the wine, and the bay leaves. Bring to a boil and continue boiling about 5 minutes, stirring occasionally. Add 3 cups of the consommé and the *Fond de Veau* and return to a boil, stirring occasionally. Reduce heat and strongly simmer for 30 minutes, stirring occasionally.

Now transfer the larger bones from the pot to a bowl and set aside. Add to the pot the remaining 3 cups consommé and the duck breast and leg/thigh pieces. Return to a boil over high heat. If the meat is not submerged, remove more bones from the pot (or if there is room to spare and still keep meat submerged, return some bones to the pot). Reduce heat and simmer until pieces are very tender, about 2 hours, making sure to keep them submerged throughout cooking. Remove from heat and transfer breasts and leg/thigh pieces to a plate. Strain the sauce through the strainer into a large deep bowl, using the bottom of a sturdy ladle to force as much through as possible. (The bones may be saved for making *Fond de Veau*.) Return the breasts and leg/thigh pieces to the sauce; make sure meat is submerged. Cool slightly, cover, and refrigerate for several hours, preferably 1 to 3 days.

TO FINISH THE SALMIS AND SERVE:
(See photograph page 45.) Combine all the

ingredients for the glazed pearl onions in a large skillet and bring to a boil over high heat. Reduce heat and strongly simmer until onions are glazed and lightly browned, 30 to 35 minutes, stirring occasionally at first and almost constantly the last few minutes to prevent scorching. Remove from heat and promptly transfer to a heatproof bowl; set aside.

Blanch the mushrooms in the 1 quart boiling water for 15 seconds to clean them, stirring constantly. Immediately drain and set aside.

Remove and discard the congealed fat from the top of the salmis and place in a heavy 4-quart saucepan. Bring to a boil over high heat, then simmer for 10 minutes, stirring occasionally. Dissolve the cornstarch in the remaining ¼ cup wine and stir it into the salmis, then add the mushrooms and simmer 15 minutes, stirring occasionally. (Meanwhile, heat 4 serving plates or wide soup bowls in a 250 degree oven.) Add the glazed onions and continue simmering 5 minutes more. Serve immediately.

To serve, trim some of the fat from the duck breasts if desired. Arrange a breast or leg/thigh piece in the center of each heated serving plate and ladle some of the sauce around the edges, making sure mushrooms and onions are in each portion.

HARE A LA ROYALE with BEET PUREE and RED WINE SAUCE

Makes 12 to 14 servings

HARE *A LA ROYALE:*
1 fresh or thawed hare (4 to 5 pounds without head); all blood or thawed juices reserved
2 pounds veal bones
1 pound fresh uncooked duck or goose foie gras (Grade B)
1 pound plus 1 ounce pork fatback with rind
½ pound boneless pork shoulder, coarsely chopped
½ cup sliced onions
2 tablespoons thinly sliced shallots
2 small peeled garlic cloves
10 thyme sprigs (very leafy single stems, each 4 to 5 inches long)
About 2 tablespoons fine sea salt
About 1 tablespoon freshly ground black pepper
2 large eggs, lightly beaten
1 ounce flash-frozen black truffles, thawed and cut into ½-inch cubes
2 tablespoons canned truffle juice
1 tablespoon Armagnac brandy
2 (about 20 x 15-inch) pieces of pork caul fat (see Note)
2 cups unpeeled chopped carrots
2 cups chopped celery
2 cups chopped leeks (mostly white part)
2 cups chopped onions
1 cup unpeeled chopped turnips
½ cup chopped shallots
6 large peeled garlic cloves, crushed
6 cups Cabernet Sauvignon wine
¼ cup rendered duck fat or pork lard (preferred) or vegetable oil
Red Wine Sauce (recipe follows)
Beet Purée (recipe follows)

SPECIAL UTENSILS:
Meat grinder fitted with a fine grinding disc
Cheesecloth
Kitchen twine
Pastry bag fitted with a Number 4 star tip
NOTE:
Caul fat is available from butcher shops. Ask for pieces with few if any holes and ones without extra-large veins of fat running through them; refrigerate, soaking in water, until used.

PREPARE THE HARE FOR STUFFING:

Heat oven to 500 degrees. Remove and discard all internal organs from the hare except the liver. Drain all blood or thawed juices into a bowl; refrigerate.

Before proceeding, keep in mind that your first task is to bone the hare, leaving the skin and meat in 1 piece, with few if any holes pierced through the skin. Your second goal is to trim as much meat from the piece of skin as possible, keeping the 2 tenderloins (the strips of meat on either side of the backbone) intact and again leaving the skin in 1 piece with few if any holes pierced through it.

Place the hare, breast up, on 1 or more large dishtowels (to absorb juices) with the neck end facing you. Bone 1 side of the hare at a time, reserving all bones. Beginning at the lower end of the rib cage and close to the midline of the breast, use a small sharp knife to carefully work the meat and skin away from the rib cage; cut as close to the bone as possible. When you reach each front and back leg, cut through the ball-and-socket joint to free the shoulder and thigh bones from the carcass; then carefully work the meat away from the shoulder and thigh bones. Next, separate the skin and meat from the backbone along its entire length to free the carcass in 1 piece; avoid piercing holes through the skin and carefully work the knife tip around 1 vertebra at a time to separate it from the skin. Lift away the carcass and set it aside.

Remove each leg/shoulder and leg/thigh bone from the surrounding skin and meat as follows: With the hare still skin side down, cut a slit the entire length of each leg/shoulder and leg/thigh bone through the meat to the bone; work meat from around each leg/shoulder and leg/thigh bone so the bone can be removed as one unit. Coarsely chop the leg bones and carcass with a cleaver; set aside.

Use a slicing knife to cut as much meat from the skin as possible, leaving each tenderloin in 1 piece; remember to avoid piercing holes through the skin. Once finished, the piece of skin will be of uneven thickness but should be about ¼- to ½-inch thick in most spots. Cover skin and refrigerate; set meat aside.

Roast the hare bones with the veal bones in the preheated oven until very dark brown on all sides, about 1½ hours. When finished, remove from oven and set aside. Meanwhile, prepare the filling.

PREPARE THE FILLING:

Coarsely chop 8 ounces of the hare meat and place in a large bowl; reserve remaining meat, refrigerated, for adding to the roasting pan when cooking the stuffed hare.

With a sharp thin-bladed knife, carefully trim away any green spots on the foie gras caused by contact with the gall bladder. Cutting crosswise, remove 8 ounces of meat from one end of the foie gras; coarsely chop this 8 ounces and add to the bowl with the coarsely chopped hare meat. Cut 3 ounces more meat from the same end of the foie gras and cut this 3 ounces into ½-inch cubes; set aside. Cut the remaining 5 ounces foie gras lengthwise into strips that are 1½ inches wide and thick; cover well and refrigerate.

Trim the rind from the fatback; coarsely chop rind and reserve, refrigerated, for adding to the roasting pan when cooking stuffed hare. Cut 4½ ounces of the fatback into 1½ inch wide and thick strips (make strips as long as possible); cover and refrigerate. Cut just enough of the remaining fatback into ½-inch cubes to yield ½ cup; set aside. Coarsely chop the remaining fatback and add to the bowl with the coarsely chopped meats; add to the bowl the pork shoulder, the hare liver, the sliced onions and shallots, the 2 small garlic cloves, and 5 of the thyme

sprigs. Grind the mixture in the meat grinder.

Place ground mixture in a large bowl. Add the reserved cubed foie gras and fatback, 2 tablespoons sea salt, 2 tablespoons of the reserved hare blood or thawed juices (reserve any leftover blood or juices, refrigerated, for the sauce), 1 tablespoon pepper, and the eggs, truffles, truffle juice, and brandy; mix gently by hand until filling is thoroughly mixed.

Now make a small test patty with 1 to 2 tablespoons of the filling and bake uncovered in a 400 degree oven for 10 minutes (if still roasting the hare and veal bones, bake the patty in the 500 degree oven for about 8 minutes). Let cool, then taste for seasoning and add more salt and pepper to remaining filling if needed. Set aside. (Refrigerate if prepared ahead.)

ASSEMBLE THE HARE:

Spread out 1 of the pieces of caul fat on a work surface and cover it with the other piece of caul; arrange the piece of hare skin, flesh side down, on top. Spread ½ of the filling evenly over the skin to within 1 inch of the edge, then arrange the reserved foie gras strips parallel to one another and in a single layer on top, forming a band of foie gras about 5 inches long and 4 inches wide; the length of the strips should run parallel to the longer sides of the skin and extend to within about 1 inch from the edge of the skin's shorter sides.

Next, cut the reserved hare tenderloins lengthwise into 1½-inch wide and thick strips; arrange ½ of the strips on either side of the foie gras strips, running parallel to them, to form 2 lengthwise bands of tenderloin with foie gras strips in between. Now arrange ½ of the reserved fatback strips on either side of the tenderloin strips, running parallel to them; once in place, the fatback strips should extend to within about 2 inches from the edge of the skin's longer sides. Now spread the remaining filling evenly over the top to cover all strips and extend to the edge of the first layer of filling.

Fold both long sides of the skin over the filling to cover it as much as possible, forming hare into a log shape; wrap log tightly in the caul, then wrap very snugly in a double thickness of cheesecloth and tightly twist the ends to close; tie ends with kitchen twine and snugly wrap the log several times with more twine so it will keep its shape while cooking. With the tip of a pointed knife, poke tiny holes through the cheesecloth and caul fat layers at about 2-inch intervals. Set aside. (The hare may be prepared to this point a day before cooking; refrigerate if prepared ahead.)

COOK THE HARE:

Heat oven to 350 degrees. In a large ungreased roasting pan (about 16 x 14 x 3½ inches), form a bed of the chopped carrots, celery, leeks, onions, turnips, and shallots, the 6 large garlic cloves, and the remaining 5 thyme sprigs. Place the packaged hare on top; add the reserved roasted hare and veal bones, leftover hare meat, and fatback rind around the edges. Pour the wine and duck fat over all the other ingredients. Bake uncovered for 3 hours. Remove from the oven and transfer hare to a platter; reserve roasting pan. Let hare cool and refrigerate overnight; keep refrigerated until just before time to reheat.

Now make the Red Wine Sauce; refrigerate overnight.

TO FINISH THE DISH AND SERVE:

(See photograph page 45.) Prepare the Beet Purée; set aside (refrigerate if made ahead).

Now remove the packaged hare from the refrigerator; remove the twine and unwrap cheesecloth, leaving the caul fat in place; cut hare crosswise into 12 to 14 slices (each slice

should be ½ to ¾ inch thick). Wrap each slice well in plastic wrap, then wrap securely in a second piece of plastic. Fill a very large deep pan with 1 inch of water and bring to a slow simmer. Place the plastic-wrapped hare slices in the hot water in a single layer (heat in 2 batches, if needed) and gently simmer for 8 minutes on each side. Transfer to a platter and cover with a dishtowel to keep warm.

Meanwhile, reheat the beet purée in a small nonstick skillet over medium heat, about 7 minutes, stirring occasionally; place in the pastry bag and set aside. Also now reheat sauce and heat the serving plates in a 250 degree oven.

Once the hare slices are heated, unwrap plastic wrap (but not caul) and place a slice on each heated serving plate; pipe 3 rosettes of beet purée onto each plate and spoon a little sauce around the hare. Serve immediately.

RED WINE SAUCE

Bones, vegetables, and pan juices from cooking hare (still in roasting pan)
3 cups Cabernet Sauvignon wine
5 thyme sprigs (very leafy single stems, each 4 to 5 inches long)
3 cups Meat or Vegetable Consommé (page 214) (preferred) or Meat or Vegetable Stock (page 214)
2½ cups *Fond de Veau* (page 214)
Reserved hare blood or thawed juices left over from preparing filling (optional)

SPECIAL UTENSIL:
Chinois

Transfer the bones and vegetables from the roasting pan to a heavy 4-quart saucepan; set aside. Drain as much fat from the roasting pan as possible, then add to the pan the wine and thyme sprigs; cook over high heat on top of the stove for 10 minutes, stirring occasionally. Remove from heat and add wine mixture and the consommé to the saucepan with the bones and vegetables. Bring to a boil over high heat, then strongly simmer for 45 minutes. Add the *Fond de Veau* and, if using, the hare blood or thawed juices. Continue cooking until liquid is a sauce consistency, about 45 minutes more. Discard bones and strain sauce through the chinois.

BEET PUREE

1½ pounds unpeeled fresh beets without stalks, trimmed and rinsed well
5 tablespoons heavy cream
2 tablespoons Meat or Vegetable Consommé (page 214) (preferred) or Meat or Vegetable Stock (page 214)
Fine sea salt and freshly ground black pepper

Place the beets in a large pot of water and cook over high heat until tender, about 45 minutes. Let cool, then peel and chop. Purée beets in a blender or food processor. Add the cream and consommé and continue processing just until blended; do *not* overmix. Season to taste with salt and pepper. Use immediately or refrigerate if made ahead.

FRESH CHESTNUT SOUFFLES with POACHED PEARS, APPLES, AND PEACHES

Makes 4 or 5 servings

3 small to medium-size firm ripe pears (preferably Bartlett)
2 medium-size Granny Smith apples
2 medium-size firm ripe peaches

Lemon water (¼ cup lemon juice mixed with 3 cups water)
6 cups water
⅓ cup sugar
2 tablespoons lemon juice
3 tablespoons unsalted butter, softened
2 tablespoons heavy cream
Sugar water (2 cups sugar mixed with 2 cups water)
A 4-inch piece of vanilla bean
SOUFFLES:
2 tablespoons unsalted butter, melted for soufflé dishes
About 5 teaspoons sugar for soufflé dishes
2 quarts water for blanching chestnuts
5½ ounces (1 cup) unpeeled fresh chestnuts
Ice water for cooling blanched chestnuts
⅔ cup half and half
¼ cup plus 2 tablespoons sugar
A 4-inch piece of vanilla bean
2 egg yolks (from large eggs)
½ cup egg whites (from about 4 large eggs), at room temperature
⅛ teaspoon lemon juice
Sifted powdered sugar

SPECIAL UTENSILS:
Chinois
4 or 5 (¾-cup-capacity) individual soufflé dishes, inside top diameter 2⅞ inches, outside base diameter 2⅞ inches, 1⅝ inches deep
Heavy baking pan, large enough to hold the soufflé dishes with at least 1 inch between dishes

PREPARE THE FRUIT FOR POACHING AND MAKE THE SAUCE:

Cut each of the three types of fruit into about 16 oval shapes, reserving all scraps except stems; the finished ovals should be skinless, about 1½ to 2 inches long, and about ½ inch wide at the widest part. Add the ovals to the lemon water as formed; once all are finished, refrigerate.

To make the sauce, place the reserved fruit scraps in a deep heavy 4-quart saucepan that is nonreactive. Add the water, sugar, and lemon juice. Bring to a boil and continue boiling until liquid reduces to the height of the scraps, about 1 hour. Remove from heat and strain through the chinois, using the bottom of a sturdy ladle to force as much through as possible; the strained liquid should yield about 2 cups.

Return strained liquid to the saucepan; bring to a boil and continue boiling until reduced to ½ cup, about 15 minutes. Remove from heat and process in a blender with the butter until smooth; then, with the machine running, add the cream and continue processing about 30 seconds more. Set aside at room temperature until ready to serve.

POACH THE FRUIT:

Place the sugar water in a 2-quart saucepan; cut the vanilla bean in half lengthwise, scrape, and add scrapings and bean halves to the pan. Bring to a boil, stirring occasionally. Drain the fruit and add it to the pan; cook just under a simmer until barely tender, 8 to 10 minutes. Transfer fruit and cooking liquid to a bowl. Set aside until ready to serve.

TO MAKE THE SOUFFLES AND SERVE:

(See photograph page 46.) Heat oven to 425 degrees. Use a pastry brush to very generously butter the soufflé dishes, including the rims, with the melted butter. Coat each dish evenly with about 1 teaspoon sugar. Refrigerate until ready to use.

Bring the water to a rolling boil in a large pot. Add the chestnuts and blanch for 5 minutes. Immediately drain and cool in the ice water;

drain again. Slice off the bottom of each shell with a sharp knife, then peel off remaining shell.

Place the peeled chestnuts in a small heavy saucepan; add the half and half and 2 tablespoons of the sugar. Cut the vanilla bean in half lengthwise, scrape, and add scrapings and bean halves to the pan. Bring to a boil, then slowly simmer until chestnuts are tender, about 10 minutes. Remove from heat and discard vanilla beans (or rinse and save for future use). Purée mixture in a food processor until smooth, then transfer to a large bowl; stir in the egg yolks, blending well. Set aside.

Place 1 inch of water in the heavy baking pan and bring to a boil on top of the stove. Meanwhile, in the medium-size bowl of an electric mixer (make sure bowl is very clean), combine the egg whites and lemon juice; beat at low speed for about 30 seconds. Increase speed to medium and beat about 30 seconds until frothy bubbles begin to form, then add 3 tablespoons of the sugar and beat at medium for 30 seconds more. Increase speed to high, add the remaining 1 tablespoon sugar, and continue beating just until stiff peaks form, about 1 minute more.

Lightly fold about ¼ of the egg white mixture into the chestnut mixture just until barely blended, then lightly fold in remaining egg whites; do *not* overmix. Gently spoon batter into the prepared soufflé dishes. Run your thumb around the top edge of each dish to form a groove about ¼ inch wide and deep between the dish and the soufflé batter. Place dishes in the pan of boiling water and cook on top of the stove for 4 minutes, keeping the water strongly simmering; then quickly transfer pan, uncovered, to the preheated oven and bake until soufflés are cooked through, puffed, and browned on top, 15 to 18 minutes.

Meanwhile, drain the fruit and arrange a portion in a large circle on each of 4 dessert plates. When the soufflés have finished cooking, remove pan from oven and immediately transfer the soufflés in their molds or unmolded to the centers of the dessert plates. (To unmold, quickly but gently run a knife around the edge of the soufflé, then turn dish on its side on a work surface and ease dish away without moving the soufflé itself. Immediately place soufflé upright and transfer with a spatula to a serving plate.) Sprinkle tops with powdered sugar and spoon about 2 tablespoons sauce around the edges of each serving of fruit. Serve promptly.

MERVEILLES

Makes about 8 dozen (1½-inch) merveilles

1¾ cups plus 2 tablespoons all-purpose flour
½ teaspoon baking powder
Pinch of salt
2 large eggs
2 tablespoons granulated sugar
4 tablespoons unsalted butter, softened
Generous ½ teaspoon very finely grated
 lemon zest
1 tablespoon Armagnac brandy
Vegetable oil for deep frying
Sifted powdered sugar

SPECIAL UTENSILS:
Cookie cutters of various shapes, no longer or
 wider than about 1½ inches (or cut dough
 out by hand)

Sift the flour, baking powder, and salt into a bowl. In the medium-size bowl of an electric mixer fitted with a paddle, beat the eggs and granulated sugar on low speed until frothy. Add the butter, lemon zest, and ½ of the flour mixture, beating until well blended, then beat in remaining flour. Add the brandy, increase speed to medium, and continue beating until dough is

stiff and elastic, about 3 minutes more. Form into a ball and place in a bowl; cover with plastic wrap directly on the surface of the dough. Refrigerate overnight.

Return covered dough to room temperature, about 1½ hours. Cut into 2 equal portions and roll out each portion to a ⅛-inch thickness. With the cookie cutters or by hand, cut dough into a variety of shapes no longer or wider than about 1½ inches; reserve scraps to fry, too. Heat the oil in a large deep pan or deep fryer to 400 degrees. Fry dough pieces in batches in the hot oil until light golden brown and cooked through, about 20 to 30 seconds on each side (maintain oil temperature at about 400 degrees for all batches). Drain on paper towels and sprinkle with powdered sugar. (See photograph pages 46-47.) Serve promptly.

BELON OYSTERS AND LOBSTER MOUSSELINE WRAPPED IN POTATOES

Makes 4 first-course servings

⅓ cup Lobster Mousseline (page 215)
18 ounces (about 2 large) Finnish potatoes
 (preferred) or russet potatoes
1 tablespoon lemon juice
Fine sea salt and freshly ground black pepper
4 shucked medium to large oysters (about 3
 ounces; preferably Belon), dark edges
 trimmed
Vegetable oil for deep frying

SPECIAL UTENSIL:
Mandoline or similar slicer with a julienne
 attachment

Make the Lobster Mousseline; refrigerate.

Peel the potatoes and very finely julienne them with the mandoline, making strips no wider than ¹⁄₁₆ inch. Place in a bowl and toss with the lemon juice. Season generously with salt and pepper. Squeeze dry, then blot with paper towels to dry thoroughly.

Cut out four 10-inch squares of plastic wrap. To form each purse, mound 1 tightly-packed tablespoon of the potatoes in the center of 1 of the plastic squares, flattening and spreading potatoes evenly to form a very thin 3-inch patty (you should not be able to see wrap through the patty); in the center of the patty, mound 2 teaspoons of the Lobster Mousseline, spreading it to about ½ inch from the edge of patty; place a drained oyster on top and season oyster and mousseline with salt and pepper; cover with 2 teaspoons more mousseline, then add ½ tightly-packed tablespoon more potatoes, spreading them to cover the mousseline; next, draw up sides and corners of the plastic wrap and wrap ingredients snugly to form a 2-inch-round purse, twisting edges of plastic so they coil very tightly, securely sealing the purse inside; with a pin, prick 2 or 3 tiny holes through the wrap to allow any juices to drain out. If the plastic rips as you prick the holes, wrap another plastic square around the first one, sealing it as before, then prick more holes.

Freeze purses until they can hold their shapes when unwrapped, at least 30 minutes and no more than 2 hours; keep frozen until time to fry.

To fry and serve: (See photograph page 50.) Heat oven to 400 degrees. Heat the oil in a large deep skillet or deep fryer to 400 degrees. When the oil is hot, remove purses from the freezer, carefully unwrap them, and fry in the hot oil until dark golden brown, about 1 minute, turning once. Drain briefly on paper towels, then place on an ungreased cookie sheet and bake uncovered for 3 minutes. (Heat serving plates in the oven at the same time.) Remove from oven and serve while still piping hot.

CREAM OF GREEN LENTIL SOUP with VEAL SHANK, "WHITE KIDNEYS," and FOIE GRAS, MAGRET OF DUCK, AND BLACK TRUFFLE SAUSAGE

Makes 4 servings

Foie Gras, *Magret* of Duck, and Black Truffle
 Sausage (recipe follows)
SOUP:
1¼ cups dried green lentils, soaked in
 water overnight in refrigerator
½ large unpeeled onion
3 quarts water for blanching veal shank
1 (3½-pound) meaty veal shank or 2 or
 more meaty pieces of veal shank to
 total 3½ pounds

2 cups unpeeled chopped tomatoes
1 cup unpeeled chopped carrots
1 cup chopped celery
1 cup chopped leeks (mostly white part)
1 cup unpeeled chopped turnips
¾ cup chopped shallots
3 medium-size unpeeled garlic cloves,
 crushed
10 large parsley sprigs
7 thyme sprigs (very leafy single stems,
 each 4 to 5 inches long)
5 medium-size bay leaves
1 tablespoon coarse salt
½ teaspoon whole black peppercorns
2 cups V-8 Juice
About 3 quarts cool water for starting soup
4 ounces very lean prosciutto, chopped
½ cup chopped onions
About ¾ cup heavy cream
Fine sea salt and freshly ground black
 pepper
1 recipe cooked "White Kidneys" (see recipe
 for Cream of Eggplant Soup, pages 180-
 181)

SPECIAL UTENSILS:
8-quart or larger soup pot or stockpot
Fine mesh strainer

First, make the Foie Gras, *Magret* of Duck, and Black Truffle Sausage; set aside, refrigerate, or freeze (depending on how far ahead made) as directed in the recipe.

MAKE THE SOUP:
Char the onion half as directed in the Poultry Stock recipe on page 214; set aside.

Meanwhile, bring the 3 quarts water for blanching the veal shank to a rolling boil in the soup pot or stockpot. Add the veal shank and return to a boil. Remove from heat and transfer shank to a bowl; drain blanching water and rinse pot well.

Return veal shank to the pot. Add the reserved charred onion half and the tomatoes, carrots, celery, leeks, turnips, ½ cup of the shallots, the garlic, parsley and thyme sprigs, bay leaves, coarse salt, peppercorns, V-8 Juice, and 3 quarts cool water; then, if needed, add more water to cover all the other ingredients. Bring to a strong simmer and continue simmering until meat is very tender, about 1 hour 15 minutes, stirring and skimming surface occasionally. Remove from heat.

Transfer veal shank to a bowl; cover and set aside. Strain stock through the strainer, using the bottom of a sturdy ladle to force as much through as possible. If the strained stock yields less than 7 cups, add water to make 7 cups; if the stock yields more than 7 cups, place in a clean pot and boil until reduced to 7 cups. (The soup may be prepared up to this point a day ahead; keep the stock and veal shank refrigerated.)

Heat a heavy 4-quart saucepan over high heat for 1 minute. Add the prosciutto, chopped onions, and the remaining ¼ cup shallots; cook until mixture barely starts to brown, about 8 minutes, stirring occasionally. Add the reserved 7 cups strained stock and bring to a boil; then drain the lentils and add to the pan. Return to a boil. Reduce heat and simmer until lentils are tender and the soup's flavors develop, about 1 hour 15 minutes, stirring occasionally.

Meanwhile, heat 4 wide soup bowls in a 250 degree oven. Remove the meat from the shank bone and trim away fat and gristle. Cut veal into ¼-inch slices; cover and set aside. Next, prepare the "White Kidneys" (duck testicles) as directed on page 181; set aside in the cooking liquid to keep moist and warm until ready to serve. If desired, reheat the sausage as directed on page 177, then cut it crosswise and on the diagonal into ¼-inch slices; set aside.

When the soup has finished cooking, measure out ¾ cup of it (mostly lentils with just a little liquid) for garnishing the soup bowls. Purée the remaining soup in a food processor. Add ¾ cup of the cream and continue processing just until blended; do *not* overmix. Strain soup through the strainer into a medium-size saucepan, using the bottom of a sturdy ladle to force as much through as possible. Thin, if needed, with more cream and season to taste with fine sea salt and pepper. Add the veal slices to the soup and reheat gently. Serve immediately.

TO SERVE:

(See photograph pages 50-51.) Spoon ¼ of the reserved ¾ cup lentil garnish into the bottom of each heated soup bowl, then ladle about ¾ cup of the soup (without veal in it) on top; arrange a portion of the veal slices, drained duck testicles (use a slotted spoon), and the sausage slices in each bowl (if preferred, serve the sausage on the side) and sprinkle all lightly with pepper.

FOIE GRAS, MAGRET OF DUCK, AND BLACK TRUFFLE SAUSAGE

4 ounces fresh uncooked duck or goose foie gras (Grade B)
4 ounces boneless and skinless *magrets de canard* (breasts of mulard duck) with fat layer still attached, coarsely chopped
4 ounces boneless pork neck or pork shoulder, coarsely chopped
4 ounces rindless pork fatback, coarsely chopped
¼ cup chopped onions
1 tablespoon finely chopped shallots
3 thyme sprigs (very leafy single stems, each about 3 inches long)
1 large peeled garlic clove
1 large egg, lightly beaten
About 1 tablespoon fine sea salt
About 2 teaspoons freshly ground black pepper
½ ounce flash-frozen black truffles, thawed and finely chopped
1 tablespoon canned truffle juice
1 tablespoon Armagnac brandy
2 (14-inch-long) pieces natural hog casing, 1-inch diameter (make sure pieces have no holes)
4 cups rendered duck fat or pork lard (preferred) or vegetable oil

SPECIAL UTENSIL:
Meat grinder fitted with a fine grinding disc, and with a sausage stuffing attachment

Heat oven to 400 degrees. With a sharp thin-bladed knife, carefully trim away any green spots on the foie gras caused by contact with the gall bladder; coarsely chop foie gras and combine in a large bowl with the *magret*, pork neck meat, fatback, onions, shallots, thyme sprigs, and garlic. Grind in the meat grinder and place in a large bowl. Add the egg, 1 tablespoon of the salt, 2 teaspoons of the pepper, and the truffles, truffle juice, and brandy, mixing by hand until thoroughly blended. Next, make a small patty with 1 to 2 tablespoons of the stuffing and bake uncovered in the preheated oven for 10 minutes. Let cool, then taste for seasoning and add more salt and pepper to the remaining stuffing, if needed. (The stuffing may be prepared several hours ahead; keep refrigerated.)

Now rinse the casing thoroughly, inside and out, under cool running water; gently squeeze dry. Fill each piece of casing until fairly firm with equal portions of the stuffing and tie ends closed. Prick a few tiny holes through the casing with a pin to release any air bubbles.

Heat the duck fat in a heavy 4-quart saucepan to 200 degrees over very low heat. Carefully ease the sausage into the hot fat and cook until done, about 1 hour; maintain fat temperature at about 200 degrees. To test doneness, prick with the tip of a pointed knife; if done, the juices will run clear. Remove from heat.

If serving the sausage within 1 hour (it may be served hot or at room temperature), transfer it to paper towels to drain; set aside until ready to slice and serve. If made up to 1 week ahead, let sausage cool in the cooking fat, then place sausage and fat in a deep glass bowl, making sure sausage is completely submerged; refrigerate. If made more than 1 week ahead, let sausage cool in the cooking fat, then drain on paper towels; wrap well in aluminum foil and freeze. If reheating frozen sausage, thaw before reheating.

To reheat the sausage, wrap in foil and heat in a warm to moderate oven just until heated through. Store any leftovers tightly wrapped and refrigerated. *Makes about 1½ pounds sausage.*

TERRINE OF FOIE GRAS, BLACK TRUFFLES, AND TRICOLORED PASTA with PROSCIUTTO AND FRESH HERB TOMATO SAUCE

Makes 22 (½-inch) slices or 1 (11 x 3¼ x 2½-inch) terrine

Tricolored Pasta Dough (recipe follows)
1½ pounds semi-preserved pure duck or goose foie gras, well chilled (see Note)
Fine sea salt and freshly ground black pepper
ASPIC:
 3 (¼-ounce) packages unflavored gelatin
 2 cups cold Meat or Vegetable Consommé (page 214)
6 quarts water for cooking pasta
¼ cup coarse salt for cooking pasta
2 tablespoons extra-virgin olive oil for cooking pasta
4½ ounces flash-frozen black truffles, thawed and cut into paper-thin slices
1 recipe chilled Prosciutto and Fresh Herb Tomato Sauce (see recipe for Terrine of Foie Gras and Spring Onions, page 204)
A few drops heavy cream for garnish (optional)

SPECIAL UTENSILS:
Large very broad-based pot for cooking pasta (broad enough to cook at least two 12 x 5-inch rectangles of pasta at a time without crowding)
Pâté terrine mold, 5-cup capacity, inside dimensions 11 inches long, 3¼ inches wide, and 2½ inches deep
2 pieces of fairly sturdy cardboard cut to just fit inside the top of the terrine mold, stacked and sealed together with foil to form 1 sturdy piece
About 2½ pounds of weights

NOTE:
If available, use the 2¾-inch-diameter log, since its diameter just fits into the terrine mold called for in this recipe. See Note in the recipe for Foie Gras in Brioche, pages 206-207, for more about this type of foie gras.

Prepare the Tricolored Pasta Dough; while dough is resting for 1 hour, slice the foie gras. To do this, line a cookie sheet with parchment or waxed paper; set aside. Heat a sharp thin-bladed knife in hot water and wipe dry; then, if using the 2¾-inch foie gras log, cut it crosswise into twenty ⅝-inch-thick slices, heating and drying the knife before cutting each slice; if using foie gras of another shape or diameter, cut into ⅝-inch-thick slices that are as close in size to the width and length of the mold as possible (so they require a minimum amount of trimming and piecing together when layered in the mold). With a spatula, transfer slices in a single layer to the prepared cookie sheet, being careful to keep them intact. Season tops generously with salt and pepper. Cover and refrigerate.

Next, roll out the pasta dough as directed in the Tricolored Pasta Dough recipe; set pasta rectangles aside.

Now make the aspic by softening the gelatin in ½ cup of the consommé for about 2 minutes. Bring the remaining 1½ cups consommé to a boil in a small pot, then remove from heat and stir in the gelatin; return to high heat and cook and stir just a few seconds until gelatin completely dissolves. Set aspic aside at room temperature while cooking the pasta, then assemble the terrine.

COOK THE PASTA AND ASSEMBLE THE TERRINE:

Combine the water, salt, and oil in the large broad-based pot; bring to a rolling boil over high heat. Meanwhile, prepare a large baking pan of ice water for cooling the pasta once cooked; the pan should be wider and longer than the rectangles and at least 3 inches deep. Cook ½ of each color of rectangle, about 2 rectangles at a time, uncovered, in the boiling water for 1½ minutes without turning, making sure each rectangle is submerged at least during the first few seconds of cooking (do *not* overcook). Immediately transfer rectangles with a broad skimmer or spatula to the ice water to cool, being very careful not to rip them (don't leave them in the ice water more than 15 minutes); then transfer to a cookie sheet lined with parchment or waxed paper, spreading the rectangles flat and leaving them quite wet. The rectangles may be stacked, but keep the 3 colors separated. Replenish water in cooking pot, if needed. When ½ of each color of rectangle is cooked, set aside cooking water, ice water, and uncooked rectangles.

Before proceeding, it may be helpful to keep in mind that the assembled terrine will consist of 6 layers of pasta rectangles (each layer is composed of 1 rectangle of each color), alternated with 5 layers of foie gras and 4 layers of truffles. As you work, trim the pasta rectangles to fit the mold; if you run out of pasta, cook more and continue assembling terrine. Gently reheat the aspic to liquify again, if needed.

To assemble the terrine, first pour ¼ cup of the aspic in the bottom of the ungreased terrine mold, then add a layer of pasta (1 rectangle of each color). Cover pasta layer with ⅓ of the foie gras slices, trimming them to fit the mold and filling in any large gaps with the trimmings. Next, add ¼ cup more aspic or enough to bring the liquid level up to cover the foie gras layer, then add another layer of pasta, then ¼ of the truffle slices. Continue adding a layer of foie gras, then pasta, then truffles, until all the foie gras and truffles have been used; end with a layer of pasta. After the last layer of pasta has been added, add more aspic to bring the liquid level up to the top of the last layer of pasta.

Once assembled, place mold on a small cookie sheet and cover mold well with plastic wrap. Position the foil-covered cardboard on top to rest directly on the top layer of pasta and distribute weights evenly over the cardboard. Refrigerate at least overnight or until the day of serving.

Finish the dish: One day ahead or early on the day of serving, make the Prosciutto and Fresh Herb Tomato Sauce; refrigerate until ready to serve.

At least 2 hours before serving, unmold the terrine as follows: Remove weights, cardboard, and plastic wrap. Place mold in a deep pan large enough to have room to spare between the mold and pan sides. Fill pan with 1½ inches of boiling water and let sit for precisely 2 minutes; then remove mold from hot water, heat the blade of a thin flexible-bladed knife, and carefully loosen sides with it. Invert onto a cookie sheet lined with parchment or waxed paper, a cutting board suitable for refrigeration, or a serving platter if you wish to present the terrine to your guests before slicing it. If the terrine doesn't immediately slip out of the mold, loosen sides again or soundly tap mold, right side up, once or twice on a solid surface; invert again, and it should slip out easily. Cover loosely and refrigerate until just before ready to present unsliced to guests or until ready to slice and serve.

TO SERVE:

(See photograph pages 52-53.) For best results, slice the terrine while well chilled so it will be as firm as possible. Heat a sharp thin-bladed knife in hot water, wipe dry, and carefully cut the terrine crosswise into ½-inch slices; reheat and dry knife before cutting each slice. With a spatula, transfer a slice to each chilled serving plate and top with freshly ground pepper. Taste sauce for seasoning, then spoon about 2 tablespoons alongside each slice; if desired, garnish sauce with a drop or two of cream swirled with the tip of a paring knife. Serve immediately. Refrigerate leftovers.

TRICOLORED PASTA DOUGH

¼ cup plus 2 tablespoons Parsley Purée (page 215)
2 cups plus 2 tablespoons finely ground semolina flour
1 teaspoon fine sea salt
1 tablespoon plus 1 teaspoon extra-virgin olive oil
4 large eggs
About 3¾ cups all-purpose flour, plus flour for rolling out dough
¼ cup water
2 egg yolks (from large eggs)
½ cup plus 2 tablespoons tomato paste

SPECIAL UTENSIL:
Pasta machine

PREPARE THE PASTA DOUGH:

First make the Parsley Purée; refrigerate. Prepare the basic dough for all 3 (yellow, green, and red) pastas as follows: In the large bowl of an electric mixer fitted with a paddle, combine the semolina, salt, oil, and eggs. Beat at medium speed until well blended, about 1 minute; the dough will still be quite wet and sticky at this point. Flour hands with all-purpose flour and form dough into a ball. Cut the ball into 3 equal portions and wrap 2 of them separately in plastic wrap. Make the remaining portion into yellow pasta dough.

For the yellow dough, break the portion of basic dough into 5 pieces and return them to the bowl of the electric mixer. Add 1¼ cups of the all-purpose flour and the water and egg yolks. Beat at medium speed until dough forms a soft, supple ball, about 2 minutes; then, if dough is still sticky, beat in up to about 2 tablespoons more all-purpose flour, 1 tablespoon at a time. Wrap in plastic wrap and set aside.

To make the green dough, break another portion of the basic dough into 5 pieces and place them in the electric mixer bowl. Add ¾ cup plus 2 tablespoons all-purpose flour and the Parsley Purée. Beat at medium speed until dough forms a soft, supple ball and is an even color, about 2 minutes; if dough is still sticky, beat in up to about 2 tablespoons more all-

177

purpose flour, 1 tablespoon at a time. Wrap in plastic wrap and set aside.

For the red pasta dough, break the remaining portion of basic dough into 5 pieces and place in a clean electric mixer bowl. Add 1¼ cups all-purpose flour and the tomato paste. Beat at medium speed until dough forms a soft, supple ball and is an even color, about 2 minutes; if needed, beat in up to about 2 tablespoons more all-purpose flour, 1 tablespoon at a time. Wrap in plastic wrap.

Let all 3 doughs rest, covered, for about 1 hour before rolling out.

ROLL OUT THE DOUGH:

Roll out each color of dough separately. To do this, unwrap 1 of the doughs (yellow, green, or red) and lightly flour it with all-purpose flour. Roll through the pasta machine 10 times on the thickest setting of machine; fold it in half after each rolling. Next, roll dough through once on each setting, this time without folding in half after each rolling, progressing from the very thickest setting to the thinnest; if needed, lightly flour dough so it doesn't stick and cut into manageable lengths. Once dough has gone through the thinnest setting, roll it through an extra time. Now cut the dough into about 12 x 5-inch rectangles; stack and set aside (they don't need to be covered). Repeat with remaining dough, keeping the 3 colors separated. *Makes about 3 pounds dough or enough for 1 terrine.*

STEAMED MAINE LOBSTER with MANGO GINGER SAUCE, SEA BEANS, and MANGO PETALS

Makes 4 servings

4 (1- to 1½-pound) active live Maine lobsters
1½ ounces (about 1 cup) sea beans (glassworts) (preferred) or about 32 dill or chervil sprigs, snipped into small pieces
Salt water (2 tablespoons coarse salt mixed with 6 cups water) for blanching sea beans
Ice water for cooling blanched sea beans
3 large ripe firm mangoes (about ¾ pound each), peeled
2 cups water for blanching ginger root
1 ounce (a scant ¼ cup) peeled and coarsely chopped ginger root
⅜ pound (1½ sticks) unsalted butter, softened
⅔ cup Lobster Consommé (page 214) (preferred), Lobster Stock (page 214), or other Consommé or Stock (page 214) for sauce
1½ cups Lobster Consommé (page 214) (preferred), Lobster Stock (page 214), or other Consommé or Stock (page 214) for reheating lobster meat
Fine sea salt and freshly ground black pepper
8 fresh basil leaves for garnish (purple preferred) (optional)
Lobster Coral Garnish (page 215) (optional)

SPECIAL UTENSILS:
Steamer or stockpot fitted with a deep basket
4 metal or wood skewers for steaming lobster tails; skewers should be longer than lobster tails but short enough to fit into steamer with basket and lid in place
Oval-shaped cookie cutter with pointed ends, about 3½ inches long and 1¾ inches wide at the widest part
Chinois

STEAM THE LOBSTERS:

Steam lobsters as directed for the lobsters in Miniature Pumpkins Stuffed with Steamed Maine Lobsters, pages 181-182, through the point of refrigerating steamed claw and skewered tail meat. (This may be done several hours ahead. The lobster heads and shells may be saved,

frozen, if desired, for making Lobster Cream Base Sauce, page 215, or Lobster Stock, page 214.)

PREPARE THE SEA BEANS:

Trim 1 inch from the thicker end of each sea bean. Bring the salt water to a rolling boil in a medium-size pot. Add beans and boil until tender, about 6 minutes. Immediately drain and cool in ice water. Drain again, cover, and refrigerate. (This may be done several hours ahead.)

PREPARE THE MANGOES:

With a sharp thin-bladed knife, cut each mango lengthwise into as many solid ⅛-inch-thick slices as possible; make slices as wide as possible and of uniform thickness. Set aside scraps and pits with pulp still attached. With the cookie cutter, cut out petals from just enough slices to yield 5 to 8 petals for each serving plate; the number needed will depend on the size of your plates. Arrange petals in a large circle on the serving plates (see photograph page 54), cover well with plastic wrap, and set aside. (The plates may be prepared to this point and left at cool room temperature for about 2 hours. Refrigerate if prepared further ahead; return plates to room temperature before heating in the oven.)

Cut just enough leftover mango slices into ⅛-inch cubes to yield ½ cup; if needed, use pulp scraps and pulp still attached to the pits to make ½ cup. Set aside for finishing the sauce. Trim remaining pulp from the reserved mango pits and coarsely chop enough to yield a scant 1 cup for starting the sauce. If prepared well ahead, refrigerate mango for the sauce. (This may be done several hours in advance.)

MAKE THE SAUCE:

Bring the 2 cups water to a boil in a medium-size pot. Add the ginger and boil until tender but still firm, about 15 minutes. Drain and cool. Purée in a blender with the reserved scant 1 cup chopped mango and the butter until fairly smooth. Cover mango ginger butter and refrigerate until firm, at least 1 hour.

To finish the sauce, combine the reserved chilled mango ginger butter and the ⅔ cup consommé in a small heavy saucepan; heat over high heat just until butter is melted and sauce is creamy, whisking constantly. Remove from heat and strain through the chinois, using the bottom of a sturdy ladle to force as much through as possible; the strained sauce should yield about 1½ cups. Return to the saucepan, add the reserved ½ cup mango cubes, and set aside. (The sauce may be finished up to 1 hour ahead.)

TO SERVE:

Heat oven to 250 degrees. If needed, bring serving plates to room temperature, then unwrap and heat in the preheated oven 10 to 15 minutes; watch carefully so petals do not brown.

Meanwhile, reheat the lobster meat in the 1½ cups consommé over medium heat just until heated through, about 6 minutes; do not let consommé reach a simmer. Remove from heat. Remove lobster tails (but not claws) from the consommé and withdraw skewers. From the thicker end of each tail, cut six ¼-inch-thick diagonal slices, leaving the remainder of the tail (about 2½ inches) in 1 piece.

Once plates are hot, remove from oven and arrange 1 or 2 sea beans between each mango petal. Arrange the ¼-inch-thick lobster slices on top of the petals and the 2½-inch pieces in the center of plates. Add the drained claw meat (use a slotted spoon) to one side. Reheat sauce, season to taste with salt and pepper, and spoon about ⅓ cup in the center of each plate. If desired, garnish with basil leaves and a light sprinkle of Lobster Coral Garnish. Serve immediately.

BAKED SEA BASS with BASQUAISE VEGETABLES

Makes 4 servings

BASQUAISE VEGETABLES:
¾ pound well-formed red bell peppers, cored and cut into very large square pieces
¾ pound well-formed yellow bell peppers, cored and cut into very large square pieces
1 pound zucchini
2 tablespoons extra-virgin olive oil
2½ ounces lean prosciutto, cut into ⅛-inch cubes (about ½ cup)
¾ cup very finely chopped onions
1½ tablespoons very finely chopped shallots
1 tablespoon minced garlic
4 ounces eggplant, peeled and cut into ⅛-inch cubes (about 1½ cups)
2 large tomatoes, peeled, seeded, and cut into ⅛-inch cubes (about 1½ cups)
½ cup Chardonnay wine
3 cups V-8 Juice
2 tablespoons tomato paste
14 very leafy thyme sprigs
2 large bay leaves
Fine sea salt and freshly ground black pepper
BAKED SEA BASS:
4 (1¾- to 2-pound) fresh whole sea bass, cleaned but not boned (leave heads and tails on)
2 tablespoons extra-virgin olive oil for greasing baking sheet
Fine sea salt and freshly ground black pepper
Fresh cilantro, sweet marjoram, or chervil leaves for garnish
12 shallots, peeled and poached until tender (about 15 minutes) for garnish (optional)

MAKE THE *BASQUAISE* VEGETABLES:

Working with 1 piece of bell pepper at a time, place the piece skin down on a cutting board and very carefully trim away the skin with a sharp thin-bladed knife, slicing horizontally as close to the skin as possible. If needed, cut pieces smaller, then skin them. Next, cut the pulp into ⅛-inch squares and combine the red and yellow squares; the combined yield should be about 1½ cups.

To prepare the zucchini, peel off the skin in ⅛-inch-thick sheets, then cut peelings into ⅛-inch cubes; the cubes should yield about 1¼ to 1½ cups.

In a heavy nonreactive 4-quart saucepan, heat the oil over high heat, 2 to 3 minutes. Add the prosciutto, onions, shallots, and garlic and sauté about 1 minute, stirring almost constantly. Add the bell peppers, zucchini cubes, eggplant, tomatoes, and wine and cook for 2 minutes, stirring frequently. Add the V-8 Juice, tomato paste, thyme sprigs, and bay leaves and season with salt and pepper. Bring to a boil, then gently simmer for about 45 minutes, stirring occasionally. Taste for seasoning and remove from heat. Remove and discard thyme sprigs and bay leaves. Set aside or, if made ahead, cool slightly, then cover and refrigerate.

BAKE THE BASS:

Heat oven to 400 degrees. Grease a large heavy baking sheet (or baking pan) with the oil. Trim fins from the bass if not already done; check to make sure all scales have been removed. Rinse and drain well. Score through the skin on both sides in a crisscross pattern, making cuts about 1 inch apart and ⅛ inch deep. Place on the prepared baking sheet and season on both sides with salt and pepper. Bake uncovered just until done, about 7 to 10 minutes on each

side (the cooking time depends on the thickness of the bass); do *not* overcook. Meanwhile, reheat vegetables and, if using, poach the shallots. Serve immediately.

TO SERVE:

(See photograph page 55.) Place each bass on a large heated serving plate and ladle the undrained vegetables around the edges. Garnish plates and eyes of the bass with cilantro (or marjoram or chervil) leaves; if desired, add whole poached shallots to the plates.

VEAL POT-AU-FEU with VEGETABLES and STUFFED CABBAGE LEAVES

Makes 4 servings

12 ounces very fresh veal sweetbreads (optional; see Note)
Cool water for soaking sweetbreads and brains
8 ounces very fresh veal brains (optional; see Note)
½ large unpeeled onion
3 medium-size unpeeled garlic cloves, crushed
About 3 quarts cool water for starting pot-au-feu broth
2 cups V-8 Juice
2 cups unpeeled chopped tomatoes
1 cup unpeeled chopped carrots
1 cup chopped celery
1 cup chopped leeks (mostly white part)
1 cup unpeeled chopped turnips
½ cup chopped shallots
10 large parsley sprigs
7 very leafy thyme sprigs
5 medium-size bay leaves
1 tablespoon coarse salt, plus salt for finishing dish and for the table
1 teaspoon whole black peppercorns
2 pounds veal shank (see Note)
2 to 4 quarts water for blanching veal shank
Stuffed Cabbage Leaves (recipe follows)
4 small tomatoes, peeled and quartered for garnish (optional)
8 ounces very fresh veal liver (optional; see Note)
Fine sea salt and freshly ground black pepper
2 tablespoons vegetable oil for sautéing liver (optional; see Note)
16 baby carrots, peeled (or regular carrots, peeled and cut into 16 oval shapes)
16 baby turnips (or regular turnips, cut into 16 oval shapes)
1 cup peeled pearl onions
3 ribs celery, scraped and cut into 2 inch-long and ½-inch-wide pieces
3 small leeks (about 8 ounces), cut crosswise into 4-inch-long pieces (white part)
1½ cups (about 1 ounce) small fresh morel mushrooms, washed quickly (do *not* eat raw)
Fine sea salt and freshly ground black pepper
FOR THE TABLE:
Warm French bread
Cornichons
Dijon mustard

SPECIAL UTENSILS:
Heavy 8-quart or larger saucepan or soup pot
Heavy deep 6-quart saucepan or soup pot
Chinois

NOTE:
If omitting the sweetbreads, brains, and liver, use 4 pounds of veal shank (instead of 2 pounds). If you choose to use the sweetbreads and brains, you will also need for poaching *each* type of meat separately: 6 cups Meat or Vegetable Consommé (page 214; or Meat or Vegetable Stock, page 214), 10 thyme sprigs,

3 bay leaves, 1 teaspoon whole black peppercorns, and ½ teaspoon fine sea salt.

PREPARE THE SWEETBREADS AND BRAINS FOR COOKING:

Trim any large chunks of fat from the sweetbreads and cover with cool water; soak for 10 minutes, then drain. Cover with fresh water again and let soak 10 minutes more; drain again. Cover a third time with fresh water and refrigerate overnight.

Rinse the brains well under cool running water. Cover with cool water and refrigerate overnight.

START THE POT-AU-FEU:

Char the onion half and garlic as directed in the Poultry Stock recipe (page 214); place in the 8-quart saucepan. Add to the pan 3 quarts of water, the V-8 Juice, the chopped tomatoes, carrots, celery, leeks, turnips, and shallots, the parsley and thyme sprigs, bay leaves, the 1 tablespoon coarse salt, and the peppercorns. If needed, add more water to cover all other ingredients. Bring to a boil. Reduce heat and simmer for 3 hours, skimming occasionally and adding more water as needed to keep all ingredients covered.

Once the pot-au-feu has simmered 3 hours, let it continue simmering while you blanch the veal shank as follows: Bring 2 quarts of water to a boil in a large pot (if using 4 pounds of veal shank, use 4 quarts water); add the veal shank and return water to a boil, then remove from heat. Drain veal shank and add to the pot-au-feu. Continue simmering pot-au-feu 2 hours more, replenishing water as needed to keep all ingredients covered; cook at least 30 minutes more after the last addition of water. Cool, then refrigerate overnight.

FINISH THE POT-AU-FEU:

First, prepare the Stuffed Cabbage Leaves to the point of steaming; refrigerate. Next, remove and discard the layer of congealed fat from the surface of the pot-au-feu. Place pot-au-feu in the 6-quart saucepan; bring to a boil, then simmer for 1 hour.

Meanwhile, if using, prepare the tomato petal garnish, poach the sweetbreads and brains, and sauté the liver.

For the tomato petals, place each quarter of the 4 small tomatoes skinned side down. With a sharp thin-bladed knife, slice off and discard the top soft portion of each, leaving a ¼-inch-thick slice of firm tomato pulp. Trim slices if needed to form them into neat petal shapes, or cut into rounds with a small cookie cutter. Cover and refrigerate.

For the sweetbreads, drain and combine in a medium-size saucepan with the 6 cups consommé, 10 thyme sprigs, 3 bay leaves, 1 teaspoon peppercorns, and ½ teaspoon fine sea salt; bring to a boil. Add the sweetbreads, bring to a simmer, and continue simmering just until cooked through, about 11 minutes. (The cooking time will depend on the thickness of each sweetbread.) To test doneness, make a cut into the thickest part of each piece; if done, the meat at the base of the cut will be very pale pink to cream colored. Transfer pieces to a bowl as done and cover with some of the poaching liquid to prevent drying out.

When sweetbreads are cool enough to handle, gently pull off any bits of fat and most of the membrane surrounding them, leaving just enough attached to hold sweetbreads together. Cut crosswise into ¾-inch slices and return to bowl of poaching liquid; refrigerate.

For the brains, drain, then pull off and discard as much of the very thin membrane surrounding brains as possible, leaving just enough to keep them intact. Trim away any large soft

white deposits. In a medium-size saucepan, combine the 6 cups consommé, 10 thyme sprigs, 3 bay leaves, 1 teaspoon peppercorns, and ½ teaspoon fine sea salt and bring to a boil. Add the brains and simmer just until cooked through, about 6 minutes. Remove from heat and immediately transfer to a bowl with a slotted spoon; divide into at least 4 pieces and cover with some of the poaching liquid to prevent drying out. Refrigerate.

For the liver, season both sides of the liver with fine sea salt and pepper. Heat the oil in a large skillet over high heat, 2 to 3 minutes. Reduce heat to medium, add the liver and cook for 1½ minutes. Turn and continue cooking just until center is pink, not red, about 1 minute more; do *not* overcook. Drain on paper towels and blot with more towels. Slice crosswise into at least 4 pieces; cover well and refrigerate.

Once the pot-au-feu has simmered for 1 hour, remove from heat. Transfer meat and bones to a bowl and strain broth through the chinois into another bowl, using the bottom of a sturdy ladle to force as much through as possible; then skim broth thoroughly. Rinse saucepan well and return broth to it.

Bone the meat, leaving meat in fairly large pieces, and trim away all fat and gristle. Return meat to the pan and add the baby carrots, baby turnips, pearl onions, celery and leek pieces, and the morels. Season to taste with fine sea salt and pepper. Bring to a simmer and continue simmering 45 minutes more. Skim surface well and remove from heat, or if using sweetbreads, brains, and liver, now add them to the pot-au-feu and simmer just until heated through, about 5 minutes. Meanwhile, steam the stuffed cabbage leaves as directed in the Stuffed Cabbage Leaves recipe. Serve immediately.

TO SERVE:

(See photograph pages 56-57.) If using, arrange a portion of the tomato petals or rounds in the center of each wide soup bowl or deep serving plate. Cut the stuffed cabbage leaves in half and add 2 halves to each bowl. With a slotted spoon, transfer an assortment of the pot-au-feu meats and vegetables to the bowls; then ladle about ½ cup broth over each serving and sprinkle very lightly with coarse salt. Serve with more coarse salt, warm French bread, Cornichons, and Dijon mustard on the side.

STUFFED CABBAGE LEAVES

1 medium-size head Savoy cabbage (about 2½ pounds)
Salt water (¼ cup coarse salt mixed with 3 quarts water) for blanching vegetables
Ice water for cooling blanched vegetables
⅓ cup peeled and very finely chopped carrots
⅓ cup peeled and very finely chopped turnips
½ cup very finely chopped leeks (mostly white part)
⅓ cup peeled and very finely chopped tomatoes
4 tablespoons unsalted butter
2 tablespoons very finely chopped shallots
Fine sea salt and freshly ground black pepper

SPECIAL UTENSIL:
Steamer

Remove from the cabbage head 6 of the largest, darkest green, and most perfect cabbage leaves (2 leaves are extras in case any rip); set aside. Very finely shred just enough of the remaining cabbage to yield 5 cups; make strips no wider than ⅛ inch (a meat slicer works well for this). Set aside.

Bring the salt water to a rolling boil in a large pot. Add the cabbage leaves and blanch until tender enough to fold, about 2 minutes, gently

stirring occasionally. Immediately transfer the leaves with a slotted spoon to the ice water, being careful not to rip them; reserve salt water. Drain leaves (reserve ice water) and blot dry with paper towels. Shave or trim the thick stem end of each leaf so it will fold easily.

Return salt water to a boil; add the shredded cabbage and blanch until tender but still crisp, about 2 minutes. Cool in the ice water, leaving salt water boiling. Drain shredded cabbage on paper towels, reserving ice water. Add the carrots to the boiling water and cook for 1 minute, then add the turnips and 30 seconds later the leeks, then continue cooking 1½ minutes more. Transfer carrot mixture to the ice water with a slotted spoon; drain on paper towels. Combine carrot mixture with the shredded cabbage and tomatoes in a bowl, mixing well.

To finish the filling, melt the butter in a large nonstick skillet over medium heat. Add the shallots and sauté for about 30 seconds. Add the shredded cabbage mixture, season generously with salt and pepper, and sauté until filling is heated through, about 1½ minutes, stirring occasionally. Remove from heat.

Spread the cabbage leaves smoother sides down on a work surface and place ¼ of the filling in the center of each; fold leaves as you would an envelope to form rolls. Place 1 stuffed cabbage leaf seam side up in the center of a large (about 1-foot) square of plastic wrap; bring all edges of the wrap together and twist wrap tightly to snugly bundle the stuffed cabbage leaf inside, forcing out as much air as possible as you wrap. Continue twisting edges of plastic until tightly coiled so it won't unwrap when the stuffed cabbage leaf is steamed; once done, the packaged leaf should be about a 2-inch ball. Next, prick 4 or 5 tiny holes through the plastic with a pin; if the holes enlarge, wrap with more plastic without removing the first piece and prick new holes. Repeat with the remaining 3 stuffed cabbage leaves. (These may be prepared to this point several hours ahead; keep refrigerated.)

When ready to serve, steam the plastic-wrapped stuffed cabbage leaves in the covered steamer over boiling water just until heated through, 5 to 7 minutes. Unwrap and serve immediately. *Makes 4 stuffed cabbage leaves.*

APPLE TURNOVERS with DATE SAUCE

Makes 4 servings

FILLING:
4 tablespoons unsalted butter, softened
2 tablespoons sugar
1 large egg
¼ cup whole or sliced almonds, ground to a fine powder
1 tablespoon all-purpose flour
1 cup pure apple juice
¼ cup dried currants
2 tablespoons Calvados brandy
1½ cups peeled and cubed Granny Smith apples (⅛-inch cubes), soaked in acidulated water until ready to use
¼ cup sliced almonds
2 tablespoons honey (preferably acacia)
1 teaspoon *ras al-hanout* (see Note)
SAUCE:
½ cup heavy cream
3 pitted dates, cut in half
A 2-inch piece of vanilla bean
¼ cup pure apple juice
Cooking liquid reserved from straining turnover filling
2 to 3 (15 x 12-inch) sheets top-quality frozen phyllo dough, thawed according to package instructions (see Note)
4 tablespoons unsalted butter, melted

About 2 tablespoons sugar
2 tablespoons dried currants reconstituted in ¼ cup Calvados brandy for at least 1 hour and drained just before using for garnish (optional)
2 tablespoons slivered almonds for garnish (optional)

SPECIAL UTENSIL:
Chinois

NOTE:
Ras al-hanout is a North African spice mixture, available in many gourmet shops. You may not need the third sheet of pastry dough, but it's a good idea to have it handy in case the other dough rips.

MAKE THE FILLING:

For the almond paste, combine 2 tablespoons of the butter with the sugar and egg in a medium-size bowl, whisking until light and creamy, about 1 minute. Add the ground almonds and flour, mixing well. Refrigerate.

Place the apple juice in a small pot and cook over high heat until reduced to ¼ cup, 15 to 20 minutes. Remove from heat and add the currants and brandy to the pot; let sit about 15 minutes.

Drain the apples and set aside. In a large skillet (preferably nonstick), melt the remaining 2 tablespoons butter over high heat. Add the sliced almonds and sauté for 30 seconds, then add the drained apples, apple juice-currant-brandy mixture, honey, and *ras al-hanout*; reduce heat to medium and continue cooking about 3 minutes more, stirring occasionally. Drain mixture in a strainer placed over a bowl. Set aside strained cooking liquid for the sauce; refrigerate apple mixture until cool, about 15 minutes.

Once apple mixture is cool, place the almond paste in a medium-size bowl and add the apple mixture to it, mixing thoroughly; refrigerate filling until ready to use.

MAKE THE SAUCE:

Combine the cream and dates in a small heavy saucepan. Cut the vanilla bean in half lengthwise, scrape, and add scrapings and bean halves to the pan. Bring to a boil. Reduce heat and gently simmer until cream reduces to about 2 tablespoons, about 10 minutes. Let cool, then remove vanilla bean halves (rinse and save them for future use).

Purée cream-date mixture in a blender or food processor with the apple juice and the reserved strained cooking liquid until smooth. Strain sauce through the chinois, using the bottom of a sturdy ladle to force as much through as possible; it should yield about ½ cup. Set aside. (Refrigerate if made more than 1 hour ahead; return to room temperature before using.)

TO FINISH THE TURNOVERS AND SERVE:

(See photograph page 58.) Heat oven to 400 degrees. Place 1 sheet of the phyllo dough on a piece of parchment or waxed paper that is slightly larger than the sheet of dough; cover remaining dough with a dishtowel so it doesn't dry out. Use a pastry brush to brush top of dough evenly with 2 tablespoons of the butter and sprinkle about 1 tablespoon sugar evenly over the top. Cut four 6-inch squares of dough from the sheet; discard scraps.

Now mound ¼ of the turnover filling in the center of 1 of the dough squares; then fold over each corner of dough, 1 corner at a time, so all 4 corners meet in the center; once corners are folded over, the butter on the dough will make the edges of dough stick together, completely sealing filling inside. Repeat with remaining 3 dough squares and filling to make 3 more

turnovers. If a dough square rips, discard it and cut out a replacement square from the extra sheet of phyllo dough; butter and sugar the new square and reassemble turnover. Place the 4 turnovers on a heavy cookie sheet lined with aluminum foil and bake uncovered for 15 minutes.

Meanwhile, place another sheet of phyllo dough on parchment or waxed paper, brush top with the remaining 2 tablespoons butter, and sprinkle top evenly with about 1 tablespoon more sugar; cut 4 more 6-inch squares from dough.

When the turnovers have cooked 15 minutes, remove pan from oven; leave oven setting at 400 degrees. Working quickly and with 1 turnover at a time, carefully transfer each baked turnover to the center of 1 of the prepared dough squares and fold corners of dough over turnover to meet in the center (just as you did earlier), pressing dough very gently into place so it completely covers and sticks to the baked crust; if needed, brush dough with more butter (the butter left on the pastry brush will do), then very gently press into place. Once all 4 turnovers are covered with a second dough square, carefully return them to the cookie sheet and continue baking uncovered until crust is golden brown and cooked through, about 10 minutes more. Check doneness by piercing completely through crust layer with the tip of a pointed knife. Remove from the oven and immediately transfer to serving plates. Let cool about 5 minutes, then spoon about 2 tablespoons sauce on each plate and garnish, if desired, with a sprinkle of drained reconstituted currants and slivered almonds. Serve immediately.

FIG MOUSSE with FIG SAUCE and PEAR "ROSES"

Makes 4 or 5 servings

FIG MOUSSE:
Vegetable oil for greasing soufflé dishes
2¾ pounds (a generous 2 quarts) medium-size ripe purple figs, stems removed
1 cup orange juice
½ cup sugar
⅓ cup loosely packed mixture of orange, lemon, and lime peelings with no white pith
¼ cup lemon juice
¼ cup lime juice
½ ounce lemon thyme sprigs (optional)
1 cup heavy cream
1 (¼-ounce) package unflavored gelatin
2 tablespoons cool water
FIG SAUCE:
½ cup fig purée reserved from preparing mousse
½ cup orange juice
¼ cup water
1 tablespoon lime juice
¼ ounce lemon thyme sprigs (optional)
Pear "Roses" (recipe follows)
Mint sprigs for garnish (optional)
Very finely ground pistachio nuts for garnish (optional)

SPECIAL UTENSILS:
4 or 5 (¾-cup-capacity) individual straight-sided soufflé dishes, inside diameter 3⅛ inches, 1¾ inches tall
Very fine mesh strainer
Chinois

MAKE THE MOUSSE:
Generously grease the soufflé dishes with vegetable oil. With a sharp thin-bladed knife, cut just enough of the prettiest and firmest figs crosswise into ⅛6-inch slices to line the bottoms and sides of the soufflé dishes; set aside all trimmings. Arrange slices in a single layer in the

dishes; the slices on the bottoms don't need to fit snugly together, but those lining the sides should. Cover dishes with plastic wrap and set aside.

Slice 2 of the remaining whole figs crosswise into ¼-inch slices; cover and reserve, refrigerated, for garnishing serving plates. Cut the remaining figs in half and place them in a heavy nonreactive 3-quart saucepan; add the reserved fig trimmings and the orange juice, sugar, citrus peelings, lemon and lime juices, and lemon thyme sprigs, if using. Bring to a boil, then simmer until liquid is a thin syrup, 20 to 25 minutes, stirring and skimming foam occasionally; stir more often toward the end of cooking time to prevent sticking. Remove from heat and let cool to room temperature. Meanwhile, whip ¾ cup of the cream until soft peaks form; refrigerate.

When the fig mixture is cool, remove and discard the citrus peelings and lemon thyme sprigs, then purée in a food processor or blender until smooth. Strain the purée through the strainer, using the bottom of a sturdy ladle to force as much through as possible; it should yield about 2¼ cups. Measure out ½ cup of the purée for the sauce; set aside. Place the remaining purée in a large bowl; set aside.

Soften the gelatin in the 2 tablespoons cool water for about 2 minutes. Bring the remaining ¼ cup cream to a boil in a small pot; remove from heat and stir in the gelatin, then cook over high heat just a few seconds, stirring constantly, until gelatin completely dissolves. Remove from heat and gradually add to the reserved bowl of fig purée, stirring constantly until well blended. Gently fold in about ¼ of the reserved whipped cream until barely blended, then lightly fold in the remaining whipped cream. Pour mousse into the prepared soufflé dishes; cover and refrigerate until firm enough to unmold, at least 4 hours. (The mousse may be prepared early on the day of serving.)

MAKE THE SAUCE:
In a small heavy saucepan, combine all the sauce ingredients, mixing well; cook just below a simmer for 5 minutes, stirring occasionally. Strain sauce through the chinois, using the bottom of a sturdy ladle to force as much through as possible; it should yield about ½ cup. Set aside or refrigerate if made ahead. (This may be done several hours in advance; serve at room temperature or chilled.)

Now prepare the Pear "Roses"; once all are formed and edges have been caramelized, transfer 1 to the side of each dessert plate with a wide spatula; serve immediately or set aside at room temperature until ready to serve.

TO SERVE:
(See photograph page 59.) To unmold the mousse, fill a deep pan with about 1½ inches of boiling water. Place the soufflé dishes in the pan and let sit for precisely 3 minutes, then remove from the hot water. Loosen sides carefully with a thin flexible-bladed knife and invert each mousse onto 1 of the dessert plates. Spoon 1 to 2 tablespoons sauce on each plate; garnish each with a portion of the reserved fig slices and, if desired, a mint sprig and sprinkle of pistachios. Serve immediately.

PEAR "ROSES"

About 2½ tablespoons lemon juice
2 medium to large firm ripe Bartlett pears
1½ quarts water
½ cup Chardonnay wine
2 tablespoons sugar
A 4-inch piece of vanilla bean
Sifted powdered sugar

SPECIAL UTENSILS:
Small melon baller
Propane torch for caramelizing roses (optional)

Set aside 2 tablespoons of the lemon juice for cooking the pears. Peel the pears and cut in half lengthwise; rub flesh with a little of the remaining lemon juice to preserve its color. Core the center of each pear half with the melon baller to form a small, neat hole; neatly trim away remaining core and rub flesh again with more lemon juice. Set aside.

In a nonreactive 3-quart saucepan, combine the water, wine, sugar, and 2 tablespoons of the lemon juice. Cut the vanilla bean in half lengthwise, scrape, and add scrapings and bean halves to the pan. Bring to a simmer, then add the pear halves and very slowly simmer until tender, about 45 minutes. Drain and let cool to room temperature. (Cover and refrigerate if prepared ahead.)

About 45 minutes before serving, form the roses. For each rose, use a sharp thin-bladed knife to cut 1 of the pear halves lengthwise into paper-thin slices (the slices must be very thin so they are flexible enough to shape into rose petals); roll 1 of the very thinnest slices snugly into a round shape to form the centermost petal and place it upright (core side down) on an ungreased cookie sheet; while keeping this center petal in place with one hand, use the other hand to wrap another pear slice, core side down, around it; continue wrapping with more petals, 1 at a time and on alternate sides of the flower, until a full rose is formed (the moisture from the pear slices will hold the petals together), using about ½ to ⅔ of the slices. Repeat with the remaining 3 pear halves to form 3 more roses. (If forming 5 roses, use the leftover slices from forming the first 4 roses for the fifth one.)

Once all roses are formed, sprinkle tops generously with powdered sugar; then, if desired, very carefully caramelize the top edges of the petals with a propane torch. *Makes 4 or 5 roses.*

BELON OYSTERS ON THE HALF SHELL with OYSTER AND DILL SAUCE

Makes 4 generous first-course servings

Salt water (1 tablespoon coarse salt mixed with 3 cups water) for blanching dill
1½ ounces trimmed dill sprigs
Ice water for cooling blanched dill
¼ pound (1 stick) unsalted butter, softened
¾ pound blanched and well drained seaweed (see recipe for Salad of Sea Scallops, page 185) or about 2 cups coarse salt
12 medium to large unopened oysters (preferably Belon), shucked and undrained (about 4½ pounds before shucking; see Note)
½ cup water
Fine sea salt and freshly ground black pepper
Snipped dill sprigs for garnish
1 to 2 teaspoons Parsley Purée (page 215) for garnish (optional)

NOTE:
Save the bottom (deeper) oyster shells for serving the oysters. Scrub shells well before using.

START THE SAUCE:
Bring the salt water to a rolling boil in a medium-size pot. Add the 1½ ounces trimmed dill sprigs and blanch for 2 minutes. Immediately drain and cool in the ice water; drain again and squeeze dry. Process with the butter in a food processor until very creamy and all dill is minced. Cover dill butter and refrigerate until firm, at least 1 hour or overnight.

If using, blanch the seaweed as directed on page 185; drain well and refrigerate. (This may be done several hours ahead.)

TO FINISH THE DISH AND SERVE:
(See photograph page 62.) Combine the undrained oysters with the ½ cup water in a small pot and warm over low heat 4 to 5 minutes; do not let water reach a simmer. Remove from heat.

To finish the sauce, transfer 2 tablespoons of the liquid from warming the oysters to a small heavy saucepan, leaving oysters in the remaining liquid to keep warm. Add the reserved chilled dill butter to the saucepan and cook over high heat just until butter is melted, whisking constantly. Remove from heat and continue whisking about 1 minute more so the butter doesn't separate from the sauce. Season to taste with salt and pepper.

If using seaweed, arrange an equal portion of it on each serving plate. If using coarse salt, make a bed of about ½ cup of it on each plate. Position 3 oyster bottom shells on top of the seaweed or salt and garnish edge of each shell with a snipped dill sprig. Now drain the oysters, blot dry with paper towels, and place 1 on each shell. Spoon 1 teaspoon or more sauce over each oyster; if desired, garnish sauce with droplets of Parsley Purée. Top with freshly ground pepper and serve quickly while the oysters are still warm.

CREAM OF EGGPLANT SOUP with SHALLOT FLANS, RABBIT TENDERLOINS, "WHITE KIDNEYS," MIREPOIX OF CRISPY SWEETBREADS, PROSCIUTTO, AND EGGPLANT, and FRIED EGGPLANT

Makes 4 servings

Shallot Flans (recipe follows)

SOUP:

3 tablespoons extra-virgin olive oil

3 cups peeled and coarsely chopped white (Thai) eggplant or purple eggplant

¾ cup coarsely chopped red bell peppers

⅓ cup chopped prosciutto (2 ounces)

¼ cup thinly sliced shallots

Freshly ground black pepper

2½ cups Meat or Vegetable Consommé (page 214)

1½ cups heavy cream

FRIED EGGPLANT:

¼ cup all-purpose flour

¼ cup plus 2 tablespoons cool water

¼ teaspoon baking soda

Vegetable oil for deep frying

1 (2- to 3-ounce) peeled and thinly sliced white (Thai) eggplant or purple eggplant, slices cut in half

"WHITE KIDNEYS" (DUCK TESTICLES):

1½ cups Meat or Vegetable Consommé (page 214) (preferred) or Meat or Vegetable Stock (page 214)

8 duck testicles (about 5 ounces)

RABBIT TENDERLOINS:

1 (1-pound) saddle of rabbit (see Note)

Fine sea salt and freshly ground black pepper

20 thyme sprigs (very leafy single stems, each 4 to 5 inches long)

1 tablespoon extra-virgin olive oil

MIREPOIX:

1 recipe Crispy Sweetbread Mirepoix (page 163)

1 tablespoon extra-virgin olive oil

⅓ cup peeled and cubed white or purple eggplant (⅛-inch cubes)

¼ cup very lean cubed prosciutto (⅛-inch cubes; about 1½ ounces)

SPECIAL UTENSILS:

Fine mesh strainer

1-quart-capacity soup tureen

NOTE:

Have your butcher leave the rabbit's stomach flaps attached for holding the thyme sprigs inside the cavity while the rabbit cooks.

First, make the flans; while they are baking, prepare the soup and other components of the dish. Once the flans are out of the oven, heat oven to 400 degrees for roasting the rabbit.

MAKE THE SOUP:

Heat the oil in a heavy 4-quart saucepan over high heat, about 2 minutes. Add the eggplant, bell peppers, prosciutto, and shallots, and season with pepper; stir well. Cook about 6 minutes, stirring and scraping pan bottom frequently. Add 2 cups of the consommé and return to a boil, then simmer for 30 minutes, stirring occasionally. Purée mixture in a food processor, then add the cream and the remaining ½ cup consommé and continue processing just until blended; do *not* overmix, or the soup will curdle. Strain soup through the strainer, using the bottom of a sturdy ladle to force as much through as possible; it should yield about 3½ cups. Transfer to a small heavy saucepan and taste for pepper seasoning (don't add salt since the mirepoix served with the soup is quite salty); set aside.

MAKE THE FRIED EGGPLANT BATTER:

Place the flour in a medium-size bowl. Gradually add the water, whisking until all lumps disappear. Whisk in the baking soda. Cover and refrigerate at least 1 hour or up to 2 hours before using. Keep refrigerated until ready to use.

PREPARE THE DUCK TESTICLES:

Bring the consommé to a boil in a small saucepan. Add the duck testicles and reduce heat to maintain consommé just below a simmer; cook just until done, 3 to 5 minutes. (To test doneness, transfer a testicle to a plate and press it lightly with your fingertips; if done, it will feel very firm.) Remove from heat. Pull off and discard any bits of fat or loose membrane from the testicles and set aside in the cooking liquid to keep warm.

PREPARE THE RABBIT TENDERLOINS:

Heat oven to 400 degrees if not already done. Score the saddle of rabbit about 6 times along each side of the backbone; make cuts about ⅛ inch deep, 1 inch long, and 1 inch apart. Season all surfaces with salt and pepper. Place saddle breast up, open the stomach flaps, and spread the thyme sprigs inside cavity; then fold stomach flaps over to completely enclose sprigs.

In a large ovenproof skillet (preferably nonstick), heat the oil over high heat, 4 to 5 minutes. Add the rabbit, breast up, and cook until underside is well browned, about 2 minutes. Turn and brown the other side, about 1 minute more; with rabbit breast down, transfer uncovered skillet to the preheated oven and roast for 15 minutes, then remove skillet momentarily from oven. Cutting as close to the bone as possible, make a deep slit along the length of the backbone on both sides to separate the tenderloins (the strips of meat on either side of the backbone) from the bone so the meat will cook evenly. Return skillet to oven and continue roasting just until tenderloins are done, about 6 minutes more. Do *not* overcook, or the meat will be dry; keep in mind that it will cook a little more when reheated. To test doneness, cut 1 of the tenderloins open; if done, the center will be very moist and white, not pink. Remove from oven; reduce oven temperature to 300 degrees for heating the soup tureen and serving bowls shortly before using.

Transfer rabbit to a cutting board and cover loosely; let sit about 10 minutes, then carve the tenderloins from the carcass and cut meat crosswise on the diagonal into ⅛-inch slices. (Save the carcass, if desired, for making stock.) Cover to keep warm.

MAKE THE MIREPOIX:

First, cook the Crispy Sweetbread Mirepoix if not already done; set aside. In a small nonstick skillet, heat the oil over high heat for about 1 minute. Add the eggplant cubes and cook for 1 minute, stirring frequently; then add the prosciutto cubes and cook and stir another minute, then add the Crispy Sweetbread Mirepoix and continue cooking 1 minute more. Drain on paper towels; set aside.

To finish the dish and serve: (See photograph page 63.) Heat oven to 300 degrees if not already done and heat the soup tureen in it. Now start heating the oil to 375 degrees for frying the eggplant (fry slices at the last possible moment so they'll still be crisp when served).

Meanwhile, spread a portion of the reserved mirepoix in the bottom of 4 wide ovenproof soup bowls and unmold the flans into the center of the bowls; then cut the duck testicles in half lengthwise and arrange them around each flan. Next, add the rabbit tenderloin slices to the bowls; set aside.

Once the oil is heated to 375 degrees, fry the eggplant slices in small batches. Just before frying each slice, coat it well with the batter and let excess drain off, then fry in the hot oil about 15 to 30 seconds until golden brown; drain on paper towels. Season slices lightly with salt and arrange them in the soup bowls.

Heat the uncovered serving bowls in the 300 degree oven for about 3 minutes. Meanwhile, reheat soup and place in the heated soup tureen for ladling into the bowls at the table. Serve immediately.

SHALLOT FLANS

Unsalted butter for greasing flan molds

¼ cup heavy cream

¼ cup milk

Salt water (1 tablespoon coarse salt mixed with 3 cups water) for cooking shallots

6 medium-size shallots (about 3½ ounces), peeled

2 large eggs

Fine sea salt and freshly ground black pepper

SPECIAL UTENSILS:

5 (¼-cup-capacity) Pyrex flan molds, 2¼-inch diameter at inside top, 1⅝-inch diameter at outside base, 1⅞ inches tall

Chinois

Heat oven to 300 degrees. Generously butter the flan molds. Combine the cream and milk in a small pot and bring to a boil; remove from heat and set aside.

Bring the salt water to a rolling boil in a small pot. Add the shallots and boil until tender, about 10 minutes; drain. Purée in a food processor with the eggs, the scalded cream-milk mixture, and a generous amount of salt and pepper until smooth. Strain purée through the chinois, using the bottom of a sturdy ladle to force as much through as possible.

Pour purée into the prepared molds and place molds in a small baking pan; add enough boiling water to come up the sides of molds 1¼ inches. Bake uncovered in the preheated oven until done, about 50 minutes. To test doneness, after 45 minutes of cooking remove a mold from the oven, loosen sides of flan with a thin flexible-bladed knife in 1 clean movement, and invert onto a plate; if done, the flan will hold its shape and when cut in half the center will be solid, not runny. Remove cooked flans from oven and let them sit in the hot water for at least 10 minutes or up to about 30 minutes, then unmold and serve promptly. (See photograph page 63.) *Makes 4 flans, plus 1 flan for testing doneness.*

PAPILLOTES OF FOIE GRAS AND SEA SCALLOPS WITH JULIENNE VEGETABLES AND CHERVIL

Makes 4 servings

Salt water (3 tablespoons coarse salt mixed with 8 cups water) for blanching vegetables

¾ cup peeled and julienned carrots (2 x ⅛-inch strips)

¾ cup peeled and julienned turnips (2 x ⅛-inch strips)

¾ cup scraped and julienned celery (2 x ⅛-inch strips)

¾ cup julienne leeks (mostly white part) (2 x ⅛-inch strips)

Ice water for cooling blanched vegetables

8 to 10 ounces sea scallops, rinsed and small tough muscle on the side of each removed

Fine sea salt and freshly ground black pepper

¾ pound fresh uncooked duck or goose foie gras (Grade A)

12 chervil (or cilantro or tarragon) sprigs, thick stems trimmed and sprigs snipped into several small pieces

Lobster Coral Garnish (page 215) (optional)

About 2 cups coarse salt for garnish

SPECIAL UTENSILS:

4 (24 x 18-inch) pieces of heavy duty aluminum foil

PREPARE THE PAPILLOTES:

Bring the salt water to a rolling boil in a large pot. Add the carrots and blanch for 1 minute; then add the turnips and 1 minute later add the celery and leeks and blanch 1 minute more. Immediately drain and cool vegetables in the ice water. Drain on paper towels and blot thoroughly dry with more towels. Set aside.

With a sharp thin-bladed knife, cut the scallops into ¼-inch slices. Season generously with salt and pepper; set aside.

With the same knife, carefully trim away any green spots on the foie gras caused by contact with the gall bladder. Dip the knife in hot water, wipe dry, and cut the foie gras crosswise into 8 equal slices; reheat and dry knife before cutting each slice. Season slices generously on both sides with salt and pepper.

Fold each piece of aluminum foil to form an 18 x 12-inch rectangle. For each papillote, mound an equal portion of the vegetables to one side of 1 of the rectangles, spreading them to within 2 to 3 inches of the edge, then lightly season with salt and pepper; top with 2 slices of foie gras and arrange a portion of the scallop slices around the edges; add ¼ of the chervil over the top and, if using, sprinkle lightly with Lobster Coral Garnish; fold the foil in half over the food and tightly seal by first rolling the edges, then crimping them. Refrigerate if prepared ahead.

TO COOK AND SERVE:

(See photograph page 64.) Heat oven to 400 degrees. Before proceeding, keep in mind that it is far better to underbake the food than to overbake it because undercooking can be rectified simply by returning the papillotes to the hot oven briefly.

Place papillotes, rolled edges up, in a single layer on an ungreased cookie sheet and bake for 7 minutes if papillotes were at room temperature or about 14 minutes if they were chilled.

Meanwhile, make a bed of coarse salt on each serving plate, using about ½ cup for each. When the papillotes are cooked, use a wide sturdy spatula to quickly and carefully transfer each, rolled edges up, to a serving plate. Serve promptly without opening. Once served, immediately cut top of foil open lengthwise so the food doesn't continue to steam; leave bottom and sides of foil in place to serve as a bowl.

MINIATURE PUMPKINS STUFFED WITH STEAMED MAINE LOBSTER, LOBSTER MOUSSELINE, AND SWEET POTATO-PUMPKIN PUREE with PUMPKIN AND LOBSTER CREAM SAUCE

Makes 4 servings

4 (1- to 1½-pound) active live Maine lobsters

PUMPKIN AND LOBSTER CREAM SAUCE:

¼ cup plus 2 tablespoons Lobster Cream Base Sauce (page 215) (preferred) or heavy cream

About ¾ cup cooked and strained pumpkin purée reserved from making the sweet potato-pumpkin purée

¼ cup Lobster Consommé (page 214) (preferred), Lobster Stock (page 214), or other Consommé or Stock (page 214)

Fine sea salt and freshly ground black pepper

½ cup Lobster Mousseline (page 215)

4 (6- to 7-ounce) well-formed miniature pumpkins for carving into serving bowls and lids

SWEET POTATO-PUMPKIN PUREE:

2¼ cups peeled and coarsely chopped sweet potatoes (from about ¾ pound sweet potatoes)

6 cups water for cooking sweet potatoes and pumpkin pulp

3 cups coarsely chopped pumpkin pulp (from about three 8-ounce miniature pumpkins)

¼ cup heavy cream

2 tablespoons unsalted butter

Fine sea salt and freshly ground black pepper

1½ cups Lobster Consommé (page 214) (preferred), Lobster Stock (page 214), or other Consommé or Stock (page 214) for reheating lobster meat

SPECIAL UTENSILS:

4 metal or wood skewers for steaming lobster tails; the skewers should be longer than the lobster tails but short enough to fit into the steamer with the basket and lid in place

Steamer or stockpot fitted with a deep basket

Fine mesh strainer

Chinois

Pastry bag fitted with a Number 4 (or approximate-size) star tip

STEAM THE LOBSTERS:

Before steaming, prepare the lobsters as follows: Ease the lobsters head first into a large pot of boiling water. Promptly cover pot and cook for precisely 1 minute. Immediately drain on paper towels and let cool briefly. Protecting your hands with thick dishtowels, twist off the heads. (If desired, save heads for making the Lobster Cream Base Sauce used in this recipe or freeze for future use.) Break off and reserve claws. Turn each tail soft side up and insert 1 of the skewers through the anal opening at the tip end of each tail, pushing it through the length of the meat so tail will stay flat when steamed.

Bring the water in the steamer to a boil over high heat. Uncover steamer and quickly add the claws, then the tails, and promptly cover. Steam just until tail meat is cooked, about 4 minutes; do *not* overcook. Immediately transfer tails (but not claws) to a dishtowel to drain, cover steamer, and continue steaming claws until cooked, about 3 minutes more; do *not* overcook. Drain claws on the towel. With skewers still in tails, remove all shells from around the tail meat, being careful to keep meat intact. Remove claw meat from the shells. (These shells may also be used for the Lobster Cream Base Sauce.) Cover claw and skewered tail meat and refrigerate. (The lobsters may be prepared to this point several hours ahead.)

If not already done, now make the Lobster Cream Base Sauce on page 215 (for the Pumpkin and Lobster Cream Sauce), and the Lobster Mousseline on page 215; refrigerate.

CARVE THE MINIATURE PUMPKINS FOR THE SERVING BOWLS AND LIDS:

With a sharp paring knife, carve the top off of each pumpkin in a neat zigzag pattern (as you would a jack-o'-lantern), ½ to ¾ inch down from the stem, to form a bowl and lid. Scoop out seeds from the bowls. Place lids on bowls, cover well, and refrigerate. (This may be done several hours ahead.)

PREPARE THE SWEET POTATO-PUMPKIN PUREE:

In a small pot, combine the sweet potatoes with 3 cups of the water; bring to a boil and continue boiling until tender, about 12 minutes. Meanwhile, boil the pumpkin pulp in a separate pot in the remaining 3 cups water until tender, about 12 minutes. Remove pans from heat.

Drain the pumpkin pulp and purée in a food processor. Strain through the strainer, using the bottom of a sturdy ladle to force as much through as possible; the strained purée should yield about 1 cup.

Drain the sweet potatoes (don't purée them) and strain through the strainer as you did the pumpkin pulp or mash with a potato masher; the strained potatoes should yield about ¾ cup. Place in a small heavy saucepan with ¼ cup of the strained pumpkin purée; set aside remaining pumpkin purée for the sauce. Add the cream and butter to the pan and season to taste with salt and pepper. Cook over high heat just a few seconds until butter melts and mixture is well blended, stirring constantly. Set aside. (This purée may be prepared up to 1 hour ahead; do not refrigerate.)

MAKE THE SAUCE:

In a small heavy saucepan, combine the reserved pumpkin purée with the Lobster Cream Base Sauce (or heavy cream) and the consommé. Bring to a boil over medium heat, whisking almost constantly. Reduce heat to low and season to taste with salt and pepper. Remove from heat and strain through the chinois, using the bottom of a sturdy ladle to force as much through as possible; the strained sauce should yield about ½ cup. Return to the saucepan and set aside in a warm place. (The sauce should be prepared as close to serving time as possible.)

TO ASSEMBLE AND SERVE:

(See photograph page 65.) Heat oven to 400 degrees. Uncover pumpkin serving bowls and lids; set lids aside. Spoon the Lobster Mousseline into the pastry bag and pipe an equal portion into the bottom of each pumpkin bowl. Rinse pastry bag and reserve it and the star tip for piping the sweet potato-pumpkin purée. Keeping the pumpkin bowls upright, cover each bowl (but not its lid) completely with aluminum foil to seal well; prick through the top of the foil once with a fork. Place bowls upright on an ungreased cookie sheet and bake until the mousseline inside is barely cooked, about 10 minutes.

Meanwhile, reheat the lobster meat in the consommé over medium heat just until heated through, about 6 minutes; do not let consommé reach a simmer. Remove from heat and set aside in the hot consommé. Also now heat the sweet potato-pumpkin purée in a small heavy saucepan over medium heat until warm but not hot, about 3 minutes, stirring occasionally; then spoon into the reserved pastry bag.

Once the mousseline inside the pumpkin bowls is hot, remove from oven; leave oven set at 400 degrees. Unwrap bowls and pipe an equal portion of the warmed purée into each. Return bowls, uncovered, to the cookie sheet; keep warm in the 400 degree oven with the door slightly ajar while slicing lobster tail meat. Just before using, heat 4 ovenproof serving plates in the same oven about 3 minutes.

To prepare the lobster tail meat, remove tails from the consommé and withdraw skewers. From the thicker end of each tail, cut 6 diagonal ¼-inch-thick slices, leaving the remainder of the tail (about 2½ inches) in 1 piece. Now reheat sauce.

Remove pumpkin bowls from the oven and place 1 on each heated serving plate. Arrange the meat from each lobster tail on top of each pumpkin and spoon about 2 tablespoons sauce over it; lean a pumpkin lid on its side against the pumpkin bowl and position the drained lobster claw meat (use a slotted spoon) in between the lid and bowl. Serve immediately.

SKATE STUFFED WITH LOBSTER MOUSSELINE with FRIED JULIENNE VEGETABLES and SWEET MARJORAM CAPER SAUCE

Makes 4 servings

SAUCE:

1 ounce sweet marjoram sprigs (28 very leafy single stems, each 5 to 7 inches long)

Salt water (2 tablespoons coarse salt mixed with 6 cups water) for blanching marjoram leaves

Ice water for cooling blanched marjoram leaves

⅜ pound (1½ sticks) unsalted butter, softened

2 tablespoons plus 1 teaspoon well drained capers

2 tablespoons Lobster Consommé (page 214) (preferred), Lobster Stock (page 214), or other Consommé or Stock (page 214)

Freshly ground black pepper

STUFFED SKATE:

1 recipe Lobster Mousseline (page 215)

4 (15- to 17-ounce) portions of skate with cartilage and skin (each about 9 to 10 ounces once skinned and filleted; see Note)

Fine sea salt and freshly ground black pepper

1 ounce sweet marjoram sprigs (28 very leafy single stems, each 5 to 7 inches long), plus leafless stems reserved from making sauce

8 (1-foot) squares pork caul fat (about 3 pounds; see Note)

About 3 to 3½ quarts milk

½ teaspoon whole black peppercorns

JULIENNE VEGETABLES:

Salt water (¼ cup coarse salt mixed with 3 quarts water) for blanching vegetables

1¼ cups peeled and julienned carrots (2½ x ⅛-inch strips)

1¼ cups peeled and julienned turnips (2½ x ⅛-inch strips)

1 cup scraped and julienned celery (2½ x ⅛-inch strips)

Ice water for cooling blanched vegetables

1 cup julienne leeks (white part only; 2½ x ⅛-inch strips)

Vegetable oil for deep frying

Fine sea salt

Sweet marjoram sprigs for garnish (optional)

SPECIAL UTENSILS:

Pastry bag fitted with ½-inch plain nozzle

Chinois

Heavy roasting pan just large enough to hold skate portions in a single layer with a little room to spare

Deep fryer

Fine mesh fry basket that fits into deep fryer or a very large skimmer

NOTE:

Select skate portions of uniform shape and thickness, each filleted and skinned in 1 piece so that it can be stuffed (there will still be a few inches of cartilage in the thinner end of each). Caul fat is available from butcher shops. Ask for pieces with few if any holes in them; refrigerate, soaking in water, until used.

START THE SAUCE:

Remove the leaves from the marjoram sprigs; set aside stems for the skate poaching liquid. Bring the salt water to a rolling boil in a medium-size pot. Add the marjoram leaves and blanch for 2 minutes. Immediately drain and cool in the ice water; drain again. Squeeze leaves dry and

process in a food processor with the butter and 1 tablespoon plus 2 teaspoons of the capers until butter is very creamy and leaves and capers are minced. Cover caper-marjoram butter and refrigerate until firm, at least 1 hour or overnight.

STUFF THE SKATE:

Make the Lobster Mousseline; refrigerate at least 1 hour. Once mousseline is chilled, open each portion of skate as if it were a book and generously season inside with salt and pepper; leave portions open. Fill the pastry bag with the mousseline and pipe ¼ of it evenly on one side of each portion of skate, then cover mousseline with the other side of skate. Generously season all surfaces with salt and pepper.

Rinse the caul fat well and squeeze dry; set aside. Next, set aside ⅓ ounce of the marjoram sprigs for the skate poaching liquid (place with reserved stems from the sauce). Remove the leaves from the remaining ⅔ ounce sprigs; set aside stems with other stems reserved for poaching liquid. Separate leaves into 8 equal portions. For each portion of skate, arrange 1 portion of leaves in the center of a caul square, spreading them evenly to cover an area the same size as the skate; place skate on top of the leaves, arrange another portion of leaves on top of the skate, and wrap in the caul; then wrap securely with a second caul square and salt and pepper both sides; refrigerate. (This may be done several hours ahead.)

BLANCH THE JULIENNE VEGETABLES:

Bring the salt water to a rolling boil in a large pot. Add the carrots, turnips, and celery and blanch for 1½ minutes. Immediately cool in the ice water; reserve salt water. Drain on paper towels, reserving ice water. Wrap in more towels to remove as much moisture as possible.

Return salt water to a boil, add the leeks, and blanch for 1½ minutes. Immediately drain and cool in the ice water. Drain on paper towels and wrap with more towels, separate from the other vegetables; refrigerate. (This may be done several hours ahead.)

FINISH THE SAUCE:

Combine the reserved chilled caper-marjoram butter with the consommé in a small heavy saucepan. Heat over high heat just until butter melts, whisking constantly. Strain through the chinois, using the bottom of a sturdy ladle to force as much through as possible; the strained sauce should yield about ⅔ cup. Stir in the remaining 2 teaspoons capers and season to taste with pepper. Return to saucepan and set aside. (The sauce may be finished up to 1 hour ahead.)

TO FINISH THE DISH AND SERVE:

(See photograph page 66.) In the heavy roasting pan, combine 3 quarts of the milk, 1 teaspoon fine sea salt, the peppercorns, and the reserved ⅓ ounce marjoram sprigs and stems; bring to a simmer on top of the stove. Add the caul-wrapped skate portions in a single layer and, if not submerged, add more milk to cover. Poach at a slow simmer for 7 minutes, then carefully turn with a wide spatula and continue poaching until cooked through, about 7 minutes more; do *not* overcook. To test doneness, remove a portion of skate from the poaching liquid and unwrap it; if flesh is flaky in the center and mousseline is firm, it's done. Remove from heat and drain on paper towels. Unwrap skate; discard caul and marjoram leaves, sprigs, and stems. Cover with aluminum foil to keep warm.

Heat serving plates in a 250 degree oven and reheat sauce over very low heat, whisking occasionally.

Meanwhile, fry the julienne vegetables as follows: Heat the oil in the deep fryer to 375 degrees. Fry the carrot-turnip-celery mixture in

batches in the hot oil just until crisp and barely browned, about 1 minute; drain on paper towels and blot with more towels. Return oil to 375 degrees before frying each batch. Season lightly with salt.

Now reduce the oil temperature to 350 degrees, then fry the leeks just 10 to 15 seconds or until crisp and barely browned. Drain on paper towels and mix with the other fried vegetables. Serve promptly while still crisp.

To serve: Arrange a portion of skate on each heated serving plate, top with a portion of the fried vegetables, and spoon about 2 tablespoons sauce around the edges. Garnish with marjoram sprigs, if desired.

BEEF POT-AU-FEU with STUFFED CABBAGE LEAVES and BONE MARROW FLANS

Makes 4 servings

½ large unpeeled onion
3 medium-size unpeeled garlic cloves, crushed
About 3 quarts cool water for starting pot-au-feu broth
2 cups V-8 Juice
2 cups unpeeled chopped tomatoes
1 cup unpeeled chopped carrots
1 cup chopped celery
1 cup chopped leeks (mostly white part)
1 cup unpeeled chopped turnips
½ cup chopped shallots
10 large parsley sprigs
7 very leafy thyme sprigs
5 medium-size bay leaves
1 tablespoon coarse salt, plus salt for finishing dish and for the table
1 teaspoon whole black peppercorns
3 quarts water for blanching meats
2¼ to 2½ pounds beef shank
1½ pounds meaty beef short ribs
1 pound first-cut boneless beef brisket
1 recipe Stuffed Cabbage Leaves (see recipe for Veal Pot-au-Feu, pages 178-179)
Bone Marrow Flans (recipe follows)
16 baby carrots, peeled (or regular carrots, peeled and cut into 16 oval shapes)
16 baby turnips (or regular turnips, cut into 16 oval shapes)
1 cup peeled pearl onions
3 ribs celery, scraped and cut into 2 inch-long and ½-inch-wide pieces
3 small leeks (about 8 ounces), cut crosswise into 4-inch-long pieces (white parts)
Fine sea salt and freshly ground black pepper
FOR THE TABLE:
Warm French bread
Cornichons
Dijon mustard

SPECIAL UTENSILS:
Heavy 8-quart saucepan or soup pot
Heavy deep 5-quart saucepan or soup pot
Chinois

START THE POT-AU-FEU:

Char the onion half and garlic as directed in the Poultry Stock recipe (page 214); place in the 8-quart saucepan. Add to the pan 3 quarts of water, the V-8 Juice, the chopped tomatoes, carrots, celery, leeks, turnips, and shallots, the parsley and thyme sprigs, bay leaves, the 1 tablespoon coarse salt, and the peppercorns. If needed, add more water to cover all other ingredients. Bring to a boil. Reduce heat and simmer for 3 hours, skimming occasionally and adding more water as needed to keep all ingredients covered.

Once the pot-au-feu has simmered 3 hours, let it continue simmering while you blanch the beef as follows: Bring the 3 quarts water to boil in a large (about 6-quart) pot. Add the beef

shank, beef ribs, and beef brisket, and return to a boil, then remove from heat; drain. Transfer brisket to a plate and refrigerate. Add the beef ribs and shank to the pot-au-feu. Continue simmering pot-au-feu for 1 hour, then add the brisket and simmer 2 hours more, replenishing water as needed to keep all ingredients covered; cook at least 30 minutes more after the last addition of water. Cool, then refrigerate overnight.

FINISH THE DISH:

First, prepare the Stuffed Cabbage Leaves to the point of steaming; refrigerate.

Next, remove and discard the layer of congealed fat from the surface of the pot-au-feu. Place pot-au-feu in the 5-quart saucepan; bring to a boil, then simmer for 1 hour. Remove from heat, transfer meat and bones to a bowl; set aside. Strain the broth through the chinois into another bowl, using the bottom of a sturdy ladle to force as much through as possible; then skim broth thoroughly. Rinse saucepan well and return broth to it; set aside.

Make the Bone Marrow Flans. While the flans are baking, finish the pot-au-feu as follows: Bone the meat, leaving it in fairly large pieces, and trim away all fat and gristle. Return meat to the pan and add the baby carrots, baby turnips, pearl onions, and celery and leek pieces; season to taste with fine sea salt and pepper. Bring to a simmer and continue simmering 45 minutes more. Skim surface well and remove from heat. Serve immediately.

TO SERVE:

(See photograph page 67.) Steam the plastic-wrapped stuffed cabbage leaves in a covered steamer over boiling water just until heated through, 5 to 7 minutes. Meanwhile, unmold a flan into the center of each of 4 wide soup bowls or deep serving plates. Transfer the brisket from the pot-au-feu to a cutting board and slice against the grain into 4 equal-size pieces; arrange 1 slice in each bowl. Slice leek pieces from the pot-au-feu into 1-inch lengths and place in the bowls. Unwrap stuffed cabbage leaves and cut each in half; add 2 halves to each bowl. With a slotted spoon, transfer an assortment of the pot-au-feu meats and vegetables to the bowls; then ladle about ½ cup broth over each serving and sprinkle very lightly with coarse salt. Serve with more coarse salt, warm French bread, Cornichons, and Dijon mustard on the side.

BONE MARROW FLANS

Unsalted butter for greasing flan molds
¼ cup heavy cream
¼ cup milk
3 cups Meat or Vegetable Consommé (page 214) (preferred), Meat or Vegetable Stock (page 214), or water for cooking bone marrow
2 to 3 ounces intact bone marrow (from about three 2½-inch-long marrowbones)
1 large egg
Fine sea salt and freshly ground black pepper

SPECIAL UTENSILS:
5 (¼-cup-capacity) Pyrex flan molds, 2¼-inch diameter at inside top, 1⅝-inch diameter at outside base, 1⅞ inches tall
Chinois

Heat oven to 300 degrees. Generously butter flan molds; set aside. Combine the cream and milk in a small pot and bring to a boil. Remove from heat and set aside.

Bring the consommé to a boil in a small pot. Add the bone marrow and strongly simmer until very tender, about 10 minutes; drain. Transfer marrow with a slotted spoon to a food processor;

add the scalded cream-milk mixture, the egg, and a generous amount of salt and pepper, and process until smooth. Strain through the chinois without forcing the liquid through.

Pour the strained liquid into the prepared molds and place molds in a small baking pan; add enough boiling water to the pan to come up the sides of the molds 1½ inches. Bake uncovered in the preheated oven until done, about 45 minutes. (To test doneness, after about 40 minutes of cooking, remove a mold from the oven, loosen sides of flan with a thin flexible-bladed knife in 1 clean movement, and invert onto a plate; if done, the flan will hold its shape and when cut in half, the center will be solid, not runny.) Remove cooked flans from oven and let them sit in the hot water for at least 10 minutes or up to 30 minutes; then unmold and serve. *Makes 4 flans, plus 1 for testing doneness.*

ORANGE, LEMON, AND LIME SNOW EGGS with CUSTARD CREAM and ORANGE, LEMON, AND LIME SAUCES

Makes 4 servings

Custard Cream (recipe follows)
Orange, Lemon, and Lime Sauces (recipe follows) (optional)
SNOW EGGS:
1 tablespoon very finely grated orange zest (see Note)
¾ cup plus 3 tablespoons sugar
1 tablespoon very finely grated lemon zest (see Note)
1 tablespoon very finely grated lime zest (see Note)
Unsalted butter for greasing cookie cutters
6 egg whites (from large eggs), separated into 3 equal portions and at room temperature
¼ teaspoon orange juice
¼ teaspoon lemon juice
¼ teaspoon lime juice
8 orange segments, seeded and membranes removed for garnish
8 lemon segments, seeded and membranes removed for garnish
8 lime segments, seeded and membranes removed for garnish
Sifted powdered sugar for garnish
Paper-thin julienne orange, lemon, and lime zest for garnish (optional)

SPECIAL UTENSILS:
One 2 x 2½-inch rectangular metal cookie cutter, 1⅛ inches tall
One 6-sided metal cookie cutter, each side 1½ inches long, 1⅛ inches tall
Two 2-inch round metal cookie cutters, 1⅛ inches tall (or 2 other cutters of another shape but about this size for a total of 4 cookie cutters for use as molds for the snow eggs)
Steamer
Propane torch for browning snow eggs (optional)

NOTE:
Be careful not to get the bitter white pith from the rind into the zest.

Make the Custard Cream; refrigerate. Within 2 hours of serving, if using, make the Orange, Lemon, and Lime Sauces; set aside at room temperature while making the snow eggs.

To start the snow eggs, prepare the orange, lemon, and lime zest-sugar pastes as follows: For the orange zest-sugar paste, combine the orange zest and 1 tablespoon of the sugar on a cutting board or plate, kneading mixture with the back of a spoon until it becomes a paste.

Make the lemon zest-sugar paste with the lemon zest and 1 tablespoon more sugar as directed for the orange zest-sugar paste; then do the same to make the lime zest-sugar paste, using the lime zest and 1 tablespoon more sugar. Set zest-sugar pastes aside separately.

FINISH THE ORANGE SNOW EGGS:

Butter the insides of the 4 cookie cutters and place each on a 10-inch square of plastic wrap; set aside.

In the large bowl of an electric mixer (make sure it's very clean), beat ⅓ of the egg whites (2 egg whites) at medium speed about 30 seconds. Increase speed to medium-high and beat about 30 seconds until very frothy. Add the orange juice, then gradually add 3 tablespoons of the sugar; turn speed to high, add 1 tablespoon more sugar, and continue beating until stiff peaks form, 1 to 2 minutes more. Turn mixer off momentarily, add the reserved orange zest-sugar paste, and beat on high speed just a few seconds until well blended.

Spoon the batter into the prepared cookie cutters, mounding it slightly above rims; level tops with a spatula, then wrap well with the plastic to tightly seal batter inside. Immediately steam the 4 snow eggs in the covered steamer over boiling water until cooked through, 6 to 7 minutes.

With tongs, transfer the cooked snow eggs from the steamer to a work surface. Carefully unwrap eggs, slice off tops even with the rims of the cutters, and slip them out of the cutters onto an ungreased cookie sheet. Cover with plastic wrap and set aside at room temperature while finishing the lemon and lime snow eggs.

FINISH THE LEMON AND LIME SNOW EGGS:

Butter the cookie cutters and place each on a 10-inch square of plastic wrap. For the lemon snow eggs, prepare, steam, and unmold them precisely as directed for the orange snow eggs, using the reserved lemon zest-sugar paste and the lemon juice (in place of the orange zest-sugar paste and orange juice). Then use the same procedure to prepare, steam, and unmold the lime snow eggs, using the reserved lime zest-sugar paste and the lime juice. Once all snow eggs are unmolded, serve promptly.

TO SERVE:

(See photograph page 68.) With the snow eggs still on the cookie sheet, arrange 2 orange segments on top of each orange snow egg, 2 lemon segments on each lemon snow egg, and 2 lime segments on each lime snow egg; sprinkle tops generously with powdered sugar. If desired, while the snow eggs are still on the cookie sheet, very carefully use a propane torch to brown their tops and sides, holding the torch about 4 to 6 inches away from the eggs; add more powdered sugar if you want a browner surface. (If you don't have a torch, this may be done under a preheated broiler about 4 inches from the heat source; watch carefully.)

Transfer an orange, lemon, and lime snow egg to each serving plate with a spatula; spoon about ⅓ cup chilled custard cream around the edges. If desired, garnish the custard cream with the orange, lemon, and lime sauces and julienne orange, lemon, and lime zest.

CUSTARD CREAM

1 cup heavy cream
1 cup milk
An 8-inch piece of vanilla bean
6 egg yolks (from large eggs)
½ cup sugar

SPECIAL UTENSILS:
Chinois placed over a heatproof bowl

In a heavy nonreactive 2-quart saucepan, combine the cream and milk. Cut the vanilla bean in half lengthwise, scrape, and add scrapings and bean halves to the pan. Bring to a boil, remove from heat and let sit for 15 minutes.

Combine the egg yolks and sugar in a medium-size bowl, whisking vigorously until thick and pale yellow, about 2 minutes. Return the cream mixture to a boil, then remove from heat and gradually add to the egg yolk mixture, whisking constantly. Return mixture to the saucepan and cook over medium heat, stirring constantly and scraping pan bottom evenly with a wooden spoon, just until it thickens and leaves a distinct trail on the back of the spoon when you draw a finger through it, about 2 to 3 minutes; do *not* let mixture boil. Immediately strain through the chinois into the bowl. (If desired, rinse and save vanilla beans for future use.) Promptly cover and refrigerate until well chilled, at least 3 hours or overnight. *Makes 2 generous cups.*

ORANGE, LEMON, AND LIME SAUCES

1 tablespoon very finely grated orange zest (see Note)
¾ cup plus 1 tablespoon sugar
1 tablespoon very finely grated lemon zest (see Note)
1 tablespoon very finely grated lime zest (see Note)
¼ cup orange juice
6 egg yolks (from large eggs), separated into 3 equal portions
¼ cup lemon juice
¼ cup lime juice
1 tablespoon crème de menthe

NOTE:
Be careful to avoid getting the bitter white pith into the zest.

First, prepare the orange, lemon, and lime zest-sugar pastes as follows: For the orange zest-sugar paste, combine the orange zest with 1 tablespoon of the sugar on a cutting board or plate, kneading mixture with the back of a spoon until it becomes a paste; set aside. Next, make the lemon zest-sugar paste as directed for the orange zest-sugar paste, using the lemon zest and 1 tablespoon more sugar, then make the lime zest-sugar paste, using the lime zest and another 1 tablespoon sugar; set aside.

To finish the orange sauce, fill a medium-size pot with 2 inches of water and bring to a simmer. Meanwhile, in a medium-size stainless steel bowl, combine the orange zest-sugar paste, orange juice, ⅓ of the egg yolks (2 yolks), and 3 tablespoons sugar; place bowl over the pot of simmering (not boiling) water and cook, whisking gently and constantly, until the mixture thickens to a fairly thick sauce consistency, 7 to 9 minutes. Remove from heat and continue whisking about 1 minute more. Transfer orange sauce to a smaller bowl; set aside.

Finish the lemon sauce exactly as directed for the orange sauce, using the lemon zest-sugar paste, the lemon juice, 2 egg yolks, and 3 tablespoons sugar; set aside.

Follow the same procedure to make the lime sauce, using the lime zest-sugar paste, lime juice, remaining 2 egg yolks, and remaining ¼ cup sugar; add the crème de menthe to the lime sauce immediately after removing it from heat. Set sauces aside at room temperature (do not refrigerate) until ready to serve. *Makes about ¼ cup of each sauce.*

PERSIMMON CAKE, FROZEN HAZELNUT SOUFFLES with CHOCOLATE SAUCE, and THREE CHOCOLATE MOUSSES with RASPBERRY SAUCE

Makes 4 servings

Frozen Hazelnut Souffles (recipe follows)
Persimmon Cake (recipe follows)
RASPBERRY SAUCE:
 ½ pound (½ dry pint) raspberries
 ¼ cup water
 2 to 3 tablespoons sugar
1 recipe Three Chocolate Mousses (page 206)
CHOCOLATE SAUCE:
 ½ cup heavy cream
 1½ ounces semisweet chocolate, cut into small pieces
 1 tablespoon unsalted butter, softened
 1 tablespoon Amaretto liqueur
Sifted powdered sugar for garnish
4 mint sprigs for garnish
Milk chocolate shavings for garnish
4 whole hazelnuts for garnish

SPECIAL UTENSIL:
Chinois

Make the Frozen Hazelnut Souffles; keep frozen until ready to serve. Next, make the Persimmon Cake; refrigerate if made ahead.

FINISH THE DISH:
On the day of serving, make the raspberry sauce. To do this, combine the raspberries, water, and 2 tablespoons sugar in a blender and process until smooth. Taste and, if the sauce is especially tart, add more sugar. Strain through the chinois, using the bottom of a sturdy ladle to force as much through as possible. Cover and refrigerate until ready to serve. (This may be prepared several hours ahead.)

Within 2 hours of serving, make the Three Chocolate Mousses; refrigerate until ready to serve.

Within 1 hour of serving, make the chocolate sauce. To do this, bring the cream to a boil in a small pot; remove from heat and set aside. Melt the chocolate pieces with the butter in the top of a double boiler over slowly simmering water, stirring occasionally. Stir in the scalded cream and liqueur and remove from heat; set aside until ready to serve.

TO SERVE:
(See photograph page 69.) Sprinkle the top of the cake generously with powdered sugar; cut into slices and place 1 to the side of each of 4 large chilled serving plates. Next, use a heated spoon (dip it in hot water and dry it) to form 4 quenelles (oval shapes) of each type of chocolate mousse, reheating spoon as needed; arrange 1 of each type of quenelle on each plate, garnish with a mint sprig, and spoon 1 to 2 tablespoons raspberry sauce around the edges.

Unmold the souffles as follows: Fill a small baking pan with ½ inch of very hot water. Working with 1 souffle at a time, set the dish in the hot water for just 15 seconds, remove dish from water, tip it on its side, and gently ease the souffle out, still wrapped in parchment paper; place souffle on 1 of the serving plates and unwrap paper. Repeat with remaining 3 souffles. Garnish top of each souffle with milk chocolate shavings and a whole hazelnut, then spoon 1 to 2 tablespoons chocolate sauce around the edges. Serve promptly.

FROZEN HAZELNUT SOUFFLES

Unsalted butter for greasing souffle dishes
3 ounces (scant ¾ cup) shelled hazelnuts, dry roasted and cooled

1 cup heavy cream
3 tablespoons amaretto liqueur
2 egg whites (from large eggs), at room temperature
⅛ teaspoon lemon juice
3 tablespoons sugar

SPECIAL UTENSILS:
4 (¾-cup-capacity) individual straight-sided souffle dishes, inside diameter 3 inches, 1⅝ inches deep
4 (16 x 3-inch) rectangles of parchment paper

Line the inside walls of each souffle dish with 1 of the parchment-paper rectangles; the paper should extend above the sides of the dish about 1½ inches. Tape ends of paper closed with cellophane tape and lightly butter dish bottoms; set aside.

Process the hazelnuts in a blender for about 30 seconds until they are the consistency of graham cracker crumbs. Set aside.

Whip the cream until soft peaks form. Add the liqueur and continue whipping just until blended; refrigerate.

In the medium-size bowl of an electric mixer (make sure bowl is very clean), combine the egg whites and lemon juice; beat at low speed for about 30 seconds. Increase speed to medium and beat about 30 seconds until frothy bubbles begin to form, then add 2 tablespoons of the sugar and beat at medium for 30 seconds more. Increase speed to high, add the remaining 1 tablespoon sugar, and continue beating just until stiff peaks form, about 1 minute more.

Lightly fold the ground hazelnuts into the reserved whipped cream, then lightly fold this mixture into the egg whites just until barely blended; do *not* overmix. Gently spoon batter into the prepared souffle dishes. Freeze at least 4 hours or overnight. *Makes 4 souffles.*

PERSIMMON CAKE

½ cup light seedless raisins
½ cup dark seedless raisins
½ cup brandy
Unsalted butter and flour for preparing cake pan
1 cup chopped ripe persimmon pulp
1 cup plus 2 tablespoons sugar
1 tablespoon unsalted butter, melted
2 teaspoons vanilla extract
⅛ teaspoon ground cloves
⅛ teaspoon freshly ground nutmeg
1 cup chopped walnuts
1 cup all-purpose flour, sifted
1 teaspoon baking soda
½ teaspoon fine sea salt
½ cup heavy cream or half and half
1 egg white (from a large egg)
1 or 2 drops lemon juice

SPECIAL UTENSILS:
7-inch tube pan
Chinois

In a small glass or ceramic bowl, combine the light and dark raisins with the brandy, making sure all raisins are submerged. Cover and let sit at room temperature for at least 3 hours, preferably overnight.

Heat oven to 350 degrees. Butter and lightly flour the tube pan; set aside.

Purée the persimmon pulp in a blender, then strain through the chinois into a large bowl, using the bottom of a sturdy ladle to force as much through as possible. Add 1 cup of the sugar and the butter, vanilla, cloves, and nutmeg, mixing until well blended. Stir in the walnuts and the raisin-brandy mixture. Combine the flour, baking soda, and salt, and gradually add to the

persimmon mixture, stirring until well mixed. Gradually add the cream (or half and half), blending well. Set aside.

In the small bowl of an electric mixer (make sure bowl is very clean), combine the egg white and lemon juice; beat on low speed for about 30 seconds. Increase speed to medium and beat about 30 seconds until frothy bubbles begin to form, then add 1 tablespoon of the sugar and beat at medium for 30 seconds more. Increase speed to high, add 1 tablespoon more sugar, and continue beating just until stiff peaks form, about 1 minute more.

Lightly fold the egg white mixture into the persimmon mixture just until barely blended; do *not* overmix. Gently spoon batter into the prepared pan. Bake until a toothpick inserted into the center of cake comes out clean, about 1 hour 10 minutes. Remove from oven and let cool to room temperature, about 1 hour more, then unmold and serve immediately or, if made ahead, wrap well and refrigerate. *Makes 1 tube cake.*

DUCK NECKS STUFFED WITH FOIE GRAS, MAGRET OF DUCK, AND BLACK TRUFFLES

Makes 4 to 6 first-course servings

STUFFED DUCK NECKS:
2 ounces flash-frozen black truffles, thawed
8 ounces fresh uncooked duck or goose foie gras (Grade B)
8 ounces boneless and skinless *magrets de canard* (breasts of mulard duck) with fat layer still attached
8 ounces rindless pork fatback
4 ounces boneless pork neck or pork shoulder
¼ cup chopped onions
1 tablespoon finely chopped shallots
3 small thyme sprigs
1 large peeled garlic clove
About 1 tablespoon fine sea salt
About 2 teaspoons freshly ground black pepper
1 large egg, lightly beaten
1 tablespoon Armagnac brandy
1 tablespoon canned truffle juice
3 duck necks
6 (14-inch) squares of pork caul fat (about 2¼ pounds; see Note)
4 to 5 cups rendered duck fat or pork lard (preferred) or vegetable oil
2 (¼-ounce) packages unflavored gelatin for aspic garnish (optional)
3 cups cold Meat or Vegetable Consommé (page 214) for aspic garnish (optional)
2 cups loosely packed mesclun or other small tender salad greens such as mache (lamb's lettuce, corn salad), radicchio, or *frisée* (curly endive) for garnish (optional)
1 recipe Balsamic Vinaigrette for garnish (optional) (see recipe for Salad of Sea Scallops, White Truffles, Fresh Hearts of Palm, and Mesclun, this page)

SPECIAL UTENSILS:
Meat grinder fitted with a fine grinding disc
Large wire cake or cookie cooling rack for aspic garnish

NOTE:
Caul fat is available from butcher shops. Ask for pieces with few if any holes and ones without extra-large veins of fat running through them; refrigerate, soaking in water, until used.

PREPARE THE STUFFED DUCK NECKS:
Heat oven to 400 degrees. Finely chop just enough of the truffles to yield 2 tablespoons; set aside. Cut the remaining truffles into ½-inch cubes; set aside separate from the chopped truffles.

With a sharp thin-bladed knife, carefully trim away any green spots on the foie gras caused by contact with the gall bladder, then cut 4 ounces each of the foie gras, *magrets*, and fatback into ½-inch cubes; combine in a small bowl and set aside.

Coarsely chop the remaining 4 ounces each of the foie gras, *magrets*, and fatback; combine in a large bowl with the pork neck meat, onions, shallots, thyme sprigs, and garlic. Grind in the meat grinder and place in a large bowl. Add the reserved 2 tablespoons finely chopped truffles, 1 tablespoon sea salt, 2 teaspoons pepper, and the egg, brandy, and truffle juice; mix well by hand. Add the reserved cubed *magret*-foie gras-fatback mixture and reserved truffle cubes and gently mix until stuffing is thoroughly blended.

Next, form a test patty with 1 to 2 tablespoons of the stuffing and bake uncovered in the preheated oven for 10 minutes. Let cool, then taste for seasoning; add more salt and pepper to the remaining stuffing if needed.

Remove and discard all excess fat from the necks. Stuff each neck with ⅓ of the stuffing, packing tightly to prevent air pockets. Rinse the caul fat squares well and squeeze dry; wrap each neck snugly in 1 of the squares, then securely wrap in a second square. Cover and refrigerate until ready to cook. (This may be done several hours before cooking the necks.)

To cook the duck necks: Place 4 cups of the duck fat in a heavy 4-quart saucepan and heat to 200 degrees over very low heat. Ease the duck necks into the hot fat and, if not submerged, add more fat to the pan. Cook until juices run clear when the necks are pierced to the center with a thin metal skewer, about 1½ hours, maintaining oil temperature at about 200 degrees. Remove from heat and cool necks in the cooking fat for 1 hour, then transfer necks and fat to a deep glass bowl, making sure necks are completely submerged. Cover and refrigerate at least overnight or up to 1 week.

TO SERVE:
(See photograph page 72.) If not using the aspic and salad greens garnish, just before serving time remove the chilled duck necks from the cooking fat and submerge, still wrapped in caul, in a large pot of boiling water for 30 seconds to melt off the remaining duck fat. Drain on paper towels and wipe dry. Cut the caul-wrapped necks into ½-inch slices, making sure slices are uniformly thick. Serve immediately on chilled serving plates, allowing 2 slices for each serving.

If using the aspic and salad greens garnish, a few hours before serving make the aspic and coat the duck neck slices with it. To do this, soften the gelatin in ½ cup of the consommé for about 2 minutes. Bring the remaining 2½ cups consommé to a boil in a medium-size pot, then remove from heat and stir in the gelatin; return to high heat, stirring just a few seconds until gelatin completely dissolves. Transfer aspic to a bowl and refrigerate until slightly thickened, about 45 minutes, stirring every 10 minutes.

Meanwhile, melt the duck fat off the necks and slice as directed above. Arrange slices in a single layer on the cooling rack about ½ inch apart. Refrigerate until well chilled, at least 20 minutes.

Once the aspic has started thickening and the duck neck slices are well chilled, place the rack holding the slices over a large cookie sheet to catch drippings and ladle about ⅓ of the aspic evenly over the tops and sides. Refrigerate slices and the remaining aspic for 10 minutes, then repeat procedure to coat tops and sides of the slices 1 or 2 more times with aspic, using it all. Refrigerate slices, still over the cookie sheet, at least 1½ hours more before serving.

Just before serving, remove the jelled aspic drippings from the cookie sheet with a spatula and cut into ¼-inch cubes. Toss the salad greens with enough vinaigrette to lightly coat them and add a portion of the greens, then the aspic cubes, to each chilled serving plate. Arrange 2 slices of duck neck on each plate and serve immediately.

SALAD OF WARM SEA SCALLOPS, WHITE TRUFFLES, FRESH HEARTS OF PALM, AND MESCLUN with BALSAMIC VINAIGRETTE

Makes 4 servings

VINAIGRETTE:
⅔ cup vegetable oil
2 tablespoons balsamic vinegar
2 teaspoons extra-virgin olive oil
Fine sea salt and freshly ground black pepper

1½ ounces fresh white or black truffles (preferred) or thawed flash-frozen black truffles
1 pound sea scallops, rinsed and small tough muscle on the side of each removed
Fine sea salt and freshly ground black pepper
6 cups loosely packed mesclun or other small tender salad greens such as mache (lamb's lettuce, corn salad), radicchio, or *frisée* (curly endive)
3 ounces finely sliced fresh hearts of palm (about ½ cup tightly packed) (preferred) or three 3-inch-long top-quality canned or jarred hearts of palm, cut crosswise into ⅛-inch slices, tossed with 2 tablespoons lemon juice to prevent discoloration
4 chervil or dill sprigs, snipped into small pieces
Salt water (¼ cup coarse salt mixed with 3 quarts water) for blanching seaweed (see Note)
¾ pound seaweed for garnish (optional) (see Note)
Ice water for cooling blanched seaweed (see Note)
4 large scallop shells on which to serve salads (optional) (see Note)
Lobster Coral Garnish (optional) (page 215)
8 small scallop shells for garnish (optional)

SPECIAL UTENSILS:
Meat slicer
2 or more different-sized round scallop-edged cookie cutters smaller than the diameter of the scallops for cutting scallops into "scallop" shapes (optional)

NOTE:
If desired, serve the salads directly on the plates instead of in large scallop shells on beds of blanched inedible seaweed.

PREPARE THE VINAIGRETTE:
Combine all the vinaigrette ingredients in a medium-size bowl, whisking until thoroughly blended. Set aside.

PREPARE THE TRUFFLES AND SCALLOPS:
Use the meat slicer to cut the truffles into paper-thin slices. Cover and refrigerate.

Cut the scallops into ⅛-inch slices with a sharp knife. If desired, cut out slices with the cookie cutter(s) to make them more attractive. Place on a cookie sheet lined with parchment or waxed paper and season tops with salt and pepper. Whisk reserved vinaigrette briefly to blend ingredients, then brush tops of scallop slices with some of it. Cover scallops and refrigerate until ready to cook; set aside vinaigrette.

IF USING, BLANCH THE SEAWEED:
Bring the salt water to a rolling boil in a large pot. Add the seaweed and blanch for 2 minutes. Immediately drain and cool in the ice water; drain well. Refrigerate if not using fairly promptly.

TO SERVE:
(See photograph page 73.) Preheat broiler. Whisk the remaining vinaigrette briefly and grease a broiler pan lightly with some of it; arrange scallop slices in the pan and set aside.

If using seaweed, divide it into 4 equal portions and mound a portion on each serving plate; position a large scallop shell on top. Place salad greens in a large mixing bowl; whisk the vinaigrette briefly and add just enough to the greens to lightly coat them (reserve at least 3 tablespoons vinaigrette for tossing with the truffle and hearts of palm slices). Season greens with salt and pepper and mound on top of the shells or directly onto chilled serving plates. In the same mixing bowl, very gently toss the truffle slices with 2 tablespoons of the vinaigrette and arrange on the salads. Add 1 tablespoon more

vinaigrette to the bowl and toss the hearts of palm slices with it; add these slices and the snipped chervil or dill to the salads.

Now broil the scallop slices about 4 inches from the heat source just until cooked through, 2 to 3 minutes; watch carefully and do *not* overcook. While still warm, arrange scallop slices on top of the salads. If desired, sprinkle salads lightly with Lobster Coral Garnish and arrange 2 small scallop shells at the edge of each plate. Serve promptly.

ZUCCHINI FLOWERS STUFFED WITH BLACK TRUFFLE AND LOBSTER MOUSSELINE with BABY ZUCCHINI, BABY YELLOW SQUASH, and TRUFFLE SAUCE

Makes 4 generous first-course servings

1 recipe Truffle Sauce (see recipe for Monkfish Wrapped in Black Truffles, page 187; see Note)
1 recipe Lobster Mousseline (page 215)
4 fresh zucchini flowers
2 tablespoons heavy cream
½ ounce flash-frozen black truffles, thawed and finely sliced
Fine sea salt and freshly ground black pepper
Salt water (2 tablespoons coarse salt mixed with 6 cups water) for cooking zucchini and yellow squash
8 baby zucchini (about ½ ounce each; stem ends untrimmed)
4 baby yellow squash (about ½ ounce each; stem ends untrimmed)
Ice water for cooling cooked zucchini and yellow squash
1½ cups Lobster Consommé (page 214) (preferred), Lobster Stock (page 214), or other Consommé or Stock (page 214)

SPECIAL UTENSILS:
Pastry bag fitted with a ½-inch plain nozzle
Steamer

NOTE:
If desired, use ½ ounce of the truffles called for in the sauce recipe to make a garnish for the plates as follows: Cut the ½ ounce truffles into paper-thin slices and finely julienne all except 8 of the slices. Cover the slices and julienne strips and refrigerate until serving time.

Make the truffle butter for the sauce (see page 187) and make the Lobster Mousseline; refrigerate both.

PREPARE THE STUFFED ZUCCHINI FLOWERS:
Remove and discard the centers from the zucchini flowers and trim stem ends. Place each flower in the center of an 11 x 7-inch piece of plastic wrap and set aside.

In a food processor, process the Lobster Mousseline with the cream, truffle slices, and a little salt and pepper just until well blended and truffles are minced; do *not* overmix. Spoon this filling into the pastry bag and pipe into the zucchini flowers by inserting nozzle at the stem end of each flower and filling to top; use all filling. Next, roll 1 of the flowers snugly in the plastic wrap to make a log-shaped roll; twist both ends of the wrap to seal the flower securely inside, continuing to twist until ends of plastic coil tightly, then prick about 8 tiny holes through the wrap with a pin. Repeat with the remaining 3 zucchini flowers. Refrigerate. (These may be prepared several hours ahead.)

TO FINISH THE DISH AND SERVE:
Heat the serving plates in a 250 degree oven. Bring the salt water to a rolling boil in a medium-size pot. Add the baby zucchini and yellow

squash and cook until tender but still firm, about 7 minutes. Immediately cool in the ice water. Drain and set aside.

Steam the zucchini flowers in a covered steamer over boiling water until cooked through, about 10 minutes, turning once. When finished cooking, remove from steamer and set aside without unwrapping.

Meanwhile, finish the sauce as directed on page 187. Also now use a sharp knife to cut the yellow squash and 4 of the zucchini into fans. To do this, carefully cut 4 to 6 parallel lengthwise slices in each with a thin-bladed knife, starting at the end opposite the stem and cutting up to (but not through) the stem. Place fans in a large skillet in a single layer and fan them out. Add the remaining 4 uncut zucchini and the consommé and cook over high heat just until zucchini and squash are heated through, about 5 minutes; drain on paper towels.

To serve, carefully unwrap the steamed zucchini flowers. On each heated serving plate, arrange 1 stuffed zucchini flower, 1 whole zucchini, 1 zucchini fan, and 1 yellow squash fan, as shown on page 74. Add about 2 tablespoons sauce to each plate; if using, garnish sauce with a portion of the julienne truffles and garnish plate with 2 truffle slices. Serve immediately.

POTATO AND BLACK TRUFFLE CAKES with BLACK TRUFFLE BALSAMIC VINAIGRETTE

Makes 4 generous first-course servings

Salt water (¼ cup coarse salt mixed with 3 quarts water) for cooking potatoes
4 large well-formed russet potatoes (about 10 ounces each and at least 2¼ inches wide at the widest point), scrubbed well
Ice water for cooling cooked potatoes
VINAIGRETTE:
 ½ cup vegetable oil
 ¼ cup canned truffle juice
 1 tablespoon plus 2 teaspoons balsamic vinegar
 1 tablespoon extra-virgin olive oil
 ½ ounce flash-frozen black truffles, thawed and finely chopped
 Fine sea salt and freshly ground black pepper
Fine sea salt and freshly ground black pepper
2 ounces flash-frozen black truffles, thawed

SPECIAL UTENSILS:
2-inch cookie cutter
Meat slicer or truffle slicer

NOTE:
 You may only need 3 potatoes, but since they tend to crack apart once cooked and sliced, it's best to cook 1 extra.

About 3½ hours before serving time, prepare the potato rounds. To do this, bring the salt water to a boil in a large pot. Add the 4 potatoes and very slowly simmer just until tender, about 50 minutes; check doneness with a thin metal skewer (if done, it will insert and withdraw easily), but do this sparingly since the potatoes, once sliced, tend to crack apart where pierced. Immediately transfer with a slotted spoon to cool in the ice water; reserve salt water.

Meanwhile, process all the vinaigrette ingredients in a blender until truffles are reduced to tiny bits; set aside.

Once the potatoes are cool enough to handle, heat a sharp thin-bladed knife in the hot salt water and cut them crosswise into ⅛-inch slices, making sure slices are of uniform thickness; reheat knife before cutting each slice. As slices are cut, place on a cookie sheet lined with parchment or waxed paper. Next, cut the best

slices into rounds with the cookie cutter, heating its cutting edge in the hot water before forming each round; you will need 28 perfect ones, but cut out several extras in case any crack apart.

Now process the vinaigrette a few seconds in the blender until ingredients are well mixed. Set aside ½ cup of it for spooning over the cakes just before serving; brush the remainder on both sides of each potato round. Season tops of rounds with salt and pepper. Cover and let sit at room temperature for about 2 hours. Meanwhile, use the meat (or truffle) slicer to cut the 2 ounces truffles into ¹⁄₁₆-inch slices. Set aside 48 of the largest slices for the cakes. Mince the remaining slices and any scraps for "frosting" tops of cakes. Cover sliced and minced truffles separately in plastic wrap; refrigerate.

TO ASSEMBLE THE CAKES AND SERVE:
 (See photograph pages 74-75.) Heat oven to 350 degrees. Once the potato rounds have marinated for 2 hours, assemble the 4 cakes in a small baking pan lined with parchment paper or aluminum foil as follows: For each cake, place a marinated potato round in the pan and season top lightly with salt and pepper; cover with 2 slices of the reserved truffles, then cover truffle slices with another potato round; season top of second potato round with salt and pepper and cover it with another 2 slices of truffles; continue in this fashion until the cake has 6 layers of truffle slices and 7 layers of potato rounds, ending with a potato round.

Once all 4 cakes are assembled, brush tops with some of the excess vinaigrette from marinating the potato rounds. Seal pan with aluminum foil and bake in the preheated oven until cakes are heated through, 10 to 12 minutes; heat the serving plates in the oven for the last 2 to 3 minutes. Remove from oven and transfer a cake to each heated serving plate.

Now process the remaining ½ cup vinaigrette in the blender (or whisk) until ingredients are thoroughly blended and spoon 1 to 2 tablespoons over each cake; then "frost" tops of cakes with the reserved minced truffles, using them all. Serve immediately, providing your guests with sharp dinner knives for cutting the cakes at the table.

BRAISED SWEETBREADS WRAPPED IN BLACK TRUFFLES with CELERY ROOT CREAM SAUCE

Makes 4 servings

1½ to 1¾ pounds very fresh veal sweetbreads; each piece at least 2¾ inches wide and long so it can be cut into 1 or more rounds with a 2¾-inch cookie cutter
Cool water for soaking sweetbreads
1 cup unpeeled chopped carrots
½ cup chopped celery
½ cup chopped leeks (mostly white part)
½ cup chopped onions
½ cup unpeeled chopped turnips
¼ cup chopped shallots
10 very leafy thyme sprigs
3 medium-size bay leaves
1 teaspoon whole black peppercorns
1 teaspoon fine sea salt
3 tablespoons plus 1 teaspoon vegetable oil
½ cup Chardonnay wine
About 2 cups Meat or Vegetable Consommé (page 214) (preferred) or Meat or Vegetable Stock (page 214)
SAUCE:
 ½ cup heavy cream
 Salt water (1 tablespoon coarse salt mixed with 3 cups water) for cooking celery root (celeriac)
 2 tablespoons lemon juice

1 cup peeled and coarsely chopped celery root, stored in acidulated water if prepared ahead
Fine sea salt and freshly ground black pepper
½ cup braising liquid (reserved from braising sweetbreads)
4½ ounces flash-frozen black truffles, thawed
2 large eggs
Fine sea salt and freshly ground black pepper
⅓ cup all-purpose flour
3 tablespoons unsalted butter

SPECIAL UTENSILS:
2¾-inch cookie cutter
Chinois

PREPARE THE SWEETBREADS FOR COOKING:
 Trim away any large chunks of fat from the sweetbreads. Cover sweetbreads with cool water and soak for 10 minutes; drain. Cover with fresh water and let soak 10 minutes more; drain again. Cover a third time with fresh water and refrigerate overnight.

BRAISE THE SWEETBREADS AND FORM SWEETBREAD ROUNDS:
 Heat oven to 375 degrees. Drain sweetbreads; set aside.

In a medium-size bowl, combine the carrots, celery, leeks, onions, turnips, shallots, thyme sprigs, bay leaves, peppercorns, and the 1 teaspoon salt. Place 3 tablespoons of the oil in a heavy 13 x 9-inch or larger roasting pan and heat over high heat on top of the stove, 1 to 2 minutes. Add the vegetable mixture and sauté until vegetables start to brown, about 10 minutes, stirring frequently. Add the wine and stir, cooking about 3 minutes, then mound the vegetables in the center of the pan and arrange the sweetbreads on top. Remove from heat and transfer pan, uncovered, to the 375 degree oven; bake for 10 minutes. Remove pan from oven momentarily and check smallest sweetbread pieces for doneness; transfer done pieces to a platter. (To judge doneness, make a cut no deeper than 1 inch into the thickest part of each sweetbread; if done, the meat at the base of the cut will be very pale pink to cream colored.) Turn over remaining sweetbreads in the pan, cover pan with aluminum foil, and continue baking until done, about 10 minutes more. Remove from the oven and transfer sweetbreads in the pan to the platter with the other sweetbreads. Set the roasting pan aside without scraping or draining it.

When sweetbreads are cool enough to handle, gently pull off any bits of fat and most of the membrane surrounding them, leaving just enough attached to hold sweetbreads together; set aside all fat and membrane trimmings.

Form the sweetbreads into four 2¾-inch rounds that are neatly shaped and of uniform thickness, each between ½ and 1 inch thick. To do this, first cut out as many sweetbread rounds as possible with the cookie cutter; if needed, start the cut by carving part way down around the outside edge of the cookie cutter with a sharp knife. Next, neatly trim each round to a ½- to 1-inch thickness and select the most attractive rounds for use; set aside all trimmings. Cover rounds and refrigerate. (These may be prepared several hours ahead.)

To the reserved roasting pan, add 2 cups of the consommé, the reserved sweetbread fat and membrane trimmings, and reserved trimmings from forming the sweetbread rounds. Cook over medium heat on top of the stove until liquid reduces to about ⅔ cup, 15 to 20 minutes, stirring occasionally. Strain this braising liquid through the chinois, using the bottom of a sturdy ladle to force as much through as possible. Skim

fat from surface of liquid, then measure out ½ cup; if needed, reduce liquid over high heat or add more consommé to make ½ cup. Set aside for the sauce. (Refrigerate if prepared ahead.)

MAKE THE SAUCE:
 Bring the cream to a boil in a small pot; remove from heat and set aside. Combine the salt water and lemon juice in a medium-size nonreactive pot and bring to a boil. Add the celery root and simmer until tender, about 30 minutes. Drain and purée in a blender or food processor, adding salt and pepper to taste; add the scalded cream and the reserved ½ cup braising liquid and continue processing until well blended. Strain through the chinois, using the bottom of a sturdy ladle to force as much through as possible; the strained liquid should yield a generous ¾ cup. Taste for seasoning. If using almost immediately, transfer to a small heavy nonreactive saucepan and set aside. If made ahead, cover and refrigerate. (The sauce may be made several hours ahead.)

PREPARE THE TRUFFLES:
 With a sharp thin-bladed knife, cut the truffles into ⅛-inch slices. Julienne 3 of the slices into ⅛-inch-thick strips for garnishing the sauce; cover and refrigerate. Mince the remaining slices and place in a medium-size bowl; cover and refrigerate. (This may be done several hours ahead.)

BREAD THE SWEETBREADS:
 In a medium-size bowl, whisk together the eggs, the remaining 1 teaspoon oil, a pinch of salt, and a generous amount of pepper. Place the flour in a separate medium-size bowl. Season the sweetbread rounds generously on both sides with salt and pepper; then bread 1 round at a time as follows: Dredge the round in the flour, shaking off excess; coat with the egg mixture, draining slightly, and place round in the bowl with the reserved minced truffles; immediately rinse hands well (so you don't get flour and egg mixture on the truffles), then press ¼ of the truffles gently into the round with your fingertips to make truffle pieces adhere, being sure to distribute them evenly. Place breaded rounds on a plate and refrigerate, covered, for 2 to 4 hours before cooking.

TO FINISH THE DISH AND SERVE:
 (See photograph page 76.) Heat oven to 350 degrees. Melt the butter in a large ovenproof skillet (preferably nonstick) over low heat. Carefully add each sweetbread round and cook until breading on the underside starts to solidify, about 3 minutes. With a sturdy spatula, very gently turn each round over, then continue cooking 3 minutes more. Immediately transfer skillet, uncovered, to the preheated oven and bake until rounds are heated through, about 8 minutes; to judge doneness, carefully cut 1 of the rounds in half vertically and check temperature of center with your fingertips.

Meanwhile, reheat sauce over medium heat, whisking occasionally. Heat serving plates in the oven with the sweetbread rounds for the last 1 to 2 minutes before removing rounds from the oven. When the sweetbread rounds are heated, transfer them to a cutting board and carefully slice each in half vertically. Arrange 2 halves in the center of each heated serving plate and spoon about 2 tablespoons sauce between the halves; garnish sauce with the reserved julienne truffles. Serve immediately.

MONKFISH WRAPPED IN BLACK TRUFFLES AND PANCETTA with TRUFFLE SAUCE

Makes 4 servings

SAUCE:
- 6 tablespoons unsalted butter, softened
- 1¼ ounces flash-frozen black truffles, thawed and coarsely chopped
- 3 tablespoons Lobster Consommé (page 214) (preferred), Lobster Stock (page 214) or other Consommé or Stock (page 214)
- Fine sea salt and freshly ground black pepper

MONKFISH:
- 1½ ounces flash-frozen black truffles, thawed
- 6 ounces *pancetta*
- 2 (10- to 12-ounce) skinless fillets of monkfish
- Freshly ground black pepper
- 2 tablespoons plus 1 teaspoon extra-virgin olive oil
- ½ ounce flash-frozen black truffles, thawed for garnish (optional)
- Lobster Coral Garnish (optional) (page 215)

SPECIAL UTENSIL:
Meat slicer

START THE SAUCE:

Cream the butter in a food processor. Add the truffles and continue processing until smooth. Cover truffle butter and refrigerate until firm, at least 1 hour or overnight.

TO FINISH THE DISH AND SERVE:

(See photograph page 77.) Heat oven to 375 degrees. Use the meat slicer to cut the 1½ ounces truffles and the *pancetta* into paper-thin slices. Set aside.

If using the truffle garnish, use the meat slicer to cut the ½ ounce truffles into paper-thin slices; julienne the slices into ⅛-inch or thinner strips. Set aside.

Cut the monkfish fillets in half crosswise to form 4 equal portions. Season generously on both sides with pepper. Heat 2 tablespoons of the oil in a very large skillet (preferably non-stick) over high heat, 2 to 3 minutes. Add the fish pieces and cook 30 to 45 seconds on each side. Drain on paper towels; let cool about 2 minutes.

Grease a cookie sheet or baking pan with the remaining 1 teaspoon oil; set aside. Now prepare each portion of monkfish as follows: Cover all surfaces of each portion, except the very ends, with ¼ of the reserved truffle slices; then wrap fish crosswise with ¼ of the reserved *pancetta* slices, sealing truffle slices against the fish and leaving ends of fish uncovered; ends of the *pancetta* slices should be underneath the fish. Once all fish portions are prepared, transfer them, seam side down, to the prepared cookie sheet. Bake uncovered in the preheated oven just until fish is cooked through, 10 to 12 minutes; do *not* overcook. Heat the serving plates in the oven for the last 2 to 3 minutes.

Meanwhile, finish the sauce. To do this, combine the reserved chilled truffle butter with the consommé in a small heavy saucepan. Heat over medium heat just until butter is melted, whisking constantly; season to taste with salt and pepper and remove from heat.

When the monkfish is cooked, cut each portion in half crosswise with a sharp knife; arrange 2 of the halves on each heated serving plate and spoon 2 tablespoons sauce in between. If using, garnish with the julienne truffles and sprinkle lightly with Lobster Coral Garnish. Serve immediately.

ROASTED CAPON WITH BLACK TRUFFLES AND FRENCH BREAD STUFFING and BLACK TRUFFLE SAUCE

Makes 4 to 6 servings

- 1 capon, dressed (about 8½ pounds dressed)
- 3 ounces flash-frozen black truffles, thawed and cut into ⅛-inch or thinner slices
- 2 (1-ounce) slices stale crusty French bread or French rolls (two 3 x 3 x 2-inch pieces of bread or equivalent in rolls)
- 1 large peeled garlic clove
- ½ cup very finely sliced shallots
- 2 teaspoons fine sea salt
- 1¾ teaspoons freshly ground black pepper
- ¾ cup vegetable oil
- 1¾ cups Meat or Vegetable Consommé (page 214) (preferred) or Meat or Vegetable Stock (page 214)
- ⅔ cup canned truffle juice
- ½ cup *Fond de Veau* (page 214)
- Very finely julienned black truffles for garnish (optional)

SPECIAL UTENSILS:
Kitchen twine
Chinois

Remove any visible fat from the capon and set aside neck and giblets. Cut off the first 2 joints of the wings and reserve with neck and giblets. Trim excess fatty skin from the neck area, leaving just enough skin to cover the neck cavity; reserve trimmings with neck and giblets. With your fingers, separate the skin from the meat around the breasts, back, thighs, and wings, being careful not to completely detach any skin or pierce holes through it. Insert the truffle slices under the skin, spacing them evenly and using them all. Cover capon, neck, giblets, and trimmings well; refrigerate overnight.

When ready to roast and serve the capon, heat oven to 500 degrees. For the stuffing, rub all surfaces of the bread with the garlic clove; set bread aside. Very finely slice the garlic clove and mix it with the shallots in a medium-size bowl, then add 6 of the thyme sprigs and the bread to the bowl.

Now remove capon from refrigerator and place breast up in a large roasting pan. Thoroughly combine the salt and pepper in a small bowl and generously season the large cavity with some of it; set remaining seasoning mixture aside. Stuff the large cavity evenly with the bread stuffing mixture. If the capon came with a liver, place it inside the neck cavity. Cover neck cavity with the skin flap and truss capon with the kitchen twine to securely close both cavities and tie the legs close to the body. Next, chop the neck into 3 or 4 pieces with a cleaver; add it and the reserved trimmings and remaining giblets to the pan. Season the outside of the capon with the remaining seasoning mixture. Break the remaining 2 thyme sprigs into pieces and sprinkle them over the capon, then pour the oil evenly over the top, rubbing some of it into the underside of the capon and on the bones, trimmings, and giblets in pan bottom.

Place the roasting pan over very high heat on top of the stove and brown the capon on all sides, about 10 minutes, checking frequently to make sure skin doesn't stick to the pan; if it does, loosen with a spatula, being careful not to rip skin or some of the truffle slices may be lost. (Note: If the skin starts sticking excessively, stop the browning procedure and continue with recipe.) Place capon breast up and transfer pan, uncovered, to the preheated oven. Roast for 30 minutes, basting every 10 minutes with the pan juices. Remove from oven and with the capon still breast up make a cut between the thigh and

body down to the thigh/hip joint on each side. Baste again and return pan to oven. Continue roasting and basting just until juices run clear, about 25 minutes more; do *not* overcook. Transfer capon to a serving platter and cover loosely, reserving roasting pan. Heat the serving plates in the still-warm oven and make the sauce.

For the sauce, skim off as much fat from the pan juices as possible, leaving at least 2 tablespoons of liquid and all the bones and giblets in pan. Add the consommé and truffle juice and bring to a boil over high heat on top of the stove, scraping pan bottom with a spoon to dissolve all browned matter. Boil for 5 minutes, stirring occasionally. Add the *Fond de Veau* and continue boiling until the sauce is dark and rich tasting, 3 to 4 minutes more. Strain sauce through the chinois, using the bottom of a sturdy ladle to force as much through as possible; it should yield about 1 cup. Pour into a sauceboat or small pitcher for serving at the table.

TO SERVE:

(See photograph page 78.) Remove the twine from the capon and, if desired, garnish serving platter with julienne truffles. Present the uncarved capon to your guests, then carve as you would a chicken; removing and chopping stuffing as you work. Place a portion of the capon, stuffing, and julienne truffles on each heated serving plate and spoon or pour a little of the sauce over the capon (the sauce is quite rich so you won't need much).

BLACK TRUFFLE ICE CREAM INSPIRED BY ANDRE DAGUIN

Makes 3 cups

- 1 cup heavy cream
- ¾ cup canned truffle juice
- ½ cup milk
- 1 ounce fresh black truffles (preferred) or thawed flash-frozen black truffles (optional)
- 6 egg yolks (from large eggs)
- ⅓ cup sugar

SPECIAL UTENSILS:
Chinois placed over a heatproof bowl
Ice cream machine

In a heavy 3-quart nonreactive saucepan, combine cream, truffle juice, milk, and if using, truffles. Bring to a boil, then remove from heat and let sit 15 minutes. Remove truffles and rinse; cover truffles well and refrigerate.

Combine the egg yolks and sugar in a medium-size bowl, whisking vigorously until thick and pale yellow, about 2 minutes. Return the cream mixture to a boil, then remove from heat and gradually add to the egg yolk mixture, whisking constantly. Return mixture to the saucepan and cook over medium heat, stirring constantly and scraping pan bottom evenly with a wooden spoon, just until it thickens and leaves a distinct trail on the back of the spoon when you draw a finger through it, about 2 minutes; do *not* let mixture boil. Immediately strain through the chinois into the bowl. Cover and refrigerate until well chilled, at least 3 hours or overnight.

Freeze in the ice cream machine according to manufacturer's instructions until firm, about 20 to 45 minutes, depending on the type of machine used. If desired, cut the reserved truffles into very fine julienne strips and sprinkle over the ice cream. (Note: This ice cream is at its best if served within a few hours after you make it.)

PETITS FOURS

(Semisweet Chocolate Truffles, White Chocolate Truffles, Molasses Madeleines, Hazelnut Tuiles, Confit of Orange Rind, Coconut Macaroons, and Tartlets of Lemon, Blackberry, Walnut, Raspberry, and Apple)

SEMISWEET CHOCOLATE TRUFFLES

Makes about 2½ dozen truffles

- 8 ounces semisweet chocolate, cut into very fine shavings
- ½ cup heavy cream
- 3 tablespoons liquor of your choice (such as rum, whiskey, Grand Marnier, kirsch, cassis) (optional)
- 4 ounces semisweet chocolate, cut into small pieces
- About ⅓ cup sifted unsweetened cocoa powder (optional)

SPECIAL UTENSIL:
1-inch melon baller

Place the 8 ounces chocolate shavings in a medium-size stainless steel mixing bowl. Bring the cream to a boil and add it to the shavings, stirring constantly with a wooden spoon until chocolate is completely melted; if needed, place bowl over a pot containing 1 inch of slowly simmering water to finish the melting process, stirring constantly. Stir in the liquor, if using. Cover tightly and refrigerate until firm, at least 2 hours or overnight.

FORM THE TRUFFLES:

Bring about 1 cup of water to a boil in a small pot; remove from heat. Remove chocolate-cream mixture from the refrigerator and form it into truffles with the melon baller, heating baller in the hot water before shaping each (start dipping the chocolate from the edges of the bowl and work toward the center); place truffles on a cookie sheet lined with parchment or waxed paper. (If the truffles stick inside the baller, heat bottom of baller in the hot water a second and they should slip out easily.) Refrigerate until firm, at least 1 hour.

TO FINISH THE TRUFFLES:

When the truffles are firm and at least 1 hour before serving, melt the 4 ounces chocolate pieces in the top of a double boiler over slowly simmering water; remove from heat, leaving the melted chocolate over the hot water. Meanwhile, if rolling the truffles in cocoa, place cocoa in a small bowl. Working quickly, dip each truffle into the melted chocolate, using a fork to turn and coat the truffle well, then return truffle to the cookie sheet to let chocolate set for about 30 seconds, then roll in cocoa and return to cookie sheet. Refrigerate finished truffles until firm, at least 1 hour, or until ready to serve.

WHITE CHOCOLATE TRUFFLES

Makes about 2½ dozen truffles

- 8 ounces white chocolate, cut into very fine shavings
- ½ cup heavy cream
- 2 tablespoons unsalted butter, softened
- 3 tablespoons liquor of your choice (such as rum, whiskey, Grand Marnier, kirsch, cassis) (optional)
- 4 ounces white chocolate, cut into small pieces

SPECIAL UTENSIL:
1-inch melon baller

Place the 8 ounces chocolate shavings in a medium-size stainless steel mixing bowl. Bring the cream to a boil and add it and the butter to the shavings, stirring constantly with a wooden spoon until chocolate and butter are completely melted; if needed, place bowl over a pot contain-

ing 1 inch of hot (not simmering) water to finish the melting process, stirring constantly. (Note: It's important to melt white chocolate very slowly, or it may become grainy.) Stir in the liquor, if using. Cover tightly and refrigerate until firm, at least 2 hours or overnight.

When mixture is firm, form it into truffles as directed for Semisweet Chocolate Truffles (preceding recipe).

Once the truffles are firm and at least 1 hour before serving, finish them as follows: Very slowly melt the 4 ounces chocolate pieces in the top of a double boiler over hot to slowly simmering water. Remove from heat, leaving chocolate over the hot water. Working quickly, dip each truffle into the melted chocolate, using a fork to turn and coat the truffle well, then return it to the cookie sheet. Refrigerate finished truffles until firm, at least 1 hour, or until ready to serve.

MOLASSES MADELEINES

Makes 5 dozen madeleines

½ cup all-purpose flour
1 teaspoon baking powder
2 large eggs
¼ cup granulated sugar
1 tablespoon dark brown sugar
Pinch of salt
Pinch of freshly ground nutmeg
6 tablespoons unsalted butter, melted
2 tablespoons molasses
Unsalted butter for greasing madeleine cups

SPECIAL UTENSILS:
40-cup madeleine tray for small (1¾ x 1¼-inch) madeleines
Pastry bag fitted with a ¼-inch plain nozzle (optional)

To make the batter, combine the flour and baking powder in a small bowl. In the medium-size bowl of an electric mixer, combine the eggs, sugars, salt, and nutmeg; beat on high speed until thick and pale yellow, 3 to 5 minutes. Sift in the flour mixture and beat at high speed just until blended. Add the melted butter and molasses and beat at low speed about 30 seconds more until just barely blended; do *not* overbeat. Cover and refrigerate overnight.

Heat oven to 400 degrees. Generously butter the madeleine cups. Spoon the batter directly into the cups, or spoon into the pastry bag and pipe into the cups, filling each cup barely to the top. Bake just until well browned and centers are puffed; do not overbake or the madeleines will be dry. Remove from oven and turn out onto a wire rack. Serve promptly. Store leftovers in an airtight container.

HAZELNUT TUILES

Makes about 2½ dozen tuiles

½ cup shelled hazelnuts, dry roasted, cooled, and finely chopped with a knife
¼ cup sugar
¼ cup light or dark corn syrup
2 tablespoons unsalted butter, melted

SPECIAL UTENSIL:
Rolling pin with a 2- to 3-inch diameter

In a medium-size bowl, combine all ingredients for the *tuiles*, mixing thoroughly. Cover and refrigerate for at least 3 hours, preferably overnight. (This may be done up to 3 days ahead; keep refrigerated until ready to use.)

Heat oven to 400 degrees. Line a cookie sheet with parchment paper. Drop the batter by ½ rounded teaspoonfuls onto the prepared cookie sheet, about 2 inches apart. With moistened fingertips, spread each portion out to form a thin

1-inch round with no holes in it; make sure the hazelnuts are evenly distributed in the round. Bake until cookies are dark golden brown, 4 to 5 minutes, watching carefully so they don't burn. (The batter will spread to resemble lace as it cooks.) Remove from oven and let cool just a few seconds; then, while the cookies are still pliable, work quickly to peel each cookie off the paper, 1 at a time (if the cookies ran together, cut them apart before peeling), and drape them over the rolling pin, smooth side down; let cool a few seconds until hard, then remove from rolling pin. If any cookies harden before being peeled off the paper, return them to the hot oven a brief moment to soften. Handle these fragile *tuiles* carefully and serve immediately or within a few hours, inverted to sit on their edges. If not serving promptly, store in an airtight container.

CONFIT OF ORANGE RIND

Makes about 3 dozen strips

1 orange with perfect skin (about 2 ounces)
6 cups water
2⅓ cups sugar

Cut the orange in half crosswise and scoop out pulp and membranes. Cut each half section of rind into about 2½ x ½-inch strips.

Bring 2 cups of the water to a boil in a heavy 2-quart nonreactive saucepan over high heat. Add the rind strips and cook 5 minutes; drain. Bring another 2 cups water to a boil in the same pan, add rind strips, and cook 5 minutes more; drain again. In the same pan, combine remaining 2 cups water with 2 cups sugar; bring to a boil. Add the rind strips and simmer at between 175 and 200 degrees until strips are very tender and sweet, about 1 hour to 1¼ hours. While cooking, wash down sugar on sides of pan frequently with a pastry brush dipped in cold water.

Once the rind has finished cooking, place a wire cooling rack over waxed paper and spoon the rind onto the rack, separating strips. Let drain 1 hour, then place strips in a bowl and toss with remaining ⅓ cup sugar, shaking off excess. Use immediately or store up to 2 hours at room temperature, then cover well and keep refrigerated until ready to use. May be made up to 1 week ahead.

COCONUT MACAROONS

Makes 2½ dozen macaroons

1 cup grated coconut, dry roasted until golden brown
⅓ cup whole or slivered almonds, ground to a fine powder
¼ cup powdered sugar
1 egg white (from a large egg)
1 tablespoon granulated sugar
4 ounces semisweet chocolate, cut into small pieces

Heat oven to 350 degrees. Line a cookie sheet with parchment paper; set aside. In a medium-size bowl, mix coconut, almonds, and powdered sugar well; set aside.

In the small bowl of an electric mixer (make sure bowl is very clean), beat the egg white at low speed for about 30 seconds. Increase speed to medium and beat about 30 seconds until frothy bubbles begin to form, then add 1½ teaspoons of the granulated sugar and beat at medium for 30 seconds more. Increase speed to high, add the remaining 1½ teaspoons granulated sugar, and continue beating just until stiff peaks form, about 1 minute more.

Gradually add the coconut mixture to the egg whites, folding with a rubber spatula until well blended. Form the batter into quenelles (oval

shapes) with 2 teaspoons, using a rounded ½ teaspoon for each quenelle; place on the prepared cookie sheet about 1 inch apart. Bake until light golden brown, about 15 minutes. Remove from oven and let cool on the cookie sheet for about 30 minutes.

Once macaroons are cool, melt the chocolate in the top of a double boiler. Drizzle chocolate over macaroons, or dip each macaroon halfway into the chocolate and return to the cookie sheet. Refrigerate until chocolate hardens, at least 15 minutes, or until ready to serve.

LEMON TARTLETS

Makes 3 dozen tartlets

1 recipe Tart Dough (page 203)
Unsalted butter for greasing tartlet molds
Flour for rolling out dough
⅓ cup sugar
⅓ cup lemon juice
1 tablespoon very finely grated lemon zest
2 large eggs
2 tablespoons unsalted butter

SPECIAL UTENSILS:
3 dozen round tartlet molds, 1⅜-inch diameter at top, ⅞-inch diameter at bottom, ⅜ inch tall

Prepare the Tart Dough; refrigerate or freeze until ready to roll out; if freezing the dough, thaw before rolling out.

Lightly butter the tartlet molds; set aside. Lay out a piece of parchment or waxed paper on a work surface and sprinkle with flour. Place dough in the center and flatten it slightly; lightly flour top, cover with another piece of parchment or waxed paper, and roll out to a ⅛-inch thickness; if dough sticks excessively to paper while rolling, lightly reflour dough. Peel off the top piece of paper and place the tartlet molds upside down on top of the dough, gently pressing molds down to cut out the dough with them; leave molds inverted on top of dough. Next, quickly turn the bottom piece of paper over so dough and paper are on top of the molds; then peel off paper and line each mold evenly with the dough, pressing it gently into place. Trim edges. Refrigerate for at least 30 minutes or overnight. (If short on time, freeze for 15 minutes.)

Heat oven to 375 degrees. Place molds containing pastry shells on a cookie sheet and bake until crusts are golden brown, 5 to 7 minutes. Let cool to room temperature.

For the filling, combine the sugar, lemon juice, lemon zest, and eggs in a heavy 2-quart nonreactive saucepan, whisking until well blended. Cook mixture over medium heat, stirring constantly and scraping pan bottom evenly with a wooden spoon, just until it thickens and leaves a distinct trail on the back of the spoon when you draw a finger through it, 3 to 4 minutes; do not let mixture boil. Remove from heat and stir in the butter.

Fill each cooled tartlet crust to the top with filling, using about ½ teaspoon in each crust. Serve immediately or, if made ahead, store uncovered and at room temperature (do not refrigerate or crusts will get soggy); remove tartlets from molds just before serving.

BLACKBERRY TARTLETS

Makes 2½ dozen tartlets

1 recipe Tart Dough (page 203)
1 recipe Pastry Cream (page 215)
Unsalted butter for greasing tartlet molds
Flour for rolling out dough
½ cup heavy cream
60 small blackberries

SPECIAL UTENSILS:
30 oval-shaped tartlet molds, 2 inches long and 1¼ inches wide at top, ½ inch tall
Pastry bag fitted with a small star tip

Make the Tart Dough; refrigerate or freeze until ready to roll out; if freezing, thaw before rolling out. One day ahead, make the Pastry Cream; refrigerate until ready to use.

On the day of serving, roll out the dough, line the tartlet molds, and bake the crusts as directed for the Lemon Tartlets (preceding recipe), except use the oval-shaped instead of the round molds; let crusts cool thoroughly before filling. (This may be done several hours ahead.)

Whip the cream until soft peaks form; set aside. Place the chilled Pastry Cream in a large bowl and whisk until fairly smooth, then add ½ of the whipped cream to it, whisking gently just until smooth. Lightly fold in the remaining whipped cream just until barely blended. Spoon this filling into the pastry bag and pipe into the cooled tartlet crusts, using about ½ teaspoon filling in each crust. Garnish each tartlet with 2 blackberries. Serve immediately or, if made ahead, store as directed for Lemon Tartlets.

WALNUT TARTLETS

Makes 3⅓ dozen tartlets

1 recipe Tart Dough (page 203)
Unsalted butter for greasing tartlet molds
Flour for rolling out dough
1⅓ cups coarsely chopped walnuts (or pecans)
1 large egg
¾ cup loosely packed light brown sugar
¼ cup dark corn syrup
1 tablespoon unsalted butter, melted and cooled
1 teaspoon vanilla extract
¼ teaspoon lemon juice

SPECIAL UTENSIL:
40 round tartlet molds, 1⅜-inch diameter at top, ⅞-inch diameter at bottom, ⅜ inch tall

Make the Tart Dough; refrigerate or freeze until ready to roll out; if freezing the dough, thaw before rolling out.

On the day of serving, roll out the dough and line the tartlet molds precisely as directed for the Lemon Tartlets (this page); refrigerate unbaked pastry shells for at least 30 minutes or overnight. (If short on time, freeze for 15 minutes.)

Heat oven to 350 degrees. For the filling, purée 1 cup of the walnuts in a blender or food processor until smooth; set aside. Place the egg in a medium-size bowl and whisk until frothy; add walnut purée and sugar, corn syrup, butter, vanilla, and lemon juice, mixing thoroughly. Stir in remaining ⅓ cup walnuts.

Fill the chilled pastry shells with the filling, using about ½ teaspoon in each shell. Place the molds on a cookie sheet and bake until filling is solid and crusts are golden brown, 18 to 20 minutes. Remove from oven and let cool at least 20 minutes before serving. If made ahead, store as directed for Lemon Tartlets.

RASPBERRY TARTLETS

Makes 2½ dozen tartlets

1 recipe Pastry Cream (page 215)
Enough top-quality frozen puff pastry dough to cut out 30 (1-inch) rounds (if dough sheets are folded, thaw just enough to unfold; if not folded, do not thaw)
About 2 tablespoons sugar for rolling out dough
60 fresh raspberries
Sifted powdered sugar (optional)

SPECIAL UTENSILS:
1-inch round scallop-edged cookie cutter
Pastry bag fitted with a ¼-inch plain nozzle

Make the Pastry Cream; refrigerate.

Cut out 30 rounds of puff pastry dough with the cookie cutter; refrigerate.

Line a cookie sheet with parchment paper; set aside. Sprinkle 1 teaspoon of sugar on a cool work surface. Remove 5 rounds from the refrigerator and press them into the sugar, coating both sides. Working quickly (before dough gets soft), roll each round into a ¹⁄₁₆-inch-thick oval; if needed, add more sugar to keep dough from sticking but don't add more than necessary since any excess sugar will caramelize when the dough is baked. Place ovals on the cookie sheet and refrigerate. Roll out the remaining rounds into ovals, adding 1 teaspoon more sugar to the work surface for each set of 5 rounds. Refrigerate ovals for at least 30 minutes or overnight.

Heat oven to 400 degrees. Spoon the Pastry Cream into the pastry bag. Remove the dough ovals from the refrigerator (leave them on the cookie sheet) and pipe a smooth ⅛-inch-thick layer of Pastry Cream on top of each to within ½ inch from the edge; reserve remaining Pastry Cream. Bake until edges of crust are golden brown, 7 to 9 minutes, checking often to make sure undersides don't overbrown. Remove from oven and transfer tartlets to a wire rack to cool, then pipe some of the Pastry Cream on top of each tartlet. Garnish each with 2 raspberries and, if desired, a sprinkle of powdered sugar. Serve immediately or, if made ahead, store as directed for Lemon Tartlets, page 188.

APPLE TARTLETS

Makes 2½ dozen tartlets

1 recipe Pastry Cream (page 215)
Enough top-quality frozen puff pastry dough to cut out 30 (1-inch) rounds (if dough sheets are folded, thaw just enough to unfold; if not folded, do not thaw)
About 2 tablespoons sugar for rolling out dough
2 tablespoons unsalted butter
1 cup cubed Granny Smith apples (⅛-inch cubes); soaked in acidulated water
¼ cup honey (preferably acacia)
⅛ teaspoon ground nutmeg
⅛ teaspoon ground allspice
Sifted powdered sugar

SPECIAL UTENSILS:
1-inch round scallop-edged cookie cutter
Pastry bag fitted with a ¼-inch plain nozzle

First, make the Pastry Cream; refrigerate. Next, prepare the puff pastry as directed for the Raspberry Tartlets (preceding recipe); refrigerate ovals for at least 30 minutes or overnight.

Heat oven to 400 degrees. Drain the apples. Melt the butter in a small nonstick skillet over medium heat. Add the apples, honey, nutmeg, and allspice; sauté until tender but still firm, 1 to 2 minutes, stirring occasionally. Drain on paper towels and blot dry with more towels.

Spoon the Pastry Cream into the pastry bag. Remove the dough ovals from the refrigerator (leave them on the cookie sheet) and pipe a smooth ⅛-inch-thick layer of Pastry Cream on each to within ½ inch from the edge. Next, spoon about 1 teaspoon apple filling on top of each tartlet. Bake until edges of crust are golden brown, 7 to 9 minutes, checking often to make sure undersides don't overbrown. Remove from oven and transfer tartlets to a wire rack to cool, then lightly sprinkle with powdered sugar. Serve immediately or, if made ahead, store as directed for Lemon Tartlets, page 188.

SEA SCALLOPS AND CORN PANCAKES with OSSETRA CAVIAR AND SOUR CREAM SAUCE

Makes 20 to 25 (3½- to 4-inch) pancakes

SAUCE:
⅓ cup dairy sour cream
2 tablespoons heavy cream
1 teaspoon lemon juice
½ teaspoon lime juice
Freshly ground black pepper
2 tablespoons plus 1 teaspoon ossetra or other top-quality caviar (about 1½ ounces)
PANCAKE BATTER:
Salt water (2 teaspoons coarse salt mixed with 2½ quarts water) for cooking corn
2 (7-inch) ears of yellow corn, shucked
Ice water for cooling cooked corn
¾ pound sea scallops, rinsed and small tough muscle on the side of each removed
Fine sea salt and freshly ground black pepper
About 1½ cups heavy cream
2 large eggs
½ cup all-purpose flour, sifted
1 tablespoon very finely sliced chives
1 teaspoon Lobster Coral Garnish (page 215) (optional) 3 cups Lobster Consommé (page 214) or Lobster Stock (page 214) (preferred), or water for poaching ¼ pound of the scallops
About 3 to 4 tablespoons extra-virgin olive oil for cooking pancakes
Dill or chervil sprigs for garnish (optional)

SPECIAL UTENSILS:
Very fine mesh strainer
3-inch scallop-edged cookie cutter for shaping cooked pancakes (optional)

START THE SAUCE:

In a medium-size bowl, combine the sour cream, heavy cream, lemon and lime juices, and a generous amount of pepper, mixing well. Cover and refrigerate if not using almost immediately. (This may be done several hours ahead.)

MAKE THE PANCAKE BATTER:

Bring the salt water to a rolling boil in a large pot. Add the ears of corn and cook just until tender, about 3 minutes. Drain and cool in the ice water; drain again. Cut the kernels from the cobs and purée kernels in a food processor. Strain through the strainer, using the bottom of a sturdy ladle to force as much through as possible; the strained purée should yield about ½ cup. Set aside.

In a food processor, process ½ pound of the scallops with a small amount of salt and pepper until very smooth. Add ½ cup of the cream and process just until well blended; do *not* overmix. Strain through the strainer as you did the corn; the strained mixture should yield 1 to 1⅓ cups. Place in a large bowl with the reserved corn purée, eggs, 1 cup more cream, a small amount of salt, and a generous amount of pepper, whisking until well mixed. Gradually add the flour, whisking until thoroughly blended. Stir in the chives and, if using, the Lobster Coral Garnish. Set batter aside.

Bring the consommé to a simmer in a large skillet. Add the remaining ¼ pound scallops and simmer (do not boil) for 3 minutes. Drain on paper towels. Finely chop the scallops and add to the reserved batter. If the batter is fairly stiff, thin with more cream. (The batter may be made up to about 4 hours ahead and kept refrigerated.)

TO COOK THE PANCAKES AND SERVE:

(See photograph page 84.) Stir 1½ tablespoons of the caviar into the sauce; set sauce and remaining caviar aside.

Warm serving plates in a 350 degree oven. Heat 1½ teaspoons of the oil in a nonstick skillet or on a griddle over medium heat, 2 to 3 minutes; then cook 1 or more small test pancakes to taste for pepper seasoning (be cautious about adding salt since the caviar in the sauce will be salty). Cook the pancakes, using about 2 tablespoons batter for each, until golden brown and cooked through, 1 to 1½ minutes on each side; if shaping the cooked pancakes with the cookie cutter, be sure to make pancakes slightly larger than the cutter. Cut out pancakes with the cookie cutter, if desired, then transfer to a heated platter in a single layer to keep warm while cooking remaining batches. Add a few drops more oil to the skillet as needed. Once all pancakes are made, place on heated serving plates. Top each pancake with a scant 1 teaspoon sauce and garnish center of sauce with a dab of the remaining caviar; if using, garnish plates with dill or chervil sprigs. Serve promptly.

RED AND YELLOW BELL PEPPER SOUPS with BROILED COD and MIREPOIX OF RED AND YELLOW BELL PEPPERS

Makes 4 servings

RED AND YELLOW BELL PEPPER SOUPS:
1 recipe Lobster Cream Base Sauce (page 215) (preferred) or 3 cups heavy cream
3 cups coarsely chopped red bell peppers (from about 2 medium-size peppers)
3 cups coarsely chopped yellow bell peppers (from about 2 medium-size peppers)
Fine sea salt and freshly ground black pepper
Consommé (preferably Lobster; page 214) for thinning soups if needed
1 recipe Mirepoix of Red and Yellow Bell Peppers (see recipe for Broiled Cod with Saffron Potatoes, page 171)
Olive oil for greasing broiling pan
Fine sea salt and freshly ground black pepper
1 (5- to 6-ounce) fillet of cod, about 1 inch thick at the thickest part
Lobster Coral Garnish (page 215) (optional)
Snipped chives for garnish (optional)

SPECIAL UTENSILS:
Chinois
Bowl divider fashioned from about 4 thicknesses of aluminum foil pressed flat together and molded to fit vertically down the center of serving bowls to keep the two soups separated

Make the Lobster Cream Base Sauce; refrigerate. Next, prepare the Mirepoix of Red and Yellow Bell Peppers; refrigerate.

MAKE THE SOUPS:

Place the coarsely chopped red bell peppers in one small pot and the coarsely chopped yellow bell peppers in another small pot. Add half (1½ cups) of the Lobster Cream Base Sauce (or heavy cream) to *each* pot and bring to a boil over high heat, stirring occasionally. Reduce heat and gently simmer until the pepper pulp is very tender and liquid reduces by about ½, about 35 minutes. Remove from heat and purée soups *separately* in a food processor. Season to taste with salt and pepper and strain *separately* through the chinois, using the bottom of a sturdy ladle to force as much through as possible; each strained soup should yield about 2 cups. Return soups to the pots and set aside. (The soups may

be made several hours ahead and kept refrigerated.)

BROIL THE COD:

Preheat broiler. Generously grease a small heavy broiling pan with olive oil. Salt and pepper the cod on both sides and add to the pan, turning to coat both sides well with some of the oil; end with skin down. Broil about 4 inches from the heat source, without turning, just until cooked through, 3 to 4 minutes; watch carefully and do *not* overcook (the cooking time will depend on thickness of fillet). Remove cod from broiler and flake. Assemble the bowls and serve immediately.

TO ASSEMBLE THE BOWLS AND SERVE:

(See photograph page 85.) Heat 4 wide soup bowls briefly in a warm oven. Meanwhile, gently reheat the two soups; if needed, thin with consommé (they should be fairly thick). Set aside 2 teaspoons of the Red and Yellow Bell Pepper Mirepoix; arrange ¼ of the remaining mirepoix in the bottom of each soup bowl. Pour the two soups into separate measuring cups with spouts. Next, get a helper to hold the "bowl divider" vertically in the center of 1 of the bowls while you pour in about ½ cup of each soup simultaneously from opposite sides of the divider; then have helper lift the divider straight up and out of the bowl. Repeat with remaining 3 servings. Arrange 8 to 10 cod flakes on top of each serving and garnish cod with the remaining mirepoix. If desired, add a light sprinkle of Lobster Coral Garnish and chives.

SALAD OF MACHE, CONFIT OF MULARD DUCK GIZZARDS, MULARD DUCK HEARTS STUFFED WITH FOIE GRAS, JULIENNE FOIE GRAS, and QUAIL EGGS

Makes 4 servings

1 recipe Confit of Mulard Duck Gizzards (page 162)
½ recipe cooked and chilled Mulard Duck Hearts Stuffed with Foie Gras (see Mulard Duck Hearts Stuffed with Foie Gras in Nests of Tricolored Pasta, pages 193-194)
8 ounces fresh uncooked duck or goose foie gras (Grade A or B)
Fine sea salt and freshly ground black pepper
2 tablespoons sherry wine vinegar
20 quail eggs
1 tablespoon vegetable oil, plus oil for vinaigrette if necessary
6 cups loosely packed mache (lamb's lettuce, corn salad), or other small tender salad greens such as mesclun, radicchio, or *frisée* (curly endive)
Burnet sprigs for garnish (optional)

SPECIAL UTENSIL:
1⅝-inch cookie cutter

Make the Confit of Mulard Duck Gizzards at least 1 day ahead; refrigerate. Prepare and cook the Mulard Duck Hearts Stuffed with Foie Gras (they may be prepared up to the point of cooking 1 day ahead); refrigerate for at least 2 hours before serving.

PREPARE THE JULIENNE FOIE GRAS AND VINAIGRETTE:

With a sharp thin-bladed knife, carefully trim away any green spots on the foie gras caused by contact with the gall bladder. Slice the foie gras into ¼-inch-wide julienne strips; salt and pepper strips on 1 side. (Refrigerate strips if not sautéing promptly; they must be well chilled before cooked.) Heat a large nonstick skillet over high heat, 2 to 3 minutes. Add the foie gras strips and

reduce heat to medium; sauté just until cooked through and lightly browned, about 2 minutes, shaking pan carefully in a back and forth motion so strips brown evenly and don't stick. Do *not* overcook, or the foie gras will loose its unique buttery texture. Drain on paper towels; cover well and set aside.

For the vinaigrette, strain the foie gras fat in the skillet and measure out ⅓ cup; add vegetable oil, if needed, to make ⅓ cup. In a medium-size bowl, whisk together the vinegar and a small amount of salt and pepper. Gradually add the ⅓ cup fat, whisking constantly. Taste for seasoning; set aside. (This may be done up to 1 hour ahead.)

TO FINISH THE DISH AND SERVE:

(See photograph page 86.) Remove the duck gizzards from the cooking fat and heat in an empty skillet just a few seconds to melt the fat from them; drain on paper towels and set aside.

Cut each chilled stuffed duck heart (still wrapped in caul) crosswise on the diagonal into ¼-inch slices, making sure foie gras is in each slice; set aside.

Now prepare the quail eggs. To do this, first gather all utensils needed: the cookie cutter, a large nonstick skillet with a lid, a spatula, and a cutting board. Next, holding the flatter end of each quail egg upright, carefully peel off the top ¼ of the egg shell with your fingertips so the contents can be quickly added to the skillet when called for; start the first crack by gently slicing through the shell or lightly tapping it crosswise with a sharp paring knife. Place opened eggs upright in an "egg carton" fashioned from crumpled aluminum foil.

Heat the vegetable oil in the uncovered skillet over medium heat, 2 to 3 minutes. Remove skillet from heat and carefully add the contents of 5 to 10 of the opened eggs; be careful not to break the yolks and keep yolks well separated (the whites may overlap a bit). Immediately cover skillet and return to medium heat; cook until whites are solid (yolks should still be runny), about 1 to 1½ minutes. Promptly remove from heat and transfer eggs with the spatula to the cutting board; then cut eggs into rounds with the cookie cutter, making sure yolks are centered. Transfer rounds to a plate in a single layer and season tops with pepper; cover to keep warm. Repeat with remaining eggs.

Place the mache in a medium-size mixing bowl; whisk the vinaigrette until ingredients are well blended, then toss mache with 3 tablespoons of it and mound a portion in the center of each serving plate. To the same mixing bowl, add the julienne foie gras, 2 tablespoons more vinaigrette, and the drained gizzards, tossing gently to keep foie gras strips intact. Arrange a drained portion of the foie gras strips and gizzards on each salad. Next, add the remaining vinaigrette to the mixing bowl and, 1 at a time, coat each slice of stuffed duck heart with it; arrange slices around the edges of the salads. Add 5 quail eggs to each salad and garnish with burnet sprigs, if desired. Serve immediately.

SAUTEED SOFT-SHELL CRABS with PANCETTA SAUCE

Makes 4 servings

SAUCE:
2 ounces lean *pancetta*
1 tablespoon extra-virgin olive oil
¼ pound (1 stick) unsalted butter, softened
2 tablespoons Lobster Consommé (page 214) (preferred), Lobster Stock (page 214), or other Consommé or Stock (page 214)
Freshly ground black pepper
8 small live soft-shell crabs (see Note)

Fine sea salt and freshly ground black pepper
4 tablespoons plus 1 teaspoon extra-virgin olive oil
1½ ounces lean *pancetta*, cut into paper-thin slices, then cut into 1 x ⅛-inch julienne strips
Dill sprigs for garnish

NOTE:
Store the uncooked crabs, before and after preparation for cooking, in a single layer on a cookie sheet; cover completely with a clean damp dishtowel and keep refrigerated.

START THE SAUCE:

Cut the *pancetta* into ⅛-inch slices and cut these slices into ¼-inch squares. Heat a small nonstick skillet over high heat about 1 minute. Add the oil and heat a few seconds until it starts to bubble. Add the *pancetta* and cook until lightly browned, 1 to 2 minutes, stirring almost constantly. Drain on paper towels and let cool to room temperature, then process in a food processor about 30 seconds until thoroughly minced and slightly moist. Add the butter and continue processing until well blended. Cover *pancetta* butter and refrigerate until firm, at least 1 hour or overnight.

PREPARE THE CRABS:

With kitchen scissors, cut off the eyes and a tiny amount of the surrounding shell from each crab. With the crab on its back, lift up and cut off the triangular apron. Next, turn crab on its stomach, lift up the soft shell-flap at each end to expose the white fingerlike gills, and remove gills by hand. Season the underside of each crab lightly with salt and pepper and store as directed in the Note above. (This may be done several hours ahead.)

FINISH THE SAUCE:

In a small heavy saucepan, combine the reserved chilled *pancetta* butter with the consommé. Cook over high heat just until the butter melts, whisking constantly. Remove from heat and set aside. (This may be done up to 1 hour ahead.)

TO FINISH THE DISH AND SERVE:

(See photograph page 87.) Heat the serving plates in a 250 degree oven. For the julienne *pancetta*, heat a small nonstick skillet over high heat for about 1 minute. Add 1 teaspoon of the oil and heat about 30 seconds more. Add the julienne *pancetta* and sauté until lightly browned, 1 to 2 minutes, stirring constantly. Drain on paper towels and set aside.

To sauté the crabs, heat 2 large nonstick skillets over high heat about 1 minute. Add 2 tablespoons of the remaining oil to *each* skillet and heat about 1 minute more. Add 4 crabs, shell down, to each skillet and immediately reduce heat to medium. Sauté until undersides are golden red-brown, about 2 minutes. Turn crabs and continue sautéing just until cooked through, about 2 minutes more, depending on their thickness; do *not* overcook. Drain on paper towels and blot tops lightly with more towels. Serve immediately.

To serve, reheat sauce and season to taste with pepper. Place each crab, shell down, on a cutting board and cut in half crosswise. Arrange 4 halves on each heated serving plate and sprinkle with a portion of the julienne *pancetta*; spoon about 2 tablespoons sauce over the top and garnish with dill sprigs.

SAUTEED SWEETBREADS WRAPPED IN FAVA BEANS with FAVA BEAN CREAM SAUCE

Makes 4 servings

1½ to 1 ¾ pounds very fresh veal sweet-

breads; each piece at least 2¾ inches wide and long so it can be cut into 1 or more rounds with a 2¾-inch cookie cutter (see Note)
Cool water for soaking sweetbreads
5 pounds fresh unshelled fava beans (see Note)
Salt water (¼ cup coarse salt mixed with 3 quarts water) for blanching fava beans
Ice water for cooling blanched fava beans
8 cups Meat or Vegetable Consommé (page 214) (preferred) or Meat or Vegetable Stock (page 214)
10 very full and leafy thyme sprigs
3 medium-size bay leaves
1 teaspoon whole black peppercorns
Fine sea salt and freshly ground black pepper
Fava Bean Sauce (recipe follows) or Sage Sauce (page 194)
2 large eggs
1 teaspoon extra-virgin olive oil
⅓ cup all-purpose flour
3 tablespoons unsalted butter
4 fresh sage or sweet marjoram leaves for garnish (optional)

SPECIAL UTENSILS:
2¾-inch cookie cutter
Fine mesh strainer

NOTE:
The 5 pounds of fava beans include what's needed for making the fava bean sauce; if substituting Sage Sauce, you will only need 3¾ pounds unshelled fava beans for breading the sweetbreads and the fava bean garnish for the serving plates.

PREPARE THE SWEETBREADS FOR COOKING:

Trim away any large chunks of fat from the sweetbreads. Cover sweetbreads with cool water and soak for 10 minutes; drain. Cover with fresh water and let soak 10 minutes more; drain again. Cover a third time with fresh water and refrigerate overnight.

PREPARE THE FAVA BEANS FOR THE GARNISH, BREADING, AND SAUCE:

Shell the fava beans. Bring the salt water to a rolling boil in a large pot. Add the shelled beans and blanch for 4 minutes. Immediately drain and cool in the ice water; drain again. Remove the thin outer membrane from each bean by cutting a shallow slit in it with a paring knife, then peel or rub membrane off. (The beans may be prepared to this point 1 day ahead; refrigerate.)

Measure out ⅔ cup of beans that have split in half horizontally (split some if needed to make ⅔ cup) for garnishing the serving plates; refrigerate. Measure out 1½ cups more beans and mince with a sharp knife; place in a medium-size bowl and reserve, refrigerated, for breading the sweetbreads. Reserve the remaining beans (about 1¼ cups), refrigerated, for the Fava Bean Sauce.

POACH THE SWEETBREADS AND FORM SWEETBREAD ROUNDS:

Drain sweetbreads. In a large pot, combine the consommé, thyme sprigs, bay leaves, peppercorns, and ½ teaspoon sea salt; bring to a boil. Add the sweetbreads and return to a boil. Reduce heat and simmer just until cooked through, 5 to 20 minutes, depending on thickness of each sweetbread; transfer pieces to a platter as done. (To test doneness, make a cut no deeper than 1 inch into the thickest part of each sweetbread; if done, the meat at the base of the cut will be very pale pink to cream colored.) Set aside to cool. Meanwhile, strain the poaching liquid through the strainer into a bowl; cover and refrigerate.

When sweetbreads are cool enough to handle,

gently pull off and discard any bits of fat and most of the membrane surrounding them, leaving just enough attached to hold sweetbreads together.

Form the sweetbreads into four 2¾-inch rounds that are neatly shaped and of uniform thickness, each between ½ and 1 inch thick. To do this, first cut out as many sweetbread rounds as possible with the cookie cutter; if needed, start the cut by carving part way down around the outside edge of the cookie cutter with a sharp knife. Next, neatly trim each round to a ½- to 1-inch thickness and select the most attractive rounds for use; save trimmings if desired for another recipe, such as the Crispy Sweetbread Mirepoix on page 163. Cover rounds and set aside; refrigerate if prepared ahead. (This may be done several hours in advance.)

Now make the Fava Bean Sauce (or the Sage Sauce), if not already done; refrigerate.

BREAD THE SWEETBREADS:

In a medium-size bowl, whisk together the eggs, oil, a pinch of salt, and a generous amount of pepper. Place the flour in a separate medium-size bowl. Season the sweetbread rounds generously on both sides with salt and pepper; then bread 1 round at a time as follows: Dredge the round in the flour, shaking off excess; then coat with the egg mixture, drain slightly, and place round in the bowl with the reserved minced fava beans; immediately rinse hands well (so you don't get flour and egg mixture on the minced beans), then press the beans gently into the round with your fingertips to make as many adhere to the meat as possible, being sure to distribute them evenly. Place prepared rounds on a platter and refrigerate covered for 2 to 4 hours before cooking.

TO FINISH THE DISH AND SERVE:

(See photograph pages 88–89.) Heat oven to 350 degrees. Melt the butter in a large ovenproof skillet (preferably nonstick) over low heat. Carefully add each sweetbread round and cook until breading on the underside starts to solidify, about 3 minutes; don't let breading brown. With a sturdy spatula, very gently turn each round over (be careful to keep breading intact) and continue cooking 3 minutes more. Immediately transfer skillet, uncovered, to the preheated oven and bake until rounds are heated through, about 8 minutes; to judge doneness, carefully cut 1 of the rounds in half vertically and check temperature of center with your fingertips. Meanwhile, arrange ¼ of the reserved ⅔ cup halved fava beans, split side down, in a large circle on each of 4 ovenproof serving plates; set aside. Heat the Fava Bean Sauce in a small heavy saucepan over medium heat, stirring constantly. (If using Sage Sauce, reheat, then discard sage leaves.)

Once the sweetbread rounds are heated, transfer them to a cutting board and immediately heat the serving plates in the 350 degree oven just until hot, about 1 minute. Meanwhile, carefully slice each heated sweetbread round in half vertically. Arrange 2 halves in the center of each heated serving plate and spoon about 2 tablespoons sauce between the halves; garnish sauce with a sage or marjoram leaf, if desired. Serve immediately.

FAVA BEAN SAUCE

½ cup heavy cream
About 1¼ cups reserved shelled and peeled fava beans
About ¾ cup reserved sweetbreads poaching liquid
1 tablespoon plus 1 teaspoon extra-virgin olive oil
Fine sea salt and freshly ground black pepper

Bring the cream to a boil in a small pot; set aside. Purée the fava beans in a blender with ¾ cup of the poaching liquid and the oil until smooth. Add the scalded cream and continue processing until well blended; season to taste with salt and pepper. If sauce is too thick (it should be a creamy consistency), thin with more poaching liquid. Refrigerate until ready to heat just before serving. *Makes about 2 cups.*

ROASTED BREAST OF SQUAB with DATE PUREE and DATE SAUCE

Makes 4 servings

DATE PUREE:
10 ounces whole or chopped pitted dates
1½ cups water
2 tablespoons Meat or Vegetable Consommé (page 214) (preferred) or Meat or Vegetable Stock (page 214)
1 teaspoon honey (preferably acacia)
¾ teaspoon ground cumin

SAUCE:
¼ cup unpeeled chopped carrots
2 tablespoons chopped celery
2 tablespoons chopped leeks (mostly white part)
2 tablespoons chopped onions
2 tablespoons unpeeled chopped turnips
1 tablespoon chopped shallots
2 to 2½ cups Meat or Vegetable Consommé (page 214) (preferred) or Meat or Vegetable Stock (page 214)
½ cup unstrained date purée reserved from making date purée for this dish
1 tablespoon honey (acacia preferred)
½ teaspoon ground cumin
1 cup *Fond de Veau* (page 214)

ROASTED BREAST OF SQUAB:
4 squab pigeons, dressed (each about ¾ pound dressed)
Fine sea salt and freshly ground black pepper
Ground cumin
2 tablespoons vegetable oil
4 scant teaspoons honey (preferably acacia)
1 teaspoon sesame seeds

SPECIAL UTENSILS:
Fine mesh strainer
Chinois
Pastry bag fitted with a Number 4 star tip

START THE DATE PUREE:

In a small saucepan, combine the dates with the 1½ cups water. Bring to a boil and continue boiling until dates are soft, about 5 minutes, stirring occasionally; drain, then purée in a food processor until smooth and creamy. Set aside ½ cup of the purée for the sauce and strain the remainder using the strainer, using the bottom of a sturdy ladle to force as much through as possible; the strained purée should yield a generous ½ cup. Set aside. (This may be done several hours ahead; keep refrigerated.)

MAKE THE SAUCE:

In a small bowl, combine the carrots, celery, leeks, onions, turnips, and shallots. Heat a heavy 3-quart saucepan over high heat for about 1 minute, then add the vegetable mixture and cook for 3 minutes, stirring occasionally. Add 2 cups of the consommé, the reserved ½ cup unstrained date purée, and the honey and cumin, stirring well; cook until liquid reduces to about 1 cup, about 25 minutes. Add the *Fond de Veau* and continue cooking until liquid is a fairly thick sauce consistency, about 5 minutes more, stirring occasionally. Strain sauce through the chinois, using the bottom of a sturdy ladle to force as much through as possible; it should yield

about 1½ cups. Set aside. (This may be done several hours ahead; keep refrigerated.)

TO FINISH THE DISH AND SERVE:

(See photograph page 90.) Heat oven to 400 degrees. From each squab, cut off and discard the first two joints of the wings; season squabs generously with salt and pepper and a fairly generous amount of cumin.

Heat the oil in a large ovenproof skillet (preferably nonstick) over high heat, 2 to 3 minutes. Add each squab, resting on 1 breast, and cook until breast is browned, about 1 minute. Repeat to brown the other breast, then brown the breasts at the midline for about 30 seconds more. Turn squabs breast up and, while still over high heat, baste top of each with a scant 1 teaspoon honey and lightly sprinkle with more cumin. Immediately transfer skillet, uncovered, to the preheated oven. Roast until breast meat is medium rare, about 15 minutes; do *not* overcook, or the meat will be dry; keep in mind that it will cook a bit more when reheated just before serving. (To test doneness, pierce breast meat with a skewer; if done, the juices will run pink, not bloody and not clear.)

When finished cooking, remove squabs from oven, leaving oven set at 400 degrees; drain on paper towels. Cover loosely and let sit about 10 minutes, then carve the breast meat from each squab and cut crosswise into ¼-inch slices. (Save carcasses, if desired, for making stock.) Fan a portion of the slices in the center of each of 4 ovenproof serving plates; set aside.

Now finish the date purée as follows: Place the reserved strained date purée in a small saucepan. Add the consommé, honey, and cumin and cook over medium heat just until warm, about 1 minute, stirring constantly. Place in the pastry bag and pipe onto the plates. Sprinkle each serving of squab with ¼ teaspoon sesame seeds and heat plates, uncovered, in the 400 degree oven just until squab is heated through, about 2 minutes.

Meanwhile, reheat sauce and thin, if needed, with more consommé. Once squab is heated, spoon about 3 tablespoons sauce on each serving plate. Serve immediately.

CREME BRULEE with RASPBERRIES

Makes 4 servings

1½ cups heavy cream
An 8-inch piece of vanilla bean
3 egg yolks (from large eggs)
¼ cup granulated sugar
¼ cup very loosely packed dark brown sugar
About 1½ cups fresh raspberries
4 small mint sprigs for garnish

SPECIAL UTENSILS:
Chinois
4 (½-cup-capacity) individual ramekins or ovenproof serving bowls
Fine mesh strainer

PREPARE THE CUSTARDS:

Heat oven to 250 degrees. Place the cream in a small pot. Cut the vanilla bean in half lengthwise, scrape, and add scrapings and bean halves to the pot. Bring to a boil, then remove from heat and let sit 15 minutes. Meanwhile, combine the egg yolks and granulated sugar in a medium-size bowl, whisking vigorously until thick and pale yellow, about 2 minutes. Return cream to a boil, then remove from heat and gradually add to the egg yolk mixture, whisking constantly; continue whisking about 1 minute more. Strain through the chinois. (Rinse and save vanilla bean halves for future use.)

Place the ungreased ramekins in a small baking pan and fill ramekins with the cream

mixture. Add 1 inch of warm water to the pan, transfer pan to the preheated oven, and bake uncovered until custards are done, about 2 hours; start checking for doneness after about 1 hour 45 minutes. When done, the custard will feel fairly firm if pressed lightly with the fingertips and will only jiggle a tiny bit if ramekin is gently shaken in a back and forth motion (at this point the center will still be slightly runny; it will thicken to a soft consistency when chilled.) Let ramekins cool on a wire rack briefly, then refrigerate until well chilled, at least 3 hours or overnight.

TO FINISH THE DISH AND SERVE:

(See photograph page 91.) Heat oven to 450 degrees and preheat broiler if it's a separate unit from the oven. Place the custards on a cookie sheet or in a baking pan that will fit under the broiler; let sit about 15 minutes at room temperature.

Meanwhile, spread the brown sugar evenly over the bottom of a small baking pan and bake in the preheated oven until dry but not starting to melt, about 4 minutes, stirring at least once; check frequently. Remove from oven and let cool briefly. Now preheat broiler, if not already done. Process the sugar a few seconds in a blender to break up hard lumps, then sift through the strainer; discard any sugar that won't go through.

Sprinkle top of each custard with about 1 teaspoon of the sifted sugar, then wipe inside edges of the ramekins well to prevent sugar from burning on them. Broil about 4 inches from the heat source just until sugar melts and starts to bubble, 1 to 2 minutes; watch carefully. Remove from broiler and top each custard with a single layer of raspberries and a mint sprig. Serve immediately.

SORBETS of MINT, RASPBERRY, HUCKLEBERRY, PERSIMMON, and LIME

Makes about 1 quart of each sorbet

MINT SORBET:
3 ounces mint sprigs (about 30 single stems, each about 6 inches long)
1 cup plus 2 tablespoons sugar
4½ cups water
1 tablespoon creme de menthe liqueur
Tiny fresh mint leaves for garnish (optional)

RASPBERRY SORBET:
1¼ pounds fresh raspberries (about 3½ cups)
1 cup plus 2 tablespoons sugar
1½ cups water
Halved or quartered frozen raspberries for garnish (optional)

HUCKLEBERRY SORBET:
1¼ pounds fresh huckleberries (4 cups)
1 cup plus 2 tablespoons sugar
1½ cups water
Fresh huckleberries for garnish (optional)

PERSIMMON SORBET:
2 cups peeled and coarsely chopped ripe persimmons (from about 1 pound unpeeled persimmons)
1 cup sugar
2 cups water
Julienne persimmon pulp for garnish (optional)

LIME SORBET:
1¼ cups sugar
3 cups water
1 cup lime juice
1 tablespoon very finely grated lime zest
Paper-thin julienne lime zest for garnish (optional)

SPECIAL UTENSILS:
Chinois
Ice cream machine

MAKE THE MINT SORBET:

Combine the 3 ounces mint sprigs, sugar, and water in a nonreactive 3-quart saucepan and bring to a boil. Reduce heat just enough to stop mixture from bubbling (you should still see steam rising from it) and continue cooking for 30 minutes. Remove from heat and strain syrup through the chinois, using the bottom of a sturdy ladle to force as much through as possible. Stir in the liqueur and refrigerate until well chilled, at least 3 hours or overnight.

Freeze in the ice cream machine according to manufacturer's instructions until firm, about 20 to 45 minutes, depending on the type of machine used. Transfer sorbet to a freezer container and freeze about 1 hour to harden further. Serve immediately (or leave in freezer and serve within a few hours) in chilled bowls, formed into quenelles (oval shapes) and garnished with tiny mint leaves, if desired. (See photograph page 93.)

MAKE THE RASPBERRY SORBET:

In a blender, purée the 1¼ pounds raspberries with the sugar and water until very smooth. Strain purée through the chinois, using the bottom of a sturdy ladle to force as much through as possible. Refrigerate until well chilled, at least 3 hours or overnight.

Freeze and serve as directed for the Mint Sorbet (see above), garnishing each serving with frozen raspberries, if desired.

MAKE THE HUCKLEBERRY SORBET:

In a blender, purée the 1¼ pounds huckleberries with the sugar and water until very smooth. Strain purée through the chinois, using the bottom of a sturdy ladle to force as much through as possible. Refrigerate until well chilled, at least 3 hours or overnight.

Freeze and serve as directed for the Mint Sorbet (see above), garnishing each serving with whole huckleberries, if desired.

MAKE THE PERSIMMON SORBET:

In a blender, purée the chopped persimmon with the sugar and water until very smooth. Strain purée through the chinois, using the bottom of a sturdy ladle to force as much through as possible. Refrigerate until well chilled, at least 3 hours or overnight.

Freeze and serve as directed for the Mint Sorbet (see above), garnishing each serving with julienne persimmon pulp, if desired.

MAKE THE LIME SORBET:

Combine the sugar, water, and lime juice in a nonreactive 4-quart saucepan. Bring to a boil, stirring until sugar dissolves. Remove syrup from heat and stir in the grated lime zest. Refrigerate until well chilled, at least 3 hours or overnight.

Freeze and serve as directed for the Mint Sorbet (see above), garnishing each serving with julienne lime zest, if desired.

CAULIFLOWER STUFFED WITH SWEETBREADS AND MULARD DUCK with BROCCOLI FLOWERETS and BROCCOLI CREAM SAUCE

Makes 4 servings

3 ounces very fresh veal sweetbreads
Cool water for soaking sweetbreads
1½ cups Meat or Vegetable Consommé (page 214) (preferred) or Meat or Vegetable Stock (page 214)
2 very leafy thyme sprigs
3 whole black peppercorns
1 small bay leaf
7 ounces boneless skinned mulard duck (preferred) or other duck or chicken meat, fat trimmed
Fine sea salt and freshly ground black pepper
1 teaspoon vegetable oil
⅓ cup heavy cream
1 teaspoon fresh thyme leaves
12 cauliflower flowerets, each about 2 inches tall and 2½ inches wide
Salt water (¼ cup coarse salt mixed with 3 quarts water) for blanching vegetables
Ice water for cooling blanched vegetables
28 broccoli flowerets, each about 1½ inches tall and 1½ inches wide
2 tablespoons peeled and cubed carrots (⅛-inch cubes)
2 tablespoons peeled and cubed turnips (⅛-inch cubes)
2 tablespoons scraped and cubed celery (⅛-inch cubes)
2 tablespoons cubed zucchini skin (peeled off in ⅛-inch-thick sheets and cut into ⅛-inch cubes)
Broccoli Cream Sauce (recipe follows)
Olive oil for greasing cookie sheet

SPECIAL UTENSIL:
Fine mesh strainer

PREPARE THE SWEETBREADS FOR COOKING:

Trim away any large chunks of fat from the sweetbreads. Cover sweetbreads with cool water and soak for 10 minutes; drain. Cover with fresh water and let soak 10 minutes more; drain again. Cover a third time with fresh water and refrigerate overnight.

PREPARE THE STUFFED CAULIFLOWER:

Heat oven to 400 degrees. For the stuffing, poach the sweetbreads as follows: Drain sweetbreads and place in a small pot with the consommé, the 2 thyme sprigs, the peppercorns, and the bay leaf. Bring to a boil, then simmer for 4 minutes. With a slotted spoon, transfer sweetbreads to a plate and set aside. Strain the poaching liquid through the strainer; cover and refrigerate.

When sweetbreads are cool enough to handle, gently pull off and discard any bits of fat and most of the membrane surrounding them, leaving just enough attached to hold sweetbreads together. Cut sweetbreads into ⅛-inch cubes; cover and refrigerate.

Cut just enough of the duck into ⅛-inch cubes to yield ½ cup. Coarsely chop the remaining duck; set aside. Season the ½ cup duck cubes with salt and pepper. Heat a small empty skillet (preferably nonstick) over high heat, about 2 minutes. Add the oil, heat about 30 seconds, then add the duck cubes, and cook for just 15 seconds, stirring constantly. Drain on paper towels and set aside.

In a food processor, combine the reserved coarsely chopped duck with a generous amount of salt and pepper and process until smooth; add the cream and continue processing just until well blended; do *not* overmix. Strain mixture through

the strainer into a medium-size bowl, using the bottom of a sturdy ladle to force as much through as possible; it should yield about ½ cup. Add the duck cubes, sweetbread cubes, and the 1 teaspoon thyme leaves to the bowl, mixing gently. Cover and refrigerate.

Trim the cauliflower flowerets into attractive round shapes that are about 1½ inches tall and 2 inches wide; trim a thin slice from the side of each floweret so it will lie flat on its side. Bring the salt water for blanching the vegetables to a rolling boil in a large nonreactive pot. Add the cauliflower and blanch until tender but still crisp, about 3 minutes. Immediately transfer with a slotted spoon to the ice water to cool, reserving salt water. Drain on paper towels, reserving ice water.

Return salt water to a boil and blanch the broccoli until tender but still crisp, 1 to 2 minutes. Cool in the ice water and drain on paper towels separate from the cauliflower; reserve salt water and ice water.

Return salt water to a boil, add the carrots, turnips, and celery, and blanch for 7 minutes, then add the zucchini skin and blanch 1 minute more. Cool in the ice water and drain on paper towels separate from the other vegetables; discard salt water and ice water.

To finish the stuffing, finely chop 2 of the broccoli flowerets; add this chopped broccoli and the cubed vegetable mixture to the reserved duck and sweetbread mixture, mixing well. Set aside the remaining broccoli and the cauliflower.

Now form a 1-inch ball of the stuffing to cook and then taste for seasoning. To cook the stuffing ball, place it in a small greased baking pan and bake in the preheated oven until cooked through, about 7 minutes; once cool, taste and if needed add more salt and pepper to the remaining stuffing.

Next, separate the stuffing into 12 equal portions and form each into a ball. With the cauliflower flowerets on their sides, slice each horizontally almost all the way through with a sharp thin-bladed knife, being very careful not to actually detach the top section from the bottom; stuff each floweret with a ball of stuffing, gently opening each just wide enough to ease the stuffing inside. Set aside. (Refrigerate if prepared ahead.)

Now make the Broccoli Cream Sauce with 14 of the reserved broccoli flowerets, reserving the remaining 12 flowerets for garnishing the serving plates; set aside or refrigerate if made ahead.

TO FINISH THE DISH AND SERVE:

(See photograph page 96.) Heat oven to 400 degrees. If the stuffed cauliflower was made ahead and chilled, let sit at room temperature about 30 minutes; then place on a cookie sheet greased generously with olive oil and bake uncovered until the stuffing is cooked through and very lightly browned, about 12 minutes. Heat the serving plates in the oven the last 2 to 3 minutes. Once the stuffed cauliflower has finished cooking, serve immediately.

Meanwhile, reheat the sauce in a small heavy nonreactive saucepan; thin if needed with some of the sweetbreads' poaching liquid. Also now reheat the reserved 12 broccoli flowerets in the remaining poaching liquid (do *not* overcook); drain on paper towels.

To serve: On each heated serving plate, arrange 3 stuffed cauliflower flowerets and 3 broccoli flowerets in a circle; spoon 2 to 3 tablespoons sauce in the center of the plate.

BROCCOLI CREAM SAUCE

¼ cup heavy cream

¼ cup milk
14 reserved blanched broccoli flowerets
2 tablespoons reserved sweetbreads poaching liquid
2 teaspoons Parsley Purée (page 215) (optional)
Fine sea salt and freshly ground black pepper

SPECIAL UTENSIL:
Chinois

Combine cream and milk in a small pot and bring to a boil; remove from heat. Purée in a blender with broccoli, poaching liquid, and Parsley Purée until smooth; season to taste with salt and pepper. Strain sauce through the chinois, using the bottom of a sturdy ladle to force as much through as possible. *Makes about ¾ cup.*

SEA SCALLOPS AND CUCUMBERS ON THE HALF SHELL with CUCUMBER SAUCE

Makes 4 servings

3 large cucumbers, about 10 ounces each (with perfect skins and diameters about equal to those of scallops)
Salt water (¼ cup coarse salt mixed with 3 quarts water) for cooking cucumbers
Ice water for cooling cooked cucumbers
¼ pound (1 stick) unsalted butter, softened
3 cups Lobster Consommé (page 214) (preferred), Lobster Stock (page 214), or other Consommé or Stock (page 214)
10 ounces sea scallops, rinsed and small tough muscle on the side of each removed
2 cups coarse salt to form beds under scallop shells (optional; see Note)
8 large scallop shells for serving (optional; see Note)
Fine sea salt and freshly ground black pepper
1 teaspoon Parsley Purée (page 215)
About ½ teaspoon Lobster Coral Garnish (page 215) (optional)

SPECIAL UTENSILS:
Lemon stripper or lemon zester with a stripper hole
Chinois

NOTE:
If desired, serve the scallops and cucumbers directly on plates instead of in scallop shells on beds of coarse salt.

PREPARE THE CUCUMBERS AND START THE SAUCE:

With the stripping utensil, peel off lengthwise parallel strips of cucumber skin from 1 of the cucumbers at about ¼-inch intervals; you will need 7 or 8 strips of peeling for garnishing each plate. Next, cut the same cucumber crosswise into ⅛-inch slices; you will need 10 to 12 slices per plate. Peel off the skin from the remaining 2 cucumbers in ¼-inch-thick sheets, reserving peelings.

Bring the salt water to a rolling boil in a large pot. Add the sheets of cucumber peeling and blanch 1 minute, then add the strips of peeling and continue cooking 2 minutes more. Immediately cool sheets and strips of peeling in the ice water, keeping salt water boiling. Reserving ice water, drain sheets and strips on paper towels. Add the reserved cucumber slices to the boiling water and cook just until tender, about 1 minute; do *not* overcook. Immediately cool in the ice water, then drain on paper towels. Wrap strips of cucumber peeling and cucumber slices separately in plastic wrap and set aside, refrigerated.

Squeeze the sheets of peeling dry, then mince. Process in a food processor with the butter until creamy. Transfer cucumber butter to a small bowl and let sit at room temperature for 1 hour

to let flavors develop, then cover and refrigerate until firm, at least 1 hour or overnight.

PREPARE THE SCALLOPS AND ASSEMBLE THE PLATES:

(See photograph page 97.) In a large skillet, bring the consommé to a simmer. Add the scallops and simmer for 1 minute (the scallops should still be raw in the center at this point). Drain on paper towels. Set aside 1 tablespoon of the cooking liquid, refrigerated, for the sauce.

With a sharp thin-bladed knife, cut the scallops into attractive ⅛-inch slices; you will need 10 to 12 slices of scallops for each plate.

If serving the dish on scallop shells, mound ½ cup coarse salt in the center of each of 4 ovenproof serving plates and position the 4 deepest shells on top. In each shell or directly on each ovenproof plate if not using shells, arrange about 10 of the scallop slices and about 10 of the reserved cucumber slices alternately in a large circle; place 1 or 2 scallop and cucumber slices in the center of the arrangement. Next, arrange the reserved strips of cucumber peeling in a crisscross pattern on top and season with salt and pepper. Cover plates with aluminum foil. (The plates may be assembled to this point up to 2 hours ahead and kept refrigerated; return plates to room temperature before heating in the oven.)

TO SERVE:

Heat the covered serving plates in a preheated 350 degree oven just until food is hot, about 10 minutes; check often toward the end of the cooking time so the scallops don't overcook and become rubbery.

Meanwhile, finish the sauce by combining the reserved chilled cucumber butter with the reserved 1 tablespoon scallop cooking liquid in a small heavy saucepan. Cook over high heat just until butter melts, whisking constantly. Strain through the chinois, using the bottom of a sturdy ladle to force as much through as possible; the strained sauce should yield about ½ cup. Return sauce to the saucepan, whisk in the Parsley Purée, then season to taste with salt and pepper. Reheat over high heat, whisking constantly.

Remove plates from the oven, unwrap, and blot edges of cucumbers well with paper towels. Spoon about 2 tablespoons sauce over each serving and, if desired, sprinkle with Lobster Coral Garnish. If using scallop shells, position 1 of the remaining shells to the side of each serving. Serve immediately.

BAKED POTATOES STUFFED WITH LOUISIANA CRAWFISH, LOBSTER MOUSSELINE AND POTATO MOUSSELINE, with LOBSTER CORAL SAUCE

Makes 4 servings

If you have difficulty procuring raw lobster coral (roe sacs) for the sauce, you may substitute Smelt Roe Sauce (pages 197-198) or Dill Sauce (page 180) with equally good results. (For more about lobster coral, see the introduction to Lobster Coral Garnish, page 215.)

Lobster Coral Sauce (recipe follows)
½ cup Lobster Mousseline (page 215)
About 3 cups coarse salt for cooking potatoes for shells
4 large well-formed russet potatoes (9 to 10 ounces each) for potato shells
3 dozen active live crawfish, as large as possible (Louisiana preferred; about 2 pounds; see Note)

POTATO MOUSSELINE:

2 large russet potatoes (9 to 10 ounces each)

Salt water (2 tablespoons coarse salt mixed with 6 cups water) for cooking potatoes

About ½ cup heavy cream

2 tablespoons unsalted butter

1 tablespoon extra-virgin olive oil

Fine sea salt and freshly ground black pepper

2 teaspoons very finely sliced chives

1 teaspoon Lobster Coral Garnish (page 215) (optional)

2 cups Lobster Consommé or Lobster Stock (page 214) (preferred) or other Consommé or Stock (page 214) for reheating crawfish

1 tablespoon very finely sliced chives for garnish

Dill sprigs for garnish (optional)

Lobster Coral Garnish (page 215) (optional)

SPECIAL UTENSILS:

Pastry bag fitted with a Number 4 star tip

Steamer

Potato masher or ricer

NOTE:

If live crawfish are not available in your area, you may substitute 4 (1- to 1½-pound) live Maine lobsters; steam the lobsters, then shell and slice the meat as directed in Miniature Pumpkins Stuffed with Steamed Maine Lobster, page 182.

Prepare the lobster coral butter for the Lobster Coral Sauce; refrigerate. Next, make the Lobster Mousseline; refrigerate. (This may be done several hours ahead.)

PREPARE THE POTATO SHELLS:

Heat oven to 400 degrees. Cover the bottom of a 12 x 8-inch baking pan with ¼ inch of coarse salt. Wrap the 4 well-formed potatoes in aluminum foil and arrange on top of the salt. Bake until tender, 1 to 1½ hours.

When cool enough to handle, remove potatoes from pan, reserving pan of salt. With a sharp thin-bladed knife, slice off the top ⅓ of each potato; discard top portion. Using a sturdy teaspoon, scoop out the pulp to form shells with ¼-inch-thick sides and ½-inch-thick bottoms, being careful not to pierce the skin; discard pulp. Spoon the Lobster Mousseline into the pastry bag and pipe an equal portion into the bottom of each shell, using it all. Wrap the shells completely with aluminum foil and refrigerate. (This may be done several hours ahead.)

PREPARE THE CRAWFISH:

Steam and peel the crawfish as directed in the Louisiana Crawfish with Lobster Flan recipe on page 207; refrigerate. If substituting lobsters, steam them and remove the meat from the shells as directed in the Miniature Pumpkins recipe; refrigerate. (This may be done several hours ahead.)

TO FINISH THE DISH:

Heat oven to 400 degrees. About 1 hour before serving time, make the potato mousseline as follows: Peel the 2 potatoes and cut into 1-inch cubes; place in a large pot with the salt water. Bring to a boil, then reduce heat, and simmer until tender, 20 to 25 minutes.

Meanwhile, finish the Lobster Coral Sauce; set aside in a warm place until ready to reheat.

When the potatoes for the mousseline are cooked, drain and, while still piping hot, mash with the masher or ricer. Place in a small saucepan, add ½ cup of the cream, the butter and oil, and a generous amount of salt and pepper. Cook over high heat just a few seconds until the butter melts and all ingredients are well blended, stirring constantly with a wooden spoon. Before

removing from heat, thin if needed with a few more drops of cream (the mousseline should be quite stiff—just soft enough to be piped through a pastry bag nozzle; if in doubt, do not thin). Cover pan with plastic wrap directly on the surface of the mousseline; set aside in a warm place.

Now place the reserved potato shells upright in the reserved pan of salt; use a fork to pierce once through top of foil covering each shell. Bake in the preheated oven for 6 minutes (the Lobster Mousseline should barely be cooked at this point). Remove pan from oven and set aside; leave oven set at 400 degrees.

Meanwhile, add to the potato mousseline the chives and, if using, the Lobster Coral Garnish; heat over medium heat just until warmed, stirring constantly with a wooden spoon. Spoon into the pastry bag.

Once the potato shells are out of the oven, unwrap shells and pipe the potato mousseline inside, using most if not all of it (see photograph pages 98-99). Return shells, uncovered, to the 400 degree oven and bake just until mousseline is heated through, about 6 minutes. Warm the serving plates in the oven the last 2 to 3 minutes. When the potatoes have finished heating, remove pan from the oven, leaving shells in the pan; immediately reduce oven setting to 250 degrees.

Reheat the crawfish in the 2 cups consommé over low heat just until warmed, about 7 minutes; do *not* let consommé reach a simmer. (If using lobster, reheat in the Miniature Pumpkins recipe.)

To serve: Drain the warmed crawfish (use a slotted spoon) and arrange an equal portion on top of each potato; garnish with a sprinkle of chives and, if using, add dill sprigs and a light sprinkle of Lobster Coral Garnish. Place the assembled potatoes on the heated serving plates; put plates, uncovered, in the 250 degree oven with the door ajar to keep warm while reheating the sauce.

To reheat sauce, cook over very high heat, whisking constantly and briskly as before, just until the bright orange color is restored, 1 to 3 minutes; remove from heat and promptly spoon about 2 tablespoons on each plate. Serve immediately.

LOBSTER CORAL SAUCE

¼ pound (1 stick) unsalted butter, softened

2 ounces (a scant ¼ cup) raw lobster coral, fresh or thawed

About ⅓ cup Lobster Consommé (page 214) (preferred), Lobster Stock (page 214), or other Consommé or Stock (page 214)

Fine sea salt and freshly ground black pepper

SPECIAL UTENSIL:

Chinois

PREPARE THE LOBSTER CORAL BUTTER:

Process the butter and lobster coral in a food processor until smooth and an even color. Cover and refrigerate until firm, at least 1 hour or up to 8 hours before using.

TO FINISH THE SAUCE:

Before proceeding, keep in mind that lobster coral curdles easily unless special care is taken during cooking. To avoid curdling, it's important to use a heavy saucepan and to constantly and *very* briskly whisk throughout the cooking process, even when the sauce is momentarily removed from heat; be sure to scrape the pan bottom evenly as you whisk. If the sauce does curdle, strain it as directed below and continue cooking.

Now finish the sauce by placing the chilled

lobster coral butter in a small heavy saucepan and adding ⅓ cup of consommé. Cook, alternating between heating over very high heat for about 5 seconds then removing from heat for about 20 seconds (to prevent the coral from curdling and let the color develop), just until sauce is a bright salmon-orange, whisking constantly and very briskly; scrape the pan bottom evenly as you whisk. The cooking time will range from about 5 to 15 minutes, depending on the intensity of the heat source and whether or not the sauce curdles and requires straining. As the sauce cooks, it will progress from its initial green color to an orange-brown and finally to the desired bright salmon-orange. (Note: During cooking, if the sauce thickens so much that whisking becomes markedly more difficult, promptly thin with more consommé and continue cooking. If the sauce starts to curdle, immediately remove from heat and without scraping pan bottom, quickly strain through the chinois into another heavy saucepan, using the bottom of a sturdy ladle to force as much through as possible; then, if needed, thin with more consommé and continue cooking to the desired color.) Once finished, remove from heat and continue whisking 1 to 2 minutes more. Season to taste with salt and pepper. *Makes about 1 cup.*

MULARD DUCK HEARTS STUFFED WITH FOIE GRAS in NESTS OF TRICOLORED PASTA with SAGE SAUCE

Makes 4 servings

Sage Sauce (recipe follows)

PASTA NOODLES (see Note):

3 tablespoons Parsley Purée (page 215)

1 cup plus 2 tablespoons finely ground semolina flour

½ teaspoon fine sea salt

2 teaspoons extra-virgin olive oil

2 large eggs

About 1 cup plus 11 tablespoons all-purpose flour, plus flour for rolling out dough

1 tablespoon water

1 egg yolk

5 tablespoons tomato paste

Mulard Duck Hearts Stuffed with Foie Gras (recipe follows)

FOR BLANCHING AND SAUTEING PASTA NOODLES:

6 quarts water

2 tablespoons coarse salt

2 tablespoons extra-virgin olive oil

Ice water for cooling blanched pasta

¼ pound (1 stick) unsalted butter

Fine sea salt and freshly ground black pepper

SPECIAL UTENSIL:

Pasta machine with a tagliatelle attachment (2-millimeter)

NOTE:

You may substitute 4 store-bought "pasta nests" for homemade pasta.

Make the Sage Sauce through the point of adding the sage leaves; refrigerate. (This may be done a day ahead.)

MAKE THE PASTA NOODLES:

First, make the Parsley Purée if not already done; set aside. Next, prepare the basic dough for all 3 (yellow, green, and red) pastas as follows: In the large bowl of an electric mixer fitted with a paddle, combine the semolina, salt, oil, and eggs. Beat at medium speed until well blended, about 1 minute; the dough will still be quite wet and sticky at this point. Flour hands

with all-purpose flour and form dough into a ball. Cut the ball into 3 equal portions and wrap 2 of them separately in plastic wrap. Make the remaining portion into yellow pasta dough.

For the yellow dough, break the portion of basic dough into 5 pieces and return them to the bowl of the electric mixer. Add 7 tablespoons of the all-purpose flour and the water and egg yolk. Beat at medium speed until dough forms a soft, supple ball, about 2 minutes; then, if dough is still sticky, beat in about 1 tablespoon more all-purpose flour. Wrap in plastic wrap and set aside.

To make the green pasta dough, break another portion of the basic dough into 5 pieces and place these in the electric mixer bowl. Add 8 tablespoons all-purpose flour and the Parsley Purée. Beat at medium speed until dough forms a soft, supple ball and is an even color, about 2 minutes; if needed, beat in about 1 tablespoon more all-purpose flour. Wrap in plastic wrap and set aside.

For the red pasta dough, break the remaining portion of basic dough into 5 pieces and place in a clean electric mixer bowl. Add 9 tablespoons all-purpose flour and the tomato paste. Beat at medium speed until dough forms a soft, supple ball and is an even color, about 2 minutes; if needed, beat in about 1 tablespoon more all-purpose flour. Wrap in plastic wrap.

Let all 3 doughs rest, covered, for about 1 hour before rolling out, then roll out each color of dough and cut into noodles as follows (complete rolling out and cutting noodles of 1 color before proceeding to the next): Unwrap dough and lightly flour it with all-purpose flour. Roll through the pasta machine 10 times on the thickest setting of machine; fold it in half after each rolling. Next, roll dough through once on each setting, this time without folding in half after each rolling, progressing from the very thickest setting to the thinnest; if needed, lightly flour dough so it doesn't stick and cut into manageable lengths. Once dough has gone through the thinnest setting, cut it into about 1-foot lengths. With the tagliatelle attachment on the machine, cut lengths into noodles and hang on coat hangers until ready to cook. Repeat with remaining 2 colors of dough. (This may be done a day ahead; store noodles at room temperature still hanging on coat hangers.)

Now prepare the Mulard Duck Hearts Stuffed with Foie Gras up to the point of cooking; refrigerate if prepared ahead.

TO FINISH THE DISH AND SERVE:

(See photograph page 100.) Heat oven to 400 degrees. First, cook the duck hearts as directed on page 194; set aside.

Now blanch the noodles as follows: If using the homemade noodles, combine the water, salt, and oil in a large pot; bring to a rolling boil over high heat. Add the yellow, green, and red noodles and cook uncovered for 1½ minutes (do not cook longer, since the noodles will be sautéed later). Immediately drain and cool in the ice water; the noodles may stay in the water up to 15 minutes before draining and sautéing.

If using commercially made pasta nests, cook them according to package instructions until about 2 minutes short of the al dente stage; cool in ice water as directed above.

Next, reheat the duck hearts as follows: Place the duck hearts (still wrapped in caul) in a large ovenproof nonstick skillet or baking pan with the remaining 2 tablespoons duck fat and bake uncovered in the preheated oven just until heated through, about 10 minutes. Once done, remove from oven, leaving oven setting at 400 degrees; drain on paper towels and set aside.

Meanwhile, sauté the noodles. To do this, drain noodles well. Heat a very large nonstick

skillet over high heat for 3 minutes. Reduce heat to medium and add the butter; when melted, add the noodles and season with salt and pepper. Cook to al dente stage, about 2 minutes, tossing constantly. Remove from heat.

Divide noodles into 4 equal portions while still in the skillet. Working with 1 portion at a time, separate the portion into 6 equal parts (for 6 nests per plate), then with tongs transfer each ⅙ to an ovenproof serving plate and swirl into a nest shape. Repeat with remaining 3 portions to form 6 nests per serving plate, then blot around edges of nests with paper towels. Once the heated duck hearts have been drained, place 1 heart (still wrapped in caul) in each nest. Return plates, uncovered, to the 400 degree oven just until all food is heated through, about 3 minutes. Meanwhile, reheat sauce; then remove and discard sage leaves and pour into a sauceboat for serving at the table. Serve immediately.

SAGE SAUCE

¼ cup unpeeled chopped carrots
2 tablespoons chopped celery
2 tablespoons chopped leeks (mostly white part)
2 tablespoons chopped onions
2 tablespoons unpeeled chopped turnips
1 tablespoon chopped shallots
½ ounce sage sprigs, plus 12 large sage leaves for infusing sauce
1 cup Meat or Vegetable Consommé (page 214) (preferred) or Meat or Vegetable Stock (page 214)
1 cup *Fond de Veau* (page 214)

SPECIAL UTENSIL:
Chinois

In a small bowl, combine the carrots, celery, leeks, onions, turnips, shallots, and the ½ ounce sage sprigs. Heat a heavy 3-quart saucepan over high heat for about 1 minute, then add the vegetable mixture. Reduce heat to medium and cook for 3 minutes, stirring occasionally. Add the consommé and cook until liquid reduces to ½ cup, 15 to 20 minutes. Add the *Fond de Veau* and continue cooking until liquid is a thin sauce consistency, 10 to 15 minutes more, stirring occasionally. Strain sauce through the chinois, using the bottom of a sturdy ladle to force as much through as possible; it should yield ⅔ to 1 cup. Add the 12 sage leaves to the sauce; refrigerate. (The sauce may be made to this point up to 1 day ahead.)

When ready to serve, reheat sauce, then remove and discard sage leaves. *Makes ⅔ to 1 cup.*

MULARD DUCK HEARTS STUFFED WITH FOIE GRAS

10 ounces fresh uncooked duck or goose foie gras (Grade A or B)
2 dozen mulard duck hearts (about 1¼ pounds)
Fine sea salt and freshly ground pepper
3 pounds pork caul fat (or enough to make 4 dozen 6-inch squares; see Note)
¼ cup rendered duck fat or pork lard (preferred) or vegetable oil

NOTE:
Caul fat is available from butcher shops. Ask for pieces with few if any holes and ones without extra-large veins of fat running through them; refrigerate, soaking in water, until used.

With a sharp thin-bladed knife, carefully trim away any green spots on the foie gras caused by contact with the gall bladder; set aside. With the duck hearts lying flat, cut a lengthwise slit in

each, about 1½ inches long, to form a pocket; the slit should start at the center top of the thicker end and its depth should be about half way through the heart. Next, cut a wedge of foie gras to fit into each duck heart pocket; the height of the wedge (if sitting like a wedge of pie) should be the length of the duck heart pocket (about 1½ inches), and the wedge's width at the widest part and its length should be about 1 inch. Lightly salt and pepper all surfaces of each wedge, then fit it into 1 of the duck heart pockets, gently working the foie gras with your hands to soften it so you can smooth any angles and mold it snugly into place; soften trimmings and work them into the pockets, too.

Now rinse the caul fat well and squeeze dry; cut out 48 (6-inch) squares that have no holes in them and trim any very large veins of fat from their edges. Snugly wrap 1 of the caul squares around each heart as you would an envelope, then securely wrap each in a second square. Generously season all surfaces of the packaged hearts with salt and pepper. If not cooking immediately, cover and refrigerate.

To cook the duck hearts, heat 2 tablespoons of the duck fat in a large nonstick skillet over high heat, 2 to 3 minutes. Reduce heat to medium and add the caul-wrapped duck hearts to the skillet in a single layer. Cook until hearts are tender and brown on all sides, about 9 minutes, turning carefully so caul doesn't unwrap; do *not* overcook, or the foie gras will loose its unique buttery texture. Remove from heat and transfer hearts to a platter; set aside until time to reheat. (Note: If you are making these stuffed duck hearts for the Salad of Mache recipe, once the hearts are cooked, refrigerate them at least 2 hours before serving.) *Makes 2 dozen stuffed duck hearts.*

LAMPREY A LA BORDELAISE

Makes 4 servings

MARINADE:
3 cups red Bordeaux wine
2 cups chopped leeks (white and green parts)
1 cup chopped onions
1 cup unpeeled chopped carrots
1 cup chopped celery
1 cup unpeeled chopped turnips
¾ cup chopped shallots
3 medium-size garlic cloves, peeled and crushed
10 very leafy thyme sprigs
3 large bay leaves
2½ to 3 pounds live freshwater lamprey or other freshwater eel (See Note)
2 tablespoons extra-virgin olive oil
Fine sea salt and freshly ground black pepper
3 cups red Bordeaux wine
6 ounces finely chopped lean prosciutto
3 cups Lobster Consommé (page 214) (preferred), Lobster Stock (page 214), or other Consommé or Stock (page 214)
1½ cups *Fond de Veau* (page 214)
Salt water (2 tablespoons coarse salt mixed with 1 quart water)
6 large leeks (1¾ to 2 pounds), cut crosswise into 1½-inch pieces (white part)

SPECIAL UTENSIL:
Chinois

NOTE:
Have eel killed, skinned, cleaned, and cut crosswise into 2-inch sections; if using lamprey, save blood for sauce.

Combine all the ingredients for the marinade in a large glass or stainless steel bowl; add the eel, cover, and refrigerate overnight.

The next day, remove the eel from the

marinade and blot dry with paper towels; set marinade aside. Heat a heavy 6-quart saucepan over high heat until very hot, about 5 minutes. Add the oil and heat for 1 minute. Add the eel, reduce heat to medium, and sauté until lightly browned on all sides, about 5 minutes. Season eel lightly with salt and pepper, then add to the pan the reserved marinade and the wine and prosciutto. Bring to a boil over high heat. Reduce heat and simmer for 30 minutes, stirring and skimming occasionally.

With the mixture still simmering, transfer eel with a slotted spoon to a bowl; cover and set aside. Add the consommé to the pan and bring to a boil over high heat, then simmer until liquid reduces by ⅓, about 1 hour 10 minutes. Add the *Fond de Veau* and continue simmering until sauce reduces to 1½ to 2 cups, about 15 minutes more. Strain sauce through the chinois, using the bottom of a sturdy ladle to force as much through as possible. Return sauce to the saucepan and, if using lamprey, add the blood. If the sauce is too thin, reduce to a sauce consistency; remove from heat and return eel to pan. Cover and set aside.

Meanwhile, bring the salt water to a rolling boil in a small pot. Add the leek pieces and simmer (do not boil) until tender, about 15 minutes; drain on paper towels and blot dry.

Also now heat the serving plates in a 250 degree oven.

TO SERVE:
(See photograph page 101.) If needed, reheat sauce and eel. Spoon 3 or 4 pieces of eel and about ¼ cup sauce on each heated serving plate and arrange 3 or 4 pieces of leek on top of the sauce. Serve immediately.

STUFFED HEN with VEGETABLES, STUFFED CABBAGE LEAVES, and GRATIN OF MACARONI

Makes 4 to 6 servings

1 (6- to 6½-pound) hen (stewing chicken) with neck and giblets
Stuffing (recipe follows)
1 large unpeeled onion, cut in half
Fine sea salt and freshly ground black pepper
About 4 quarts water
2 cups V-8 Juice
2½ cups unpeeled chopped tomatoes
1½ cups unpeeled chopped carrots
1½ cups chopped celery
1½ cups chopped leeks (mostly white part)
1½ cups unpeeled chopped turnips
¾ cup chopped shallots
¼ cup coarse salt
15 large parsley sprigs
15 very leafy thyme sprigs
3 large unpeeled garlic cloves, crushed
7 large bay leaves
2 teaspoons whole black peppercorns
1 recipe Stuffed Cabbage Leaves prepared up to the point of steaming (see recipe for Veal Pot-au-Feu, pages 178-179; see Note)
GRATIN OF MACARONI:
3 quarts broth reserved from cooking hen
1½ cups elbow macaroni
3 tablespoons unsalted butter, softened
Fine sea salt and freshly ground black pepper
½ cup finely grated Parmesan cheese (preferably imported)
2 dozen pearl onions, peeled
6 large shallots, peeled
2 medium-size leeks (mostly white part), cut into 3-inch pieces
2 dozen baby carrots, peeled
6 fresh uncooked artichoke hearts (preferred)

or 6 canned artichoke hearts packed in water, drained
20 (2½-inch-long) asparagus tips, tough skin from thicker ends peeled with a vegetable peeler
1 cup shelled green peas

SPECIAL UTENSILS:
3-inch needle and strong thread for sewing cavity of hen and trussing
10-quart or larger soup pot or stockpot
8-inch gratin dish or other ovenproof dish
Steamer

NOTE:
If desired, add to the cabbage leaf filling 1 thinly sliced artichoke heart (cooked as directed in the Poached Artichoke Hearts recipe on page 215, or 1 canned heart); keep stuffed cabbage leaves refrigerated until ready to steam them.

First make the stuffing; refrigerate at least 3 hours before using.

STUFF AND COOK THE HEN:
Char both onion halves simultaneously in the same small skillet as directed in the Poultry Stock recipe on page 214; set aside.

Tuck the wings underneath the back of the hen and place it breast up in a large roasting pan. Generously season the large and neck cavities with fine sea salt and pepper. Fill the large cavity with the stuffing (if you have a little left over, fill the neck cavity, too); sew up cavity (or cavities, if both are stuffed) with the needle and thread, then truss hen with more thread to tie legs close to the body. Use a knife with a pointed tip to prick about 10 tiny holes through the skin covering the large cavity (do the same with the skin over the neck cavity, if stuffed) to prevent stuffing from overexpanding while cooking.

Place the soup pot over high heat and add 4 quarts of water and the V-8 Juice to it. Add to the pot the reserved charred onion halves, the chopped tomatoes, carrots, celery, leeks, turnips, and shallots, and the coarse salt, parsley and thyme sprigs, garlic, bay leaves, and peppercorns; then add the stuffed hen and the hen's neck and gizzard. Add more water, if needed, to cover all the other ingredients. Bring to a boil. Reduce heat and strongly simmer for 30 minutes.

Now prick holes again through the skin covering the hen's cavity (or cavities) and continue cooking until tender, 1 to 1½ hours more, skimming occasionally; do *not* overcook. To judge doneness, insert a skewer between the thigh and body down to the thigh/hip joint and withdraw it; wait a few seconds, then if the juices run clear, it's done. Transfer hen to a platter and set aside until cool enough to handle.

Meanwhile, return the broth in the pot to a boil and continue boiling until reduced to 3 quarts, about 30 to 45 minutes. Remove from heat and strain. If not finishing the dish fairly promptly, cool briefly and refrigerate.

When the hen is cool enough to handle, carefully remove the stuffing from the cavity (or cavities), keeping it as intact as possible; then carve the hen into 8 pieces. Cover stuffing and hen pieces and set aside; cover and refrigerate if prepared ahead.

Now prepare the stuffed cabbage leaves, if not already done, up to the point of steaming; refrigerate.

TO FINISH THE DISH AND SERVE:
(See photograph pages 102-103.) Heat oven to 450 degrees. Also preheat broiler if it's a separate unit from oven.

For the Gratin of Macaroni, bring the reserved 3 quarts broth to a rolling boil in a 4-quart pot over high heat. Add the macaroni,

reduce heat to medium, and cook for 8 minutes. Transfer macaroni with a slotted spoon to a colander to drain; set broth aside.

Butter the bottom and sides of the gratin dish with 1 tablespoon of the butter. Line the bottom of the dish with ½ of the macaroni, then cut the remaining butter in small pieces and dot macaroni with ½ of it; lightly season top with salt and pepper and sprinkle evenly with 3 tablespoons of the Parmesan. Add the remaining macaroni to the dish and dot with the remaining butter. Season top with more salt and pepper and sprinkle with 4 tablespoons more Parmesan. Pour ⅓ cup of the reserved broth evenly over the top; set aside remaining broth for finishing the hen dish. Bake uncovered in the preheated oven for 15 minutes.

Remove macaroni from oven and immediately reduce oven setting to 350 degrees for reheating stuffing. Sprinkle the remaining 1 tablespoon Parmesan over the top of the macaroni and cover to keep warm until time to brown top under the broiler just before serving.

Meanwhile, finish the hen dish as follows: Bring the reserved broth to a boil. Add the pearl onions, whole shallots, and pieces of leek; reduce heat and simmer for 15 minutes. Add the hen pieces and return to a simmer, add the carrots and artichoke hearts, then 5 minutes later add the asparagus tips and peas; continue cooking 10 minutes more. Remove from heat and set aside.

Reheat the stuffing, covered, in the 350 degree oven for about 15 minutes; once reheated, slice into 4 to 6 pieces and cover to keep warm.

At the last possible moment, steam the plastic-wrapped stuffed cabbage leaves in the covered steamer over boiling water just until heated through, 5 to 7 minutes; once steamed, remove stuffed leaves from steamer and set aside, still wrapped in plastic.

When the hen dish and stuffed cabbage leaves have finished cooking and the stuffing has been reheated and sliced, uncover the gratin of macaroni and broil about 4 inches from the heat source until top is browned and bubbly, about 1 minute; watch closely. Serve immediately.

To serve: Arrange a portion of the hen, stuffing, and an assortment of the vegetables in each wide soup bowl. Unwrap the stuffed cabbage leaves and cut in half if serving more than 4 people; add to the bowls. Ladle enough broth over the top to cover the vegetables. Serve with the macaroni on the side.

STUFFING

14 ounces (about ⅓ large loaf) Brioche (pages 214-215) (preferred) or other white bread, crust trimmed and bread cut into 2-inch cubes (about 4½ cups)
1 cup milk
⅓ cup finely chopped prosciutto (2 ounces)
½ cup thinly sliced onions
¼ cup thinly sliced shallots
3 large peeled garlic cloves, crushed
Leaves from 2 ounces fresh parsley sprigs (about 30 large sprigs)
2 tablespoons fresh thyme leaves
6 ounces chicken livers
Liver and heart from hen, if received
1 large egg, lightly beaten
1 tablespoon all-purpose flour
2 teaspoons sugar
2 teaspoons fine sea salt
Freshly ground black pepper

In a medium-size bowl, soak the Brioche in the milk for 5 minutes; squeeze dry and set aside. In a food processor, combine the pros-

ciutto, onions, shallots, garlic, and parsley and thyme leaves; process mixture until finely chopped. Add the chicken livers and the heart and liver from the hen; continue processing until all ingredients are minced. Transfer mixture to a medium-size bowl and add the egg, flour, sugar, salt, a generous amount of pepper, and the reserved Brioche, mixing thoroughly by hand. Cover and refrigerate until well chilled, at least 3 hours, before stuffing the hen. *Makes about 2 cups.*

BANANA AND CHOCOLATE MOUSSE CAKE, GRAND MARNIER ICE CREAM IN A HAZELNUT CORNET, and FRESH FRUIT

Makes 8 servings

CAKE:
Butter and flour for preparing cake pan
5 large eggs
¾ cup sugar
½ teaspoon vanilla extract
½ cup plus 3 tablespoons cake flour
Scant ½ cup unsweetened cocoa powder
3 tablespoons unsalted butter, melted
BANANA MOUSSE FILLING:
1¾ cups heavy cream
1 cup (about 1½ large) well-mashed overripe bananas
½ teaspoon vanilla extract
3 tablespoons sugar
2 tablespoons dark rum
2 teaspoons unflavored gelatin
1 large overripe banana, sliced crosswise into 1½-inch pieces
CHOCOLATE MOUSSE FILLING:
3½ ounces semisweet chocolate, cut into small pieces
1 cup heavy cream
Grand Marnier Ice Cream (recipe follows)
Hazelnut Cornets (recipe follows)
8 medium to large oranges, peeled, seeded, and separated into segments without membranes
About 1½ cups fresh raspberries
2 dozen fresh strawberries, cut into ¼-inch slices
16 fresh ripe tamarillos (tree tomatoes), peeled and cut into ¼-inch slices (optional)
Sifted powdered sugar for garnish
16 mint sprigs for garnish

SPECIAL UTENSILS:
8-inch round cake pan
Rim from a 7-inch springform pan; the rim must be at least 2 inches tall

MAKE THE CAKE:
Heat oven to 375 degrees. Butter and lightly flour the 8-inch cake pan; set aside.

For the cake batter, combine the eggs, sugar, and vanilla in a large stainless steel mixing bowl. Bring 2 inches of water to boil in a saucepan; while pan is still over high heat, place the mixing bowl over it and cook until the sugar completely dissolves and mixture is warm to the touch, whisking constantly; remove from heat. Transfer to the large bowl of an electric mixer and beat at high speed until light and holds a ribbon, about 5 minutes; reduce speed to medium and continue beating 10 minutes more.

Meanwhile, sift together the flour and cocoa. When the egg-sugar-vanilla mixture has been beaten 10 minutes, use a slotted spoon to quickly and lightly stir in the flour-cocoa mixture, ⅓ at a time, stirring just until barely blended. Lightly stir in the butter; do *not* overmix.

Pour the batter gently into the prepared pan. Bake until the top of cake springs back when lightly pressed, 30 to 35 minutes. Remove from

oven and let cool in the pan for 15 minutes, then unmold onto a platter; cover and refrigerate for at least 1 hour.

Next, slice two ½-inch-thick horizontal slices from the chilled cake with a bread knife. Cut the slices into 7-inch rounds with the 7-inch springform pan rim; wrap the cake rounds together in plastic wrap and refrigerate while making the banana mousse filling.

For the banana filling, combine ¾ cup of the cream with the 1 cup mashed bananas and the vanilla in a 2-quart pot; bring to a boil. Reduce heat and simmer until bananas are very soft, 5 to 7 minutes. Purée mixture in a blender with the sugar and rum until smooth; set aside.

In a very small saucepan, soften the gelatin in ¼ cup of the cream for about 2 minutes, then cook over high heat just until gelatin completely dissolves, about 1 minute, stirring constantly; add to the banana purée, stirring until well blended. Let cool to room temperature (do not refrigerate).

Meanwhile, whip the remaining ¾ cup cream until soft peaks form; refrigerate. Once the banana mixture is cool, add the whipped cream to it, gently folding until barely blended; set aside (do not refrigerate).

Now place the 7-inch springform rim in the center of a serving platter and carefully lay 1 of the cake rounds inside it. Pour the banana filling on top of the round without decreasing the filling's volume. Arrange the banana slices on top to form a small circle in the center of the filling with the ends of slices touching one another. Refrigerate until filling is firm, about 30 minutes.

After the cake has chilled at least 25 minutes, keep it refrigerated while preparing the chocolate mousse filling as follows: Place the chocolate pieces in a medium-size stainless steel bowl and melt over a pan of slowly simmering water, stirring occasionally; set aside.

Whip the cream until soft peaks form. Working quickly, use a rubber spatula to lightly fold about ¼ of the whipped cream into the melted chocolate just until well blended. Gently fold in the remaining whipped cream just until barely blended; do *not* overmix. Promptly pour this chocolate filling on top of the banana filling and smooth the surface; cover with the second cake round, lightly pressing it down to expel any air bubbles and make the cake of even thickness. Cover with plastic wrap and refrigerate at least 6 hours or overnight; keep refrigerated until ready to unmold and serve.

TO FINISH THE DISH AND SERVE:
(See photograph page 104.) If desired, 1 day ahead prepare the Grand Marnier Ice Cream to the point of freezing and prepare the batter for the Hazelnut Cornets; refrigerate.

On the day of serving, freeze the ice cream as directed; if needed, transfer from ice cream machine to freezer to store until ready to serve. As close to serving time as possible, finish the cornets.

To serve: First unmold the cake. To do this, heat a sharp thin-bladed knife in hot water, dry it, and carefully loosen sides of cake, then carefully remove the springform rim. Sprinkle cake generously with powdered sugar and slice into 8 wedges, reheating and drying the knife before cutting each slice. Arrange a wedge of cake to one side of each serving plate. Beside each wedge arrange a portion of the orange segments in a circular pattern; mound about 12 raspberries on top, sprinkle with powdered sugar, and garnish with a mint sprig. Fan a portion of the strawberry slices and, if using, the tamarillo slices on the plate; fill a cornet with a scoop of ice cream formed into a quenelle (oval shape) and position it next to the strawberries and tamaril-

los; garnish ice cream with a mint sprig. Serve immediately.

GRAND MARNIER ICE CREAM

1½ cups heavy cream
1 cup milk
½ cup orange juice
7 egg yolks (from large eggs)
¼ cup tightly packed pieces orange peel
¾ cup sugar
¼ cup plus 2 tablespoons Grand Marnier

SPECIAL UTENSILS:
Chinois placed over a heatproof bowl
Ice cream machine

In a heavy 3-quart nonreactive saucepan, combine the cream, milk, orange juice, and orange peel. Bring to a boil, then remove from heat, and let sit 15 minutes.

Combine the egg yolks and sugar in a large bowl, whisking vigorously until thick and pale yellow, about 2 minutes. Return the cream mixture to a boil, then remove from heat, and gradually add to the egg yolk mixture, whisking constantly. Return mixture to the saucepan and cook over medium heat, stirring constantly and scraping pan bottom evenly with a wooden spoon, just until it thickens and leaves a distinct trail on the back of the spoon when you draw a finger through it, about 2 to 3 minutes; do *not* let mixture boil. Immediately strain through the chinois into the bowl. Stir in the Grand Marnier, promptly cover, and refrigerate until well chilled, at least 3 hours or overnight.

Freeze in the ice cream machine according to manufacturer's instructions until firm, about 20 to 45 minutes, depending on the type of machine used. *Makes about 1 quart.*

HAZELNUT CORNETS

Scant ¾ cup shelled hazelnuts, dry roasted, cooled, and finely chopped with a knife
¼ cup plus 2 tablespoons sugar
¼ cup plus 2 tablespoons light or dark corn syrup
3 tablespoons unsalted butter, melted

SPECIAL UTENSIL:
Metal cornet (conical-shaped) mold, about 4 inches long and with a 1¾-inch diameter at the larger end

MAKE THE BATTER:
In a medium-size bowl, combine all the ingredients for the cornets, mixing thoroughly. Cover and refrigerate for at least 3 hours, preferably overnight. (The batter may be made up to 3 days ahead; keep refrigerated until used.)

TO FINISH THE CORNETS:
Heat oven to 400 degrees. Line a cookie sheet with parchment paper. For each cookie, place 2 rounded teaspoons of batter on the prepared cookie sheet, at least 3 inches apart. With moistened fingertips, spread each portion out to form a thin 3-inch round with no holes in it; make sure the hazelnuts are evenly distributed in the round. Bake until dark golden brown, about 9 to 11 minutes, turning pan after 5 minutes to brown the lacelike cookies evenly; watch carefully so they don't burn. Remove from oven and let cool just a few seconds until cookies can be peeled off the paper; then, while they are still pliable, work quickly to form each, 1 at a time, into a cornet. To do this, first peel the cookie off of the paper (if the cookies ran together, cut them apart before peeling) and place on a work surface, smooth side up; roll the cookie around the cornet mold to form a small ice-cream-cone shape. Let the cornet cool a few

seconds, then slip the mold out of it. Repeat with remaining cookies. If any cookies harden before being shaped into cornets, return to the hot oven a moment to soften. Handle these fragile cornets carefully and use immediately or within a few hours. If not using promptly, store in an airtight container. *Makes about 1 dozen cornets.*

CACTUS PEAR SORBET with CACTUS PEAR SAUCE, BLOOD ORANGE MOUSSE, and PASSION FRUIT SOUFFLE with PASSION FRUIT SAUCE

CACTUS PEAR SORBET with CACTUS PEAR SAUCE

Makes 1 quart sorbet and ½ cup sauce

5 cups chopped ripe cactus pear pulp and
 seeds (from about 3¼ pounds cactus pears;
 see Note)
2 cups orange juice
1 cup sugar
1 cup water
2 tablespoons gold tequila
4 mint sprigs for garnish

SPECIAL UTENSILS:
Chinois
Ice cream machine

NOTE:
 If desired, neatly cut the pears in half so that once pulp and seeds are scooped out, the skins may be used as serving bowls for the sorbet; rinse and drain the skins well before using.

 To make the fruit purée for the sorbet, place 4 cups of the cactus pear pulp and seeds in a medium-size pot; add 1½ cups of the orange juice and the sugar and water. Bring to a boil over high heat, then strongly simmer for 15 minutes, skimming foam and stirring occasionally. Remove from heat and let cool to room temperature. Purée in a blender until smooth. Strain purée through the chinois into a bowl, then stir in the tequila. Cover and refrigerate until well chilled, at least 3 hours or overnight.
 Meanwhile, make the sauce as follows: Combine the remaining 1 cup cactus pear pulp and seeds and remaining ½ cup orange juice in a small pot. Bring to a boil over high heat, then strongly simmer for 15 minutes, skimming foam and stirring occasionally. Remove from heat and let cool to room temperature. Purée in a blender until smooth and strain through the chinois. Refrigerate until ready to serve.
 On the day of serving, freeze the purée for the sorbet in the ice cream machine according to manufacturer's instructions until firm, about 20 to 45 minutes, depending on the type of machine used. Next, transfer sorbet to a freezer container and freeze about 1 hour to harden further. Serve immediately (or leave in freezer and serve within a few hours).

TO SERVE:
 (See photograph page 105.) Form the sorbet into quenelles (oval shapes) or small scoops and place in chilled serving bowls or in the cactus pear shells arranged on dessert plates. Top each serving with some of the sauce and garnish with a mint sprig.

BLOOD ORANGE MOUSSE

Makes 4 servings

2 cups blood orange juice, strained (from
 about 3¼ pounds blood oranges)
3 tablespoons sugar

1¾ teaspoons unflavored gelatin
⅔ cup heavy cream
3 blood oranges, peeled, seeded, and
 separated into segments without
 membranes for garnish
4 mint sprigs for garnish

SPECIAL UTENSILS:
4 (½-cup-capacity) plastic molds, inside top
 diameter 2¾ inches, outside base diameter
 2 inches, 1⅛ inches deep

 Combine the orange juice and sugar in a small pot, stirring until sugar dissolves. Cook over high heat until reduced to 1 cup, 20 to 25 minutes. Remove from heat. Pour ⅓ cup of the hot syrup into a glass measuring cup; add to the cup ¼ teaspoon of the gelatin, stirring until completely dissolved. Pour equal amounts of this aspic into the ungreased molds, using it all; refrigerate until firm, about 15 minutes. Set aside remaining syrup.
 Meanwhile, whip the cream in a medium-size bowl just until fairly stiff peaks form; refrigerate. Next, add the remaining 1½ teaspoons gelatin to the reserved syrup; let gelatin soften about 2 minutes. Return mixture to high heat and cook just a few seconds until gelatin completely dissolves, stirring constantly. Cool to room temperature, then gradually add to the whipped cream, gently folding until barely blended; do *not* overmix.
 Once the aspic in the molds is firm, spoon equal portions of the whipped cream mixture into them. Refrigerate at least 6 hours before unmolding.
 To serve: (See photograph page 105.) Unmold the mousses as follows: Fill a deep pan with about 1½ inches of boiling water. Place the molds in the pan and let sit for precisely 45 seconds, then remove from the hot water. Loosen sides carefully with a thin flexible-bladed knife and invert each mousse onto a dessert plate; garnish edges with the orange segments and a mint sprig. Serve immediately.

PASSION FRUIT SOUFFLE with PASSION FRUIT SAUCE

Makes 4 servings

18 ounces ripe (wrinkled-skinned) passion
 fruits (about 14)
About 7 tablespoons plus 1 teaspoon sugar
2 tablespoons unsalted butter, melted
2 egg yolks (from large eggs)
⅓ cup egg whites (from about 3 large eggs),
 at room temperature
⅛ teaspoon lemon juice
Sifted powdered sugar

SPECIAL UTENSILS:
Chinois
4 (¾-cup capacity) individual, straight-sided
 soufflé dishes, inside diameter 3 inches,
 1⅝ inches deep
Heavy baking pan large enough to hold
 soufflé dishes with at least 1 inch between
 dishes and sides of pan

 For the sauce, cut 9 ounces of the fruit in half and squeeze the pulp and juices into the bowl of a blender; process about 15 seconds to help separate the seeds from the pulp. Strain through the chinois, using the bottom of a sturdy ladle to force as much through as possible; the strained sauce should yield about ¼ cup. Add 1 tablespoon of the sugar, stirring until dissolved. Cover and refrigerate until serving time. (This may be done several hours ahead.)
 For the soufflés, heat oven to 425 degrees. Use a pastry brush to very generously butter the soufflé dishes, including rims, with the melted

butter. Coat each dish evenly with about 1 teaspoon sugar. Refrigerate until ready to use.
 Cut the remaining 9 ounces passion fruit in half and squeeze pulp and juices into the blender bowl; process about 15 seconds, then strain through the chinois into a medium-size bowl, using the bottom of a sturdy ladle to force as much through as possible. Add the egg yolks and 2 tablespoons of the sugar to the bowl, whisking until thoroughly blended and frothy. Set aside.
 Place 1 inch of water in the heavy baking pan and bring to a boil on the stove. Meanwhile, in the medium-size bowl of an electric mixer (make sure bowl is very clean), combine the egg whites and lemon juice; beat at low speed for about 30 seconds. Increase speed to medium and beat about 30 seconds until frothy bubbles begin to form, then add 2 tablespoons of the sugar and beat at medium for 30 seconds more. Increase speed to high, add 1 tablespoon more sugar, and continue beating just until stiff peaks form, about 1 minute more.
 Lightly fold about ¼ of the egg white mixture into the passion fruit mixture just until barely blended, then lightly fold in remaining egg whites; do *not* overmix. Gently spoon batter into the prepared soufflé dishes. Run your thumb around the top edge of each dish to form a groove about ¼ inch wide and deep between the dish and the soufflé batter. Place dishes in the pan of boiling water and cook for 4 minutes, keeping the water strongly simmering; then quickly transfer pan, uncovered, to the preheated oven and bake until soufflés are cooked through, puffed, and browned on top, 12 to 14 minutes. Meanwhile, place sauce in a small sauceboat for serving at the table. Remove cooked soufflés from oven and promptly serve on dessert plates, sprinkled with powdered sugar. (See photograph page 105.)

TERRINE OF SMOKED SALMON, SPINACH, AND ANCHOVY BUTTER

Makes 22 (½-inch slices or 1 (11 x 3¼ x 2½-inch) terrine

Salt water (¼ cup coarse salt mixed with 3
 quarts water) for cooking spinach
2 pounds fresh spinach (very large flat
 leaves), washed thoroughly and stems
 trimmed
Ice water for cooling cooked spinach
¾ pound (3 sticks) unsalted butter, softened
25 large anchovy fillets (canned and packed
 in oil), drained (about 2 ounces drained)
2 pounds 6 ounces smoked fillet of salmon,
 cut into paper-thin slices
1 medium-size red or green tomato, peeled,
 seeded, and finely julienned for garnish
 (optional)
1 recipe Herb Vinaigrette (see recipe for Herb
 Ravioli and Smoked Tuna, page 207) for
 garnish (optional)
Dill sprigs or the herb in the Vinaigrette for
 garnish (optional)

SPECIAL UTENSILS:
Pâté terrine mold, 5-cup capacity, inside
 dimensions 11 inches long, 3¼ inches
 wide, and 2½ inches deep
2 pieces of fairly sturdy cardboard cut to just
 fit inside the top of the terrine mold,
 stacked and sealed together with foil to
 form 1 sturdy piece
5 to 7 pounds of weights (1 brick plus another
 ¼ brick work well for this; scrub bricks
 clean and seal in aluminum foil)

 To prepare the spinach leaves, bring the salt water to a rolling boil in a large nonreactive pot. Add the spinach and cook just until tender, about 1 minute. Immediately drain and cool in the ice water. Drain leaves, unfolded and in single layers, on paper towels or dishtowels. Blot with more towels to dry thoroughly. Set aside or, if prepared ahead, wrap in paper towels and refrigerate. (This may be done several hours ahead.)
 To prepare the anchovy butter, process the butter with the anchovies in a food processor until smooth and creamy; the mixture may be fairly runny. Transfer to a small bowl. (This may be made several hours ahead and kept refrigerated; return to a soft spreading consistency before using.)
 To assemble the terrine, first use a pastry brush to brush the sides and bottom of the terrine mold generously with some of the anchovy butter. Line the bottom of the mold with a single layer of salmon slices, without overlapping them; as you form each layer of salmon, trim away any dark or dry areas and trim slices to just fit the mold. Brush the salmon layer lightly and evenly with some of the anchovy butter, then arrange a single layer of spinach leaves on top (it's okay if the spinach leaves overlap a little). Next, lightly brush leaves with some of the anchovy butter; if needed, hold leaves in place while you brush and use your fingertips to smooth butter evenly. Continue layering with salmon, then anchovy butter, then spinach, then more anchovy butter, until all the salmon and spinach are used. (You will have ¼ to ½ cup anchovy butter left over, which is excellent used as a spread for brioche toast.) Press down each layer lightly as you work to remove air pockets and make the finished terrine of uniform thickness.
 Once assembled, place mold on a small cookie sheet and cover well with plastic wrap. Position the foil-covered cardboard on top to rest directly

on the food, then distribute weights evenly over cardboard. Refrigerate overnight.

TO SERVE:

(See photograph page 108.) At least 2 hours before serving, unmold the terrine. To do this, remove weights, cardboard, and plastic wrap. Place mold in a deep pan large enough to have room to spare between the mold and pan sides. Fill pan with 1 inch of boiling water and let sit for precisely 1 minute; remove mold from hot water and carefully loosen sides with a thin flexible-bladed knife. Invert onto a cookie sheet lined with parchment or waxed paper, a cutting board suitable for refrigerating, or a serving platter if you wish to present the terrine to your guests before slicing it. If the terrine doesn't immediately slip out of the mold, loosen sides again or soundly tap mold, right side up, once or twice on a solid surface; invert again, and it should slip out easily. Refrigerate until just before ready to present unsliced to your guests or until ready to slice; for best results, slice while still well chilled so terrine is as firm as possible, then serve immediately.

If serving as a first course or main course, heat a sharp thin-bladed knife in hot water, wipe dry, and carefully cut terrine crosswise into ½-inch slices; reheat and dry knife before cutting each slice. Place 1 slice on each chilled serving plate; if desired, garnish with a portion of the julienne tomatoes, about 1 tablespoon of the vinaigrette, and dill or other herb sprigs.

If serving as a canapé, cut terrine into ¼-inch slices, then cut each slice in half. Serve on sliced brioche trimmed to the size of the terrine slices. Refrigerate leftovers.

SALAD OF MOREL MUSHROOMS STUFFED WITH LOUISIANA CRAWFISH ON FRESH HEARTS OF PALM, ENOKI MUSHROOMS, ASPARAGUS, AND BELL PEPPERS with CRAWFISH VINAIGRETTE and HERB VINAIGRETTE

Makes 4 servings

28 active live crawfish, as large as possible (Louisiana preferred; about 1½ pounds)
8 asparagus spears
½ well-formed medium-size red bell pepper, cored and cut in half crosswise
½ well-formed medium-size yellow bell pepper, cored and cut in half crosswise
Salt water (2 tablespoons coarse salt mixed with 6 cups water) for cooking asparagus and bell peppers
Ice water for cooling cooked asparagus and bell peppers
2 tablespoons extra-virgin olive oil
24 morel mushrooms (fresh preferred; about 4 ounces fresh or 2 ounces dried; do *not* eat raw; see Note)
Fine sea salt and freshly ground black pepper
1 recipe Herb Vinaigrette (see recipe for Herb Ravioli and Smoked Tuna, page 207)
Crawfish Vinaigrette (recipe follows)
6 cups loosely packed mesclun or other small tender salad greens such as radicchio, mache (lamb's lettuce, corn salad), or *frisée* (curly endive)
3½ ounces fresh enoki mushrooms, bottom 1 inch of stems trimmed away
3 ounces finely sliced fresh hearts of palm (about ½ cup, tightly packed) (preferred) or three 3-inch-long top-quality canned or jarred hearts of palm, cut crosswise into ⅛-inch slices; tossed with 2 tablespoons lemon juice to prevent discoloration

SPECIAL UTENSIL:
Steamer

NOTE:

If using fresh morels, wash them quickly under cool running water, then trim ends of stems. If using dried morels, reconstitute them by soaking in a large bowl of cool water for 30 minutes; drain and gently squeeze completely dry before using.

PREPARE THE CRAWFISH:

In a covered steamer over rapidly boiling water, steam the crawfish until shells turn bright red, about 5 minutes; do *not* overcook. Immediately transfer to a large bowl. When cool enough to handle, set aside 4 of the most attractive crawfish for garnishing the serving plates. Peel the remaining crawfish as follows: First separate each head section from the tail by gently twisting the head section off; reserve heads for the Crawfish Vinaigrette.

From each tail, peel away the first 2 or 3 rings of shell surrounding the meat, then squeeze the base of the tail with two fingers of one hand while gently pulling the tail meat out of the remaining shell with the other hand, releasing the tail meat in 1 piece; reserve shells with the heads for the Crawfish Vinaigrette. If needed, trim thick ends of tails with a paring knife to make them look neat. Cover the peeled tails and the 4 whole crawfish separately; refrigerate. Refrigerate heads and shells until ready to make the Crawfish Vinaigrette. (This may be done several hours ahead.)

PREPARE THE ASPARAGUS AND BELL PEPPERS:

Trim the asparagus to form 2½-inch tips; use trimmings in another recipe. Set aside.

Working with 1 piece of red and yellow bell pepper at a time, place the piece skin down on a cutting board and very carefully trim away the skin with a sharp thin-bladed knife, slicing horizontally as close to the skin as possible. Next, cut the pulp into 2 x ⅛ x ⅛-inch julienne strips; set aside.

Bring the salt water to a rolling boil in a medium-size nonreactive pot. Add the asparagus and cook just until tender, about 4 minutes. Immediately transfer to the ice water to cool, reserving salt water; drain on paper towels, reserving ice water. Return salt water to a boil. Add the red and yellow bell peppers and cook for 1 minute; drain and cool in the ice water. Drain on paper towels. Cover asparagus and bell peppers separately and refrigerate. (This may be done several hours ahead.)

PREPARE THE CRAWFISH-STUFFED MORELS:

In a large skillet (preferably nonstick), heat the oil over high heat, about 2 minutes. Add the morels and sauté for 1 minute, stirring occasionally. Reduce heat to medium, season with salt and pepper, and continue cooking and stirring 5 minutes more. Drain on paper towels.

Once cool enough to handle, enlarge the opening at the stem end of each morel if needed and insert the thicker end of a crawfish into each. Place in a single layer on a baking sheet lined with parchment paper; refrigerate. (This may be done several hours ahead.)

Now prepare the Herb Vinaigrette; refrigerate.

TO FINISH THE DISH AND SERVE:

(See photograph pages 110-111.) Heat oven to 375 degrees. First, prepare the Crawfish Vinaigrette; set aside at room temperature (do not refrigerate).

Next, place the salad greens in a large mixing bowl; whisk the Herb Vinaigrette briefly and toss the greens with ¼ cup of it. To one side of each of 4 large serving plates, arrange a bed of the tossed greens upon which the enokis will rest, using about ⅔ of the greens for this; beside each arrangement of greens, form a smaller bed of greens (use them all) and place 1 whole crawfish on top.

In the same mixing bowl, toss the enokis with 1 tablespoon of the remaining Herb Vinaigrette and arrange a portion on each larger bed of salad greens. In the same bowl, gently toss the asparagus and bell peppers with 2 tablespoons more Herb Vinaigrette and arrange on the plates opposite the whole crawfish. Next, toss the hearts of palm slices with 2 tablespoons more Herb Vinaigrette; arrange ¼ of the slices on each plate opposite the enokis.

Now brush the crawfish-stuffed morels with some of the remaining Herb Vinaigrette; transfer baking sheet, uncovered, to the preheated oven and heat for 3 minutes. Remove from oven and arrange a portion of the morels on top of each serving of hearts of palm, then spoon ¼ of the Crawfish Vinaigrette around the edges. Serve immediately.

CRAWFISH VINAIGRETTE

½ pound (2 sticks) unsalted butter
Reserved crawfish heads and shells
About 2 tablespoons Lobster Consommé (page 214) (preferred), or Meat or Vegetable Consommé (page 214)
1 tablespoon sherry wine vinegar
1 tablespoon extra-virgin olive oil
Fine sea salt and freshly ground black pepper

SPECIAL UTENSILS:
Very fine mesh strainer
Chinois

Place the butter in a large skillet (preferably nonstick) and add the crawfish heads and shells. Cook over high heat until butter melts, stirring constantly. Reduce heat to medium and continue cooking 3 minutes more, stirring occasionally. Let cool to room temperature.

Process the mixture in a food processor until all shells are reduced to tiny bits. Strain through the strainer into a medium-size bowl, using the bottom of a sturdy ladle to force as much through as possible; the strained mixture should yield about ⅓ cup. Whisk in 2 tablespoons of the consommé and the vinegar and oil, then season to taste with salt and pepper. If the vinaigrette separates, place the bowl over a pot of boiling water and whisk vigorously until smooth. Strain vinaigrette through the chinois and, if needed, thin with more consommé. Set aside at room temperature until ready to use. *Makes a generous ⅓ cup.*

STEAMED MAINE LOBSTER AND ZUCCHINI with SMELT ROE SAUCE

Makes 4 servings

¼ pound (1 stick) unsalted butter, softened
¼ cup plus 1 teaspoon smelt roe (2 ounces)
4 (1- to 1½-pound) active live Maine lobsters
¾ pound medium-size zucchini with perfect skins
Salt water (¼ cup coarse salt mixed with 3 quarts water) for blanching strips of zucchini peeling and zucchini slices
Ice water for cooling blanched strips of zucchini peeling and zucchini slices
Fine sea salt and freshly ground pepper
2 tablespoons Lobster Consommé (page 214) (preferred), Lobster Stock (page 214), or other Consommé or Stock (page 214)
1 teaspoon smelt roe for garnish (optional)
Fresh cilantro leaves or dill sprigs for garnish (optional)

4 lobster heads (from the lobsters called for above) for garnish (optional); cleaned out, rinsed, and drained well, bases trimmed so heads can stand upright

SPECIAL UTENSILS:
Steamer or stockpot fitted with a deep basket
4 metal or wood skewers for steaming lobster tails; the skewers should be longer than the lobster tails but short enough to fit into the steamer with the basket and lid in place
Lemon stripper or lemon zester with a stripper hole

START THE SAUCE:

Process the butter with the ¼ cup plus 1 teaspoon smelt roe in a food processor until creamy. Cover smelt roe butter and refrigerate until firm, at least 1 hour or overnight.

STEAM THE LOBSTERS:

Steam lobsters as directed in Miniature Pumpkins Stuffed with Steamed Maine Lobster, page 182, through the point of refrigerating steamed claw and skewered tail meat. (This may be done several hours ahead. The lobster heads and shells may be saved, frozen if desired, for making Lobster Cream Base Sauce, page 215, or Lobster Stock, page 214.)

PREPARE THE ZUCCHINI:

With the stripping utensil, peel off lengthwise parallel strips of zucchini skin from each zucchini at about ¼-inch intervals; you will need 7 or 8 strips of peeling for garnishing each plate. Next, cut the same zucchini crosswise into ⅛-inch slices; you will need about 17 slices for each plate (about 68 slices total).

Bring the salt water to a rolling boil in a large pot. Add the strips of zucchini peeling and cook just until tender, 1 to 2 minutes. Immediately transfer strips to the ice water with a slotted spoon, keeping salt water boiling. Add the zucchini slices to the boiling water and cook just until tender, about 2 minutes; do *not* overcook. Immediately drain slices and cool in the ice water with the strips. Drain well. Set aside or cover and refrigerate if made ahead. (This may be done several hours ahead.)

ASSEMBLE THE PLATES:

(See photograph page 112.) Remove lobster meat from refrigerator and withdraw skewers from tails. From the thicker end of each tail cut 10 to 15 diagonal slices, leaving the last 1½ inches of the thinner end in 1 piece.

Place 1 or 2 lobster tail meat slices (don't use the 1½-inch pieces) and zucchini slices in the center of each of 4 ovenproof serving plates; then make a large circular pattern, alternating slices of the remaining lobster tail meat (except the 1½-inch pieces) and zucchini slices; arrange the strips of zucchini peeling on top in a criss-cross pattern and season with salt and pepper; place lobster claws opposite one another at the top of the plate and the 1½-inch piece of tail meat at the bottom. Cover plates with aluminum foil. (The plates may be assembled to this point up to 3 hours ahead and kept refrigerated; return to room temperature before heating in the oven.)

TO SERVE:

Heat the covered serving plates in a preheated 350 degree oven for 10 minutes.

Meanwhile, finish the sauce by combining the reserved chilled smelt roe butter with the consommé in a small heavy saucepan. Heat over high heat just until hot, whisking constantly; do not overheat, or the smelt roe will curdle and turn white. Remove from heat and season to taste with salt and pepper.

Unwrap heated serving plates and spoon about 2 tablespoons sauce around the edges of

each. If desired, garnish plates with the 1 teaspoon smelt roe and cilantro leaves or dill sprigs, and arrange a lobster head upright on each plate. Serve immediately.

SAUTEED FOIE GRAS with RHUBARB PUREE and RHUBARB SAUCE

Makes 4 servings

RHUBARB SAUCE:
⅓ cup sugar
1½ cups chopped rhubarb (from about 9 ounces trimmed stalks)
1 cup Meat or Vegetable Consommé (page 214) (preferred), or Meat or Vegetable Stock (page 214)
¼ cup unpeeled chopped carrots
2 tablespoons chopped celery
2 tablespoons chopped leeks (mostly white part)
2 tablespoons chopped onions
2 tablespoons unpeeled chopped turnips
1 tablespoon chopped shallots
1 cup *Fond de Veau* (page 214)
12½ ounces trimmed rhubarb stalks (about seven 5½-inch-long trimmed stalks)
2 quarts water
¼ cup plus 2 tablespoons sugar
1 whole fresh uncooked duck or goose foie gras (Grade A; about 1 pound)
Fine sea salt and freshly ground black pepper

SPECIAL UTENSILS:
Chinois
Fine mesh strainer

MAKE THE SAUCE:
Place the sugar in a heavy 4-quart saucepan and cook over high heat until a rich caramel color, 3 to 4 minutes, stirring almost constantly with a wooden spoon; be careful not to let it burn. Add the rhubarb, stirring just until all pieces are well coated, then promptly add the consommé, carrots, celery, leeks, onions, turnips, and shallots; cook until mixture reduces to about 1 cup, about 20 minutes, stirring occasionally. Add the *Fond de Veau* and bring to a boil. Reduce heat and simmer about 7 minutes, stirring occasionally. Remove from heat and strain through the chinois, using the bottom of a sturdy ladle to force as much through as possible. Return sauce to the saucepan and cook over medium heat until reduced to ½ cup, about 15 minutes. Set aside. (This may be done up to 2 days ahead; keep refrigerated.)

PREPARE THE SLICED RHUBARB GARNISH AND RHUBARB PUREE:
For the garnish, cut just enough of the rhubarb stalks into ⅛-inch slices to yield about 17 slices for arranging in a large circle on each of 4 ovenproof serving plates (see photograph page 113; the number of slices needed will depend on the size of your plates). Set remaining rhubarb stalks aside. Combine the 2 quarts water with ¼ cup of the sugar in a medium-size nonreactive pot and bring to a boil. Add the rhubarb slices and cook over medium heat until tender, about 1 minute. Drain slices on paper towels and arrange a portion of them in a large circle on each serving plate. Cover plates with plastic wrap or aluminum foil; set side. (The plates may be prepared to this point up to 4 hours ahead; if not serving dish within 1 hour, refrigerate.)

For the purée, chop just enough of the remaining rhubarb stalks to yield 1½ cups. Place chopped rhubarb in a small heavy nonreactive saucepan with the remaining 2 tablespoons sugar; cook over low heat until mushy, about 30 minutes, stirring occasionally. (Note: Be sure to cook slowly, or the rhubarb will turn white.) Remove from heat and strain through the fine

mesh strainer into a small bowl, using the bottom of a sturdy ladle to force as much through as possible; the strained purée should yield about ¼ cup. Set aside. (This may be done up to 4 hours ahead; refrigerate if prepared more than 1 hour in advance.)

TO FINISH THE DISH AND SERVE:
Heat oven to 300 degrees. If serving plates were refrigerated, return to room temperature. Next, unwrap and mound ¼ of the rhubarb purée in the center of each; set aside.

With a sharp thin-bladed knife, carefully trim away any green spots on the foie gras caused by contact with the gall bladder. Cut the foie gras crosswise into 1-inch-thick slices on the diagonal; be sure to cut slices uniformly thick. Season lightly on both sides with salt and pepper; set aside.

Heat a very large (empty) nonstick skillet over high heat until very hot, 5 to 7 minutes. Meanwhile, start reheating sauce over very low heat, stirring occasionally.

Once the skillet is hot, place the uncovered serving plates in the preheated oven to be heating for about 4 minutes while you sauté the foie gras, then immediately add the foie gras slices in a single layer to the hot skillet and sauté just until browned and done, 1½ to 2 minutes on each side; do *not* overcook, or the foie gras will dry out and loose its unique buttery texture. (Remove skillet from heat momentarily or reduce heat if you are concerned that foie gras will burn on the outside before the inside cooks. To test doneness, pierce a slice with a thin wood or metal skewer to its center and withdraw skewer, then press very gently around skewer hole; if after a few seconds the juices from the hole run slightly pink, not clear and not bloody, it's done.) Drain on paper towels and blot with more towels.

Once the serving plates have heated for about 4 minutes, remove from oven. Arrange a slice of the foie gras on top of each serving of purée and spoon 1 to 2 tablespoons sauce over it. Serve immediately.

NAGE OF VENUS CLAMS with TOMATO ROUNDS, JULIENNE VEGETABLES, and WARM BASIL VINAIGRETTE

Makes 4 servings

Warm Basil Vinaigrette (recipe follows)
10 pounds live clams with tightly closed shells (Venus preferred)
2 cups Chardonnay wine
4 tablespoons unsalted butter
3 tablespoons very finely chopped shallots
9 parsley sprigs
½ teaspoon whole black peppercorns
Salt water (1 tablespoon coarse salt mixed with 3 cups water) for cooking julienne vegetables
⅓ cup peeled and julienned carrots (2 x ⅛-inch strips)
⅓ cup scraped and julienned celery (2 x ⅛-inch strips)
⅓ cup julienne leeks (2 x ⅛-inch strips; mostly white part)
Ice water for cooling cooked julienne vegetables
3 large vine-ripened tomatoes, peeled and quartered (about 1½ pounds)
36 tiny fresh basil leaves for garnish (optional)
4 small basil sprigs for garnish (optional)
Lobster Coral Garnish (page 215) (optional)

SPECIAL UTENSIL:
1⅝-inch cookie cutter

Make the Parsley Purée and basil butter for the Warm Basil Vinaigrette; refrigerate.

COOK THE CLAMS:
Rinse the clams under cool running water, scrubbing shells clean with a vegetable brush; drain well. In an 8-quart or larger pot, combine the wine, butter, shallots, parsley sprigs, and peppercorns; bring to a boil over high heat. Add the clams, cover, and cook just until shells open, about 6 minutes. Remove from heat. Transfer clams to a plate and strain the cooking liquid. Reserve 6 tablespoons of the liquid, refrigerated, for the vinaigrette. Remove the clams from their shells; cool slightly and refrigerate. (This may be done several hours ahead.)

COOK THE JULIENNE VEGETABLES:
Bring the salt water to a rolling boil in a medium-size pot. Add the carrots and 30 seconds later add the celery and leeks; cook until tender, about 1½ minutes. Immediately drain and cool in the ice water; drain on paper towels. Refrigerate. (This may be done several hours ahead.)

TO FINISH THE DISH AND SERVE:
(See photograph page 114.) About 1 hour before serving, prepare the tomato rounds as follows: Place the quartered tomatoes skinned side down on a work surface. With a sharp thin-bladed knife, slice off and discard the top soft portion of each, leaving a ¼-inch-thick slice of firm tomato pulp. Cut out as many rounds as possible from the slices with the cookie cutter, then carefully slice each round in half horizontally to form two ⅛-inch-thick rounds. Select the prettiest 36 rounds and set aside 4 of them for garnishing centers of the serving plates at the last minute. Arrange ¼ of the remaining rounds in a large circle on each of 4 serving plates. Cover plates with plastic wrap and set aside.

Next, if desired, remove clams and julienne vegetables from the refrigerator to let them return to room temperature. Now finish the Warm Basil Vinaigrette; set aside.

When ready to serve, unwrap the serving plates and mound a portion of the julienne vegetables in the center of each; arrange a portion of the clams around the edges of the vegetables and, if desired, garnish tomato rounds with tiny basil leaves. If needed, warm the vinaigrette over low heat (do not let it boil, or it will turn brown), then spoon about 2 tablespoons over each serving of vegetables; garnish center of plate with 1 of the reserved tomato rounds and add a basil sprig and a light sprinkle of Lobster Coral Garnish, if desired. Serve immediately.

WARM BASIL VINAIGRETTE

1 teaspoon Parsley Purée (page 215)
Salt water (1 tablespoon coarse salt mixed with 3 cups water) for cooking the 1 ounce basil leaves
1 ounce fresh basil leaves
Ice water for cooling cooked basil leaves
4 tablespoons unsalted butter, softened
1 teaspoon sherry wine vinegar
Fine sea salt and freshly ground black pepper
6 tablespoons reserved clam cooking liquid
2 tablespoons extra-virgin olive oil
5 large fresh basil leaves

Prepare the Parsley Purée; refrigerate. Prepare the basil butter as follows: Bring the salt water to a rolling boil in a small nonreactive pot. Add the 1 ounce basil leaves and cook for 2 minutes. Immediately drain and cool in the ice water. Drain again and squeeze dry. Process leaves in a food processor with the butter until all leaves are minced and butter is very creamy

and evenly green. Cover basil butter and refrigerate until firm, at least 1 hour or overnight.

To finish the vinaigrette, combine the vinegar, ¼ teaspoon of the salt, and a generous amount of pepper in a small heavy saucepan. Heat over medium heat just a few seconds until the salt completely dissolves, whisking constantly. Remove from heat and add the reserved chilled basil butter and 1 tablespoon of the clam cooking liquid. Return to medium heat and cook until butter melts, whisking almost constantly. Transfer to a blender and process with the oil, the 5 large uncooked basil leaves, the remaining 5 tablespoons clam cooking liquid, and the Parsley Purée until very smooth. Taste for seasoning. *Makes ¾ cup.*

ROASTED RABBIT TENDERLOINS with SAUPIQUET, FAVA BEANS, and THYME SAUCE

Makes 4 servings

SAUCE:
¼ cup unpeeled chopped carrots
2 tablespoons chopped celery
2 tablespoons chopped leeks (mostly white part)
2 tablespoons chopped onions
2 tablespoons unpeeled chopped turnips
1 tablespoon chopped shallots
½ ounce thyme sprigs, plus 10 very leafy sprigs for infusing sauce once made
1 cup Meat or Vegetable Consommé (page 214) (preferred) or Meat or Vegetable Stock (page 214)
1 cup *Fond de Veau* (page 214)
FAVA BEANS:
3 pounds fresh unshelled fava beans
Salt water (2 tablespoons coarse salt mixed with 6 cups water) for blanching fava beans
Ice water for cooling blanched fava beans
4 tablespoons unsalted butter
Fine sea salt and freshly ground black pepper
SAUPIQUET:
2 teaspoons vegetable oil
2 tablespoons very finely chopped shallots
1 tablespoon finely sliced spring (green) onion tops
1 teaspoon fresh thyme leaves
½ cup (about 4 ounces) rabbit or poultry livers (see Note)
Fine sea salt and freshly ground black pepper
1 tablespoon plus 1 teaspoon Vosne-Romanée 1972 vinegar, balsamic vinegar, or sherry wine vinegar
RABBIT TENDERLOINS:
4 (1-pound) saddles of rabbit (see Note)
Fine sea salt and freshly ground black pepper
½ ounce thyme sprigs
3 tablespoons vegetable oil
Thyme sprigs for garnish (optional)

SPECIAL UTENSILS:
Chinois
Fine mesh strainer

NOTE:
When purchasing the rabbits for this recipe, have your butcher include the livers for the *saupiquet*. Also have the butcher leave each rabbit's stomach flaps attached for holding the thyme sprigs inside the cavities while the rabbits cook.

MAKE THE SAUCE:
In a small bowl, combine the carrots, celery, leeks, onions, turnips, shallots, and the ½ ounce thyme sprigs. Heat a heavy 3-quart saucepan over high heat for about 1 minute, then add the

vegetable mixture. Reduce heat to medium and cook for 3 minutes, stirring occasionally. Add the consommé and cook until liquid reduces to ½ cup, 15 to 20 minutes. Add the *Fond de Veau* and continue cooking until liquid is a thin sauce consistency, 10 to 15 minutes more, stirring occasionally. Strain sauce through the chinois, using the bottom of a sturdy ladle to force as much through as possible; it should yield ⅔ to 1 cup. Add the 10 thyme sprigs to the sauce; refrigerate.

PREPARE THE FAVA BEANS FOR SAUTEING:

Shell the fava beans. Bring the salt water to a rolling boil in a medium-size pot. Add the shelled beans and blanch for 4 minutes. Immediately drain and cool in the ice water; drain again. Remove the thin outer membrane from each bean by cutting a shallow slit in it with a paring knife, then peel or rub membrane off. Set aside. (Refrigerate if prepared more than 1 hour ahead.)

MAKE THE *SAUPIQUET:*

In a small nonstick skillet, heat the oil over high heat for 1 minute. Add the shallots, spring onions, and thyme leaves; sauté for 1 minute, stirring frequently. Add the livers and season with salt and pepper; reduce heat to low and sauté until centers of livers are only slightly pink, 5 to 7 minutes, stirring occasionally. Add the vinegar and continue cooking just 30 seconds more, stirring constantly. Purée mixture in a blender, then strain purée through the strainer, using the bottom of a sturdy ladle to force as much through as possible. Cover and refrigerate if not using almost immediately. (This may be made several hours ahead.)

TO FINISH THE DISH AND SERVE:

(See photograph page 115.) Heat oven to 400 degrees. For the rabbit tenderloins, score each saddle of rabbit about 6 times along each side of the backbone; make cuts about ⅛ inch deep, 1 inch long, and 1 inch apart. Season all surfaces with salt and pepper. Separate thyme sprigs into 4 equal portions, then place each saddle breast up, open the stomach flaps, and spread a portion of thyme sprigs inside cavity; fold stomach flaps over to completely enclose sprigs.

Heat an ungreased heavy roasting pan in the preheated oven for about 10 minutes. Meanwhile, in a very large skillet (preferably nonstick), heat 2 tablespoons of the oil over high heat until very hot, 4 to 5 minutes. Add 2 of the rabbits, breast up, to the hot skillet and cook until undersides are well browned, about 2 minutes. Turn and brown the other sides, about 1 minute more, then transfer rabbits, breast down, to the heated roasting pan and set pan aside on stove; leave oven at 400 degrees.

Add the remaining 1 tablespoon oil to the hot skillet and repeat to brown the remaining 2 rabbits, then place them breast down in the roasting pan. Bake uncovered in the 400 degree oven for 15 minutes, then remove pan momentarily from oven. Cutting as close to the bone as possible, make a deep slit along the length of each rabbit's backbone on both sides to separate the tenderloin (the strip of meat on either side of the backbone) from the bone so the meat will cook evenly. Return pan to oven and continue baking just until tenderloins are done, about 6 minutes more. Do *not* overcook, or the meat will be dry; keep in mind that it will cook a little more when reheated. To test doneness, cut 1 of the tenderloins open; if done, the center will be very moist and white, not pink. Remove from oven, leaving oven set at 400 degrees.

Transfer rabbits to a cutting board and cover loosely; let sit about 10 minutes, then carve the tenderloins from each carcass and cut meat

crosswise on the diagonal into ½-inch slices. If desired, also cut off the stomach flaps and julienne into matchstick strips for garnishing the plates. (Save carcasses, if desired, for making stock.) Serve immediately.

To serve: Gently warm *saupiquet* if needed, then spoon ¼ of it down the center of each of 4 ovenproof serving plates, forming a narrow mound about 4 inches long; cover *saupiquet* with a portion of the rabbit tenderloin slices and, if using, the julienne rabbit. Transfer plates, uncovered, to the preheated oven and bake just until rabbit is heated, 3 to 4 minutes.

Meanwhile, sauté the fava beans in the butter and season to taste with salt and pepper. Reheat sauce, then remove and discard thyme sprigs in it.

Once the serving plates are out of the oven, add a portion of fava beans and spoon about 2 tablespoons sauce around the edges of the rabbit. Garnish with thyme sprigs, if desired.

CHOCOLATE PASTA with MOCHA SAUCE and WHITE CHOCOLATE CURLS

Makes 4 dessert servings

CHOCOLATE NOODLES:
¼ cup unsweetened cocoa powder
2 tablespoons plus 1 teaspoon water
1 large egg
1 teaspoon vegetable oil
½ cup plus 1 tablespoon finely ground semolina flour
2 tablespoons sugar
6 to 7 tablespoons all-purpose flour, plus additional flour for rolling out dough
MOCHA SAUCE:
1 cup heavy cream
1 cup milk
¼ cup freshly ground espresso coffee beans (very finely ground) or ¼ cup instant espresso coffee powder for an even smoother sauce
3 tablespoons unsweetened cocoa powder
6 egg yolks (from large eggs)
½ cup sugar
4 quarts water for cooking noodles
1 tablespoon vegetable oil for cooking noodles
3 ounces white chocolate curls or shavings for garnish
Small fresh mint leaves for garnish (optional)
Sifted unsweetened cocoa powder for garnish (optional)

SPECIAL UTENSILS:
Pasta machine with a linguini attachment
Chinois

MAKE THE NOODLES:

In a small bowl, dissolve the cocoa in the water; set aside. In the medium-size bowl of an electric mixer fitted with a paddle, combine the egg, oil, semolina, and sugar. Beat mixture at medium speed until elastic, about 2 minutes. Add the dissolved cocoa and 6 tablespoons of the all-purpose flour and continue beating at medium until well blended, 1 to 2 minutes more; then, if dough is still very sticky, beat in up to 1 tablespoon more all-purpose flour, 1 teaspoon at a time. Form dough into a ball and wrap in plastic wrap; let rest for 1 hour.

Cut the dough into 2 equal portions; rewrap 1 portion and set aside. Lightly flour the remaining portion with all-purpose flour and roll through the pasta machine 10 times on the thickest setting of machine; fold it in half after each rolling. Next, roll dough through once on each setting, this time without folding in half after each rolling, progressing from the very thickest setting to the thinnest; if needed, lightly flour

dough so it doesn't stick and cut into manageable lengths. Once dough has gone through the thinnest setting, cut into about 1-foot lengths. With the linguini attachment on the machine, cut lengths into noodles and hang on coat hangers until ready to cook. Repeat with the remaining portion of dough. (This may be done 1 day ahead; store noodles at room temperature, still hanging on coat hangers.)

TO FINISH THE DISH AND SERVE:

(See photograph pages 116-117.) First make the sauce as follows: In a heavy 2-quart non-reactive saucepan, combine the cream, milk, coffee, and cocoa; bring to a boil, stirring occasionally. Remove from heat and let sit for 15 minutes.

Combine the egg yolks and sugar in a medium-size bowl, whisking vigorously until thick and pale yellow, about 2 minutes. Return the cream mixture to a boil, then remove from heat and gradually add to the egg yolk mixture, whisking constantly. Return mixture to the saucepan and cook over medium heat, stirring constantly and scraping pan bottom evenly with a wooden spoon, just until it thickens and leaves a distinct trail on the back of the spoon when you draw a finger through it, about 2 minutes; do *not* let boil. Immediately strain sauce through the chinois into another heavy saucepan. Cover to keep warm while cooking the noodles.

For cooking the noodles, combine the water and oil in a large pot; bring to a rolling boil. Add noodles and cook uncovered to al dente stage, about 2 minutes; drain into a colander. Next, reheat sauce over medium-low heat, stirring frequently; do *not* let boil. Serve immediately.

To serve: For each serving, roll ¼ of the noodles onto a large fork and place on a serving plate; spoon 3 to 4 tablespoons sauce on top and garnish with white chocolate curls; if desired, add mint leaves around the edges of the plate and lightly sprinkle all with cocoa powder. Serve leftover sauce in a sauceboat at the table.

FRESH RASPBERRIES AND ORANGE SECTIONS IN PUFF PASTRY with BASIL CUSTARD SAUCE

Makes 4 servings

1 recipe Pastry Cream (page 215)
Basil Custard Sauce (recipe follows)
Enough top-quality frozen puff pastry dough to cut out 12 to 16 (3-inch) rounds (if dough sheets are folded, thaw just enough to unfold; if not folded, do not thaw)
About ½ to ¾ cup sugar for rolling out dough
½ cup heavy cream
4 medium to large oranges, peeled, seeded, and separated into segments without membranes
1 heaping cup fresh raspberries
Sifted powdered sugar
4 basil sprigs for garnish
Several very small basil leaves for garnish
1 recipe Confit of Orange Rind (page 169) drained while still hot for garnish (optional)

SPECIAL UTENSILS:
Enough heavy baking sheets to hold twelve to sixteen 4-inch rounds of puff pastry dough and still fit in refrigerator
3-inch cookie cutter
4-inch cookie cutter

Make the Pastry Cream; refrigerate. Next, make the custard cream for the Basil Custard Sauce and refrigerate; if making on the same day as serving the sauce, finish the sauce now, then refrigerate.

PREPARE THE PUFF PASTRY:

Heat oven to 400 degrees. Cut out at least twelve 3-inch rounds of frozen puff pastry dough with the 3-inch cookie cutter. (You will only need 12 rounds, but it's a good idea to prepare 3 or 4 extras in case any crack apart as the pastry is assembled.) Refrigerate dough rounds.

Line the baking sheets with parchment paper; set aside. Sprinkle 2 tablespoons of the sugar on a cool work surface suitable for rolling out dough. Remove 3 of the dough rounds from the refrigerator and press them into the sugar on the work surface, coating both sides with as much of it as possible; then sprinkle 1 tablespoon more sugar on the work surface and roll each round to a ¹⁄₁₆-inch-thickness, adding a little more sugar if needed to keep dough from sticking. Next, cut three 4-inch rounds from the rolled out dough with the 4-inch cookie cutter and place on the prepared baking sheet about ½ inch apart; refrigerate until ready to bake. Repeat to roll out the remaining 3-inch rounds to a ¹⁄₁₆-inch-thickness and cut them into 4-inch rounds; add 1 to 2 tablespoons more sugar to the work surface before rolling out each set of 3 rounds.

Once all 4-inch rounds have been formed, bake until dark golden brown, about 8 minutes, checking often toward the end of cooking time to make sure undersides don't overbrown. Remove from oven and let cool on the parchment paper about 3 minutes, then promptly (before the rounds harden) lift 1 at a time from the paper and use scissors to trim away any caramelized sugar from around the edges to make them neat. Set aside.

FINISH THE PUFF PASTRY FILLING:

Whip the cream until soft peaks form; set aside. Place the chilled Pastry Cream in a large bowl and whisk until fairly smooth, then add ½ of the whipped cream to it, whisking gently just until smooth. Lightly fold in the remaining whipped cream just until barely blended.

TO ASSEMBLE THE PASTRIES AND SERVE:

(See photograph page 118.) For each pastry, place a dab of the puff pastry filling in the center of a serving plate and "glue" a puff pastry round to it, flatter side down; arrange ¼ of the orange segments on one round's top edges, then fill the round's center with about 2 heaping teaspoons of the filling; cover with a second puff pastry round, flatter side down, and along the second round's top edges arrange ¼ of the raspberries, then fill center with about 2 heaping teaspoons more of the filling; dust the flatter side of a third puff pastry round with powdered sugar and cover the raspberry layer with it; garnish center of top round with a sprig of basil.

Once all 4 pastries are assembled, spoon about 2 tablespoons sauce to one side of each; garnish sauce with very small basil leaves and, if desired, drained Confit of Orange Rind. Serve immediately.

BASIL CUSTARD SAUCE

CUSTARD CREAM:
½ cup heavy cream
½ cup milk
½ ounce basil sprigs
A 4-inch piece of vanilla bean
3 egg yolks (from large eggs)
¼ cup sugar
6 cups water for cooking the 1½ ounces basil leaves
1½ ounces fresh basil leaves
Ice water for cooling cooked basil leaves

SPECIAL UTENSILS:
Chinois placed over a large heatproof bowl

MAKE THE CUSTARD CREAM:

In a small heavy nonreactive saucepan, combine the cream, milk, and the ½ ounce basil sprigs. Cut the vanilla bean in half lengthwise, scrape, and add scrapings and bean halves to the pan. Bring to a boil, then remove from heat and let sit for 15 minutes.

Combine the egg yolks and sugar in a medium-size bowl, whisking vigorously until thick and pale yellow, about 2 minutes. Return the cream mixture to a boil, then remove from heat and gradually add to the egg yolk mixture, whisking constantly. Return mixture to the saucepan and cook over medium heat, stirring constantly and scraping pan bottom evenly with a wooden spoon, just until it thickens and leaves a distinct trail on the back of the spoon when you draw a finger through it, about 2 to 3 minutes; do not let mixture boil. Immediately strain through the chinois into the bowl. (If desired, rinse and save vanilla beans for future use.) Promptly cover this custard cream and refrigerate at least 30 minutes before using; keep refrigerated until ready to use.

TO FINISH THE SAUCE:

Bring the 6 cups water to a rolling boil in a medium-size pot. Add the 1½ ounces basil leaves and cook over high heat for 2 minutes. Immediately drain and cool in the ice water; drain again and squeeze dry. Mince the leaves in a food processor, then add the chilled custard cream and continue processing until thoroughly blended. Cover sauce and refrigerate until well chilled and flavors develop, about 2 hours. Strain sauce through the chinois, using the bottom of a sturdy ladle to force as much through as possible. Refrigerate until ready to serve. *Makes 1 scant cup.*

LACE-BATTERED FRIED CALAMARI with FRIED PARSLEY

Makes 4 first-course servings

LACE BATTER:
 1 cup all-purpose flour
 1½ cups cool water
 1 teaspoon baking soda
1¼ to 1½ pounds fresh calamari (8 or 9 small calamari)
5 large parsley sprigs
Vegetable oil for deep frying
Fine sea salt
About 8 lime wedges for garnish (optional)

PREPARE THE BATTER:

Place the flour in a medium-size bowl. Gradually add the water, whisking until all lumps disappear. Whisk in the baking soda. Cover batter and refrigerate at least 1 hour or up to 2 hours before using. Keep refrigerated until ready to use.

PREPARE THE CALAMARI AND PARSLEY:

Rinse the calamari under cool running water. Trim off and reserve the tentacles. Separate the heads from the bodies; discard heads. From each body, pull out and discard all soft matter and the long quill. Peel off and discard the very thin spotted outer skin and the fins. Rinse tentacles and bodies well, removing any matter from inside bodies you may have missed during the initial cleaning.

Next, with a sharp knife slice off and discard about ½ inch of the tip end of each body. Cut bodies crosswise into ¼-inch ringlets. Set aside. (If prepared ahead, cover ringlets and tentacles with water and refrigerate.)

Trim thick stems from the parsley sprigs. Wash and dry thoroughly. If prepared ahead, wrap in paper towels and refrigerate.

FRY THE CALAMARI AND PARSLEY:

Heat the oil in a deep fryer or deep pan to 375 degrees. Meanwhile, if calamari has been soaking in water, drain well on paper towels. Fry calamari in small batches. Just before frying each batch, coat with batter and let excess drain off, then gently ease, piece by piece, into the hot oil. Fry until dark golden brown, about 1 minute, turning at least once. Do not crowd. Remove with a slotted spoon and drain on paper towels. Repeat with remaining batches, keeping oil temperature at about 375 degrees. Season lightly with salt and set aside momentarily while frying the parsley.

To fry parsley, first make sure oil is at 375 degrees. Take special care when adding the parsley to the hot oil since the oil may pop excessively; ease parsley in and fry about 30 seconds. Drain on paper towels briefly, then sprinkle over the calamari. (See photograph page 122.) Serve immediately with lime wedges on the side, if desired.

CHILLED MAINE LOBSTER and LOBSTER CORN CAKES with SALAD OF MACHE, RADICCHIO, AND FRISEE

Makes 4 servings

4 (1- to 1½-pound) active live Maine lobsters
Salt water (2 teaspoons coarse salt mixed with 2½ quarts water) for cooking corn
2 (7-inch) ears of yellow corn, shucked
Ice water for cooling cooked corn
1¼ teaspoons unflavored gelatin
2 tablespoons cold Lobster Consommé (page 214) (preferred) or other Consommé (page 214)
5 (1-inch-long) snippets of dill sprigs
½ cup heavy cream
½ teaspoon very finely sliced chives

½ teaspoon Lobster Coral Garnish (page 215) (optional)
Fine sea salt and freshly ground black pepper
1 recipe Balsamic Vinaigrette (see recipe for Salad of Sea Scallops, White Truffles, Fresh Hearts of Palm, and Mesclun, page 185)
4 cups loosely packed mixture of mache (lamb's lettuce, corn salad), radicchio, and *frisée* (curly endive) (about 3 cups mache, ¾ cup radicchio, and ¼ cup *frisée*) or another mixture of small, tender salad greens
Dill sprigs for garnish

SPECIAL UTENSILS:
Steamer or stockpot fitted with a deep basket
4 metal or wooden skewers longer than the lobster tails but short enough to fit into the steamer with basket and lid in place
Fine mesh strainer
5 (¼-cup-capacity) Pyrex flan molds, 2¼-inch diameter at inside top, 1⅝-inch diameter at outside base, 1⅞ inches tall

PREPARE THE LOBSTERS:

Steam lobsters as directed in Miniature Pumpkins Stuffed with Steamed Maine Lobster, page 182, up through the point of removing the steamed tail and claw meat from the shells. (The heads and shells may be saved frozen for making Lobster Cream Base Sauce, page 215, or Lobster Stock, page 214.)

Withdraw skewers from tails. From the thicker end of each tail, cut 6 diagonal ¼-inch-thick slices, leaving the remainder of the tail (about 2½ inches) in 1 piece. If meat is not completely cooked through, return it to the steamer a little longer; do *not* overcook. Set aside 10 of the ¼-inch slices for the lobster corn cakes and another 4 slices for garnishing the salads; cover and refrigerate. Arrange the remaining ¼-inch slices, the 2½-inch-long pieces, and the claw meat on the serving plates as pictured on page 123, leaving space for the salads and lobster corn cakes. Cover plates and refrigerate until serving time. (This may be done several hours ahead.)

MAKE THE LOBSTER CORN CAKES:

(This recipe makes 5 cakes.) Bring the salt water to a rolling boil in a large pot. Add the ears of corn and cook just until tender, about 3 minutes. Drain and cool in the ice water; drain again. Cut the kernels from the cobs and purée kernels in a food processor. Strain through the strainer, using the bottom of a sturdy ladle to force as much through as possible; the strained purée should yield about ½ cup. Set aside.

For the aspic, combine ¼ teaspoon of the gelatin with the consommé in a very small saucepan; let gelatin soften for about 2 minutes, then cook over low heat until gelatin completely dissolves, 1 to 2 minutes, stirring constantly. Immediately pour ⅕ of the aspic into the bottom of each ungreased flan mold. Arrange a snippet of dill on top of each portion. Place molds on a small cookie sheet and refrigerate until jelled, at least 10 minutes.

Meanwhile, whip 6 tablespoons of the cream in a chilled medium-size bowl just until soft peaks form; refrigerate. Heat the remaining 2 tablespoons cream with the remaining 1 teaspoon gelatin in a very small saucepan over low heat until cream is hot and gelatin dissolves, about 3 minutes, stirring constantly. Remove from heat and continue stirring until cool, about 2 minutes more. Then, working as quickly as possible, gradually add the gelatin-cream mixture to the reserved whipped cream, folding it in with a rubber spatula. Next, fold in the reserved corn purée, the chives, and, if using, the Lobster Coral Garnish, mixing just enough to blend well; do *not* overmix. Season batter generously with salt and pepper (the strength of the seasonings

will diminish once cakes are chilled), folding just until well blended. Spoon 1 scant tablespoon of the batter into each chilled flan mold, smoothing surface; add 1 slice of the reserved lobster tail meat to the mold, another scant tablespoon batter, another slice of lobster meat, and then fill mold to the top with some of the remaining batter. Gently tap molds on a flat surface to expel air bubbles. Refrigerate until firm, at least 30 minutes. (These may be made several hours ahead; keep refrigerated until ready to serve.)

TO SERVE:

(See photograph page 123.) Make the Balsamic Vinaigrette if not already prepared. Unwrap serving plates, then unmold 4 of the lobster corn cakes as follows: Place 1 of the molds in a small pan and fill pan with 1¼ inches of very hot water. Let sit precisely 45 seconds (no longer or the aspic on the bottom of the cake will melt). Remove mold from the hot water, insert a thin flexible-bladed knife between the cake and mold to create an air pocket, and invert onto 1 of the serving plates. Use the same pan of hot water to unmold the remaining 3 cakes.

Now brush tops of the lobster meat with some of the vinaigrette and toss salad greens with enough of the remaining vinaigrette to lightly coat them. Arrange the greens on each plate to resemble a flower or mound them neatly, and garnish centers with the reserved lobster slices. Garnish lobster with dill sprigs and serve immediately.

GREEN AND WHITE ASPARAGUS IN PUFF PASTRY with ASPARAGUS CREAM SAUCE

Makes 4 servings

20 (7-inch-long) slender green asparagus spears, thick woody ends rimmed
20 (7-inch-long) slender white asparagus spears, thick woody ends trimmed (see Note)
Salt water (¼ cup coarse salt mixed with 3 quarts water) for cooking asparagus
Ice water for cooling cooked asparagus
1 recipe Asparagus Cream Sauce (see recipe for *Chartreuse* of Asparagus, pages 212-213; see Note)
Enough top-quality frozen puff pastry dough to cut out 4 (3½-inch) rounds (if dough sheets are folded, thaw just enough to unfold; if not folded, do not thaw)
1 egg yolk (from a large egg)
4 cups Consommé of your choice (page 214) (preferred), Stock of your choice (page 214), or water for reheating asparagus tips
Chervil or dill sprigs, snipped for garnish

SPECIAL UTENSIL:
3½-inch cookie cutter

NOTE:
If white asparagus spears are not available, substitute *green* ones. Reserve 1¾ cups of the trimmings from forming the green asparagus tips (as directed in the recipe below) for making the sauce; you may use the Consommé of your choice (Meat, Lobster, or Vegetable, page 214) in the sauce.

Trim the green and white asparagus spears into 3½-inch-long tips, reserving all *green* trimmings. Peel 1½ inches of the skin from the thick ends of the green and white tips with a vegetable peeler; discard this skin and set tips aside. Coarsely slice enough of the green trimmings to yield 1¾ cups for the sauce.

Bring the salt water to a rolling boil in a large nonreactive pot. Add the reserved 1¾ cups green asparagus trimmings and cook over high

heat for 4 minutes. Immediately transfer with a slotted spoon to the ice water to cool, reserving salt water. Drain the trimmings on paper towels, reserving ice water; set trimmings aside.

Return salt water to a rolling boil. Add the white asparagus tips and cook for 2 minutes, then add the green tips and continue cooking 4 minutes more. Immediately drain and cool in the ice water; drain again on paper towels. If desired, cut 4 of the green tips into ⅛-inch slices for garnishing the sauce. Set tips and garnish aside. (Refrigerate if prepared ahead.)

Now prepare the Asparagus Cream Sauce; refrigerate until ready to use. (This may be done several hours ahead.)

TO FINISH THE DISH AND SERVE:

(See photograph page 124.) Heat oven to 400 degrees. Cut out 4 rounds of frozen puff pastry dough with the cookie cutter; discard scraps. Score the edges of the rounds with the dull side of a paring knife, making cuts ¼ inch long and about ¼ inch apart. Place rounds on a cookie sheet lined with parchment paper and lightly brush tops with some of the egg yolk; avoid getting any yolk on the scored edges or sides of the dough, or it won't rise properly. Bake in the preheated oven until well browned, puffed, and cooked through, about 20 minutes. (Make sure insides of these fragile pastries are done by carefully slicing 1 of them in half horizontally with a bread knife.) Remove from oven and immediately reduce oven setting to 300 degrees.

Once the pastries are out of the oven, bring the consommé to a boil in a medium-size pot. Add the green and white asparagus tips and cook just until heated through, about 1 minute. Drain on paper towels and blot dry.

Meanwhile, slice the puff pastries in half horizontally. If any top or bottom halves are thicker than 1 inch, trim to a 1-inch thickness. Scoop out flaky insides of bottom halves to form bowls for holding the asparagus tips and place 1 bowl in the center of each serving plate. Fill each bowl with ¼ of the heated asparagus tips and, if desired, top with some of the snipped chervil or dill, then cover bowls with pastry tops. Heat the plates, uncovered, in the 300 degree oven for 3 to 5 minutes.

Meanwhile, gently reheat sauce, whisking constantly; do not overheat, or it will turn brown. Once the serving plates are heated, spoon 2 to 3 tablespoons sauce around the edges of each puff pastry; garnish sauce with snipped chervil or dill and, if using, the reserved ⅛-inch asparagus slices. Serve immediately.

SAUTEED BABY EELS AND MIREPOIX OF RED AND YELLOW BELL PEPPERS with GARLIC AND CHIVE SAUCE

Makes 4 servings

2 quarts water for poaching garlic cloves and blanching bell peppers
3 ounces garlic cloves, peeled (½ cup)
¼ pound (1 stick) unsalted butter, softened
¾ pound well-formed red bell peppers, cored and cut into very large square pieces
¾ pound well-formed yellow bell peppers, cored and cut into very large square pieces
1 pound live baby eels (*piballes*) (preferred) or 1 pound frozen baby eels, thawed
¼ cup Lobster Consommé (page 214) (preferred) or Lobster Stock (page 214), or other Consommé or Stock (page 214)
Fine sea salt and freshly ground black pepper
¼ cup extra-virgin olive oil
½ ounce chives, snipped into 4-inch lengths for garnish
2 tablespoons very finely sliced chives

SPECIAL UTENSILS:
Heatproof fine mesh strainer
chinois

START THE SAUCE:

Bring 2 cups of the water to a rolling boil in a medium-size pot. Add the garlic cloves and cook over high heat for 5 minutes; drain. In the same pot, combine the garlic cloves with 2 cups more water. Bring to a boil, then continue boiling until tender, about 7 minutes more. Drain and refrigerate until cool, at least 10 minutes; then purée with the butter in a food processor until smooth. Cover and refrigerate until garlic butter is firm, at least 1 hour or overnight.

PREPARE THE MIREPOIX OF BELL PEPPERS:

Working with 1 piece of bell pepper at a time, place the piece skin down on a cutting board and very carefully trim away the skin with a sharp thin-bladed knife, slicing horizontally as close to the skin as possible. If needed, cut pieces smaller, then skin them. Next, cut the pulp into ⅛-inch squares and combine the red and yellow squares; the combined yield should be about 1½ cups.

Bring the remaining 1 quart water to a rolling boil in a small pot. Place the bell peppers in the heatproof strainer and dip strainer bowl into the boiling water for 30 seconds to blanch peppers (keep peppers in the strainer so they can be removed quickly from the water once blanched). Drain on paper towels. Cover and refrigerate. (This may be done several hours ahead.)

RINSE THE EELS:

Place the eels in the strainer and rinse thoroughly under cool running water. Let drain briefly, then place strainer over a bowl and drain thoroughly, about 10 minutes more; moisture left on them will make the oil pop excessively when cooked. Cover and refrigerate if not cooking almost immediately. (This may be done up to 1 hour ahead.)

FINISH THE SAUCE:

In a small heavy saucepan, combine the reserved chilled garlic butter with the consommé. Cook over high heat just until butter melts, whisking constantly. Remove from heat and strain through the chinois, using the bottom of a sturdy ladle to force as much through as possible; the strained sauce should yield about ⅔ cup. Season with salt and pepper and return to the saucepan. Set aside. (This may be done up to 1 hour ahead.)

SAUTE THE EELS AND SERVE:

(See photograph page 125.) Heat the serving plates in a 250 degree oven. Heat the oil in a very large nonstick skillet over high heat, about 3 minutes. Add the eels and sauté about 1 minute. Season with salt and pepper, add the reserved bell pepper mirepoix, and continue cooking until eels turn opaque and white, 1 to 2 minutes more, stirring almost constantly. Remove from heat and taste for seasoning. Drain on paper towels. Place an equal portion of the sautéed eels in the center of each heated serving plate and garnish edges with the snipped chives. Reheat sauce a few seconds over high heat, whisking constantly, then stir in the sliced chives and spoon about 3 tablespoons over each serving. Serve immediately.

SAUTEED RED SNAPPER and NIÇOISE OLIVES with BLACK OLIVE AND ANCHOVY QUENELLES, BASIL SAUCE, and TOMATO AND OLIVE FLOWERS

Makes 4 servings

SAUCE:
Salt water (¼ cup coarse salt mixed with 3 quarts water) for blanching basil leaves
5 ounces fresh basil leaves (about 2½ cups very tightly packed)
Ice water for cooling blanched basil leaves
½ pound (2 sticks) unsalted butter, softened
¼ cup Lobster Consommé (page 214) (preferred), Lobster Stock (page 214), or other Consommé or Stock (page 214)
2 teaspoons Parsley Purée (page 215) (optional)
Fine sea salt and freshly ground black pepper
QUENELLE MIXTURE:
2 tablespoons extra-virgin olive oil
7½ ounces drained small black olives (preferably Niçoise; about 1½ cups), pitted
2 large anchovy fillets (canned and packed in oil), drained (about ¼ ounce drained)
1 large peeled garlic clove, minced or crushed
Freshly ground black pepper
3 tablespoons plus 1 teaspoon extra-virgin olive oil
1 cup Niçoise olives, cut in half lengthwise and pitted for garnishing red snapper and sauce and for Tomato and Olive Flowers (see Note)
4 (5- to 6-ounce) fillets of red snapper, cut about 1 inch thick
Fine sea salt and freshly ground black pepper
1 medium vine-ripened tomato (about 7 ounces), peeled and quartered for garnish (optional)
4 medium-size basil leaves, cut into very fine julienne strips for garnish (optional)
About 40 whole small basil leaves for garnish (optional)
Lobster Coral Garnish (page 215) (optional)

SPECIAL UTENSIL:
Chinois

NOTE:
If not making the Tomato and Olive Flower garnish, you will only need ¾ cup olives.

START THE SAUCE:

Bring the salt water to a rolling boil in a large nonreactive pot. Add the basil leaves and blanch for 2 minutes; immediately drain and cool in the ice water. Drain again and squeeze dry; purée in a food processor with the butter until butter is very creamy and green and all basil is minced. Cover basil butter and refrigerate until firm, at least 1 hour or overnight.

PREPARE THE QUENELLE MIXTURE:

Heat 1 tablespoon of the oil in a large nonstick skillet over high heat, about 2 minutes. Meanwhile, drain olives well. Carefully add the olives, anchovies, and garlic to the skillet and sauté for 1 minute, stirring constantly. Reduce heat to medium and continue cooking just until garlic is browned, about 1 minute more. While mixture is still hot, purée in a blender with the remaining 1 tablespoon oil until smooth. Season to taste with pepper. Cover and set aside or, if made more than 4 hours ahead, refrigerate; return to room temperature before using. (This may be prepared a day ahead.)

IF USING, PREPARE THE TOMATO AND BASIL GARNISH:

Place the tomato quarters skinned side down. With a sharp thin-bladed knife, slice off and discard the top soft portion of each, leaving a ¼-inch-thick slice of firm tomato pulp. Carefully cut each slice horizontally into 3 pieces (preferably) or in half (make slices as thin as possible and uniformly thick), then trim slices into 24 petal shapes that are about 1½ inches long and ½ inch wide at the widest part (if slices are fairly thick, make petals smaller); reserve any leftover slices and the trimmings. Cover petals and set aside.

For the tomato-basil julienne, cut the remaining tomato slices and trimmings into about 3 x ⅛-inch julienne strips and mix with the julienne basil leaves. Cover and set aside. (This may be done up to 1 hour ahead.)

SAUTE THE NIÇOISE OLIVE HALVES AND START ASSEMBLING PLATES:

Heat 1 teaspoon of the oil in a small skillet (preferably nonstick) over medium heat, about 2 minutes. Add the olive halves and sauté for 2 minutes, stirring occasionally. Drain on paper towels.

If using, arrange 6 of the reserved tomato petals to one side of each ovenproof serving plate in a flower shape (see photograph page 126); arrange 7 of the olive halves, cut side down, in the center of each flower. Set aside remaining olive halves.

Now separate the reserved quenelle mixture into 12 equal portions. Use 2 teaspoons to mold each portion into a quenelle (oval shape); as formed, arrange 3 quenelles on each plate. Cover plates with plastic wrap and set aside at room temperature. (The plates may be assembled to this point up to 1 hour ahead.)

FINISH THE SAUCE:

In a small heavy saucepan, combine the reserved chilled basil butter with the consommé. Cook over high heat just until butter melts, whisking constantly. Strain through the chinois, using the bottom of a sturdy ladle to force as much through as possible; the strained sauce should yield 1 generous cup. Return to the saucepan, stir in the Parsley Purée, if using, and season to taste with salt and pepper. Set aside. (The sauce may be finished up to 1 hour ahead.)

TO SAUTE THE RED SNAPPER AND SERVE:

Heat oven to 350 degrees. Trim edges of each fillet to make it neat and score skin in a diagonal crisscross pattern. Season on both sides with salt and pepper. Heat the remaining 3 tablespoons oil in a very large skillet (preferably nonstick) over high heat, about 3 minutes. Add fillets, skin down, to the skillet, reduce heat to medium, and cook until undersides are brown and crisp, about 4 minutes. Turn and continue cooking just until cooked through, about 3 minutes more; do *not* overcook. Drain on paper towels, skin up. Blot tops of fillets with more towels, being careful not to pull off any skin as you blot.

Unwrap serving plates and arrange a fillet, skin up, on each; garnish top of each fillet with about 20 of the reserved olive halves, cut side down; set aside leftover olive halves. If using, arrange ¼ of the reserved tomato-basil julienne on each plate. Now heat plates, uncovered, in the preheated oven for 5 minutes.

Meanwhile, reheat sauce over high heat, whisking constantly; if too thin (it should have a thin cream sauce consistency), let sauce reduce for 1 to 2 minutes, whisking constantly.

When plates have heated for 5 minutes, remove from oven and blot any oil from the quenelles with paper towels. If using, garnish plates with the whole small basil leaves, then spoon 3 to 4 tablespoons sauce alongside each fillet and decorate sauce with the remaining

olive halves, cut side down. If desired, sprinkle lightly with Lobster Coral Garnish. Serve immediately.

PRIME RIB with BONE MARROW FLAN, CONFIT OF ONIONS IN RED WINE, SAGE POTATO CHIPS, and MARCHAND DE VIN SAUCE

Makes 4 servings

SAGE POTATO CHIPS:
2 tablespoons lemon juice
4 large well-shaped russet potatoes (each about 10 ounces and at least 2¼ inches wide at the widest point), scrubbed well
Vegetable oil for deep frying
2 egg yolks (from large eggs), lightly beaten
10 or more perfect sage leaves (each no longer than 2½ inches and about ¾ inch wide), cut in half crosswise
Fine sea salt and freshly ground black pepper
Marchand de Vin Sauce (recipe follows)
CONFIT OF ONIONS IN RED WINE:
4 cups julienne sweet onions (preferably Vidalia; 3 x ¼-inch strips)
3½ cups Cabernet Sauvignon wine
½ cup sugar
1 recipe Bone Marrow Flan (see recipe for Beef Pot-au-Feu, page 183)
¼ cup plus 2 tablespoons vegetable oil for cooking prime rib steaks
4 (16- to 18-ounce) bone-in prime rib steaks, each 1 to 1½ inches thick
Fine sea salt and freshly ground black pepper
Rock salt for garnish (optional)

SPECIAL UTENSILS:
Mandoline or similar slicer
2-inch-round scallop-edged cookie cutter

PREPARE THE POTATO CHIPS:

Place the lemon juice in a medium-size bowl. With the mandoline, slice the unpeeled potatoes lengthwise into paper-thin slices, tossing them with the lemon juice as made. You will need at least 40 slices with no rips in them to make 20 potato chips, but it's a good idea to prepare several more so that you have at least 5 potato chips for each serving plus a few to experiment with.

Next, flash-fry the potato slices as follows: Heat the oil in a deep fryer or deep pan until very hot and just short of smoking. Meanwhile, drain potato slices and blot thoroughly dry with a cloth dishtowel, then cut out slices with the cookie cutter to form at least 40 rounds. Have ready a cloth towel for draining fried slices. Flash-fry the rounds in small batches in the hot oil just 5 to 10 seconds to soften them (as soon as you put a batch of rounds into the oil, start removing them); do not let rounds brown or start to get crisp. Drain on the cloth towel.

Now assemble the potato chips. To do this, line a cookie sheet with parchment or waxed paper. Place the egg yolks in a small bowl. Working in batches of 8 potato rounds, first blot rounds with a cloth towel to absorb all oil possible, then brush tops of 4 of them with some of the egg yolk, and place half a sage leaf in the center of each; brush tops of the remaining 4 rounds with egg yolk and invert onto the first 4 rounds, pressing edges lightly together to completely seal sage leaves inside. Repeat with remaining rounds and sage leaves. Cover and refrigerate if serving within 2 hours or freeze if made further ahead. (To freeze, cover cookie sheet with aluminum foil and freeze until potato chips are frozen hard, then transfer them to a freezer container, and return to freezer. These

may be kept frozen up to 2 weeks; do not thaw before frying.)

Prepare the sauce if not already done; refrigerate if made ahead.

MAKE THE CONFIT OF ONIONS:

In a large heavy skillet, combine the onions, wine, and sugar. Bring to a boil over high heat, then simmer until onions are very tender and liquid is a fairly thick syrup, 45 to 50 minutes, stirring occasionally. Set aside. (Refrigerate if made ahead; this may be done a day in advance.)

TO FINISH THE DISH AND SERVE:

(See photograph page 127.) Make the flans as directed on page 183. Once out of the oven, leave oven set at 300 degrees and let flans sit in the pan of hot water in which they cooked for at least 10 minutes or up to 30 minutes; unmold and serve promptly.

When the flans have finished baking, cook the prime rib steaks; meanwhile, reheat the sauce and onion confit over very low heat and begin heating the frying oil for the potato chips to 400 degrees so they can be fried quickly once the steaks are cooked and sliced (use a large enough frying pan to fry the chips in 1 or 2 batches without crowding).

For the steaks, heat 3 tablespoons of oil in *each* of 2 very large heavy skillets over high heat, about 3½ minutes. Meanwhile, season the steaks generously on both sides with salt and pepper. Add 2 steaks to each hot skillet and cook about 3 minutes on each side for rare, or about 4 minutes per side for medium rare (the cooking time will depend on the thickness of the steaks). Transfer steaks to a platter and cover 3 of them loosely with aluminum foil to keep warm; carve the meat from the remaining steak with a boning knife and cut it against the grain into 1-inch-thick slices, then cover to keep warm. Repeat with the remaining 3 steaks.

Unmold a flan to one side of each of 4 ovenproof serving plates and arrange 2 small mounds of onion confit on either side of the flan; arrange the prime rib slices on the plates, then heat uncovered in the 300 degree oven for up to 5 minutes to keep food warm. Fry the potato chips in batches in the 400 degree oil just for about 30 seconds until golden brown; drain briefly on a cloth dishtowel and season with salt and pepper. Once all chips are fried, remove serving plates from oven and arrange about 5 chips on each, then spoon 2 to 3 tablespoons sauce around the edges of the prime rib and sprinkle meat lightly with rock salt, if desired. Serve promptly while the potato chips are still piping hot and crisp.

MARCHAND DE VIN SAUCE

¼ cup cubed lean prosciutto (¼-inch cubes)
½ cup unpeeled chopped carrots
¼ cup chopped celery
¼ cup chopped leeks (mostly white part)
¼ cup chopped onions
¼ cup unpeeled chopped turnips
2 tablespoons chopped shallots
20 very leafy thyme sprigs, each 4 to 5 inches long
3 large garlic cloves, peeled and crushed
½ teaspoon whole black peppercorns
1½ cups Cabernet Sauvignon wine
2 cups Meat or Vegetable Consommé (page 214) (preferred) or Meat or Vegetable Stock (page 214)
2 cups *Fond de Veau* (page 214)

SPECIAL UTENSIL:
Chinois

In a medium-size bowl, combine the prosciutto, carrots, celery, leeks, onions, turnips, shallots, garlic, thyme sprigs, and peppercorns. Heat a heavy 4-quart saucepan over high heat for about 1 minute, then add the prosciutto-vegetable mixture and cook about 2 minutes, stirring occasionally. Add 1 cup of the wine and cook until reduced by half, about 4 minutes, stirring occasionally. Add the consommé and strongly simmer until liquid in pan reduces by half, about 30 minutes, stirring occasionally. Add the *Fond de Veau* and strongly simmer about 20 minutes, then add the remaining ½ cup wine and continue simmering until liquid is a sauce consistency, about 10 minutes more. Strain sauce through the chinois, using the bottom of a sturdy ladle to force as much through as possible. Use immediately or refrigerate until time to reheat and serve. *Makes about 1¾ cups.*

COCONUT ICE CREAM with FRIED COCONUT, FRIED PEACHES, POACHED PEACHES, and CARAMEL SAUCE

Makes 4 servings

Coconut Ice Cream (recipe follows)
1¾ cups sugar
1½ cups heavy cream
1 recipe Lace Batter (see recipe for Lace-Battered Fried Calamari, page 200)
4 medium-size firm ripe peaches
3 cups water
2 tablespoons lemon juice
Vegetable oil for deep frying
1¼ cups coarsely grated fresh coconut
Sifted powdered sugar
Mint sprigs, snipped for garnish (optional)

First, make the Coconut Ice Cream; transfer from ice cream machine to freezer until ready to serve.

For the sauce, place ¾ cup of the sugar in a heavy 3-quart saucepan; cook over high heat until melted and medium brown, 5 to 6 minutes, stirring frequently with a wooden spoon. Reduce heat to medium and very gradually stir in 1 cup of the cream (don't add the cream too quickly, or the mixture may boil over), then stir in the remaining ½ cup cream. Remove sauce from heat and pour into a large heatproof bowl; place bowl over a large bowl of ice filled halfway with water and whisk sauce until light caramel brown and a cake batter consistency, 4 to 5 minutes. Set aside. (Refrigerate if made ahead; return to room temperature before serving.)

Make the Lace Batter; refrigerate for at least 1 hour but no more than 2 hours before using.

Meanwhile, slice 2 of the unpeeled peaches into ¾-inch-thick wedges; cover and set aside for frying. Peel the remaining 2 peaches and slice into ¼-inch-thick wedges. Poach these peeled wedges as follows: In a medium-size pot, combine the water and lemon juice with the remaining 1 cup sugar; bring to a boil, stirring until sugar dissolves. Add the peeled peach wedges and cook just until tender, about 5 minutes. Drain on paper towels; if desired, cut 2 of the wedges into julienne strips for garnishing the ice cream; cover poached peach wedges and julienne strips and set aside.

TO FINISH THE DISH AND SERVE:

(See photograph page 128.) Once the batter has chilled at least 1 hour, fry the coconut and the unpeeled peach wedges. To fry the coconut, heat the oil in a deep pan or deep fryer to 375 degrees. Just before frying, coat coconut with the batter and let excess drain off. Fry in batches in the hot oil until golden brown, about 1 minute, stirring oil gently with a heatproof slotted spoon

so coconut browns evenly. Drain on paper towels and blot very lightly with more towels; set aside.

As you did the coconut, batter the peach wedges and fry them in the same 375 degree oil; fry until golden brown and tender, about 1½ minutes, turning at least once. Do not crowd. Drain on paper towels separate from the coconut and blot.

Now arrange ¼ of the reserved poached peach wedges in a large circle on each serving plate and spoon about 3 tablespoons sauce in the center of the plate. Next, sprinkle the fried peaches and coconut generously with powdered sugar; mound a portion of the coconut on top of the sauce on each plate, then arrange the fried peaches around the edges of coconut. Form the ice cream into quenelles (oval shapes) or scoops and place on top of the coconut; if desired, garnish ice cream with mint sprigs and julienne peaches. Serve immediately.

COCONUT ICE CREAM

1 (15-ounce) can cream of coconut (1½ cups)
1 cup heavy cream
1 cup milk
½ cup coarsely grated fresh coconut
½ cup fresh coconut milk (optional)
6 egg yolks (from large eggs)
½ cup sugar

SPECIAL UTENSILS:
Chinois placed over a heatproof bowl
Ice cream machine

In a heavy 3-quart nonreactive saucepan, combine the cream of coconut, cream, milk, coconut meat, and if using, the coconut milk. Bring to a boil, then remove from heat and let sit 15 minutes.

Combine the egg yolks and sugar in a medium-size bowl, whisking vigorously until thick and pale yellow, about 2 minutes.

Return the cream of coconut mixture to a boil, then remove from heat and gradually add to the egg yolk mixture, whisking constantly. Return mixture to the saucepan and cook over medium heat, stirring constantly and scraping pan bottom with a wooden spoon, just until it thickens and leaves a distinct trail on the back of the spoon when you draw a finger through it, about 2 to 3 minutes; do not let mixture boil. Immediately strain through the chinois into the bowl. Promptly cover and refrigerate until well chilled, at least 3 hours or overnight.

Freeze in the ice cream machine according to manufacturer's instructions until firm, about 25 to 50 minutes, depending on the type of machine used. *Makes 1 quart.*

CHERRY CLAFOUTIS

Makes one 9½-inch tart or 6 servings

Tart Dough (recipe follows)
1 large egg
2 egg yolks (from large eggs)
2 tablespoons sugar
¾ cup heavy cream
A 4-inch piece of vanilla bean
2 tablespoons kirsch
1 drop almond extract (optional)
1 pound fresh ripe cherries, pitted (3 cups pitted)
Unsalted butter for greasing tart pan

SPECIAL UTENSILS:
9½-inch tart pan, 1 inch tall with a removable bottom
Pie weights (or about 3¼ cups uncooked rice or dried beans)

Prepare the Tart Dough.

ROLL OUT THE DOUGH:

Generously butter the tart pan; set aside. Lay out a piece of parchment or waxed paper on a work surface and lightly sprinkle with flour. Place dough in the center and flatten it slightly; lightly flour top, cover with another piece of parchment or waxed paper, and roll out to a ⅛-inch thickness; if dough sticks excessively to paper while rolling, lightly flour dough again. Peel off top piece of paper and carefully invert dough onto the prepared tart pan. Peel off the second sheet of paper and line bottom and sides of pan evenly with the dough, pressing it gently into place. Trim the edges and prick the dough lining the pan bottom several times with a fork. Refrigerate for at least 30 minutes or overnight. (If short on time, freeze for 15 minutes.)

TO MAKE THE FILLING AND FINISH THE TART:

(See photograph page 129.) Heat oven to 375 degrees. In a medium-size heatproof bowl, combine the egg, egg yolks, and sugar, whisking vigorously until thick and pale yellow, about 2 minutes.

Place the cream in a small saucepan; cut the vanilla bean in half lengthwise, scrape, and add scrapings and bean halves to the pan. Bring to a boil, then remove from heat, and gradually add to the egg-sugar mixture, whisking constantly until sugar dissolves. Stir in the kirsch and, if using, the almond extract. Set filling aside.

Now cover the prepared tart shell with aluminum foil and place pie weights (or rice or beans) in the bottom and up the sides. Place pan on a cookie sheet and bake until edges are very light brown and firm to the touch, about 15 minutes. Remove pie weights and foil. If crust on pan bottom is not cooked through, continue baking (without weights or foil) until lightly browned, 5 to 7 minutes more. Remove pan from oven; leave oven setting at 375 degrees.

Arrange the cherries in a single layer in the cooked crust. Remove vanilla beans from the filling (rinse and save beans for future use) and pour over the cherries. Place tart, uncovered and still on the cookie sheet, in the 375 degree oven and bake until filling is firm and edges of crust are golden brown, 25 to 30 minutes. Let cool at room temperature for about 2 hours before serving. Once cooled, refrigerate if not serving fairly promptly. (This tart is at its best if served the same day it's made.)

TART DOUGH

¼ cup sugar
½ teaspoon very finely grated lemon zest
6 tablespoons unsalted butter, softened
½ large lightly beaten egg
¼ teaspoon vanilla extract
Pinch of salt
1 cup all-purpose flour, sifted

On a cutting board or plate, combine 1 teaspoon of the sugar with the lemon zest, kneading with the back of a spoon until it becomes a paste. Place the paste in the medium-size bowl of an electric mixer. Add the butter, the remaining 3 tablespoons plus 2 teaspoons sugar, the egg, vanilla extract, and salt. Beat at medium speed until light and creamy, 1 to 2 minutes, scraping sides down as needed. Turn speed to low and gradually add the flour, beating just until well blended; do *not* overbeat. Form dough into a ball and cover with plastic wrap. Refrigerate for at least 2 hours or overnight before rolling out. Freeze if made more than 1 day ahead; thaw before using. *Makes 9 ounces of dough or enough for one 9½-inch tart.*

POTATO RAVIOLI WITH SEA SCALLOP FILLING

Makes 4 first-course servings or about 20 ravioli

FILLING:

1 medium vine-ripened tomato (about 7 ounces), peeled and quartered
4 cups Lobster Consommé or Lobster Stock (page 214) (preferred), other Consommé or Stock (page 214), or water
6 ounces sea scallops, rinsed and small tough muscle on the side of each removed
1 teaspoon lemon juice
Fine sea salt and freshly ground black pepper
2 tablespoons very finely sliced chives (preferred) or very finely chopped spring (green) onion tops
1 teaspoon minced fresh cilantro leaves
2 tablespoons lemon juice
3 large well-shaped russet potatoes, scrubbed (about 3½ pounds; see Note)
1 tablespoon extra-virgin olive oil
Vegetable oil for deep frying
2 to 3 egg yolks (from large eggs)
Fine sea salt and freshly ground black pepper
Snipped chives for garnish (optional)
Fresh cilantro leaves for garnish (optional)

SPECIAL UTENSILS:
Mandoline or similar slicer
Fine mesh strainer
Oval-shaped cookie cutter with pointed ends, 3½ inches long and 1¾ inches wide at the widest part

NOTE:

You may only need 2 potatoes, but it's a good idea to have an extra one in case any potato slices rip. The potatoes should be at least 4½ inches long.

START THE FILLING:

Place the tomato quarters skinned side down. With a sharp thin-bladed knife, slice off and discard the top soft portion of each, leaving a ½-inch-thick slice of firm tomato pulp. Cut these slices into ⅛-inch squares and place in a medium-size bowl. Set aside.

Bring the consommé to a slow simmer in a large skillet. Add the scallops and continue to simmer for 1 minute. Remove from heat. Drain on paper towels. With a sharp thin-bladed knife, cut scallops into ⅛-inch slices and cut these slices into ⅛-inch cubes. Add cubes and the 1 teaspoon lemon juice to the reserved tomato squares and season generously with salt and pepper. Cover scallop-tomato mixture and refrigerate. (This may be done several hours ahead.)

PREPARE THE POTATO SLICES:

Place the 2 tablespoons lemon juice in a medium-size bowl. With the mandoline, slice 2 of the unpeeled potatoes lengthwise into paper-thin slices, tossing them with the lemon juice as made. (If desired, slice the third potato now, or wait to see if it's needed.) Set aside or, if prepared ahead, cover with plastic wrap directly on the slices and refrigerate. (This may be done several hours ahead.)

FINISH THE FILLING AND ASSEMBLE THE RAVIOLI:

For the filling, mix the sliced chives and minced cilantro into the reserved scallop-tomato mixture. Heat the olive oil in a small nonstick skillet over high heat, 2 to 3 minutes. Add the filling and sauté for 1 minute, stirring constantly. Remove and season to taste with salt and pepper. Drain filling in the strainer, forcing out all liquid possible; discard liquid. Set aside.

Flash-fry the potato slices as follows: Heat the vegetable oil in a deep fryer until very hot and just short of smoking. Meanwhile, drain potato slices and blot thoroughly dry with a cloth dishtowel. Have ready another cloth towel for draining the fried slices. Once oil is very hot, flash-fry the slices in small batches just 5 to 10 seconds to soften them (as soon as you put a batch of slices into the oil, start removing them); do not let slices brown or start to get crisp. Drain on the cloth towel.

Line a cookie sheet with parchment or waxed paper. In a small bowl, lightly beat 2 of the egg yolks (you may not need the third). Making 4 ravioli at a time, first blot 8 of the potato slices with a cloth towel to absorb as much oil as possible. Brush tops of 4 of the slices evenly with some of the egg yolk and mound 2 teaspoons filling in the center of each; then brush the remaining 4 slices with egg yolk and cover the first slices with them, egg yolk side down. Next, press edges firmly together with your fingertips to seal, forming a ⅛-inch or wider border around each and forcing out as much air as possible from the filling. Cut each ravioli into an oval shape with the cookie cutter, making sure filling is centered in the oval. Place finished ravioli on the prepared cookie sheet, then double-check that edges are still completely sealed; if not, coat edges with more egg yolk. (If ravioli don't stay completely sealed after using more egg yolk, there is too much moisture in the filling and/or on the potato slices; to correct this, disassemble any ravioli that aren't sealed, then drain all filling, and blot all potato slices again.) Continue making ravioli until all filling is used; you will have enough for about 20 ravioli.

Once all ravioli are made, fry immediately or cover and refrigerate if using within 1 hour, or freeze if made further ahead. (Cover cookie sheet with aluminum foil and freeze until ravioli are frozen hard, then transfer them to a freezer container and return to freezer. These may be kept frozen up to 2 weeks; do not thaw before frying.)

TO FRY AND SERVE:

First, heat serving plates in a 250 degree oven.

In a large deep fryer or large pan, heat the oil to 400 degrees. Fry ravioli in no more than 2 batches, without crowding, so they can be served quickly while still very crisp. (Note: The frying time is the same for freshly made or frozen ravioli.) Fry in the hot oil about 30 seconds or just until golden brown and hot in the centers, turning at least once. Drain briefly on paper towels, blot tops with more towels, and season with salt and pepper. Transfer to the heated serving plates and garnish with snipped chives and cilantro leaves, if desired. Serve promptly.

CHILLED CONSOMME OF THREE MELONS AND SAUTERNES with JULIENNE VEGETABLES AND MINT

Makes 4 servings

⅛ medium-size ripe watermelon (about 2½ pounds)
½ medium-size ripe honeydew melon, seeded (about 1¾ pounds)
½ medium-size ripe cantaloupe, seeded (about 1 pound)
1¼ cups plus 2 tablespoons high-quality Sauternes wine, such as Château Nairac 1974 or Château Silhot 1971, 1974, or 1982
3 cups Meat or Vegetable Consommé (page 214)
¼ cup unpeeled finely chopped carrots

¼ cup finely chopped celery
¼ cup finely chopped onions
¼ cup finely chopped leeks (white and green parts)
¼ cup unpeeled finely chopped turnips
¼ cup unpeeled finely chopped tomatoes
2 tablespoons finely chopped shallots
4 large parsley sprigs
1 large garlic clove, peeled and minced
1 cup egg whites (from about 8 large eggs)
Fine sea salt and freshly ground black pepper
Salt water (1 tablespoon coarse salt mixed with 3 cups water) for cooking julienne vegetables for garnish
⅓ cup peeled and julienned carrots (2 x ⅛-inch strips) for garnish
⅓ cup scraped and julienned celery (2 x ⅛-inch strips) for garnish
Ice water for cooling cooked julienne vegetables for garnish
⅓ cup julienne leeks (white part only; 2 x ⅛-inch strips) for garnish
12 large fresh mint or lemon verbena leaves, cut into a fine julienne for garnish
Tiny fresh mint or lemon verbena leaves for garnish

SPECIAL UTENSILS:
1-inch melon baller
Fine mesh strainer
Deep 4-quart saucepan or other large deep pot with a relatively small (about 8-inch) diameter, so that a fairly thick crustlike layer can form across the consommé as it clarifies
Chinois
Cheesecloth

PREPARE THE MELON BALLS AND MELON CONSOMME:

Use the melon baller to make 16 to 18 well-formed melon balls from *each* of the three melons; seed the watermelon balls as you form them. (You will only need about 40 melon balls total, but this will give you extras.) Place in a bowl and add ¼ cup of the wine; cover and refrigerate until ready to use.

Scoop out and combine enough of the remaining pulp from the three melons to yield 4 cups, being sure to remove all seeds. Purée the pulp in a food processor (it will be very watery), then strain through the strainer into a bowl, using the bottom of a sturdy ladle to force as much through as possible; the strained purée should yield about 2 cups.

Place the strained purée in the saucepan; add the consommé and 1 cup of the wine and bring to a boil. Meanwhile, in a food processor, mince together the carrots, celery, onions, leeks, turnips, tomatoes, shallots, parsley sprigs, and garlic. Transfer mixture to a large bowl and add the egg whites, mixing thoroughly. Add mixture to the boiling melon purée-consommé-wine mixture and bring to a very slow simmer, stirring very gently during the first 2 to 3 minutes of cooking to prevent sticking (disturb the surface as little as possible while stirring so that a layer of solids can start forming across it). Reduce heat and, *without stirring*, continue very slowly simmering 45 minutes more. Remove from heat.

Strain the melon consommé through the chinois lined with damp cheesecloth, precisely as directed for straining any consommé (see Consommé, page 214, for how to do this); then cover and refrigerate until well chilled, at least 3 hours or overnight.

COOK THE JULIENNE VEGETABLE GARNISH:

Bring the salt water to a rolling boil in a medium-size pot. Add the carrots and 30 seconds later add the celery and leeks; cook until tender, about 1½ minutes. Immediately drain and cool in the ice water; drain on paper towels;

set aside. (Refrigerate if prepared ahead; this may be done several hours in advance.)

TO SERVE:

(See photograph pages 132-133.) Chill 4 wide soup bowls. Just before serving, add the remaining 2 tablespoons wine to the melon consommé and season to taste with salt and pepper. Arrange about 10 drained melon balls in the bottom of each chilled soup bowl and ladle about ½ cup melon consommé over them. Sprinkle ¼ of the vegetables and julienne mint (or lemon verbena) around but not on the melon balls in each bowl and garnish melon balls with tiny mint leaves. Serve immediately.

TERRINE OF FOIE GRAS AND SPRING ONIONS with PROSCIUTTO AND FRESH HERB TOMATO SAUCE

Makes 22 (½-inch) slices or 1 (11 x 3¼ x 2½-inch) terrine

Salt water (½ cup coarse salt mixed with 6 quarts water) for cooking spring onions
3 pounds spring (green) onions, cut into ¼-inch slices (3 quarts sliced)
Ice water for cooling cooked spring onions
4 (¼-ounce) packages unflavored gelatin
1½ cups *cold* Meat or Vegetable Consommé (page 214)
1¼ pounds semi-preserved 100-percent duck or goose foie gras, well chilled (see Note)
Fine sea salt and freshly ground black pepper
Prosciutto and Fresh Herb Tomato Sauce (recipe follows)
A few drops heavy cream for garnish (optional)

SPECIAL UTENSIL:
Pâté terrine mold, 5-cup capacity, inside dimensions 11 inches long, 3¼ inches wide, and 2½ inches deep

NOTE:

If available, use the 2¾-inch-diameter log, since slices from it will fit into the terrine mold called for in this recipe. See the Note on the recipe for Foie Gras in Brioche, pages 206-207, for more about this type of foie gras.

To cook the spring onions, bring the salt water to a rolling boil in an 8-quart or larger pot. Add the onions and cook over high heat just until tender, about 5 minutes. Immediately drain and cool in the ice water; drain on paper towels. Wrap in a clean cloth towel, squeeze dry, and place in a medium-size bowl. Season generously with salt and pepper. Set aside.

For the aspic, soften the gelatin in ½ cup of the consommé for about 2 minutes. Bring the remaining 1 cup consommé to a boil in a small pot, then remove from heat and stir in the gelatin; return to high heat and cook and stir just a few seconds until gelatin completely dissolves. Add the aspic to the bowl with the spring onions; set aside (do not refrigerate).

Now slice the foie gras. To do this, line a cookie sheet with parchment or waxed paper; set aside. Heat a sharp thin-bladed knife in hot water and wipe dry; then, if using the 2¾-inch foie gras log, cut it crosswise into ½-inch slices, heating and drying knife before cutting each slice; if using foie gras of another shape or diameter, cut into ½-inch-thick slices that are as close in size to the width and length of the mold as possible (so they require a minimum amount of trimming and piecing together when layered in the mold). With a spatula, transfer slices in a single layer to the prepared cookie sheet, being careful to keep them intact. Season tops generously with salt and pepper; set aside.

ASSEMBLE THE TERRINE:

First, divide the spring onion-aspic mixture into 4 portions; make 2 of the portions slightly larger than the other 2 (the larger ones will be used to form the bottom and top layers of the terrine). Place 1 of the larger portions in the bottom of the ungreased terrine mold, spreading it out evenly. Cover with ⅓ of the foie gras slices, trimming them to fit the mold and filling in any large gaps with the trimmings. Next, add 1 of the smaller portions of spring onions, working some of the onions between the foie gras and sides of mold so that the unmolded terrine will be completely covered with onions. Add another ⅓ of the foie gras slices and cover with another smaller portion of onions, add the last ⅓ foie gras slices, then add the final (larger) layer of onions. Cover well and refrigerate at least overnight or up to 2 days before serving.

FINISH THE DISH:

One day ahead or early on the day of serving, make the Prosciutto and Fresh Herb Tomato Sauce; refrigerate until ready to serve.

At least 2 hours before serving, unmold the terrine as directed for the Terrine of Foie Gras, Black Truffles, and Tricolored Pasta (see Finish the dish, page 177). Once the terrine is unmolded, pat spring onions into place so no foie gras shows through. Cover loosely and refrigerate until ready to serve.

TO SERVE:

(See photograph page 134.) Serve as directed for the Terrine of Foie Gras, Black Truffles, and Tricolored Pasta, page 177.

PROSCIUTTO AND FRESH HERB TOMATO SAUCE

¼ cup extra-virgin olive oil
1½ cups chopped onions
½ cup chopped shallots
2 tablespoons chopped garlic
½ pound prosciutto, finely chopped
6 cups peeled and coarsely chopped vine-ripened tomatoes
2 cups Meat or Vegetable Consommé (page 214) (preferred) or Meat or Vegetable Stock (page 214)
1 cup Chardonnay wine
1 cup V-8 Juice
1 (6-ounce) can tomato paste
3 cups (about 2 ounces) loosely packed fresh basil leaves
15 large parsley sprigs
10 very leafy thyme sprigs
1 tablespoon fine sea salt
About 30 turns freshly ground black pepper
15 dill sprigs (optional)
7 sage sprigs (optional)

SPECIAL UTENSIL:
Very fine mesh strainer or chinois

Heat the oil in a nonreactive 6-quart saucepan or casserole over high heat for 1 minute. Add the onions and shallots and sauté about 1 minute, stirring occasionally. Add the garlic and cook 1 minute; add the prosciutto and cook 1 minute more. Add the tomatoes, 2 cups of the consommé, the wine, V-8 Juice, tomato paste, basil leaves, parsley and thyme sprigs, salt, pepper, and, if using the dill and sage sprigs, stirring. Bring to a boil. Reduce heat and strongly simmer for 1 hour, stirring occasionally. Purée mixture in batches in a blender and strain purée through the strainer or chinois, using the bottom of a sturdy ladle to force as much through as possible. Refrigerate until well chilled, at least 3 hours or overnight, before serving. If needed, thin with more consommé just before serving. Makes about 5 cups.

SAUTEED SWORDFISH AND OSSETRA CAVIAR CAKES with CAVIAR SAUCE

Makes 4 servings

¼ pound (1 stick) unsalted butter, softened
2 ounces (3 tablespoons plus ½ teaspoon) pressed caviar
1¾ pounds swordfish or tuna steaks, cut crosswise (against the grain) into ½-inch slices (see Note)
Freshly ground black pepper
2 tablespoons extra-virgin olive oil
1 cup (about 10 ounces) ossetra or other top-quality caviar
2 tablespoons Lobster Consommé (page 214) (preferred), Lobster Stock (page 214), or other Consommé or Stock (page 214)

SPECIAL UTENSIL:
2¾-inch cookie cutter

NOTE:

Make sure the steaks are broad enough for cutting rounds from them with a 2¾-inch cookie cutter; the slices should be uniformly thick.

START THE SAUCE:

Process the butter and pressed caviar in a food processor until very creamy. Cover caviar butter and refrigerate until firm, at least 1 hour or overnight.

TO MAKE THE CAKES AND SERVE:

(See photograph pages 134-135.) Heat oven to 400 degrees. Use the cookie cutter to cut out 12 rounds from the swordfish slices. Season rounds on both sides with pepper.

Heat the oil in a very large skillet (preferably nonstick) over high heat, about 4 minutes. Add 6 of the swordfish rounds to the very hot skillet and sauté for 30 seconds on each side. Immediately remove from skillet and drain on paper towels; blot tops and cover with more towels to prevent drying out. (The rounds must be quite rare at this point, since they will be cooked further once the cakes are assembled and swordfish should be served rare.) Repeat with the remaining 6 rounds.

To form each cake, place a swordfish round in the center of an ovenproof serving plate; use a butter knife to spread 4 teaspoons of the caviar over the top and sides of the round; cover with another swordfish round and spread top and sides with 4 teaspoons more caviar; cover with a third swordfish round, spread with 4 teaspoons more caviar, then smooth all surfaces of finished cake to make a pretty presentation. Once all cakes are assembled, transfer plates to the preheated oven and bake uncovered just until heated through, 4 to 6 minutes; watch carefully so that heat from the plates doesn't curdle the caviar.

Meanwhile, finish the sauce by combining the reserved chilled caviar butter and consommé in a small heavy saucepan. Cook over high heat just until butter melts and sauce is heated, whisking constantly; do *not* overheat or the caviar will curdle. Remove from heat and season to taste with pepper. Spoon about 2 tablespoons sauce on each plate and serve immediately.

SAUTEED PUERTO RICAN SHRIMP with SHRIMP QUENELLES, CHANTERELLE MUSHROOMS, and CHANTERELLE MUSHROOM SAUCE

Makes 4 servings

5 ounces fresh chanterelle mushrooms, brushed clean

5½ tablespoons extra-virgin olive oil
Fine sea salt and freshly ground black pepper
¼ pound (1 stick) unsalted butter, softened
29 large unpeeled shrimp tails (Puerto Rican shrimp preferred; about 1½ pounds), peeled and deveined (see Note)
⅓ cup plus 1 tablespoon heavy cream
1 teaspoon very finely sliced chives
½ teaspoon Lobster Coral Garnish (page 215) (optional)
2 or 3 thyme sprigs, snipped into tiny pieces for garnish
2¼ cups plus 3 tablespoons Lobster Consommé (page 214) (preferred), Lobster Stock (page 214), or other Consommé or Stock (page 214)
4 shrimp heads, rinsed and drained well for garnish (optional; see Note)

SPECIAL UTENSILS:
Very fine mesh strainer
Chinois

NOTE:

If unpeeled shrimp tails are not available, use 29 (about 1¼ pounds) large peeled and deveined shrimp; 24 of the tails are for sautéing and the other 5 (about ¼ pound peeled) are for the quenelles. If using shrimp heads for garnish, get them when you buy the shrimp.

PREPARE THE CHANTERELLES AND START THE SAUCE:

Select 24 of the smallest, most attractive whole chanterelles and separate their caps and stems; set stems aside. Heat 1½ tablespoons of the oil in a large skillet (preferably nonstick) over high heat until very hot, about 3 minutes. Add the chanterelle caps, season with salt and pepper, and sauté about 1 minute, stirring almost constantly. Reduce heat to medium and continue cooking for 5 minutes more, stirring occasionally. Remove from pan with a slotted spoon and drain on paper towels. Cover and reserve, refrigerated, for garnishing the plates.

In the same hot skillet, heat 1 tablespoon more oil over high heat for about 30 seconds. Add the reserved chanterelle stems and the remaining whole chanterelles and season lightly with salt and pepper; cook and stir for 5 minutes. Drain on paper towels, let cool to room temperature, then process in a food processor with the butter until smooth and creamy. Cover chanterelle butter and refrigerate until firm, at least 1 hour or overnight.

PREPARE THE QUENELLE MIXTURE:

Purée 5 shrimp (about 4 ounces) and a little salt and pepper in a food processor; add the cream and continue processing just a few seconds until well blended; do *not* overmix. Strain through the strainer, using the bottom of a sturdy ladle to force as much through as possible; the strained purée should yield about ½ cup. Stir in the chives and, if using, the Lobster Coral Garnish. Cover and refrigerate until ready to form the quenelles. (This mixture may be prepared several hours ahead.)

START ASSEMBLING THE PLATES:

Arrange 6 of the reserved sautéed chanterelle caps in a large circle on each of 4 ovenproof serving plates; arrange 2 or 3 snippets of thyme on each cap. Cover plates with plastic wrap and set aside. (The plates may be assembled to this point up to 2 hours ahead.)

FINISH THE SAUCE:

In a small heavy saucepan, combine the reserved chilled chanterelle butter with ¼ cup plus 3 tablespoons of the consommé; heat over high heat just until butter melts, whisking constantly. Strain through the chinois, using the bottom of a sturdy ladle to force as much through as possible; the strained sauce should

yield about ⅔ cup. Return to the saucepan and season to taste with salt and pepper; set aside. (This may be done up to 1 hour ahead.)

TO FINISH THE DISH AND SERVE:

(See photograph page 136) Heat oven to 350 degrees. For the quenelles, place the remaining 2 cups consommé in a small skillet and bring to a simmer; remove from heat. Separate the quenelle mixture into 12 equal portions and mold each into a quenelle (oval shape) with 2 teaspoons; as formed, ease the quenelle into the hot consommé. Once all quenelles are formed, return skillet to low heat and heat (do not let consommé reach a simmer) just until cooked through, about 3 minutes; set aside in the hot consommé.

To sauté the shrimp, place the remaining 3 tablespoons oil in a very large skillet (preferably nonstick) and heat over high heat, about 3 minutes. Add the remaining 24 shrimp, season generously with salt and pepper, and sauté just until cooked through, about 2 minutes on the first side and 1½ minutes on the second side; do *not* overcook. Drain on paper towels.

Meanwhile, unwrap serving plates and heat in the preheated oven just until chanterelle caps are hot, about 3 minutes. Also now reheat sauce.

Once serving plates are heated, arrange 6 of the sautéed shrimp in the middle of each plate and to one side add 3 drained quenelles (use a slotted spoon). Spoon 2 to 3 tablespoons sauce over each serving and, if desired, garnish plates with shrimp heads. Serve immediately.

RACK OF VEAL STUFFED WITH HONEY MUSHROOMS with PAILLASSON POTATOES and THYME SAUCE

Makes 4 generous servings

1 recipe Thyme Sauce (see recipe for Roasted Rabbit Tenderloins, pages 198-199)
¾ cup plus 1 tablespoon vegetable oil
1¼ pounds small fresh honey mushrooms or mousseron mushrooms, stems discarded and caps brushed clean (do *not* eat honey mushrooms raw)
1 (5-bone) rack of veal (about 3½ pounds trimmed)
About ¾ pound pork caul fat (see Note)
Fine sea salt and freshly ground black pepper
1¾ pounds Finnish potatoes (preferred) or russet potatoes
1 tablespoon lemon juice
30 thyme sprigs (very leafy single stems, each 4 to 5 inches long)
Thyme sprigs for garnish (optional)

SPECIAL UTENSILS:
Pastry bag without a nozzle
Kitchen twine
Mandoline or similar slicer with a julienne attachment

NOTE:
Caul fat is available from butcher shops. Ask for pieces with few if any holes and ones without extra-large veins of fat running through them; refrigerate, soaking in water, until used.

Make the sauce through the point of adding the 10 thyme sprigs; refrigerate.

STUFF THE VEAL:

Heat ¼ cup of the oil in a very large skillet (preferably nonstick) over high heat until very hot, 4 to 5 minutes. Add the mushrooms and sauté for 1 minute, stirring frequently. Reduce heat to medium and continue cooking until well browned, about 6 minutes more, stirring occasionally. Drain on paper towels and let cool to room temperature.

With a long thin-bladed knife, make a 1- to 1½-inch-wide slit lengthwise through the center of the veal to form a pocket. Place 2 cups of the cooled mushrooms in the pastry bag (set aside remaining mushrooms for the potato dish) and pipe into the veal pocket, filling it as full as possible. Remove any leftover mushrooms from the pastry bag and add to mushrooms reserved for the potatoes.

Rinse the caul fat well and squeeze dry; then wrap the veal rack securely with a double layer of caul so the stuffing won't fall out when cooked. Next, tightly wrap veal with several rings of kitchen twine lengthwise and crosswise, including between each rib, so the meat keeps its shape while cooking. Season generously on all surfaces with salt and pepper. Set aside. (Refrigerate if prepared ahead; this may be done several hours in advance.)

START THE POTATO DISH:

Peel the potatoes and finely julienne them with the mandoline, making strips about 3 inches long and no wider than ¹⁄₁₆ inch; as cut, place in a bowl and toss with the lemon juice. Cover with plastic wrap directly on the surface of the potatoes; refrigerate. (This may be done up to 2 hours ahead.)

TO FINISH THE DISH AND SERVE:

(See photograph page 137) Heat oven to 500 degrees. For the veal, place 3 tablespoons of the oil in a large heavy roasting pan; heat over high heat on the stove until very hot, 4 to 5 minutes. Carefully add the 30 thyme sprigs to the center of the pan and place the caul-wrapped veal on top. Brown veal on all surfaces, 12 to 14 minutes; end with bone side down. Transfer pan, uncovered, to the preheated oven and roast until medium rare, about 30 to 35 minutes, or until a meat thermometer inserted in the thickest part of the meat registers about 135 degrees; the cooking time will be longer if veal was chilled before roasting. Remove from oven and immediately reduce oven setting to 450 degrees for cooking the potatoes. Let veal sit about 10 minutes, then unwrap the twine, leaving caul in place. With a long thin-bladed knife, slice veal between the ribs into 4 equal portions. Cover to keep warm while cooking the potato dish.

To finish the potato dish, squeeze the potatoes dry, then season generously with salt and pepper. Place 2 tablespoons of the oil in a large ovenproof skillet (preferably nonstick); heat over high heat, about 3 minutes. Add ½ of the potatoes to the hot skillet, spreading them out evenly and packing them down with the back of a spoon. Cook about 1 minute, constantly shaking pan in a back and forth motion so they don't stick. Add the reserved mushrooms evenly over the top, then add 2 tablespoons more oil, then the remaining potatoes, spreading and packing this second layer of potatoes as you did the first. Continue cooking and shaking pan in a back and forth motion until potatoes are well browned on the underside, about 2 minutes more. Remove skillet from heat momentarily and carefully flip potato mixture over with 2 spatulas as you would a pancake, keeping it in 1 piece. Return skillet to high heat and add the remaining 2 tablespoons oil; continue cooking until well browned on the underside, about 2 minutes more. Immediately transfer skillet, uncovered, to the 450 degree oven and bake until potatoes are cooked through, about 15 minutes.

Meanwhile, reheat sauce, then remove and discard thyme sprigs; keep warm over very low heat.

When the potatoes have finished cooking, slip them out of the skillet in 1 piece onto paper towels to drain briefly; meanwhile heat the serving plates in the hot oven a minute or so. Cut potatoes into 4 wedges and season tops lightly

with salt and pepper. Serve immediately.

To serve: On each heated serving plate place a portion of veal (still wrapped in caul) and a wedge of potatoes; spoon about 2 tablespoons sauce around the veal and, if desired, garnish with thyme sprigs.

PEACH CHARLOTTES with PEACH SAUCE

Makes 4 servings

2½ cups peeled and finely chopped firm ripe peaches
1½ cups plus 3 tablespoons sugar
A 2-inch piece of vanilla bean
3 tablespoons unsalted butter for sautéing the chopped peaches
1 pound white bread, cut into ¼-inch slices with crusts trimmed away
½ pound unsalted butter, melted
1½ cups peeled and coarsely chopped firm ripe peaches mixed with 2 tablespoons lemon juice
About 2 to 3 tablespoons peach liqueur
Sugar water (2 tablespoons sugar mixed with 3 cups water) for cooking peach-wedge garnish (optional)
1 cup firm ripe peach wedges (¼-inch-thick wedges) for garnish (optional)
Small and tiny fresh mint leaves for garnish (optional)
About 1 tablespoon Raspberry Sauce (see recipe for Persimmon Cake, page 184) for garnish (optional)

SPECIAL UTENSILS:
Fine mesh strainer
2 round cookie cutters, one about ½ inch in diameter wider than the inside bottom of the soufflé dishes used in this recipe and the other about ½ inch wider than the inside top of the dishes
4 (¾ cup-capacity) individual soufflé dishes, about 3 inches in diameter and about 1½ inches deep

MAKE THE CHARLOTTES:

Heat oven to 500 degrees. Combine the 2½ cups finely chopped peaches and 3 tablespoons of the sugar in a bowl; cut the vanilla bean in half lengthwise, scrape, and add the scrapings and bean halves to the bowl. Melt the 3 tablespoons butter in a large nonstick skillet over medium heat. Add the peach-sugar-vanilla mixture and sauté until peaches are tender but still firm, 2 to 3 minutes, stirring occasionally. Drain peaches in the strainer placed over a medium-size bowl for about 15 minutes. Set aside ⅔ cup of the strained liquid for the sauce; if the liquid yields less than ⅔ cup, add peach liqueur or water to make ⅔ cup (keep in mind that you will add at least 2 tablespoons peach liqueur to this liquid when finishing the sauce). Remove the vanilla bean halves from the strainer and rinse; reserve for the sauce. Set peaches aside in the strainer.

Meanwhile, prepare the soufflé dishes as follows: Use the cookie cutter that is slightly wider than the inside bottom of the soufflé dishes to cut out 4 rounds of bread for lining the bottoms of the dishes. With the other cookie cutter, cut out 4 more bread rounds for lids for the dishes. Cut the remaining bread into rectangles for lining the walls of the dishes with a single layer of bread; cut the rectangles fairly large so they can be compressed to fit snugly together without any gaps.

Place the ½ pound melted butter in a bowl and the remaining 1½ cups sugar in a separate bowl. Remove all bread from the soufflé dishes and butter dishes with some of the melted butter. Next, dip 1 of the bread rounds for lining the bottoms of the dishes into the butter just for

a second to moisten both sides; then dredge round in the sugar, smoothing it to coat evenly, and place in the bottom of 1 of the soufflé dishes. Repeat with remaining 3 bottom rounds. Butter and sugar the bread rectangles in the same fashion and line the sides of the dishes with them; then fill dishes with the drained peaches, using them all. Now butter and sugar the lids as you did the other bread and compress them into place on top of the charlottes, completely sealing the peaches inside.

Wipe the outside of the soufflé dishes well with a damp cloth so the sugar doesn't caramelize on them during baking. Completely cover the dishes with aluminum foil to seal tightly; fold excess foil underneath and flatten it so dishes sit level. Refrigerate if prepared ahead.

Place the foil-wrapped charlottes in a 2-inch deep baking pan lined with foil. Bake in the preheated oven until the sugar on the charlotte tops and sides starts to caramelize, about 1 hour. (To test doneness, after 45 minutes of cooking, very carefully remove a charlotte from the pan with tongs; any drippings will be extremely hot. Unwrap foil and insert a knife between the side of the dish and the bread so you can check its color; if it's dark golden brown, it's done. If not done, wrap charlotte with a fresh piece of foil and continue baking.)

Meanwhile, make the sauce and, if using, prepare the peach wedge garnish.

MAKE THE SAUCE:

Combine the reserved ⅔ cup cooking liquid and reserved vanilla bean halves in a large nonstick skillet; heat over medium heat for 1 minute. Add the 1½ cups coarsely chopped peaches and any of their juices; simmer for 5 minutes, stirring occasionally. Remove from heat and discard vanilla beans, then purée mixture in a blender with 2 tablespoons of the peach liqueur until smooth. If desired, thin sauce with more liqueur. Set aside.

MAKE THE PEACH WEDGE GARNISH:

Bring the sugar water to a boil in a small saucepan over high heat. Add the peach wedges and cook until tender, 1 to 2 minutes. Remove from heat and drain on paper towels. Set aside.

TO SERVE:

(See photograph page 138.) Once the charlottes have finished cooking, unmold each (remember any drippings are extremely hot). To do this, very carefully unwrap the charlotte and loosen sides with a knife, then invert a heatproof serving plate on top and quickly invert both, so the charlotte unmolds onto the center of the plate. When all charlottes are unmolded, let cool 10 minutes; then, if using, arrange the peach wedges in a half circle around the edges of the plates and garnish wedges with small mint leaves. Spoon about 3 tablespoons sauce on each plate opposite the peach wedges and, if desired, garnish with droplets of Raspberry Sauce and tiny mint leaves. Serve immediately.

CHOCOLATE "HATS" with THREE CHOCOLATE SAUCES

Makes 4 servings

CHOCOLATE ROUNDS:
4 ounces semisweet chocolate, cut into small pieces
Vegetable oil for greasing parchment paper
4 ounces white chocolate, cut into small pieces
CHOCOLATE SAUCES:
1½ ounces semisweet chocolate, cut into small pieces

1½ ounces white chocolate, cut into small pieces

1½ ounces bittersweet chocolate, cut into small pieces

¾ cup heavy cream

4 teaspoons unsalted butter

1 tablespoon sugar

3 tablespoons chocolate liqueur or Grand Marnier

Three Chocolate Mousses (recipe follows)

3 ounces semisweet chocolate, cut into shavings for garnish

Sifted powdered sugar for garnish

SPECIAL UTENSILS:

Long thin metal spatula

2 perfectly flat cookie sheets, each about 16 x 11 inches

2½-inch cookie cutter

Pastry bag fitted with a ¼-inch plain nozzle

MAKE THE CHOCOLATE ROUNDS:

Melt the semisweet chocolate pieces in the top of a double boiler over slowly simmering water, stirring occasionally. Place a piece of parchment paper cut to the size of the cookie sheets on a work surface and very lightly grease with vegetable oil. Pour the melted chocolate on top of the paper, spreading it evenly with the metal spatula into a ¹⁄₁₆-inch-thick rectangle. Very carefully transfer this chocolate-lined paper to 1 of the cookie sheets and refrigerate until firm, about 30 minutes. Repeat with the white chocolate to form a ¹⁄₁₆-inch-thick rectangle and place on the second cookie sheet; refrigerate until firm. (Note: It's important to melt white chocolate very slowly, or it may become grainy.)

Once the semisweet and white chocolate rectangles are firm, cut out 10 perfect rounds from each rectangle as follows: Working in the coolest area of your kitchen, lay out another piece of parchment paper the same size as the cookie sheets; then remove the semisweet chocolate rectangle from the refrigerator and, working quickly before the chocolate softens, cut out 10 rounds from it with the cookie cutter. Place rounds in a single layer on the fresh parchment paper and immediately transfer paper to the cookie sheet that held the rectangle. Refrigerate promptly. (Note: You will only need 8 rounds but since they're very fragile, it's a good idea to cut 2 extras. If the chocolate gets too soft as you're cutting out the rounds, refrigerate it again for 15 minutes, then continue forming the rounds. If needed, melt cracked rounds and any scraps and repeat procedure to form 10 perfect rounds.) Reserve leftover semisweet chocolate, if desired, to make up some of the 1½ ounces semisweet chocolate needed for the sauce.

Now repeat with the white chocolate rectangle to cut out 10 perfect rounds from it; promptly refrigerate these rounds on the parchment paper with the semisweet rounds. If desired, reserve leftover white chocolate for use in the white chocolate sauce. (The rounds may be prepared a day ahead; keep covered and refrigerated until ready to use.)

MAKE THE SAUCES:

If using the leftover semisweet and white chocolate from making the chocolate rounds for the sauce, first weigh these leftovers and add more chocolate to make 1½ ounces of each; set aside separately.

Melt the bittersweet chocolate pieces in the top of a double boiler over slowly simmering water. Add ¼ cup of the cream, 2 teaspoons of the butter, and the sugar, stirring until sugar dissolves. Stir in 1 tablespoon of the chocolate liqueur or Grand Marnier and remove from heat. Set this bittersweet chocolate sauce aside.

To make the semisweet chocolate sauce, melt the 1½ ounces semisweet chocolate pieces in the

top of a double boiler over slowly simmering water. Stir in ¼ cup of the cream and the remaining 2 teaspoons butter, then 1 tablespoon of the liqueur. Remove sauce from heat and set aside.

To make the white chocolate sauce, melt the 1½ ounces white chocolate pieces in the top of a double boiler over slowly simmering water. Stir in the remaining ¼ cup cream, then the remaining 1 tablespoon liqueur; remove from heat and set aside. (These sauces may be made up to 2 hours ahead; do not refrigerate.)

Now make the Three Chocolate Mousses; set aside (do not refrigerate mousses, or they will be too thick to pipe through the pastry bag).

TO ASSEMBLE THE HATS AND SERVE:

(See photograph page 139) Place a semisweet chocolate round in the center of each of 4 dessert plates. Spoon the semisweet chocolate mousse into the pastry bag and pipe a ½-inch-thick layer onto each round, then cover with a white chocolate round; refrigerate for 10 minutes.

Meanwhile, rinse out the pastry bag and blot the inside dry, then spoon in the white chocolate mousse. Once the partially formed hats have chilled 10 minutes, remove from the refrigerator and pipe a ½-inch-thick layer of white chocolate mousse on top of each and cover with a second white chocolate round; refrigerate 10 minutes more.

Meanwhile, rinse and blot dry the pastry bag again and spoon the milk chocolate mousse inside. Once the hats have chilled the second 10 minutes, remove from refrigerator and pipe a ½-inch-thick layer of milk chocolate mousse on top of each and cover with a second semisweet chocolate round; then mound ¼ of the chocolate shavings on top of each hat to make it pointed and sprinkle with powdered sugar. (The plates may be assembled to this point up to 1 hour ahead and set aside at cool room temperature.)

Just before serving, spoon about 1 tablespoon of each of the 3 sauces around the edges of each hat and, if desired, garnish white chocolate sauce with droplets of the other 2 sauces.

THREE CHOCOLATE MOUSSES

2 ounces milk chocolate, cut into small pieces

2 ounces semisweet chocolate, cut into small pieces

2 ounces white chocolate, cut into small pieces

1 cup heavy cream

3 egg whites (from large eggs), at room temperature

½ teaspoon lemon juice

3 tablespoons sugar

Melt the 3 chocolates separately in the tops of double boilers over slowly simmering water (or in stainless steel mixing bowls resting on saucepans that contain 1 inch of slowly simmering water). Remove from heat, leaving the chocolates over the hot water.

Meanwhile, whip the cream until soft peaks form; refrigerate. Next, in the medium-size bowl of an electric mixer (make sure bowl is very clean), combine the egg whites and lemon juice; beat at low speed for about 30 seconds. Increase speed to medium and beat about 30 seconds until frothy bubbles begin to form, then add 2 tablespoons of the sugar and beat at medium for 30 seconds more. Increase speed to high, add the remaining 1 tablespoon sugar, and continue beating just until stiff peaks form, about 1 minute more.

Remove the reserved pans or bowls of melted chocolate from the hot water and place them on a work surface. For the milk chocolate mousse, add ⅓ of the reserved whipped cream and ⅓ of

the egg whites to the milk chocolate, gently folding with a rubber spatula until ingredients are barely blended; set milk chocolate mousse aside. To make the semisweet chocolate mousse, gently fold ½ of the remaining whipped cream and egg whites into the semisweet chocolate; set aside. For the white chocolate mousse, lightly fold the remaining whipped cream and egg whites into the white chocolate. *Makes about 1½ cups of each mousse.*

SMOKED SALMON, SMOKED ROCKFISH, AND SMOKED TUNA with OSSETRA CAVIAR AND SOUR CREAM SAUCE

Makes 4 servings

SAUCE:

⅓ cup dairy sour cream

2 tablespoons heavy cream

1 teaspoon lemon juice

½ teaspoon lime juice

Freshly ground black pepper

2 tablespoons plus 1 teaspoon ossetra caviar (about 1½ ounces)

Juice from ½ lime

Freshly ground black pepper

About 2½ ounces each smoked fillet of salmon, smoked fillet of rockfish, and smoked fillet of tuna (or any 3 of your favorite smoked fishes), cut into paper-thin slices

Mesclun or other small tender salad greens, such as radicchio, mache (lamb's lettuce, corn salad), or *frisée* (curly endive) for garnish (optional)

Small red, yellow, and green tomatoes of various shapes for garnish (optional)

Small fresh green and purple basil leaves for garnish (optional)

To start the sauce, combine the sour cream, heavy cream, lemon and lime juices, and a generous amount of freshly ground pepper in a medium-size bowl, mixing well. Cover and refrigerate if made ahead. (The sauce may be made to this point a day ahead.)

When ready to serve, rub a few drops of lime juice on each of 4 chilled serving plates and sprinkle plates with freshly ground pepper. Trim any dark or dry edges from the fish slices and arrange on the plates (see photograph pages 142-143). Gently stir 2 tablespoons of the caviar into the sauce. Top each portion of fish with ¼ of the sauce and garnish sauce with ¼ teaspoon more caviar. If desired, add the vegetable and herb garnishes. Serve immediately.

FOIE GRAS in BRIOCHE

Makes 4 first-course servings

4 (½-inch-thick) slices Brioche from large loaf (pages 214-215)

6 ounces semi-preserved 100-percent duck or goose foie gras, well chilled (if available, use the 2¾-inch-diameter log, since when sliced crosswise, it will fit into the hole cut in the Brioche without trimming; if not available, you will need enough semi-preserved foie gras for four ½-inch-thick rounds with 2¾-inch diameters; see Note)

Freshly ground black pepper

½ cup cold Meat or Vegetable Consommé (page 214) for aspic garnish (optional)

1 teaspoon unflavored gelatin for aspic garnish (optional)

About 1½ cups, loosely packed, small tender salad greens such as mache (lamb's lettuce, corn salad), mesclun, radicchio, or *frisée* (curly endive) for garnish (optional)

1 to 2 tablespoons Balsamic Vinaigrette (see recipe for Salad of Warm Sea Scallops, White Truffles, Fresh Hearts of Palm, and Mesclun, page 185) for garnish (optional)

SPECIAL UTENSIL:

2¾-inch cookie cutter

NOTE:

Be sure to use 100-percent foie gras. Semi-preserved foie gras is also known as "partially cooked," "half-cooked," "*semi-conserve*," or "*mi-cuit*" foie gras; these terms indicate that the

foie gras has been pasteurized and vacuum-packed (not sterilized and canned). Products such as "pâté of foie gras," "parfait of foie gras," and "mousse of foie gras" are *not* acceptable substitutes in this recipe since they are not 100-percent foie gras.

If using, make the aspic as follows: Combine the consommé and gelatin in a small saucepan; let gelatin soften for about 2 minutes, then cook over low heat until completely dissolved, 1 to 2 minutes, stirring constantly. Immediately pour aspic onto a wide deep serving plate to form a very shallow pool. Refrigerate until firm, about 30 minutes.

Meanwhile, preheat broiler. With the cookie cutter, cut a hole in the center of each slice of brioche. Cover slices and set aside.

Heat a sharp thin-bladed knife in hot water and wipe dry; then, if using the 2¾-inch-diameter foie gras log, cut it crosswise into four ½-inch-thick slices, heating and drying knife before cutting each slice. If using foie gras of another shape or diameter, cut into ½-inch-thick slices, then use the cookie cutter used for the brioche to cut the slices into 2¾-inch-diameter rounds. Toast the brioche on both sides under the preheated broiler, then carefully insert a foie gras round into the hole in each slice. Place slices on the serving plates and season top of foie gras lightly with pepper.

If using, now toss the salad greens with just enough vinaigrette to lightly coat them; arrange a portion near the edge of each plate. Remove the aspic from the refrigerator. Lift the sheet of aspic off the plate with your fingertips and break it into small pieces; mound ¼ on each serving of salad greens. Serve immediately.

HERB RAVIOLI AND SMOKED TUNA with JULIENNE VEGETABLES and HERB VINAIGRETTE

Makes 4 servings

VINAIGRETTE:
½ cup plus 2 tablespoons vegetable oil
¼ cup plus 2 tablespoons fine quality herb vinegar
2 tablespoons plus 2 teaspoons extra-virgin olive oil
½ teaspoon fine sea salt
Freshly ground black pepper
Leaves from 1 or 2 fresh herb sprigs (same herb as in vinegar) (optional)
RAVIOLI:
1 tablespoon water
1 cup plus 2 tablespoons finely ground semolina flour, plus flour for cookie sheet
2 large eggs, lightly beaten
1 tablespoon extra-virgin olive oil
½ teaspoon fine sea salt
About 4 tablespoons plus 2 teaspoons all-purpose flour, plus flour for rolling out dough
About 60 small or trimmed leaves from fresh herbs with thin flexible leaves (see Note)
2 quarts water for cooking ravioli
1 teaspoon coarse salt for cooking ravioli
1 teaspoon extra-virgin olive oil for cooking ravioli
Ice water for cooling cooked ravioli
Fine sea salt and freshly ground black pepper
14 ounces smoked fillet of tuna or salmon, cut into ⅛-inch-thick slices
Salt water (1 tablespoon coarse salt mixed with 3 cups water) for cooking vegetables
⅓ cup peeled and julienned carrots (2 x ⅛-inch strips)

⅓ cup scraped and julienned celery (2 x ⅛-inch strips)
⅓ cup julienne leeks (mostly white part; 2 x ⅛-inch strips)
Ice water for cooling cooked vegetables
Fresh herb leaves or snipped herb sprigs (same herb as in ravioli) for garnish

SPECIAL UTENSILS:
Pasta machine
2-inch round scallop-edged cookie cutter

NOTE:
Select thin flexible leaves so they don't rip the ravioli dough when rolled through the pasta machine. Some herbs that work especially well are basil, chervil, chives, cilantro, dill, sweet marjoram, parsley, and tarragon; thyme, sage, and rosemary do not work as well.

MAKE THE VINAIGRETTE:
Combine all the vinaigrette ingredients in a medium-size bowl, whisking until thoroughly blended. Refrigerate until ready to use.

MAKE THE RAVIOLI:
Place the 1 tablespoon water in the medium-size bowl of an electric mixer fitted with dough hooks or a paddle. Add the 1 cup plus 2 tablespoons semolina and the eggs, oil, and salt. Beat at medium speed until dough is elastic and somewhat spongy, 2 to 3 minutes. Add 4 tablespoons of the all-purpose flour, 1 tablespoon at a time, beating until well blended between additions. Once the last addition is mixed in, if the dough is still very sticky, add up to 2 teaspoons more all-purpose flour, 1 teaspoon at a time. Form dough into a ball, wrap with plastic wrap, and let rest at room temperature for about 1 hour. (If made ahead, refrigerate until 1 hour before rolling out.)

To roll out dough, cut the dough into 2 equal portions. Wrap 1 portion in plastic wrap and set aside. Lightly flour the remaining portion with all-purpose flour and roll through the pasta machine 10 times on the thickest setting; fold dough in half after each rolling. Next, roll dough through once on each setting, this time without folding in half after each rolling, progressing from the very thickest setting to the thinnest; if needed, lightly flour dough so it doesn't stick and cut into manageable lengths. Cover rolled-out dough with a dry towel and repeat procedure with reserved half of dough.

Thoroughly dry the herb leaves with paper towels. Flour a large cookie sheet with semolina; set aside. Next, cut a 5½ x 2½-inch rectangle from the dough; cover remaining dough. Cut the rectangle in half to form 2 rectangles, each 2¾ x 2½ inches. Arrange a small herb leaf to one side of each rectangle, then fold dough over to cover the leaf, forming 2 roughly square-shaped pieces of dough with a leaf centered in each. Now roll each square through the pasta machine on the thinnest setting and cut out with the cookie cutter to form 2 round scallop-edged ravioli, making sure leaves are centered or nearly so; place on the prepared cookie sheet. Repeat with remaining dough until you've formed at least 48 ravioli with no rips in the dough (you will have enough dough to make about 55 to 60 ravioli). Cook immediately or store uncovered at room temperature for up to 2 hours before cooking.

COOK AND MARINATE THE RAVIOLI AND PREPARE THE TUNA:
To cook the ravioli, combine the water, salt, and oil in a medium-size pot and bring to a rolling boil over high heat. Add a small batch of ravioli and cook uncovered to al dente stage, about 5 minutes. Immediately transfer with a slotted spoon to the ice water. Repeat with remaining ravioli, then drain and blot dry with dishtowels.

Process the vinaigrette in a blender for a few seconds to blend ingredients well; then use a pastry brush to brush a cookie sheet generously with some of it, leaving remaining vinaigrette in blender to remix just before using again. Lightly salt and pepper the pan. Arrange the ravioli in a single layer in the pan and brush tops with some of the vinaigrette. Let sit at room temperature 30 to 45 minutes before serving.

For the tuna, process the remaining vinaigrette a few seconds in the blender, then use the pastry brush to brush a separate cookie sheet generously with some of it; reserve at least 2 tablespoons vinaigrette for the vegetables. Lightly salt and pepper the pan. With the same cookie cutter used for the ravioli rounds, cut out 20 tuna rounds from the tuna slices and place on the prepared cookie sheet; turn tuna rounds over to coat both sides with vinaigrette. Let sit at room temperature 30 to 45 minutes before serving.

TO FINISH THE DISH AND SERVE:
(See photograph page 144.) Bring the salt water to a rolling boil in a medium-size pot. Add the carrots and cook for 30 seconds, then add the celery and leeks and cook 1½ minutes more. Immediately drain vegetables and cool in the ice water; drain on paper towels and place in a bowl.

Process the remaining vinaigrette in the blender a few seconds, then add 2 tablespoons to the vegetables, tossing to coat well. Separate vegetables into 4 equal portions and arrange a portion in the center of each serving plate; on top form a small circle with alternate rounds of tuna and ravioli, using 5 tuna and 5 ravioli rounds for each plate. Arrange the remaining ravioli around the edges of the plates and place an herb leaf or snipped herb sprig in between each. Serve immediately.

LOUISIANA CRAWFISH, LOBSTER FLAN, and ASPARAGUS with GINGER SAUCE and ASPARAGUS CREAM SAUCE

Makes 4 servings

Ginger Sauce (recipe follows)
1 cup Lobster Mousseline (page 215) for flans
3 dozen active live crawfish, as large as possible (Louisiana preferred; about 2 pounds)
Salt water (¼ cup coarse salt mixed with 3 quarts water) for cooking asparagus
16 (9-inch-long) thick asparagus spears (about 1 pound), woody ends trimmed
Ice water for cooling cooked asparagus
Asparagus Cream Sauce (recipe follows)
Butter for greasing flan molds
4 cups Lobster Consommé or Stock (page 214) (preferred) or other Consommé or Stock (page 214) for reheating asparagus tips and crawfish

SPECIAL UTENSILS:
Steamer
4 (¼-cup-capacity) Pyrex flan molds, 2¼-inch diameter at inside top, 1⅝-inch diameter at outside base, 1⅞ inches tall

Prepare the ginger butter for the Ginger Sauce; refrigerate. Next, make the Lobster Mousseline; refrigerate.

STEAM AND PEEL THE CRAWFISH:
In a covered steamer over rapidly boiling water, steam the crawfish until shells turn bright red, about 5 minutes; do *not* overcook. Immediately transfer to a large bowl. When cool enough to handle, separate each head section from the tail by gently twisting the head section off;

discard head sections or save for making stock.

From each tail, peel away the first 2 or 3 rings of shell surrounding the meat, then squeeze the base of the tail with two fingers of one hand while gently pulling the tail meat out of the remaining shell with the other hand, releasing the tail meat in 1 piece; save shells if desired for making stock. If needed, trim thick ends of tails with a paring knife to make them look neat. Cover and refrigerate until time to reheat. (This may be done several hours ahead.)

PREPARE THE ASPARAGUS:
Bring the salt water to a rolling boil in a medium-size nonreactive pot. Add the asparagus spears and cook just until tender, about 4 minutes. Immediately drain and cool in the ice water; drain again. Trim the asparagus to form 3½-inch tips, reserving all trimmings. Cut the tips in half lengthwise; cover and refrigerate until time to reheat. Slice just enough of the trimmings into ⅛-inch slices to yield 2½ tablespoons; cover and reserve, refrigerated, for garnishing the plates. Coarsely slice just enough of the remaining trimmings to yield ¾ cup for the Asparagus Cream Sauce. (This may be done several hours ahead.)

Now make the Asparagus Cream Sauce; refrigerate until ready to reheat just before serving. (This sauce may be prepared several hours ahead.)

TO FINISH THE DISH AND SERVE:
(See photograph page 145.) Heat oven to 250 degrees. Finish the Ginger Sauce; set aside at room temperature.

Next, bake the flans as follows: Lightly butter the flan molds and spoon ¼ of the Lobster Mousseline into each; carefully tap the molds on a flat surface to expel air bubbles. Place molds in a baking pan; add enough boiling water to the pan to come up the sides of molds about 1¼ inches. Cover pan with aluminum foil and bake until done, 15 to 20 minutes. (To check doneness, after 15 minutes of cooking, remove a mold from the pan and lightly press top of flan with your fingertips; if done, it will feel firm and slightly spongy. If in doubt, cook the full 20 minutes.) Remove cooked flans from oven, leaving oven set at 250 degrees. Let flans sit in the pan of hot water, still covered, up to 15 minutes before serving.

Once the flans are out of the oven, reheat the asparagus tips in 2 cups of the consommé over low heat just until warm, about 7 minutes. Meanwhile, slowly reheat the crawfish in the remaining 2 cups consommé just until warm, about 7 minutes; do not let consommé reach a simmer.

When the asparagus and crawfish are warm, assemble the serving plates. Meanwhile, reheat the sauces over low heat; do not overheat the asparagus sauce, or it will turn brown.

To assemble each serving plate, loosen the sides of a flan with a thin flexible-bladed knife in one clean movement and invert onto the center of the plate; arrange 8 crawfish around the edges of the flan and 1 crawfish on top; place 1 asparagus tip between each crawfish on the plate and garnish flan and edges of plate with ¼ of the reserved ⅛-inch asparagus slices. Once all plates are assembled, cover loosely with aluminum foil and heat in the 250 degree oven for 5 minutes, then uncover and spoon about 2 tablespoons of each sauce around opposite edges of each flan. Serve immediately.

GINGER SAUCE

2 cups water for blanching ginger root
2 ounces peeled and coarsely chopped ginger root (a scant ½ cup)
¼ pound (1 stick) unsalted butter, softened
3 tablespoons Lobster Consommé (page 214) (preferred), Lobster Stock (page 214), or other Consommé or Stock (page 214)

SPECIAL UTENSIL:
Chinois

PREPARE THE GINGER BUTTER:

Bring the water to a boil in a small pot. Add the ginger and boil until tender but still firm, about 15 minutes. Drain and cool. Purée in a food processor with the butter until fairly smooth. Cover and refrigerate until firm, at least 1 hour or overnight.

TO FINISH THE SAUCE:

Within 1 hour of serving, combine the chilled ginger butter with the consommé in a small heavy saucepan. Cook over high heat just until butter melts, whisking constantly. Remove from heat and strain through the chinois, using the bottom of a sturdy ladle to force as much through as possible. Return to saucepan and set aside until ready to reheat. *Makes about ⅔ cup.*

ASPARAGUS CREAM SAUCE

¼ cup plus 2 tablespoons heavy cream
¾ cup reserved coarsely sliced asparagus trimmings
2 tablespoons Lobster Consommé (page 214) (preferred), Lobster Stock (page 214), or other Consommé or Stock (page 214)
Fine sea salt and freshly ground black pepper
1 teaspoon Parsley Purée (page 215) (optional)

SPECIAL UTENSIL:
Chinois

Bring the cream to a boil in a small pot. Remove from heat and purée in a blender with the asparagus, consommé, and a little salt and pepper. Add the Parsley Purée, if using, and continue processing just until well blended. Strain purée through the chinois, using the bottom of a sturdy ladle to force as much through as possible. Taste for seasoning. *Makes about ⅔ cup.*

SAUTEED ABALONES with ENOKI MUSHROOMS and ENOKI SAUCE

Makes 4 servings

7 ounces fresh enoki mushrooms
4 tablespoons extra-virgin olive oil
¼ pound (1 stick) unsalted butter, softened
3 tablespoons Lobster Consommé (page 214) (preferred), Lobster Stock (page 214), or other Consommé or Stock (page 214)
Fine sea salt and freshly ground black pepper
12 abalone steaks, trimmed and pounded to a ¼-inch-thickness (about 10 ounces)
4 abalone shells for garnish (optional)
Fresh marjoram (or chervil, thyme, or dill) leaves and sprigs for garnish (optional)
Lobster Coral Garnish (optional) (page 215)

SPECIAL UTENSIL:
Chinois

MAKE THE SAUCE:

Trim away the bottom inch of the enoki stems and cut stems in half crosswise. Set aside top half of stems, covered well and refrigerated, for sautéing. Divide the bottom half of stems into 2 equal portions and separate 1 portion into 10 clumps for use in the sauce.

To start the sauce, heat 1 tablespoon of the oil in a large nonstick skillet over high heat for 1 minute. Reduce heat to medium, add the 10 clumps of enokis, and sauté until browned, about 3 minutes, stirring occasionally. Drain on paper towels. Refrigerate until cool, about 5 minutes, then process in a food processor with the butter until smooth and creamy. Cover enoki butter and refrigerate until firm, at least 1 hour or overnight.

Within 1 hour of serving, finish the sauce. To do this, combine the chilled enoki butter and the consommé in a small heavy saucepan. Heat over medium heat just until butter melts, whisking constantly. Remove from heat and strain through the chinois, using the bottom of a sturdy ladle to force as much through as possible; the strained sauce should yield ½ to ⅔ cup. Return to the saucepan and set aside.

TO FINISH THE DISH AND SERVE:

(See photograph page 146.) Heat oven to 400 degrees. Heat 1 tablespoon of the oil in a large nonstick skillet over medium heat until hot, about 2 minutes. Add the reserved top portion of enokis, season with salt and pepper, and sauté until very lightly browned, about 3 minutes, stirring frequently. Drain on paper towels and cover to keep warm; set aside.

Season the abalone steaks on both sides with salt and pepper. Heat a very large nonstick skillet over high heat for 2 minutes, then add the remaining 2 tablespoons oil, and heat 1 minute more. Add ½ of the steaks to the hot oil and sauté just until cooked through, about 45 seconds on each side; do *not* overcook. Drain on paper towels and blot tops with more towels. Repeat to cook the remaining steaks, using the same oil; drain and blot. Cut each steak in half vertically and serve promptly.

To serve: If using abalone shells, position 1 shell near the edge of each of 4 ovenproof serving plates and spoon ¼ of the sautéed enokis into each, letting some overflow onto the plate; if not using shells, spoon enokis directly into the center of the plates. Arrange an equal portion of the abalone pieces on each plate around the shells or around enokis if not using shells; then heat plates, uncovered, in the preheated oven until all food is hot, about 2 minutes. Meanwhile, reheat sauce. Once plates are out of the oven, spoon 2 to 3 tablespoons sauce around the edges of each serving of abalone. Garnish, if desired, with marjoram leaves and sprigs and a light sprinkle of Lobster Coral Garnish.

SALAD OF ROASTED MILK-FED LAMB, LAMB LIVER QUENELLES, BLACK OLIVE QUENELLES, ARTICHOKES, and CAULIFLOWER with VOSNE-ROMANEE 1972 VINAIGRETTE

Makes 4 servings

4 Poached Artichoke Hearts (page 215) (preferred) or 4 canned artichoke hearts packed in water
BLACK OLIVE QUENELLE MIXTURE:
 2 tablespoons extra-virgin olive oil
 1½ cups pitted black olives (preferably Niçoise), well drained
 1 large peeled garlic clove, minced or crushed
 Freshly ground black pepper
LAMB LIVER QUENELLE MIXTURE:
 2 teaspoons vegetable oil
 2 tablespoons very finely chopped shallots
 1 tablespoon finely sliced spring (green) onion tops
 1 teaspoon fresh thyme leaves
 ½ cup lamb livers (about 4 ounces; or ½

cup young veal livers or coarsely chopped poultry or rabbit livers)
 Fine sea salt and freshly ground black pepper
 1 tablespoon plus 1 teaspoon Vosne-Romanée 1972 vinegar or balsamic or sherry wine vinegar
VOSNE-ROMANEE 1972 VINAIGRETTE:
 ⅔ cup vegetable oil
 2 tablespoons Vosne-Romanée 1972 vinegar or balsamic or sherry wine vinegar
 2 teaspoons extra-virgin olive oil
 Fine sea salt and freshly ground black pepper
1 trimmed rack of young lamb (milk-fed preferred; 1¼ to 1½ pounds)
Fine sea salt and freshly ground black pepper
3 tablespoons vegetable oil
2 dozen thyme sprigs
6 cups loosely packed young Bibb lettuce or other small tender salad greens such as mesclun, radicchio, mache (lamb's lettuce, corn salad), or *frisée* (curly endive)
1 large cauliflower floweret, broken into smaller flowerets, then cut into paper-thin slices
2 tablespoons very finely sliced chives
10 chervil sprigs, snipped into small pieces
8 dill sprigs, snipped into small pieces

SPECIAL UTENSILS:
Fine mesh strainer
Kitchen twine

If using fresh artichoke hearts, poach them as directed on page 215; refrigerate in the cooking liquid. (This may be done at least 1 day ahead.)

PREPARE THE OLIVE QUENELLE MIXTURE:

Heat 1 tablespoon of the oil in a large nonstick skillet over high heat, about 2 minutes. Carefully add the olives and garlic and sauté for 1 minute, stirring constantly. Reduce heat to medium and continue cooking just until garlic is browned, about 1 minute more. While mixture is still hot, purée in a blender with the remaining 1 tablespoon oil until smooth. Season to taste with pepper. Cover and set aside or, if made more than 4 hours ahead, refrigerate; return to room temperature before using. (This may be prepared a day ahead.)

PREPARE THE LIVER QUENELLE MIXTURE:

In a small nonstick skillet, heat the oil over high heat for 1 minute. Add the shallots, spring onions, and thyme leaves; sauté for 1 minute, stirring frequently. Add the livers and season with salt and pepper; reduce heat to low and sauté until centers of livers are only slightly pink, 5 to 7 minutes, stirring occasionally. Add the vinegar and continue cooking just 30 seconds more, stirring constantly. Purée mixture in a blender, then strain purée through the strainer, using the bottom of a sturdy ladle to force as much through as possible. Cover and refrigerate if not using almost immediately. (This may be prepared several hours ahead; return to room temperature before using.)

TO FINISH THE DISH AND SERVE:

(See photograph page 147.) Heat oven to 500 degrees. Combine all the vinaigrette ingredients in a medium-size bowl, whisking until thoroughly blended. Set aside.

Now prepare the lamb. Season the lamb rack generously with salt and pepper, then tie it fairly snugly with several rings of kitchen twine lengthwise and crosswise, including between each chop, so the lamb keeps its shape while cooking. Heat the oil in a heavy roasting pan over high heat until very hot, about 4 minutes. Add the lamb, fat side down, and brown all surfaces, about 7

minutes; end with fat side up. Scatter the thyme sprigs over the top of the lamb and transfer pan, uncovered, to the preheated oven; roast until medium rare, about 7 to 9 minutes. Judge doneness by cutting between 2 ribs to check color of the meat's center or by piercing with a skewer; if the juices run pink, not clear and not bloody, it's done. Transfer lamb to a cutting board and let sit about 10 minutes; then carve the meat from the bones in 1 piece and cut crosswise on the diagonal into ½-inch slices. Cover to keep warm.

Now separate the reserved olive quenelle mixture into 12 equal portions. Use 2 teaspoons to mold each portion into a quenelle (oval shape); as formed, arrange 3 quenelles near the edge of each serving plate. Next, separate the reserved liver quenelle mixture into 8 equal portions and form into quenelles as directed for the olive quenelles; arrange 2 on each plate opposite the olive quenelles.

Drain the artichoke hearts and cut into ⅛-inch slices; set aside. In a mixing bowl, toss the salad greens with 3 tablespoons of the vinaigrette and mound a portion on each of the serving plates. In the same mixing bowl, combine the artichoke and cauliflower slices with ¼ cup more vinaigrette; transfer slices with a slotted spoon to the salads, leaving excess vinaigrette in the bowl. Arrange ¼ of the lamb slices on each salad and brush with some of the excess vinaigrette. Sprinkle salads with chives and snipped chervil and dill sprigs. Serve immediately.

APRICOT TARTE TATIN with APRICOT CUSTARD SAUCE

Makes one 8½-inch tart or 4 to 6 servings

Shortcrust Pastry Dough (recipe follows)
1 recipe Custard Cream (see recipe for Basil Custard Sauce, pages 199-200; omit basil sprigs)
2½ pounds firm ripe unpeeled apricots, cut in half and pitted
Flour for rolling out dough
About ¾ cup sugar
4 tablespoons unsalted butter, softened
10 large fresh mint leaves, very finely julienned for garnish (optional)

SPECIAL UTENSILS:
Chinois
8½-inch heavy ovenproof nonstick skillet

Make the Shortcrust Pastry Dough; refrigerate for at least 2 hours before rolling out. Next, make the Custard Cream for the sauce, omitting basil sprigs; refrigerate at least 30 minutes before finishing the sauce.

FINISH THE SAUCE:

Purée just enough of the apricot halves in a blender to yield ½ cup purée (this will take about 8 halves). Stir the purée into the chilled custard cream. Strain sauce through the chinois, using the bottom of a sturdy ladle to force as much through as possible; it should yield about 1½ cups. Refrigerate until ready to serve. (This may be done several hours ahead.)

ROLL OUT THE DOUGH:

Place the dough on a lightly floured surface and roll out to a ⅛ inch-thickness, then cut out an 8½-inch round from it to fit the skillet being used for baking the tart. Place round on a baking sheet lined with parchment paper and prick several times with a fork. Refrigerate for at least 1 hour. (This may be done several hours ahead.)

TO FINISH THE TART AND SERVE:

(See photograph page 148.) Heat oven to 400 degrees. Evenly distribute ½ cup of the sugar in the bottom of the skillet being used for the tart. Cook over medium heat just until sugar becomes a light caramel-colored syrup, 4 to 5 minutes, stirring constantly with a wooden spoon. Immediately remove skillet from heat and place on a heatproof surface. Carefully arrange the remaining apricot halves in the skillet as follows: Form a ring of halves around the sides of the pan, sitting on their sides in a single layer and tightly fitted together like stacked spoons. (It's important to pack them tightly, or there may be gaps in the finished tart since apricots will shrink as cooked.)

Next, form another ring of apricot halves snugly inside the first ring (this second ring will fill up the pan), again placing them on their sides and fitting them tightly together. Don't be concerned if the 2 rings are not perfect circles, but do try to squeeze in all except 6 of the halves.

Dot the top of the rings with the butter and, if the apricots are not very sweet, sprinkle with ¼ cup more sugar. Arrange the remaining 6 apricot halves, cut side down, in the center of the pan to form a slight mound.

Remove the dough round from the refrigerator and arrange it evenly over the apricots; press edges down to fit snugly between the apricots and sides of skillet (you may need to trim the edges first). Place skillet in a large baking pan lined with aluminum foil to catch drippings. Bake until the crust is golden brown and cooked through, 35 to 40 minutes. Remove from the oven.

Let tart cool in the pan for 5 minutes, then, working over a heatproof bowl, tilt the skillet just enough to drain off juices; set juices aside. Invert a heatproof serving platter over the skillet, and while holding it very tightly against the skillet top so the hot juices don't spatter on you, quickly turn both over to unmold the tart onto the platter. Let cool about 10 minutes more, then tilt the platter to drain off all juices into the bowl.

Pour the juices from the bowl into the same skillet used for the tart; cook over high heat until reduced to a fairly thick and rich caramel-colored syrup, about 5 minutes. Remove from heat and pour the syrup evenly over the tart. Promptly present the finished tart to your guests and serve before the crust has a chance to get soggy.

To serve: Cut the tart into wedges and serve on dessert plates with some of the sauce spooned around the edges. If desired, garnish sauce with julienne mint leaves.

SHORTCRUST PASTRY DOUGH

6 tablespoons unsalted butter, softened
1 cup all-purpose flour, sifted
3 tablespoons powdered sugar
¼ teaspoon fine sea salt
½ large beaten egg
1½ teaspoons milk
½ teaspoon vanilla extract

Combine all the ingredients in the small bowl of an electric mixer fitted with a paddle. Beat at low speed for 1 minute, then increase speed to medium, and continue beating about 30 seconds more until dough forms a ball; do *not* overmix. With floured hands, remove dough from bowl and shape into a smooth ball. Wrap in plastic wrap and refrigerate for at least 2 hours or overnight before rolling out. Freeze if made more than 1 day ahead; thaw before using. *Makes about 10 ounces of dough or enough for one 8½-inch tart.*

PEPPERMINT MOUSSE on CHOCOLATE LEAVES with MINT CUSTARD SAUCE

Makes 4 servings

PEPPERMINT MOUSSE:
4½ ounces white chocolate, cut into small pieces
½ cup heavy cream
3 tablespoons sugar
2 large eggs, separated and at room temperature
1 tablespoon crème de menthe
1 tablespoon water
¼ teaspoon lemon juice
1 ounce semisweet chocolate, very finely chopped
Mint Custard Sauce (recipe follows)
Chocolate Leaves (recipe follows)
Mint sprigs for garnish (optional)

Melt the white chocolate in the top of a double boiler over hot to slowly simmering water, stirring occasionally; set aside in a warm place. (Note: It's especially important to melt white chocolate very slowly, or it may become grainy.) Meanwhile, whip the cream until soft peaks form; refrigerate.

In a medium-size stainless steel bowl, combine 1 tablespoon of the sugar with the egg yolks, crème de menthe, and water. Place the bowl on top of a pot filled with 1 inch of simmering (not boiling) water and cook until mixture has a thick cream soup consistency, 5 to 7 minutes, whisking constantly and vigorously. Set aside.

In the medium-size bowl of an electric mixer (make sure bowl is very clean), combine the egg whites and lemon juice; beat at low speed for about 30 seconds. Increase speed to medium and beat about 30 seconds until frothy bubbles begin to form, then add 1 tablespoon of the sugar and beat at medium for 30 seconds. Increase speed to high, add the remaining 1 tablespoon sugar, and continue beating just until stiff peaks form, about 1 minute more.

Working quickly, gently fold the crème de menthe mixture into the melted white chocolate with a rubber spatula, mixing just until barely blended. Lightly fold in ½ of the egg whites, then the remaining egg whites, then the whipped cream, and then the semisweet chocolate; do *not* overmix. Cover mousse and refrigerate overnight.

On the same day as making the mousse or early on the day of serving, make the Mint Custard Sauce; refrigerate. On the day of serving, make the Chocolate Leaves; refrigerate.

TO SERVE:

(See photograph page 149.) Spoon 3 tablespoons sauce in the center of each of 4 large chilled serving plates and arrange a large chocolate leaf (or several small leaves) on top of each portion. Use 2 tablespoons heated in hot water to form the mousse into 12 quenelles (oval shapes), reheating spoons before forming each quenelle; arrange quenelles on top of the chocolate leaves. Garnish the edges of the leaves with mint sprigs, if desired. Serve immediately.

MINT CUSTARD SAUCE

½ cup heavy cream
½ cup milk
1 ounce mint sprigs (about 10 single stems, each about 6 inches long)
A 4-inch piece of vanilla bean
3 egg yolks (from large eggs)
⅓ cup sugar

SPECIAL UTENSILS:
Chinois placed over a heatproof bowl

In a heavy nonreactive 2-quart saucepan, combine the cream, milk, and mint sprigs; cut the vanilla bean in half lengthwise, scrape, and add scrapings and bean halves to the pan. Bring to a boil, then remove from heat and let sit at least 15 minutes or up to 1 hour.

Combine the egg yolks and sugar in a small bowl, whisking vigorously until thick and pale yellow, about 2 minutes. Return the cream mixture to a boil; remove from heat, discard mint sprigs, and gradually add to the egg yolk mixture, whisking constantly. Return mixture to the saucepan and cook over medium heat, stirring constantly and scraping pan bottom evenly with a wooden spoon, just until it thickens and leaves a distinct trail on the back of the spoon when you draw a finger through it, about 2 minutes; do not let mixture boil. Immediately strain through the chinois into the bowl. (Rinse and save vanilla beans for future use, if desired.) Cover and refrigerate until well chilled, at least 3 hours or overnight. *Makes 1 generous cup.*

CHOCOLATE LEAVES

4 to 6 large (about 5 x 5-inch) attractive fresh inedible leaves, such as fig, maple, or ivy (select flexible, moderately large-veined leaves), or several attractive fresh mint and/or basil leaves (select small to medium-size flat leaves)
6 to 8 ounces dark *pâté à glacer* (chocolate coating) or semisweet or bittersweet chocolate, coarsely chopped
Vegetable oil for greasing inedible leaves

SPECIAL UTENSIL:
Small artist's brush or pastry brush

IF PAINTING INEDIBLE LEAVES:
Separate the leaves and trim stems to a ¼- to ½-inch length. If the veins on the leaves' undersides are very prominent, shave or trim them with a sharp thin-bladed knife. (The chocolate leaves are most likely to crack around these markedly raised veins as the real leaves are peeled away from them.) Blanch the leaves in a large pot of boiling water for 2 minutes, then immediately transfer to ice water to cool. Drain on paper towels and pat both sides thoroughly dry. Arrange in a single layer, veined side up, on a piece of parchment or waxed paper; set aside.

Place the *pâté à glacer* (or other chocolate) in the top of a double boiler and cook over slowly simmering water until half melted, stirring occasionally. Remove from heat and stir until all the chocolate is melted. (Repeat melting procedure as needed while coating the leaves.)

Use the artist's brush or pastry brush to very lightly coat the veined sides of the leaves with oil. Next, working quickly and touching the chocolate with your hands as little as possible to avoid leaving fingerprints, brush the oiled side of each leaf with a thin (about 1/16-inch) and even layer of chocolate; be careful not to get chocolate on the very edges or on the opposite side of the leaf, or you won't be able to peel the real leaf off the chocolate leaf. Place leaves, chocolate side up, in a single layer on a plate and freeze about 2 minutes until chocolate sets. Then brush the leaves with another thin even layer of chocolate; freeze again until chocolate sets. Repeat this procedure until you've brushed 3 or 4 layers of chocolate on each leaf; end by freezing just until chocolate sets.

Carefully peel the real leaves away from the chocolate leaves, starting at the stem ends and handling chocolate as little as possible. Mend any cracked areas by brushing with more chocolate. Refrigerate chocolate leaves at least 15 minutes before using; keep refrigerated until ready to use.

IF PAINTING EDIBLE LEAVES:
Wash and dry the leaves thoroughly; arrange in a single layer on a piece of parchment or waxed paper. Use the artist's brush or pastry brush to apply a thin even layer of chocolate on one side of each leaf; place chocolate side up on a plate and freeze for 5 minutes. Remove leaves from freezer and paint a thin even layer of chocolate on the second (uncoated) side of the leaves; freeze again for 5 minutes. Repeat this procedure until all leaves have 2 layers of chocolate on each side. Once finished, refrigerate leaves at least 15 minutes before using; keep refrigerated until ready to use. *Makes enough chocolate leaves to garnish 4 to 6 desserts.*

CAULIFLOWER, TOMATO, CARROT, BROCCOLI, AND BEET GRANITES

Makes 1 generous quart of each granité

CAULIFLOWER GRANITE:
Salt water (2 tablespoons coarse salt mixed with 1 quart water) for cooking cauliflower
1 pound cauliflower flowerets (about 4 cups), broken into equal-size pieces
Ice water for cooling cooked cauliflower
1½ cups water
2 tablespoons apple cider vinegar
1 tablespoon sugar
Freshly ground black pepper

TOMATO GRANITE:
1½ pounds vine-ripened tomatoes, peeled
1 cup V-8 Juice
¼ cup plus 2 tablespoons tomato paste
¼ cup plus 1 tablespoon apple cider vinegar
3 tablespoons sugar
5 drops Tabasco sauce
Freshly ground black pepper

CARROT GRANITE:
Salt water (2 tablespoons coarse salt mixed with 1 quart water) for cooking carrots
4 cups peeled and chopped carrots
Ice water for cooling cooked carrots
1½ cups water
2 tablespoons sugar
2 tablespoons apple cider vinegar
Freshly ground black pepper

BROCCOLI GRANITE:
Salt water (2 tablespoons coarse salt mixed with 1 quart water) for cooking broccoli
1 pound broccoli flowerets (about 4 cups), broken into equal-size pieces
Ice water for cooling cooked broccoli
1½ cups water
2 tablespoons sugar
2 tablespoons apple cider vinegar
Freshly ground black pepper

BEET GRANITE:
Salt water (2 tablespoons coarse salt mixed with 1 quart water) for cooking beets
1 pound unpeeled beets, rinsed well
Ice water for cooling cooked beets
2 cups water
¼ cup apple cider vinegar
2 tablespoons sugar
Freshly ground black pepper

SPECIAL UTENSIL:
Ice cream machine

MAKE THE CAULIFLOWER GRANITE:

Bring the salt water to a rolling boil in a large pot. Add the cauliflower and cook until tender, about 6 minutes. Immediately drain and cool in the ice water. Drain again and purée in a blender with the remaining ingredients until very smooth.

Freeze in the ice cream machine according to manufacturer's instructions until firm, about 20 to 45 minutes, depending on the type of machine used; then transfer granité to a freezer container and freeze about 1 hour to harden further. Serve immediately (or leave in freezer and serve within a few hours) in chilled bowls, formed into quenelles (oval shapes). (See photograph page 152.)

MAKE THE TOMATO GRANITE:

Cut the tomatoes in half, then scoop out the seeds; the pulp should yield about 2½ cups. Purée pulp in a blender with the remaining ingredients until very smooth. Freeze and serve as directed for the cauliflower granité (see above).

MAKE THE CARROT GRANITE:

Make and serve precisely as directed for the cauliflower granité (see above), except allow 10 to 15 minutes for cooking the carrots until tender and use 2 tablespoons sugar (instead of the 1 tablespoon in the cauliflower granité recipe).

MAKE THE BROCCOLI GRANITE:

Make and serve precisely as directed for the cauliflower granité (see above), except allow about 5 minutes for cooking the broccoli until tender and use 2 tablespoons sugar (instead of the 1 tablespoon in the cauliflower granité recipe).

MAKE THE BEET GRANITE:

Bring the salt water to a rolling boil; add the beets and cook until tender, about 30 minutes. Immediately cool in the ice water, then peel, and coarsely chop. Purée in a blender with the remaining ingredients until very smooth. Freeze and serve as directed for the cauliflower granité (see above).

CHILLED CREAM OF AVOCADO AND CHEVRE SOUP with CHEVRE QUENELLES and DILL

Makes 4 servings

QUENELLE MIXTURE:
5½ ounces chèvre cheese, softened (the youngest possible, preferably 3 to 5 days old)
2 teaspoons extra-virgin olive oil
2 to 4 tablespoons heavy cream
Fine sea salt and freshly ground black pepper

SOUP:
1 tablespoon Parsley Purée (page 215) (optional)
1 medium-size ripe avocado (about 9 ounces)
About 2¼ cups Vegetable Consommé (page 214) (preferred) or Vegetable Stock (page 214)
4 ounces chèvre cheese, softened (the youngest possible, preferably 3 to 5 days old)
½ cup heavy cream
1 teaspoon extra-virgin olive oil
¼ teaspoon lemon juice
Fine sea salt and freshly ground black pepper
1 medium-size ripe avocado (about 9 ounces) for garnish
Dill sprigs for garnish
About 1 teaspoon Parsley Purée (page 215) for garnish (optional)

PREPARE THE QUENELLE MIXTURE:

Combine the chèvre and oil in a small bowl, mixing with a fork until creamy. Mix in 2 tablespoons of the cream, then thin if needed with more cream (the mixture should be the consistency of softened cream cheese). Season to taste with salt and pepper; set aside. (If made more than 1 hour ahead, refrigerate; return to room temperature before forming the quenelles.)

MAKE THE SOUP:

If using and if not already made, make the Parsley Purée; refrigerate. Peel and halve the avocado. Process in a blender with 2 cups of the consommé until smooth, then add the chèvre, and process until well blended. Next, add the cream, oil, lemon juice, the Parsley Purée, and a little salt and pepper and continue processing just a few seconds more until smooth; do *not* overmix, or the soup will curdle. Cover and refrigerate until well chilled, at least 2 hours or up to 4 hours, before serving.

TO SERVE:

(See photograph page 153.) Chill the soup bowls. At the last possible moment (to prevent discoloration), prepare the avocado garnish as follows: Cut the avocado in half lengthwise and carefully remove the pit so the avocado meat stays intact and attractive. Neatly peel each half; then place halves pitted side down and cut crosswise into ¼-inch slices. Arrange 4 slices around the edges of each chilled soup bowl with ends facing center of bowl. Cut some of the remaining slices into 16 small triangles; set aside.

Divide the quenelle mixture into 16 equal portions. Use 2 teaspoons to mold each portion into a quenelle (oval shape), heating the spoons in a bowl of hot water before forming each; as formed, arrange 1 quenelle under the arch of each avocado slice in the bowls; next, garnish each quenelle with 1 of the reserved avocado triangles. Taste soup for seasoning and, if needed, thin with more consommé; then ladle about ½ cup into the center of each bowl. Garnish the avocado slices with dill sprigs, and, if desired, garnish soup with drops of Parsley Purée. Serve immediately.

VEGETABLE TERRINE PROVENÇALE with RED AND YELLOW BELL PEPPER SAUCES

Makes 22 (½-inch) slices or 1 (11 x 3¼ x 2½-inch) terrine

5 Poached Artichoke Hearts (page 215) (preferred) or 1 (14-ounce) can artichoke hearts packed in water
2 cups thinly sliced onions
1 cup Vegetable Consommé (page 214) (preferred) or Vegetable Stock (page 214)
3 tablespoons sugar
Fine sea salt and freshly ground black pepper
2 large well-formed green bell peppers (about 1 pound)
2 large well-formed red bell peppers (about 1 pound)
2 large well-formed yellow or orange bell peppers (about 1 pound)
Vegetable oil for deep frying bell peppers
Ice water for cooling fried bell peppers
2½ to 3½ cups extra-virgin olive oil
3 small to medium vine-ripened tomatoes, peeled, quartered, and seeded (about 1 pound)
3 large garlic cloves, minced
4 cups sliced yellow squash (⅛-inch-thick slices, about 1 pound)
4 cups sliced zucchini (⅛-inch-thick slices, about 1 pound)
1 large eggplant (about 26 ounces, at least 7 inches long)

ASPIC:
3 (¼-ounce) packages unflavored gelatin
1½ cups cold Vegetable Consommé (page 214)

BELL PEPPER SAUCES:
1 large red bell pepper (about 8 ounces), coarsely chopped
About 3 cups heavy cream
Fine sea salt and freshly ground black pepper
1 large yellow bell pepper (about 8 ounces), coarsely chopped
12 fresh basil leaves (preferably purple) for garnish (optional)
Dill sprigs for garnish (optional)
12 chive stems, finely sliced for garnish (optional)
12 chive stems for garnish (optional)

SPECIAL UTENSILS:
Meat slicer
Pâté terrine mold, 5-cup capacity, inside dimensions 11 inches long, 3¼ inches wide, and 2½ inches deep
2 pieces fairly sturdy cardboard cut to just fit inside the top of the terrine mold, stacked and sealed together with foil to form 1 sturdy piece
5 to 7 pounds of weights (1 whole brick plus another ¼ brick work well for this, scrubbed clean and sealed in aluminum foil)
Fine mesh strainer

If using fresh artichoke hearts, poach them as directed on page 215; refrigerate in the cooking liquid.

PREPARE THE ONIONS:

Cut the onion slices in half crosswise to form strips. Heat a large skillet (preferably nonstick) over high heat, 2 to 3 minutes. Add the onions, consommé, sugar, ½ teaspoon sea salt, and a generous amount of pepper. Cook over high heat until most of the liquid evaporates and the onions glaze, about 15 minutes, stirring occasionally. Set aside.

PREPARE THE BELL PEPPERS:

Dry the bell peppers thoroughly. Heat the vegetable oil in a deep fryer or deep pan to 375 degrees. Frying 1 at a time, carefully ease a pepper into the hot oil and fry until the skin pulls away from the pulp and chars slightly, 8 to 10 minutes, turning occasionally. Immediately cool in the ice water, then peel off skin with your hands or rub it off with a clean dishtowel. Drain well on paper towels. Once all peppers are fried, quarter them lengthwise, core, and seed. Trim any curled edges and ribs so each quarter lies flat. Separate colors and cover; set aside.

PREPARE THE TOMATOES:

In a small skillet (preferably nonstick), heat 2 tablespoons of the olive oil over high heat, 2 to 3 minutes. Add the tomatoes and ⅓ of the minced garlic and season with salt and pepper. Sauté until tomatoes are tender but still firm, about 1 minute, turning at least once. Drain on paper towels; cover and set aside.

PREPARE THE SQUASH AND ZUCCHINI:

Heat a very large skillet (preferably nonstick) over high heat, 2 to 3 minutes. Add 3 tablespoons of the olive oil and heat until very hot, about 2 minutes more. Add the squash, ½ of the remaining minced garlic, and a generous amount of salt and pepper. Sauté just until squash is tender and lightly browned, about 5 minutes, stirring frequently. Drain on paper towels and set aside.

In the same hot skillet, heat 3 tablespoons more olive oil over high heat until very hot, about 2 minutes. Add the zucchini, the remaining ⅓ minced garlic, and a generous amount of salt and pepper. Sauté just until zucchini is tender and lightly browned, about 5 minutes, stirring frequently. Drain on paper towels; set aside separate from the squash.

PREPARE THE EGGPLANT:

Use the meat slicer to cut the unpeeled eggplant lengthwise into paper-thin slices. Line a cookie sheet with several thicknesses of paper towels or paper bags for draining slices after sautéing. Have plenty of extra paper towels or paper bags ready since the slices will absorb a lot of oil as sautéed and must be drained well.

Heat 3 tablespoons olive oil in a very large skillet (preferably nonstick) over high heat, about 3 minutes. Working with batches of 2 eggplant slices, sauté the slices about 30 seconds on each side until transparent, being careful not to tear them. Drain on paper towels, separating layers of slices with more paper towels. Add about 3 tablespoons more olive oil to the skillet as needed to keep slices moistened with (but not floating in) oil. You will need a total of 2 to 3 cups of oil for this. Set aside.

MAKE THE ASPIC AND ASSEMBLE THE TERRINE:

For the aspic, soften the gelatin in ½ cup of the consommé for about 2 minutes. Bring the remaining 1 cup consommé to a boil in a small pot, then remove from heat, and stir in the gelatin; return to high heat and cook, stirring just a few seconds until gelatin completely dissolves. Remove from heat.

To assemble the terrine, first blot the eggplant slices thoroughly with fresh paper towels to absorb as much oil as possible. Next, line the bottom and sides of the ungreased terrine mold with them. To do this, first start at one corner of the mold and completely line the right (or left) side of mold with slices; the length of each slice should run parallel to the ends of the mold, and each slice should overlap the previous one at least 1 inch. Make sure the end of each slice covers at least ½ of the bottom of the mold and the other end drapes over the side of mold about 2½ inches. (Once the mold is filled, the ends draped over sides will be folded over to completely cover the other ingredients.) As you line the mold, alternate slices so that after 1 slice is positioned with its larger end in the bottom of the mold (and the smaller end overlapping the side), the next slice is positioned with the smaller end in the bottom of mold (and the larger end overlapping side). Repeat to line the other (left or right) side of mold, then line each end with the remaining slices. Once done, there should be no gaps in the lining through which the mold can be seen. Season the lining with salt and pepper.

Layer the bottom of the mold with the reserved red bell pepper quarters, making sure that there are no gaps in the layer, then pour 3 tablespoons aspic over the top. Next, add a layer of the remaining reserved vegetables; as you finish each layer, season it lightly with more salt and pepper, add 3 tablespoons aspic over top, then lightly press layer down to make it uniformly thick and compact. Layer vegetables in the following order: yellow bell peppers, zucchini, whole drained artichoke hearts (center them in a row down the length of the mold and fill in gaps with some of the zucchini and squash slices), squash, onions, tomatoes, and green bell peppers. Once assembled, the mold should be filled to the top and all aspic used.

Place mold on a small cookie sheet. Fold the eggplant slices over to completely cover other ingredients. Cover mold well with plastic wrap and position the foil-covered cardboard on top to rest directly on the food, then distribute weights evenly over cardboard. Refrigerate overnight.

MAKE THE BELL PEPPER SAUCES:

For the red bell pepper sauce, in a small saucepan combine the red bell pepper with 1½ cups of the cream; season generously with salt and pepper. Bring to a boil over medium heat, stirring occasionally, then simmer until the pulp of the peppers is very tender and cream reduces by about ½, about 35 minutes. Purée in a food processor and taste for seasoning. Strain through the strainer, using the bottom of a sturdy ladle to force as much through as possible; the strained sauce should yield 1¼ to 1½ cups. Cover and refrigerate until well chilled, at least 3 hours or overnight. The sauce will thicken as it chills; if needed, thin with more cream just before serving.

Make the yellow bell pepper sauce as directed for the red bell pepper sauce; refrigerate.

TO SERVE:

(See photograph page 154.) At least 3 hours before serving, unmold the terrine. To do this, remove weights, cardboard, and plastic wrap. Place mold in a deep pan large enough to have room to spare between the mold and pan sides.

Fill pan with 1½ inches of boiling water and let sit for precisely 2 minutes, then invert mold onto a cookie sheet lined with parchment or waxed paper, a cutting board suitable for refrigeration, or a serving platter if you wish to present the terrine to your guests before slicing it. If the terrine doesn't immediately slip out of the mold, soundly tap it, right side up, once or twice on a solid surface; invert again, and it should slip out easily. Blot terrine with paper towels to absorb as much oil as possible. Refrigerate until just before ready to present unsliced to your guests or until ready to slice; for best results, slice while still well chilled so terrine is as firm as possible.

When ready to slice, use a sharp thin-bladed knife or an electric knife to carefully cut terrine crosswise into ½-inch slices. Arrange 1 slice on each chilled serving plate and spoon about 1 tablespoon of each chilled sauce around the edges. If desired, garnish each sauce with droplets of the other sauce and garnish plates with basil leaves, dill sprigs, and a sprinkle of sliced chives and chive stems. Serve immediately.

BLANQUETTE OF FRESH VEGETABLES with CARROT AND CHARDONNAY CREAM SAUCE

Makes 4 servings

Carrot and Chardonnay Cream Sauce (recipe follows)
1 recipe Mirepoix of Red and Yellow Bell Peppers (see recipe for Broiled Cod with Saffron Potatoes, page 171)
Salt water (2 tablespoons coarse salt mixed with 6 cups water) for blanching green vegetables and red cabbage
Ice water for cooling blanched vegetables
5 dozen 2½-inch-long green asparagus tips (about 1½ pounds after trimming)
⅓ cup shelled fava beans
2 dozen small snow peas, tips trimmed
8 small spring (green) onions, trimmed and cut into 4-inch lengths
1 medium-size zucchini, carved into 8 oval shapes
1¼ cups very finely shredded green cabbage
¼ cup shelled green peas
½ cup tiny broccoli flowerets (each about ½ inch long)
1¼ cups very finely shredded red cabbage
Salt water (2 tablespoons coarse salt mixed with 6 cups water) for blanching nongreen vegetables
1 cup small cauliflower flowerets (each about 1 inch long)
1 large russet potato, peeled and carved into 8 oval shapes and soaked in water until time to blanch
1 large turnip, peeled and carved into 8 oval shapes
1 (5- to 7-inch) ear of yellow corn
3 medium to large carrots, peeled and carved into 8 oval shapes
1 medium-size sweet potato, peeled and carved into 8 oval shapes
1 medium-size vine-ripened tomato, peeled and quartered
A few snipped chives
A few snipped chervil, cilantro, tarragon, or dill sprigs

SPECIAL UTENSILS:
4 very large ovenproof serving plates

Make the Carrot and Chardonnay Cream Sauce; refrigerate. Next, prepare the Mirepoix of Red and Yellow Bell Peppers; refrigerate.

Now blanch all the remaining vegetables except the tomato as follows: First, blanch each type of green vegetable and the red cabbage separately. To do this, bring the salt water to a

rolling boil in a medium-size nonreactive pot and blanch each kind of vegetable until tender but still crisp; the approximate blanching time in minutes is provided behind each vegetable's name in the following list: asparagus, 4; fava beans, 4; snow peas, 3; spring onions, 2½; zucchini ovals, 2; green cabbage, 2; green peas, 1½; broccoli, 1; red cabbage, 1½. (The red cabbage must be cooked last because it will color the water; other vegetables can be cooked in any order.) As each is blanched, immediately transfer to the ice water with a slotted spoon to cool; drain on paper towels separate from any other vegetable.

Once all are blanched, cooled, and drained, remove the thin outer shell from the fava beans by cutting a shallow slit in each with a paring knife and peeling or rubbing the membrane off. Set aside.

Next, blanch the nongreen vegetables precisely as you did the green vegetables, using a fresh batch of salt water; blanch in the following order, using the approximate times given for vegetable: cauliflower, 3; potato ovals, 4; turnip ovals, 3; ear of corn, 3½; carrot ovals, 6; sweet potato ovals, 4.

Once all are blanched, cooled, and drained, cut the corn kernels from the cob. Set aside.

Now place the tomato quarters skinned side down. Cut away the top soft portion of each, leaving a ¼-inch-thick slice of firm tomato pulp. Cut these slices lengthwise into ¼-inch-wide julienne strips; cut just enough of the julienne strips into ⅛-inch squares to yield 2 teaspoons of squares for garnishing the center of the serving plates. Reserve julienne strips and squares separately. Cover and refrigerate all vegetables if prepared ahead.

ASSEMBLE THE SERVING PLATES:

(See photograph page 154.) As you assemble each plate, work from the center outward and arrange the vegetables in a radial pattern.

First, mix the green and red cabbages together and separate into 4 equal portions; mound a portion in the center of each plate and spread it to form a 3-inch-wide bed. On top of each cabbage bed arrange ¼ of the potato, sweet potato, and turnip ovals; around the edges of the cabbage arrange ¼ of the zucchini and carrot ovals, snow peas, and cauliflower and broccoli flowerets; nearer the edges of the plate add a portion of the asparagus, green peas, corn, and fava beans (set aside 4 for garnishing the center of plates), then to one side form an arrangement of snipped chives, snipped chervil sprigs (or cilantro, tarragon, or dill), ¼ of the spring onion pieces, and a portion of the julienne tomatoes; in the center of the plate sprinkle ¼ of the Mirepoix of Red and Yellow Bell Peppers and the tomato squares and garnish center with a fava bean; cover plate with aluminum foil. Repeat to assemble the remaining 3 plates. Set aside or refrigerate if assembled more than 1 hour ahead; return plates to room temperature before heating in oven. (The plates may be assembled up to 3 hours in advance.)

TO SERVE:

Heat the foil-covered serving plates in a preheated 350 degree oven just until vegetables are heated through, about 10 minutes; do *not* overcook. Meanwhile, reheat sauce and taste for seasoning; place in a sauceboat for serving at the table. Once plates are out of the oven, unwrap and serve promptly.

CARROT AND CHARDONNAY CREAM SAUCE

3 tablespoons unsalted butter
2½ tablespoons finely chopped shallots

1½ cups peeled and sliced baby carrots (preferred) or regular carrots
Fine sea salt and freshly ground black pepper
1 cup Chardonnay wine
1½ cups Vegetable Consommé (page 214) (preferred) or Vegetable Stock (page 214)
¾ cup heavy cream

SPECIAL UTENSIL:
Chinois

Melt the butter in a large skillet (preferably nonstick) over medium heat. Add the shallots and sauté for 1 minute, stirring occasionally. Add the carrots and a little salt and pepper and sauté for another 1 minute, then add the wine, and cook until most of it evaporates, about 8 minutes, stirring occasionally. Add 1 cup of the consommé and cook until carrots are tender but still a bit crisp, 18 to 20 minutes, stirring occasionally. Add ½ cup of the cream and continue cooking 5 minutes more.

Purée mixture in a blender; add the remaining ½ cup consommé and ¼ cup cream and continue processing until well blended. Strain sauce through the chinois, using the bottom of a sturdy ladle to force as much through as possible. *Makes about 1½ cups.*

LACE-BATTERED FRIED VEGETABLES with LIME MOUSSELINE

Makes 4 first-course servings

VEGETABLES FOR FRYING:
1 recipe Poached Artichoke Hearts, soaking in poaching liquid (page 215) (preferred) or 1 (14-ounce) can artichoke hearts packed in water
2 (9-inch) salsify roots, peeled and cut into 3-inch pieces
12 small cauliflower flowerets
60 French beans (*haricots verts*; about 3 ounces)
20 (2½-inch) asparagus tips
12 small broccoli flowerets
6 fresh chanterelle mushrooms (or your favorite cultivated mushroom), cut into quarters
12 medium-size cherry tomatoes, stems removed
Salt water (¼ cup coarse salt mixed with 3 quarts water) for blanching salsify, cauliflower, French beans, asparagus, and broccoli before frying
Ice water for cooling blanched vegetables
1 recipe Lace Batter (see recipe for Lace-Battered Fried Calamari, page 200)
LIME MOUSSELINE:
¼ cup heavy cream
4 egg yolks (from large eggs), lightly beaten
¼ cup lime juice
1 tablespoon water
Fine sea salt and freshly ground black pepper
RAW VEGETABLE GARNISHES (optional):
12 artichoke leaves
1 (9-inch) salsify root, scrubbed well, ends trimmed, and cut diagonally into 4 pieces
8 small cauliflower flowerets
12 French beans (*haricots verts*; about ½ ounce)
8 (2- to 3-inch) asparagus tips
8 small broccoli flowerets
2 fresh chanterelle mushrooms or cultivated mushrooms, sliced or quartered
20 tiny cherry tomatoes
Vegetable oil for deep frying

Fine sea salt and freshly ground black pepper
About 24 paper-thin slices lime (from 1 large lime)
Fresh chervil leaves or snipped dill sprigs for garnish

PREPARE THE VEGETABLES FOR FRYING:

Prepare the Poached Artichoke Hearts; refrigerate in the poaching liquid.

Next, bring the salt water to a rolling boil in a nonreactive pot, then separately blanch in it the salsify, the cauliflower, the French beans, the asparagus, and the broccoli until tender but still crisp; the approximate blanching time in minutes is provided below for each vegetable: salsify, 5; cauliflower, 3; French beans, 4; asparagus, 4; broccoli, 1.

As each is blanched, immediately transfer to the ice water with a slotted spoon to cool; then drain on paper towels separate from any other vegetable before blanching the next one.

Once finished, blot vegetables thoroughly dry, then wrap each type of vegetable separately in paper towels; before wrapping the salsify, quarter each piece lengthwise. Refrigerate until ready to fry. (This may be done several hours ahead.)

TO FINISH THE DISH AND SERVE:

(See photograph page 155.) Make the Lace Batter; refrigerate at least 1 hour but no more than 2 hours before using.

Next, make the lime mousseline as follows: Bring the cream to a boil in a small pot; remove from heat and set aside.

Bring 2 inches of water to a simmer in a 2-quart pot. Meanwhile, in a large wide heatproof bowl combine the egg yolks, lime juice, and the 1 tablespoon water, whisking until frothy; set bowl over the simmering water and immediately start whisking constantly and very vigorously until mixture is light and thickens enough to leave a distinct track on the back of a wooden spoon when you draw a finger through it, about 7 to 8 minutes. Add the scalded cream and continue cooking and whisking about 1 minute more, then season to taste with salt and pepper, and remove from heat. Set aside at room temperature.

Next, if using the raw vegetable garnish, arrange a portion of each type of vegetable to one side of each serving plate; set aside.

Now fry the vegetables and serve promptly while still hot. To fry the vegetables, heat the oil in a deep fryer or deep pan to between 380 and 400 degrees. Meanwhile, cut the artichoke hearts into quarters and drain on paper towels; set aside. Just before frying each type of vegetable (fry the tomatoes last; other vegetables may be cooked in any order), coat each piece with Lace Batter, let a little of the excess drain off, and ease piece into the hot oil. Fry until dark golden brown, turning at least once; use the approximate frying times in minutes listed below for guidance: salsify, 1; cauliflower, 2; French beans, 1; asparagus, 1; artichoke hearts, 1; broccoli, 3; mushrooms, 1½; cherry tomatoes, ¼.

Once fried, drain each type of vegetable separately on paper towels and while still piping hot, sprinkle lightly with salt and pepper; cover with a dishtowel to keep warm while frying remaining vegetables.

To serve: Arrange a portion of each fried vegetable on each serving plate and spoon 2 small amounts of mousseline around the edges; garnish mousseline with chervil leaves or dill sprigs and arrange lime slices on and around the fried vegetables.

BRAISED BELGIAN ENDIVE and SAUTEED FENNEL with FENNEL SAUCE

Makes 4 servings

About 1 tablespoon Parsley Purée (page 215)
1½ medium-size fennel bulbs (about 12 ounces)
¼ cup extra-virgin olive oil
About 1 cup Vegetable Consommé (page 214) (preferred) or Vegetable Stock (page 214)
Fine sea salt and freshly ground black pepper
4 small to medium Belgian endives (about 18 ounces), stem ends trimmed
1½ cups water
¼ cup sugar
¼ cup lemon juice
4 tablespoons unsalted butter
About 1 tablespoon heavy cream for garnish (optional)
Fennel or dill sprigs for garnish

SPECIAL UTENSIL:
Chinois

SAUTE THE FENNEL AND MAKE THE SAUCE:

Make the Parsley Purée; refrigerate. Trim fennel sprigs (feathery leaves) from the bulbs; set aside for the sauce. Next, trim any stalks from the bulbs and cut the whole bulb in half lengthwise (between the trimmed stalks). Core the solid part of the stem from the 3 half bulbs. With the halves cut side down, use a sharp thin-bladed knife to cut them lengthwise into ⅛-inch or thinner slices; the sliced fennel should yield about 2½ cups.

Heat 2 tablespoons of the oil in a large skillet (preferably nonstick) over high heat for about 1 minute. Add the sliced fennel and sauté about 2 minutes, stirring occasionally. Add the consommé and season with salt and pepper. Reduce heat to medium and continue cooking until fennel is tender, about 10 minutes more, stirring occasionally; remove from heat. Measure out 1 cup of drained sautéed fennel (use a slotted spoon) and set aside.

For the sauce, purée the remaining undrained sautéed fennel in a blender with any reserved fennel sprigs (from trimming fennel bulbs), ¼ cup more of the consommé, and the remaining 2 tablespoons oil. Add 1 tablespoon of the Parsley Purée and continue processing until very smooth and creamy. Strain sauce through the chinois, using the bottom of a sturdy ladle to force as much through as possible; it should yield about 6 tablespoons. Season to taste with salt and pepper; set aside. (Refrigerate sautéed fennel and sauce if prepared ahead.)

TO FINISH THE DISH AND SERVE:

(See photograph page 156.) Cut each endive in half lengthwise and core the solid parts of the stems. In a very large skillet (preferably nonstick), combine the water, sugar, lemon juice, butter, and 1 teaspoon fine sea salt; bring to a boil over high heat. Add the endive halves, cut side down and in a single layer; reduce heat and simmer until the liquid reduces by about ½, about 35 minutes. Turn endive halves over, then continue cooking until all surfaces are caramelized, about 8 minutes more, turning frequently. When finished cooking, set endive aside in the skillet, continuing to turn occasionally to avoid overbrowning (if needed, transfer to a platter and cover to keep warm).

Meanwhile, heat the serving plates in a 250 degree oven. Reheat sautéed fennel, if necessary. Reheat sauce, whisking constantly; thin, if necessary, with more consommé (it should be a thick creamy consistency). Taste sauce for seasoning and if its color dulled when reheated, stir in a little more Parsley Purée.

To serve: In the center of each heated serving plate, mound ¼ of the sautéed fennel and arrange 2 endive halves on top; spoon 1 to 2 tablespoons sauce on the plate and garnish sauce, if desired, with droplets of cream swirled with the tip of a paring knife; garnish plate with fennel leaves or dill sprigs. Serve immediately.

CHARTREUSE OF ASPARAGUS TIPS, ASPARAGUS FLAN, AND FRIED JULIENNE VEGETABLES with ASPARAGUS CREAM SAUCE

Makes 4 servings

50 (7-inch-long) asparagus spears (about 1½ pounds), thick woody ends trimmed
Salt water (¼ cup coarse salt mixed with 3 quarts water) for cooking vegetables
Ice water for cooling cooked vegetables
1¼ cups peeled and julienned carrots (2½ x ⅛-inch strips)
1¼ cups peeled and julienned turnips (2½ x ⅛-inch strips)
1 cup scraped and julienned celery (2½ x ⅛-inch strips)
1 cup julienne leeks (white part only; 2½ x ⅛-inch strips)
Asparagus Cream Sauce (recipe follows)
Vegetable oil for deep frying
Fine sea salt
FLANS (see Note):
Unsalted butter for greasing ramekins
¾ cup heavy cream
¾ cup milk
About 2 cups coarsely sliced and cooked asparagus trimmings (reserved from preparing asparagus spears for this recipe)
3 large eggs, lightly beaten
Fine sea salt and freshly ground black pepper

SPECIAL UTENSILS:
8 (¼-cup-capacity) individual straight-sided ramekins or soufflé dishes, 3 inches in diameter, 1¾ inches deep
Chinois

NOTE:
This recipe makes 8 flans: 4 for the *chartreuses*, one for testing doneness as the flans are cooking, and 3 extras.

Trim the asparagus spears into 1½-inch-long tips, reserving all trimmings; set tips aside. Coarsely slice the trimmings and measure out 1¾ cups for the sauce; the remaining trimmings (about 2 cups) are for the flans.

Bring the salt water to a rolling boil in a large nonreactive pot. Add the 1¾ cups asparagus trimmings for the sauce and cook over high heat for 4 minutes. Immediately transfer with a slotted spoon to the ice water to cool, reserving salt water. Drain the trimmings on paper towels, reserving ice water; refrigerate until ready to make the sauce.

Return salt water to a rolling boil. Add the (about) 2 cups trimmings for the flans and cook 4 minutes. Cool in the ice water and drain on paper towels, reserving salt and ice water; refrigerate until ready to make the flans.

Return salt water to a rolling boil. Add the reserved asparagus tips and cook just until tender, about 4 minutes. Cool in the ice water and drain on paper towels, reserving salt and ice water. Slice the tips in half lengthwise; cover and reserve, refrigerated, for garnishing the flans.

To blanch the julienne vegetables, return the salt water to a rolling boil. Add the carrots, turnips, and celery and blanch for 1½ minutes. Immediately cool in the ice water and drain on paper towels; reserve salt and ice water. Wrap in

more towels to remove as much moisture as possible.

Return salt water to a boil, then add the leeks and blanch for 1½ minutes. Immediately drain and cool in the ice water. Drain on paper towels and wrap with more towels, separate from the other vegetables; refrigerate. (This may be done several hours ahead.)

Make the Asparagus Cream Sauce; refrigerate until ready to reheat just before serving. (The sauce may be prepared several hours ahead.)

TO FINISH THE DISH AND SERVE:

(See photograph page 157.) Make the flans as follows: Heat oven to 300 degrees. Generously butter the ramekins. Combine the cream and milk in a small pot and bring to a boil. Remove from heat and let cool to room temperature.

Process the asparagus trimmings reserved for the flans in a food processor or blender for 1 minute; then add the eggs, the scalded cream-milk mixture, and a generous amount of salt and pepper and continue processing until smooth. Strain liquid through the chinois, using the bottom of a ladle to force as much through as possible. Pour the liquid into the prepared ramekins and place in a deep baking pan; add enough boiling water to come up almost to the tops of the ramekins. Bake uncovered in the preheated oven until done, 50 minutes to 1 hour. To test doneness, after 50 minutes of cooking, remove a ramekin from the oven, loosen sides with a thin flexible-bladed knife in one clean movement, and invert onto a plate; if done, the flan will hold its shape and when cut in half, the center will be solid, not runny. Remove cooked flans from the oven and let them sit in the hot water for at least 10 minutes or up to about 30 minutes before assembling the plates and serving.

Once the flans have finished baking, reduce oven setting to 250 degrees for heating the serving plates once assembled. Next, start heating the frying oil for the julienne vegetables in a deep fryer or large deep pan to 375 degrees. Meanwhile, unmold a flan onto the center of each serving plate; then arrange ¼ of the halved asparagus tips upright around the sides of each flan with cut sides facing in. As finished, transfer each plate, uncovered, to the 250 degree oven to keep warm; the flans may stay in the warm oven up to 15 minutes. Once the last plate is in the oven, continue heating them while frying the julienne vegetables.

When the frying oil is at 375 degrees, fry the carrot-turnip-celery mixture in batches in the hot oil just until crisp and barely browned, about 1 minute; drain on paper towels and blot with more towels, reserving ice water; refrigerate until ready to season lightly with salt. Return oil to 375 degrees before frying each batch.

Now reduce the oil temperature to 350 degrees and fry the leeks just 10 to 15 seconds or until crisp and barely browned. Drain on paper towels and mix with the other fried vegetables. Serve promptly while the vegetables are still crisp.

To serve: Reheat sauce over medium low heat, whisking constantly; do not overheat, or it will turn brown. Remove the serving plates from the oven; separate the fried vegetables into 4 equal portions and mound ½ of each portion on top of each flan. Spoon about 2 tablespoons sauce around the edges of each flan and garnish sauce with the remaining fried vegetables.

ASPARAGUS CREAM SAUCE

¾ cup heavy cream
1¾ cups reserved coarsely sliced asparagus trimmings

¼ cup Vegetable Consommé (page 214)
(preferred) or Vegetable Stock (page 214)
Fine sea salt and freshly ground black pepper
2 teaspoons Parsley Purée (page 215)
(optional)

SPECIAL UTENSIL:
Chinois

Bring the cream to a boil in a small pot. Remove from heat and purée in a blender with the asparagus, consommé, and a little salt and pepper. Add the Parsley Purée, if using, and continue processing just until well blended. Strain purée through the chinois, using the bottom of a sturdy ladle to force as much through as possible. Taste for seasoning. *Makes about 1⅔ cups.*

ANN AMERNICK'S TUILES

Makes about 5½ dozen

Only make these *tuiles* during cool months (when the temperature is under about 60 degrees) and when the humidity is very low, since you need to chill the baking sheet(s) outside between baking each batch. The sheets can't be refrigerated or put out in humid weather because you must not have any condensation on them.

¾ cup granulated sugar
½ cup powdered sugar, sifted
7 tablespoons plus 2 teaspoons cake flour, sifted
1 cup egg whites (from about 8 large eggs), at room temperature
7 tablespoons unsalted butter, melted and cooled
1 teaspoon vanilla extract
1½ cups sliced almonds
Butter for greasing baking sheet(s)

SPECIAL UTENSILS:
1 or 2 brand-new heavy nonstick baking sheets that have been conditioned (preferred; see Note) or old heavy nonstick ones
Thin metal spatula
Rolling pin with a 2- to 3-inch diameter

NOTE:
To condition a brand-new heavy nonstick baking sheet, scour the pan vigorously for about 1 minute with a soapless scouring pad. (Don't worry about marring the finish; you want to remove some, though not all, of its "nonstick" quality.) Rinse well with hot water (don't use soap) and wipe dry with paper towels. Next, butter the pan generously, then wipe it well with paper towels and rinse again with hot water. Repeat this exact procedure (scour, rinse, wipe dry, butter, wipe again, rinse again) at least 2 more times. Now the pan is ready to use.
After using the conditioned pan, clean it by rinsing under hot water; never use soap on it. Wipe dry with paper towels. Ideally, use only for making these *tuiles*.

PREPARE THE BATTER:
In a medium-size bowl, combine the sugars and flour, mixing by hand (do not use an electric mixer for this recipe) until thoroughly blended and free of any lumps. Add the egg whites, gently mixing with a large spoon until batter is completely smooth (it should have no lumps or air bubbles in it), about 2 minutes. Stir in the butter and vanilla. Cover and refrigerate overnight or up to 1 week before using. Add the almonds to the batter just before ready to form and bake the *tuiles*.

TO FINISH THE *TUILES*:
Heat oven to 350 degrees. If using an old nonstick baking sheet (or sheets), butter very lightly. If using a baking sheet specially conditioned for this recipe, it will already have on it a very light film of butter, which is perfect. Place the pan outside in the cool air until chilled; do not refrigerate.
Preparing 2 *tuiles* at a time, place 1 rounded teaspoon of batter on each half of the chilled pan and spread each portion out with your fingertips to form a very thin 6-inch round that has no holes in it; make sure that the almonds are well distributed in the round and in a single layer. Bake until evenly browned, 4 to 5 minutes; watch carefully so they don't burn. Remove from oven and let cool about 1 minute, then use the spatula to lift up the edge of each *tuile* so you can pick it up with your hands; immediately drape each over the rolling pin, smoother side down. Let the *tuiles* cool thoroughly, then very carefully lift these fragile cookies off the rolling pin and set aside in a dry place at room temperature. (Your first few *tuiles* may be less than perfect, but once you become accustomed to making them, you'll be delighted with the results.)
Next, wipe the pan clean with paper towels and place outside to chill again; then lightly butter pan—whether it's old or new—and repeat until all *tuiles* are baked. Serve as soon as possible, inverted to sit on their edges. (See photograph pages 158-159.)

KATHY DINARDO'S CHEESECAKE with CONFIT OF PARIS MUSHROOMS

Makes 16 servings (or one 10-inch cheesecake and 2 cups confit)

CHEESECAKE CRUST:
2½ cups (about 9 ounces) finely ground graham cracker crumbs
1 cup coarsely chopped walnuts
¼ cup sugar
1 teaspoon ground cinnamon
2 pinches of salt
6 tablespoons unsalted butter, melted
CHEESECAKE FILLING:
3 (8-ounce) packages cream cheese, softened
⅔ cup sugar
3 large eggs, at room temperature
¼ teaspoon fine sea salt
3 cups dairy sour cream
2 tablespoons unsalted butter, melted
1 tablespoon plus 1½ teaspoons high-quality dark rum
1 tablespoon lemon juice
1 teaspoon vanilla extract
CONFIT OF PARIS MUSHROOMS:
2 cups water
¼ cup lemon juice
1½ pounds extra-large fresh button mushrooms (*champignons de Paris*), washed (the whitest ones possible)
1½ cups sugar

SPECIAL UTENSIL:
10-inch cheesecake pan, 3 inches deep, with a removable bottom

MAKE THE CHEESECAKE:
Heat oven to 350 degrees. To prepare the crust, combine the graham cracker crumbs, walnuts, sugar, cinnamon, and salt in a large bowl, mixing well. Line the bottom of the ungreased cheesecake pan evenly with the mixture, pressing firmly into place; dribble the butter over the top. Set aside.
For the filling, place the cream cheese in the large bowl of an electric mixer and beat until creamy. With the machine at medium speed, beat in the sugar until well blended. Beat in the eggs and salt, then the sour cream, butter, rum, lemon juice, and vanilla.
Pour filling on top of the prepared crust and tap pan solidly on a work surface a few times to dispel air bubbles. Bake on the middle shelf of the oven until top is set enough so that when it is very lightly pressed, no batter sticks to your fingertips and no fingerprints are left behind on the surface, about 45 minutes. Turn off oven and leave the door ajar 1 to 2 inches for 1 hour to finish cooking. Refrigerate for at least 8 hours or overnight; the cake will become firm as it chills.

MAKE THE CONFIT:
Combine the 2 cups water with the lemon juice in a heavy nonreactive 2-quart saucepan. Separate the mushroom caps from the stems. Cut the caps into ¼-inch slices, placing them in the lemon water as cut to prevent browning. Add the sugar and bring to a boil, then gently simmer for 1½ hours, stirring occasionally. Remove from heat and serve immediately. (If made ahead, set aside at room temperature for up to 2 hours, then refrigerate.)

TO SERVE:
(See photograph page 160.) Run a thin flexible-bladed knife around the edges of the cheesecake; remove sides of pan and slice cake into wedges. Serve on dessert plates topped with some of the undrained confit, or serve confit in a sauceboat at the table. Refrigerate leftovers.

POULTRY STOCK

Makes about 3 quarts

½ large unpeeled onion
3 medium-size unpeeled garlic cloves, crushed
5 pounds chicken or other poultry wings, backs, and/or necks (about 2½ quarts) or about 3 quarts poultry bones
2 cups V-8 Juice
2 cups unpeeled chopped tomatoes
1 cup unpeeled chopped carrots
1 cup chopped celery
1 cup chopped leeks (mostly white part)
1 cup unpeeled chopped turnips
½ cup chopped shallots
10 large parsley sprigs
7 very leafy thyme sprigs
5 medium-size bay leaves
1 tablespoon coarse salt
½ teaspoon whole black peppercorns
About 3 quarts cool water

SPECIAL UTENSILS:
10-quart or larger stockpot
Chinois

CHAR THE ONION AND GARLIC:

Heat a small empty skillet (preferably non-stick) over high heat until extremely hot, about 10 minutes. Place the onion half, cut side down, in the skillet and cook until cut side is completely and evenly charred black, about 20 minutes; check cut side frequently and, if not browning evenly, lightly press onion down occasionally. After onion has cooked about 15 minutes, add the garlic to the skillet and cook until charred black on both sides, about 5 minutes. Remove from heat and transfer onion and garlic to the stockpot. (Charring the onion and garlic helps give color and flavor to the stock.)

TO FINISH THE STOCK:

Add all remaining ingredients except the water to the pot, then add at least 3 quarts cool water (more if necessary) to cover the other ingredients. Bring to a boil. Reduce heat and simmer uncovered at least 6 hours or up to 12 hours, skimming occasionally and adding more water as needed to keep about 3 quarts of liquid in the pot; cook at least 30 minutes after the last addition of water. Remove from heat.

. Strain stock through the chinois, using the bottom of a sturdy ladle to force as much through as possible. The stock is now ready to use as is (immediately or let cool, then refrigerate or freeze) or use to make Consommé (this page). The stock will keep well refrigerated for up to about 3 days and frozen for up to 4 weeks.

BEEF STOCK

Makes about 3 quarts

Make the beef stock as directed for the Poultry Stock (above), using instead of poultry pieces 2¼ pounds beef soup bones, 1½ pounds beef marrow bones, and 1 pound oxtails blanched as follows: Bring 5 quarts water to a rolling boil in a large stockpot. Add the soup bones, marrow bones, and oxtails and return to a boil. Remove from heat and drain. Use immediately or cool and refrigerate if blanched ahead.

VEAL STOCK

Makes about 3 quarts

Make the veal stock as directed for the Poultry Stock (this page), using instead of poultry pieces 2 pounds veal bones and 2 pounds veal shank, blanched as for Beef Stock (above).

LOBSTER STOCK

Makes about 3 quarts

Make the lobster stock as directed for the Poultry Stock (this page), using instead of poultry pieces 3 pounds (about 4 quarts) lobster shells from raw or cooked lobsters, including heads if possible, simmered for 45 minutes to 1 hour (instead of 6 to 12 hours).

VEGETABLE STOCK

Makes about 3 quarts

1½ medium-size unpeeled onions
6 medium-size unpeeled garlic cloves, crushed
3 cups unpeeled chopped tomatoes
3 cups unpeeled chopped carrots
3 cups chopped celery
3 cups chopped leeks (mostly white part)
3 cups unpeeled chopped turnips
¾ cup chopped shallots
15 large parsley sprigs
15 large dill sprigs
15 very leafy thyme sprigs
15 chive stems
3 large bay leaves
2 tablespoons coarse salt
1 teaspoon whole black peppercorns
2 cups V-8 Juice
About 5 quarts cool water

SPECIAL UTENSILS:
8-quart or larger stockpot
Chinois

Cut the whole onion in half and char the 2 halves simultaneously in the same small skillet and the garlic as directed for Poultry Stock (this page); place in the stockpot. Meanwhile, chop the remaining onion half; set aside.

Once the onion halves and garlic are in the stockpot, add all remaining ingredients except the water; then add at least 5 quarts cool water (more if necessary) to cover the other ingredients. Bring to a boil. Reduce heat and simmer uncovered at least 6 hours or up to 12 hours, skimming occasionally. (Note: During the first several hours of cooking, add more water as needed to keep about 5 quarts of liquid in the pot; when about 2 hours of cooking time remain, stop adding water and let liquid reduce to about 3 quarts.) Remove from heat. Strain and use as directed for the Poultry Stock.

CONSOMMÉ

(How to Clarify Stock)

Makes about 1 to 3 quarts consommé

For vegetable stock, simply omit the ground beef or fish from the clarification process.

1½ to 3½ quarts strained Beef, Veal, Poultry, Lobster, or Vegetable Stock (this page)
¼ cup unpeeled finely chopped carrots
¼ cup finely chopped celery
¼ cup finely chopped onions
¼ cup finely chopped leeks (white and green parts)
¼ cup unpeeled finely chopped turnips
¼ cup unpeeled finely chopped tomatoes
2 tablespoons finely chopped shallots
4 large parsley sprigs
1 large garlic clove, peeled and minced
6 ounces scallops or skinned and coarsely chopped fillets of pike, halibut, or flounder (if clarifying Lobster Stock) or 6 ounces lean ground beef (if clarifying Poultry, Beef, or Veal Stock)
1 cup egg whites (from about 8 large eggs)
Fine sea salt and freshly ground black pepper

SPECIAL UTENSILS:
Deep 4-quart saucepan or other large deep pot with a relatively small (about 8-inch) diameter so clarification ingredients can form a fairly thick crustlike layer across the stock as it clarifies
Chinois
Cheesecloth

Skim the stock thoroughly and bring to a boil in the saucepan. Meanwhile, in a food processor mince together the carrots, celery, onions, leeks, turnips, tomatoes, shallots, parsley sprigs, garlic, and the scallops or fish, if using. Transfer mixture to a large bowl and add the egg whites and the beef, if using; mix thoroughly. Add mixture to the boiling stock and bring to a very slow simmer, stirring gently during the first 2 to 3 minutes of cooking to prevent sticking (disturb the surface as little as possible while stirring so a layer of solids can form across it). Reduce heat and, *without* stirring, continue very slowly simmering 45 minutes more; keep stock from strongly bubbling so a fairly thick crustlike layer can develop over the surface. Remove from heat.

Line the chinois with 8 or more thicknesses of damp cheesecloth and ladle consommé through it into a large bowl, leaving crust behind in pan; do not force consommé through chinois or food particles may also slip through.

Once strained, the consommé should be amber colored, completely translucent, and free of particles or fat globules. If not, use one or more of the following corrective procedures: Skim the surface until clear by laying single sheets of toilet tissue across the surface—just for a second—and then lifting them off; and/or continue straining consommé through the cheesecloth until clear; and/or refrigerate until the fat congeals on the surface and it can be lifted off.

Season the finished consommé to taste with salt and pepper. Use immediately, refrigerate, or freeze (in freezer containers or in covered ice cube trays) until ready to use. Consommé keeps well refrigerated for up to about 3 days and frozen for up to 4 weeks.

FOND DE VEAU

Makes 2 to 2½ cups

4½ pounds veal bones
4 pounds calves' feet
1 large unpeeled onion, cut in half
6 medium-size unpeeled garlic cloves, crushed
2 cups unpeeled chopped tomatoes
1 cup unpeeled chopped carrots
1 cup chopped celery
1 cup chopped leeks (mostly white part)
1 cup unpeeled chopped turnips
½ cup chopped shallots
20 large parsley sprigs
15 very leafy thyme sprigs
10 medium-size bay leaves
2 tablespoons coarse salt
1 teaspoon whole black peppercorns
2 cups V-8 Juice
1 (6-ounce) can tomato paste
Several gallons cool water

SPECIAL UTENSILS:
12-quart stockpot
Large fine mesh strainer or chinois
Heavy 4-quart saucepan

Heat oven to 500 degrees. Place veal bones and calves' feet in a large roasting pan and brown until dark on all sides, about 2½ hours.

Meanwhile, char both onion halves simultaneously in the same small skillet and the garlic as directed in the Poultry Stock recipe (this page); set aside until called for.

When the veal bones and calves' feet are browned, place them in the stockpot; set aside roasting pan. Add all remaining ingredients except the water to the pot, then add enough cool water to cover the other ingredients. Bring to a boil. Reduce heat and strongly simmer uncovered for at least 3 hours, preferably 8, skimming occasionally and adding more water as needed to keep all ingredients covered.

Meanwhile, deglaze the roasting pan as follows: Drain any fat from the pan but don't scrape pan. Add 2 quarts water and bring to a boil over high heat on the stove. Continue cooking 1 to 2 minutes while scraping pan bottom and sides with a spoon to dissolve all browned matter. Add this liquid to the stockpot.

Once the mixture has strongly simmered 3 to 8 hours, reduce heat and slowly simmer for 2 more hours, adding only enough water to keep about 5 cups of liquid in the pot. During these 2 hours, the liquid will reduce and thicken to a gruel consistency; stir frequently so the mixture doesn't stick to the pan bottom and scorch. If it does scorch, change pots immediately without scraping bottom of pot.

Remove from heat. Let cool about 1 hour, then discard bones and strain through the strainer or chinois, using the bottom of a sturdy ladle to force as much through as possible. Measure the strained sauce's yield and make a note of it; it should be between 4 and 6 cups. (The *Fond de Veau* may be refrigerated at this point and finished the next day.)

Place the strained sauce in the 4-quart saucepan with equal parts cool water. Bring to a rolling boil, skimming occasionally. Reduce heat and strongly simmer until reduced to 2 to 2½ cups, about 2 hours 15 minutes, stirring and skimming occasionally. Once done, the sauce should be very thick and a rich dark brown. Use immediately, cool and refrigerate, or freeze. This will keep up to 1 week refrigerated or 4 weeks frozen.

BRIOCHE

Makes 1 (10½ x 3½-inch) loaf, 2 (8½ x 4½-inch) loaves, or about 3½ pounds dough

⅓ cup very warm water
1 (¼-ounce) package active dry yeast (*not* quick-rising)
2⅓ cups cake flour, plus flour for mixing bowl and rolling out dough
2 cups bromated flour
⅓ cup sugar
2½ teaspoons fine sea salt
6 large eggs, at room temperature
⅝ pound (2½ sticks) unsalted butter, softened for about 15 minutes and cut into 1-inch cubes
Butter for greasing loaf pan(s)

SPECIAL UTENSILS:
1 large loaf pan (5 inches deep, outside dimensions at bottom 10½ inches long and 3½ inches wide) or 2 small loaf pans (3 inches deep, outside dimensions at bottom 8½ inches long and 4½ inches wide)

Combine the water and yeast in a small bowl; let sit 10 minutes, then stir with a very clean spoon until yeast is completely dissolved. Set aside.

Into the large bowl of an electric mixer fitted with dough hooks, sift together the flours, sugar, and salt. Add the eggs and beat for 1 minute at low speed, scraping down the sides with a rubber spatula as needed. Slowly add the dissolved yeast and continue beating at low speed for 5 minutes. Stop the machine momentarily, scrape dough off the dough hooks, and return machine to low speed; beat 5 minutes more. Add the

butter cubes, ¼ at a time, beating for about 1 minute after each addition; if needed, stop machine again to scrape dough from hooks. Once all butter has been added, continue beating until completely blended into the dough, 10 to 15 minutes more. (The mixing time will depend on the softness of the butter and the type of electric mixer used; if in doubt, mix more, not less.)

Place dough in a large floured mixing bowl and cover with plastic wrap (the dough will stick to a cloth towel). Set aside in a warm place until doubled in size, about 3 hours. Turn dough onto a generously floured work surface and gently work the air out of it (instead of punching it down) by folding it over several times while lightly pressing it down. Return dough to the bowl, cover with plastic wrap, and refrigerate overnight.

Very generously butter the loaf pan(s), including the rim; set aside. Turn dough onto a floured work surface. With floured hands, mold dough into a 10 x 5-inch rectangle that is about 2 inches thick. Cut the rectangle in half lengthwise with a pastry scraper or large knife to form two 10 x 2½-inch rectangles.

Cut each rectangle crosswise into 8 equal-size pieces; each piece should be about 2½ inches long, 1¼ inches wide, and 2 inches thick. Roll each piece of dough gently between your palms to form it into a smooth log whose length is equal to the width of the loaf pan(s).

If using the larger loaf pan, arrange 8 of the logs crosswise in the pan to make a single layer, then form a second layer with the remaining 8 logs placed crosswise. If using the smaller pans, arrange 8 logs crosswise in each pan, fitting them snugly together to make a single layer. Let dough rise uncovered in a warm place until about ½ inch above the top of the pan(s), about 3 hours. Bake in a preheated 350 degree oven until done and well browned on top, 35 to 40 minutes. Remove from oven and immediately turn brioche out onto a wire rack.

If using almost immediately, let the bread cool about 10 minutes, then slice and serve. If serving within a few hours, promptly wrap the very hot bread in aluminum foil and store at room temperature until ready to use. If freezing, immediately wrap the very hot bread in foil and promptly freeze; when ready to use, reheat (without thawing and still wrapped in foil) in a 250 degree oven until heated through, about 20 to 25 minutes. The bread may be kept frozen with very good results for up to 1 month.

LOBSTER CORAL GARNISH

Makes ½ cup

"Lobster coral" is the green sac of roe contained in the head of some but not all female lobsters. You may also use *precooked* lobster coral (lobster caviar) in this recipe. If precooked coral isn't available in your area, it may be purchased by mail-order from Caspian Caviars in Camden, Maine.

8 ounces raw lobster coral or cooked lobster coral (lobster caviar), fresh or thawed
2 cups water (if using *raw* lobster coral)
Ice water (if using *raw* lobster coral)

SPECIAL UTENSIL:
Fine mesh strainer

Heat oven to 400 degrees.

If using raw lobster coral, bundle the coral sacs snugly together in a piece of plastic wrap, bringing all edges of wrap together and twisting them until coiled very tightly so package will stay sealed while cooking. Bring the water to a boil in a small pot. Add the packaged coral and

boil until bright red and firm, 3 to 5 minutes. Immediately drain and cool in the ice water; drain again and unwrap.

If using *precooked* lobster coral, do *not* boil.

Spread the cooked lobster coral on a cookie sheet lined with parchment paper, breaking up any clumps. Bake uncovered in the preheated oven for 15 minutes. Remove pan from oven momentarily and stir coral well, crushing any remaining clumps. Continue baking until very dry, about 15 minutes more. Let cool to room temperature.

Working over a bowl, sift the coral through the strainer, using your fingertips to force as much through as possible; if some bits are too hard to force through, process them a few seconds in a blender, then sift through strainer. Use immediately, refrigerate, or freeze. The garnish will keep well for up to 2 weeks refrigerated or for up to 1 month frozen.

LOBSTER CREAM BASE SAUCE

Makes about 3 cups

¾ cup unpeeled finely chopped carrots
¾ cup finely chopped celery
¾ cup finely chopped leeks (mostly white part)
¾ cup unpeeled finely chopped turnips
½ cup finely chopped onions
3 tablespoons finely chopped shallots
½ ounce parsley sprigs (about ½ small bunch)
1 tablespoon coarse salt
1 teaspoon whole black peppercorns
Lobster shells from 4 raw and/or cooked lobsters (about 3 pounds or 3 to 4 quarts shells, heads included if possible)
1 cup Chardonnay wine
5 cups heavy cream

SPECIAL UTENSIL:
Very fine mesh strainer or chinois

Heat a heavy 6-quart saucepan over high heat for about 1 minute. Add the carrots, celery, leeks, turnips, onions, shallots, parsley sprigs, salt, peppercorns, and lobster shells. Cook for 5 minutes, stirring occasionally. Add the wine and bring to a boil, then simmer for 10 minutes, stirring occasionally. Add the cream, return to a boil, then simmer for 15 minutes more. Remove from heat. Remove and discard the larger shells, then strain sauce through the strainer or chinois, using the bottom of a sturdy ladle to force as much through as possible. Use immediately or cool slightly, cover, and refrigerate. Use within 48 hours; do not freeze.

LOBSTER MOUSSELINE

Makes about 1 cup, or enough for 1 to 2 dozen quenelles

1 (1- to 1½-pound) active live Maine lobster
3 ounces sea scallops; rinsed and small tough muscle on the side of each removed
About ½ teaspoon fine sea salt
Freshly ground black pepper
About ½ cup heavy cream
½ teaspoon very finely sliced chives (optional)
½ teaspoon Lobster Coral Garnish (this page) (optional)

SPECIAL UTENSIL:
Very fine mesh strainer

Ease the lobster, head first, into a large pot of boiling water. Promptly cover pot and cook for precisely 1 minute. Immediately drain on paper towels and let cool briefly. Protecting your hands with thick dishtowels, twist off the head and claws, then remove the tail and claw meat from

the shells. (The head and shells may be saved, frozen if desired, for making Lobster Cream Base Sauce (this page) or Lobster Stock, page 214.

Process the lobster meat in a food processor with the scallops, ½ teaspoon of the salt, and a generous amount of pepper until smooth. Add ½ cup of the cream and continue processing just a few seconds until well blended; do *not* overmix. Strain mousseline through the strainer, using a rubber spatula to force as much through as possible; the strained mousseline should yield about 1 cup. Stir in the chives and Lobster Coral Garnish, if using.

Now form and cook a test quenelle to taste for seasoning and judging texture. To do this, mold a scant 1 teaspoon of the mousseline into a quenelle; cook uncovered in a small pan of hot (not simmering) water for 5 minutes. Remove from heat and transfer quenelle with a slotted spoon to a dish. Let cool briefly, then taste. The ideal quenelle should be well seasoned and so tender that it melts in your mouth. If underseasoned, add more salt and pepper to the remaining mousseline, whisking just until blended. If texture is rubbery, add 1 tablespoon more cream to the mousseline, whisking until barely blended. Next, form and cook another small test quenelle. Check its texture and, if needed, add up to 1 tablespoon more cream to the remaining mousseline, keeping in mind that the finished mousseline must be stiff enough to hold its shape, whether used as a filling or for quenelles. Cover and refrigerate mousseline at least 1 hour before using. Use within 8 hours.

PARSLEY PUREE

Makes 3 to 4 tablespoons

6 to 7 ounces parsley sprigs (about 2 large bunches)
Salt water (¼ cup coarse salt mixed with 3 quarts water) for cooking parsley sprigs
Ice water for cooling cooked parsley sprigs
2 tablespoons vegetable oil

SPECIAL UTENSIL:
Fine mesh strainer

Trim any thick stems from the parsley sprigs; discard trimmings. Bring the salt water to a rolling boil in a large nonreactive pot over high heat. Add the parsley sprigs and cook for 2 minutes. Immediately drain and cool in the ice water. Drain again and squeeze dry. Purée in a food processor with the oil until smooth. Strain purée through the strainer, using the bottom of a sturdy ladle to force as much through as possible. Use immediately or cover and refrigerate until ready to use. The purée will keep up to about 5 days refrigerated.

PASTRY CREAM

Makes about 1 cup

1 cup milk
A 4-inch piece of vanilla bean
3 egg yolks (from large eggs)
¼ cup sugar
2 tablespoons plus 1 teaspoon cornstarch

Place the milk in a small heavy nonreactive saucepan. Cut the vanilla bean in half lengthwise, scrape, and add the scrapings and bean halves to the pan. Bring to a boil, then remove from heat, and let sit 15 minutes.

In a medium-size bowl, combine the egg yolks, sugar, and cornstarch, whisking vigorously until thick and pale yellow, about 2 minutes. Return the milk mixture to a boil, then remove from heat and gradually add to the egg

yolk mixture, whisking constantly. Return mixture to the saucepan and cook over medium heat, whisking constantly and scraping pan bottom evenly, just until thick and starting to boil, about 2 to 3 minutes. (Note: If lumps appear in the mixture while cooking, immediately remove from heat and whisk vigorously until smooth, then continue cooking.) Remove from heat and transfer to a heatproof bowl; cover with plastic wrap directly on the surface of the cream. Chill for at least 30 minutes before using. This may be made a day ahead.

POACHED ARTICHOKE HEARTS

Makes 4 to 6 artichoke hearts

2 lemons, cut in half
4 to 6 medium-size artichokes (about 2 to 2½ pounds)
2 cups Consommé of your choice (page 214) (preferred), Stock of your choice (page 214), or water
¼ cup extra-virgin olive oil
¼ teaspoon fine sea salt
10 whole black peppercorns
10 fresh or dried juniper berries
3 very leafy thyme sprigs
1 large bay leaf

Add the juice from 1 of the lemon halves to a medium-size bowl of cool water. Remove the leaves and chokes from the artichokes. While preparing each, rub the artichoke meat with 1 of the remaining lemon halves to prevent discoloration. Once each is prepared, place in the lemon water.

Next, drain the hearts and place in a small nonreactive pot. Add the juice from the remaining 2 lemon halves and the consommé, oil, salt, peppercorns, juniper berries, thyme sprigs, and bay leaf. Bring to a boil, then simmer until hearts are tender, about 20 minutes. If using immediately, drain. If made ahead, refrigerate in the cooking liquid. The hearts may be poached at least 1 day before using and will keep several days refrigerated in the cooking liquid.

Index